Monet

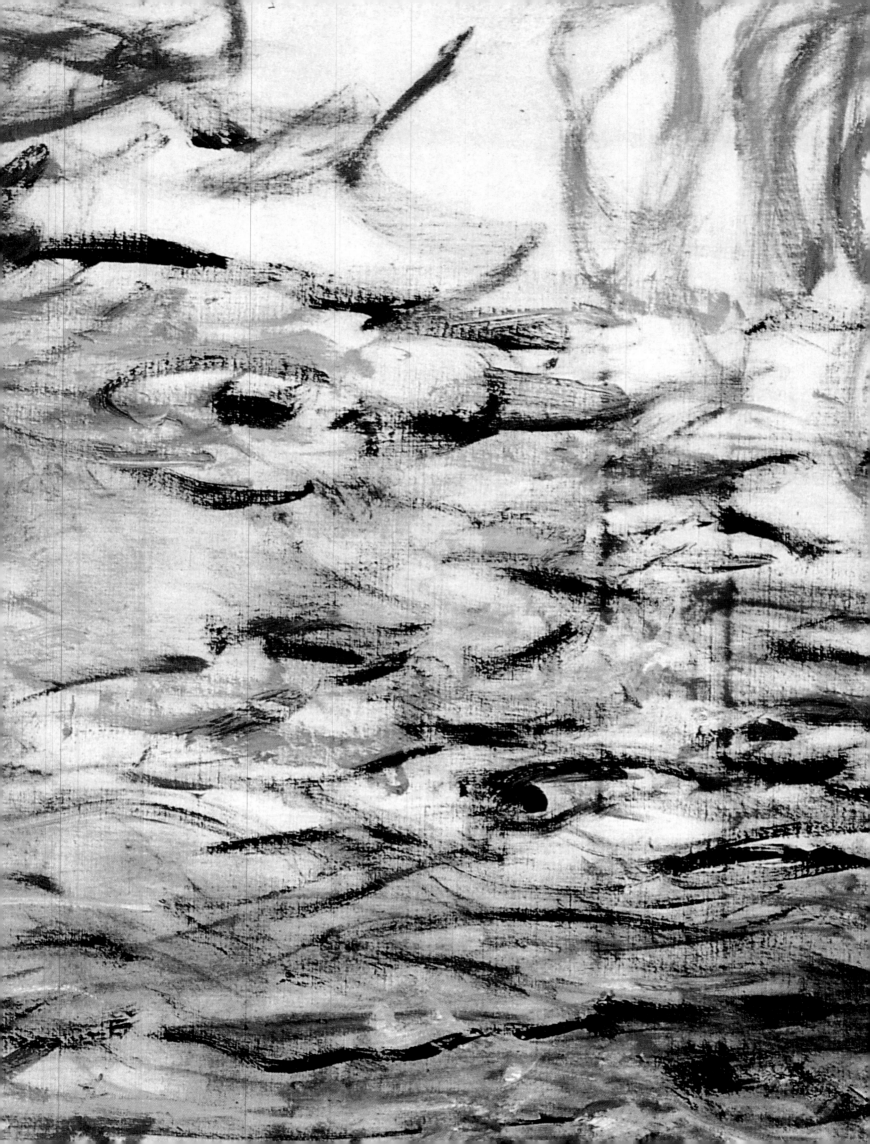

Daniel Wildenstein

Monet

or the Triumph of Impressionism

TASCHEN

WILDENSTEIN
INSTITUTE

PAGE 2:
Water-Lilies (detail)
1919–1920
Cat. no. 1902

RIGHT:
Claude Monet in the door
of his second studio,
27 October 1905
Photo Baron de Meyer
Archives Durand-Ruel

PAGE 7:
Monet in the first studio,
photographed by Choumoff in 1920.
Reproduced in *Revue de l'Art*, February 1927.
Roger-Viollet Collection

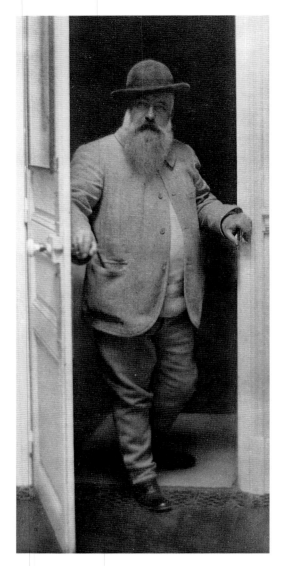

This biography of Monet is a revised version
of the first volume of the four-volume
catalogue also published by TASCHEN.
The numbering of Monet's works as well
as the figures in bold print in the text
correspond to the catalogue numbers in
the original volumes II–IV.

© 2006 TASCHEN GmbH
Hohenzollernring 53, D–50672 Köln
www.taschen.com

Original edition: © 1999 Benedikt Taschen Verlag GmbH
Conception and layout: Gilles Néret, Paris
Research consultancy: Rodolphe Walter, Michèle Paret
English translation: Chris Miller, Oxford; Peter Snowdon, Paris

Printed in China
ISBN-13: 978-0-681-56794-8
ISBN-10: 0-681-56794-5

Contents

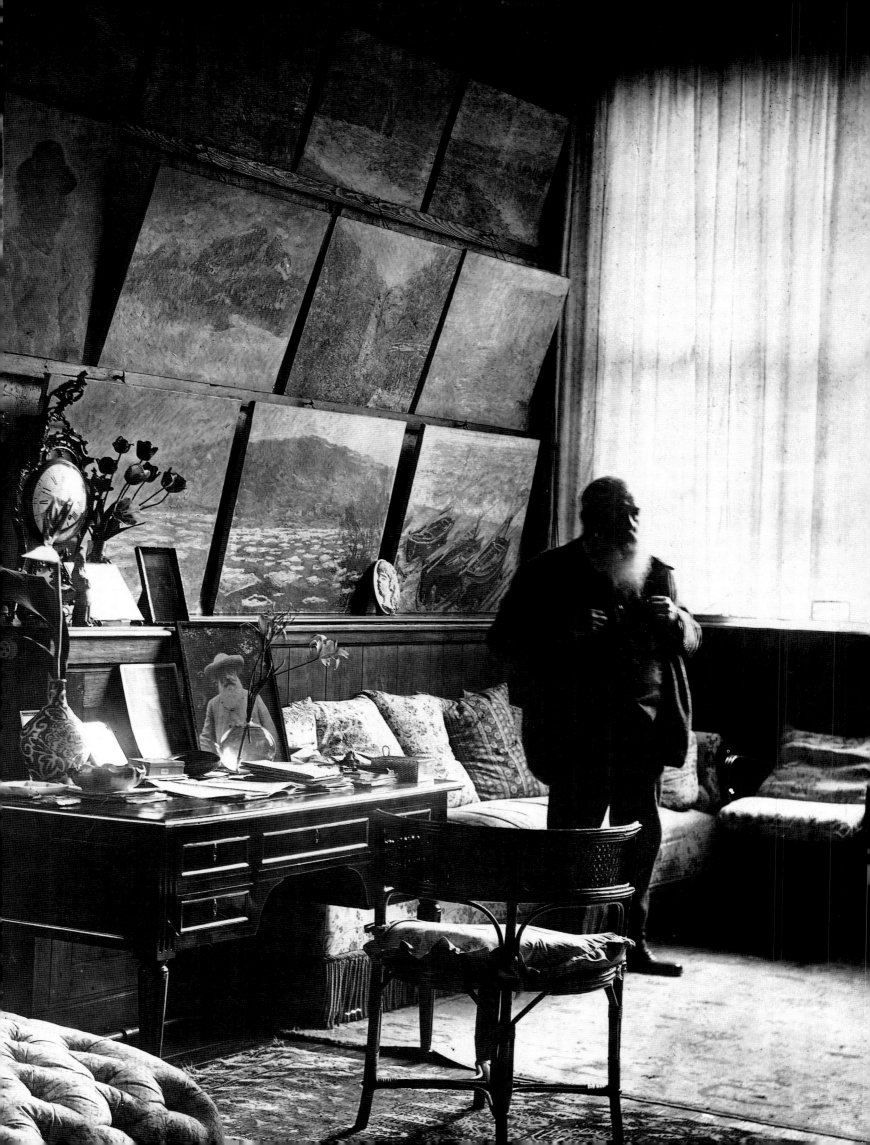

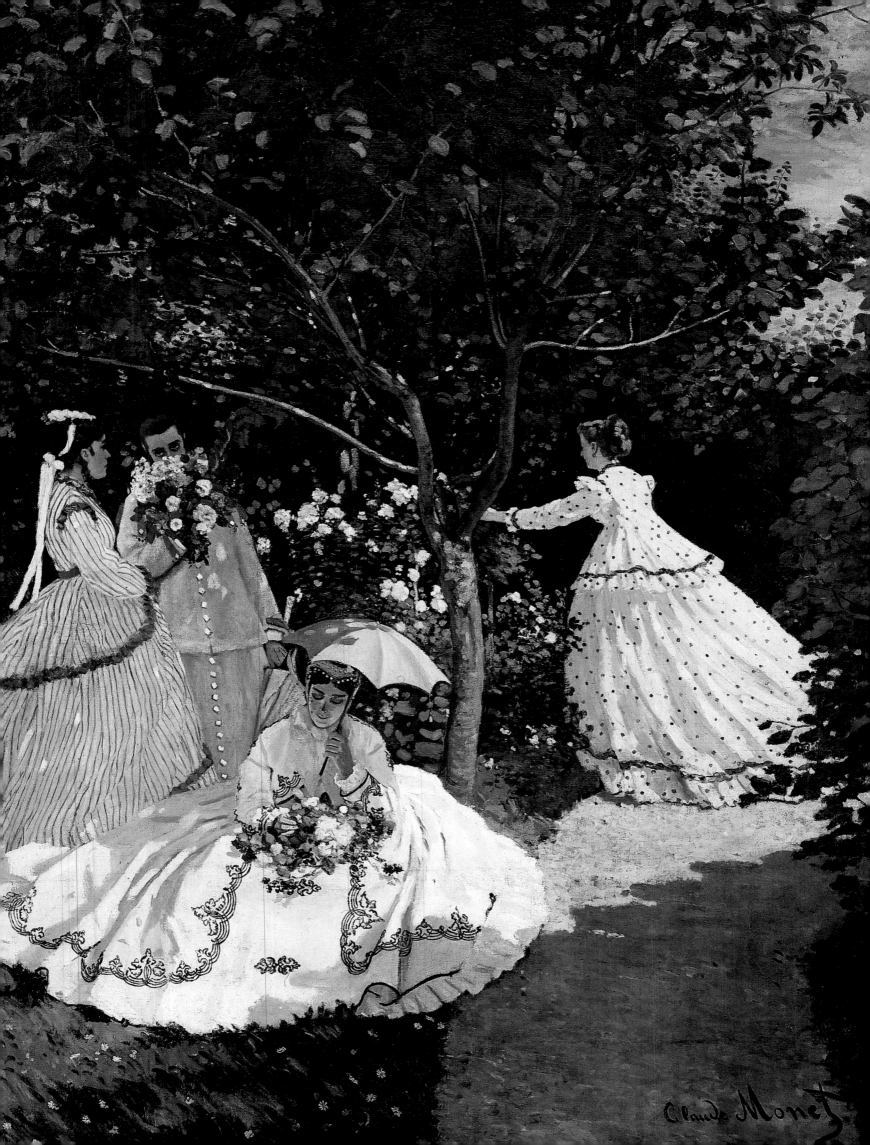

The Triumph of Impressionism

Origins and Birth

Towards the end of the 18th century, one Léon Pascal Monet lived in Paris with his wife, Catherine Chaumerat; he had been born in Avignon in 1761. The family of his father, Claude Monet, is thought to have had its roots in the Dauphiné; Catherine, born in Lyon in 1772, was the widow of Isidore Gaillard.

Shortly after the Monets moved to Paris, their son Claude Adolphe, was born, on 3 February 1800. After a rather eventful childhood during which he was enrolled on the books of the merchant navy at Le Havre as an apprentice ordinary seaman, Adolphe returned to Paris. He was living at 7 Rue d'Enghien on 20 May 1835, when he married Louise-Justine Aubrée. She was the daughter of François-Léonard Aubrée and Marie-Françoise Toffard (or Toffart); born 31 July 1805 in Paris, she was thirty years old when she married, having lost her husband a little more than a year previously. Her late husband, Emmanuel Cleriadus Despaux, had been a man of means; many years were to pass before she enjoyed a a similar standard of living in her second marriage.

By 1836, when their first son, Léon Pascal was born, the Monet-Aubrées had moved from the Rue d'Enghien to 39 Rue Caumartin. They moved again to 45 Rue Laffitte, where they occupied a small set of rooms just south of the hill of Montmartre, in the last house before the church of Notre-Dame-de-Lorette. There, on 14 November 1840, Louise-Justine gave birth to a second son, Oscar-Claude; his parents called him Oscar but he was to become famous as Claude Monet.

One striking fact about Monet's origins is that both sides of his family had converged on Paris, where his four grandparents settled around 1800, forty years before he was born; his father and mother were both born in Paris. Claude Monet, therefore, could lay claim to being of genuine Parisian stock, a distinction later generations rarely enjoyed.

The Move to Le Havre

Oscar-Claude was baptised on 20 May 1841 at Notre-Dame-de-Lorette. From the parish register we learn that his godfather, Claude-Pascal Monet, had come specially from Nancy, where he was a merchant; he was accompanied by his wife Antoinette-Reine Fresson, Oscar-Claude's godmother.

Oscar-Claude's mother was musical; her singing was part of the background of his childhood. His father's occupation remains obscure but was of a

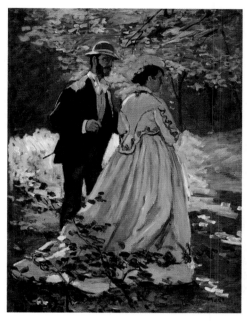

The Walkers
1865
Cat. no. 61

LEFT:
Women in the Garden
1866
Cat. no. 67

François I Tower, at the Entrance to the Port of Le Havre
Pencil on paper
1857
(D.W. 1991, V, p. 68, D 48)

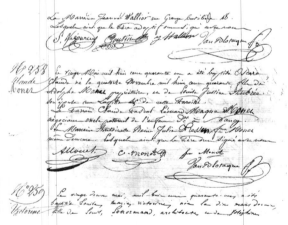

Claude Monet's certificate of baptism
20 May 1841
(Excerpt from the parish register)

business nature. In official documents he is described as a shop keeper, but this was a very common description at the time and conveys little.

He seems, at all events, not to have prospered. He left Paris for Le Havre at an unknown date, probably around 1845, and the whole family moved with him, including his grandparents, the Monet-Chaumerats. Le Havre was chosen because Marie-Jeanne Gaillard, a half-sister of Adolphe Monet from Catherine Chaumat's first marriage, was living there. She was married to Jacques Lecadre, a "wholesale grocer and supplier of ships' provisions", and offered her half-brother a job in her husband's business. As "Aunt Lecadre", she was to play an important role in Monet's life.

Adolphe Monet took an increasingly large role in the management of his brother-in-law's company and set up home in the Ingouville quarter of Le Havre, at 30 Rue d'Eprémenil. It was a fairly large house which allowed him to take in lodgers, and close to the Lecadre business, whose main entrance was 13 Rue Fontenelle. The nearby annexe to the business was at 71 Quai d'Orléans, alongside the famous Bassin du Commerce.

Like many of the well-to-do Le Havre bourgeoisie, the Lecadres had a country house in Sainte-Adresse, an old fishing village that Alphonse Karr was later to transform into a famous resort which stretches out along the Seine estuary to the Channel. There Pascal Monet, Claude's paternal grandfather, died, on 27 April 1851. Jacques Lecadre, his step-daughter's husband, and the village priest, a "friend of the deceased", were the two witnesses to sign the death certificate.

The family connection with the Lecadres meant that the Monets were related to one of the foremost families in Le Havre, which counted several merchants and a doctor amongst its members. Indeed Dr Lecadre practised at 7 and later at 9 Rue du Chillou with such success that there is a Rue du Docteur-Lecadre in Le Havre to this day.

Mill on the Lézarde
Pencil on paper
1857
(D. W. 1991, V, p. 74, D 83)

The Schoolboy

On 1 April 1851, at ten years old, after primary education at a private school, Claude entered the Le Havre "collège communal", from which a nephew of Dr Lecadre's had already graduated. The school buildings which were completed in 1837, were on to Rue de la Mailleraye, which led down to the outer port. Despite its recent construction, its two-storey premises were too cramped to accommodate the 197 pupils enrolled by the headmaster, Félix Dantu, for the year 1851–1852. The school provided a "classical" education (with Latin and Greek from the first form on) and also housed a school of commerce and the municipal drawing school.

Forty-five boarders were condemned to a soulless existence in a dormitory which was far below regulation standards. Monet, living close by in the Ingouville quarter, could sleep at home. He probably took his midday meal at the school as a half-boarder. The lack of space at the school meant plenty of pushing and shoving at meal-times and in the playground, which was lit, in winter, by a single gasolier.

Oscar began the academic year in the grammar set of the first form, whose teacher was M. Blanchard; M. Ochard taught drawing. "I was naturally undisciplined", Monet was to say fifty years later. "Even in my childhood, I could never be got to obey rules... The school always felt like a prison, I could never resign myself to living there, even four hours a day." The four hours were those of the school timetable, which provided for two classes of a little over two hours each, one in the morning, one in the afternoon.

By his own account, Monet spent most of his time outdoors, "when the sun was inviting, the sea beautiful, and it felt so good running along the clifftops in the open air, or splashing about in the water." True, the Le Havre port and beach were scarcely five minutes walk from Rue de la Mailleraye, but

The church of Notre-Dame-de-Lorette, Paris
Postcard, early 20th century

the Sainte-Adresse cliffs were over three kilometres away. The school's regime was, in certain respects, liberal, notably in eschewing all corporal punishment, but repeated truancy meant expulsion. And Monet could scarcely escape notice when wearing the regulation tunic and kepi (which had just replaced the stovepipe hat). On the other hand, on Thursdays and Sundays day boys and half-boarders were free, as were all pupils during the holidays.

What we know about the atmosphere at the Monets' house during the summer holidays comes to us from a nephew of their civil-servant tenant. Having stayed with his uncle for a week during the summer of 1853, Théophile Béguin-Billecocq noted much later that he had met "Monsieur Monet, his wife, who had an exceptional voice, and their two sons, the second of whom, though then called Oscar, was to attain fame as Claude Monet". He speaks of Mme Monet's talent and describes the Monet household's lifestyle: "I enjoyed this short holiday immensely. In the daytime there were walks and seabathing, in the evening improvised concerts and balls; everyone came together and brought the house alive with laughter. The hosts at least knew how to enjoy life."

After the summer, Claude went back to school to "make a fair job of learning the essentials of reading, writing and arithmetic with just a touch of spelling", though this apparently casual attitude did not prevent him in later life from writing excellent prose, exercising a businessman's flair for figures and exhibiting considerable cultivation. His school-friends remembered him as "a good-humoured character, well-liked by his peers". If we exempt drawing, a subject widely considered beneath notice, Monet was not one of the "swots" who competed for class prizes.

Ochard's Student – Early Efforts

At the Le Havre school, drawing had been taught since 1829 by François-Charles Ochard, who continued to teach the subject until his death in 1870. Born in 1800 at Saint-Valéry-en-Caux, he was a former pupil of David, who had exhibited portraits at the 1835 and 1837 Salons and a Breton landscape in the 1841 Salon. He did two large paintings for the church of Saint-François-du-Havre, having first gone to Antwerp to copy Rubens. He was primarily a teacher who divided his time between the municipal school of drawing, the town's main private establishments, and the "collège". A capable and very patient teacher, well able to hold his students' attention, he gained a notable number of disciples over the course of his career, amongst whom were the history painter Adolphe Yvon and Charles-Marie Lhullier, better known as Lhuillier, who in or around 1861 painted Claude Monet as a soldier.

In his later recollections Monet makes no mention of this period of drawing instruction under Ochard and it is thus probable that his artistic tendencies emerged spontaneously and in a completely different direction: "I drew garlands in the margins of my books and covered the blue paper of my exercise books with the most fantastical ornaments, which included highly irreverent drawings of my masters, full-face or profile, with maximum distortion." He would draw in pen or pencil, and then, emboldened by success, tear out the pages and "willingly" offer them to his colleagues.

Most of Monet's surviving juvenilia come from a single sketch-book. It contains not only rather clumsy attempts at caricature, but sketches of people, boats and, more especially, landscapes, all using fairly classical technique; several of them are dated 1857. His apprenticeship in caricature thus went hand-in-hand with drawing.

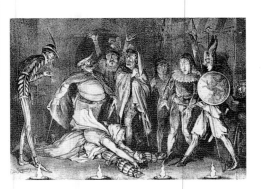

The Tour de Nesle in the Gleyre Studio
Lithograph published in *Le Boulevard*,
8 February 1863
After a drawing by Félix Régamey
Photograph B.N.F., Paris

PAGE 13, FROM LEFT TO RIGHT AND FROM
BOTTOM TO TOP:
Mario Uchard
Pencil on paper
Chicago (IL), The Art Institute of Chicago
(D. W. 1991, V, p. 147, D 499)

Jules Didier, Butterfly Man
Pencil on grey-blue paper with white pastel
highlights
c. 1860
Chicago (IL), The Art Institute of Chicago
(D.W. 1991, V, p. 151, D 515)

Rufus Croutinelli
Black crayon on paper
c. 1895
Chicago (IL), The Art Institute of Chicago
(D.W. 1991,V, p. 145, D 495)

Léon Manchon Wearing a Jacket
Black crayon on grey paper with white pastel
highlights
c. 1858
Chicago (IL), The Art Institute of Chicago
(D.W. 1991,V, p. 142, D 481)

Théodore Pelloquet
Black crayon on brown paper
c. 1857
Paris, Musée Marmottan
(D.W. 1991,V, p. 149, D 508)

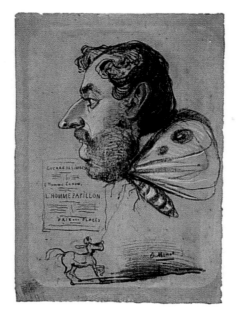

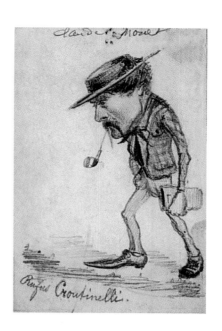

Corner of a Studio
c. 1861
Cat. no. 6

Hunting Trophy
1862
Cat. no. 10

Monet later claimed to have left school at fourteen or fifteen, that is, late in the school year of 1855–56. But his memory tended to antedate events in his youth and it is quite possible he stayed under Ochard's direction until 1856–1857. It should be said that the drawings in the sketch-book were not made during drawing classes at the school; those that specify a date and place were done on Sundays, at least during the first six months of 1857. Whether the choice of subject-matter was Monet's we cannot know.

His Mother's Death

Le Havre was expanding as never before; in August, 1857, Napoléon III and the Empress Eugénie made an official visit to the town. Whole new suburbs arose; street lighting spread through the city, reaching the Le Havre pier and the streets of Sainte-Adresse in 1858. New docks were built and an agency was opened on the Quai d'Orléans by a company later to become the famous Compagnie Transatlantique. Relics of the past were being demolished; a whole section of the Tour François Premier which Monet had drawn in the 1857 sketch-book was torn down in 1861.

As the Sunday outings of the 1857 sketch-book testify, Monet needed to get out of the house. There had been a family tragedy; his mother had died on 28 January 1857. No more songs or concerts at 30 Rue d'Eprémenil, and no more protection from his father, who was inclined to consider his younger son a failure. He had, perhaps, allowed Monet to leave school in the summer of 1857, in all probability without his Baccalauréat; but he had no desire to see his son make a career as an artist and caricaturist. Perhaps he suggested work in the family's wholesale grocery.

It was at this point that Aunt Lecadre stepped in. Without children herself and recently widowed by the death of Jacques Lecadre in September 1858, she was now able to devote all her attention to her nephew. Art was a suitable pursuit for a woman of her social position and, finding in it some consolation, she occupied herself with painting "as unmarried women do". What was more, she had long known the painter Amand Gautier and had a studio to which she could invite Monet. Under her auspices, he was allowed to continue with drawing, either with Ochard at the municipal school, or in private lessons with other Le Havre artists.

The death of Jacques Lecadre had brought about considerable material as well as psychological changes. Adolphe Monet had been living in the Rue Fontenelle since his wife's death, and had taken over the management of the business, in which role he continued until his retirement in 1860. Aunt Lecadre had a private income, and lived for several years in an apartment at 5 Place du Commerce, before returning to the family home at 13 Rue Fontenelle.

Caricatures

The caricatures handed out at school were such a success that Claude Monet was soon much in demand. He made the most of this vogue by charging between ten and twenty francs per portrait, depending on his estimate of the client's worth. Soon he was able to make one napoleon (20 francs) his standard price without any loss of custom.

Monet later claimed that he had sought commercial profit from his carica-

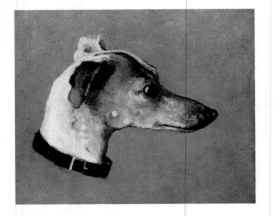

Greyhound's Head
c. 1862–1863
Cat. no. 12

tures because his mother paid him only a small allowance. This is not credible; Louise-Justine Aubrée had died, as we have seen, in January 1857, at a time when Monet was almost certainly too young to be making a profit from his drawings. And the school authorities would not have allowed a student to conduct a business. We have already noted that Monet tended to antedate events in his youth; where his mother's death was concerned, this combined with a willful vagueness that evoked her presence at events which occurred long after her death.

The caricatures brought in the sum of 2,000 francs after expenses and pocket money; this means over a hundred drawings, since the maximum price was 20 francs. In fact, less than a hundred original works have survived; for many of them, the signature O. Monet was no guarantee of survival. Of the surviving drawings, about fifteen are types rather than commissioned caricatures. Among the latter, few depict Le Havre dignataries whom we can still identify.

Popularity probably led Monet to glut his market. To sell his works and flatter his models, Monet exhibited them at Gravier's, a stationer, framer and ironmonger's shop on the Rue de Paris. Every Sunday, new caricatures would go up, framed in gold beading. Passers-by would gather at the shop-window, exclaiming at the likenesses. Monet would walk by affecting not to notice, but inwardly lapping up the applause and laughter: "I was just bursting with pride."

In later life, he omitted to point out that his style was honed by much copying of famous caricaturists. *Le Gaulois* of 1858 afforded him works by Carjat and Hadol; *Le Journal amusant* printed Nadar's works. There was also Nadar's own *Panthéon*, a second version of which could be found in *Le Figaro* in December 1858. Monet neither sold nor exhibited these copies, which long remained unknown, hidden away among the painter's papers. One curious case is the portrait of the short-story writer, Mario Uchard, that he copied from Carjat. Deceived by the similarity of the two names, historians thought it a caricature of Ochard. But Ochard was, according to contemporary accounts, "tall, bald and ruddy, with a fine, fan-like beard" and quite unlike Monet's copy.

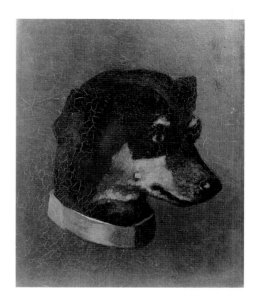

Dog's Head
c. 1862–1863
Cat. no. 11

Meeting Boudin

Monet's notion of seascapes was defined by Gudin, and he rather disliked the paintings that often hung above his caricatures at Gravier's. He eventually discovered that the painter was an old friend of the shop's owner; his name was Eugène Boudin. Monet, fifteen years his junior, found Boudin's retiring air, heavy-set face and big walking boots covered in dust and sand somewhat repulsive.

"You should get to know Monsieur Boudin", the framer told him. "Whatever people say about him, I can tell you, he knows his job... He could give you good advice." The framer was insistent; Monet was not convinced. But one day he came into the shop without noticing the self-effacing Boudin at the back of the shop. The owner introduced Boudin to "this young man, who has such a talent for caricature." Boudin began by praising Monet's little works: "They're amusing, they're full of zest, full of life. You have a gift", before adding "I hope you are not going to confine yourself to this kind of thing" and recommending, "Study, learn to see and to paint, draw, do landscapes." And since the subject was dear to him, he continued, if we are to believe Thiébault-Sisson, in somewhat lyrical vein.

The accounts of this first meeting seem to have been embellished; it was not until the summer that Monet made his first working expedition with his

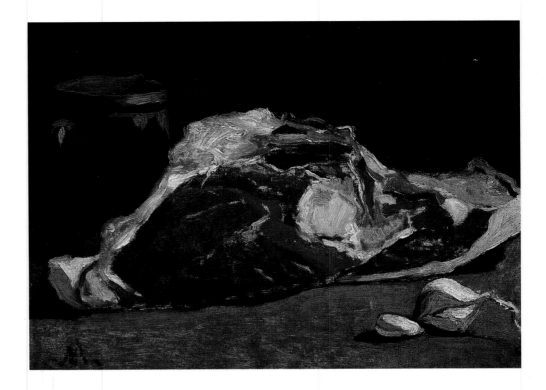

new mentor. According to Jean-Aubry, it was for this expedition that Monet bought his first paint-box; the two men walked around Montgeon forest, going through Frileuse to Rouelles, north-east of Le Havre. There Boudin set up his easel and went to work. This time, it was a revelation: "I watched more attentively, and then, it was as if a veil had been torn aside ... I grasped what painting could be."

On Thiébault-Sisson's account, this event had a longer incubation. "Boudin, with untiring kindness, set about educating me. Eventually my eyes were opened, I understood nature; I learned to love it at the same time." But Jean-Aubry and Thiébault-Sisson agree on one thing: the adolescent Monet received his first painting lessons at the hands of a modest and good-natured, but determined older man, under whose direction he painted a *View from Rouelles* (1) that appeared as number 380 in the Le Havre municipal exhibition of August – September 1858.

The picture shows a valley and stream, either the Rouelles or the Lézarde, which the Rouelles flows into. The painting was therefore known to some contemporaries as "Vue des bords de la Lézarde". Presumed lost, the painting was discovered after a hundred years and positively identified. It is signed O. Monet, dated [18]58 and still bears the number 380 from the 1858 catalogue. The two *Landscapes (Vallée de Rouelles)* in the same exhibition by Boudin (nos. **51** and **52**) show a kinship that contemporaries were quick to observe and that Claude Monet never sought to deny: "If I became a painter," he told Jean-Aubry, "it is to Eugène Boudin that I owe the fact."

The Le Havre municipal exhibition thus allows us to date Claude Monet's first landscape painting to the early summer of 1858; he was seventeen and a half years old. His meeting with Boudin in the framer's shop had probably occurred a few months earlier.

Monet continued to study nature at Boudin's side. In a traditional studio, he would have been confined to pencil; with Boudin, he learnt the use of pastels and oils to fix the colours of the outside world. That summer, Boudin went to Honfleur where he exhibited the paintings normally referred to as the *Regattas of 14 July*, though this appellation is erroneous; under the Empire the national

holiday was 15 August. Some authors have Monet accompanying Boudin to the Côte de Grâce, where he learned "to observe tone-values, atmosphere and perspective exactly".

He continued to represent his compatriots in increasingly effective caricatures. In 1859, a visiting company triumphed at the Le Havre theatre. Monet caricatured the actors and certain members of the orchestra. Lacour, the artist and photographer, was so impressed that he exhibited this series of caricatures – a miniature *Panthéon* of the Le Havre theatre – in his shop-window in the Place de l'Hôtel de Ville. Paul-Eugène Lecadre, eight years older than his cousin, posed for Monet in all his finery; "Oscar" captured his nonchalant stance and endearingly frank gaze. The notary Léon Monchon was depicted against a background of humorous posters: "Notary, for marrying thereof. Payment facilitated. Immediate entry to pleasures guaranteed." The grocer's son could get away with a lot in Le Havre.

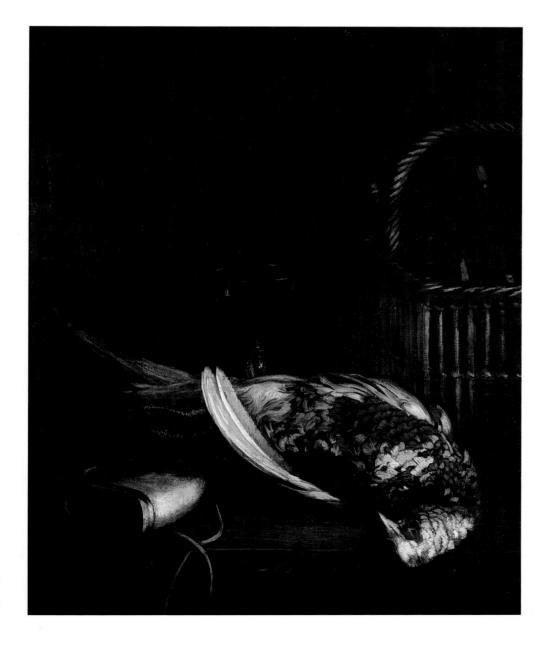

Still Life with Pheasant
c. 1861
Cat. no. 7

Grant Applications

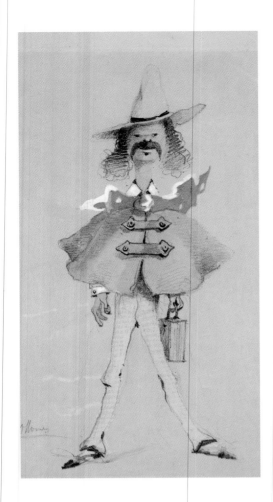

"Six months later, despite my mother's objections – she thought the company of a man with Boudin's reputation would be my downfall – I told my father straight out that I wanted to be a painter, and that I was going to go and live in Paris to learn how.

- You won't get a penny out of me!
- I'll manage without."

That is the legend according to Thiébault-Sisson. Well, Boudin did indeed have a bad reputation. But the rest is inaccurate: Claude's mother died well before Claude met Boudin, and Adolphe Monet at first supported his son's vocation.

He even applied for a grant from the Le Havre municipality to allow his son to study painting in Paris. Dated 6 August 1858, the application was made during the exhibition in which the *View from Rouelles* had appeared. It cites two teachers, Ochard and Wissant, and was clearly unsuccessful, since a second was made on 21 March 1859. The references now included Boudin. Were the applications made without Monet's knowledge? It seems unlikely.

On 18 May 1859, the Municipal Council considered which candidate was to follow in the footsteps of Boudin and Riou and receive the 12,000-franc grant provided for by the municipal budget. Maître Marcel, notary and acting president, read out the titles of the candidates' works. One of the most highly recommended candidates was Henri Cassinelli, whom Monet had caricatured as "Rufus Croutinelli". A still life was enclosed with the application of "Monnet [sic!] (Oscar)" (2). This, the president noted, might lead one to do less than jus-

tice to his talent, if it "had not been so completely revealed by his witty sketches, which we all know", and which showed "a remarkable natural disposition for caricature". Monet was thus indeed a local celebrity as early as 1859.

But there was a sting in the tail: "Is there not a danger that this precocious success, that the direction hitherto pursued, his extraordinary facility of line, may keep this young artist from the more serious and thankless studies that alone justify muncipal liberality?" This was not a question but a verdict. Instead of Claude Monet, a young sculptor and a future architect received grants from the Le Havre municipality; the grant was doubled in their favour.

Paris

Without waiting for the verdict, Claude Monet went to Paris to visit the Salon, which opened on 15 April 1859. He took the opportunity to make contact with artists to whom he had letters of introduction. The day after these first meetings, on 18 May, he wrote to Boudin, not about his brief impressions of the Salon at the Palais de l'Industrie but about his conversations with the artists.

His first visit was to his Aunt Lecadre's correspondent, Amand Gautier, who lived at 8 Rue de l'Isly, a few yards from the Hôtel du Nouveau-Monde on the Place du Havre where Monet was staying. Gautier received him with great warmth, not least because he had frequently enjoyed the princely hospitality of a Le Havre family, the Gaudiberts, the previous year. Monet expressed his admiration of Gautier's *Sisters of Charity*, which he had seen at the Salon; Gautier, not without vanity, showed him a series of small paintings that he was

PAGE 20, ABOVE:
The Painter Wearing a Pointed Hat
Pencil on beige paper with gouache highlights
(D.W. 1991,V, p. 138, D 466)

PAGE 20, BELOW:
Luncheon on the Grass
Pencil on paper
c. 1865
Paris, Musée Marmottan
(D.W. 1991,V, p. 79, D 106)

BELOW:
Frédéric Bazille
The Improvised Ambulance
(Claude Monet wounded)
c. 1866
Paris, Musée d'Orsay

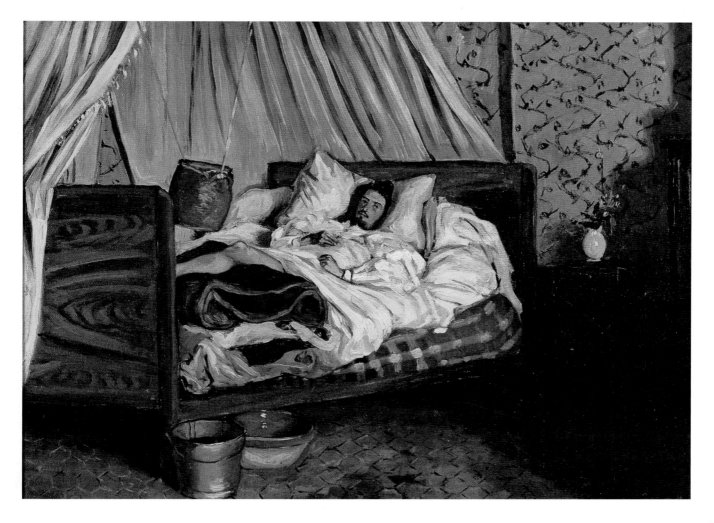

working on, and suggested that Boudin himself must soon come to Paris. Probably on the recommendation of Ochard, who had taught both of them, Monet then visited Lhuillier. Lhuillier enjoyed the use of a studio provided for him by Louise-Marie Becq de Fouquières; from the transcription of his letter by Gustave Cohen, it seems that Monet thought this a man's name. Lhuillier had made 6,000 francs on the sale of his Salon *Portraits of MM. X..., interior*, from which many commissions followed; but the painting did not impress Monet.

With two still lifes under his arm (3–4), Monet climbed up to the Chemin du Ronde de la Barrière Rochechouart to visit Troyon, whose works in the

Charles Lhuiller
Portrait of Monet in Uniform
1861
Paris, Musée Marmottan

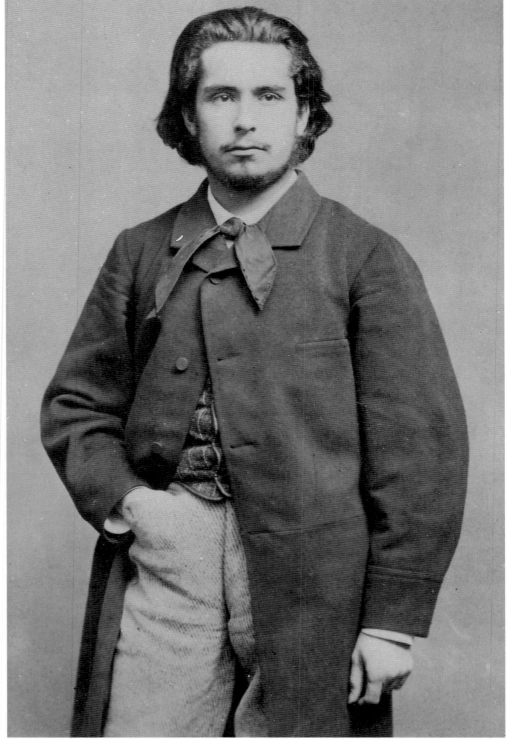

Claude Monet aged twenty
Photograph: Carjat

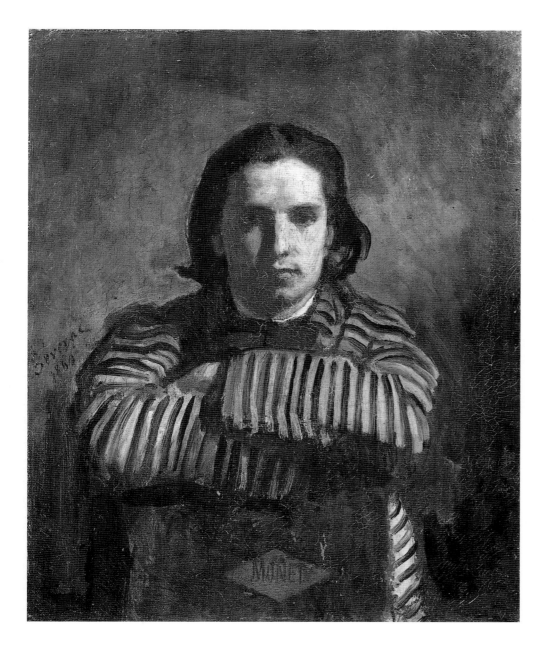

Gilbert A. de Séverac
Portrait of Claude Monet
1865
Paris, Musée Marmottan

The Hôtel du Cheval-Blanc at Chailly

The Hôtel du Lion-d'Or at Chailly

Salon he had greatly admired. "Kind and unpretentious", Troyon felt that Monet's pictures had certain colouristic qualities and effects, but were a little facile; he recommended serious study in a life class, advising that Thomas Couture's was the best. In Troyon's view, drawing was not an end in itself; painting should not be neglected, one should make copies in the Louvre and landscape studies in the country, but these had to be "taken further" than Boudin's works, which, Troyon thought, lacked "finish".

Troyon's recommendations – a couple of months work in Paris, then a return to Le Havre to study landscape, followed by a definitive move to Paris in the winter – were approved by Adolphe Monet and Aunt Lecadre. So much for stormy departures from Le Havre and relentless paternal opposition.

Things looked good. The required allowances were forthcoming, as long as the rest of Monet's stay was spent hard at work in an "atelier". A second letter from Monet to Boudin, dated 3 June 1859, tells us nothing about his choice of atelier but suggests that he was already at work. The letter also contains his detailed judgements on the Salon which he had by now seen several times. The then famous Yvon's work he finds absorbing but unsatisfactory. He is still impressed by the Troyon pictures, though in some of them "the shadows are a

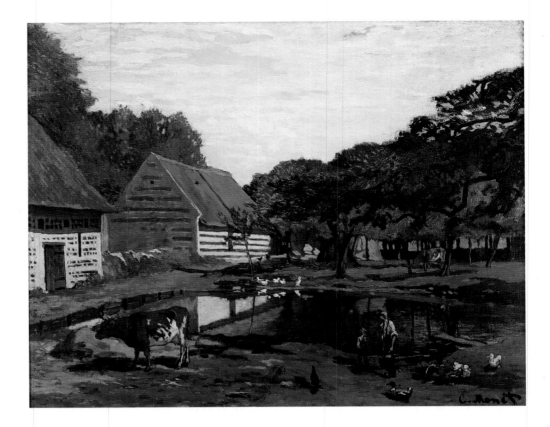

little too black"; he is rather disappointed by this year's crop of Delacroix, which he regards as "evocations and sketches". Ironically, his own works were often to be arraigned under this heading. More even than Corot, he admires Daubigny, that "fine fellow". As to the painters of seascapes, and Isabey in particular, their poverty constituted an opportunity that Boudin should seize upon.

A letter of introduction from Le Havre had put Monet in touch with Monginot, whose *Bertrand and Raton* "makes an impression" and nothing more. Monet chose not to communicate this sentiment to his host, who kindly put his studio at Monet's disposal; he took the opportunity to paint some still lifes and there caught his first glimpse of Edouard Manet.

Thomas Couture

"Since I wrote to you, things have changed", Monet wrote to Boudin on 3 June 1859. He had left his hotel to take rooms at 5 Rue Rodier, in the Faubourg Montmartre. This meant that his family had, despite the lack of a grant, allowed Monet to stay on in Paris; Troyon had revised his advice. The 2,000 francs earned from caricatures and looked after by Aunt Lecadre, combined with an allowance from his father, were enough for him to live on for a while; a young man could survive on 125 francs a month at that time. But "distracting, dazzling Paris" led him into unexpected expenses; his correspondence was already less regular.

His family had allowed him to stay in Paris only if he entered the atelier of Thomas Couture, who prepared students for the Ecole des Beaux-Arts; not only Troyon, but now Monginot, too, recommended him. "Of the strength of my refusal I need hardly tell you", Monet stated, emphasising the independence of mind that he had always shown. In fact, Monet could hardly have afforded Couture's expensive course. But perhaps the highly sarcastic Couture offered him a cold reception. It is easy to imagine the young Monet – carrying the two

still lifes that Troyon had seen – presenting himself to Couture and receiving, instead of the expected compliments, forthright criticism. Monet does not take the criticism lying down; Couture loses his temper and refuses to accept a new student who had limited means to boot.

This would explain the virulent tone Monet adopted in his letter to Boudin of 20 February 1860: "By way of news, I can tell you that Couture, that bad-tempered fellow, has completely given up painting. It's no great pity; in this exhibition, he had some really bad paintings." Couture, like many of his contemporaries, found it difficult to move from the sketch, at which he excelled, to the finished painting and to give it the required "finish"; his difficulties were well known, but Monet would hardly have rejoiced at Couture's discomfort had his ire not been aroused.

The Académie Suisse

In February 1860 Monet moved again, to 18 Rue Pigalle on the corner of the Rue de la Bruyère where one "Mme Houssemène, landlady of furnished appartments" rented out garret rooms on the sixth floor.

Since he was not to attend Couture, Claude had to find another "atelier"; he decided on the "private academy" named after its founder, Suisse. In his letter of 20 February, he speaks of both a life-class in which he is drawing with other landscape artists and of an atelier where he is working with a certain Jacque. It has therefore been thought that Monet studied with Charles Jacque, the Barbizon painter. In fact, the "life class" and the atelier seem to be one and the same, where Jacque (or Jacques?) worked as a monitor, assisting the now aged Suisse.

The Académie Suisse was particularly successful under the Restoration and the reign of Louis-Philippe; among its pupils were Delacroix, Bonington, Isabey, Gigoux, Corot and Courbet. Courbet remained faithful to his old master, the "père Suisse" and painted his portrait – distinguished features, round glasses, grey hair – in 1861. Often presented as a former model of David's, Suisse was a painter himself. His academy was on the Ile de la Cité, near the Pont Saint-Michel and the Boulevard du Palais. It was in an old building at 4 Quai des Orfèvres, whose ground floor was occupied by shops: a vintner, a barometer-maker and a pewterer. A wooden stair case with a bannister of metal and wood led to the second floor, where, on the right, a small door led into Suisse's apartment. This was a small flat comprising three tiled rooms, one of them with a fireplace, and a big kitchen. The studio itself was on a kind of mezzanine, lit by two windows, one overlooking the courtyard, one overlooking the river. In 1863, the "dentist without diploma" Sabra established his practice in the left-hand apartment on the second floor; his patients would sometimes wander into the studio by mistake and be confronted with naked models.

In summer, the academy opened at six in the morning; in the evening there was a session from 7 to 10 pm. We can imagine the students perched on benches "not excessively upholstered", working, chatting and smoking in a room whose walls had been blackened by generations of students. Each month, for a fixed sum, the student was entitled to a male model for three weeks and a female model for the fourth. Pencil, paint-brush, palette-knife; there were no restrictions. The life-study could become a free composition if one so desired; there was, apparently, no supervision or correction.

Under these conditions, the appeal of Suisse's domain is easily explained. In traditional ateliers, the student began by drawing first from engravings, then

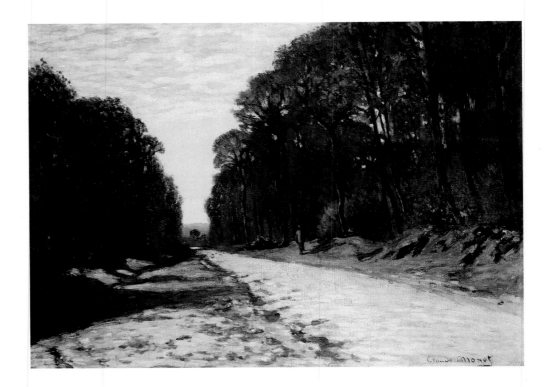

Road in Forest
1864
Cat. no. 17

The little road from Macherin (south of Barbizon) to Fontainebleau

from plaster-casts; life classes came next. Only after achieving complete mastery of drawing did the student begin painting, devoting many hours of practice to preliminary sketches.

Monet appreciated the atmosphere of unconstrained industry that prevailed at Suisse's. His letter of 20 February presents a picture of fulfilment as he works among the other academy members, all of them, that year, landscape artists like himself. He is "constantly drawing figures", and notes with satisfaction that the others "are beginning to see that it's a good thing". Perhaps he exaggerates his diligence for Boudin's sake, but there is no sign of the revolutionary here; he incites his colleagues to a very modern kind of self-discipline. Pissarro was certainly one of these colleagues; Monet says that he worked "in the Corot mould". Cézanne was not a colleague at Suisse's; he reached Paris only in April 1861, when Monet was already in the army.

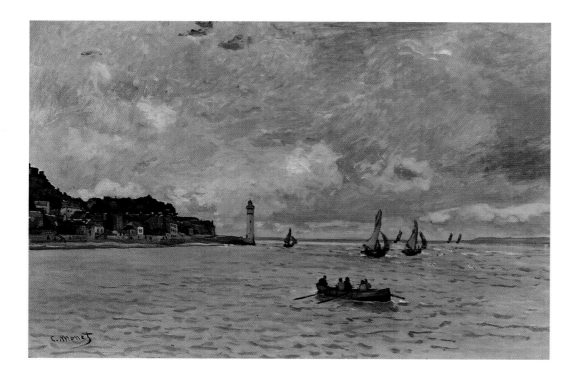

From Delacroix to Daubigny

The letter to Boudin of 20 February 1860, written the day after Monet had visited the Ecole de 1830 exhibition in the Boulevard des Italiens, suggests that his opinions had been changing, whether under the influence of artistic feelings, personal resentment or peer pressure. At this point he dislikes Troyon almost as much as Rosa Bonheur, perhaps because Troyon had sent him to Couture. Couture he considers lost to painting, but many people thought this; it is less original than the praise heaped on Decamps, Rousseau, Dupré, Courbet, Corot and Millet. His unconditional admiration for Delacroix, plainly and simply expressed, is in sharp contrast with his reactions to the previous year's Salon. On the other hand, the new exhibition was little short of a retrospective; the sixteen Delacroix paintings spanned some twenty-five years, and included *Hamlet*, *The Disciples at Emmaus*, and *The Ship* or, more precisely, *The Shipwreck of Don Juan*, which particularly impressed him.

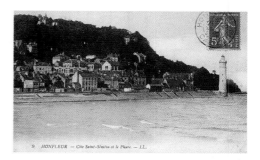

Honfleur, the Saint-Siméon hill and the Hospice Lighthouse
Postcard, early 20th century

ABOVE:
The Lighthouse by the Hospice
1864
Cat. no. 38

One should not overestimate these impressions; they are predictable enough in a young man whom Boudin's influence had already detached from conventional views. It would also be wrong to conceal his admiration for Marilhat, as has been done; it spoils our image of the young prodigy whom only masterpieces impress. Marilhat's painting is not without interest, and his African subjects prefigure the Algerian expedition that Monet was soon to make.

Monet was quick to underline how good an eye he had. One anecdote is particularly revealing; it concerns a little Daubigny, *Grape-picking at Twilight with Crescent Moon*, which hung on his wall in the Rue Pigalle. He told Boudin in February 1860 that it now belonged to him; two months later, on 21 April, he proudly announced, "Gautier has made an engraving after my Daubigny." The story as told to Marc Elder is that Monet found the painting "among the rubbish piled up in the corners" of the studio that Aunt Lecadre placed at his disposal for his stays in Le Havre. He liked the picture, but did not have it cleaned until his aunt had agreed to give it to him. The cleaning revealed Daubigny's signature. "It was a great joy to me... to have noticed, discovered a picture by a master. It authenticated my eye for these things."

The road from Trouville to Honfleur, as it looks now

Road by Saint-Siméon Farm
1864
Cat. no. 25

Was Aunt Lecadre truly unaware that she possessed a work by a renowned contemporary? The "discovery" must have been facilitated by Monet's recent visit to the Salon of 1859, where there were five Daubignys on show, including a *Setting Sun* and a *Moonrise*. The gift may have been a New Year's present, since in February 1860 the gift was still recent.

Monet's own account continues thus: needing money to "live it up with his friends", he at length found a buyer, one Thomas, an art-dealer whose shop was at 18 Rue du Bac. Thomas was willing to pay 400 francs if the painting was acknowledged by Daubigny. Monet was for giving up, but a bolder friend dragged him along and he obtained the necessary certificate. He thus sacrificed a work of great interest to the group with whom he was working. Monet's eye comes out of the story well; he himself makes a poor showing as the youth just up from the provinces desperate at any cost to join his friends' partying. The favourite place for these parties was the notorious Brasserie des Martyrs.

The Brasserie des Martyrs

Monet's lodgings in the Rue Rodier and then, in the Rue Pigalle were not far from the "Bavarian-style brasserie" founded by Schoen and whose landlord of several years was Bourgeois. It stood at 9 Rue des Martyrs, on the left as you went up, not far from the house Murger had moved into after the success of his "Scenes from Bohemian Life" – the "19th century Procope". Its facade was four windows wide and built in wood and ashlar. On the ground floor, the café was enormous, five bays deep and extended into a covered courtyard that contained two billiard tables. On the first floor, there were four more billiard tables in a large room, and in an adjacent gallery, divans for weary patrons. Customers who reached the second floor found five billiard tables and several rooms with open fires. On the third floor, four rooms without fireplaces would seem to have been for the staff, unless they were reserved for a particular kind of clientele. The 5,000 franc rent, which went up to 7,000 in 1864, suggests the scale of the establishment.

Alfred Delvau commented on the luxury of the Brasserie. "The air circulates better there – and the waiters too", he noted, even during peak hours when pipe-smoke and alcohol fumes softened the light from the whistling gas-lamps in their white globes. Shouts resounded in this space without producing the constant din experienced in other cafés.

The Brasserie was first known as the headquarters of the poets, but acquired a new and more mixed clientele when, in around 1859, the realists abandoned the Rue Hautefeuille and Courbet's domain, the Brasserie Andler. This was a historic migration; Paris's centre of gravity moved towards the Right Bank. There, around the Gare Saint-Lazare, the naturalists and impressionists established themselves.

In his *Les Derniers Bohèmes* (The Last Bohemians), Firmin Maillard speaks of the strange assembly of "rhyme-spinners", "stale, chair-bound orators", "master painters and painter-students of nature", all "wandering knights of the pen or brush, bold questers of the infinite, impudent dealers in dreams". In this milieu, wit counted for more than ideas, and the voice of the true creator might easily be drowned.

Discussions sometimes gave way to pitched battles, notably when the pupils of Picot were ranged against those of Couture. Monet himself does not speak of these combats, and when Gustave Geffroy asked him about his memories of the Brasserie, Monet simply referred him to *Les Derniers Bohèmes*. Among other

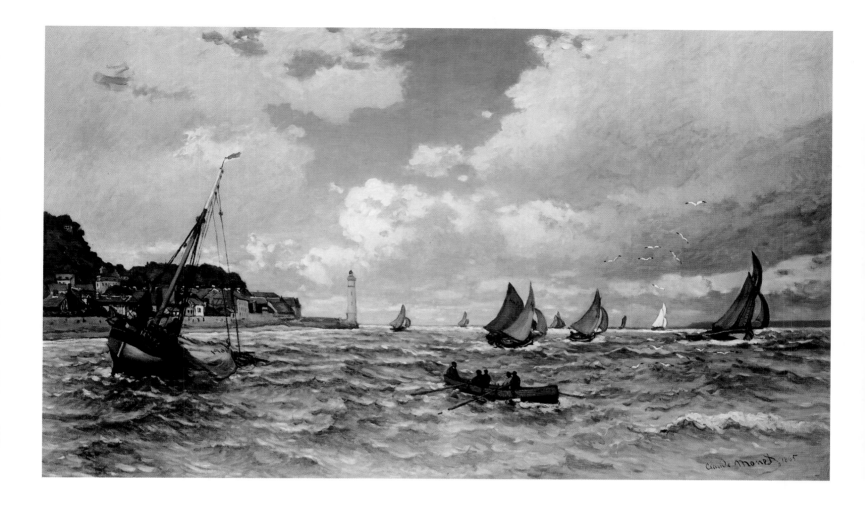

Mouth of the Seine at Honfleur
1865
Cat. no. 51

such "wild characters as [himself] at that time", Monet cited Maillard and Delvau, whose memoirs celebrate this little circle, Castagnary, a friend of Courbet (of whom Monet had caught the odd glimpse but had not yet approached), Alphonse Daudet, who was to become famous some years later, Alphonse Duchesne, who wrote for *Le Figaro* despite his progressive ideas, Albert Glatigny, a sort of "phthisic Pierrot" who would gravitate towards the Parnassian school of poetry, and Théodore Pelloquet, most bohemian of the bohemians, who merits particular attention.

Pelloquet was a journalist who found himself out of work when *Le National* was closed down after the coup of 2 December 1851. Disenchanted with politics, he turned to art criticism, and when *Le Siècle* offered him a column, he became a proselyte for the younger painters. Monet depicted this small, balding man, wrapped in one of his voluminous overcoats, not from life but from the *Panthéon Nadar*. If, as seems likely, the caricature was made before Monet left Le Havre, he must have been very surprised to come across the original in the Brasserie des Martyrs. The two men became inseparable. When he first met Clemenceau in the Quartier latin, Monet was accompanied by Pelloquet, whom Clemenceau described as "this intermittent journalist, full of wit and brimming with nonchalance, who didn't give a damn about anyone or anything, himself included." Clemenceau's first impressions of Monet (which may be slightly later) are also worth recording: "He impressed me as a man of fervent enthusiasm, something of a bohemian; I remember his large, passionate eyes, the slightly Arab curve of his nose, and a black beard in wild disorder."

Monet's visits to the Brasserie des Martyrs have given rise to some rather tall stories. Firmin Maillard was the first to recount the charming tale in which Monet needed just "two pencil strokes" to make an inspired caricature of Emile

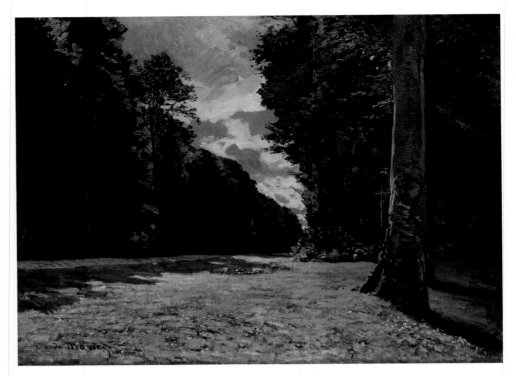

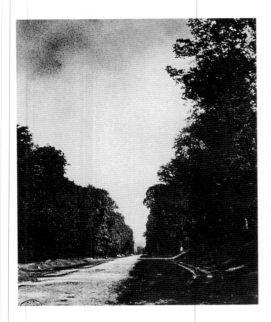

The Pavé de Chailly
Photograph B.N.F., Paris

Benassit, a genre painter and the *Boulevard's* caricaturist. "Leaning over Monet's shoulder, an old man with a long white beard looked on, smiling: it was old Andrieu." His arm around the shoulder of his son Jules, a future member of the Commune, the kindly old man "thought that if Monet wished to do illustrations for *La Presse de la Jeunesse* (The Press of the Young), of which he, Andrieu senior, was the editor, that would be an excellent thing." Unfortunately, this was pure fantasy. *La Presse de la Jeunesse* folded in April 1857, two years before Monet came to Paris. But legends die hard.

The legends tend, on the other hand, to pass discreetly over Chapter IV of *The Last of the Bohemians*, entitled "And Those Women!" We are told by Firmin that Héloïse, Marguerite, Adrienne (Noisette), Eugénie, Clotilde or Hermance "were always ready to offer their beautiful bodies in exchange for a

Honfleur, The Chapel of Notre-Dame de Grâce
Postcard, early 20th century

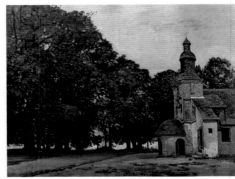

The Chapel of Notre-Dame de Grâce at Honfleur
1864
Cat. no. 35

The Bodmer Oak, Forest of Fontainebleau
1865
Cat. no. 60

Karl Bodmer
Within the Forest
c. 1850
Paris, Musée du Louvre

passage...to immortality." Even if these eminently approachable beauties were paid in hopes and not in coin of the realm, a young man of twenty needing to work hard would have been well advised to avoid the Brasserie. It gives us a new insight into Monet's bitter remarks to Geffroy: "I used to go to the notorious Brasserie in the Rue des Martyrs, where I wasted a lot of time; it did me the greatest harm."

The Impasse

The few surviving works suggest that Monet's output during his first stay in Paris was not substantial. Of his entire production of caricatures, if we except

Honfleur, the old port and the Lieutenance
Postcard, early 20th century

La Lieutenance at Honfleur
1864
Cat. no. 31

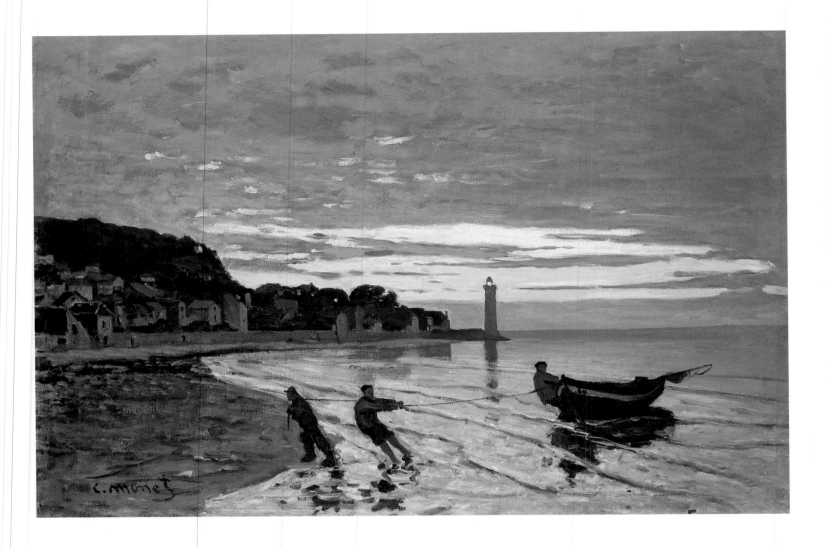

Towing of a Boat at Honfleur
1864
Cat. no. 37

those of unidentified models which may equally date from his Le Havre days, there remain a portrait of Jules Didier, who won the Prix de Rome in 1857, caricatured as a butterfly man on a leash held by a female centaur, and a paniconographic caricature showing the actor Laferrière, still playing the leading man in his sixties, theatrically posed against posters of his extensive repertoire and dressed in the uniform that he wore in *Histoire d'un drapeau* (Story of a Flag). This appeared in the *Diogène* of 24 March 1860, and is the only recorded publication of the young Monet. The caricature of Pierre Petit intended for *Le Gaulois* and *Le Charivari* (The Din) and other caricatures listed in a letter to Amand Gautier on 11 August 1860 would seem to be a record of disappointed hopes.

At the Académie Suisse, Monet was "constantly drawing figures"; probably he painted too, there and in the studio lent to him by Monginot. But none of his academic drawings have survived, and of the paintings made in either Le Havre or Paris since the *View from Rouelles* (1) of the summer of 1858, only a *Landscape with Factories* (5) that is difficult to place, a *Corner of a Studio* dated [18]61 and a *Still Life with Pheasant* (6–7) are known; three paintings, for more than two and a half years' work.

The still lifes presented to the municipality of Le Havre and to Troyon (2, 3–4) have disappeared. So have the landscapes painted during the fortnight or three-weeks' stay that Monet planned for the spring of 1860, when he and two friends were to stay in the "charming little region" of Champigny, where the banks of the Marne are lined with cafés, looking out on its wooded islands. There is nothing in the surviving paintings to remind us of Corot, whose influ-

ence had been briefly imparted to Monet by Pissarro's enthusiasm. Nothing to suggest Boudin either, who apparently remained Monet's model, though Monet believed that he tended to perceive nature "with greater breadth" than Boudin. Nothing, in short, that presaged the landscape artist he was to become.

Nor is there any trace of his purely commercial paintings, of which some were certainly produced during his first stay in Paris. These were "portraits of concierges at 100 sous, at ten francs, sometimes even at fifteen francs, with frame... I did a bit of everything, and it stood me in good stead in the hard years that were to come". The concierges were unconcerned at his failure to sign, and Monet had no reason to compromise his name with this hasty output; hence their disappearance.

Monogrammed "O.M." or signed "O. Monet", the serious works themselves were not identified early enough with the famous "Claude" Monet to be saved. On the other hand, given his confessions about the time wasted in the Brasserie, one wonders if so very many paintings were produced.

And now someting happened in Le Havre that was to weigh heavily on Claude Monet's existence. On 3 January 1860, at the maternity hospital in the Rue de la Chapelle, a young servant-woman, Amande-Célistine Vatine, resident of the Rue des Pincettes, gave birth to an illegitimate child who was given the first name Marie. The father of the child was none other than Adolphe Monet, now in his fiftieth year. Too honest or too much in love to abandon his mistress, he now had to face increased expenses just after he had, as it seems, retired.

His father's amours had an immediate effect on Monet, at a time when he was himself badly in need of good example. He may not have been immediately informed of the birth of his half-sister, but the extra expenses that his father thus incurred reduced the allowance that he paid to Claude at a time when Parisian life had already eaten up most, if not all, of the 2,000 francs from the caricatures. No question now of posing as a dandy at the Brasserie. Whichever way Monet turned, the prospects were bleak. And there was the imminent threat of conscription.

Sun Setting over the Sea
Pastel
c. 1862
Boston (MA), Museum of Fine Arts
(D.W., 1991, V, p. 161, P 34)

Conscription

Monet was still officially a resident of Le Havre, South Canton. There he awaited the fortunes of the class of 1860 to which he belonged. On 9 January 1861, the Prefect of Seine-Inférieure requested the Mayors of the département to "publicly announce at the end of the parish mass" the date at which young men should meet for the draw that would determine whether they served in the army. For the South Canton of Le Havre, the draw was on Saturday, 2 March. As the regulation required, at one o' clock Monet presented himself before the Sub-Prefect, gave "his name, first names, and those of his father and his mother", and took a number from the urn. He drew a low number. A month later, the "sub-distribution of the contingent within the cantons" was published; of the 228 men on the South Canton list, the first 73 would be conscripted. The number that he had drawn was under 74. He was now sure that he had drawn an "unlucky number" and that he would, over the course of the summer, have to enter the army for seven years' active service.

The law of 26 April 1855 provided that young men included in the annual contingent could be exonerated through payment of sums destined to ensure a replacement. For the class of 1860, the price of exoneration was 2,500 francs. For this sum, Monet's family could buy his discharge. Monet later stated that his family were willing to do this if he had been prepared to leave Paris, return to Le Havre, and "put his nose to the grindstone" in the family business.

Monet, however, would not on any account countenance the renunciation of a life dedicated to art. His moral and financial life was now so constrained that the idea of getting away from things was enticing; seven years' military service rather attracted than intimidated him. Tempted by the stories of a soldier-friend who belonged to the African chasseurs, he found the idea of military life "full of appeal". His friend wore an elegant uniform and spoke lyrically of long gallops under the beating sun and cold nights spent in the desert – all the paraphernalia of oriental imagery that had beckoned to Monet in the paintings of Marilhat. It again worked its magic.

To choose his regiment, in this case the African chasseurs, he needed to enlist a few months before recruitment and sign up for a period equivalent to that of conscription. On 25 March 1861, the Ministry of War issued the list of army corps receiving volunteers; the 2nd and 3rd Regiments of the African chasseurs were among these, but the 1st Regiment finally received the "student" Monet Oscar-Claude, thanks to a special ministerial exemption dated 20 April 1861. He was inducted into the army on 29 April and, being of good health and vigorous appearance, was reckoned "fit for service".

Entries in the regimental roll are traditionally standardized, but from Monet's we learn that he measured 1.65 m, that he had brown eyes, chestnut eyebrows and hair; the note "round chin" implies that he was clean-shaven; the "straight" nose contradicts the "slightly Arab curve" that Clemenceau remembered.

Algeria

The 1st Regiment of the African chasseurs had been founded in 1832; it was then stationed in Algeria, but had distinguished itself on the field of Isly, in the Crimea and at Solférino. Since the death of Colonel Montalembert, carried off by cholera during an operation in Morocco in autumn 1859, the commanding officer of the regiment's six squadrons was Colonel de Lascours. The 5th

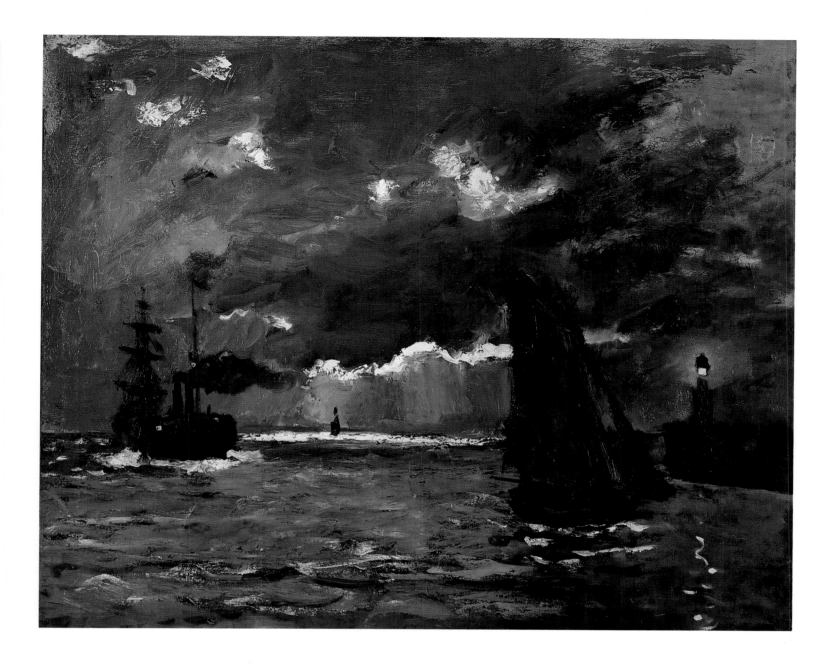

Seascape, Night Effect
1866
Cat. no. 71

squadron had seen action in Syria in September 1869; the 6th was to go to Mexico in 1862. The 1st and 2nd were to follow. Monet had chosen an elite regiment deployed by the Empire on the battlefields of Europe and abroad. In peacetime, the 1st regiment of the African chasseurs provided escorts for the tours of Maréchal Pélissier, Duke of Malakoff, the Governor-General of Algeria.

Claude disembarked at Algiers and joined his regiment in its barracks at Mustapha, at the gates of the town where it was housed in single-storey, mud-brick buildings. He is registered as having "joined the regiment" on 10 June and was assigned to the 2nd squadron as a cavalryman, second class. The squadron comprised some one hundred men under a captain assisted by several subalterns; non-commissioned officers were numerous throughout the French army at this time. The situation was fairly calm in 1861; recruits could be instructed without haste. Monet, who had "never sat on a horse", had to train at length in the riding school. It is not clear whether he was ever a good enough horseman to take part in the riding columns that exercised the horses and exhibited the regiment's strength to the local population.

Confinement to humble tasks in the barracks was not, perhaps, the stuff of memory. In the interview with Thiébault-Sisson of 1900, he claimed "to have

spent years that were genuinely delightful"; by 1914, Aryvelde was recording a more mixed impression: "I wasn't too unhappy in uniform." The note struck with Geffroy just after the 1914–1918 war was resolutely positive: "It did me a great deal of good in every way; it made me less harum-scarum." If we set aside for a moment the exotic climate, this account seems likely to be accurate, at least as regards morale.

It would be surprising if Monet's artistic vision had not been enriched. Lyric pronouncements on this theme are the rule. Geffroy speaks of "this dazzling land with its hot sun and intense light", of the "sea with its silver-crested waves" and of "the intoxication of plant-life abundant in flowers and fruit". But he is justifiably discreet about the influence of this spectacle on Claude Monet. In 1889, in the *Gil Blas*, Hugues Le Roux went much further: "Africa put the finishing touches to his mastery of colour. It taught him to see into shadow, and follow the brilliant decomposition of light to be found there, to set afloat an atmosphere around objects that trembles and encircles them like a halo"; in short, Monet was an Impressionist while still a private in the African chasseurs. Monet himself in 1900 suggested the true dimensions of the experience: "My

Fishing Boats, partial
study for no. 77
1866
Cat. no. 76

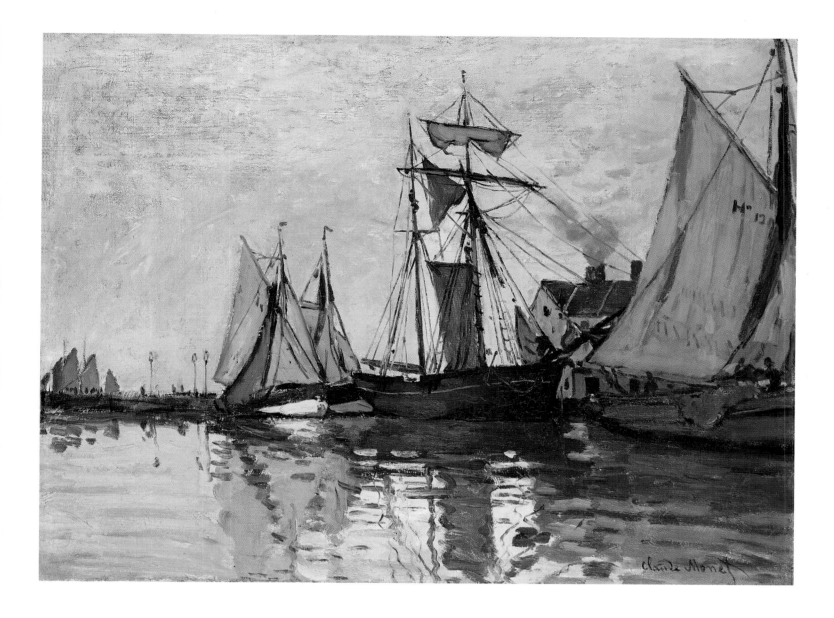

vision gained so much. I wasn't aware of the fact at first. It took a long time for the impressions of light and colour that I received to sort themselves out; but the seeds of my future experiments were there."

The "deferred" effect of his stay in Algeria is credible; but what did he paint while he was there? It seems likely that he went armed with pencil and paint-box, but there are conflicting accounts of the use to which he put them. Le Roux is ambiguous, and tells us more about the antimilitarist tendency of the *Gil Blas* than about Monet's activities in Algeria: "During his two years in an Algerian garrison, he made as many hasty studies as he did guard duties." Thiébault-Sisson was no more explicit in 1926 when he portrayed Monet as delighted to have cut short his stay in Algeria, where he apparently "never for a moment thought of doing any painting". Twenty-five years earlier, Thiébault-Sisson recorded more realistic sentiments: "I saw new things all the time, and in my spare moments, I set myself to render them."

What "spare moments" were available to a cavalryman-painter, second class, in Africa, under the Second Empire? The answer lies in two short sentences confided to Arnyvelde: "The officers frequently made use of my talents. It gained me a few favours." Hence commissioned work, such as the portrait of his captain that Monet painted "to get some leave", of which we know only through a mention by Clemenceau.

Le Havre, entrance to the port at high tide
Postcard, 1904

ABOVE:
Boats in the Port of Honfleur
1866
Cat. no. 77a

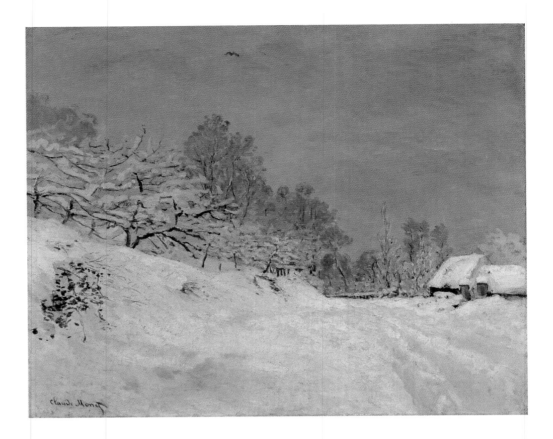

The Road in front of Saint-Siméon Farm in Winter
1867
Cat. no. 79

Hasty sketches of the landscape must certainly have been more frequent than finished work. On the other hand, Orientalism was in fashion, and some of the officers may have wanted paintings in this style from one of their men. This was apparently the source of the *Algerian Scene* (8) à la Fromentin, which later caused an exchange of letters between Monet, anxious to recover a piece of juvenilia that he had not at first recognised, and Durand-Ruel.

Monet's Algerian service was, in any case, too short to have produced too many works. The incident that ended his military career is well known. Bored with his endless sessions in the riding school, with staying "tied hand and foot to the barracks or the camp", he climbed on a baggage-train mule, spurred it to a gallop, and swept out of the barracks gate; he finished up under the Mustapha olive groves, where a patrol picked him up that evening and placed him in a cell. He had fainted and was saved from court martial by this fortuitous bout of typhoid fever.

There is, however, no mention of this incident in the regimental roll; on the contrary, we find a "good conduct certificate" delivered to Monet on his leaving the corps. Was this escapade put down to fever? Or was the whole episode a feverish nightmare? Thiébault-Sisson is the only interviewer to have reported this anecdote, a suspicious circumstance in itself; and he did so only in 1926, after Monet's death, when he was safe from contradiction.

Nor does the illness itself appear in the regimental roll, though this may be explained by medical confidentiality. Monet spoke of it too often and consistently for us to doubt it. On his own account, he was ill for three weeks. After two months rest in Algeria, he was allowed six months convalescence in Paris. He was in Le Havre by the summer of 1862, so his illness must have begun in the spring of that year. Having reached his regiment in June 1861, Monet had spent only a year under normal military conditions. His stay in Algeria lasted less than the two years he accorded it in memory, but this was not his only such lapse.

The Meeting with Jongkind

During his leave, Monet was not allowed to dress in civilian clothes, and Charles Lhuillier painted him in his African chasseur's uniform: blue tunic, red trousers, lanyard and kepi. This did not prevent him slipping on his art-student's smock from time to time and setting out with his easel for the places he knew so well.

In the absence of Boudin, who was away in Honfleur and Trouville, Monet worked alone. One day, he set up his easel next to a Caux farm close to the Cap de Hève; the farmstead was surrounded by trees and in amongst the apple trees stood "tumble-down ruins". He saw a cow grazing and decided to make a study of it, however, in order to make it lifelike, he was forced to follow the animal as it moved. A giant of a man, watching this rigmarole, offered to keep the beast still, and nearly lost an eye in the process; his efforts were more comical than effective.

The man turned out to be an Englishman rather like those whom Monet had caricatured in Le Havre. He was well informed about French affairs and deeply interested in painting. Sure that his young interlocutor would share his admiration for Jongkind, he organised a meeting which took place the following Sunday. Sitting in the orchard of a rustic inn, the three men did ample justice to the Norman cider and cuisine. Johan Barthold Jongkind became particularly expansive; the fields rang with his guttural intonations. Monet did not communicate his judgement of two years before, that Jongkind was "dead to art".

Monet confirmed this account, and, with the exception of place, it is attested by a contemporary document. In a letter dated 30 October 1862, Aunt Lecadre informed Amand Gautier that Monet "had met Jongkind by the seaside; Jongkind gave him some tips. I would have liked him to show Jongkind some of his so-called finished works, but he shied away from it despite my insistence." Allowed to see nothing but a few sketches, Jongkind invited Monet to go out and paint with him. There he gave Monet some technical advice about "the hows and whys of his own style" and the "knowing spontaneity" which was its hallmark.

At the time of his stay in Le Havre, Jongkind was well acquainted with his "good friend Boudin"; we cannot therefore accept the tradition that Monet introduced them. Nor can we accept the story of all three painting together, at least in 1862. The company of others could only have softened the impact of Jongkind's passionate, energetic manner. Monet made no mistake about this: "From that moment on, he was my true master, and it is to him that I owe the real education of my eye."

Aunt Lecadre had great respect for Jongkind's talent, but confesses to her "shame" that she was repelled by his "eccentric appearance and reputation as a carouser". She mastered her prejudice to the extent of inviting him to dinner, but the "manners" of her guest were not "completely edifying". She counted on Gautier's discretion, as she considered Jongkind "a very great artist and above all a very good-natured fellow", reproaching herself for "not having given him a more gracious reception".

The source of Mme Lecadre's unease emerges from Monet's story of Jongkind arriving for dinner with a woman whom he refrained from introducing. During the meal, Aunt Lecadre passed a plate to Monet, asking him to pass it on to "Madame Jongkind". The "husband" burst out laughing, exclaiming that "she was not his wife". Seeing all eyes looking down in embarrassment, he explained with all the candour his blue eyes could muster that "she was not his

Johann-Barthold Jongkind
The Beach at Sainte-Adresse
Watercolour
1863
Musée du Louvre, Paris

wife, she was an angel!" In this way Jongkind's hosts learnt of the role played by Mme Ferrer in saving him from the gutter. But Jongkind's backing of Monet's talents was to have some considerable effect on the decision Aunt Lecadre was about to make.

Exoneration

At the end of his leave, Monet was to rejoin his regiment in Algeria, and he was not looking forward to it. The law allowed those already in the army to buy themselves out. On 8 April 1861, the Ministry of War had reiterated that, in such cases, exoneration was to be pronounced by the administrative council of the regiment in question, on presentation of receipts to the amount of 550 francs for every year still to serve. Monet had been inducted on 29 April 1861, and thus had five and a half years still to serve as of the autumn of 1862. The sum was consequently greater than the 2,500 francs originally required to buy him out before conscription.

Alphonse Monet could no longer provide such a sum, but Aunt Lecadre took the affair in hand and accomplished the required formalities. On 30 October, she informed Amand Gautier: "My nephew Oscar has remained here with me while he awaits the annulment of his enlistment in the African chasseurs." The terms of her explanation are revealing: "By freeing him of his obligation, I thought less of his own satisfaction than of matters that are almost personal to me. I didn't want to reproach myself with either having stood in the way of his artistic career or leaving him too long in a bad school; he would have become completely demoralised." Some unflattering remarks about the army in Africa follow.

As to the future, Mme Lecadre was at a loss. She noted that her nephew's "conduct" was "infinitely better than in the past", but she was "fearful of giving him his freedom" since she knew how he had used it before. Monet acted the grateful, well-behaved young man in order to get his way: "He works, he uses his time well and spends all his time with us and seems happy", but he could not convince his aunt of the quality of his work. "His studies are still sketches of the kind you have seen – but when he wants to finish, to make a picture, it turns into the most terrible daubs in which he takes a complacent delight and finds idiots willing to compliment him."

Aware of the inanity of her remarks and feeling that she was not "his equal", the good woman now "kept her thoughts entirely to herself", but was not vindictive and still sought to serve his career: "Yet I want at all costs to get him out of this hole and put his very real talents to use and force him to work seriously. He has to make a position for himself, because I won't always be there." It is clear that she seeks affirmation when she asks her correspondent: "Don't you think that my nephew should return to Paris and study under the direction and advice of masters?" No doubt a positive answer was forthcoming.

Three weeks later, on 21 November 1862, the military authorities pronounced the exoneration of the chasseur, second class, Monet, and delivered a "good conduct certificate" for the time that he had spent in the army. This was shortly after his twenty-second birthday. Now he could at last devote himself to his chosen career with the full support of his family.

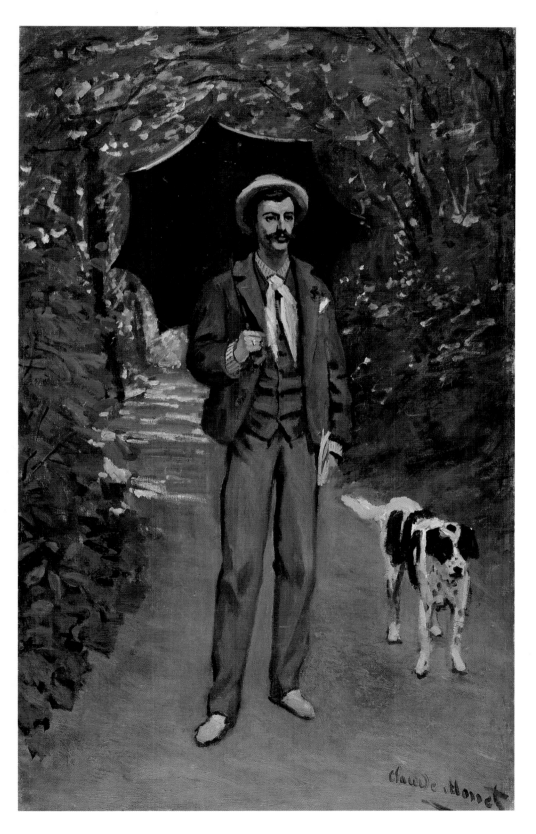

Portrait of Victor Jacquemont Holding a Parasol
1865
Cat. no. 54

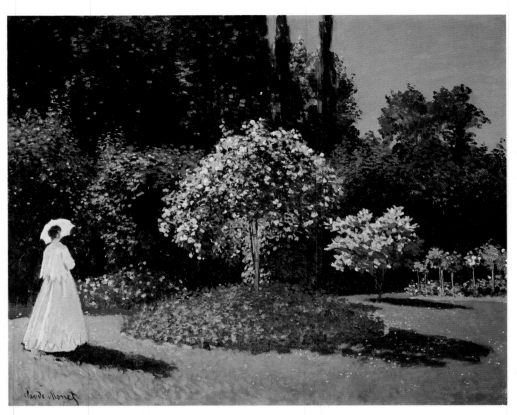

Jeanne-Marguerite Lecadre in the Garden
1866
Cat. no. 68

The park of The Coteau at Sainte-Adresse
(Property of the Lecadre family)

Toulmouche

Having cost his aunt 3,000 francs to buy him out of the army and remaining indebted to her for his allowances, Monet was forced to accept without protest remarks such as this from his father: "Get it into your head that you are going to work, seriously this time. I want to see you in a studio, under the discipline of a reputable master. If you decide to be independent again, I shall cut off your allowance without a word. Am I making myself clear?"

No stone was left unturned; Monet's family appealed to their new relation, the painter Auguste Toulmouche. On 3 December 1861 in his hometown of Nantes, he had married Marie, a cousin of the Le Havre Lecadres who had originated from Nantes. The "boudoir painter" had won a 2nd medal at the 1861 Salon, causing the *Gazette des Beaux-Arts* (Fine Arts Gazette) to make a flattering comparison with Stevens. Married, bemedalled, Toulmouche rather than Jongkind or Gautier, seemed to possess the qualities required in a guardian. "The great man of the family" was thus to become his cousin's correspondent and hand over his allowance every month. He was to be his true artistic mentor and report back to Le Havre on Monet's progress.

Claude Monet took the train for Paris, as full of promises as his relations were of advice. One of his first visits was to Toulmouche, who was living at 70a Rue Notre-Dame-des-Champs, close to the ladies of the aristocratic Faubourg Saint-Germain who commissioned his society portraits. Monet gave this account of the interview: "I had no sooner arrived than I felt the need to give Toulmouche a specimen of my knowledge. I took a canvas and painted a still life... Ah! I can still see it! There was a kidney and a little plate with some butter... I had been studying these objects. They particularly attracted me, I don't know why, and I painted them with fervour." This account is corroborated by the existence of *The Cutlet* (**9**), identified by Marc Elder, who also reports Monet's words above. According to other authors, Monet went to Toulmouche with "a collection of studies". The two versions are not irreconcilable. Monet

left Le Havre with several landscape studies, but knew his man and had taken care to provide the inevitable touchstone of the time, a still life.

On the point of Toulmouche's reactions, there is a certain consensus. Some are recorded in direct speech: "It's good, but it's showy" – "You have real promise, but you must focus your energies" – "Young man, you have many talents. You must enter an 'atelier'..." Monet himself reported that it was said of him: "I was very talented, but I needed studio-work." Not until 1926 was there a discordant note, sounded by Thiébault-Sisson: "Taken into the artist's studio, Claude Monet, at the sight of Toulmouche's paintings, was immediately overcome with a powerful dislike of the man who was to direct and, if need be, criticise him." Outraged at the notion of taking Toulmouche as his guide, Monet "never darkened his doorstep again." This is pure invention. Monet had every reason to play the game. He accepted Toulmouche's compliments and his advice namely, that Monet should go to Gleyre, "the master of us all."

Charles Gleyre and his Academy

Monet entered Gleyre's Academy on Toulmouche's recommendation in late autumn 1862. He remained much longer than he was subsequently willing to admit. Gleyre was to become something of an Aunt Sally in Monet's interviews; nicknamed "Glaire" [egg-white, mucus, phlegm], he was accused of too great a fidelity to the classics and condemned as narrow-minded. He was, in fact, a reserved and endearing personality and not the spokesman of the conventional that people have seen in him. He twice won Salon medals, notably for *Evening* (or *Lost Illusions*), a work that rather overshadowed the rest of his career. He ceased to exhibit after 1849, dividing his time between pupils and painting; the latter remained his torment and his vital necessity. "For two months now I have been unable to work," he wrote on 5 January 1851, "I find myself disgusted by my profession: painting fills me with horror, as water does a rabid dog."

When artists were first called upon to choose their representatives on the jury, Gleyre was elected to a modest rank. The events of 1870–1871 had profoundly shaken Gleyre, a Swiss citizen who cherished a great affection for France. On 5 May 1874 he was visiting an exhibition organised to raise money for the inhabitants of Alsace-Lorraine when he collapsed and died. The day after his death, Taine wrote in the *Journal des Débats* celebrating Gleyre's "perpetual and almost invariably successful quest for pure and perfect beauty". Duranty noted that "the man of poetic reverie" had also possessed "fine, energetic faculties and a mastery of rich, violent colours". Paul Mantz showed greater perception, writing in *La Gazette des Beaux-Arts* that "the man was clearly greater than his work".

Despite the efforts of his biographers and friends, Charles Clément and Emile Montégut, Gleyre himself, and his teaching in particular, were unsparingly criticised shortly after his death. Ingratitude and ignorance had their part in this. Rehabilitation came only in 1930; it was begun by Robert Rey's *Renaissance du sentiment antique* (Renaissance of Classical Sentiment) and assisted, without exaggeration, by the chronicles of the work of Frédéric Bazille.

When Monet returned to Paris, Gleyre was living alone in a respectable apartment block in the Faubourg Saint-Germain at 94 Rue du Bac; he had a tiny apartment on the fourth storey, on the left of the courtyard onto which his windows looked. An internal staircase, so cramped as to be positively dangerous, allowed access to a studio in the attics, which remained more or less in its original state until around 1960. The spartan furnishing of the apartment, as

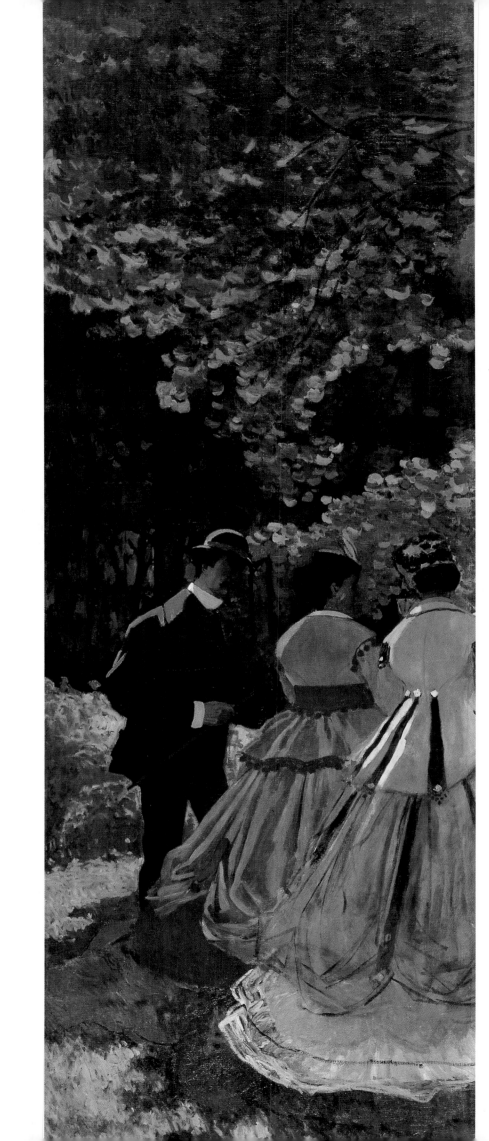

Luncheon on the Grass, Left Panel
1865
Cat. no. 63/1

44 · CHARLES GLEYRE AND HIS ACADEMY

described by Clément, suggests that it was for Gleyre's own painting and for receiving visitors. Bazille notes that his first visit to Gleyre in company with Bouchet-Doumenq took place "in his private studio".

The public studio was rented in the name of the successive student-assistants, at Gleyre's insistence, so it is now very difficult to indentify. But the apparently fantastical address given by George du Maurier in his novel *Trilby* – "chez M. Carrel (alias Gleyre) Rue Notre-Dame-des-Potirons [pumpkins]-Saint-Michel" – disguises the very real Rue Notre-Dame-des-Champs, part of which looks towards the Boulevard Saint-Michel. Nowhere in the Rue Notre-Dame, which contained many studios, were there quite so many as at number 70a, which then possessed seven, not counting the "glazed galleries"; all of this was spread over several buildings, most of them on one floor, separated from the road by number 70 and dispersed among the inner courtyards and gardens.

In 1863, six of these studios were occupied by painters, of whom the most famous was Gérome. All of them exhibited at the Salon, three of them under the description "pupil of M. Gleyre". Among them was Toulmouche, whom Monet visited when he arrived in Paris and whose father owned all of them. Everything suggests that the Académie Gleyre occupied the seventh studio.

Life in the Studio

Trilby offers a fairly conventional description of the Académie Gleyre, in the matters of furniture – stove, platform for the model, stools, low chairs, easels; the decoration of the walls, caricatures and palette scrapings and the herd of art-students gathered there. The same might have been said of almost every studio in Paris. Clément gathered some more informative accounts, but our most direct source is the letters from Frédéric Bazille to his family in Montpellier, whose experience is no doubt representative of his "classmates".

His first interview, in Gleyre's private studio, was apparently typical: "He looked me up and down for a long time, but didn't say a word to me; it seems he is like that with everyone, he is so shy." On Monday 10 November, two days after writing those lines, Bazille entered the public studio to undergo the "bizutage" or ritual humiliation of the new student. On top of this ordeal, he had to pay 15 francs for the welcome, 30 francs for the material and 30 francs for three months' advance. Initial expenses once acquitted, the monthly cost was thus a mere 10 francs, thanks mainly to the generosity of Gleyre who told the pupils of Delaroche when they came to request instruction: "I accept, but on one condition: that you don't give me a single sou. I remember when I was regularly forced to go without dinner to save the 25 or 30 francs that I had to pay every month to M. Hersent's student-teacher."

The doors opened at 8 am and seem to have remained open every working day, though in the extreme cold of the winter of 1862–1863, the studio opened only four times a week. At around midday, the students could eat the "rapins", the art-student's repast, at 15 sous (0.75 francs); which consisted of a chop and a cup full of bread over which gruel was poured. In the afternoon, there was a further work session, which Bazille would leave at three or four in order to attend his course in medicine.

Custom required that beginners attend endless drawing sessions. On 10 February, Bazille, who had begun a nude study, noted that "there were many students of my ability or rather lack of it." At the end of February he "still hadn't got onto colour" and was not expecting to before he could draw better. The "boss" made an appearance twice a week, often on a Monday, as Monet

later stated. "He would come quietly into the studio", Anker told Clément, "and begin his round, stopping at every student. He spoke only to those whom he corrected and spoke quietly, so quietly that one's neighbour scarcely heard what he said." He did not like "swank" and he did not like "oddities". He advised his students to prepare shades on the palette lest "this confounded colour" turn their heads.

Gleyre was too modest to pontificate about art and too liberal to seek to impose his rather exclusive views, though he sometimes proposed "a little subject for composition that everyone does as best he can". Bazille, on whose information we depend, promised to send his first tolerable composition back to his family in Montpellier; he could not send his normal studies, which were "all dirty" by the end of the week "and covered in caricatures by his neighbours". We can guess the identity of one of these impertinent caricaturists. Whether Monet took part in a performance of the *La Tour des Nesles* (The Nesles Tower) given by his colleagues at the studio on 23 November we do not know; we do know that the performance was attended by many artists including Gérome, who had not far to come. A collection was made for the unemployed of Seine-Inférieure; Bazille had a minor role in the play and, for his pains, was one of those caricatured by Félix Régamey in *Le Boulevard* of 8 February.

It has been said that Bazille, Monet, Renoir and Sisley immediately made friends at the Académie Gleyre. But Bazille was at this point much closer to young colleagues from Montpellier, and it was in their honour that he requested his parents to send him a salted cod purée, a local speciality, in late December 1862. Neither Renoir nor Sisley are mentioned in his letters for the time being, and Monet receives his first mention only in spring 1863. In a letter to his father, which we date to 22 March, having first announced that Viscount Lepic, son of the Emperor's aide-de-camp, has entered the Academy for "improvement", he adds: "this young man and another from Le Havre, called Monet, who knows M. Wanner, are my best friends among the 'rapins'". This is the first evidence of the growing friendship between Bazille and Monet.

It is also evidence that Monet remained at Gleyre's at least until that date. If Monet was noticeable for his rebelliousness, Bazille did not choose to record the fact. Bazille was delighted by the place: "I am getting to like my work in the studio more and more; it will be the greatest happiness, if not the greatest honour of my life." Gleyre's compliments, on one occasion spoken "so that everyone could hear", overjoyed this respectful and very likeable student.

For the time being, Monet continued in his role of well-behaved young man. Aunt Lecadre thought Amand Gautier better qualified than anyone to recognise Monet's talents, and wrote to him thus on 20 March: "This child who had taken a wrong turn and was lost for so long, who caused me such pain, now acknowledges his mistakes. He told me so by letter, and thanked me for having let him depart... The many misfortunes that he has suffered have transformed him and prepared him to work, and he thanks me for having bought him out of the army. He says all this quite simply and I feel that he is saying what he thinks, and am as happy about it as his father." This confidence was no doubt short-lived, but deserves a mention.

PAGE 47:
The Bodmer Oak
1865
Cat. no. 60a

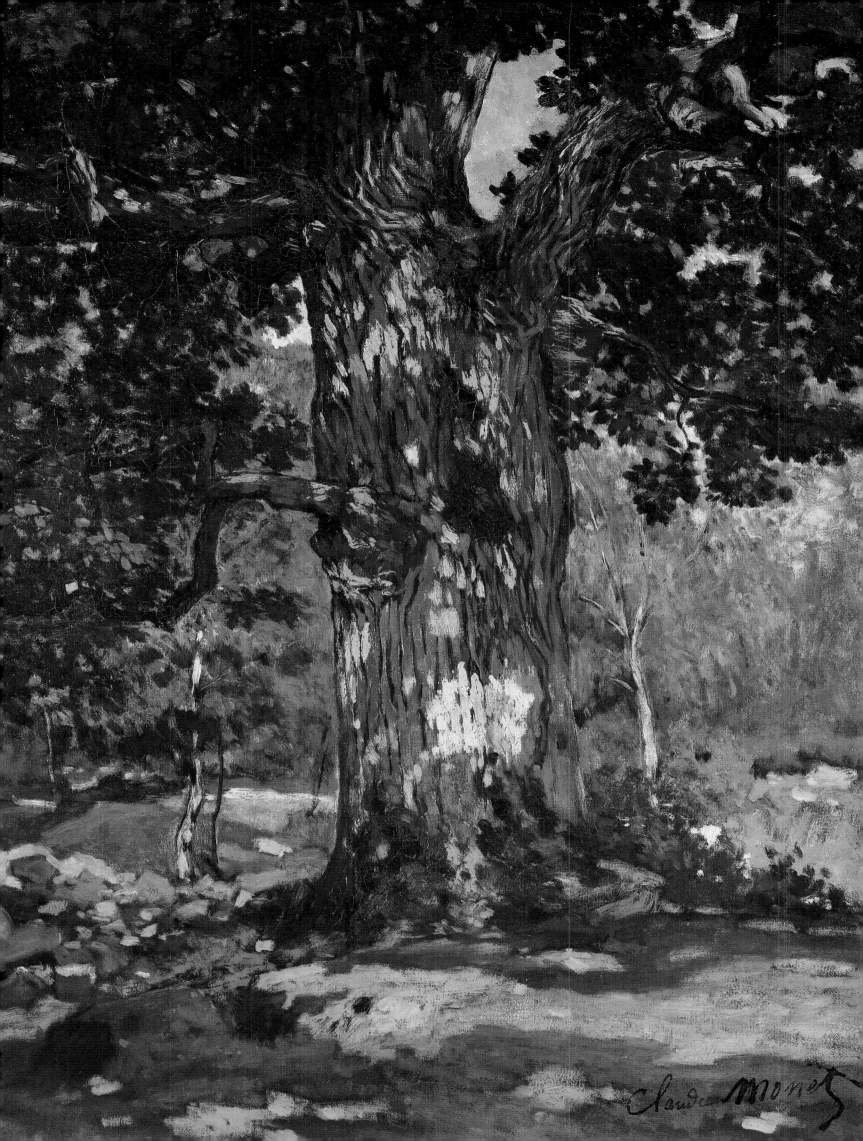

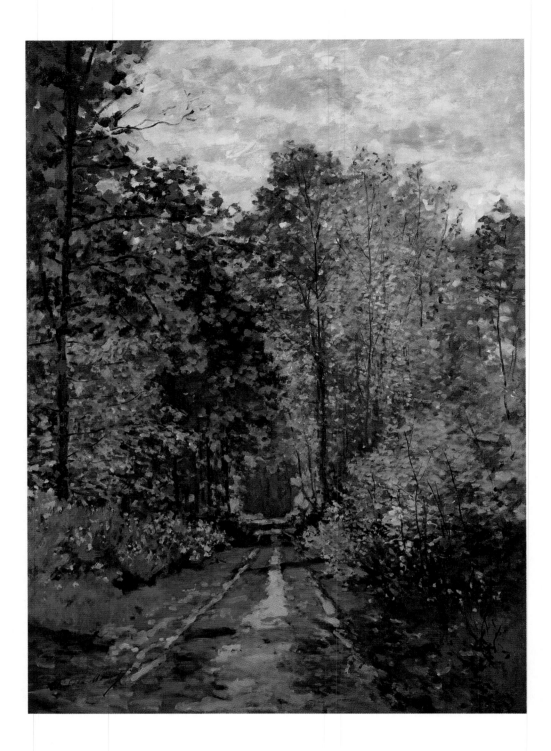

Path in the Forest
1865
Cat. no. 58

Chailly-en-Bière

Excitement grew with the approach of the Salon, the best students in the studio working furiously at their entries. The young students were not ready to compete, and Bazille wrote to his parents to say that he was planning to make the most of his Easter holidays and the exceptional weather by painting some landscapes in the Fontainebleau forest "with two or three friends". Albert Boyme thinks that the idea was suggested by Gleyre himself. If this were the case, and Gleyre had recommended outdoor work, he would be totally rehabilitated. In fact, the sentence by G. Poulain on which Boyme bases his claim is this: "The honest Gleyre advised [Bazille] as well as Monet and Renoir, to work outside the studio if they wished to make serious progress." Gleyre meant "outside the Académie", in a private studio, not out of doors.

On Easter Sunday, 5 April 1863, Frédéric informed his father that he was staying in Chailly, a little village "in the middle of the forest" (both the topography and Millet's *The Angelus* militate against this description) "close to the most picturesque places". The two friends put up at "the excellent" Cheval Blanc inn, where full-board cost only 3.75 francs a day. On his return, Bazille was glad to have benefited from the advice of Monet, whom he describes as "pretty good at landscapes". No mention of the other companion.

Chailly-en-Bière is two kilometres from Barbizon and looks out over the same stretches of forest, notably the Bas-Préau celebrated for its ancient oaks and beeches. It was much more rustic and much less famous; the contrast is striking even today. By opting for Chailly, Monet and his friends chose to keep their distance from the masters of the Barbizon school; Jongkind's influence may have been a factor in this decision.

Unlike Bazille, Monet did not return to Paris after the one-week stay. In May, well after the Salon had opened, he was still in Chailly. His correspondent, Toulmouche, was concerned by his protégé's continued absence and alerted "Madame Lecadre, the doctor's wife". She, in turn, wrote to Monet, her cousin, that "he must under no circumstances remain in the country, and that it was a serious lapse to have given up the studio so soon." When he wrote to Amand Gautier on 23 May, reporting the tenor of his aunt's letter, Monet categorically denied that he had left the Academy; he was expecting to return to his drawing sessions there. He explained his temporary removal from the Academy in terms of Chailly's "infinite charm", which he had been unable to resist, and declared that he was now satisfied with his experiments, which had been more intense than ever before. Yet it would seem that no painting survives from this first session in the forest of Fontainebleau, which was apparently devoted to exploratory studies.

As soon as he got back from Chailly, Monet very likely hastened to the two Salons at the Palais d'Industrie, which were already open. We can guess at his reactions, particularly to Manet's *The Luncheon in the Grass*, but have no contemporary record to confirm our conjecture or tell us whether he visited Manet's one-man show at the Martinet's that spring.

The Demise of the Academy

As summer approached, it was announced that the Gleyre Academy would have to close for a while for lack of funds. Bazille wrote to tell his father this, as he was impatient to return to Montpellier for the holidays. Monet spent the summer holidays at Le Havre and Sainte-Adresse, where he painted the *Farmyard in Normandy* (**16**), the first landscape to have survived since his return from Algeria. It still bears the mark of various influences, as do the other pictures that he painted in 1862 and 1863 (**9–15**).

When term restarted in early October, almost all of Bazille's friends had returned; they greeted him with "wild cries". Some weeks later, we read that "Villa and Monet are the only students of my studio that I spend a lot of time with; they are very fond of me, as I am of them, for they are charming fellows." Written when the second year of studies was well under way, this letter is decisive evidence about the duration of Monet's study with Gleyre.

The winter was severe; in January 1864 the temperature reached -10 degrees. Bazille was distraught: "M. Gleyre is quite ill. It seems that the poor man is in danger of losing his sight, all his students are deeply distressed, because everyone who knows him loves him. The studio itself is ailing, I mean that funds are

Flowering Garden
1866
Cat. no. 69

lacking... At all events, we will go on for another six months, since we have paid two terms in advance." Ten days later: "M. Gleyre is better, but the studio is still ailing."

Having temporarily closed for six months early in the year, the studio was forced to close definitively in July 1864. Bazille remained a devotee to the last. Renoir did the same; he preferred this "most estimable Swiss painter" to his masters at the Ecole des Beaux-Arts. He had, as he put it, learnt "the painter's 'métier' from Gleyre", though this contradicts his other remark that Gleyre "could be of no assistance to his students". Gleyre is supposed to have asked him "You, no doubt, paint to amuse yourself?", to which Renoir famously retorts: "I certainly do, and if it didn't amuse me, I can tell you that I wouldn't do it."

This anecdote was recorded long after the event, and is somewhat akin to those recounted by Monet in his efforts to convince people that he had quit the studio in haste. Hugues Le Roux started the whole story in 1889 when he noted the following exchange between Gleyre and Monet over the latter's first nude study. Gleyre: "This is good, young man, but you have an unfortunate tendency to see nature too crudely as it is. Look at the toes of your man, you have given him the feet of a messenger boy." Monet: "But, Monsieur, the model..." Gleyre: "Models aren't really up to it. We must always have antiquity in mind." These remarks are exacerbated in Thiébault-Sisson's account by the way in which Gleyre had settled comfortably in his student's chair. Monet decided there and then to give up a man who was so ignorant of "truth, life, nature" in this way. He remained a few weeks thereafter only in hope of persuading his friends to join his "secession".

According to Marcel Pays, in 1921, "a fortnight of such strenuous lessons" was enough to drive Monet away. The sex of the model had changed since 1900, and had become a woman "more vigorous than graceful" whose buxom form Monet scrupulously reproduced. Gleyre is made to invoke the authority of Praxiteles to impose the canons of classical beauty in preference to an excessive fidelity to reality. "Let's get out of here," was Monet's immediate decision, and he convinced Bazille, Renoir and Sisley that they should follow him.

These anecdotes are more witty than substantial. The incident and its consequences can only have occurred at the beginning of an attendance that continued for more than a year and perhaps for two. Or is it supposed to have taken place during the studio's final moments, when Gleyre was ill and distraught at the imminent closure of his studio? Yet it seems that the story was not a complete invention; it is a kind of studio legend. Zola, in his novel *L'Œuvre*, recounts a similar dialogue placed in the mouths of Mazel (Cabanel) and his student Fagerolles: "The two thighs are not symmetrical" – "Look, Monsieur, that's the way they are" – "If they are like that, they're wrong." Zola's novel, which gave Monet great pleasure and "awoke memories on every page", was published in 1885–1886, shortly before the Le Roux article; it is not inconceivable that Zola influenced Monet's account.

Honfleur

Monet's contacts with Amand Gautier were increasingly few and far between. By the end of winter 1863–1864, Aunt Lecadre's correspondent had not seen a specimen of his protégé's work for nearly a year. Gautier therefore invited Monet to come and work with him at 8 Rue de l'Isly. Monet took a rather circuitous route along the Quais and through the Tuileries gardens, arriving late;

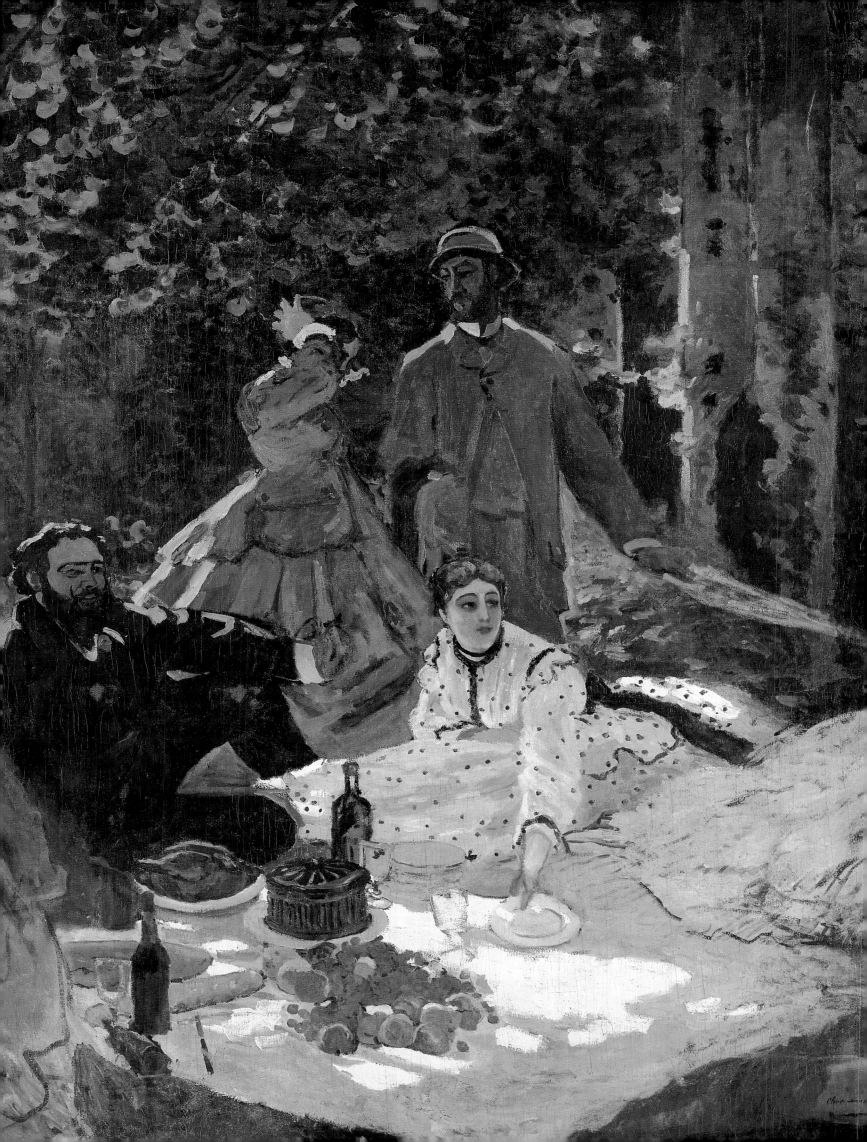

his reception was consequently rather brusque, and the meeting was adjourned to another day. Monet wrote to apologise some days later, on 7 March; doing his best to flatter Gautier, Monet assured him that he was enjoying his work and invited him to come to dinner and assess his studies. The address he gave, 20 Rue Mazarine, is the first with which we are acquainted since Monet's return to Paris. It was a fairly large block in wood and ashlar which had been restored in 1856. Monet occupied the only studio in the building, part of a tiny attic flat on the fifth floor overlooking the courtyard. From the Rue Mazarine it was a few steps to have lunch at the Hôtel du Berri in the Rue de Seine, where Bazille was a regular.

Bazille was at home during the Easter holidays, preparing for a medical exam, but Monet was able to return to Chailly. This we know from the *Road in Forest* (**17**) dated 1864; which bears a strong affinity to *Woodbearers in Fontainebleau Forest* (**18**) and *Le Pavé de Chailly*, which appeared at the 1866 Salon under the title *Fontainebleau Forest* (**19**).

But the major event of 1864 was the trip to Normandy. As early as December of the previous year, Monet had invited Bazille to spend some days with his family in Le Havre during the spring. Was he expecting too much of his family? At all events, we know from Bazille's letters that by March the invitation had been replaced by the proposal of a fortnight's stay together on the opposite bank of the Seine estuary, at Honfleur. They left Paris in the second half of May, stopping at Rouen where they visited the gothic splendours of the city and were overwhelmed by Delacroix's *The Justice of Trajan* in the Musée des Beaux Arts. They continued down the Seine by boat.

When they reached Honfleur, they rented two rooms from a baker and went in quest of "easy to find" motifs in the port and countryside. They were delighted to discover an ideal spot west of Honfleur: the Saint-Siméon farm at the foot of the Côte de Grace, between the Trouville road and the sea-cliffs. The farmer's wife, Mme Toutain, and her daughter, were very happy to serve meals to the two painters, who could thus remain on the spot all day. They would get up at five and work without a break until eight in the evening.

On one occasion they crossed the estuary to Le Havre. Bazille visited the Wanners, who were family friends, and vainly attempted to contact the Fontanes, whose property reminded him of his parents' house at Méric. This accident gave them both time to work on studies of the shoreline at Sainte-Adresse (**22**).

Bazille had to return to Paris to prepare for the second part of his medical exams; he had failed in April, and did so again now. Monet stayed behind, as he had in Chailly. He was still in Honfleur in mid-July, and overjoyed to have received a letter from one Eugénie, whose presence in his life is thus revealed. But what was a young Parisienne when weighed against Monet's desire to "do everything" in a landscape "more beautiful every day"? Convinced of the difficulty of his task, he was determined not to be content with "near misses". He also warned Bazille against Villa, with whom Bazille had become such friends at Gleyre's that he was sharing a studio with him at 115 Rue de Vaugirard.

By late August, departure was definitely not on the agenda; Boudin and Jongkind, his first masters, were there, and all three were as happy working together as they were when playing dominos afterwards. Ribot was expected. If Bazille were to return, he would see how great a variety the partial yellowing of the leaves imparted to the effects. Landscape studies were not Monet's only occupation; he was also painting still lifes and only sorry that he could not devote more time to them, since one of his flower paintings seemed to him "the best thing yet". It was probably this painting that he sent to an October exhibi-

Jar of Peaches
1866
Cat. no. 70

tion in Rouen (20). Sometimes they would all make a sortie together as far as Trouville where new subjects awaited him; he was hoping to get back to them the following year, and a drawing made of the Port of Touques was evidence of this.

On 13 September, Monet was still in Honfleur, writing to Boudin to apologise for not joining him at Villerville. Jongkind, Mme Ferrer at his side, had not left Honfleur. It was not so much this second opportunity to work alongside Jongkind, but Monet's own prodigious efforts over the last year that had widened the gap between the *Farmyard in Normandy* (16) of the previous year and works of much freer treatment painted during the summer and autumn of 1864 such as *La Lieutenance at Honfleur* (31–32), *La Rue de La Bavolle at Honfleur* (33–34), *Boatyard near Honfleur* (26–27), *The Lighthouse by the Hospice* (38), *Saint-Siméon Farm*, the series of paintings of the road which runs alongside it in both directions (24–25, 28–30, 36), and finally his painting of *The Chapel of Notre-Dame de Grâce at Honfleur*, which stands right at the top of the Côte de Grâce (35).

In mid-October, Monet spent several days at Sainte-Adresse to appease his family's concern at his long absence. He painted some studies in oil near the Cap de La Hève (39–40) but a fierce argument broke out and he was told to "get out and not come back for a long time"; if he was not careful, he would be cut off without a penny. This threw him into terrible disarray; he owed mother Toutain over 800 francs. Thanks to an admirer for whom he had painted a picture, he was able to pay off a quarter of the account.

He needed money, and sent three pictures to Bazille, who was on holiday in Montpellier; Bruyas was supposed to sell them. The sale fell through, but the event affords an interesting insight into Monet's working methods. He had intended to send Bazille a study which, he felt, showed Corot's influence, along with two pictures painted at Saint-Siméon. The latter two were not studies, but paintings that he intended to complete from studies made at Sainte-Adresse. Unhappy with the repeats, he sent the original studies. But the fact remains that he had contemplated painting pictures away from the motif itself.

After a short trip to Rouen, where the cool welcome for his *Flowers* disappointed him, he returned to Honfleur, which was by now all but deserted. In late October-early November, he wrote Boudin a second apologetic letter, telling him that one M. Gaudibert – probably the art-lover mentioned above – had commissioned him to paint two further pictures. Shortly afterwards, on 11 July 1864, Louis-Joseph, Gaudibert's son, married Marguerite-Eugénie, daughter of the notary Marcel; she was to be immortalised under the title *Madame Gaudibert*.

On 6 November 1864, seeking to leave the Norman coast without dishonourably avoiding payment of his debts, Monet knew not "which way to turn". A pressing demand was sent to Bazille, who must have responded, for Monet returned to Paris before the end of the year. He bore with him a considerable harvest of studies, some of Sainte-Adresse, most of them of Honfleur.

The Rue de Furstenberg and the First Salon

In a further attempt to help his friend, Bazille requested his mother's cousin, Commandant Lejosne, to help him place some of Monet's pictures. At the same time, he asked his parents to return post-haste the studies which had failed to sell in Montpellier; Monet was hoping to use them for a 400-franc commission for three pictures that he had just obtained.

PAGES 54 AND 55:
Luncheon on the Grass (study)
1865
Cat. no. 62

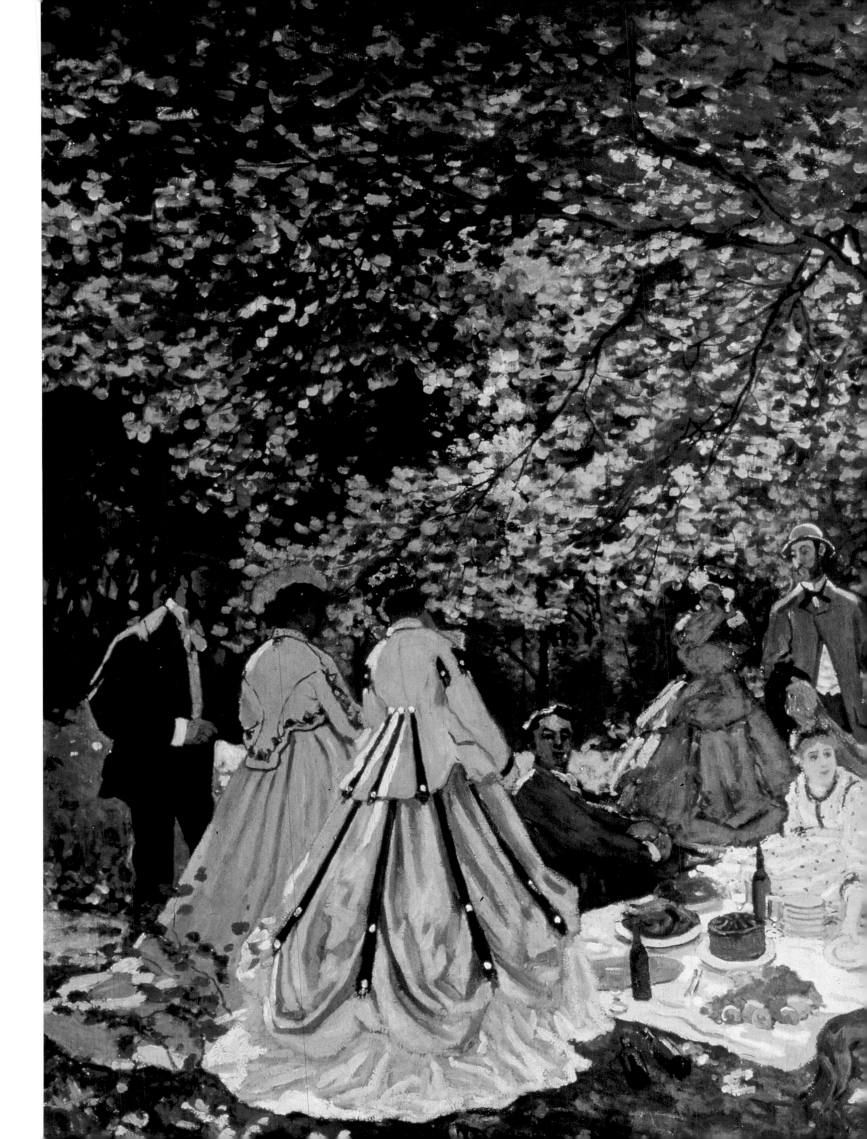

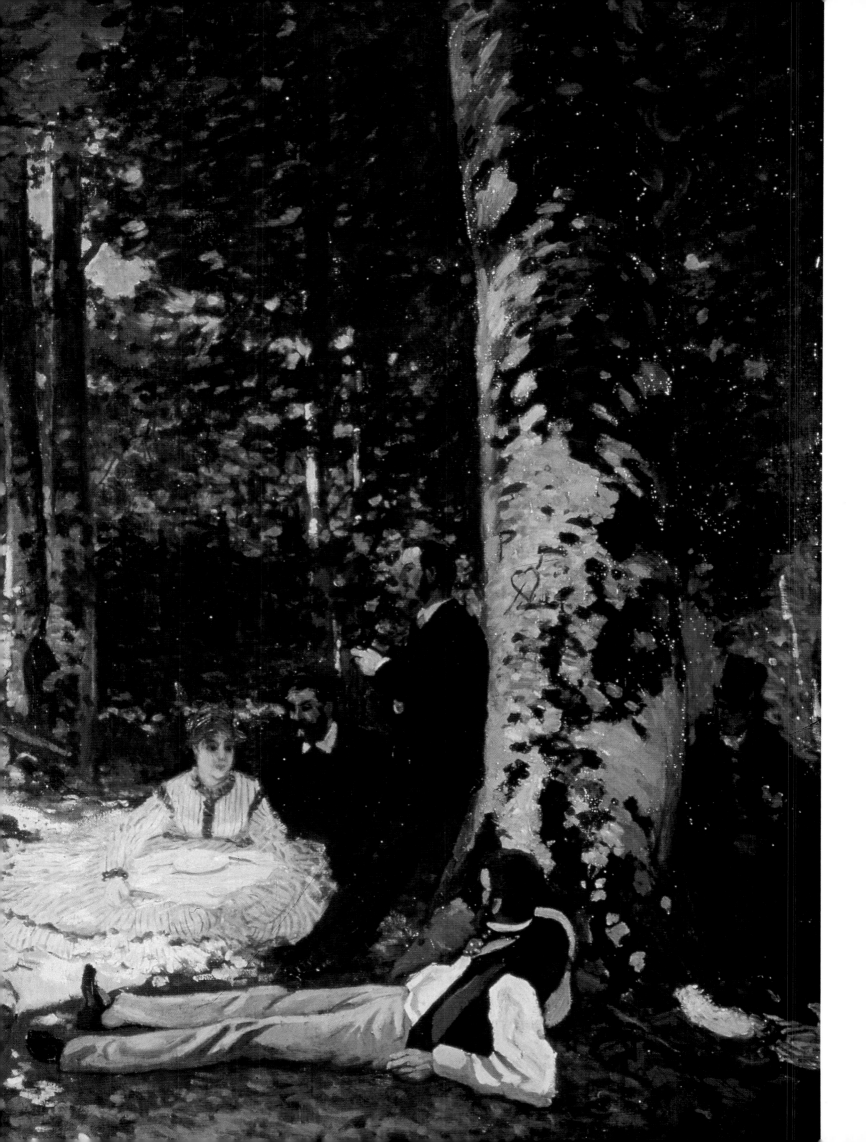

Bazille left the studio he was sharing with L.-E. Villa in the Rue de Vaugirard and went to paint in Monet's studio until he found a large flat with studio on the sixth floor of 6 Rue de Furstenberg where he could both live and work. The studio was spacious enough to be used by Monet too, who thus saved some money, though he took on a share of the rent. Monet's father had handed over 250 francs during a visit to Paris, which was of no small assistance. Bazille's family also came up with some money, and Bazille was finally able to move in during the last days of 1864, when Paris was experiencing extreme temperatures and the Seine was frozen over.

A tradition derived from Monet's own words has it that from a window of 6 Rue de Furstenberg, he and Bazille watched Delacroix at work in his studio. It is true that the garden windows of the studio give a view of Delacroix's studio; unfortunately, he had been dead two years when the two moved into the Rue de Furstenberg! The suggestion has therefore been made that the event occurred two years earlier, when the two were visiting a friend. Even this seems unlikely; Monet and Bazille had met for the first time in November 1862, and within a few months of that date Delacroix was already so ill that he painted very little. The procession of models that our authors inconsistently describe is thus highly improbable; it is more likely that Monet heard a friend of Delacroix', Célestin Nanteuil, who lived in the same block, describe Delacroix' working methods; Monet then transposed Nanteuil's description to his own past and the historians believed him.

We know what one corner of the shared studio looked like, since Bazille painted it. Bazille, who favoured landscapes populated with figures, painted the studio deserted. But visitors to the studio were not lacking. There were old friends from the Gleyre studio, such as Renoir and Sisley; Pissarro, whom Monet had met earlier at the Académie Suisse; and Cézanne, who had entered the same Academy shortly after Monet had left for the army. Gilbert A. Severac, another visitor, painted Monet's portrait in 1865: we see him clean-shaven, romantic locks falling over the collar of his striped jacket, his gaze serious and determined. Later Courbet, too, would visit. Bazille introduced Monet to the Lesjosnes, and there he met Fantin-Latour and other eminent persons.

His social activities were not allowed to stand in the way of his work. His goal was the Salon of 1865 and his method was to repeat with variants the best of the previous year's studies. He chose to concentrate on two views of the estuary, one from Honfleur, the other from Sainte-Adresse. Working feverishly, he was able to deposit the works before the 20 March deadline (51–52).

Having met the deadline, he could take himself off to Chailly. "We are expecting you", he wrote to Bazille on 9 April; he was not, apparently, alone. On 28 April, the invitation was renewed; Bazille should come "with all those gentlemen" and Monet promised to return to Paris for the opening of the Salon. He knew by now that the jury, on which sat artists as different from one another as Cabanel and Corot, Gérome and Français, with Gleyre as acting member, had chosen two of his submissions and given them the number 1.

On Monday, 1 May, the Palais de l'Industrie opened its doors. Monet's pictures were prominently exhibited, and a small crowd at first prevented him from seeing them. A friend spotted him: "Well, you've made quite a hit with your boats. See, that's Manet looking at them." Deeply offended by both the hostile reception for his *Jesus Insulted* and the scandal of his *Olympia*, Manet reacted with predictable anger to ignorant or malicious congratulations on the work of his near-homonym: "Who is this urchin with his despicable pastiches of my painting?" Those who were hoping to introduce the two artists decided to postpone the event.

Camille with a Small Dog
1866
Cat. no. 64

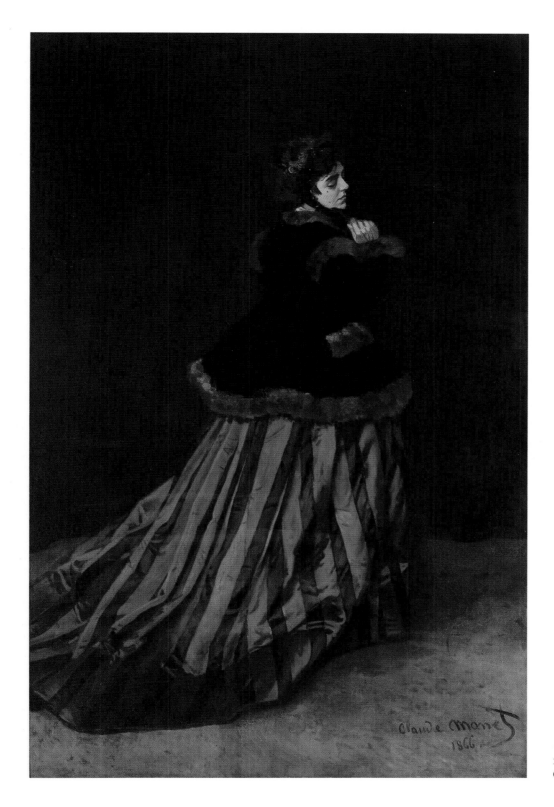

Camille or *The Woman with a Green Dress*
1866
Cat. no. 65

Renoir appeared in the catalogue as a "pupil of M. Gleyre". Monet gave no such reference, despite the express requirement in the Salon regulations. Bazille, quite without jealousy, was delighted by the unexpected success of his friend, writing to his mother that "several very talented painters with whom he is not acquainted have written to compliment him." Among the critics, Paul Mantz of the *Gazette des Beaux-Arts* showed particular perception. The paintings revealed themselves as "early works" by a certain lack of "finesse", but impressed with their "striking sense of ensemble"; Mantz went on to praise the "the taste displayed by the harmonious colours within the range of similar tones, the sense of tone-values" combined with "a bold manner of perceiving things and commanding the spectator's attention."

Without waiting for these eulogies to reach the press, Monet took the train for Melun where a regular coach-service to Chailly was available. In his haste, he had forgotten to pack paper and pencils, and wrote to Bazille to ask him to bring these with a little cash. To hasten his arrival, he informed him that "the young Gabrielle" was on her way; this seems to have been an incentive for Bazille.

The *Luncheon on the Grass*

The traditional motifs afforded by Chailly – a farmyard, the beeches of the Pavé de Chailly, the oaks of the Bas-Bréau (55–60) – were not the main reasons for Monet's haste. He was in the early throes of a major project; a *Luncheon on the Grass* with life-size figures in contemporary dress sitting in a beech wood. Bazille was acquainted with the project by a P.S. in Monet's letter of early May: "I want your opinion on the choice of landscape for my figures, sometimes I am afraid of what I'm getting myself into." The paper and pencils were for the preliminary sketches.

Bazille came to Chailly at some time in May, staying for a while and dividing his time between his own work and Monet's demands. This – or a slightly later stay – must have been the occasion reported by Poulain, when a clumsy English discus-thrower injured Monet's leg, and he was confined to bed; Bazille painted him in *The Improvised Ambulance*.

Monet made fragmentary studies at Chailly; the size of the intended painting meant that it could not be produced out of doors. Bazille returned to Paris, where he worked on several paintings, preferring to spend his weekends on the Seine, particularly at Bougival where he won first prize in the regatta on 16 July. Monet was impatient at his long absence, and appealed to him to return in the name of their "close friendship of before". Relations between the two were beginning to go awry; Bazille was drawn to Renoir, who began to "tutoyer" him at this time, something Monet never did. The moral and social divide between them was widening.

Meanwhile the studies for the *Luncheon* had gone "wonderfully well", and only the figures of the men were now lacking. Despite the presence in Chailly of a pleasant little group of artists and one or two of their muses, Monet could not do without the tall figure – 1.88 metres – of Bazille, which had become integral to the painting. On 16 August, he wrote again in despair. Bazille finished the paintings on which he was working and reached Chailly on Saturday 19 August. Both men now stayed at M. Barbey's hotel, the Lion-d'Or, Monet having quarrelled with the landlord of the Cheval-Blanc, M. Paillard.

For several days, rain inhibited Monet's progress. The Thursday after his arrival, Bazille had been able to pose only twice, but, good weather intervening,

Frédéric Bazille
Portraits of the Family or Family Reunion
1867
Paris, Musée d'Orsay

the sessions became more intense. This was no doubt when the only preliminary study to have survived was produced; it was destined for the left-hand side of the final painting, and represented *The Walkers* (**61**).

In September, after Bazille's departure, Monet finalised the ensemble composition in a study painted indoors; it was later dated to 1866, and is now in Moscow (**61**). Bazille's tall figure is recognisable stretched out at the foot of the beech tree and standing in various positions. The seated young man to the left of the picture is thought to represent a friend from the Gleyre Academy, Albert Lambron des Piltières. The fourth male figure from the right is sometimes thought to be Sisley. As for the female models, "the young Gabrielle", whose arrival was announced in early May, doubtless posed for one or more figures; she is perhaps seen wearing the polka-dot dress (**62** and **63/2**) that we encounter again in *Women in the Garden* (**67**). It is quite possible that "la petite Eugénie", Monet's correspondent of the previous summer is also present. We know that he had himself photographed with her at Cadart's.

With autumn coming on, Monet was in some financial disarray. He left Chailly and returned to the studio in the Rue de Furstenberg. He was having problems with the rent; Bazille was late in sending his share from Méric and seems to have given notice unilaterally. Despite all this, Monet began the transformation from sketch to final composition. He had acquired an immense canvas some 4.65m high and more than 6m wide (**63**). On 14 October, he wrote to Bazille, who had been detained at Méric, telling him that everything was ready and that he should bring his "summer things" to pose in. Bazille is clearly the bearded man with the cane at the extreme left-hand side of the studies (**61–62**); in the final version, however, a clean-shaven man appears instead (**63/1**). But perhaps this was simply to avoid too great a resemblance between the four male figures.

Admiring visitors flocked to the studio and a great success was expected at the Salon. Yet the picture was not submitted that year or the next, and remained unfinished. One explanation given for this is the discouraging influence of Courbet. The two men had known each other for some time, but it is by no means certain that Courbet had come to Chailly in 1865, though we know that he attended the Fontainebleau races in June. When he returned to Paris that autumn after a long stay on the coast of Normandy, he came to the Rue de Furstenberg to see Monet's picture and, if Bazille is to be believed, was "delighted" with it. It is even possible that he, rather than Lambron, posed for the final picture, wearing a handle-bar moustache to make him less recognisable (**63b**). When this fact is considered in combination with the ample forms of some of the women in the composition, which recall those of Courbet's *Demoiselles of the Banks of the Seine*, the broad treatment and the use of areas of dark background colour (something Monet had not yet given up), it seems unlikely that Courbet was so discouraging.

It is more likely that, despite the encouragement he had received, Monet abandoned the project because it was so difficult and so expensive. In addition, he had to leave the excellent Rue de Furstenberg studio on 15 January. It was not just a question of money. There was also an artistic obstacle; it seems that Monet threw himself into the figures and their costumes, which he consistently retouched, without realising that he had mastered the painting's real subject, the effects of light filtering through the foliage and playing on persons and objects alike. In the last analysis, the future of the "new painting" did not lie in vast compositions of this kind, in which, for all their innovations, we recognise a last homage to the academic. The failure of the *Luncheon on the Grass* testifies to this desperate effort to combine irreconcilable opposites.

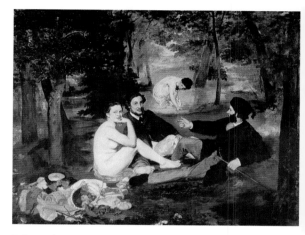

Edouard Manet
Luncheon on the Grass
1863
Paris, Musée d'Orsay

The church of Saint-Germain-l'Auxerrois
Postcard, c. 1900

ABOVE:
Saint-Germain-l'Auxerrois
1867
Cat. no. 84

Camille

When they left their studio, both painters headed for the Right Bank. Bazille set up in the Rue Godot-de-Mauroy near the Eglise de la Madeleine. Monet returned to the area in which he had lived before and rented a little studio without annexes on the third floor of a block that belonged to a friend of Gautier, Louise-Marie Becq de Fouquières, at 1 Place (or Rue) Pigalle, on the corner of Rue Duperré. He brought his huge canvas (**63**) with him; the move was the first of the many vicissitudes that the painting was to suffer.

Recognising that he would not finish before the deadline, he gave new thought to what to submit, and decided on *Le Pavé de Chailly*, which was already old (**19**). At the same time, he began a life-size female figure. It was winter, and he had to work very fast, so he posed his model indoors and on a plain background.

The model was Camille-Léonie Doncieux, his new conquest, a nineteen-year-old whose family had come to the capital from Lyon when she was very young. In the first pictures in which she appears, she is easily recognisable by the lick of hair that hangs down over her cheek (**64**). She wore a loose-fitting

green dress with wide stripes and a sort of puce velvet "caraco"-style jacket with fur cuffs and collar. The silk dress – "dazzling as Veronese's" as W. Burger noted in 1870 – transformed Camille into *The Woman with a Green Dress* (65). The portrait was finished in four days, and Monet was able to send two canvases to the Palais de l'Industrie for the 20 March deadline.

The jury had grown to forty-eight, compared to the twelve members of the previous year, and proved very severe. Monet knew that his two pictures had been accepted well before Holtzapffel's famous suicide on 12 April 1866 – apparently in reaction to the jury's unfavourable verdict – and Cézanne's protest. Once again, unlike Bazille and Sisley, he had refused to describe himself as a pupil of Gleyre, despite the fact that Gleyre was vice-president of the jury that year and almost certainly did his best for Monet. Zola admits in *Mon Salon* that though the pupils were "acting up these days", Gleyre had "behaved impeccably".

No sooner had he learnt the good news than his prospects were darkened by the threat of Aunt Lecadre apparently deciding to cut off his allowance. A. Gautier persuaded Mme Lecadre, now impressed by her nephew's success, to continue to provide for his "everyday" expenses; she was, however, resolute that she would not pay off his debts. He was still her "poor boy" and "meek as a lamb" and she knew nothing about his relations with the fair sex.

Assured of his aunt's support, Monet left Paris in the second half of April for Sèvres, where he had rented a little house in the Chemin des Closeaux, near the station of Ville-d'Avray; this is the name that has generally been used of Monet's first sojourn in the Paris suburb. He was resigned, at least for the immediate future, to giving up "the big things that I had planned", preferring to finish more modest works and asking Gautier to help him to sell them. By escaping from Paris he had hoped to put his stock of paintings out of reach of his creditors, but "those gentlemen" had taken umbrage at his departure and were threatening to send in the bailiffs.

Meanwhile *Camille* at the Salon was obtaining a "succès fou", not all of whose consequences were satisfactory. Unfortunate comparisons were again made with Manet. The caption to Gill's caricature of the Monet ran: "Monet or Manet?" and replied "Monet". For Manet, these incessant comparisons, generally to his disadvantage, were becoming a sort of obsession. Duranty noted: "Manet is absolutely tormented by his rival Monet. Indeed, he says that having Ma[g]netised him, he would now be glad to demonetize him." The mediation of Zacharie Astruc led to a meeting between the two; their antagonism, fuelled by provocations not of their making, was buried.

One critic, at least, did not seek to contrast Monet with Manet when praising the former: this was the greatest of them all, Emile Zola. A firm supporter of Manet, he wrote in *L'Evénement* of 11 May: "I confess that the picture which longest detained me was the *Camille* by M. Monet... Yes indeed! Here is a temperament to reckon with, here is a real man amid a crowd of eunuchs." Villemessant, the editor of the paper, was alarmed at the protests caused by Zola's attack on the jury and by his defence of Manet. He asked Théodore Pelloquet to take up the cudgels on behalf of a more conventional and reassuring viewpoint, which Pelloquet did with such zeal that Zola, nauseated, published his "Farewell to Art Criticism" on 20 May, four days after Pelloquet's article had appeared. Pelloquet is often presented as supportive of the young painters, and Monet must have found the article a particularly bitter pill to swallow from the man he had befriended at the Brasserie des Martyrs.

Garden of the Princess
1867
Cat. no. 85

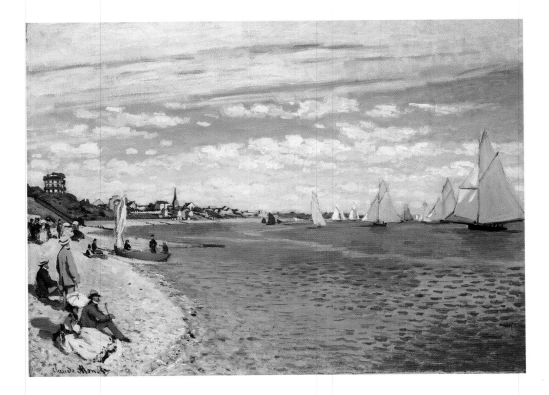

Regatta at Sainte-Adresse
1867
Cat. no. 91

Le Havre, the promenade along the front
Postcard, 1900

Women in the Garden

Aunt Lecadre was "delighted" with her nephew's success. He had sold several paintings for a total of 800 francs, the firm Cadart and Luquet had paid him an advance for a smaller replica of *Camille* (**66**), and, despite his decision to "put the big things aside", he began a new big painting, the famous *Women in the Garden* (**67**).

The 2.50m-high picture was painted directly in the open air. Monet was forced to dig a trench so that he could lower the picture with a pulley system when he wanted to work on the upper section. This time, the figures were not life-size; Camille posed for the three on the left, and for the fourth, on the right, Monet again used the woman with reddish-blond hair, wearing the polka-dot dress encountered in *Luncheon on the Grass* (**63/2**).

Over the course of the winter, Monet had recounted to Courbet obscure stories about his "past escapades" with Amand Gautier. Gautier, recently married, was not best pleased by Monet's indiscretion. Courbet nevertheless came to Ville-d'Avray, and on one occasion when Monet was unable to paint for lack of sunlight, advised him to "work on the landscape" while he was waiting. This led to discussions about technique, but Monet remained faithful to his principles; his experiments with painting out of doors were being taken further again with *Women in the Garden*, and he had given up the areas of flat colour practised by Courbet.

With the onset of summer, Monet left Ville-d'Avray for the coast of Normandy. Courbet, who was on holiday and staying at Deauville with M. de Choiseul, met Monet at the Casino with "his lady" and invited them to dine with himself and Boudin. When he visited his family at Sainte-Adresse, Monet took his oils and left his mistress behind; he made use of the oils at the Coteau (**69**), where he painted his elegant cousin Jeanne-Marguerite Lecadre silhouetted against the gardens (**68**).

In Honfleur, Monet established his studio at the Cheval-Blanc hotel and worked with passionate energy in the port and on the shore (**71–76**). As winter

approached, he asked Bazille and Astruc to send him several paintings, in particular *Camille* (**65**) and the smaller replica for which he had been paid an advance (**66**). He was sufficiently low on funds to scratch over a "Woman in White" and use the canvas for a large marine landscape intended for the Salon. This was probably the *Port of Honfleur* (**77**), still unfinished in February, 1867 when Dubourg visited the studio at the Cheval-Blanc; he also saw some "rather fine snow effects", the *The Road by Saint Siméon Farm* (**79–82**), and stopped in front of "a picture almost three metres high begun in nature and out of doors" which did not altogether convince him. This was the *Women in the Garden*, which had been brought down from Ville-d'Avray to Honfleur and finished in the studio (**67**).

Monet had left Ville-d'Avray in difficult circumstances and he was worried that what he had left behind might be seized by the bailiffs; Bazille was asked to fend off his creditor, Mme Rolina. Bazille was unsuccessful, as, it seems, were Sisley and Monet himself, but the figures of Monet's losses as they appear in much later reports are too high to be credible. Monet told R. Gimpel that he had taken a knife to 200 pictures to avoid them being distrained by a butcher for a 300 franc debt; Thiébault-Sisson's account of 200 pictures confiscated over a period of some six years seems more in line with reality.

Before the end of the winter, Monet came to stay with Bazille, who was by now back on the Left Bank at 20 Rue Visconti in Saint-Germain-des-Prés. Renoir was already staying with him; Bazille now had two "impecunious painters" on his hands. Monet was ready to submit *Women in the Garden* (**67**) and *Port of Honfleur* within the deadlines set by the Salon organisers; the advent of the Universal Exposition had caused them to advance the deadline. The blow fell on 29 March 1867, when the jury (Gleyre was now only an acting member) announced its decisions: none of Monet's pictures had been accepted. When Jules Breton was asked why the jury had been so severe on Monet, he replied: "I refused him precisely because he is making progress." Renoir, Bazille, Sisley, Pissarro and Cézanne were also rejected. A petition was made to the dealer Latouche, asking him to organise a new Salon des Réfusés. Aware that it was likely to fail, Monet and a group of some twelve young artists planned a collective exhibition on private premises. Bazille was convinced that this would be successful; it would, after all, have the support of masters such as Courbet, Corot, Diaz, Daubigny and Monet "who is the best of the lot." In his enthusiasm, he painted a portrait of his friend. But the funds collected, 2,500 francs, were insufficient, and the project was abandoned; everyone went their own way.

Monet decided to appeal directly to the public. His statements on this subject have been variously reported. He seems to have exhibited the *Port of Honfleur* (**77**) at Hagerman's in the Rue Auber and *Women in the Garden* (**67**) at Latouche's in the Rue La Fayette; but it also transpires that Latouche bought a *Quai du Louvre* (**83**) from him at this time, and comparison of the various accounts shows complete confusion about what was exhibited where. Monet is said to have hidden at the back of the shop and heard other artists offering contrasting judgements on his picture. But here the versions again diverge, and though Diaz' views are consistently reported as favourable, criticism is expressed on one occasion by Corot, on another by Daumier and also by Manet, whose viewpoint was at least a predictable component of such stories.

By now, Monet was in desperate need of money. Seeing that no one was offering a reasonable price for *Women in the Garden*, Bazille bought it for what was then a huge sum, 2,500 francs, payable in monthly instalments of 50 francs. The purchase was greeted with enthusiasm at Méric, and for Monet too, this was heartening news.

JOURNAL AMUSANT. N° 649.

PROMENADE AU SALON, — par BERTALL (suite).

1787. LE NAVIRE DE L'ESTAMINET HOLLANDAIS (PALAIS-ROYAL),
 par M. MONET.

Voilà enfin de l'art véritablement naïf et sincère. M. Monet avait quatre ans et demi quand il a fait ce tableau. De tels débuts sont du meilleur augure. L'horloge marche à ravir le dimanche, dit-on, et les jours de fête. La mer qui est d'un si beau vert remue, et le bâtiment se balance sur les flots de parchemin. Acheté par l'horloger du passage Vivienne.

Boats Coming out of the Port of Le Havre
The painting is only known through the cartoon published in the *Journal amusant* on 6 June, 1868
Cat. no. 89

PAGES 64 AND 65:
Garden at Sainte-Adresse
1867
Cat. no. 95

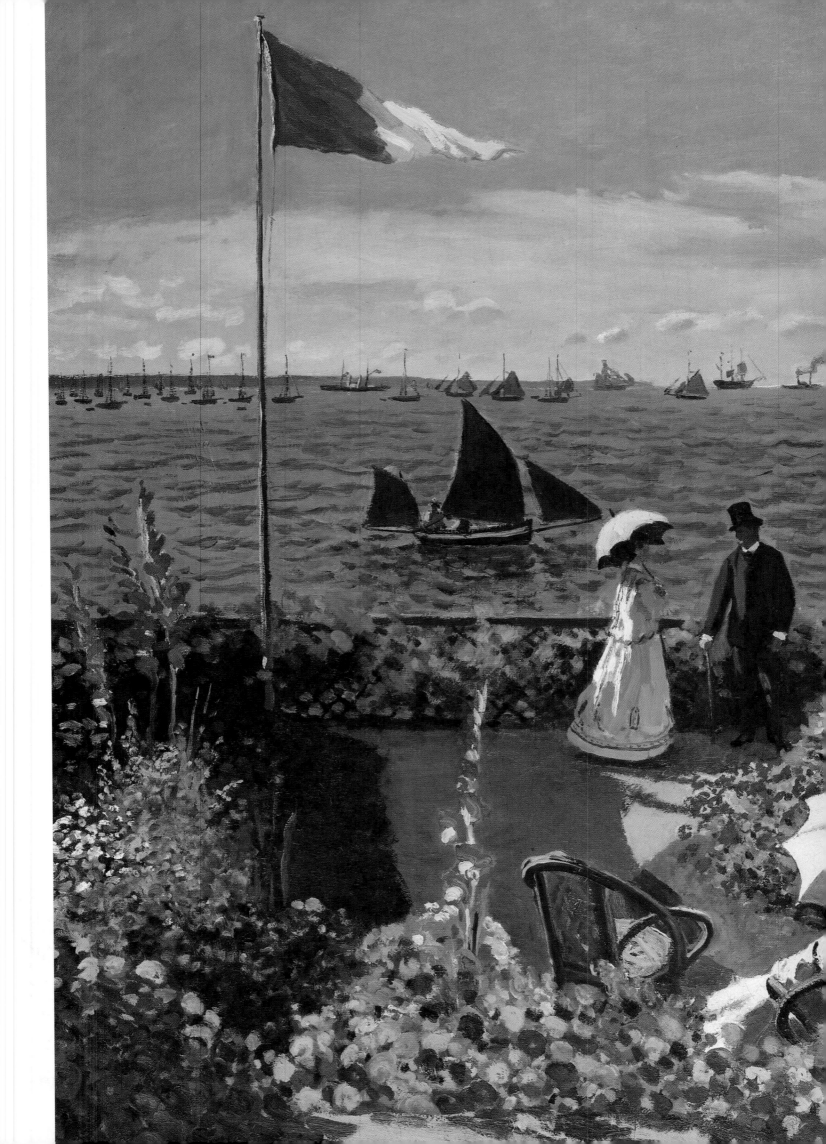

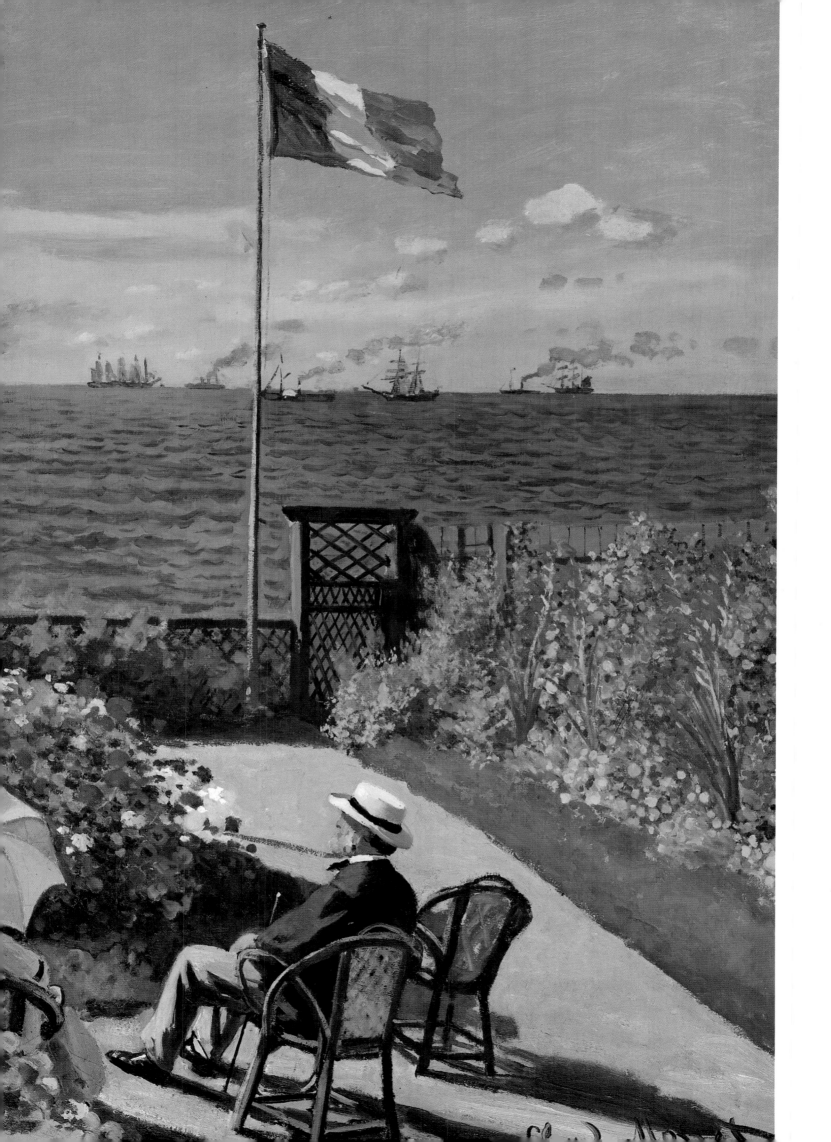

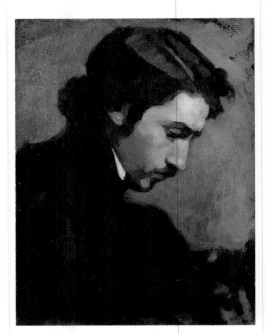

Jean Monet in his Cradle
1867
Cat. no. 101

Portrait of a Man
1867
Cat. no. 99

The Birth of Jean

In spring 1867, Monet worked with Renoir in various parts of the Colonnade du Louvre, painting views of Paris; the tender early green of the plane trees in *Quai du Louvre* (83) has become more mature in *Garden of the Princess* (85) and by the time that *Saint-Germain-l'Auxerrois* (84) was painted, the chestnut trees were in bloom. Monet's depiction of architecture was still scrupulous, but the framing of the view was bold, particularly in the *Garden of the Princess*. Monet's palette is fairly pale; the simplified outlines of people, horses and coaches seem to move along at the whim of the brushstroke.

Courbet's exhibition at the Pont de l'Alma contained "bad things", in Monet's opinion; Monet's letter to Bazille does not mention *The Mother Grégoire* which was in the exhibition, and had prompted Courbet to declare loudly in the middle of the Louvre's Salon Carré that "All the same, if *The Mother Grégoire* were here, this lot would all come tumbling down." Monet preferred Edouard Manet's exhibition, though he felt that Manet, too, had been "too swayed by praise". Monet drew two conclusions from this dual spectacle,

namely: not to listen to flatterers, and to be very demanding of oneself. In the fine portrait of him painted by Carolus Duran in that year, the determination in his expression is manifest.

One problem overshadowed all this; Camille was pregnant. The birth was expected in the summer. On 8 April, Monet informed his father. Two days later, Bazille also wrote. Adolphe Monet's reply to Bazille is well known. Monet's family were not angry with him for "failing" with the Salon jury; it was his conduct they disapproved of. If he abandoned the "evil way" into which he had fallen, then his aunt would be glad to welcome him to Sainte-Adresse. As to his "mistress", Monet should know better than anyone "what she was worth and what she deserved". Adolphe Monet, oblivious of his own relations with Amande Vatine (whom he married only in 1870), suggested that his son simply abandon Camille.

Monet resolved to feign submission while ignoring his father's advice. He went to visit Camille and found her ill and in bed. She was willing to accept the arrangements he proposed; in order to save money, she should go back to her family, and he would send her money as and when he could. The main thing in her eyes was his willingness to recognise their child. On 10 June, after selling two pictures to Cadart and Letouche, he took the train for Le Havre. He entrusted Camille to the care of a medical student, Ernest Cabadé, whose good offices were rewarded with a portrait (100).

On 8 August 1867, at six in the evening, in a room on the ground floor of 8 L'Impasse Saint-Louis de Batignolles, Camille gave birth to a "big, handsome boy"; Monet was astonished at the affection inspired in him by the child, but the reader of his letters written shortly before the birth is not. The birth certificate was issued at the Mairie of the 17th arrondissement; the child, Jean-Armand-Claude Monet, is registered as the legitimate son of Claude-Oscar Monet and of Camille-Léonie Doncieux, his wife. This was clearly false, but in the absence of the father, the registrar and two witnesses, Zacharie Astruc and Alfred Hatté, duly perjured themselves and signed. A marginal note of 3 March 1871 refutes the first entry by noting that the child was legitimised by marriage on 28 June 1870. Alfred Hatté was a gentleman of independent means who had rented to Monet and Camille the room in which the birth had taken place. Monet had not wished to "annoy his family" by being present at the birth.

A Return to his Roots

Monet's position in 1867 was a strange one. Aware of his responsibilities in Paris (not least through Bazille's promptings and reminders), at Sainte-Adresse he was still his Aunt Lecadre's "poor boy". "Everything here – work and family – is fine; if it were not for the birth, I should be perfectly happy." While Camille was languishing in the Impasse Saint-Louis, Monet had set up in the Rue des Phares, in the house in which his aunt spent her summer months. He could get nothing out of her but food and lodging, and appealed to Bazille for an advance on the 2,500 francs payable for the *Women in the Garden* with an insistence which was positively shocking; it is as if he were unaware that Bazille, too, had parents to convince.

To escape from his financial worries, he plunged into his work with renewed ardour. It is not known when he crossed the Seine to Honfleur (86–87) or when he confronted the storm-waves breaking around the Le Havre jetty (88). But by June, he already had "some twenty pictures well advanced, some stunning seascapes and figures and gardens" with "an enormous

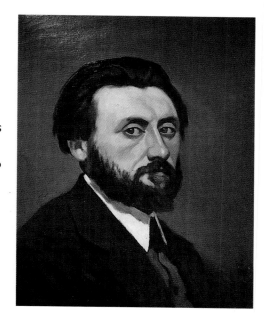

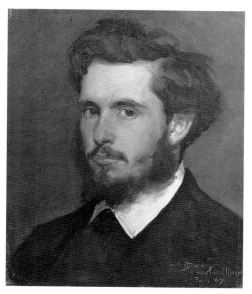

Above:
Portrait of Ernest Cabadé
1867
Cat. no. 100

Charles Durand known as Carolus-Duran
Portrait of Claude Monet
Paris, Musée Marmottan

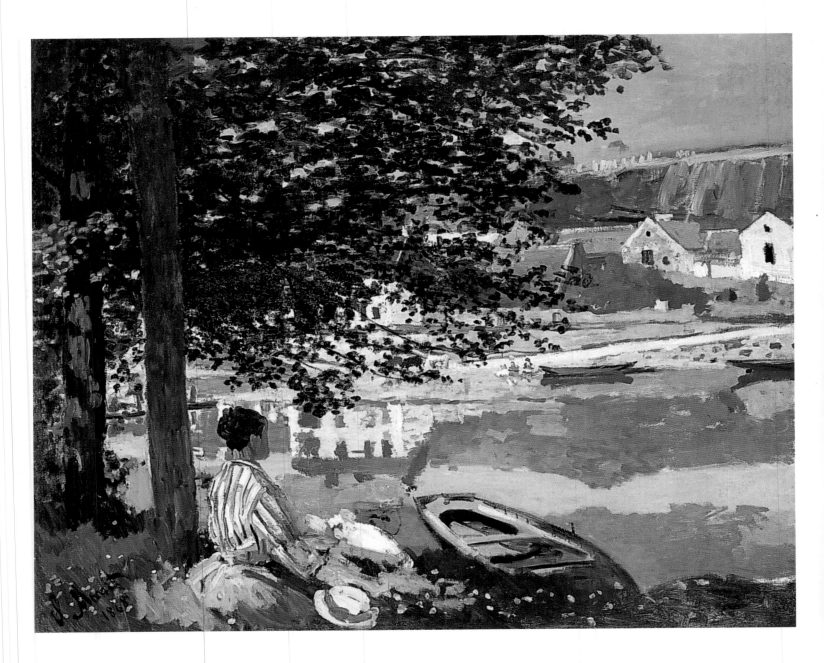

River Scene at Bennecourt
1868
Cat. no. 110

steamship" for the Salon (**89**). *Regatta at Sainte-Adresse*, in which Adolphe Monet is clearly recognisable on the beach (**91**), belongs to this first batch. But Monet had overtired himself; in early July, he was afraid that he might lose his sight, and the doctor suggested that he avoid working in the open air. Some days later, things were back to normal, and he could start work again. With one exception (**93**), he painted Sainte-Adresse facing east, with the village church visible to the left (**90-92**); the same church stands in the centre of the *Street in Sainte-Adresse* (**98**). *A Hut at Sainte-Adresse* (**94**) presages the steeply-angled views over the sea that Monet was to paint in the 1880s from the clifftops of the Pays de Caux.

The most famous work painted during this spurt of creativity is *Garden at Sainte-Adresse* (**95**), in which the colours of gladioli, geraniums and nasturtiums are juxtaposed with sea, boats and sky in a painting that heralds the major works of Impressionism. There were also some beautiful still lifes (**102–104**). The place given to Adolphe Monet in this and other paintings of the period (**91** and **96**) testifies to their excellent relations; besides, Adolphe was beginning to have confidence in his son's future and, like Aunt Lecadre, occasionally expressed an indulgent admiration.

The pictures of Jean in his cradle (101, 108) tell us that Monet returned to Paris several times in the months after his son's birth. He spent more time in the capital as winter came on; when it began to be really cold, he went to Bougival to paint the first *Ice Floes on the Seine at Bougival* (105–106) of his career. He was now living in the room at the Impasse de Saint-Louis with Camille. On 1 January 1868, he spent a day "almost without a fire", on the evening of which he wrote to Bazille in terms as desperate as they were unjust. Bazille replied in measured and dignified fashion; he would soon be able to invite Monet to share the new studio that he was moving into at 9 Rue de la Paix (which became, Rue de Condamine in 1869), near the Impasse Saint-Louis. Intensely and unswervingly loyal to Monet, he persuaded Commandant Lejosne to buy a still life from Monet.

Hoping to reduce his outgoings and return to the seascape motif, Monet returned to his family for January and February and worked in the open air on *The Jetty at Le Havre* for the Salon (109). Léon Billot, a Le Havre columnist, was out walking in snow-covered countryside on a day cold enough "to crack the pebbles" when he came upon a curious sight. "We saw a footwarmer, then an easel, then a man huddled in three overcoats, wearing gloves, and with his face half-frozen; it was Monet studying a snow-effect. There are soldiers of art who lack nothing for courage."

Monet returned from Le Havre towards the end of the winter. F. Martin described the return in nautical fashion, "Monet is furling his colours and hopes on Thursday to get a tow as far as Paris", a style at one with Monet's seascapes. He just had time to add a few finishing touches and to select some frames before the paintings were submitted; the deadline was 20 March. A few days later, Monet formed a "ring" with a group of friends and helped to push up the prices for the first public auction in Paris of the works of Boudin. It was the least he could do.

A Low Point

The Salon jury was more moderate this year, and Monet discovered that one of his two pictures had been admitted, *Boats Coming out of the Port of Le Havre* (89), thanks to Daubigny, who headed the poll that year. This painting which scandalised the ignorant, promised the connoisseur better things to come. It was hung neither better nor worse than Manet's *Portrait of Monsieur Emile Zola*, Bazille's *The Family* and Renoir's *Lise*, and disappeared without trace at an unknown date. All that remains of it are two rather mischievous caricatures and a description by Zola in *My Salon*.

Zola's article on Monet, which he considered one of the best of his series, *The Actualists*, covered Monet's work to date; it dwelt in detail on *The Jetty at Le Havre* (109), which had just been refused by the Salon, and *Women in the Garden* (67), which had been refused the year before. Zola had clearly studied these pictures at length. He, too, lived in Batignolles, and was to appear in Bazille's *The Studio in the Rue de la Condamine* alongside Manet, Monet and their friends.

To escape from the Parisian air and influences, Monet decided to move to the country with his wife and young son. It was probably on Zola's recommendation that he took full-board accommodation at Gloton, a village on the outskirts of Bennecourt. The inn was run by Mme Dumont. Zola had first been there in 1866 with Cézanne and Guillemet, and had often returned. This village, close to Bonnières-sur-Seine, was a revelation for Monet, and one that he never forgot, since he eventually settled close-by, at Giverny, where he died; it was to be his last and most famous residence. Of the various pictures painted at Bennecourt in the spring of 1868, we know of a rough sketch sold to Zacharie Astruc, since lost (111), and a fine painting usually called *River Scene at Bennecourt* for lack of a more specific identification (110).

Monet's stay at Gloton ended as abruptly as that at Ville-d'Avray. A letter from Monet to Bazille, dated "Paris, 20 June", recounts his being thrown out of the inn "stark naked". Having placed Camille and "poor little Jean" in the village, he returned to the capital whence he was hoping to leave that night for Le Havre in order to try his luck with M. Gaudibert, who had been favourably impressed by his small measure of success with the Salon. The following evening, before leaving Bennecourt, he "did something stupid"; he threw himself into the Seine. Fortunately, there were no ill effects. The incident has given rise to considerable controversy but the reality is simple enough: Monet gave way to an unthinking act of despair, but was too good a swimmer to drown in a branch of the Seine in mid-summer. His courage got the better of his despair, and never again was there any question of suicide.

Madame Gaudibert

When Monet arrived in Le Havre in late June of 1868, the Exposition Internationale Maritime was at its height. Fortunately, the opening of the painting section was planned for the second half of July, and Monet had time to prepare the five pictures that he had submitted. This work, and the steps he was forced to take in quest of funds, did not take up all his time. He worked on his usual subjects (122–116) and even found time to relax a little, in particular on the day when Gustave Courbet took him to visit Alexandre Dumas who was then living in Le Havre. After the introductions, it was decided that the very next day they would visit the beautiful Ernestine, the landlady of a highly reputed inn at

Page 71:
Portrait of Mrs Gaudibert
1868
Cat. no. 121

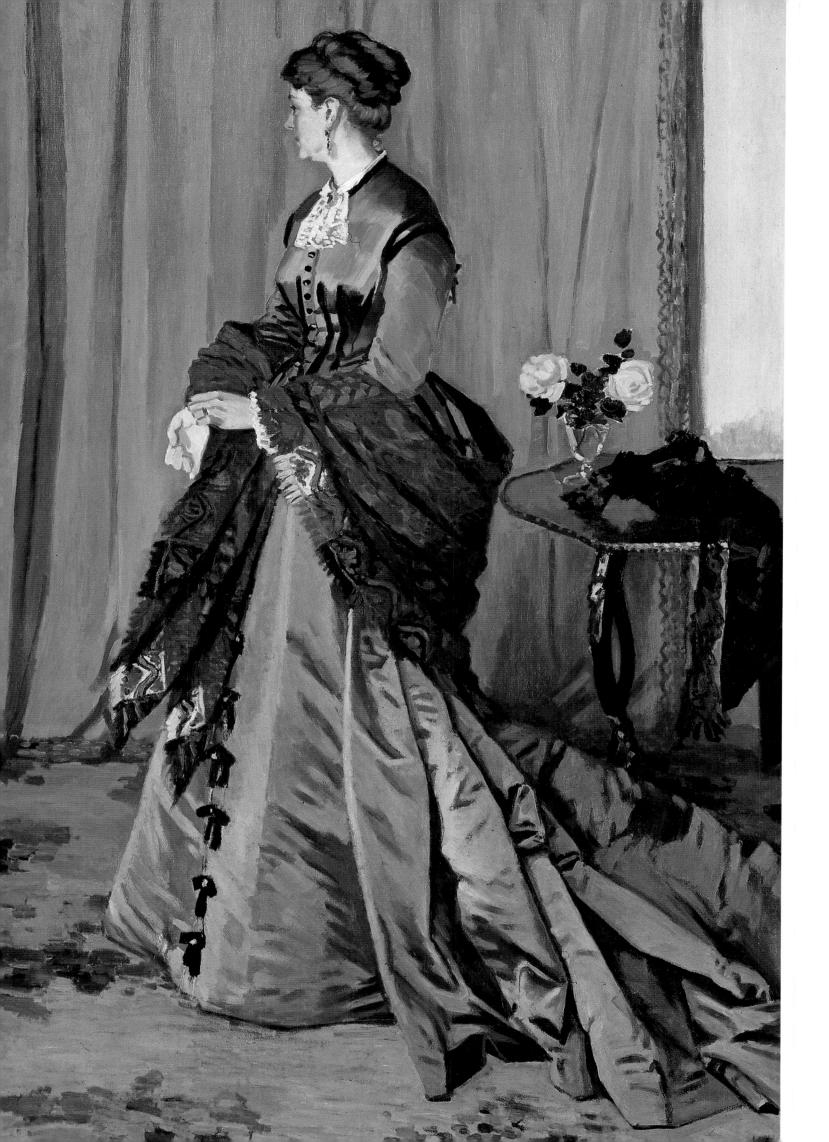

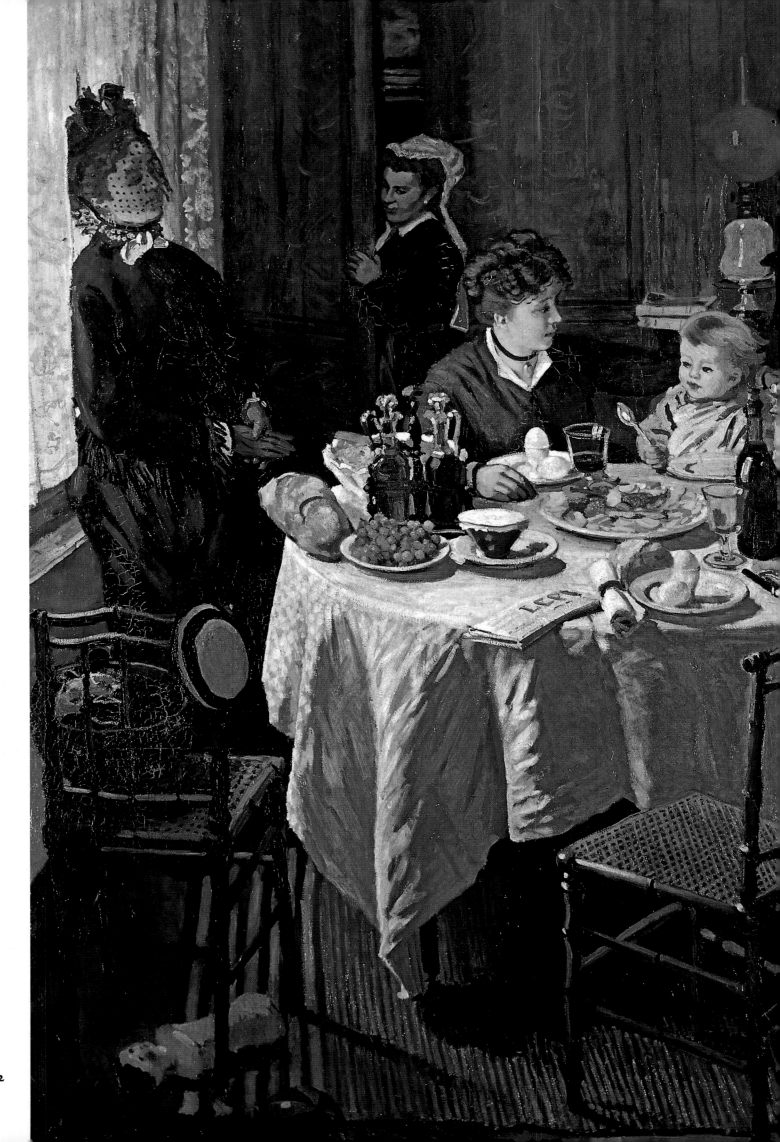

An Interior after Dinner
c. 1868–1869
Cat. no. 130

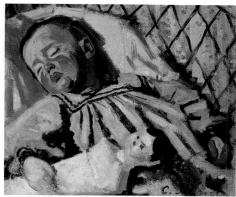

Jean Monet Sleeping
1868
Cat. no. 108

Saint-Jouin, a fishing village north of Le Havre, a little before Etretat. On this expedition, Monet was a silent spectator of Dumas' memorable wit and his two companions' gastronomic exploits.

His family could not be persuaded to receive Camille and Jean; Monet brought them to Fécamp, the great port of the Newfoundland fishermen, where he hoped to find a refuge and new sources of inspiration (117–119). His financial position was alarming in early August, but improved a month later when Louis-Joachim Gaudibert summoned him back to Le Havre to paint Mme Gaudibert, his wife.

By Monday, 7 September, when Monet arrived, Mme Gaudibert had left for the estate of her father, the notary Marcel, on the outskirts of the town; this was the Château des Ardennes-Saint-Louis, in the parish of Montivilliers. No matter; he was to paint the portrait of Louis-Joachim himself (120), whose parents would thus have a faithful likeness of their "much-adored progeny". Unfortunately, when F. Martin visited them in early October, they made no secret of disliking the portrait, which they considered "scrappy and vulgar". Louis-Joachim took Monet to the Château des Ardennes to remove him from the ambit of parental wrath, and it was there that he painted the *Portrait of Mrs Gaudibert* (121).

In early October, the members of the jury of the *Exposition Maritime* were preparing their verdict. Among them were men who knew Monet well, including Ochard, his former teacher, Cassinelli, alias "Croutinelli", Manchon, the "notary, for marrying thereof", Wanner, a friend of the Bazille family, and Martin. Martin told Boudin that the jury was expecting to award a silver medal to their mutual friend. The news that *Camille* had been purchased by Arsène Houssaye, the director of *L'Artiste*, and that he intended to donate it to the Palais de Luxembourg, made quite a stir, but did not silence the gossips, who were led by Léon Billot: "From Camille's gait, from the provocative way in which she tramps the pavement, it is easy to guess that she is not a society woman, but a *Camille*." (The reference to a harlot "foule le trottoir" is unmis-

PAGE 72:
The Luncheon
1868
Cat. no. 132

The Magpie
1869
Cat. no. 133

takable in French.) Not even M. Gaudibert was willing to receive her. Monet nevertheless brought her closer to Montivilliers, finding lodgings on the Le Havre-Etretat road.

The award predicted by Martin was not immediately forthcoming. Forty silver medals were initially awarded but Monet did not receive one. Fortunately, the organisers agreed to award four more medals, and this time, Monet was among the winners, thanks to *Camille* (**65**) and *Port of Honfleur* (**77**). In honouring these less-than-recent pictures, the jury made clear its aversion to more audacious recent works and, with the exception of *Camille*, Monet's work found no takers at the *Exposition Maritime*.

The disappointment this caused Monet does not in itself explain the desolate terms in which he wrote to Bazille in late October: "Painting is no good, and I have definitely given up all hopes of glory." For all that he was "delightfully received in a charming part of the country", however the Château des Ardennes was no defence against the infernal series of "disappointments, insults, hopes, renewed disappointments". Here at the castle he was working on a portrait; this was either the painting of Louis-Joachim's three-year-old son (**123**), or the second portrait of Louis-Joachim himself (**122**). It seems likely that the portrait of Mme Gaudibert, painted when the roses were in bloom, was finished by now. The effort this work had cost him – was perhaps still costing him – along with the cool reception some of the family gave to a masterpiece that was to immortalise them (**121**) – probably explains the deep depression Monet was experiencing at this time.

Louis-Joachim alone saw things as they were; he praised the painting to Boudin and continued to support Monet. Traces of this support can be found until 1870, when Gaudibert, the most faithful of Monet's admirers, died. His widow died in Le Havre on 26 October 1877 in her thirty-third year. She had been twenty-two years old when Monet stilled the passage of time and delivered her noble aspect to eternity.

Dream and Awakening

Winter had dispersed the house-guests at the castle; Monet rejoined Camille at Etretat. There, alone with his family (129–131), he had a few weeks' peace. Jean had gained a godfather in Bazille at his baptism in April 1868 and was in rude health (131). He was to appear in the Salon, "with other figures round him, just as they should be", in the famous *The Luncheon* (132). Out in the open air, there was an abundance of things to paint; the pebble beach dominated by the huge clefts in the cliff-face (127), the fishing-fleet setting out, or the countryside "perhaps still more agreeable in winter than in summer" (128 and 123). He lacked materials for these many projects, and ordered paints and canvases from Bazille. The address that he gave, that of his father and Aunt Lecadre at 13 Rue Fontenelle du Havre, makes it clear that he was still on good terms with his family.

Monet's happiness was barely troubled by the distraint and sale of the paintings in the Exposition Maritime as soon as the exposition closed; M. Gaudibert bought them, to the great satisfaction of his protégé. His dream would be "to stay within reach of Le Havre for ever" and spend only one month a year in Paris until he could return there in triumph.

Infantry Guards Wandering along the River
1870
Cat. no. 149

Upper Reaches of the Seine at Bougival
(see Cat. no. 149)

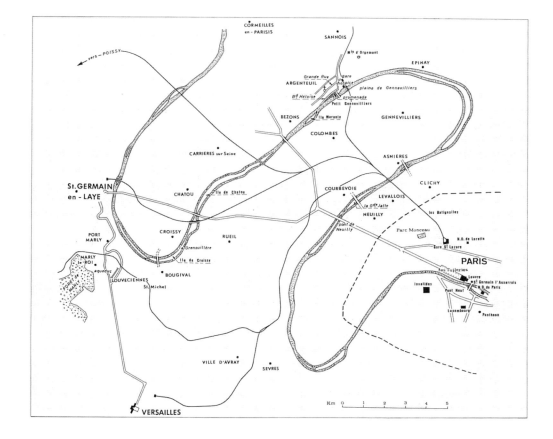

Map of the western end of the Paris region showing the places at which Monet worked

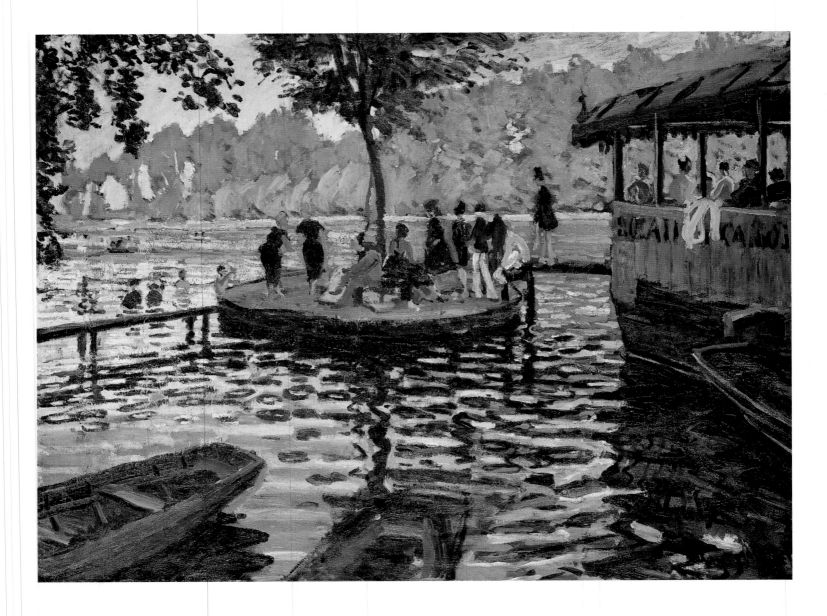

Monet's dismissive mention of the Café Guerbois in one of his letters from Etretat suggests that he took little part in the famous meetings there, despite its proximity to the room in Batignolles; he was never one of the "regulars". Auguste Guerbois, founder of the café, was born in La Roche-Guyon and was a man of strong personality and considerable presence. One of the attractions of the café was that Guerbois knew the Seine well; he probably advised the artists and painters of the Batignolles group on their choice of country retreats.

The Etretat days could not last. M. Gaudibert could not subsidise Monet's entire existence, and Aunt Lecadre, unhappy about a liaison now openly conducted on the very outskirts of Le Havre, would no longer pay for Monet's board and lodging. It was thus a "half-starved, downhearted" Monet who returned to Paris at the end of the winter. Bazille once again took him in. Claude's family was hostile, but Camille's parents were willing to forgive her if she married. As Bazille put it, "They're not overjoyed, but they don't want their daughter to starve."

Monet put the finishing touches to his Salon submissions in the studio in the Rue de la Condamine. These were *The Magpie* (**133**) and a seascape (**126**) on which he worked under the eye of Z. Astruc. On 22 March 1869, the composition of the jury was announced: Gleyre and Daubigny were both members. In the last week of April, Bazille wrote to tell his father that his own *Village View*

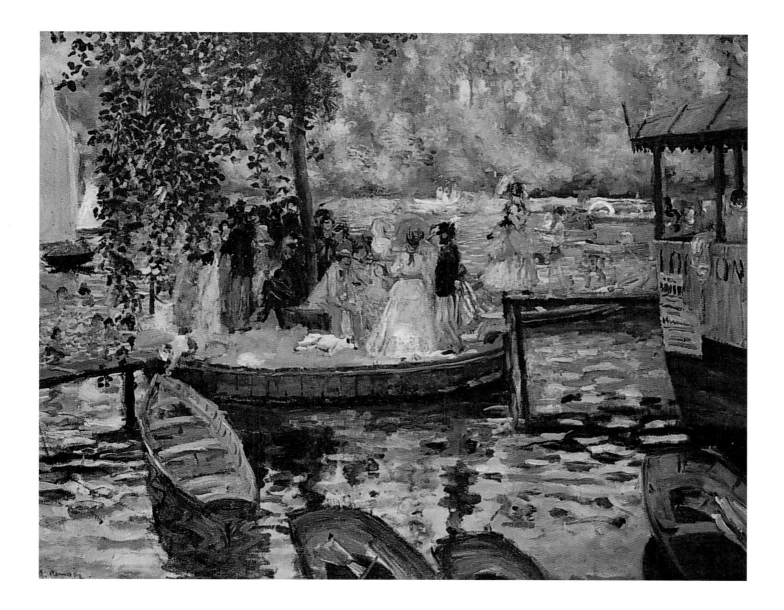

had been accepted, but that Monet's offerings had all been rejected. The man responsible for this rejection, along with many others, was the redoubtable Gérome, who had topped the list of elected members and considered the representatives of the younger generation of painters a "gang of lunatics".

Monet bore this bitter blow with fortitude. Remembering the success of his private exhibition of two years before, he again contacted Latouche, who was still exhibiting Monet's view of Paris of earlier that year. Latouche agreed to come to his aid again, and before the Salon opened at the Palais de l'Industrie, crowds were forming around the shop window in the Rue de La Fayette, where a study of Sainte-Adresse was "making devotees" in Boudin's slightly odd expression, by its unexpectedly "violent painting". It may have been a scandalous success, but any success at all was better than oblivion. For Monet, this meant a harrowing change of plan. He would have to give up the Normandy coast and settle near the capital somewhere where he could both paint as he wished and keep an eye on events in Paris.

La Grenouillère

Monet already knew of such a place; he had worked at Bougival, on the left bank of the Seine, between Chatou and Port Marly, during the winter of 1867–1868. It was a place frequented by oarsmen, artists and loose women. He found a peasant house in the village of Saint-Michel, at the top of a small rise. Moving there cost him the remnants of M. Gaudibert's generosity, and soon money was at an end. A request for funds addressed to Houssaye on 2 June seems not to have reached him; at all events, food, light and fuel were soon running out. Monet made pathetic appeals to Bazille, but there was a great gulf of incomprehension between the well-off young man on holiday at Méric and the indigent painter whose child was starving. Bazille's suggestion that he should go to Le Havre on foot or split logs for himself seems a bad joke in the context of Monet's destitution.

Renoir, who lived with his parents very close to Saint-Michel, at Voisins, on the outskirts of Louveciennes, often came by to walk down to the Seine with Monet. His friend's misery moved him to stuff his pockets with bread from the family table. One Sunday, he distinguished himself by cooking a rabbit in various sauces for a distinguished visitor. His account of the situation at Saint-Michel is a revealing one: "I'm at my parents', and am most always round at Monet's, where things are, incidentally, pretty bad. Some days they don't get to eat. Still, I'm not unhappy, because, for painting, Monet is good company."

The two painters worked side-by-side facing the Grenouillère of the Ile de Croissy. Dredging work has radically changed the site of the Grenouillère; fortunately Maupassant's story *La Femme de Paul* (Paul's Wife) provides an excellent description of this "floating café". "The huge raft, covered with a tarred roof held up by wooden columns, is linked to the Ile de Croissy by two gangplanks, one of which leads to the middle of this aquatic establishment, while the other communicates with a tiny island on which a single tree grows; the island is nicknamed "the flowerpot" and from it you reach the bank near the offices of the bathing establishment." The components of Maupassant's descriptions are to be found, variously combined, in the two friends' pictures. One of Monet's canvases features the trees of the Ile de Croissy, the bathing-huts and one end of the gangplank (135); in two others, there is the floating café with the sign "ROWING-BOATS FOR HIRE", linked by a gangplank to "Flowerpot" island (alias "the Camembert") with its little tree, whence a second gangway leads to the Île de Croissy, which is outside the field of vision (134 and 136).

In late September, Monet was complaining to Bazille about how difficult things were; he was preparing a big *Grenouillère*, a veritable "dream" for the Salon (136), but as yet he had only produced some unsatisfactory rough sketches. His pessimism was unjustified; at the Grenouillère his touch was acquiring unprecedented grace and delicacy. The study of reflections broken by wavelets set constantly rocking by bathers and boats had produced a wealth of observation that neither the calm surface of the river at Bennecourt nor the heavy seas of Etretat had inspired. These advances in technique were the heart of Impressionism, and Renoir and Monet must be associated in equal measure with the achievement.

When bad weather prevented them working out of doors, the two friends painted still lifes (139–141). In the autumn, Renoir returned to Paris. Monet went there only occasionally to meet a possible admirer of his work or catch up with friends at the Café Guerbois. He nevertheless took the time to pose for Fantin-Latour's *A Studio at Batignolles* and Bazille's *The Studio in the Rue de la Condamine*. On New Year's day, a short voyage took him to Sivry, on the

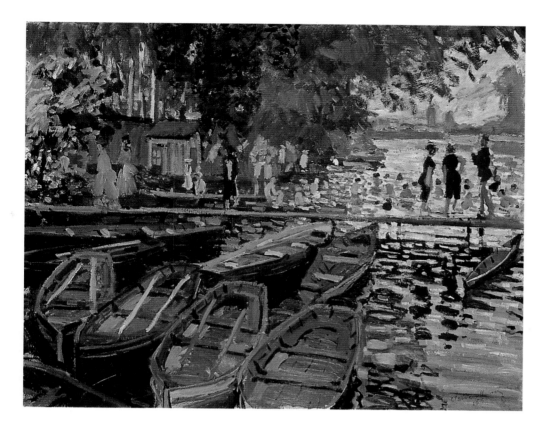

Bathers at La Grenouillère
1869
Cat. no. 135

edge of the forest of Fontainebleau, where he dated his *Boar's Head* 4 January 1870 (**146**).

At the end of these short absences, he was delighted to return to his young family at Saint-Michel (**142**). The snow was deep that winter, and he went out to paint in it; mostly he stayed on the hill on which the village stood and went to work in the forest of Marly (**144**) or at Louveciennes where he returned again and again to the Versailles road (**145**, **147–148**). This had the further merit of enabling him to eat with Pissarro, who lived beside this road. Sometimes he went down to the Seine and painted the strong winter current of the river dominated by the sombre hills (*The Seine at Bougival*) (**143**). Later, the same vista was painted without snow (**150**), while *Infantry Guards Wandering along the River* shows the river from the opposite direction (**149**).

When the sun again began to shine, he set up on the Ile de Croissy, where he painted *The Seine at Bougival in the Evening* (**151**); on the horizon, there is the Marly aqueduct that brought water to the Château de Versailles; to the right, we can make out the vertical of the road bridge, the central motif of the famous *The Bridge at Bougival* (**152**), which, with the *Train in the Countryside* (**153**), was the final product of this outstandingly fertile period.

Marriage

The approach of the Salon was producing a wave of excitement among artists; discussion at the Guerbois Café grew heated. The election of jury members took place on 24 March 1870; Arsène Houssaye, as Inspector-general of Fine Arts, was in charge of counting the vote. Daubigny and Corot had the most votes; their names figured on both the official list and, with Millet and Ziem, a dissident list. The conservative majority sought to disarm the opposition by, as Burty put it, "admitting almost everything at all admissible", which amounted to some three thousand paintings. There was one signal omission: Claude

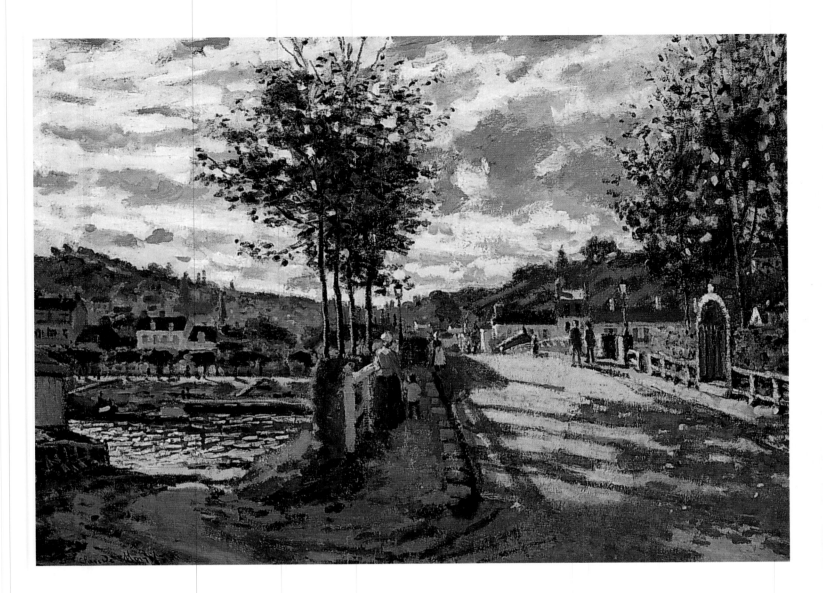

The old road bridge at Bougival
(see Cat. no. 152)

ABOVE:
The Bridge at Bougival
1870
Cat. no. 152

Monet. Millet and Daubigny had worked hard in his favour, and Daubigny was outraged that his views had been disregarded; he resigned, quickly followed by Corot. They were replaced by Chaplin and Vollon.

The more perceptive critics wrote encouraging words about the rejection. Jean Ravenel strongly implied that Monet had submitted *The Luncheon* (**132**) and *La Grenouillère* (**136**). Following in the footsteps of Castagnary and Burty, Houssaye lent his support to Monet in the pages of *L'Artiste*. Associating him with Renoir, he stated that the two were the masters of the "nature for nature" school. Renoir had shown greater prudence and compromised with the authorities; the reference, "a pupil of Gleyre", continued to accompany his submissions, and contributed to their acceptability. Monet's intransigence defined him as the true leader of the group; the modest position accorded him by Fantin-Latour in *A Studio at Batignolles* was no reflection of Monet's true rank.

On 28 June, with war all too clearly impending, Claude Monet, resident of Bougival, was married to Camille-Léonie Doncieux, resident of 17 Boulevard des Batignolles (her parent's house, as marriage conventions required) at the town hall of the 8th arrondissement. Four witnesses signed the register: Gustave Courbet, Gustave Monet, whose relationship to Claude is not known, and two admirers of Monet's work, Paul Dubois, a doctor of medicine, and the journalist Antoine Lafont.

The marriage contract received on 21 June by Maître Aumont-Thiéville provided for husband and wife to each have separate ownership of their posses-

sions and contains several clauses whose purpose was essentially that of keeping Camille safe from the difficulties into which her husband's debts might bring her. The most interesting is Article 5, by which her parents made Camille a gift, exclusive to her among their heirs and unless a further child was born to them, of the sum of 12,000 francs payable only three months after the death of M Doncieux; two years' interest at 5%, that is, 1200 francs, were payable at once, and thereafter the annual interest only. Some astonishment has been expressed both at how small this dowry was and at the fact that it was not to be paid at once. But Camille's parents were not rich; they rented a modest flat and owned no property. Their position was little affected by a curious inheritance that came to Mme Doncieux and her younger daughter Geneviève.

On the day of the marriage, Monet proved unable to provide any official documentation of his position in regard to military service. At the head of the census form for the class of 1870, destined for the military bureau of the Paris Hôtel de Ville, the Mayor had written: "Omitted in 1860." This was liable to lead Monet directly back to the medical board, as instructions had recently been sent out that the census of the class of 1870 should include all those who had

Entrance to the Port of Trouville
1870
Cat. no. 154

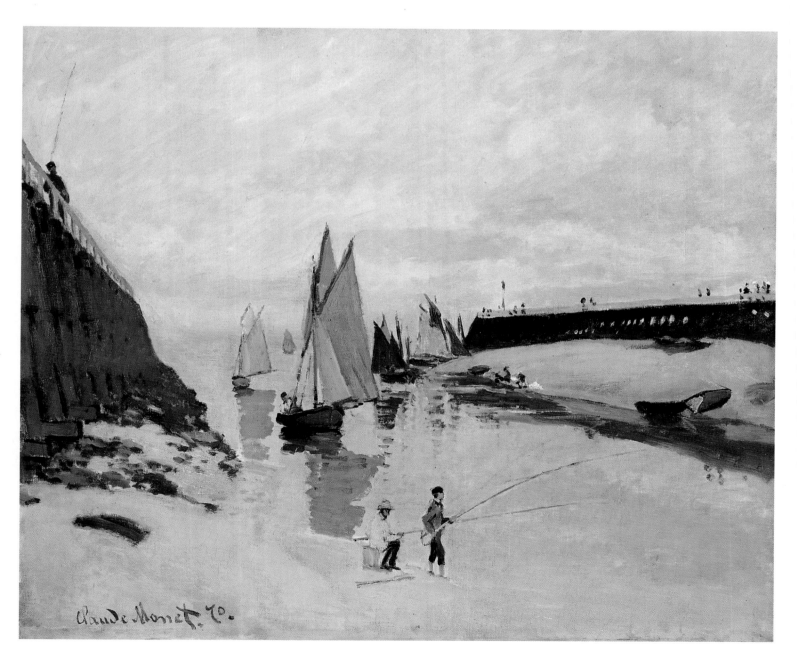

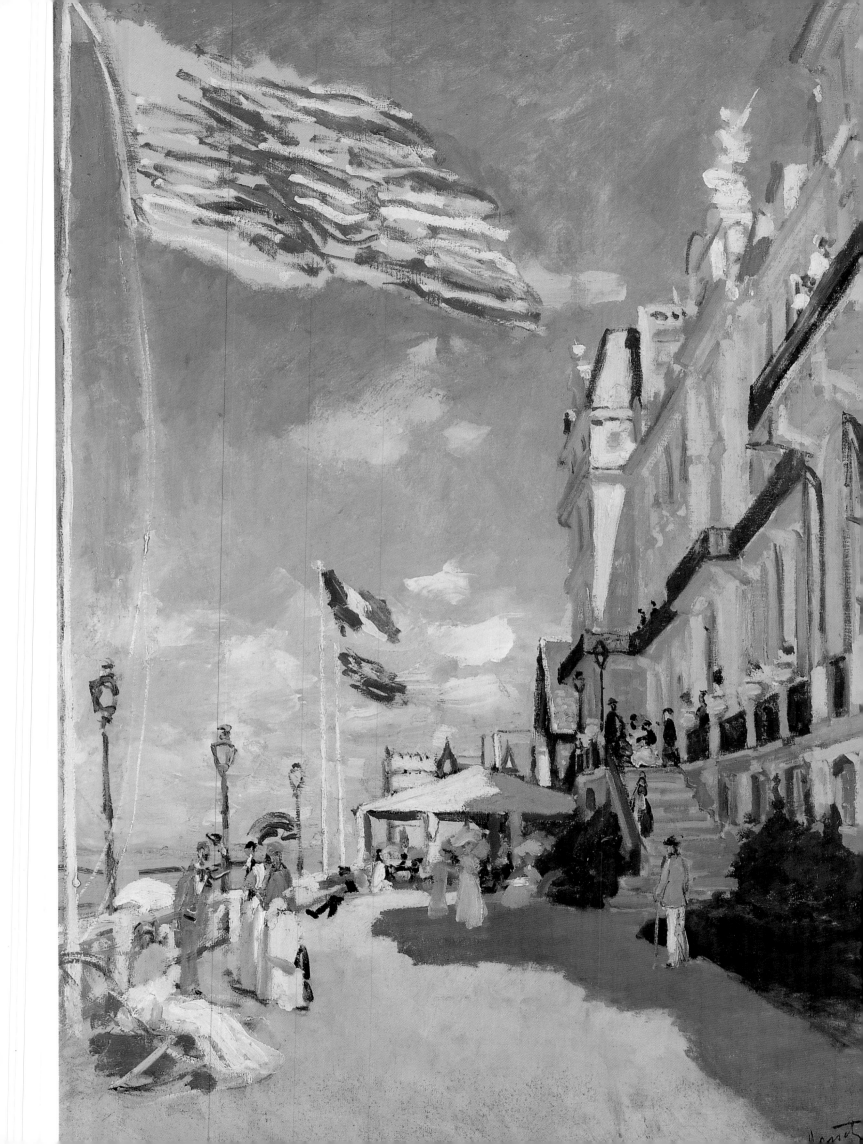

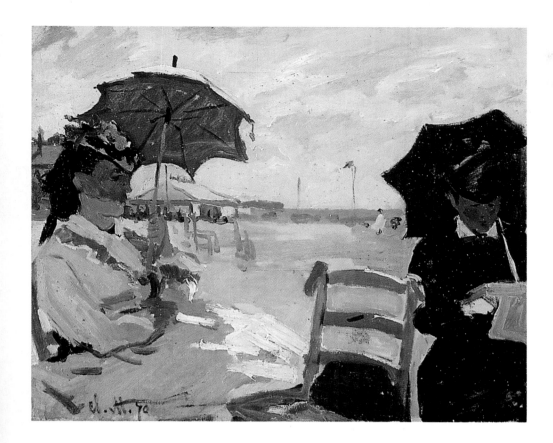

The Beach at Trouville
1870
Cat. no. 158

not yet done their military service. Lower down the page were noted the claims "that the young man is proposing to make before the board", relative to his having entered the "Ier ch[asseur] d'Afrique" and to his marriage of the same day. On the back of the form the magistrate requested that the regiment's administration inform him as to the accuracy of the declarations of "sieur Monet". Monet's marriage constituted a reason for exemption, as did his past service; but the army was soon to call up those who had served in preference to those who had not. Monet now knew that the authorities were interested in him as a reservist, and was not anxious to facilitate his call-up.

Trouville and the War

When the marriage settlement was drawn up, Monet faced the Doncieux clan without assistance. His own family apparently took no interest in a marriage of which they did not approve. In fact, Aunt Lecadre was too ill to concern herself with her nephew's affairs and died at Sainte-Adresse a few days after the marriage, on 7 July 1870. She was eighty years old. What opinion did she take to her grave of this prodigal nephew whose genius she had foreseen but whose last two years had been marked by a series of failures culminating in an unsatisfactory marriage? The witnesses who signed the death certificate were Monet's great-nephews Lecadre, one a doctor, the other a merchant, and neither likely to entertain very favourable views of their art-student cousin whose allowance had diminished their expected inheritance.

Before leaving Bougival in early spring with Camille and Jean, Monet deposited a number of pictures with Pissarro at Louveciennes to avoid their being distrained. The Monets went to Trouville, where they took a room in the Hôtel Tivoli, an establishment "especially recommended to salesmen"; the landlord's name was Lang.

PAGE 82:
Hôtel des Roches Noires, Trouville
1870
Cat. no. 155

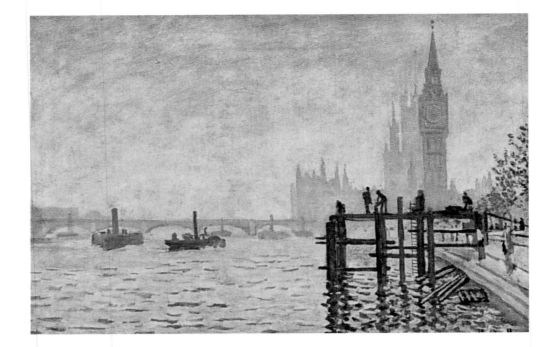

The Thames below Westminster
1871
Cat. no. 166

With the exception of *Entrance to the Port of Trouville* (**154**), painted at the mouth of the River Touques, what most interested Monet was the society aspect of this famous seaside resort. Setting up his easel either on the seafront terrace in front of *Hôtel des Roches Noires, Trouville* (**155**) or on the beach (**156–162**), he set down the image of a carefree society whose elegant parasols would not protect it from the catastrophe of the forthcoming war. His rough sketches of women in close-up (**158–162**) are of evident originality. The contrast between Boudin's beaches and Monet's panoramas is revealing; instead of facing out to sea as Boudin did, Monet gives a tangential view of the beach, structuring his painting around the line of building facades, which interested him quite as much as the strollers or the beaches.

On 19 July, France declared war on Prussia. On 6 August came the defeat at Fröschwiller. On 10 August, Bazille enrolled in the 3rd Zouave regiment. At Trouville, the season continued. When Boudin and his wife came to stay in Trouville on 12 August, they met the Monets. A year before his death, Boudin was to write to Monet: "I can still see you with that poor Camille in the Hôtel Tivoli. I have even kept a drawing I made that shows you on the beach... Little Jean is playing in the sand and his papa is sitting on the ground with a sketch in his hand."

On 4 September, after the surrender of Sedan, the Republic was proclaimed; the National Defence Government declared its intention to defend every inch of French territory. Monet felt no more concerned than he had under the Empire. On 9 September, he visited Le Havre, where his father was alarmed to discover that his financial difficulties persisted. Lacking the courage to face his landlord at Trouville, he asked Boudin to look after Camille. The rumours of peace circulating at Le Havre did not inhibit the brisk trade of the transatlantic liners now criss-crossing the Channel to London. Monet was more inclined to pity these fugitives in their flight than condemn their defeatism.

On 13 September, Boudin left for Brittany, where Monet wrote rather disheartened letters to him. This suggests that Monet was still on the Normandy coast in early 1870. He would by then have had time to assess the situation carefully. It was less alarming than it had first seemed; the Germans were busy with the sieges of Paris and Metz, and no assault on Normandy was imminent.

Moltke's instructions were categorical: "His Majesty desires that under no circumstances should the Ist army commit itself to a long-term engagement outside Le Havre."

George Dubosc, in his *The 1870 War in Normandy* describes the situation: "France's major Atlantic port, Le Havre, a munitions and provisions supply centre for French armies in the west and a fortified town, had prepared itself for resistance by serious and thorough organisation, in an outpouring of patriotism." In fact, after some initial hesitation, the military authorities combined with the pro-war political forces to take the situation in hand. Men capable of bearing arms, and especially former soldiers, were called up for service in the French national army, the mobile or sedentary national guard, or commando or reconnaissance units.

On the further bank of the Seine estuary, a man of Monet's physique could hardly go unnoticed now that the season had ended. The idea of dying for Gambetta or Alsace-Lorraine was not appealing; he took the boat for England. His departure at an unknown date was one of those many events that passed unnoticed amid the cataclysm. It is, by contrast, a matter of record that Bazille was killed on 18 November 1870 near Beaune-la-Rolande. No "tutoiement" between Monet and Bazille; theirs were irredeemably different languages.

London

In London, after some initial difficulties, things soon enough turned out well. Monet met Daubigny, who introduced him to Paul Durand-Ruel, who had also

Boats in the Port of London
1871
Cat. no. 167

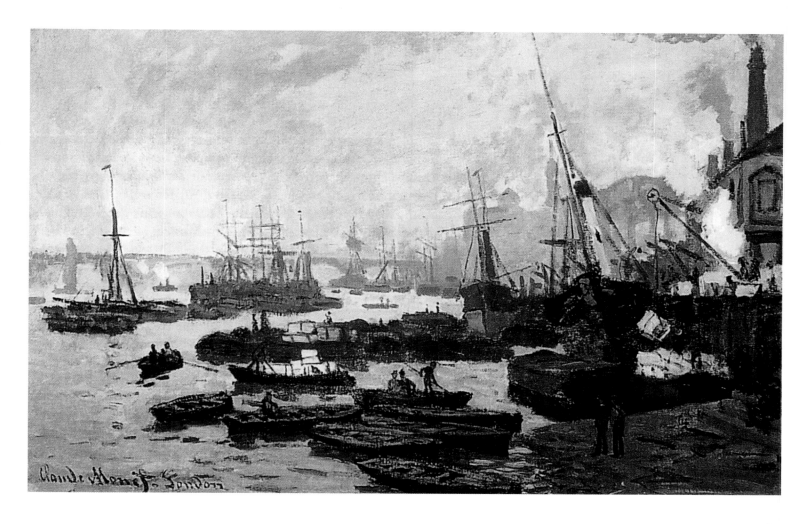

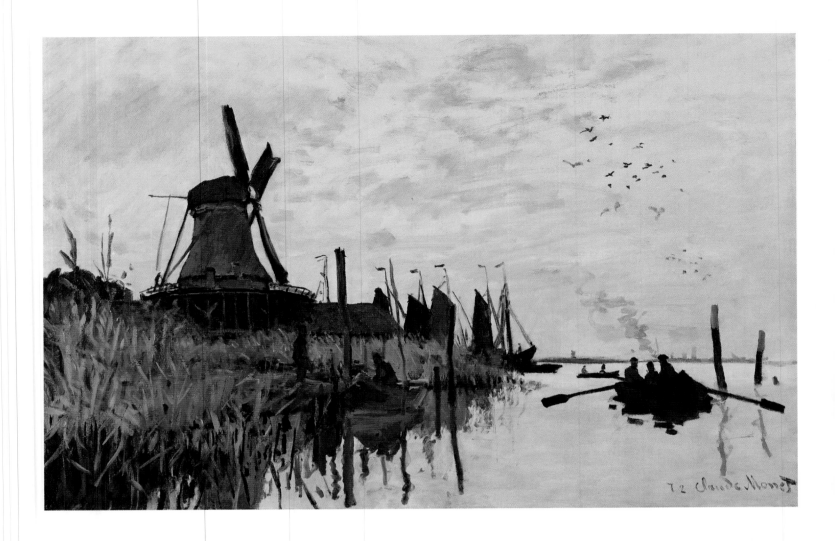

Windmill at Zaandam
1871
Cat. no. 177

Map of the Netherlands, late 19th century

fled to England. "Here is a man who will be better than any of us... Buy: I promise to take any [pictures] you can't sell and give you paintings of mine in exchange." Durand-Ruel had already taken notice of Monet's works in the 1870 Salon and defended his name in the paper that he edited, *La Revue internationale de l'Art et de la Curiosité (The International Art and Curiosities Magazine)*. He did not purchase immediately, but the first annual Durand-Ruel exhibition in London, which opened at 168 New Bond Street on 10 December 1870, included a Monet picture, *Entrance to the Port of Trouville* (**154**).

It seems, then, that Monet had taken some of his most recent studies with him to London, unless they had come with Camille, who is generally thought to have arrived a little later than her husband. Shortly after her arrival, she posed for *Meditation, Mrs. Monet Sitting on a Sofa* (**163**). Jean Monet does not appear in any of the London pictures, nor those from Holland; but we know that he accompanied his parents in all their travels. Monet first took up residence at 11 Arundel Street, Piccadilly Circus. Then he and his family moved to Kensington, where by January they were living at 1 Bath Place, as the lodgers of a Mrs Theobald.

Monet was determined to put his exile to good account. He painted *The Thames below Westminster* (**166**) from the Victoria Embankment; Westminster Bridge is also shrouded in mist. This was a homage to the England of literary tradition, though the chimneys of the tugboats show that the Port of London was close by. He went downriver as far as London Bridge and beyond; returning upriver, he painted the Upper Pool, whose changing tide contrasted with the constantly febrile activity on its quays (**167–168**). A very different and

relaxed impression is suggested by the views of *Hyde Park* and *Green Park*'s vast green spaces populated by the silhouettes of strolling couples and by those lying on the grass (164–165).

Thanks to Durand-Ruel, Monet met Pissarro, who had taken refuge in Lower Norwood. The two friends visited the museums together to renew their acquaintance with the English school, in particular with Constable and Turner;

Windmills near Zaandam
1871
Cat. no. 181

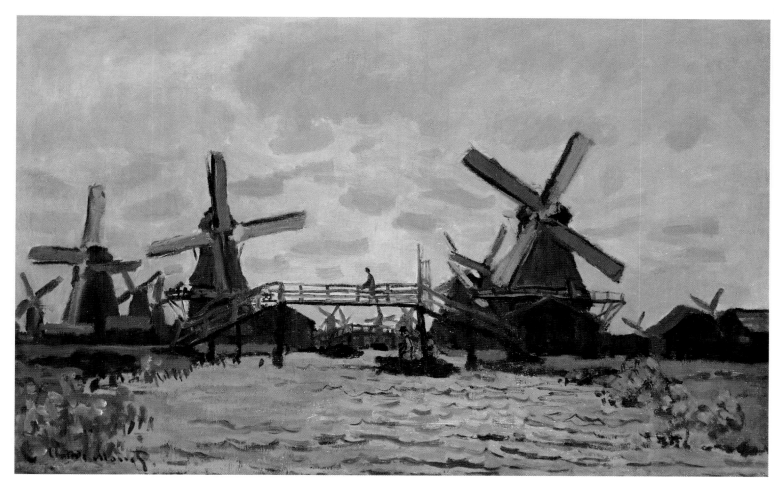

the Turner legacy was on display at the National Gallery and in South Kensington. At times the influence of these two English masters has been exaggerated, however it is clear that, together with London's unique atmosphere, they are amongst the most significant factors that presided over the birth of Impressionism.

Neither Monet nor Pissarro had paintings accepted by the Royal Academy, but they were both included in the International Fine Arts Exhibition that opened on 1 May in Kensington and for which Du Sommerard, the General Commissioner for France, had requested Durand-Ruel's aid. The catalogue mentions two Monet titles, *Meditation, Mrs. Monet Sitting on a Sofa*, entitled *Repose* (163) and an unidentified portrait of *Camille*; it would seem that two seascapes also featured.

Throughout their stay, the refugees continued to receive news of France. Thus Monet learnt of the death of his father at Sainte-Adresse on 17 January 1871. On 24 January 1871, Monet granted power of attorney to Louis Delafolie to collect his share of the inheritance, which had been substantially diminished by Adolphe Monet's marriage to Amande-Célestine Vatine two and a half months before his death. On the same occasion, Adolphe Monet had recog-

The windmills near Zaandam, as they appear today

nised Marie Vatine as his legitimate daughter, providing Claude with a half-sister whose very existence has passed unnoticed in previous biographies. Adolphe Monet seems to have taken the opportunity of his son's absence and his sister's death to formalise this attachment. His bride was registered as domiciled in the "same street", a euphemism for cohabitation.

The news about France and the war was not encouraging: Paris was besieged and its suburbs occupied. Pissarro learnt that his house had been requisitioned and some of his paintings vandalised by soldiers. Monet was directly affected by this news, as he had left paintings with Pissarro, but was eventually able to recover most of these. The armistice with the German Empire, signed on 28 January 1871, placed Le Havre (defended by Général Leroy), Trouville and West Normandy (under the command of Général Saussier) outside the occupied zone. Monet's exile was therefore justified a posteriori only by his fervent desire to avoid recruitment. On 18 March the insurrection later known as the Paris Commune broke out. The Bloody Week of repression began on 21 May, during which the newspapers wrongly announced the death of Courbet. Monet furiously condemned the repressive policy of Versailles in a letter to Pissarro; it is the only political reaction that we know of on Monet's part throughout this troubled period.

Delayed by last minute difficulties, Monet eventually left England only in late May. He left behind a certain number of pictures and no regrets at all for what he ironically called "this charming country". This was somewhat ungrateful, for this English stay had probably saved his life, which after all had been the main objective of his exile.

Zaandam

It is difficult to imagine why Monet, whose material interests in Le Havre, Paris and Louveciennes required urgent attention, delayed his return to France and went first to Holland. A letter dated "Zaandam, 2 June 1871" informs Pissarro that they had arrived safely, though Jean and Camille had been badly seasick.

View of the Voorzaan
1871
Cat. no. 176

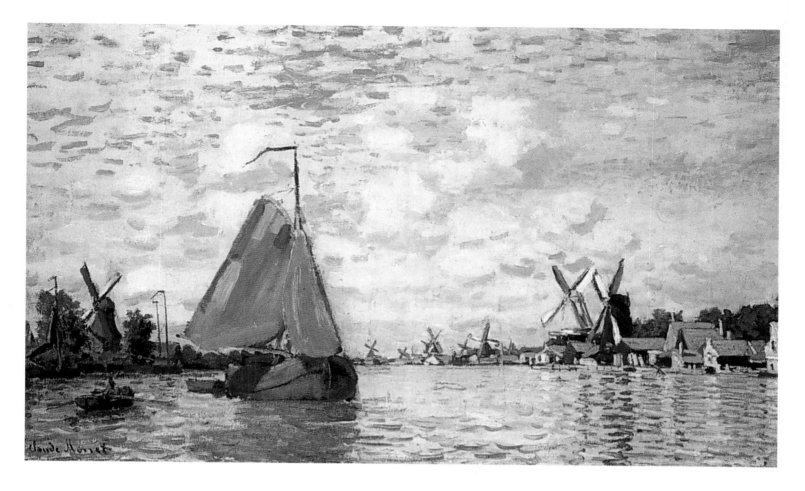

The Zaan at Zaandam
1871
Cat. no. 172

Their voyage "through almost the whole of Holland" revealed to Monet a country "much more beautiful than people say". The voyage had taken longer than usual as Zaandam was surrounded by water; to get there from Amsterdam, a mere twelve kilometres or so away, took two and a half hours, with changes at Haarlem and Uitgeest.

Monet had not chosen this remote town by accident. Pissarro knew the place, and the idea of going there may have been suggested to him by Daubigny or by something that Jongkind had said. Zaandam was not unknown to French artists; on his arrival, Monet met the landscape painter Michel Lévy. On 2 June, he and his family registered at the Beurs hotel, whose landlord was named Dorpema; they seem to have appreciated Dutch hospitality. Within a fortnight he was, as he wrote to Pissarro, "working at white-heat", and had just enough time left to visit the Amsterdam museums on 22 June, when he signed the visitors' book at the Riijksmuseum. A rather confusing affair preoccupied him, a matter of selling some frames in London, but for once he seems not overly concerned about money matters. The Durand-Ruel archives indicate that he had sold two pictures in June for 325 and 300 francs; nevertheless, Camille was helping out by giving French conversation lessons to the local bourgeoisie. The parents of one of her students, Gurtje Van de Stadt, commissioned a portrait of their daughter (192). This seems to have been the only picture that Monet sold in Zaandam, where cultivated circles remained devoted to the Dutch landscape artists of the preceding generation, such as Van der Maaten and Hilverdink. Remembering that Ary Scheffer had been born in Dordrecht, they allowed him some merit, too.

In 1871, Zaandam had some 12,000 inhabitants; its traditional industries were expanding rapidly, and steam machinery was increasingly coming into play, but the windmills were still important and Claude Monet saw hundreds of

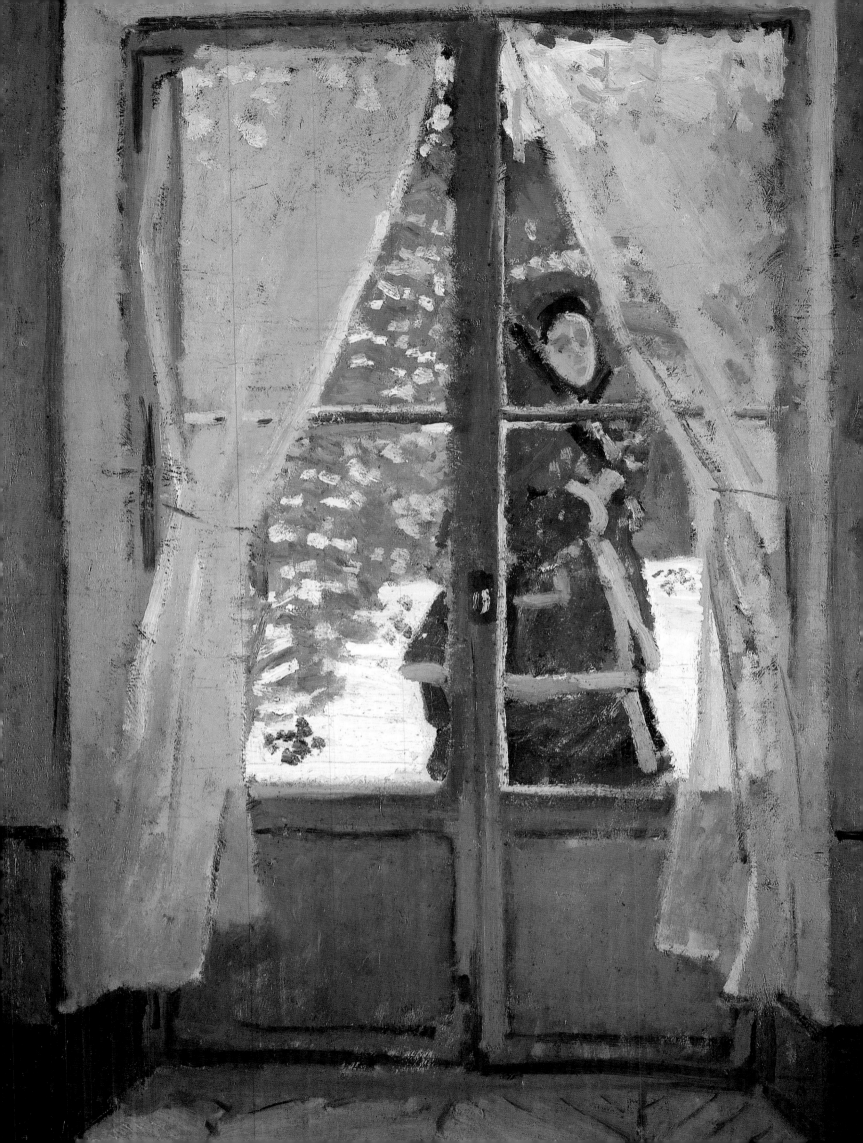

them. Anything that could be crushed, pumped, sawn, worked, turned, shelled – wood, grain, oil, cement, paint, paper and minerals – was sent to the windmills; each mill had a particular function and its own name. Some dated from the time when Peter the Great had served his apprenticeship in the shipyards of Zaandam, others from the 18th century, others again had just been built. There was a veritable forest of sails, their colours changing with the seasons, both around and within Zaandam, whose rustic charm was as yet relatively unspoilt.

There was water everywhere. A whole network of canals crossed by wooden bridges communicated with the Wormerveer to the north and crossed Zaandam before reaching a dyke with two locks, the Dam, on which buildings were perched. South of the Dam, the river widened to form the Voorzaan, which split around a large island before reaching the Ij, the arm of the sea that links Amsterdam and the Zuidersee.

Monet was surrounded by subjects, and gave himself up without stint to the landscape. Some paintings show the narrow canals bordered with windmills (170, 180–182), others the Zaan upstream from the Dam with the neat little villas of the west bank (186–187), the older and more traditional houses on the east bank (185), or the mills, houses and barns on either bank (172–173). The Dam itself and the houses built on it are seen from the Zaan upstream of the dyke (191) or from the banks of the Voorzaan, where, at the tip of the masts, the national flags fly of the ships tied up at the quays. The eastern quay or Hogendijk is the site of the famous *The Blue House at Zaandam* (184) built in 1729. On the other side, the Zuiddijk presented the green gables of its red-roofed houses behind a row of plane trees; their facades continued round a bend in the river and ended with the Zuiderkerk spire and the belltower of the town hall (183). More extensive views lay before Monet when he set up on the Dam and painted the waters of the Voorzaan, with the windmills of the island in the background (174–176). Having admired the island from afar, he then painted the Oosterkattegat, a sturdy paint-mill, on the island; it is depicted looking back towards Zaandam, whose belltower can be made out in the distance (171). The sea obviously exercised considerable fascination over Monet (177, 178). This is particularly clear in his view of an arm of the sea in which the Rietland bank is reduced to a thin strip of headland (179).

These subjects, with their wealth of colours, were seen in that light so special to Holland that the sky, now clear and serene, now thunderous with clouds, is reflected in the sometimes calm, sometimes troubled surface of the water. This merely hints at the treasures with which Monet returned from Holland. "There is subject-matter for a lifetime here", he wrote on arrival, and, a little later "It's incomparably entertaining". A strange choice of word? For Monet, it perfectly expressed the alacrity with which he sought to paint an image of traditional Holland from which he rigorously excluded all elements of modernity; an image archetypal, idealised and too perfect to last.

Rue de l'Isly

Monet returned to Paris in the autumn of 1871 and took up residence in the Hôtel de Londres et de New York, in the Place du Havre in front of the Gare Saint-Lazare. On 19 November, he was repeating his invitation to Pissarro to drop by, so he had arrived some time before that date. Just around the corner from the hotel, he had the use of the studio long occupied by Amand Gautier at 8 Rue de l'Isly, on the fourth floor of a building that belonged to the Viscount

PAGE 90:
The Red Kerchief, Portrait of Mrs Monet
1873
Cat. no. 257

de Montesquiou-Fezensac, the inspiration of Proust and Huysmans. From 1872 to 1874 inclusive, the studio was rented in the name of "Monnet" for 450 francs a year, though by late 1871, in a letter to Pissarro, Monet was already speaking of it as "his" studio, as though he were the sole occupant.

One of his first tasks was to recover the paintings that he had left in France when war broke out. "If you were to be so kind as to make a parcel of the few canvases of mine in your possession," he wrote to Pissarro on 21 December, "it would give me the greatest pleasure." This referred to the Louveciennes pictures; no paintings are mentioned as lost. As to works that might still be at Bazille's last home in the Rue des Beaux-Arts, Monet was able to call on the assistance of Edmond Maître, who had been asked to act as Bazille's Paris executor.

Paul Durand-Ruel had returned to Paris, but illness followed by his wife's death had interrupted his business. When he resumed operations, he was, by his own admission, sadly missing his wife's prudent advice, and overreached himself in unwise purchases. Monet was one of those who most profited by this, but for now his only resource was patience and other buyers. One of these was his old client, Latouche, to whom he sold at least one of the canvases with which he had returned from Holland. Latouche sold it on to Durand-Ruel with a seascape in April, 1872.

The Reader
1872
Cat. no. 205

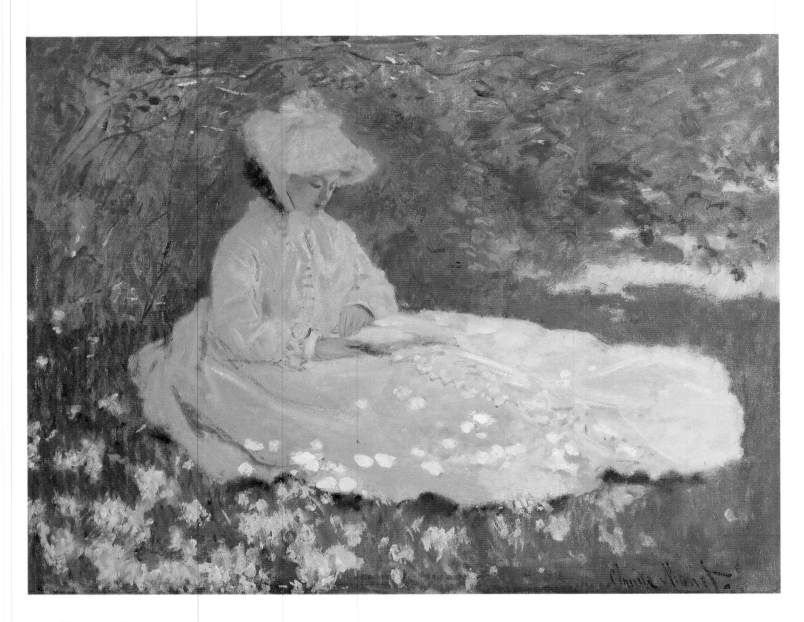

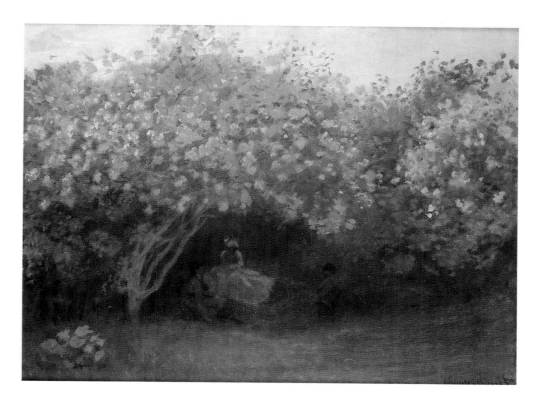

Lilacs, Grey Weather
1872
Cat. no. 203

One overcast day, Monet went down to the Seine and, in company with Renoir, painted the *The Pont-Neuf in Paris* (**193**) looking downstream towards the statue of the Vert-Galant on the right. But for the most part he painted in the studio in the Rue de l'Isly, working up the Zaandam studies which were much admired by his visitors, notably by Boudin, who was now living at 31 Rue Saint-Lazare, and often dropped in. In late afternoon, Camille and Jean would come to the studio and make a foursome.

They were worried about Courbet, who was still a prisoner at Sainte-Pélagie (he had been imprisoned after the Commune for his part in the destruction of the Vendôme Column). Boudin wrote to him on behalf of his friends (Monet and Gautier are mentioned by name). This New Year's Day letter was very carefully composed, as it was expected to be read by the police censors of the Préfecture de Police. In fact, when the letter reached him, Courbet was out on parole and had just been transferred to the clinic of Dr Duval at Neuilly where Dr Nélaton operated on him. Courbet made clear how welcome their sympathy was at a time when many friends had abandoned him; he would be glad to see Boudin, Monet, Gautier and "even some women". Not a word about Monet's recent behaviour, but there was strong praise for the courage of Gautier, who had been elected to the Commune's Federation of Artists, had taken an active part in their sessions, and had consequently found himself in trouble with the authorities when the Commune fell.

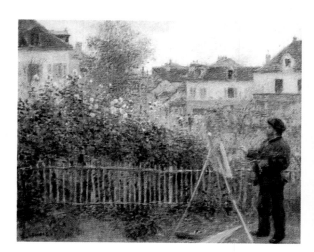

Auguste Renoir
Monet Painting in his Garden
1873
Hartford, Wadsworth Atheneum

Manet had taken a harsh view of Courbet's own conduct during his trial, which he considered cowardly, but was nonetheless on friendly terms with Courbet's friends, Monet in particular. When he found out that Monet wished to settle in Paris, he spoke to his friends, the Aubry family, who owned a lot of property in the suburbs. Louis-Eugène Aubry, who had been a notary in Paris and the mayor of Argenteuil, had not survived the end of the Empire. His widow, sister of the historian Ludovic Vitet – this was the origin of the double-barrelled name Aubry-Vitet thereafter assumed by the family – agreed to let one of her houses to Monet for an annual rent of 1,000 francs payable in quarterly instalments. On 21 December 1871, Monet wrote to Pissarro that he was "up to

his ears" in the move. On 2 January 1872, Boudin went to the house-warming party at Monet's. These were the auspicious occasions which led to the golden age of Impressionist painting.

Early Days in Argenteuil and the Trip to Rouen

Argentueil was then a very pretty town built in a pleasant position on a little vine-covered hill which ran down to the edge of the right bank of the Seine. As the "county town", it possessed a justice of the peace, two bailiffs, two notaries, three doctors and two pharmacists for its 8,000 inhabitants. It was the junction of the western and northern railway networks, and was linked to the Gare Saint-Lazare, a mere ten kilometres away, by an hourly train service.

The Aubry house, near the hospital-asylum of the Porte Saint-Denis, was Monet's first Argenteuil residence, and was just below the station, on the edge of the old town and close to the Seine. Théodule Ribot had lived there; the studio was "a lean-to with huge windows... that Ribot had transformed into a kind of dark cell". Monet stripped the glass of its blackpaper screens and could then see "everything that happened on the Seine, some forty or fifty paces distant". He later claimed to have used this prospect when painting his first "nautical scenes in Argenteuil" in the studio (Thiébault-Sisson). But on this point he was in error; not only was the studio too far from the Seine for this to be true, but there is no painting from the early years of his stay in Argenteuil which match this prospect.

There were two bridges across the Seine, the railway bridge, and the road bridge with its toll-gate; both were destroyed in September, 1870, and both were rapidly rebuilt. There was still scaffolding on the road-bridge when Monet crossed it and set up his easel on the Petit-Gennevilliers bank, upstream of the bridge. In one of the two paintings that the scene inspired, entitled *Le Pont de bois*, we can see, just beyond the bridge's second span, the Argenteuil port with some of the motifs that recur so frequently thereafter: to the left, the floating

Argenteuil, Boulevard Héloïse
Postcard, 1900

Fête at Argenteuil
1872
Cat. no. 241

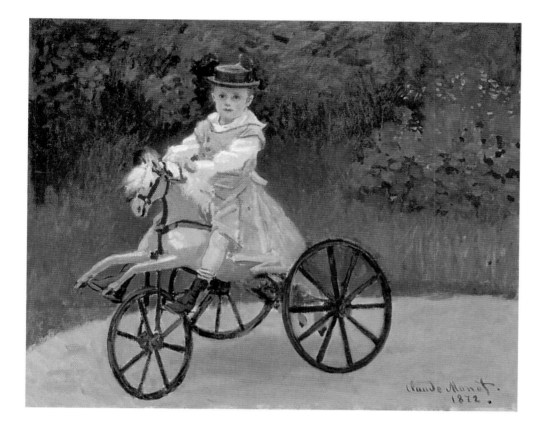

shed where rowing-boats could be hired; partly hidden by the pier and scaffolding on the right, the tree-lined promenade of Argenteuil; and in the background, the little turret of a mock-Louis XIII manor house, beside which a factory chimney, smokeless, marks the centre of the painting; on the Seine, there are boats and a plume of smoke rising from a tug (**195**).

When the scaffolding and coffer dams of the rebuilding were removed, the Argenteuil road-bridge revealed itself to be a composite of limestone rubble, brick, cast-iron, wood and reinforced concrete. These materials, with their various colours, the two toll-houses in stone and brick on the right bank, combined with the Seine, the expanse of the Ile-de-France sky and the trees of the promenade to form one of the most characteristic themes of Impressionism (**225**).

Hitherto, one of Monet's favourite haunts had been a relatively distant point on the left bank, towards Colombes, where there were few walkers to disturb him; there a branch of the Seine reflected the tall poplars of the Ile Marante. Monet painted two short series, one towards Bezons in the west (**196**, **199–200**), the other looking north-west towards Argenteuil (**197–198**). In the two paintings of this group, we can make out the aforementioned manor to the right, the spire of the very recent basilica and the Sannois hills. While he was Monet's guest, Sisley painted the same motif as well as other views of Argenteuil.

It was a magnificent spring, and the gardens and orchards (**201**) were in flower. Monet set up his easel in the orchard of his own house and painted figures among the blossom (**202–205**). We recognise Camille (**202–203**) and another woman who is wearing a pale dress and hat. She is probably Sisley's wife (**202**, **205**), in which case the male figure stretched at the feet of the young woman in *Lilacs, Grey Weather* (**203**) is probably Sisley himself. As to the pots with blue-gazed tops visible in *The Garden* (**202**), the tradition that Monet brought these back from Holland seems probable enough, though they are not authentic Delftware.

Despite Argenteuil's many attractions, Monet's abundant energy of early 1872 overflowed into other places and activities. It was probably at the behest of his brother, Léon, that he took part in the 23rd Rouen municipal exhibition in March. The catalogue mentions an "An Interior" which is, in fact, *Meditation, Mrs. Monet Sitting on a Sofa* (**163**) and a "Canal à Zaandam" which belonged to Léon Monet himself, who had bought it for 200 francs.

Monet was immensely prolific during his stay in Rouen. He no longer avoided the signs of industrialisation, which are obvious enough in *The Robec Stream* (**206**) and *The Goods Train* (**213**). Déville, where Léon lived, on the outskirts of Rouen, became the subject of several paintings (**213-215**), and Monet also painted *The Mont Riboudet in Rouen in Springtime* (**216**), which was then still largely as nature had made it; it stands between Rouen and Déville. But the great attraction here was the Seine, with the two motifs that only Rouen could offer: the towers of its gothic cathedral (**210, 217–218**) and the big sailing-ships that docked at Rouen after their great ocean voyages (**207–212, 218**).

The Port of Argenteuil

From his return to Rouen, until the end of the year, almost all of Monet's painting was done on the banks of the Seine. Most of the pictures painted on the right bank, the Argenteuil side, look west; beyond the trees of the promenade, the manor house contrasts with the two chimneys of the factory, which frame it; on the other side of the port there was the Ile Marante (**221–224, 251**).

Turning to face the east, Monet painted *The Port at Argenteuil* (**225**), a panorama described by Régamey in 1927 as "an incomparable miracle in which Monet's art is akin to that of Vermeer"; the painting is now part of the Camondo-Bequest in the Louvre. To the left, are the plane trees of the prome-

Monet photographed in the Netherlands,
1871 or 1874
Photograph L. Greiner, Amsterdam

The Artist's House at Argenteuil
1873
Cat. no. 284

PAGE 97:
Camille Monet at the Window
1873
Cat. no. 287

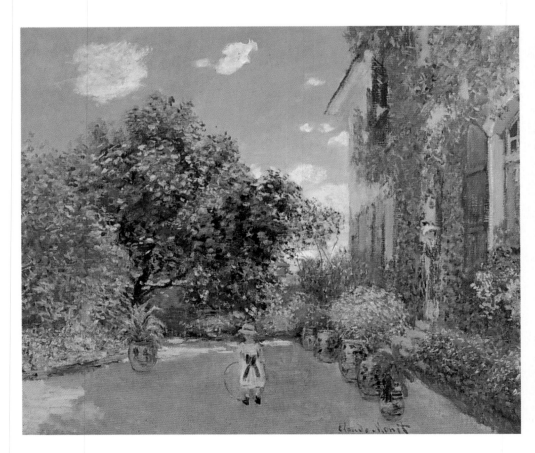

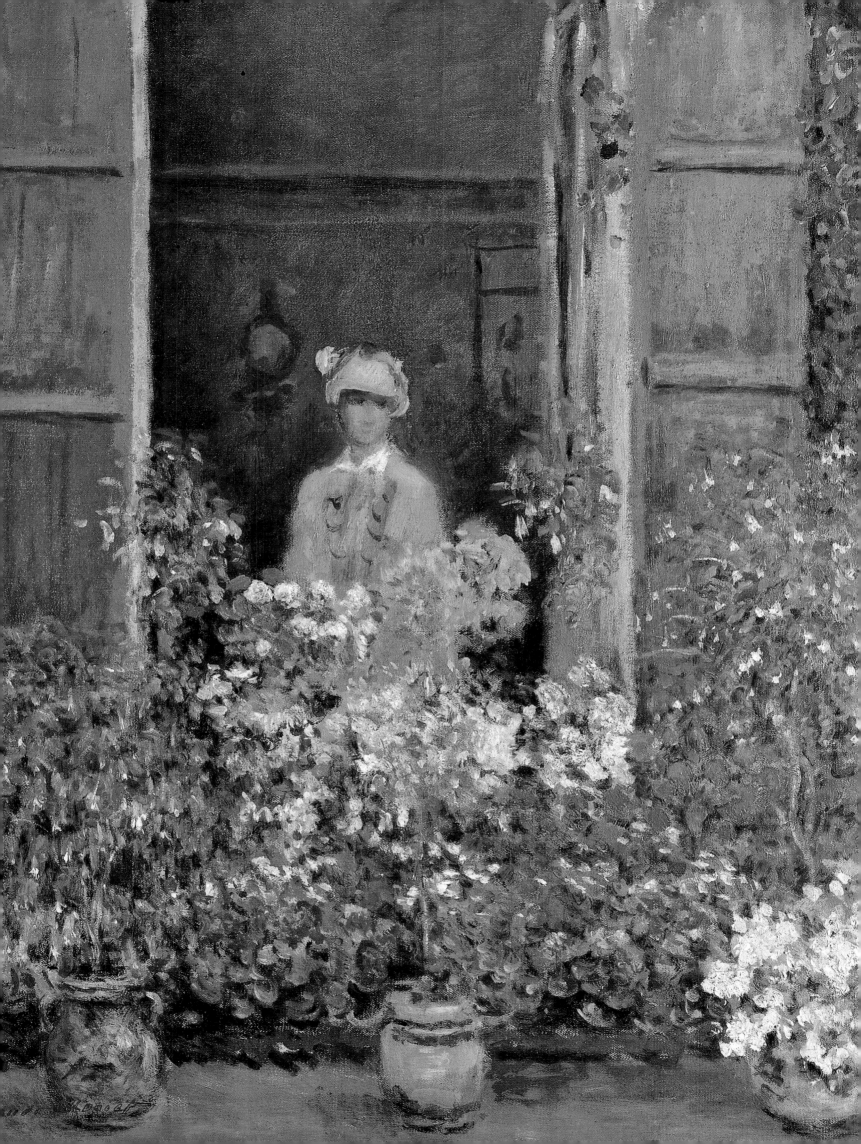

Auguste Renoir
Claude Monet Reading
1872
Paris, Musée Marmottan

nade, the double-width towpath and the gentle slope of the hill on which there are some strollers. Could they be Sisley, his wife in her pale dress and Camille? The seated figures watch the rowers. In the foreground, to the right, we see the floating premises of the hot baths, moored close to the bank and recognisable from the first letters of its sign; further off, the wash-house boats; parallel with the top of the line of trees, the toll-house stands higher than it did in reality at the entrance to the bridge, five of whose seven spans are represented. In the middle of the Seine, a tug and two sailing-boats; on the mast of one of them there flutters the bold scarlet of a pennant; the smoke from the tug is carried off by the south-west wind that has filled the blue sky with great rainclouds; the parallel shadows of the trees are long, the days of summer are drawing to an end (cf **252–253**).

Most of the paintings from the left bank can only have been made from a boat. This is probably the famous studio-boat, whose creation Monet described thus: "A fair wind brought me just enough money, all in one go, to buy myself a boat and have a little wooden cabin built on it, just big enough to set up my easel in." (Thiébault-Sisson) And thus came into being some of the canvases that show the little, brightly-painted houses that stand on one side of the boat-building yards of Petit-Gennevilliers. As usual, the views are downstream (**226–228**). The exception is *Regatta at Argenteuil*, which looks west: the afternoon sun barely lights the bank, the houses and the sails, while in the background we recognise the road-bridge (**233**). Caillebotte, whose property was just out of frame to the right, bought the painting; for him, it was a familiar scene. For another group of paintings, the studio-boat must have been moored at the outlet of the little arm of the Seine near the Ile Marante; we see not just the spire of the basilica but, in the distance, the Orgemont hill topped by a windmill that can just be made out in one of the paintings (**229–232**).

Away from the river there were other attractive subjects. Close to his house was the hospital-asylum with other old houses (**240**); a little further off, the entrance to the promenade is blocked by the fairground in which *Fête at Argenteuil* (**241**) was held from Ascension Day until Pentecost; next to the promenade runs *The Boulevard Héloïse at Argenteuil* (**247**), which Sisley also painted. Leaving the boulevard, the two painters would enter the old town of Argenteuil, where, side by side, they painted *The Old Rue de la Chaussée at Argenteuil* (**239**). *The Railway Station at Argenteuil* (**242**) offered Monet a first prospect of locomotives with tall smokestacks. Continuing on through the new suburbs of Argenteuil, he would come to the countryside on the other side, where, in fine

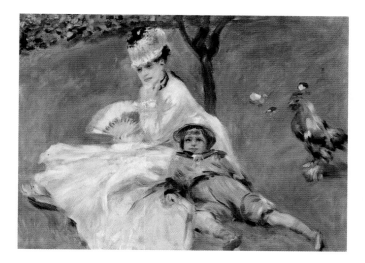

summery weather, he painted two general views. The one reminds us that Argenteuil was once known for its white wine (**219**); for the other, he must have climbed the Sannois hills (**220**). During the winter, he recorded the *Fog Effect*, much appreciated by Durand-Ruel (**249-250**).

If we add *Jean Monet on his Horse Tricycle* (**238**) and a few still lifes (**244–246**), we have a fairly complete record of what survives of his astoundingly prolific first year in Argenteuil. (Hereafter only these paintings will be mentioned whose subject matter is new a particularly original interpretation of a subject already encountered.)

Income

The year 1872 was remarkable not only for its (extant) production, but for the income that this production generated. Monet sold five pictures to Latouche, two to Millot, one to his brother, Léon, and one to Edouard Manet; but his best client by far was Paul Durand-Ruel, who bought a significant number of paintings and continued to exhibit Monet in his exhibitions in London. According to the painter's notebooks, of the 12,100 francs that he received in 1872 for 38 paintings, Durand-Ruel bought 29 for a total of 9,800 francs. The highest sum – 600 francs – was paid for a picture painted in the Fontainebleau forest; the lowest price commonly paid was 300 francs; even at that price, Durand-Ruel was taking a risk. Most of the paintings that he bought from Monet at this stage remained in store for many years.

The revenue from painting was increased by other sources. On 14 June 1872, while still officially resident in the Rue de l'Isly, Paris, he signed a power of attorney at the office of Maître Merceron, an Argenteuil notary; on 9 July, he signed a receipt made out to an inhabitant of Le Havre, Florentin Ruffin. These two operations were connected and related to a transaction in which Ruffin had been the intermediary. This was probably the execution of his father's will; the sum must have been a small one or Monet would probably have completed the paperwork himself. At the end of the year, on 21 December, the first six-monthly payment of the interest on Camille's dowry was made: 300 francs of interest on a capital of 12,000, invested at 5% a year.

Monet's stay in Argenteuil coincided with economic recovery in France and seemed destined for success. Boudin wrote on 12 December 1872 to his friend Martin: "Monet sometimes visits; he seems happy with his life, despite the

PAGE 98 AND ABOVE, FROM LEFT TO RIGHT:
Camille Monet and a Child in the Garden
1875
Cat. no. 382

Edouard Manet
The Monet Family in the Garden
1874
New York, The Metropolitan Museum of Art

Auguste Renoir
Camille Monet and her Son in the Garden at Argenteuil
1874
Washington (DC), National Gallery of Art

The Bench
1873
Cat. no. 281

resistance his painting meets with." The year 1873 was an even better one in financial terms. The total for sales of paintings reached 24,800 francs, double that of the year before. Durand-Ruel again had the lion's share in this; on 28 February, his account books note the purchase of 25 paintings by Monet for 12,100 francs, a considerable transaction. Prices varied between 300, 400 and 500 francs; one *Grenouillère* (**136**) painting alone reached 2000 francs on its own. In December, Durand-Ruel bought a batch of nine paintings for 7,000 francs, making an average price of 777 francs.

In the *Recueil d'estampes* (Print Collection) that he published in four volumes in 1873, Durand-Ruel included three views of Zaandam by Monet (**171, 172, 185**) and *Apple Trees in Blossom* (**201**). In his preface to the collection, Armand Silvestre compared Monet with Pissarro and Sisley, stating that Monet was "the cleverest and most audacious" of the three; he noted the influence of "Japanese images" in the study of reflections in the water. This was perceptive. We do not know where Monet first encountered the prints of artists such as Hiroshige or Hokusai, whether in Le Havre, Paris, Zaandam, Amsterdam or London, but we do know that they interested him intensely. Alas, the December transaction was the high watermark of Monet's affairs for some time to come. Durand-Ruel, a victim of the brief recession in France of the years

Poppies at Argenteuil
1873
Cat. no. 274

1872–1873, was losing clientele because of his commitment to avant-garde painting, and was forced to make a substantial reduction in his purchases; he may even have stopped buying altogether for a few years.

Monet was fortunate; other clients appear in his account books in 1873. They were Hecht (possibly one of the brothers of the banking firm Albert and Henri Hecht) and Michel Lévy, the painter whom he had met at Zaandam; Beriot, who paid 1,000 francs for a view of Paris, *Garden of the Princess* (**85**); Nunès, who had been brought to Monet by his cousin, Pissarro, and who bought a "View of Argenteuil"; the art-dealer Dubourg, who bought three pictures for a total of 1,500 francs; and finally Théodore Duret, future lawyer and author of *Les Peintres impressionistes* (The Impressionist Painters). Duret bought *A Hut at Sainte-Adresse* (**94**) in May, but paid by instalments and consistently late, so that Monet had to appeal to Pissarro for his assistance in a letter in September 1873.

The Doncieux Inheritance

In a letter to Pissarro, Monet informed him of the death of M. Doncieux, Camille's father, on 22 September 1873 at the Dubois nursing home, Rue du Faubourg Saint-Denis in Paris. The Monets went into mourning, but after the first shock of emotion, the inheritance had to be dealt with. On 16 October 1873, before his Argenteuil notary, Monet authorised Camille "to register as heir in half", her sister Geneviève-Françoise being the other half. On the same day, at the request of Mme Veuve Doncieux, her younger daughter Geneviève and Camille herself, Maître Aumont-Thiéville, a Paris notary, took the inventory of the Doncieux household at 17 Boulevard des Batignolles. The valuation of the furnishings and jewellery by Maître L.-E. Baudyr came to 3,196 francs. The widow declared that, since the death of her husband, she had sold the shares that M. Doncieux had owned for 5,500 francs and that there was no "last specie", that is, cash, at the time of the death.

The Pritelly inheritance occupied a large part of the inventory. Pritelly, a former district tax collector in Reuil, who had died on 28 May 1867, had made Geneviève Doncieux his sole heir. Mme Doncieux, who had received an individual inheritance, enjoyed usufruct over the inheritance as a whole; it was therefore she who received the rental income from the house in Bougival left to Geneviève, along with some shares and various objects, including an Ary Scheffer portrait and a bust by Brunet. M. Doncieux had responded to M. de Pritelly's rather equivocal gesture, as we know, by making Camille an "exclusive" gift of 12,000 francs.

Half of this sum was payable by Mme Doncieux in person; on 24 November, she handed over 4,000 francs to Mme Monet but asked for a delay until 1 January 1877, for the payment of the remainder. The remaining 6,000 francs was to be raised from M. Doncieux's inheritance, which was quite insufficient; the liquidation settlement assigned only 2,130 francs to Camille. Geneviève's surrogate guardian disputed the decision, which was defended jointly by Claude Monet and Mme Doncieux represented by their advocate, Maître Postel-Dubois. On 16 June 1784, the first Chamber of the Tribunal de la Seine gave a verdict in favour of the liquidation settlement. On 28 October 1874, Maître Aumont-Thiéville was able to settle the inheritance; he confirmed the deadline for Mme Doncieux to pay Camille the 2,000 francs that she personally owed her; of the 2,130 francs assigned by the liquidation of the inheritance, 2,000 had already been paid at that date.

The result of these toings and froings was that of the 12,000 francs owed her on the death of her father, Camille received only 6,000 at first. Her hopes were now limited to the 2,000 francs that her mother had agreed to pay her by 1 January, 1877; until then, she would receive interest on this sum at 5%, that is 100 francs payable by two half-yearly instalments of 50 francs on 21 June and 21 December of each year starting in 1874. Even this tiny income vanished on 2 October 1875, when the capital of 2,000 francs was transferred to Carpentier, an ironmonger, evidently to repay debts contracted by Monet. It was a harbinger of the poverty to come.

Tomorrow's Men

Though less abundant than in the previous year, Monet's production in 1873 was just as interesting and varied. *The Red Kerchief, Portrait of Mrs. Monet* (257) began the year with snow effects, hoar-frosts and thaws (254–256), but flowers became the year's main theme. There were fruit trees (271–273), *Poppies at Argenteuil* (274–276), flower-beds in bloom (277) and gardens, in particular that of the Aubry house (280–287) in which the temptations of *The Luncheon* (285) were laid out. The young Jean Monet takes up a boyish posture there; a servant was taken on to look after him (280). Camille did not give up the large hats that she wore with such elegance (274–285), but seems to have acquired a taste for toques, one of them dark (280–281), the other light (280–281). In *The Bench* (281), though she is in ill-health and has aged, she so resembles her yet unborn son, Michel Monet, that all those who met him remark on it.

Monet rather neglected the Seine that year. One picture shows the road-bridge, now freed of its scaffolding, cut off by the frame just beyond the toll-house (278). There is also the first appearance of *The Railway Bridge at Argenteuil* (279). In autumn, Monet returned to the banks of the Seine near the Ile Marante (290–291). While working with Renoir, who also painted the railway-bridge, he painted *Duck Pond in Autumn* (289).

Away from Argenteuil, the Seine and even the sea returned to favour. Monet made a trip to Normandy from which he returned with a view of Etretat (258), two *Sainte-Adresse* (265–266) and a group of paintings of the port of Le Havre (259–264), one of which was to cause quite a stir (263). Two other pictures are the record of a short visit to Asnières, near Paris; the disorderly accumulation of suburban bungalows has surrounded some older buildings, whose reflection in the Seine is boldly interrupted by the dark mass of the barges (269–270). Late in the year, Nadar's studio on the second floor of the building on the corner of the Rue Daunou and the great boulevards gave Monet a steep angle on *The Boulevard des Capucines* (292–293). The *Charivari* criticised what it saw as the "black shavings" in this painting; these, in combination with its violet-blue atmosphere, for which William C. Seitz makes such an excellent case, have stimulated much criticism and commentary.

There was nothing fortuitous about Monet's presence in Nadar's studio. In the spring of 1874, it was to be the site of the first exhibition of the group formed by Renoir, Pissarro, Sisley, Monet himself and their friends. The exhibition was the climactic moment in a long story which has been magisterially told by John Rewald. We therefore confine ourselves to certain previously unpublished points that particularly concern Monet.

It will be remembered that, as early as 1867, the idea of an exhibition independent of the Salon had been envisaged by Bazille, Monet and a few friends. The notion had been abandoned when insufficient funds were forthcoming,

PAGE 102:
Camille and Jean Monet in the Garden at Argenteuil
1873
Cat. no. 282

and the young painters had continued to face the jury's decisions with mixed fortunes. Monet's rejection in 1870 had been particularly painful and unjust. After the Franco-Prussian War, he had given up trying, as had Pissarro and Sisley. The record of Monet's efforts was: 1865, two pictures accepted; 1866, two pictures accepted; 1867, rejection; 1868, one picture accepted; 1869, rejection; 1870 rejection. In short, after an initial welcome, his paintings had been greeted with increasing distrust, which became complete ostracism as the views and achievements of Monet and the younger generation of painters became clearer. Renoir had persisted with his submissions and received two successive complete rejections (Gleyre was no longer on the jury). The Salon des Réfusés that had been allowed in 1873 was no real solution for the Batignolles group. Besides, even before the opening of the official Salon, a letter from Monet to Pissarro informs us that preparations for their own exhibition were sufficiently well-advanced for a single further meeting to bring them to fruition. This was optimistic; it seems likely that several further meetings were required before the first draft of the statutes was produced and signed, in pencil: "Monet, Porte St-Denis (Argenteuil)."

"I see a renewal. We are the men of tomorrow; our day is coming." Thus Zola to his disciple Paul Alexis, shortly after the 1871 Armistice. Two years later, though he did not commit himself personally to the artists' battle as he had done before the war on Manet's behalf – Manet was known to be hostile to the new society – he granted the obedient Alexis power of attorney. Alexis made the most of the "pulpit" that Zola was able to provide for him in the columns of *L'Avenir National* (The Nation's Future) to launch a fervent appeal to the "artistic corporation"; he besought them to organise their "management committee." Already, he said, a plan for subscriptions and exhibitions was afoot; all those who were interested should contact him.

Under the Presidency of Thiers and more especially of Mac-Mahon, an appeal of this kind, seasoned with social and political considerations, was bordering on the subversive. Soon *L'Avenir National* was prosecuted; it had to cease publication on 26 October 1873. The Alexis article was published on 5 May 1873 over six columns; it was anxiously awaited by those who had inspired it. The very next day, Monet, on behalf of "a group of painters" gathered at his house, thanked the journalist; Alexis, in turn, reproduced the letter in a new article (12 May) in which he stated that he had received many such letters, and that they testified to the formation of an association. He believed that Monet would have with him "several artists of great merit" including Pissarro, Jongkind, Sisley, Béliard, A. Gautier, Guillaumin, Authier, Numa Coste and Visconti. In fact, only Pissarro, Sisley, Béliard, and Guillaumin were ultimately involved (Numa Coste was a close friend of Zola's). But the heedless Alexis included them all in the "group of naturalists"; Zola delighted in the the description "naturalist", and the name might well have gone down into history for the new generation of both painters and novelists had it not been for one Louis Leroy, of whom more later.

Impression

It took much longer to express the various intentions of the group in a text acceptable to all of them than Monet had initially supposed. With mid-September 1873 drawing closer, he was still asking Pissarro to come to Argenteuil to go over "some improvements in the form of certain articles" with "a gentleman member who is well up in the matter." The meeting took place in

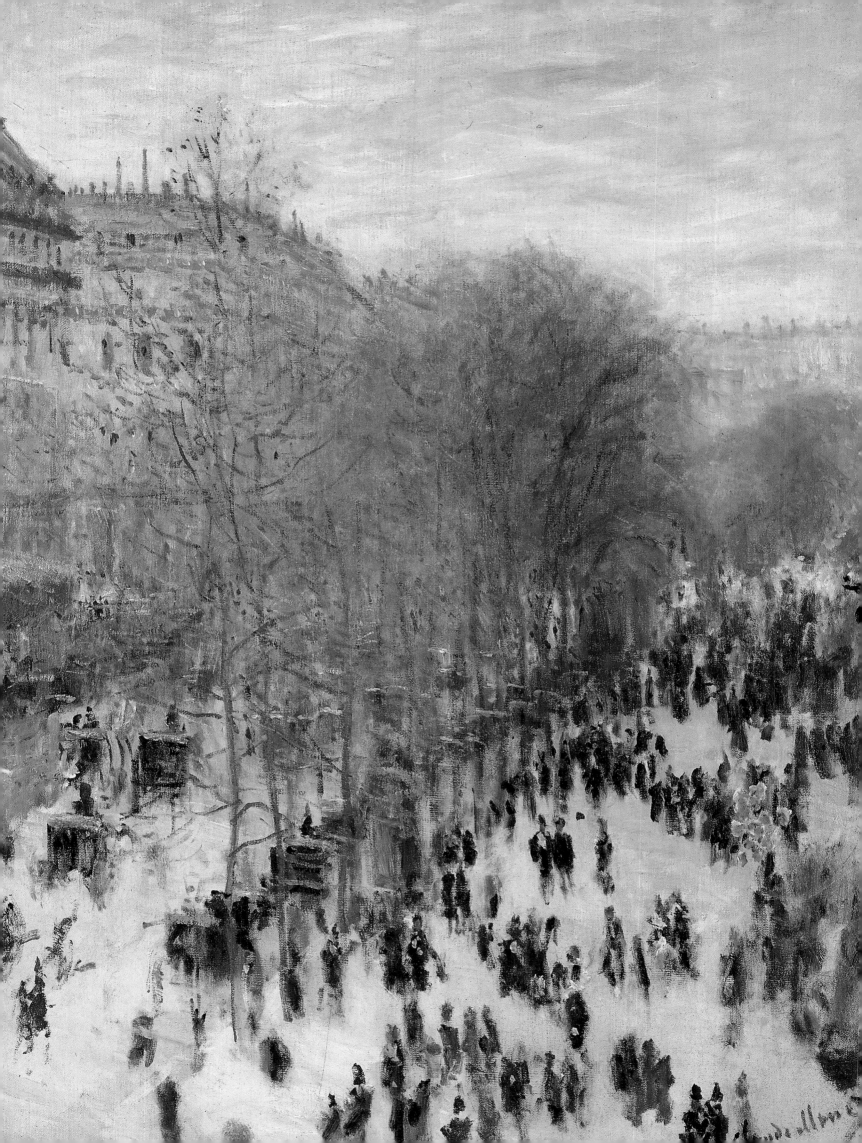

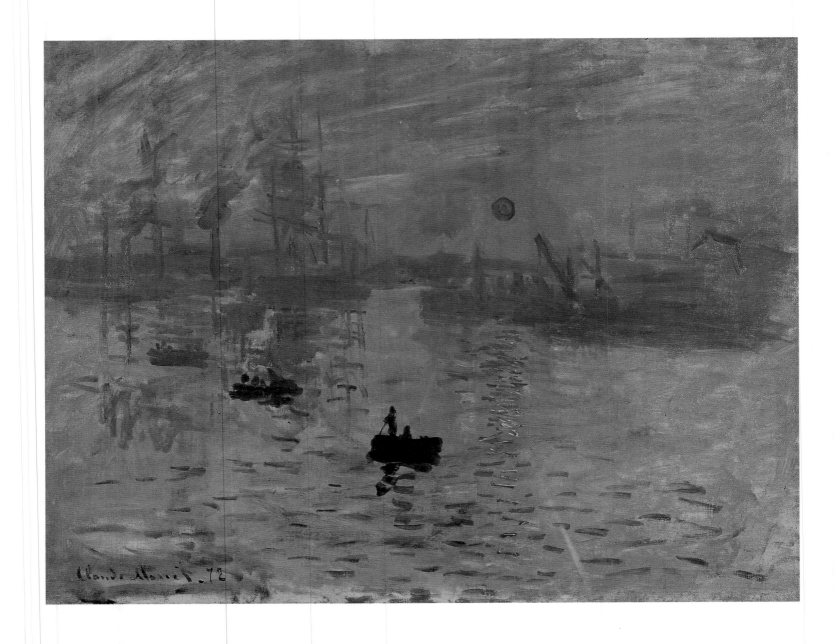

Impression, Sunrise
1873
Cat. no. 263

the absence of Renoir. Renoir was a "moderate"; Pissarro drew on the charter of the bakers of Pointoise, where he lived. Monet had a limited interest in ideology and seems to have confined himself to the role of peacemaker in the negotiations. The text thus studied was perhaps the second draft of the regulations, in which the term "cooperative society" appeared; Renoir is said to have insisted on its removal. The definitive version of the charter was dated 27 December. Monet was one of the seven provisional directors, but was not part of the "supervisory committee", which consisted of Béliard, the sculptor Ottin and Renoir.

If drafting had seemed difficult, recruitment turned out to be still more problematic. On 5 December, Monet went to Paris in the hope of collecting five signatures; he came back without a single one. Of all the artists that he cites that day in a letter to Pissarro, only Robert and Feyen-Perrin were to become subscribers; the latter paid only 10% of the figure agreed, and took no part in the exhibition. The others, Lançon, Michel Lévy, the redoubtable La Rochenoire, Los Rios, the sculptor, and Solari, a friend of Zola simply did not reply. Corot congratulated another friend of Zola's, Guillemet, for not involving himself "with that bunch", and Guillemet's fidelity to the Salon of that year was rewarded with a second medal.

Monet was forced to acknowledge the sad fact that it was difficult to progress beyond the 15 founding members, and in his letter to Pissarro of 11 December 1873 wondered why there was so little sympathy for their cause. His own recommendation is thought to have been instrumental in persuading Boudin to join. In January, disappointed by the fruitlessness of his own efforts and perhaps also by the muted role he himself had played since the formation of the supervisory committee, he left for the coast, at some risk of seeming to abandon the cause. At Le Havre he stayed in the Hôtel de l'Amirauté, where he painted seascapes that gave him a lot of trouble (**294–297**). He was absent from Paris for the first Hoschedé sale, during which three of his works were sold to different buyers; he was sorry not to have been able to buy back *The Blue House at Zaandam* (**184**), which was acquired by Baudry. The prices were reassuring, at between 400 and 500 francs.

His friends continued to organise and campaign. Degas obtained more signatures than anyone. At the last minute, in March, Burty managed to persuade Bracquemond to exhibit, though the list had already been finalised. There were thirty participants; a list of these, the subscribers who eventually refused to exhibit and the artists of all kinds who had refused to take part, makes it clear that the "trade union" aspect, with its concomitant emphasis on numbers, had predominated over criteria of style.

According to the original arrangements, each 60 francs subscription entitled the subscriber to exhibit two works of art. This limitation was not observed; there were 30 exhibitors, none of whom had paid more than one subscription, and 165 catalogue entries (300 had been expected on the basis of 150 shares/subscriptions). Monet had paid only one share, but had nine catalogue entries, some of which were two sketches. The story has it that Edmond Renoir, who was responsible for printing the catalogue, asked Monet for his titles. For (**263**), painted the previous year at Le Havre, Monet answered "Put 'Impression'." Hence the famous appellation: *Impression, Sunrise*.

The *Société anonyme coopérative d'artistes* stole a march on the Salon, opening on 15 April 1874 at 35 Boulevard des Capucines; Nadar had just vacated the rooms, which were hung with russet wool. The public flocked in, despite a 1 franc entrance fee which equalled that of the official Salon; the catalogue cost 50 centimes. There was a hard core of admirers among the public, but most came for amusement. Ernest Chesneau, writing in the *Paris-Journal*, favoured the new school and Monet in particular, but criticised the heterogeneity of the exhibition. He felt that it had been wrong to include senior artists such as Nittis, Boudin, Bracquemond, Brandon, Lépine, and Gustave Colin; "between two works simultaneously presented, the verdict [of the public] will go to the conventional work rather than the innovative. This is what happens at the Boulevard des Capucines."

The conservative press refused any publicity to a movement subversive of the moral order and generally refrained from commenting on the exhibition. The other newspapers, for the most part, preferred the concept of an independent exhibition to the paintings exhibited, which perplexed even those favourably inclined; criteria for praise proved elusive. Chesneau rightly felt that the tendency towards lighter colours was spreading to the Salon itself. His critique is perhaps better informed than those of Burty, E. d'Hervilly, Léon de Lora, Jean Prouvaire (a.k.a. Catulle Mendès), A. Silvestre, or Castagnary. He had had the chance, however, to read his colleagues' views by the time his own article appeared (7 May). Armand Silvestre spoke perceptively enough of the vision of Monet, Pissarro and Sisley, who were again identified with one another: "They seek nothing but the effect of an impression, leaving the search

Claude Monet c. 1875, in the early days of Impressionism

The building at 35 Boulevard des Capucines in which the first Impressionism exposition was held in 1874
Photograph: Nadar, B.N.F., Paris

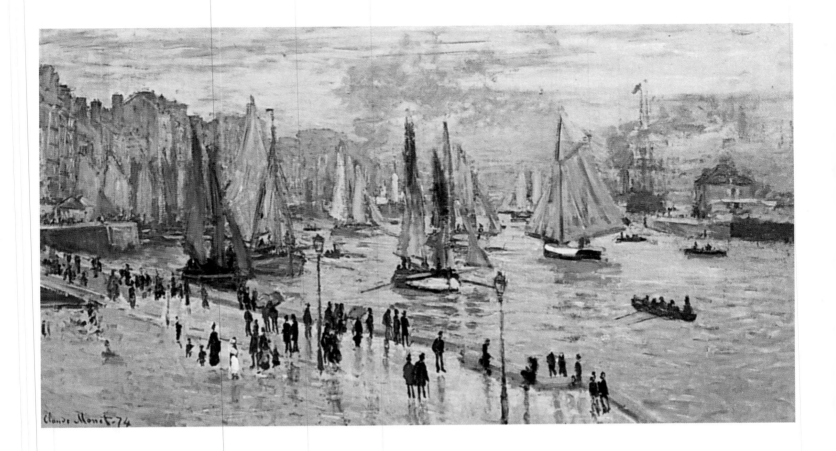

Le Havre, the Great Quay
The commercial port
Postcards, early 20th century

TOP:
Fishing Boats Leaving the Port of Le Havre
1874
Cat. no. 296

for expression to those devoted to line." But his generally benevolent piece was completely eclipsed by the malicious and caustic criticism of Louis Leroy in *Le Charivari* on 25 April 1874. The word "impression", was not new, having been used by Castagnary of Corot and Théophile Gautier of Daubigny; but it was offered by the catalogue, and Leroy gleefully accepted it, entitling his article "Exhibition of Impressionists". Thinking to annihilate the movement at its first manifestation, he provided the name under which it was immortalised and a footnote to its history.

With the exception of the pastels, none of the pictures exhibited by Monet were overlooked by the critics, as a cursory glance over the reviews of *Impression, Sunrise* (263), *Poppies at Argenteuil* (274), *The Seine at Asnières* (269) and *The Boulevard des Capucines* (292) will show (references for those not mentioned here can be found in the notes on the paintings). The last-named was the most frequently mentioned – it was even cited in an English newspaper – along with the reassuring *The Luncheon* (132) which Monet had insisted on exhibiting in retaliation for its refusal by the 1870 Salon.

Making the Best of Hard Times

We have seen that in January 1874, although the exhibition preparations were in full swing, Monet left Argenteuil for Le Havre. Towards the end of the winter, he again absented himself; this time he went to Amsterdam. This second stay in Holland, for which the proof is some dozen undated paintings, is thought by some biographers to have occurred in 1872; stylistic reasons make 1874 the likelier date. No Monet letters are extant for the period 23 January to 1 April. Two of the twelve Amsterdam paintings (298–309) are of snow, and we know that it snowed in Amsterdam on 10 February 1874. The later paintings

The Windmill on the Onbekende Gracht
1874
Cat. no. 302

show trees just coming into leaf. Was this possible in March 1874? Did Monet make a further brief trip to Amsterdam after the opening of the exhibition? We do not know.

The Amsterdam paintings show great variety of subject-matter and effects. Monet seems to have found a room close to the central station and to have remained within a radius of some 1,500 metres of the station, though Amsterdam's canals must have made these expeditions longer on the ground. To the North was the Ij, the arm of the sea that appears in some of the Zaandam pictures, which he painted at the same time as the port (**289–299**). Two images of snow were painted not far from his lodgings, one to the west of the station (**201**) the other to the south at the end of Gelderskad (**300**). There are two views of the old houses of the quarter (**303–304**), one of which shows the famous Schreijerstoren, the tower climbed by women to wave goodbye to departing sailors (**303**). A little to the east, there are two different views from the Montalban Tower of the waters of the Oude Schans at its foot (**306–307**). Further to the south, on the banks of the Amstel – the river that gave Amsterdam its name – Monet painted the Zuiderkerk at the end of Groenburgval (**308–309**); the subject is reminiscent of the paintings of some old Dutch masters. From almost the same spot, he painted the Amstel itself as it stretches away towards the bulbous, baroque tower of the Mint (**305**). Finally, having walked further east than usual, he set up his easel on the "unknown quayside" and saved from oblivion the mill of the same name, which was soon to be demolished, *The Windmill on the Onbekende Gracht* (**302**).

This second voyage to Holland, far from the influence of his friends, was a sort of study retreat for Monet, whose style gained in authority and depth. Always open to new ideas, Monet ardently pursued his researches right to the end of his life.

His lifelong researches were, however, of little assistance in earning his liv-

Period "Stereophoto" showing how the same view was so precisely reproduced in the Monet painting no. 302
Amsterdam, Municipal Archives

The Road Bridge at Argenteuil
1874
Cat. no. 312

ing in 1874. Durand-Ruel was no longer buying. He had contrived to pass on to Monet one of his best clients, the famous baritone Faure who, in 1869, had played Mephisto in the première of Gounod's *Faust*; in 1877, Manet painted him costumed as Hamlet. That year, Faure's purchases as recorded in Monet's account-books amounted to 4,200 francs. Hoschedé, no doubt encouraged by the result of his auction of the previous year, bought 4,800 francs worth of paintings. Durand-Ruel was the intermediary. Faure paid 300 francs per painting and obtained five rough sketches for a total of 600 francs; Hoschedé bought *Impression, Sunrise* (263) for 800 francs, and four others at 1,000 francs each. Hoschedé, wholesale cloth merchant, refused to bargain, and his account suffered accordingly. The remainder of the 10,554 francs Monet recorded as revenue for that year came from sales to O'Doard and Martin and through an exchange with Dubourg. This fell far short of his 1873 income.

One immediate consequence was difficulty with the rent. He appealed to Manet for assistance on 1 April 1874, the date on which the rent was due. Monet was asking for 100 francs; Manet, who was himself out of pocket at the time, forwarded the note to Duret with an explanation. Tabarant published both documents in 1928, expressing perplexity that both Monet's letter and Manet's note should have finished up in Manet's hands. There is a simple explanation: Duret must have been absent when Manet had it sent to him and

Edouard Manet
Monet Painting in his Studio Boat
1874
Munich, Bayerische Staatsgemäldesammlungen

bridge is most often painted from the point where it meets the further bank; we recognise the floating shed where boats could be hired (318–321). Two paintings made on the superstructure of the bridge offer a steeply-angled view westward (334–335).

The railway-bridge is, at times, scarcely visible through the arches of its neighbour (313, 316); at others, it is painted in its own right (318–321). The regattas depicted against the Petit-Gennevilliers houses must have been painted from the studio-boat (333, 336-337, 339), which itself makes a discreet appearance in one painting (316) and floats in the foreground of another (323). Sailing-boats are an element in many pictures and often a subject in themselves. *Boaters at Argenteuil* (324) merits special attention as the same subject was painted by Renoir.

The promenade, one end of which is occupied by the fairground, is close to the river (345-346). Water is again centre-stage in *Geese in the Brook* (347); the geese are painted in a decor similar to that of *Duck Pond in Autumn* (289). *Meadow at Bezons* (341), with its great meadow full of ripe, yellowing grass, is unique, whereas *The Main Street at Argenteuil* (344) returns to a theme that Alfred Sisley had already used. Finally, *Manet Painting in Monet's Garden at Argenteuil* (342) is a good introduction to the great encounters of the summer of 1874.

Manet's loan suggests that there was no longer any hostility between the two, despite their differences. Over the course of the summer, their relationship was closer than ever. Manet stayed with his cousin, De Jouy, in Gennevilliers, and took the opportunity to join Monet by the Seine; he was often in the company of his brother-in-law, Rudolf Leehof, and a female model. It is sometimes said that Monet's example converted the older painter to outdoor painting and the lighter colours of Impressionism. But this underestimates the landscapes and seascapes that Manet had already painted, which testify to a slow process of absorption; as early as the meetings at the Café Guerbois, Manet had been mak-

The road bridge at Argenteuil
Photograph, c. 1875

An inn on the site of the ferryman's house on
the promenade at Argenteuil
Photograph, c. 1875

the note was returned to Manet, who advanced the 100 francs. We know that
Monet reimbursed him on 27 May.

In his letter Monet informs Manet that he is "extremely busy with moving
out of the studio". Which studio is this? It may be the Rue de l'Isly studio,
which he had ceased to rent in 1874. But the little lean-to at Argenteuil could
not easily accommodate all the paintings, and some other accommodation was
required, especially since delays with the rent had made Mme Aubry rather dis-
trustful. A document dated 18 June indicates that Monet rented a bungalow
belonging to Flament, an Argenteuil carpenter. The bungalow was to become
available on 1 October 1874; the price, 1,400 francs a year, was 400 more than
Mme Aubry had charged. The brand new house stood just opposite the station
and was identified for the benefit of visitors such as Cézanne and Chocquet,
dinner-guests in February, 1876, as the "pink house with green shutters".

Great Encounters

The Seine had been eclipsed by other subjects in 1873; in 1874 it was again the
centre of attention. Two views of the bridge look towards the promenade and
take in the café in the former ferryman's house amid the trees (311–312). But the

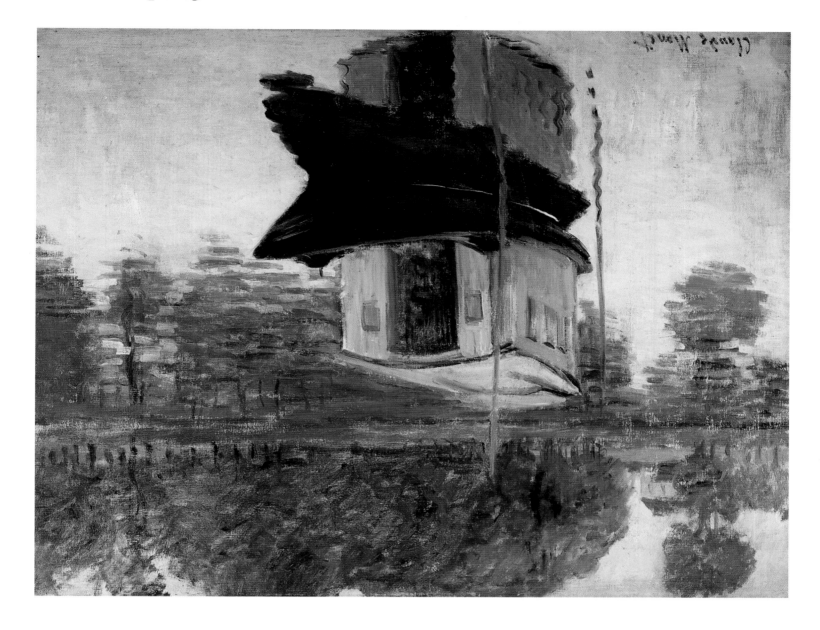

The Studio Boat
1874
Cat. no. 323

ing experiments similar to those of the other Batignolles painters. The fact remains that the combined influence of the Seine, the port of Argenteuil and the presence of Monet and his works was revelatory, and almost immediately produced some masterpieces.

These include *The Rowers* and *Monet Painting in his Studio*, painted looking towards Bezons, which depict the familiar industrial scenery whose existence Manet acknowledged rather more frankly. Monet, whom Zola had hailed in 1868 as the painter of modern life, was increasingly averse to such modernity when it meant industrialisation corrupting the landscape. In Monet's Port of Argenteuil pictures, the plumes of smoke become ever rarer at a time when steam navigation was increasingly common. Tugs gradually disappear from the Seine as painted by Monet. True, in 1865 and 1876, he painted his share of locomotives and stations, but he soon turned away from this theme. Nothing in Monet's works tells us that between the garden at Giverny and the water-lily pond ran a railway line with four trains daily.

Manet was exasperated when painting *The Monet Family in the Garden* by Renoir's decision to paint the same subject. Renoir roughed out the painting now known as *Madame Monet and Her Son*. The story goes that Manet whispered in Monet's ear: "He has no talent, this lad! You're a friend of his, tell him

to give up painting!" The remark was reported first to Renoir and then to Marc Elder; it does little honour to Manet's judgement and Monet's discretion. If true, it reflects the differences of outlook between Renoir, who took his "commissar's" role seriously, and Manet, who consistently opposed the new group, demanding of his friends after the success of *Bon Bock* at the 1873 Salon: "Why not stay with me? Can't you see I'm better placed than you are?"

The fact remains that 1874 was an extraordinary summer; Monet, Manet and Renoir were united beneath the broad skies of the Ile de France in a flower-filled garden that bordered the light-stippled surface of the Seine. These were decisive moments in the history of the little town of Argenteuil, moments when the convergence of three great painters brought Impressionism to its zenith. Dissension about how to present the new movement seems insignificant in this context. Yet, despite the positive overall effect of the exhibition, the general meeting of the *Société anonyme* under Renoir's chairmanship dissolved the *Société* on 17 December 1874, not least because a substantial déficit remained. One hope had been abandoned, but hopes and aspirations remained.

The Hôtel Drouot

When his friends departed, Monet was not unhappy to find himself alone. Hereafter he did his best to avoid inviting others to paint with him. Caillebotte began to buy pictures from him in 1876, but did not regularly come to paint at Gennevilliers until several years after Monet had left Argenteuil. We should therefore give little heed to the rather fanciful accounts of Caillebotte working at his master's side.

In late 1874 and early 1875 Monet undertook a major winter "campaign", staying close to Argenteuil. Of this remarkable set of paintings (348–364), one of the most famous is *The Train Engine in the Snow* (356). It has been thought that *The Coal-Dockers* (364) was painted at Argenteuil, but the true location is the Asnières road-bridge on the right bank. Monet would have seen the the porters unloading coal for the gasworks factory at Clichy from the Argenteuil train as it crossed the Seine at Asnières. One day, he stopped there to record their repetitive movements.

When the weather was fine he went down the Seine to Chatou and painted the Saint-Germain railway-bridge (367). At some point, perhaps then, he contracted a debt to Fournaise, the inn-keeper painted by Renoir in *The Boatmen's Lunch*. Fournaise's restaurant was near the Chatou road, some two kilometres upstream of La Grenouillère, and according to Renoir, he and Monet had known Fournaise since 1869. At all events, Monet noted in his accounts of January, 1877: "Fournaise (note 75) 94 fr. so outstanding." The Petit-Gennevilliers bank of the Seine came in for considerable attention in 1875 (368–372), but Monet also sought out a prospect further down the same bank (373–375). There is a beautiful series of paintings that shows figures standing in flowering meadowland at the foot of a group of poplars (377–380). And whereas *Poppies at Argenteuil* of 1873 (274) is set on a hillside, the 1874 painting is of the Gennevilliers plain.

Camille and Jean posed together for *The Walk, Woman with a Parasol* (381); this was a theme that continued to haunt Monet for many years. Wearing a sumptuous theatrical costume and a strange blonde wig, Camille became the famous *Camille Monet in Japanese Costume* (387) to which the finishing touches were put the following year; this was the culmination of Monet's predilection for the "japonneries", on which we have already remarked.

PAGE 115:
The Walk, Woman with a Parasol
1875
Cat. no. 381

Eugène Boudin
The Beach at Trouville
Watercolour
1865
Paris, Musée d'Orsay

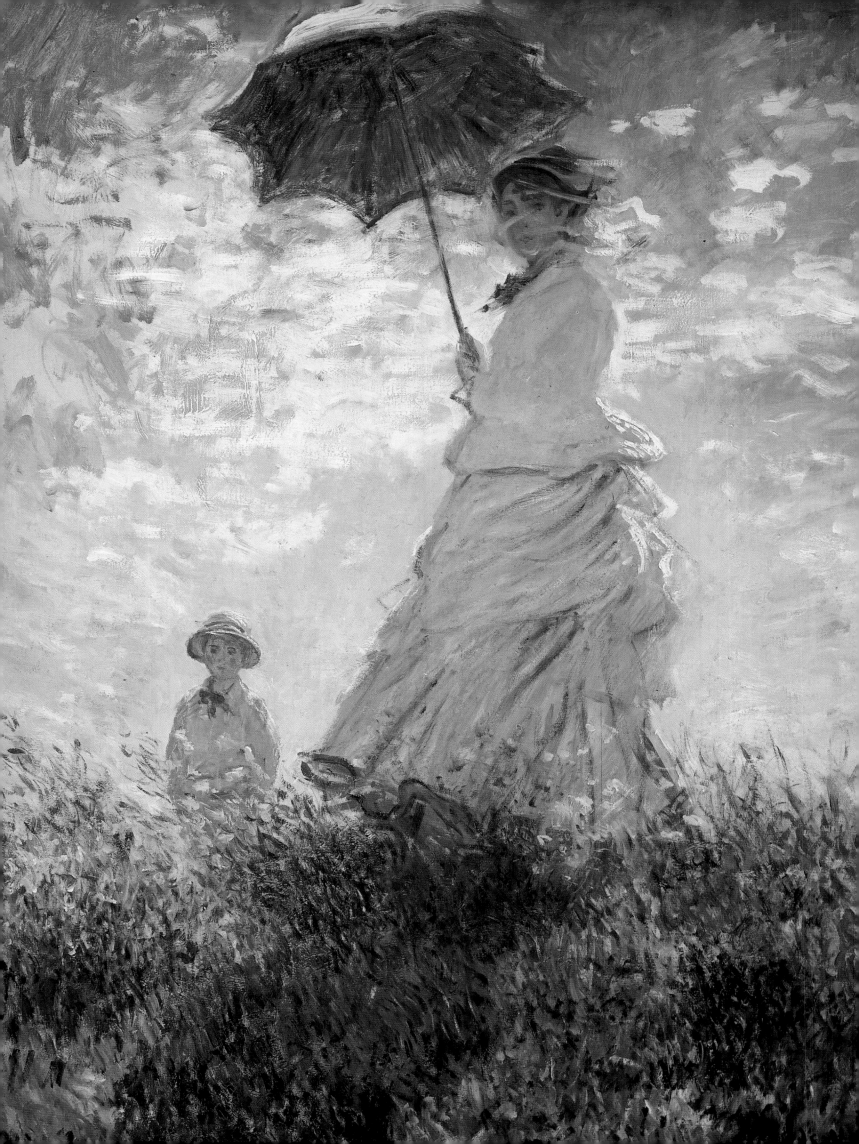

In 1875, sailing-boats still played a major role in Monet's pictures (368–375), though their sails are often furled; by 1876, they had disappeared almost completely. The studio-boat, on the other hand, was the subject of several studies (390–393). One such study came into Zola's hands, though there is no record of any transaction in Monet's accounts (393). It may have been a gift. The garden of the Flament house in which Monet was living was a frequent motif in the 1875 paintings (382-386) and it remained so in 1876 (406–415). A whole series of paintings shows the little pink bungalow peeping through the greenery (406–410).

To return to the history of Impressionism, the main event of 1875 was the 24 March auction, which was intended to do duty for the exhibition that the group had failed to organise. Only Berthe Morisot, Sisley and Monet responded favourably to the requests of Renoir, who seems to have instigated the whole enterprise. Maître Charles Pillet conducted operations at the Hôtel Drouot; Durand-Ruel was the valuer. One hundred and sixty-three works by the four artists were sold. The works were infinitely more homogeneous than those of the 1874 exhibition, and produced such hostility in the crowd that the police had to be called to maintain order. Lost in the crowd, many of the Impressionists' admirers were there. They included Blémont, Rouart, Charpentier, Hoschedé, Dollfus, Hecht and Arosa. The anonymous critic of *L'Art* commented ironically on the admirers' professions, noting that support came from "a few well-intentioned fellows strong on groceries, calico and flannel". The same critic spoke of the "ignorant aberrations" of Claude Monet, whom some were nevertheless beginning to compare with Turner.

The prices were disappointing. The highest was the 480 francs generously paid by Hoschedé for a work by Berthe Morisot. Not all of the 20 pictures by Monet in the catalogue fetched 200 francs, and only two went for (a little) more than 300 francs. The net profit recorded in Monet's account-book, 2,825 francs, refers only to the paintings that he was not forced to buy back, either directly or through the intervention of Durand-Ruel. Tradition has it that Monet met Victor Chocquet leaving the Hôtel Drouot clutching a Monet that he had just bought for 100 francs. But the story falls down on three different counts: no picture was sold for so low a price; Chocquet, like Duret and Caillebotte, does not appear on the list of purchasers, and a letter written by Monet in February 1876 refers to their meeting for the first time shortly thereafter. Since Renoir claims to have met him at the sale, Chocquet may well have been present at the Hôtel Drouot.

Journalist friends who announced and favourably reviewed the sale were unable to influence the general reaction. It should not be forgotten that sales of works from the studios of Corot and Millet had placed on the market a large number of paintings whose buyers might otherwise have been attracted to the Impressionist sale. As to the petty bourgeoisie who had created the Republic by voting for the Constitution of 1875, they were, if anything, more conservative in their artistic tastes than the rakes and tycoons of the Second Empire.

At all events, the income registered in Monet's ledgers for the entire year of 1875 was a mere 9,765 francs, a long way below his income of just after the Franco-Prussian War. This explains the anguish expressed in his appeals to Manet, his constant resource when times were bad. Manet did his best to interest the famous Albert Wolff, a critic with *Le Figaro*. He himself even bought paintings from Monet. The only encouraging point was the number of those who bought directly from Monet; they included Faure, Blémont, Ernest May, Rouart, Fromenthal and Meixmoron de Dombasle, a painter from Alsace-Lorraine who was subsequently to introduce Impressionism to Nancy. For the time being, it was not catching on in Paris.

Edouard Manet
Victorine Meurent in Spanish Costume
1862
New York, The Metropolitan Museum of Art

PAGE 116:
Camille Monet in Japanese Costume
1875
Cat. no. 387

Study of a Woman
Black crayon on paper
(D. W. 1991, V, p. 124, D 424)

The Garden, Gladioli
1876
Cat. no. 415

Misfortune in the Rue Le Peletier

Two important events occurred in the early months of 1876: Monet's meeting with Chocquet and the second group exhibition. This second exhibition was undoubtedly more significant. On a visit to Argenteuil with Cézanne in early February, Chocquet bought a sketch and a pastel for which he paid 100 and 20 francs respectively. The next purchase came only in 1887, and was for 50 francs. These transactions are so insignificant that we need hardly dwell on a collector who admired other artists more. Of more importance was the fact that Chocquet's apartment on the fifth floor of the Rue de Rivoli provided Monet with the vantage point from which he painted four views of the *The Tuileries* (401–404) in the spring of 1876; the subject matter had perhaps been suggested by Renoir, who had painted the same scene.

The dissolution of the *Société coopérative* in December 1874 was not an admission of defeat. In April 1876 a second exhibition was organised in Durand-Ruel's house at 11 Rue Peletier. The majority of the 18 works by "Monnet" (sic) were lent by the baritone Faure; Chocquet's very recent acquisition appeared in the catalogue as *Autumn on the Seine at Argenteuil* (291). Despite the absence of his protégé, Cézanne, Chocquet went to great lengths to impart his appreciation

of the painters. But neither he nor the journalists who favoured the Impressionists were able to move mountains, and an audience smaller than that of 1874 came mainly in order to mock.

The press was somewhat more favourable this time. Not only was the principle of an independent exhibition accepted, but there was general approval of its layout, which brought together the works of each artist. The 1874 show had been hung in a rather confusing manner. Moreover, the number of press items about the exhibition marked a considerable advance. True, the number of those resolutely opposed to the movement had also grown; but even attacks were better than silence. In *Le Figaro* of 3 April, Albert Wolff himself, the doyen of art critics, condescended to speak. His verdict is notorious: "Misfortune in the Rue Le Peletier." A not insignificant group of critics found themselves somewhat at a loss, embarrassed at the difficulty of explaining an attraction exerted, whether they liked it or not, by these works of the "intransigent" or "impressionist" painters (the two terms were almost equally common). The converted were few in number, but exceedingly well-informed, largely from direct contact with the artists themselves. Two famous writers, Zola and Mallarmé, were unable to place their articles in Paris without censorship, and wrote, one for a Russian (*Messager d'Europe*), the other for an English magazine (*The Monthly Review*).

Claude Monet was more and more often identified as the leader of the group. Bertall, who hated the Impressionists, found this scandalous. Zola was glad of it. The more traditional landscapes were found reassuring, the more "flickering" were alarming (368–369); the reproach that these were no more than sketches was often heard. The painting that inspired the most passionate responses was *Camille Monet in Japanese Costume* (387); it appeared in the catalogue as "Japonnerie". For A. de Lostalot, whose article in the *Chronique des Arts* was written before the catalogue appeared, the landscapes were unsatisfactory, but he acknowledged the "remarkable verve and finesse" of the gown worn by Camille in *Camille Monet in Japanese Costume*. No such praise from C. Bigot, F. Percheron or S. Boubée. The latter informed the readers of the conservative *Gazette de France* that "*La Chinoise* [sic] has two heads, that of a 'demimondaine' on the shoulders, and a monster's head placed – we dare not say where...." This odd accusation did not stop the painting raising 2,020 francs for Monet when it was sold at the Hôtel Drouot on 14 April 1876.

An essay by Duranty, *La Nouvelle Peinture* (The New Painting) attempted a definition of Impressionism; 750 copies were printed. The author did not depart from his realist principles, and, after a heated plea in the Impressionists' favour, made his reservations clear; the landscape artists, whose mastery of colour he acknowledged, were requested to "invite form to the banquet". This led immediately to suspicions that Degas and Duranty had colluded in the essay, and was a warning of the fissile nature of the group. The suspicions were almost certainly unfounded, but Cézanne was more categorical when he wrote to Pissarro in July, 1878: "If we must exhibit with Monet, I hope our cooperative's Exhibition will be a flop."

Cézanne continues in characteristically trenchant vein: "Monet [makes] money." He was probably thinking of the sale of *Camille Monet in Japanese Costume*, and he was wrong: Monet's account-books show that his total revenue for 1877 was 12,313 francs, a very slight increase over the previous year. Modest as the improvement was, it was achieved only by sometimes pressing appeals to his prospective clients. There was last-minute confusion about the purchase of *The Train Engine in the Snow* (356). A loan of 1,500 francs guaranteed by the fictitious sale of 15 paintings to Gustave Monet put the price of a single picture at 100 francs. Even where the sales were real, the paintings were selling for no

Claude Monet during the Vétheuil period
Photograph Benque, Paris, c. 1880

Ernest Hoschedé
Anonymous photograph
The ruined philanthropist left this photograph,
with many more of his papers, with one of his
creditors at Vétheuil.

The three eldest Hoschedé daughters surround-
ing their little brother Jacques, who is dressed
up as a girl. From left to right: Marthe,
Suzanne (the later *Woman with Parasol*),
Jacques and Blanche, who married Jean,
Claude Monet's eldest son.
Photograph Paul Berthier, c. 1873

more than 200 francs apiece. Monet was not alone in this. Boudin and Manet
found the same difficulty. The evidence is clear: for artists, times were hard.

Ernest Hoschedé

The number of admirers buying directly from Monet fell in 1876, but some of
those whom we encounter for the first time were to become loyal supporters.
Outstanding among these were Dr de Bellio and the painter Caillebotte, who
often paid for paintings in advance. Monet noted "advances", like normal sales,
in the income column of his account book, but without a corresponding title, as
the work might not yet exist. Monet used this system with others too, and it
could cause tension when the work paid for in advance was not quickly forth-
coming.

We know little about the relationship between Monet and Caillebotte, but
there is ample correspondance between Monet and de Bellio. We shall make use
of an unpublished collection of letters from de Bellio to Monet. Not all of this
correspondence, nor the considerable evidence of the life and dealings of Ernest
Hoschedé – that improvident patron of the arts – can be published here. But
the role played in Monet's life by Hoschedé, his wife and his children is such
that we must briefly turn the spotlight on him.

The four Hoschedé Children: Jacques, Suzanne, Blanche and Germaine
Pastel
c. 1880
(D.W. 1991, V, p. 167, P 68)

Ernest Hoschedé was born in Paris on 18 December 1837. His father, Edouard Casimir Hoschedé, was a shop assistant, and his mother, born Honorine Saintonge, a cashier. They were, in short, of modest origins, but by hard work they built up a solid fortune. In partnership with Blémont, M. Hoschedé senior took over from Herbet and Loreau at the head of the old fabric company Chevreux-Aubertot at 35 Rue Poissonière, on the corner of the Boulevard Poissonière. There, Ernest began what should have been an uneventful career as a Parisian merchant. He worked in sales, and in spring 1861 accompanied his father, now M. Blémont, on business trips to Great Britain and Ireland. His family rather encouraged these voyages – Hoschedé travelled as far as Switzerland and Italy on holiday – not so much to foster his experience of international trade as to remove him from the company of Alice Raingo, a young woman of seventeen with whom he was in love. From the first, the Hoschedé family had set itself against the match. His mother, an intelligent woman who kept a diary and loved "The Magic Flute", was a possessive woman, and had forebodings of catastrophe. "Ah! Ernest, Ernest! What a fate awaits you!", she wrote in her journal on 4 February 1863.

Ernest disregarded his parent's reservations and married Alice on 16 April 1863. His parents snubbed the wedding by leaving for Lyon. The circles into which their son had married were elevated ones, perhaps too elevated for him. Mme Raingo, born Coralie Boulade, was the illegitimate daughter of a Lodève

clothier; her husband, Alphonse Raingo, born in Tournai, was one of the most prominent members of the large Belgian community of Paris. The naturalisation file of Alphonse Raingo's brother Jules includes a letter from Baron Haussmann testifying to the considerable fortune possessed by the "Raingo brothers." Alphonse and Coralie had nine children, but could still offer Alice a dowry of 100,000 francs and a 15,000 francs trousseau, figures whose meaning is clear if we set them alongside the 12,000 francs gift (never paid in full) and 500 franc trousseau of Camille Doncieux.

On their return from their honeymoon, Ernest was finally able to introduce his wife to his parents. Alice threw her arms around her mother-in-law's neck, begging her to "forgive her, to love her". That evening, Mme Hoschedé wrote in her journal: "This young woman has wit, intelligence in plenty and, I believe, strength of will. Her conversation is easy, though I find her voice rather loud. She seemed to me more delicate and prettier than in her photograph." Things settled down, and the prejudice against Alice diminished as Hoschedé grandchildren came into the world. These were Marthe (18 April 1864), Blanche (12 November 1865), Suzanne (29 April 1868), Jacques (26 July 1869) and Germaine (15 August 1873). M. Hoschedé senior had retired in the meantime, and Ernest took his place. He immediately alarmed his mother by his pessimistic remarks, but when his parents visited the shop on Rue Poissonnière, he posed as "a very busy man" and everything seemed in order.

Alice's father died in January 1870; he had spent over a million on one of his sons-in-law, but his legacy nevertheless came to 2.5 million gold francs, of which Alice inherited one ninth; this included the Chateau de Rottembourg at Montgeron, which was valued overall at 175,000 francs. The chateau in which Ernest led his tycoon's lifestyle (on one occasion he brought his guests to Montgeron by a special, private train) was not his own but his wife's. We do not know when he became addicted to collecting; but it was this mania, along with his wild prodigality and limited business sense, that brought him down.

A first sign of the impending crash was the auction of 13 January 1874 in which three Monet pictures were among a total of over 80 paintings sold. But the prices were reasonable, and no one was worried at this stage, not even Mme Hoschedé senior, whose main concern was her husband's health. The death of Edouard Casimir Hoschedé on 29 May 1874 deprived Ernest of a father whom he feared and respected; thereafter, his collector's instinct ran out of control. He paid very high prices, and a second sale on 20 April 1875 opened everyone's eyes to the real state of things.

Ernest did his best to continue the deception, but no one would grant him credit. In September, he was forced to leave the family business, where "his presence had become impossible". He informed his mother, and made the most of his new role as a persecuted and desperate man, arranging a rendez-vous in the parc Monceau, half-way between the Rue de Courcelles, where she lived, and his own residence at 56 Boulevard Haussmann. "My salvation is possible", he claimed, but when his mother pressed him to change his lifestyle, he claimed that Alice refused to leave Rottembourg. Things came to a point where, on 1 January 1876, Mme Hoschedé's gifts to her grandchildren included not only books and money but "a garment for each of them", while at Montgeron the high life continued.

The Château de Rottembourg at Montgeron, owned by Ernest Hoschedé
Postcard, early 20th century

From Parc Monceau to the Château de Rottembourg

After 1876, Monet began to look outside Argenteuil for subject-matter. Some of his paintings of it and its environs were admirably accomplished, but a measure of lassitude is visible, and Paris again began to attract him. By the spring, he had painted not only the *Tuileries* (401–404), as mentioned above, but some views of the Parc Monceau (398–400). A walk from the Gare Saint-Lazare to the Louvre and the Tuileries is not surprising; but what led Monet to this noble garden of the 8th arrondissement? The answer, of course, is an invitation from

Turkeys
1876
Cat. no. 416

The Pond at Montgeron
1876
Cat. no. 420

Ernest Hoschedé, whose daughter Blanche later said that she first met the painter in the Parc Monceau. And Alice Hoschedé's elegant silhouette is clearly discernible in a view of the park bought by her husband; she is holding the hand of a young girl, probably her youngest daughter, Germaine (**399**).

In July, Edouard Manet and his wife spent a fortnight at the chateau, where he painted several works; in one of these Hoschedé poses nonchalantly. A little while later, Monet, too, was invited to Rottembourg. Hoschedé had commissioned him to paint a number of large-scale pictures that were intended to decorate the great panelled walls of the chateau. He used a studio in one of the pavilions in the grounds. He recorded "advances for decorative works" as of September 1876. Certain payments made in kind – one for 608 francs – suggest how difficult the Hoschedé's finances were becoming; he must have made use of stock from the Rue Poissonière shop. After his pseudo-departure of September 1875, Hoschedé had persuaded Tissier, one of his partners, to take a share in a new company, "Hoschedé (famous merchant), Tissier, Bourely and Co"; it was founded on 1 August 1876, with a capital of 2,900,000 francs and sixty salespersons.

Monet's work at Rottembourg extended through the summer, during which he painted *Turkeys* (**416**) and *The Rose Bushes in the Garden at Montgeron* (**417–418**), into autumn, when he painted *Hunting* (**433**) and two *Undergrowth*, paintings strewn with autumn leaves (**431–432**). A letter to Gustave Manet tells us that he was still there on 4 December; this must have been when he painted *Germaine Hoschedé with Her Doll* (**434**). By then, he had already painted *The Pond at Montgeron* (**419–420**) and *Arriving at Montgeron* (**421**).

Hoschedé had bought, though not fully paid for, a little fisherman's house, la Léthumière, on the River at Yerres, where Monet went to make some studies (**419–420**). On the same occasion, Monet painted a larger house in Yerres itself,

belonging to an engineer called Debatiste (422). It seems likely that Monet met Caillebotte while he was there; Caillebotte owned a house on the edge of Yerres and sent his *Yerres Garden* to the second group exhibition in 1876.

Did Camille accompany Monet to Rottembourg? It is possible, though Blanche Hoschedé in her *Notes Posthumes* does not mention Camille's presence. If she did come, she must soon have returned to Argenteuil, since Jean was now a pupil at the Fayette school. Monet wrote from Montgeron to de Bellio in the first fortnight of November expressing his anxiety about Camille's situation at Argenteuil, alone and without money. When Hoschedé returned to Paris to try and sort out his dwindling affairs, the painter was alone with Alice Hoschedé and her children. She had time and leisure to compare the "great artist" – he had been presented thus to the Hoschedé children – with her somewhat infantile husband.

How far did these comparisons go? Nine months later, on 20 August 1877, having fled Paris four days before her husband's bankruptcy was announced, Alice Hoschedé gave birth to the last of her children, Jean-Pierre Hoschedé. In later life, J.-P. Hoschedé implied that he considered himself to be Monet's son, cultivating his resemblance to Monet, as we see in the photographs of Monet and himself that he published one above the other in his 1960 book. There is, however, no evidence in Monet's treatment of the Hoschedé children that he viewed Jean-Pierre as his son. The suggestion that Suzanne Hoschedé was also Monet's illegitimate child is merely an invention.

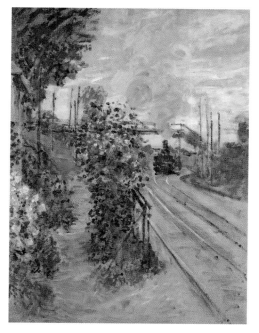

Arriving at Montgeron
1876
Cat. no. 421

The Gare Saint-Lazare

When he returned to Argenteuil late in the year, Monet's first concern was to find out whether the intricate procedures that he had initiated in order to obtain permission to paint inside the Gare Saint-Lazare had succeeded. On 17 January 1877, he announced to the publisher Charpentier that he was moving into 17 Rue de la Moncey, close to the station. His flat was on the ground floor of a five-storey block and typical of the bachelor flats so common in Paris during the last century. There was a small room without a fireplace, a bedroom, a closet, and no mention of a studio. The room was rented in the name of Caillebotte, who every quarter handed over to his friend the 175 francs rent.

The Rue Moncey pied-à-terre allowed the painter to receive clients who found it difficult to travel to Argenteuil. Discretion was guaranteed; this may have been a relevant consideration in relation to Alice Hoschedé. It also offered him a base for his major painting "campaign" on the platforms of the Gare Saint-Lazare and all around the station, on the Pont de l'Europe and in the cutting and tunnel of Batignolles. For most Monet paintings we have no preparatory drawings; for these paintings we have several preliminary studies. Given the restrictions imposed by both trains and passengers, Monet could not complete paintings on the spot (438–499).

Monet thus made himself the premier painter of that most Parisian of stations, the Gare Saint-Lazare. From here, trains left for such places immortalised by Impressionism as the Normandy coast, Rouen, Chatou, Bougival, Louveciennes, Ville-d'Avray, Argenteuil, Vétheuil, Pontoise, Eragny and Giverny. In their day, the locomotives with their high smokestacks were symbols of progress, the most famous being the Lison in Zola's *The Human Animal*. Today, they have the prestige of things long vanished, evanescent as the plumes of smoke that furled round them.

Zola's purposes in *The Human Animal* are quite different, but his descrip-

PAGES 126–127:
Saint-Lazare Station
1877
Cat. no. 438

Tracks Coming out of Saint-Lazare Station
1877
Cat. no. 445

tion might almost be drawn from Monet's images: "Opposite, under this dusting of light, the houses of the Rue de Rome grew blurred, then vanished as though swept away. To the left, the covered markets opened up the smoke-stained panes of their vast porticoes... Amid the ghostly passage of wagons and machinery cluttering the rails, a red signal stained the pale light.... An express locomotive, with its two vast, devouring wheels, stood alone, while the thick, black smoke of its smokestack rose slowly, vertically into the calm air... And he saw emerging from the bridge a whiteness profuse and swirling like a bank of snow, taking flight through its array of iron girders."

From March 1877, several views of *Saint-Lazare Station* begin to appear in the lists of sales recorded by Monet. Hoschedé himself bought three of them (**439, 440, 445**). Of the thirty paintings that Monet exhibited at the third group exhibition in April 1877, eleven had been lent by "M.H.", whose identity is obvious. Two of the paintings entitled *Saint-Lazare Station* in the catalogue belonged to "M.H."; de Bellio owned a third; and four others were the property of the artist. For the first time, thanks to its "godfather" Louis Leroy, the group exhibition was officially called *Exhibition of Impressionists*. It was held at 6 Rue Le Peletier, just around the corner from the Galerie Durand-Ruel. On Wednesday 4 April, the preview was a success as enjoyable as it was short-lived. The next day, the majority of the reviews were hostile, though none could deny the

importance of the exhibition, which the attacks merely emphasised. The fire was directed above all at Cézanne, though Roger Ballu, the Inspector of Fine Arts, saw little distinction between Cézanne and Monet: "Children entertaining themselves with paper and paint do better", he wrote in the *Chronique des Arts* on 14 April.

Along with *Turkeys* (**416**), described in the catalogue as an "unfinished decoration" – "Great gods! What will it be when the last brushstroke has been added?" the *Le Moniteur Universel* wondered – the *Saint-Lazare Station* paintings attracted most attention. Unaware that their damning words were in fact complimentary, several commentators pointed to the synesthesia of the paintings, their ability to provoke a muliplicity of sensations. Thus Baron Grimm in *Le Figaro*: "[Monet] has, in the last analysis, attempted to give us the disagreeable impression of several locomotives whistling all at once." Or the anonymous critic of *Le Moniteur Universel*: "The artist has sought to impart the impression produced on travellers by the noise of engines on arrival and departure." Criticism of this kind is ultimately more instructive than the systematic praise of Georges Rivière in the magazine *L'Impressioniste*, which was specially created to ensure the success of the exhibition and did not long survive it.

Saint-Lazare Station (suburban line side)
Pencil on paper
Paris, Musée Marmottan
(D. W. 1991, V, p. 81, D 125)

Exterior of Saint-Lazare Station (The Signal)
1877
Cat. no. 448

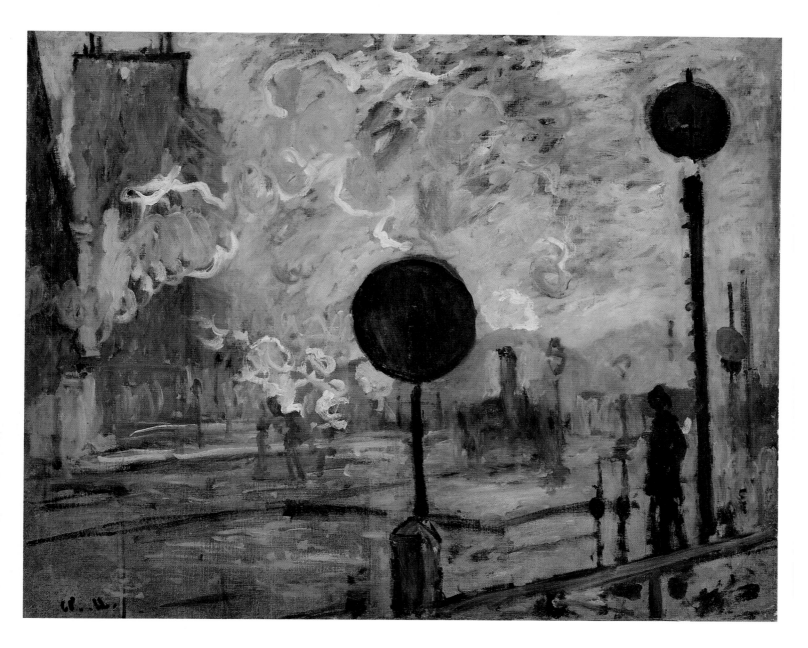

Springtime through the Branches
1878
Cat. no. 455

PAYSAGE A COURBEVOIE.
— Mais on ne voit que le milieu d'un arbre !...
— Dame ! si le sujet plaît, l'artiste peut le compléter en vendant **deux autres toiles.**

A cartoon by Draner, featuring no 455, which appeared in *Le Charivari* on 23 April 1879
Photograph B.N.F., Paris

Leaving Argenteuil

"The Extreme Poverty of the Impressionists" was the title of an article in *Le Populaire* of March 1924 and Monet was indeed begging his friends for help with unprecedented intensity. His account-book for 1877 shows a substantial figure for sales and advances: 15,917.50 francs, his best result since 1873. But on closer examination, we see that he had been forced to accept extremely low prices. He sold ten paintings to de Bellio on 1 June for 1,000 francs; each picture was a mere 100 francs. And after May, there were fewer and fewer purchases and advances from Hoschedé, who could now only offer small sums. In October, he asked Monet to undertake the sale of a few pictures that he had been able to save from the distraint that followed his bankruptcy. Even so, Monet, when revising his accounts in 1881, noted that he had received 8,389 francs from Hoschedé in 1877: a very considerable sum.

The ruin of his patron hastened Monet's own financial collapse. In December, he sold five rough sketches to the baker Murer for 125 francs, and committed himself to deliver a further four paintings against an advance of 200 francs! It was a promise that would quickly lead to bitter recriminations. Often overtaken by urgent debts, Monet could no longer cover the day-to-day expenses of Argenteuil and the incidental expenses of Parisian visits from the proceeds of his sales. In May, the paint merchant, Voisinoth, paid 1,350 francs for 16 paintings; only 50 francs of this was not already spoken for. From 1874 on, the pages of his account-book are black with "IOUs to pay", "goods to pay", "accounts to pay", and "promissory notes to pay". Many of them are crossed out as having been settled, but some promissory notes were simply renewed. In January 1877, the total "debts to date" proved so depressing that Monet simply gave up in mid-calculation. New "sums to pay" were added throughout the year, and the deadlines for these were often stretched, as those for earlier debts had been.

The accounts give us some notion of the Monets' way of life in Argenteuil. Direct purchases from Bordeaux and Narbonne suggest that quite a lot of wine was drunk. Notes countersigned regularly by "Marie" and "Sylvain" suggest the simultaneous presence of two servants, as well as a gardener named Lelièvre, who seems to be part-time. A debt of 240 francs to Pleyel and Wolff might indicate the purchase or hire of a musical instrument. All trades and crafts are represented; the complete list is far too long for inclusion, but one creditor's name should be mentioned, that of Braque. In Monet's day, this family of long-established Argenteuil artisans included a carpenter, a locksmith and a house-painter; some years after the departure of Monet, the housepainter had a son called Georges who was to take painting in a direction radically different from that of Impressionism.

Monet was worried not only about his finances but about the health of his wife. The portrait *Camille Holding a Posy of Violets* is revelatory in this respect (436). Two undated letters, one to Manet, the other to de Bellio, speak of Camille as being seriously ill. The Argenteuil doctor had called in a colleague for a second opinion; an operation was discussed. Monet believed that Camille was suffering from "ulceration of the womb", from which it has been inferred that she had suffered an attempted abortion. But such ulcerations, if that was, indeed, what she was suffering from, can be caused by tubercular or cancerous lesions. It seems as though no operation eventually took place, perhaps thanks to the prudent advice of de Bellio.

When did this malady occur? It was certainly during the last period of Monet's residence in Argenteuil. During the summer of 1877, Camille was pregnant, and gave birth in March 1878. Late in her pregnancy, there were problems, apparently quite distinct from the grave illness that we have spoken of, and which might be dated to the early months of the pregnancy; it is difficult to believe that, if they had preceded it, Monet would have risked a pregnancy immediately afterwards, when his wife had not had a child for some ten years.

Storm clouds were gathering on every side, yet the painter's parting views of Argenteuil possess a serenity extraordinary by any standards. Several times, he painted a motif that he had first attempted in 1872, the edge of the promenade, looking downstream, with the manor house behind it. In at least two paintings, he depicted the bathing establishment moored to the bank; the factory chimneys treated very discreetly, and sometimes omitted altogether. In the foreground, flowers recently planted by the owner of the bathing establishment allowed the warm colours of Monet's garden theme to be allied with that of the Seine in a last homage; the Seine is seen looking west (450–463).

By the time the flowers had faded, Monet was spending his afternoons in Paris. By the end of December, he was so tormented that he had time neither to finish a painting nor accept a lunch invitation. He was desperate to find the money that he needed if he was to leave Argenteuil on 15 January 1878 without his creditors seizing his furniture and paintings. He succeeded, and was able to leave safely; he was not, as he claimed to de Bellio, "rid of all his creditors", merely of the most pressing of them. The humbler ones still had long to wait, as this letter, dated "Argenteuil, 16 July 1896" [whose original spelling the English cannot easily imitate] suggests:

"Monsieur Monnet,

I anser your letter to tell you that I have recieved the 200 francs and that you have made two persons happy me and my husband as we did not have a penny on 14 July morning and you can imagine what a surprise wen the postman arrived with your kind letter and as I have debts myself I quickly distributed the great part ovit to keep the others happy also you ask for my account

here it is. I have three times recieved 30 francs at the bailiffs which makes 90 francs and I have recieved from you one time 50 francs and one time 30 francs so: 80 francs plus the welcome 200 francs which have arrived so hoportunely which means that I have recieved altogether 370 francs. We had stopped the acount with you at one thousand francs in Argenteuil. But when you left Paris there was a new account to add of 120 francs which made altogether 1120 francs thus taking away the 370 francs that I have recieved there remains outstanding 750 francs you will chek your account there cannot be any herror.

I finnish by shaking an honest man's hand and his family's
fPrétot
Rue de la voie des Bancs S. et O. Argenteuil"

Virginie Levasseur, "f[emme]", that is wife of Prétot, as she designates herself, was a laundry-woman. Her money had been hard-earned at the wash-house moored on the Seine. She was a "good soul", as people said at the time, implying that her good nature could be exploited. Her letter shows that, at a time when Monet's glory had brought financial security, he had still not paid off more than a small part of the debt that he had contracted ten years previously with a woman who lived on the breadline. Those who see in the recourse to bailiffs a creditor's persecution of the financially oppressed artist should take the story of Mrs Prétot to heart.

L'Ile de la Grande Jatte

The departure from Argenteuil brought new difficulties in its wake. On 8 January, when Monet told Murer that he was forced to move out on 15 January, he still did not know where he would be going. The pied-à-terre at Rue Moncey was cluttered with paintings and could not accommodate Monet, his ten-year-old son and pregnant wife for the duration of the winter. In the short respite accorded by Flament, his landlord in Argenteuil, and thanks to the 200 francs sent by de Bellio, Monet was finally able to find somewhere to rent in Paris. On 20 January, the mover's cart was loaded but money was lacking to pay for the move. It was probably a loan of 160 francs from Caillebotte which allowed him to leave Argenteuil definitively.

As the Rue de Moncey apartment remained his business address, it was not until Monet's letter to Dr Gachet on 15 February that we discover his new address: 26 Rue d'Edimbourg, in the Quartier de l'Europe, equidistant between the Rue Moncey and the Parc Monceau. The Monet family moved into a fairly large third-floor flat facing onto the courtyard of a five-storey apartment block. It comprised a hall, a dining-room, a living-room, and three other rooms with a fireplace for 1,360 francs a year.

On 9 February, the doctors announced that the "event" – the birth of a child – was imminent. Dr Gachet was informed both of this and of the fact that "many indispensable things" were lacking. This undisguised begging letter led him to contribute a further 50 francs, a long way from the generosity of Caillebotte, de Bellio, and Manet, who between them raised a draft of 1,000 francs intended to replace an older bill of the same kind; this seems to have been quite separate from the loan of 1,200 francs made to Monet on 9 January 1878.

Relations with Manet had been excellent since the summer of 1874, and we find Manet signing the birth certificate of Michel Monet as a witness at the town hall of the 8th arrondissement. The certificate states that the child was born on 17 March 1878 at 11 o'clock in the residence of his parents. The other witness was Emmanuel Chabrier, whom Manet had included in *The Masked*

Ball at the Opera. Chabrier had not yet begun his career as a composer, but a legacy from his mother had allowed him to start a collection; a month after Michel's birth, he bought three paintings from Monet for 300 francs. This addition to Monet's income can also be attributed to Manet's friendship.

In search of new subject-matter, Monet remembered the L'Île de la Grande Jatte that he had seen from the Argenteuil train as it crossed the bridge at Asnières. Two kilometres from the gates of Paris, and close to where the painter was living, La Grande Jatte was easily accessible thanks to the iron bridge that leads to Neuilly and Levallois-Perret. Monet walked the length of the island, from the western point facing the Neuilly Bridge (454) to the eastern end, from which one can see the chimneys of the Clichy gasworks (455–458). One of his themes was the view afforded through the greenery to the Courbevoie bank (459–461). A painting in this series was caricatured during the fourth group exhibition in 1879 (457). Only a few years after Monet's Grande Jatte expeditions, Seurat's paintings of the same island demonstrate how far neo-Impressionist idealisation had moved away from the fundamental naturalism of early Impressionism.

The Exposition Universelle

The approach of the Exposition Universelle of 1878 discouraged the Impressionists from organising their own exhibition. Opened with great ceremony on 1 May by General Mac-Mahon, the President of France, the Exposition attracted vast crowds to the Champ de Mars and the Trocadéro Palace, which had been specially constructed for this purpose. The Salon at the Palais de l'Industrie was eclipsed; its opening was postponed from 15 to 26 May. Renoir continued to sign himself a "pupil of Gleyre" and exhibited *The Café*; his friends did their best to contain their anger. In a matter of days, the Faure and Laurent Richard sales, combined with the dispersal of the Daubigny studio, to flood the market.

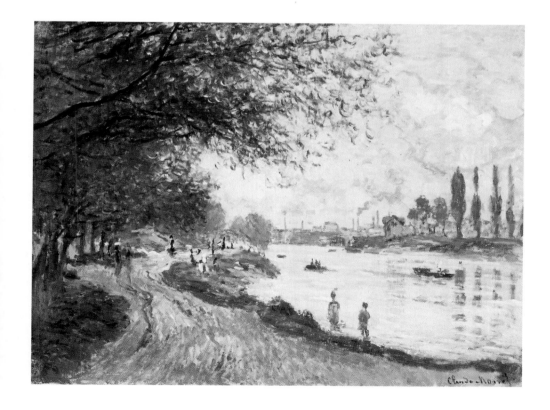

The Isle La Grande Jatte
1878
Cat. no. 461

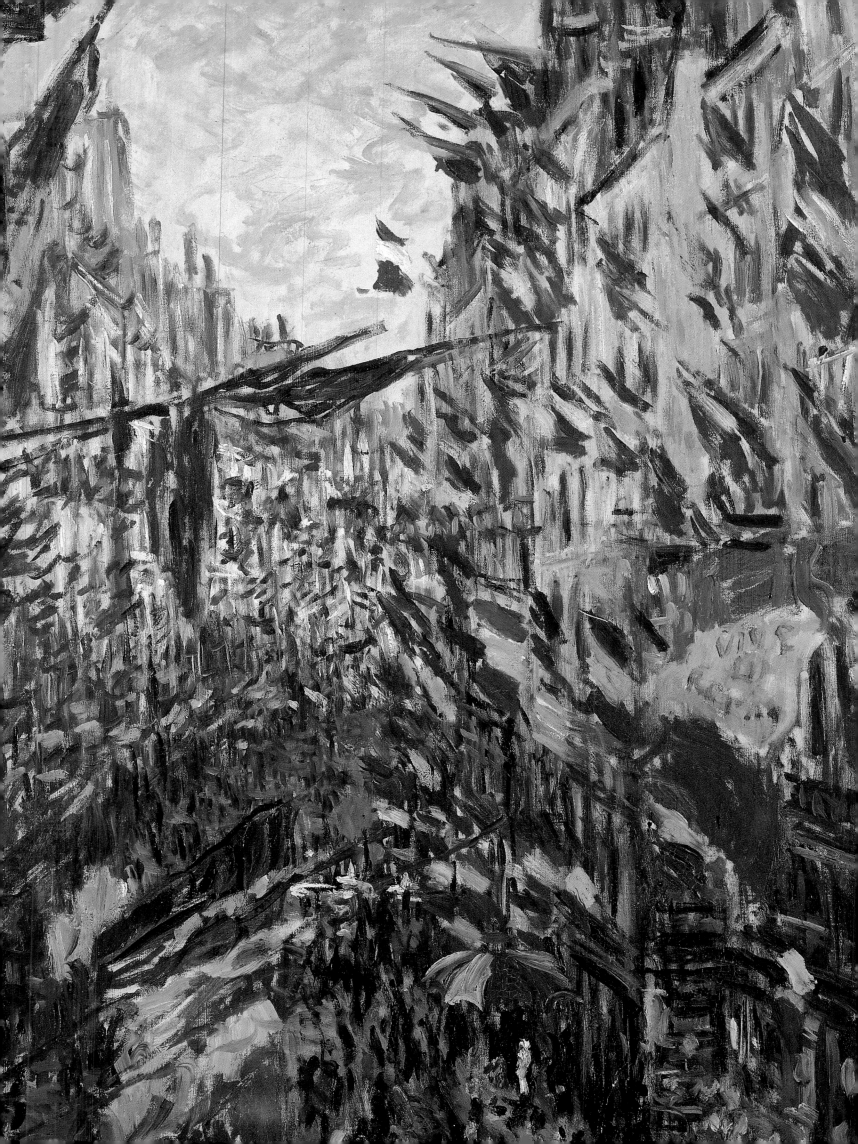

Théodore Duret published *Les Peintres Impressionistes* (The Impressionist Painters), a booklet intended to aid his friends' cause; he had just bought *The Zaan at Zaandam* (**172**) at the Daubigny sale and proclaimed Monet as "the Impressionist par excellence".

Ernest Chesneau drew attention in *La Gazette des Beaux-Arts* to Monet's affinities with Japanese art, which had been the revelation of the Exposition universelle; meanwhile, the "Impressionist par excellence" was close to going under. Unable to exhibit, he was forced to invite potential clients to visit, but when in their company was embarrassed to make his needs known to them, preferring to do so by letter. This required a campaign of letter-writing, conducted on rainy days or after the light had gone. After his excursions to la Grande Jatte, he remembered that he had, in the past, painted in the Parc Monceau, and went back to working there; it was a mere ten minutes from his flat (**466–468**). One of the pictures painted there was bought in June by de Bellio for 200 francs.

The Republic had decided to make 30 June a national festival, celebrating the renaissance of Paris and France during the euphoria of the Exposition. Parisians were invited to bedeck their houses with flags and bunting for this occasion. The Quartier de l'Europe responded to this call, as Manet's painting of what is now the Rue de Berne, *Rue Mosnier Bedecked* shows. Monet preferred to wander into the centre of Paris. "I liked the flags", he told Gimpel in 1920. "The first 30th of June national holiday, I was walking with the tools of my trade in the Rue Montorgueil; the street was bedecked with flags and there were huge crowds; I spotted a balcony, asked if I could paint from it. I could. Later, I came down incognito!"

Monet's choice of the old streets between the Les Halles and the Boulevards was no accident; the 30 June issue of *Le Figaro* had recommended to its readers the spectacle which had begun the previous evening at the Saint-Martin and Saint-Denis gates, and the Rue Mandar, which runs into the Rue Montorgueil. The cloth trade was a tradition in this area, and lots of bunting had been made; during the festivities, vehicles were excluded from certain streets. This was enough to tempt an artist familiar with the charm of these narrow streets with their gothic gables.

Happy with his work in the Rue Montorgueil, Monet left, he says, incognito; but who did he know in this crowd of shopkeepers? Close by, the Rue Saint-Denis offered a similar spectacle, so similar indeed that almost from the start there was great confusion as to the titles and locations of the two versions of *The Rue Montorgueil, 30th of June 1878* (**469–470**). Did Monet begin, or even finish, both paintings on one day? It cannot be ruled out, though the decorations would have been in place by the evening of 29 June and must have remained there until 30 June. At all events, as early as 11 July, *The Rue Montorgueil, 30th of June 1878* (**469**) was sold to de Bellio "in settlement of debt", so we know at least that much about the speed of Monet's execution and the immediate effect produced upon de Bellio by the painting. Another connoisseur was equally struck a few days later; this was Hoschedé, who bought *The Rue Saint Denis, 30th of June 1878* (**470**).

The Last Hoschedé Sale

Hoschedé's acquisition of a painting in July 1878 is somewhat surprising. He had been declared bankrupt the year before, and this had been confirmed by the Court of Appeal on 6 April 1878. His debts amounted to more than two million

The Rue Montorgueil, 30th of June 1878
1878
Cat. no. 469

PAGE 134:
The Rue Saint-Denis, 30th of June 1878
1878
Cat. no. 470

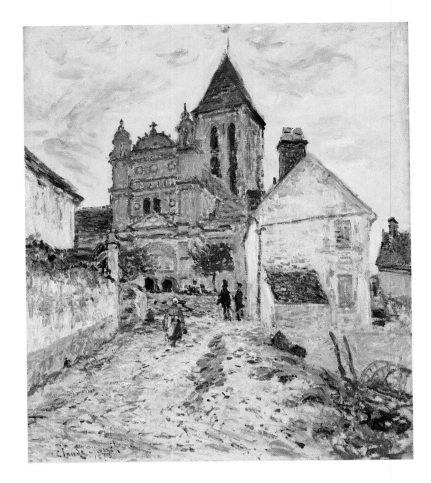

francs for 151 creditors. Georges Petit reclaimed 70,000 francs, Durand-Ruel 12,500 francs, the famous couturier Worth 10,192 francs. The Château de Rottembourg, which belonged to Mme Hoschedé, was mortagaged for 204,681 francs to an inhabitant of Montgeron, M. Blache. Claims were also made by members of the Raingo family. Alice herself, whose properties were to be separately administered under the marriage settlement, reclaimed 90,349 francs in a "division of assets", in order to recover some part of the sum that was to be divided up among the creditors. She received only 250,000 francs of a total of 906,879 francs recovered, since more than 600,000 were deducted in costs after the case had lasted until 1887.

Operations began in July 1877 with the sale of the furniture from the Boulevard Haussmann residence. The same occurred in Montgeron; the inventory was compiled on 7 September 1877. The château itself went to Blache for 131,000 francs on 15 May 1878. Some days later, on 5 and 6 June, the collection of paintings and valuables was auctioned at the Hôtel Drouot, at the request of the official receiver, M. Maillard; Maître Dubourg presided, with Charles George and Georges Petit as valuers.

The catalogue of this last Hoschedé sale contained more than 100 items, of which 48 were works by Impressionists. Monet was represented by twelve catalogued and four uncatalogued paintings. Prices ranged between 35 and 505 francs; the latter was the price obtained by Monet's *Saint-Germain-l'Auxerrois* (84) and was the highest price paid. Monet's pictures fetched a total of 2,415 francs; the average price was 155 francs. The average for the 12 paintings in the catalogue was 184 francs.

Georges Petit bought three pictures for 38, 60 and 75 francs respectively, acting partly or wholly for Monet. De Bellio obtained a non-catalogued work

for 35 francs and *Impression, Sunrise* (263) for 210. Mary Cassat obtained *The Beach at Trouville* (157) for 200 francs. Faure paid 50 francs for one painting and 130 francs for another; *The Thames below Westminster* (166) cost him 250 francs. He was more generous than Chocquet, who obtained *Young Girls in a Bed of Dahlias* (383) for 62 francs and *Wood Lane, Autumn* (432) for 95 francs. He had bought a rough sketch from Monet in January for 50 francs, so he had now obtained three works for very little outlay. Monet did not take this kindly.

Compared to the prices that Monet himself offered his clients, the auction did not devalue his work. Sisley came well behind him with an average price of 114 francs and Pissarro looked on in horror as one of his paintings was sold for 10, another for seven francs, and none of them for more than 100 francs. Manet outsold his friends by a substantial margin; the average price for his works was more than 500 francs. But none of his works reached 1,000 francs, whereas a Théodore Rousseau had fetched 10,000 francs the day before.

By selling all the Impressionist works on the second day, the organisers of the auction would seem to have deliberately sacrificed the young painters to the hostility of the public. If we are to believe Paul Durand-Ruel, paintings were several times presented upside down to demonstrate how incomprehensible they were. But it seems unlikely that the auctioneer would have tolerated any such thing. It is no more likely that Georges Petit, the official valuer and a creditor to the tune of 70,000 francs, should have clearly signalled the horror inspired in him by Impressionist paintings (as Tabarant reports of him). The fact remains that the total revenue from two days of sales was 69,227 francs, well below what Hoschedé had originally paid.

As if to break the camel's back, within a fortnight of his collection being broken up, Hoschedé was sentenced to a month in prison as a result of a charge brought by the official receiver. Yet, one month later, he found the 100 francs that he needed to buy *The Rue Saint-Denis, 30th of June 1878* (470). He kept it for just a few days: Monet noted on 1 August that it had been sold on to Chabrier at 200 francs. Hoschedé's activities as an art dealer, carried on in the midst of his other activities, had brought him low; his 100 per cent margin on this picture should not be begrudged him.

Vétheuil: Another New Start

During the month of August, Monet left Paris for a stay in the country, of which our first record is the letter from de Bellio, who is hoping to "choose from the harvest" that Monet will bring back. We know where he was staying from a letter to Murer of 1 September: "I have set up shop on the banks of the Seine at Vétheuil in a ravishing spot." It seems that he remembered the borders of the Ile de France, known to him since his stay in Bennecourt, and had set his heart on this little town, which, with its 622 inhabitants, one doctor and a post-office, offered more facilities than a mere village.

The eight o'clock train from the Gare Saint-Lazare brought the traveller to Mantes, 57 kilometres away; there, he had to take the service run by M. Papavoine – pronounced Papavén – for about 10 kilometres. After crossing the Seine parallel to the old bridge that Corot had painted, this bone-shaking vehicle climbed the slope of Saint-Martin-la-Garenne. From there, a wonderful prospect opened up: the river, full of islands, formed a perfect oxbow bend. The chalk cliffs of the right banks bordering the Arthies plateau ran as far as La Roche-Guyon and beyond. On the left bank, the Plain of Lavacourt and the

Panoramic view of Vétheuil. The loop of the Seine looking upstream. The two branches of the Seine surround the island of Saint-Martin, where Monet often worked.
Postcard, c. 1900

Outskirts of Vétheuil, at the foot of the slopes on the right bank of the Seine, at the time when Claude Monet used to frequent the spot in 1878, on the way to Mantes.
Some of his paintings show the same view in greater close-up. See Cat. nos. 525–527.
Postcard, c. 1900

Forest of Moisson stretched into the distance. On the eastern tip of the bend, where the verdant Vienne valley reaches the Seine, stands the ancient town of Vétheuil. The old houses with their grey-brown tiles are clustered around the church, which has been a classified monument since 1845: the central belltower and the choir are 13th century, the nave was reconstructed in the first half of the 16th century, and its superlative Renaissance facade faces the Seine. Monet immediately started work on this inviting theme (473–474), which forms a perfect transition between the *Saint-Germain-l'Auxerrois* (84) of his youth and the Rouen Cathedrals that he painted in his fifties.

After a few days spent at the Cheval-Blanc Hotel, whose landlady was the widow Auger, Monet moved into a little house on the Mantes road. Living there with him were not only Camille, Jean, and the young Michel, but Hoschedé, his wife and their children. This makes twelve people, leaving aside the servants whose departure the Hoschedé family could not yet face; the private tutor and nurse packed their bags soon enough, but the cook remained. Hoschedé's letters to his mother are a useful complement to the information that we glean from Monet's own correspondence. The weather was awful, and the sunshine of 3 September was the first they had seen since they had moved to Vétheuil. But the cold, rainy weather soon returned, inhibiting Monet's work on the islands, and making the barn that served as a collective sitting-room unbearably cold. The corner of the garden sheltered by the back wall was preferable to the barn, which was protected from the rain but open to the wind. Rottenbourg was a fading memory.

All this did nothing for the health of Camille. She unwisely drank alcohol against the cold, which put an end to her slight recovery. On another day, too long a walk exhausted her. Towards the end of September, Monet was so alarmed that he tried to bring Dr de Bellio to visit them. A few days later, Camille decided that she must wean Michel. Yet her generosity of spirit was not affected by illness, and showing concern for Alice Hoschedé's low spirits, she asked the eldest Hoschedé daughter, Marthe, if she knew why Alice was sad.

What was to be done to entertain the children? In mid-September, they were thrilled with the Vétheuil festival with its "stupid games" (as Hoschedé called them). After their private tutor had departed unpaid, Hoschedé himself taught them for a few weeks. He was contributing to the *Voltaire*, thanks to the good offices of Manet; this little job came on top of the 500 francs a month that his mother allowed him, and he had the knack of worming the occasional supplement out of her.

Letters and short visits to Paris allowed Monet to continue to prospect for clients. He had little to show for it at first: 450 francs in August, 460 francs in September. Almost half of his money came from de Bellio. The tardy letter to Murer on 1 September 1878 deeply offended the baker, who was convinced that others were treated with more respect. On 6 September, Monet's reply was a clever but aggressively ironic defence, in which Hoschedé, a past master of such letters, must have lent a hand. The tone of both correspondents grew calmer over the next few days, but after delivering a painting in December, Monet returned to his dilatory habits.

In October, things improved considerably, thanks to the sale of the first works painted in Vétheuil. The art-dealer, Lucquet acquired six landscapes for 1,000 francs; five pictures went to de Bellio for 750 francs, producing a revenue of 300 francs after deduction of advances. Four pictures were delivered to Hecht for a sum of 500 francs. The total revenue for the month amounted to 1,890 francs. The reception for Monet's recent production convinced him that he should remain in Vétheuil. His own joy at discovering new subject-matter was

The arrival of Père Papavoine's car in Vétheuil
Photograph c. 1885

Banks of the Seine at Lavacourt
1878
Cat. no. 495

Monet's house in Vétheuil
Photograph P. Baudin, Paris

echoed by the reactions of his clients. Camille Monet's health came off second-best.

Settling In

The little house on the Mantes road, for whose rent Hoschedé seems to have become responsible, could no longer respectably accommodate both families. Monet found a more comfortable dwelling at the other end of town, and the landlady, the Widow Elliott, agreed to rent it to him despite the rumours of debt already circulating. The lease specifies that the three, six or nine years rental began on 1 October, which allows us to date the move to within a few days. The 600-franc rent was payable quarterly and was much lower than the Paris rents of the time; the first payment was due on 1 January 1879. Monet had spent the revenue of the month before and November had been a disaster; he had had nothing in that month but a 10-franc advance from his brother. He made a flying visit to Paris to attempt to collect the 150 francs due, returned on 13 December and went to La Roche-Guyon on 18 December to sign the lease in the office of the notary, Maître Delaplane.

The house where Monet was to spend the next three and a half years was on the north-western edge of Vétheuil, on the road to Chantemesle and La Roche-Guyon. On the ground floor, there was a kitchen and the traditional French layout of combined sitting and dining-rooms. On the first floor, there were three rooms, two of them with fireplaces, and a bathroom; above this were a maid's room, a water-closet and an attic. The existence of an "English-style toilet" was a luxury little heard of outside the towns at this time. The main facade was south-west; its other side abutted the hillside, into which two caves had been excavated. From the first-floor windows there was a view of the Seine. In winter, the sun set behind the peasant houses of the village of Lavacourt on

The entrance of Vétheuil from the road to
La Roche-Guyon
Postcard, c. 1900

ABOVE:
The Road in Vétheuil in Winter
1879
Cat. no. 510

the opposite bank. In the foreground were the trees of the orchard that was
rented with the house. With its stone stairs on which Monet set out his big blue
patterned pots, the garden sloped gently down to the "port", where in the past
Daubigny had often moored his boat, the "Botin", and where Monet's studio-
boat was now tied up. Rabbit hutches and a chicken-run supplied the table.

Simultaneous with his move to Vétheuil came another move within Paris.
Monet ended his lease at the Rue d'Edimbourg and moved his studio from the
Rue Moncey round the corner to 20 Rue de Vintimille. The new address
appears in Monet's letters as of December; in the Vétheuil lease it is presented
as his official residence. The Vintimille lease was in Caillebotte's name and was
for a small, ground-floor flat. Hoschedé, too, had a Paris apartment – paid for
by his mother – at 64 Rue de Lisbonne, near the Parc Monceau.

Throughout this period, Monet worked ceaselessly. As though some reserve
were in order, he seems to have avoided the motifs offered by Vétheuil itself.
After his studies of the church, he confined himself to painting *The Steps* and a
Farmyard characteristic of the architecture of the region's many smallholdings
(**493–494**). There were many apple trees; Monet painted them in the Vienne
valley and near the Chantemesle road (**488–491**). The village, which is visible in
the distance in one of the paintings of this series (**490**), is completely absent
from the many pictures that Monet painted on the islands. These offered a vast
range of subjects, as they extended from the branch of the Mousseaux, three

kilometres upstream, to the Iles de Moisson further downstream (481–487). Lavacourt also tempted Monet's eye. Two views were made from the Vétheuil shore (475–476). He then crossed to the Lavacourt bank to paint several versions of the *Banks of the Seine at Lavacourt* (495–499), mostly looking west. Only one of this group faces east; a tug is visible on the river (500). Another tug appears towing a convoy of barges upriver under a plume of smoke (501), but these were the last such symbols of modernity to appear in the Vétheuil paintings.

The days were already drawing in by the time Monet set up his easel closer to the house and painted *The Road Coming into Vétheuil* (502). He returned to this subject several times, and it requires some explanation. The tower on the hill is not the belltower of the church, but the "Chalet de Belvédère", also called "Les Tourelles" in which Mme Elliott lived. At the foot of the hill, to the left of the road stands a little group of houses, the last of which was the Monet-Hoschedé house; in the background there is the Chênay hill that marks the end of the Arthies plateau.

The highpoint of 1878 was the *Jean-Pierre Hoschedé, also called "Bébé Jean"* (503), painted as a new year present for Alice. It and its companion-piece of early 1879, the *Portrait of Michel Monet as a Baby* (504), symbolise the strange existence led by Claude Monet, by now the effective head of both families; Hoschedé spent most of his time elsewhere.

As Quick to Hope as to Despair

The winter of 1878–1879 was so severe that the Prefect of the Seine-et-Oise had to announce the end of the hunting season on 9 February, "given that snow covers the ground". Two months later, *Le Journal de Mantes* was asking: "Have we by any chance changed latitudes? In mid-April the countryside lies bare and sterile. Everything is gloomy." Monet courageously made the most of this prolonged winter weather, concentrating on two subjects that he had made his own: the road close to his house, which he found particularly fascinating when the snow was dirty (508–510), and the Lavacourt bank, this time mainly looking upriver (511–517). He then turned towards the by now familiar Vétheuil and painted a fine panorama of the village (507). Two paintings that differ slightly in viewpoint focus more closely on the houses huddled around their shepherd, the church; for both of them, Monet must have moored the studio-boat some way out from the bank, or perhaps placed his easel on one of the islands. Above the snow-covered bank, we can see the walled gardens with their lattice-work gates (505–506).

The paintings from the first winter spent in Vétheuil have a melancholy quality that might have been inspired as much by the artist's worries as by the season itself. But when spring burst into life, joy returned to Monet's palette and he painted the flowering of the orchards (519–521) and the meadows (522–524). He began a period of almost frenzied activity, his subject-matter constantly changing: there are scenes close to the Mantes road (526–527), houses partly hidden by a curtain of branches (528), and a little branch of the Seine overshadowed by Chantemesle hill (529–530). A series of views of Vétheuil reflected in the water vary in viewpoint and light effects (531–534). There is a greater similarity between the pictures of Lavacourt, which are almost all from the same viewpoint (538–540), with one exception, a view of the belltower of Saint-Martin-la-Garenne emerging from the line of the horizon, painted in portrait format (537). There are also two images of a happy and care-

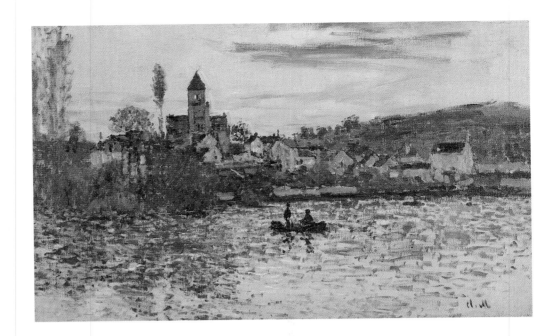

The Seine at Vétheuil
1879
Cat. no. 532

General view of Vétheuil, taken from the Lava-court bank
Postcard, c. 1900

free life, *A Meadow* (535) and *Poppy Field near Vétheuil* (536). The reality was quite different, as Monet's letters of this period show. The tone varies, depending on the correspondent; an order for cognac addressed to Duret has a comic note, but the disheartened words of his letter to de Bellio in March are no doubt closer to his heart. January had brought in 1,070 francs, but February and March had seen nothing but two payments of 100 francs each from Caillebotte.

There was no question of Monet offering himself up to the mercies of the Salon jury, though Renoir continued to do so; he was much praised for his *Portrait of Madame G. C.[harpentier] ... and her children*. Even the organisation of a fourth group exhibition at first left Monet indifferent. But with Caillebotte offering 2,500 francs for him to take part, how could he resist? He was penniless. He agreed to participate "reluctantly and so as not to look like a traitor to the cause"; Caillebotte organised everything.

The exhibition opened on 10 April 1879 at 28 Avenue de l'Opéra. The catalogue lists 29 works by Monet; only Pissarro exhibited as many. The next day, Albert Wolff opened the by now traditional hostilities: "M. Monet has sent 30 landscapes that look as if they were done in a single afternoon... He is stuck in this mess and will never get out of it." The counter-attack was led by Philippe Burty in the *République française*, where Monet showed himself "yet again the most gifted of artists". Two days later, Montjoyeux in *Le Gaulois* recognised in Monet "an artist's temperament stretched to its utmost, quick to hope and quick to despair". Duranty, in *La Chronique des Arts*, took technical analysis further, emphasising how much Monet had learnt from Jongkind, Boudin and Manet. Armand Silvestre, writing for *La Vie Moderne*, announced, on behalf of "Messieurs les Indépendants" (this was the name adopted by the exhibitors), the funeral of "Messieurs les Impressionistes", a theme taken up in *Arts*, where G. Tardieu declared that Impressionism was now inclined to compromise, and would soon "be dining in town".

Paris society was no longer so disapproving; it came to the exhibition for entertainment rather than edification, but the acrimony of the past had faded. When the exhibition closed on 11 May, the participants each received 439 francs. Monet, who had not darkened its door, recorded this sum alongside the 300 francs that Mary Cassat paid for a painting called "Printemps", one of two

that he had pierced before sending them off to Caillebotte, who, showering them with praise, quickly had them repaired.

Neither Caillebotte's compliments nor the favourable criticism of the exhibition prevented Monet entering a depression that was at its blackest on 14 May when he wrote to Manet. His wife and child were almost constantly ill, the weather was unbearable, his painting was unsuccessful and his whole miserable existence was a failure. He repeated these sentiments in a letter to Hoschedé, who should, Monet thought, encourage him to leave Vétheuil, where he felt he was just a drain on his friend's resources. Hoschedé did nothing of the sort. Did Monet really want to leave? At all events, the communal life continued, at least for those with the strength to survive it.

The Baritone Scapegoat

The financial doldrums continued. In July, Monet was almost entirely dependent on Caillebotte, who paid him an advance of 1,000 francs and gave him a further 700, the amount of the first four quarterly payments for the Rue Vin-

A Meadow
1879
Cat. no. 535

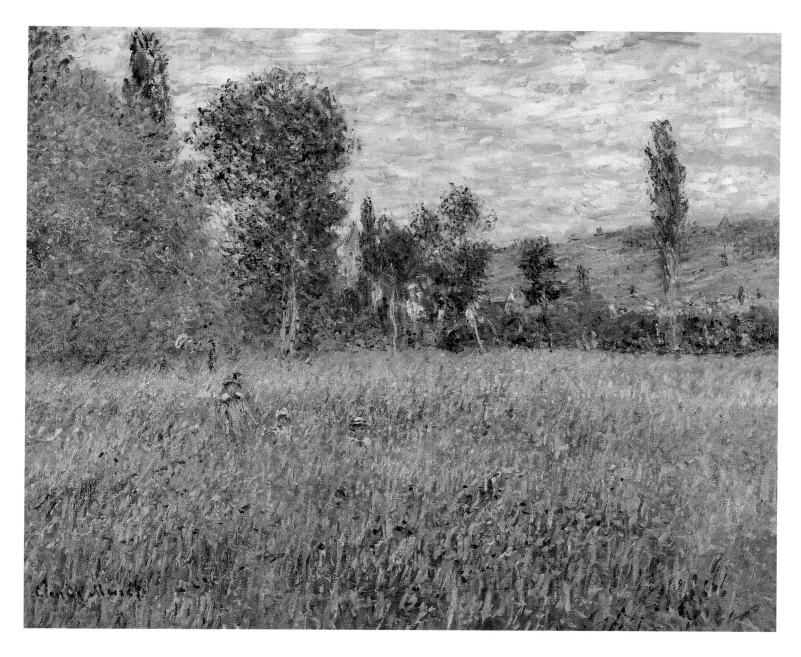

Camille Monet on her Deathbed
1879
Cat. no. 543

timille studio. Hoschedé sold a "Vétheuil" to Duret for 150 francs. Alice Hoschedé was giving piano lessons; Mme Hoschedé senior was doing her best to respond to her son's incessant demands for money, but the debts were accumulating. Mme Lefèvre, the grocer, was demanding 3,000 francs; the widow Auger 800; the draper, Mme Ozanne, was "implacable".

Monet was even running out of paint. He decided that he must make a trip to Paris and attempt to find clients. On 16 July, he returned empty-handed. Grieved at the depression this evoked in him, Alice took Hoschedé to task for his absence. In the letter she sent that evening – a second letter set out her reproaches at greater length – Hoschedé was no longer "My dear" but "My dear friend". The distance between them was increasingly marked.

In August, nothing: 100 francs advanced by Rouart, 200 by Caillebotte, not a single painting sold. De Bellio replied in forthright style to a desperate appeal that unfortunately reached him when he too was hard up: "With your permission, I went round to the Rue Vintimille to see your paintings before taking round some friends to whom I had mentioned them, and I must tell you in all

honesty, as you expect of me, that it is not possible to think of making money on paintings so very far from completion. My dear friend, you are stuck in a vicious circle and I don't know how you will get out of it."

Coming from a faithful admirer such as de Bellio, the reproach that Monet was presenting half-finished paintings is worth noting, especially since it coincides with that of Zola. Writing for the St. Petersburg journal, the *Messager d'Europe*, Zola states: "The impressionists are in my view...pioneers. For a time they placed great hopes in Monet; but he now seems exhausted by the haste of his production; he is content with approximations; he does not study nature with the passion shown by the true creators." That was in 1879 and in Russian; but Zola went on to confirm these views in *Le Voltaire* a year later: "M. Monet has given too free a rein to his facility... Many sketchy works have left his studio when things have been difficult, and that is no good at all, that way leads the road to shoddy picture-making... M. Monet today bears the stigma of his haste, of his need to sell."

It would be facile to imagine that Zola's perception had stood still since his 1868 *My Salon* articles and that he consequently failed to understand the new painting. He had, after all, taken up the cudgels in favour of Manet's *Argenteuil* in 1875. It is possible that he was speaking of bungled paintings that Monet afterwards destroyed, or others that Monet retouched, either spontaneously or at a client's request.

It is in the context of criticisms from normally favourable sources that we should place an amusing story about *Vétheuil in the Fog* (518). Visiting Giverny, André Arnyvelde admired the work, which he found "dazzlingly beautiful". Monet then told him that he had once offered this picture to Faure, who had burst into laughter: "My poor Monet, I wouldn't give you 50 francs for this... Come now....you're not serious." Several art-dealers had similar reactions, but the painting eventually found a buyer. Several years later, having in the meanwhile bought it back, Monet again showed it to the admiring but unrecognising Faure, who exclaimed: "Oh, oh, it's really good. Will you let me have it?" Faure offered 600 francs, but Monet was determined to keep the painting, which now had a symbolic value for him.

This is the legend of *Vétheuil in the Fog*. It has been repeated by generations of historians as proof of the unworthiness of Monet's admirers, and the baritone has become a scapegoat. Is the story true? We cannot know; but we should note that Faure, de Bellio and Zola were at one in their demands, and, harsh as they may have seemed at the time, they were salutary in effect, steering Monet away from the temptations to which his facility exposed him.

The Death of Camille

Claude Monet was disheartened; financial catastrophe was impending and Camille's health was gradually declining. Immediately after they had arrived at Vétheuil, Camille had been able to join the family on its walks. Later she would watch the children playing as she lay on a chaise-longue by the side of the road; for the rest of her life, Germaine Hoschedé would remember Camille's hand gently stroking her hair. By mid-May 1879, Hoschedé was writing to his mother: "It is the state of Mme Monet that most concerns us at the moment. I think she cannot have more than a few days to live and her slow death is a very sad thing."

Camille was in the hands not of the Vétheuil doctor, but of Dr Tichy of La Roche-Guyon, who was also attending Mme Elliott. After 10 August, Camille

could not keep her food down. On 17 August, Monet sought the professional help and financial assistance of de Bellio. We have given the doctor's answer on the second matter; on the first he was no more helpful, confining himself to a laconic P.S.: "I am very sorry to hear that Mme Monet is in the sad state of which you paint so black a picture. But let us hope that with care, with a great deal of care, she will recover."

Why this insistence on "care"? Did de Bellio feel that care was lacking? That was the opinion of a near neighbour, the painter Léon Peltier. A private income of 20,000 francs meant that Peltier could take life easy and not worry whether his paintings sold or not. Pipe in mouth, wearing a cravat, he posed for Monet (542) and provided him with free firewood during the winter. His son Jean played with Monet's children. Peltier made unfavourable remarks about Monet's behaviour in relation to Camille and her illness; the remarks were confined to his family and we do not know what he saw or what he heard to justify his opinion.

By this point, Camille was so ill that only a miracle could save her. It seems likely that she was suffering from cancer of the uterus, aggravated by the birth of Michel, which had by this time spread to the digestive and urinary tracts. Whatever Alice Hoschedé's feelings, she did her best for Camille. "Mme Monet's terrible illness takes up all my time, except for the children and the piano lessons", she wrote on 26 August. "I fear that the poor woman's suffering must ultimately be quite fatal. It's horrible to see her undergoing this torture and to feel that death is therefore desirable."

Alice was a practising Catholic, and wanted her friend to die a Christian death, to which the fact that the Monets had made a civil but not a religious marriage was an obstacle. On 31 August, the Abbé Amaury, the Vétheuil priest, visited Camille; on his return he wrote in his records "rehabilitation of the marriage of Claude Monet and Camille-Léonie Doncieux." The following day, Hoschedé wrote to his mother: "Thanks to Alice, she yesterday received the last sacraments and is a little calmer today." A little later, Alice wrote to her mother-in-law: "Yes, one great happiness for me amongst all this sadness was to see my poor friend receive her God with faith and conviction and receive the last sacraments."

Four long days and five long nights after the priest's visit, Camille died, on Friday, 5 September, at around 10.30 am. Monet informed de Bellio of the "fateful news" that same day, asking him to inform those whom it concerned. He writes that Camille "suffered horribly". Hoschedé provided a more consoling version for his mother: "The poor woman died in absolute calm and, over the last two days, without suffering." Alice had no reason to spare her correspondent in this way: "The poor woman suffered greatly, her death was long and horrible, and she was conscious until the last minute. It was heart-rending to see her bid a sad farewell to her children." No mention here of a farewell to her husband. Had she nothing to say to him?

At four in the afternoon, Aimé Paillet (a mason) and Louis-Gustave Havard (a clockmaker), "friends of the deceased woman", went to the Vétheuil Mairie to witness the death certificate, which was issued by Louis-François Finet, the mayor and registrar. While Camille lay on her deathbed, a strange temptation overcame Monet. "At first he resisted, but the vague idea took form, began to be an obsession. At last he gave way, took up a small canvas, and began a study" (543). The words are those of Zola in his novel *L'Œuvre*, but it is clear that Monet's conduct inspired this passage.

As was the custom at this time, Alice did nothing to soften the blow for her children: "My elder daughters were very courageous and very good; they helped

Nasturtiums in a Blue Vase
1879
Cat. no. 547

me in the sad, last duties and spent two days in vigil over the poor dead woman. These have been great lessons for them and they will experience soon enough all the sadness of this world", she wrote to her mother-in-law. Monet was awaiting the arrival of the postman with a parcel containing Camille's medallion, which de Bellio had redeemed from the pawnbroker's at Monet's request; he wished it to be replaced around Camille's neck "before she left".

The Confrères de la Charité dealt with funerals at Vétheuil. They came to place Camille in her coffin. The burial took place on 7 September at 2 o'clock in the afternoon, "because it was Sunday", as Hoschedé explained to his mother. The procession went up the stairs that led to church and cemetery. Not far from the enclosing wall, opposite the entrance to the cemetery, the grave had been dug. The Abbé Maury gave absolution to she who was *The Woman with a Green Dress.*

Did Camille's mother attend the burial service? She was only fifty years old and living in Paris. Did she know about her daughter's illness? Did she care? Her letters to Camille, like all the letters written and received by Camille and the photos in which she appeared, were destroyed at the behest of the jealous Alice, who now reigned unchallenged over Monet's life.

Still Life: Apples and Grapes
1879
Cat. no. 546

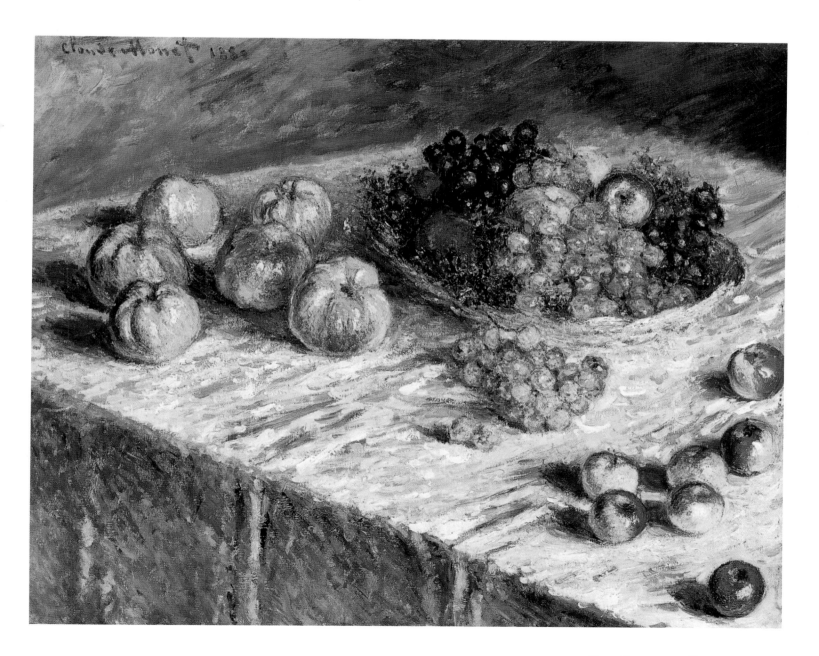

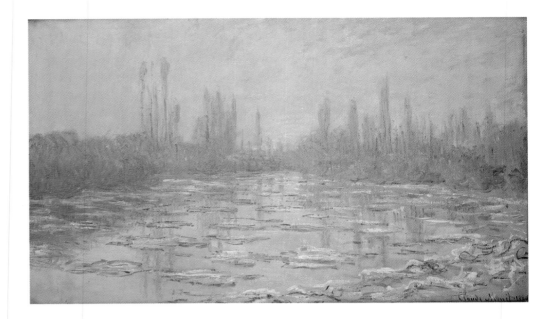

Floating Ice
1880
Cat. no. 567

Merciless People, Merciless Winter

Camille's death left a gaping hole in Monet's life. His replies to those who sent him letters of condolence show his distress. He was uncertain what he should now do, and new problems were arising as a result of the death that June of Mme Elliott. Her two daughters, the widows Chauvel and Origet, quarrelled about the inheritance. After a sale of household belongings in which Hoschedé (registered as Haugedé) acquired various items at knock-down prices, the daughters put the three houses, including Monet's, up for auction. No buyer was forthcoming.

Mme Chauvel was disappointed and had absolutely no intention of making a gift of the house to lodgers whose presence had been a factor in preventing its sale. She asked the notary, Maître Delaplane, to inform Mme Origet about the rumours suggesting that the Hoschedé and Monnet (sic!) families, who had not paid any rent for the last two quarters, were to leave Vétheuil within the fortnight. Mme Origet reacted quickly: "I had a talk with my son about the possibility of M. Monet leaving, which would justify the termination of M. Hoschedé's lease, my son assuring me that, given the two quarters outstanding, there was no need for courtesies. I ask you to do what is required, without waiting for the Hoschedé family to leave Vétheuil." Thus Mme Origet to her notary. In fact, there was only the lease that Monet had signed, and this was sent by Mme Origet's son to Maître Delaplane on 22 October so that he could start proceedings.

This was the situation that Monet was facing when, on 11 October, he left for Paris with a parcel of 17 pictures that he was determined to sell; if he failed, he would find himself homeless. On this occasion, he was at least partly successful. True, advances from Caillebotte represented some 700 francs out of the 1,750 francs income of October, but de Bellio took five paintings against advances and added 200 francs of fresh money. Faure bought "The Small Branch of the Seine" for 100 francs and May *The Seine at Lavacourt* (539) for the same amount, which he had already advanced; another *The Seine at Lavacourt* (541) went to Lefèvre for 300 francs.

"Those Elliott women" received their quarterly payments, and life at Vétheuil continued in Hoschedé's absence. In late October, the cook, Madeleine Bordat, married a neighbour, the plasterer Lauvray; she remained in

the Hoschedés' employment for some time thereafter, increasingly angry at having to wait for her wages. As she was no longer doing the laundry, Alice had it done by a laundry up on the plateau at Follainville. She herself was working desperately hard and even had to saw up the firewood. She was suffering from headaches, and was sufficiently worried about them to consult her homeopathic doctor in Paris, Dr Love.

Creditors besieged the house. One Théodore came to put pressure on Hoschedé in his absence; left on his own downstairs, he went into the dining-room, took up a vase with a magnificent bouquet of flowers in it and smashed it over the piano, filling the piano with water. Alice and her daughters were forced to take the piano to pieces. A second visit from this rather wild person apparently rendered several piano keys mute with anxiety! Marthe's amusing letter to her father about this incident informs us that the *Nasturtiums in a Blue Vase* (547) on which Monet was working were in a different vase.

In the period immediately following Camille's death, it seems that the painter worked mostly indoors, completing unfinished pictures, retouching those which had been rejected because too much bare canvas was showing and completing a group of still lifes of fruits and flowers (544–548). In early December, Monet was too involved with a still life of game to accept an invitation from a local art-lover, M. Coqueret; a month later, he was awaiting pheasants for further still lifes (549–551).

His intimacy with Alice had grown. Hoschedé was at last aware of the danger, and suggested that his wife join him in Paris. Without making any decision, she contrived to gain time: "I am also very sad about the accounts that you have prepared for me. If we spend a relatively large amount here, what would it be in Paris? Anyway, we'll talk about all this." Since Hoschedé was still without work, Monet helped out his partner with the last few francs that he possessed. This was generous indeed. November had brought in only 575 francs, of which 500 were for six paintings sold to Cantin.

The winter was particularly severe. "It is bitterly cold," Marthe noted in her letter about the *Nasturtiums,* "It snowed yesterday and everything is freezing up

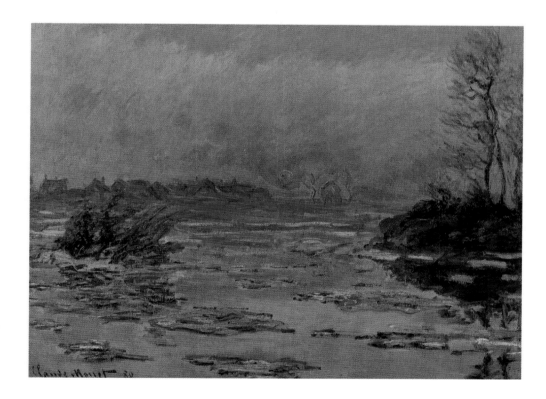

Sunset on the Seine in Winter
1880
Cat. no. 574

amazingly, the flowers in the orchard are frozen, the water in the streams ditto, we can't so much as put our noses to the window without them freezing up too." Alice confirmed on 5 December: "We are still very cold, and the Seine is still rising. Gabrielle [Guerbois, the ferryman] was to have removed the landing stage yesterday, but he didn't come, and now it's under water."

Three days later, Hoschedé arrived at Mantes and found the snow packed so firm that the trip to Vétheuil would take three hours. But this was an improvement on the previous Thursday, when Papavoine's "conveyance" had stuck firmly in the drifts near the village of Dennemont. The *Journal de Mantes* of 10 December, reporting on this event, noted that the "pitiless winter" was much worse than anything seen in previous years. Enormous blocks of ice floated down the Seine. Then the temperature fell to -25 degrees and the Seine froze over completely.

Poverty and Hope

One effect of the snowdrifts and the communication difficulties was rising prices. "Céleste" of Lavacourt was now charging an extra 50 centimes per sack of potatoes because the ferry charge had gone up. The market-gardener Arsène, who came down from the village of Fontenay-Saint-Père, had to dig through the snowface like a miner in order to reach Vétheuil, where he sold his "blessed vegetables at crazy prices", as Alice wrote to Hoschedé. Several of the children were ill. Marthe had a bad sore throat, Germaine had eczema and spent entire nights screaming, Jacques and Jean-Pierre were coughing. During the day, Alice kept a close eye on Michel and Jean-Pierre for fear of their burning themselves at the fire.

Vétheuil in Summer
1880
Cat. no. 605

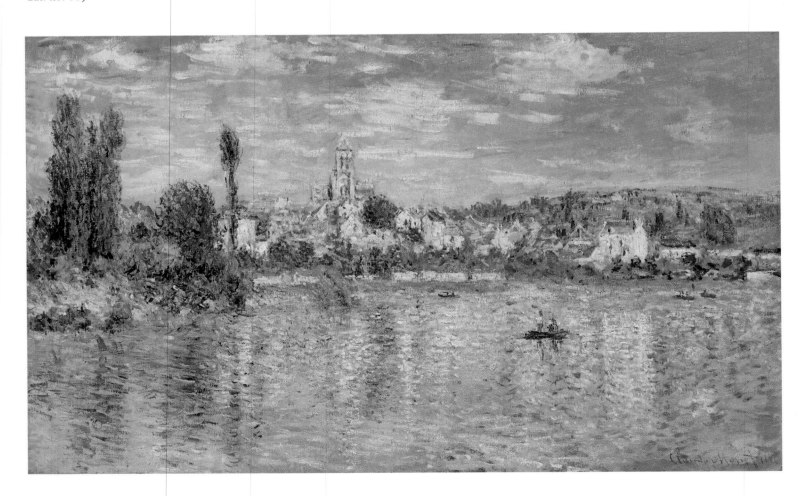

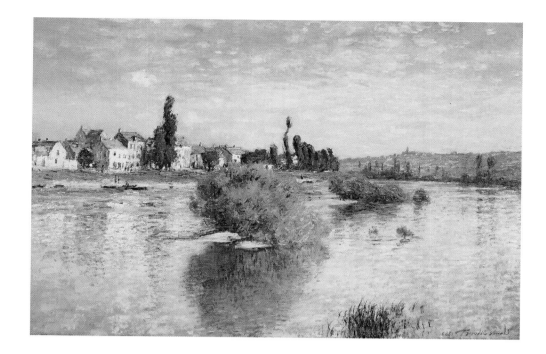

In mid-December, Monet had to face recriminations from Hoschedé. Alice took his part: "I shan't reply to the reproaches you make about M. Monet, who is as unhappy as anyone when there is a lack of money here, and who was fortunately able to help us last month... He is working hard."

The work in question was the first winter landscapes of 1879–1880. Monet had to brave Siberian temperatures to paint them. An unknown traveller was found dead from exposure at Jeufosse near Bennecourt and an inhabitant of La Roche-Guyon was found frozen to death under the snow. "Have you crossed it?" asked the *Journal de Mantes* about the Seine, on whose frozen surface an entire marriage party had walked. At Vétheuil, the Seine was completely frozen over. This is very clear in *View of Vétheuil in Winter* (552), which Monet painted from the middle of the frozen Seine; it is also clear in the *Frost, Grey Weather* painted on the small branch of the Seine and the floating ice in front of Lavacourt (553–558). People walked from one bank to the other (557 has been subjected to overpainting to remove the apparent anomaly of figures walking on the frozen river) and the Hoschedé and Monet children played on the ice.

They were unaware of the waves of creditors who besieged the house. The latest addition was Madeleine, the cook. The Follainville laundry declined to return their washing, so that Alice was forced to use the servants' sheets to make her bed. On 24 December, Jacques had nothing suitable to wear and so could not accompany his mother and sisters to midnight mass. Suzanne, the prettiest of the Hoschedé girls, had to borrow Jean Monet's boots. Christmas Day was grim. There were no presents, with the exception of a few toys that Alice had unearthed for the two young ones. Hoschedé's absence was "loosening tongues throughout the neighbourhood", as Alice reported.

The next day, a package of clothes arrived from Hoschedé's mother, but still no money. In the market, Alice was roundly rebuked by a butter-seller to whom she owed 30 francs; she could not afford a sack of potatoes. On 28 December, Alice had but five francs to run the whole household. On the evening of the same day, Monet set off for Paris with some "Winter Effects"; the trip was made possible by a loan of 50 francs from the postmistress, Mlle Portet, who owed her appointment to Hoschedé. These had been hard times. Monet had been working furiously and instructing Hoschedé, via Alice's letters,

on how to approach clients. A reply from de Bellio was deeply disappointing. Monet announced his arrival in Paris to Duret and Chocquet. Chocquet bought nothing, Duret bought an "Winter Effect" for 150 francs.

True, this money did not come in until January, but the overall revenue for December was satisfactory: 1,625 francs. The average price of Monet's paintings had risen considerably. Two still lifes were bought by Theulier for 800 francs. G. Petit went as high as 500 francs for a third, probably *Fruit Basket (Apples and Grapes)* (545). Landscapes were not selling so well, yet Petit paid 300 francs for an "Winter Effect". On Petit's advice, Monet decided that he should stop selling his pictures at the very low prices which necessity had too often constrained him to do.

Icebreak and Renewal

In the last few days of 1879 there was a sudden rise in the temperature. "We have a terrifying thaw", Alice announced on 29 December. "The whole mass of snow is falling on us from the tops of the hills, the courtyard is flooded, the water will be inside the house if things continue, it's raining buckets." The rain eventually stopped, and New Year's Day, for which Monet and Hoschedé had returned to Vétheuil, was a relaxed occasion. But the thaw was only partial. The Seine was still completely frozen over. On Sunday, 4 January, Hoschedé had returned to Paris and Alice had gone up to bed with the children; Claude was sleeping on the ground floor. They were unaware that the breakup of the ice had reached Mantes at about 9 o'clock that evening, and the floods were carrying an ice-mountain downstream.

"On Monday, at five in the morning," Alice wrote to Hoschedé, "I was woken by a terrifying noise, like thunder; a few minutes later, I heard Madeleine knocking on M. Monet's window, telling him to get up. I immediately did the same, while the booming sound was mixed with cries coming from Lavacourt. I quickly ran to the window, and, dark as it was, I could see blocks of white falling; this time, it was the real break-up of the ice floes."

In Lavacourt, lights were coming and going, calls for help resounded through the night; the inhabitants knew that their houses were in immediate danger because they were on the bank. They were lucky: the blocks of ice were carried over to the far side of the meander and wrought havoc with the gardens on the Vétheuil bank, smashing down garden walls and breaking trees off at the stump. This lasted more than two hours. When things grew a little calmer, the men of Lavacourt overcame their fear and risked their lives in quest of flotsam; it was said that there were corpses drifting on the river.

That day Monet hired a carriage and with his partner and their children explored La Roche and Gloton, an outlying village of Bennecourt: the beauty of the landscape was "heart-rending." On Tuesday, Vétheuil still had striking sights to offer. A sea of ice stretched beneath the orchard from the Île Namur to the port. The little islands had disappeared, the poplars had been broken off. During the afternoon, the procession of pack-ice resumed for an hour, then things again grew calmer. They took the opportunity to cross the Seine the next day. The plain behind Lavacourt was strewn with blocks of ice in the midst of which the inhabitants were collecting cartloads of wood from the wrecks.

Such was the break-up of the ice as reported by Alice in three letters to her husband. On Thursday, 8 January, Monet described the events: "Here we had a terrible débâcle and of course I tried to make something of it," he wrote to de Bellio. He wrote in the past tense, and four days after the Seine had broken its

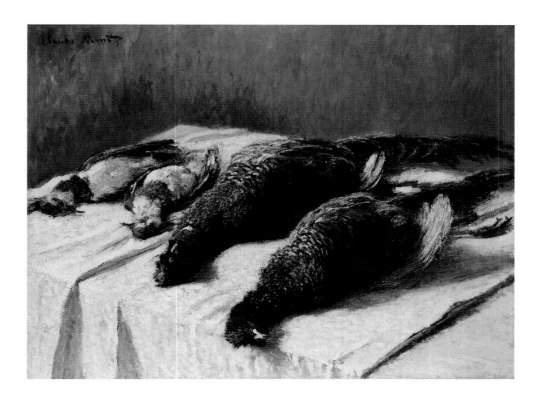

Pheasants and Lapwings
Winter 1879–1880
Cat. no. 550

inspired by the dark days of winter helped to restore the financial situation. In December, G. Petit's eye had been caught by two "Winter Effects" and a still life, and he had promised his support. The success of the biggest *Floating Ice* (**568**) was yet to come.

For the moment, it was de Bellio who felt the cost of this change for the better. In his letter of 8 January quoted above, Monet informed de Bellio of Petit's purchases, without specifying that the 300 francs he had received for the "Winter Effects" was the combined and not the unit price. This was Monet's new slogan: "Buy less – pay more."

De Bellio replied on 12 January, greeting the purchases as "good news" but warning Monet against his "new recruit"; the cost of one picture accidentally sold "for a little more money" might create an obligation to set higher prices and risk alienating other clients. De Bellio was willing to do as Monet suggested, and buy less, but he would demand better pictures from now on; he had his little stock of Monets already. His collection comprised some paintings of "great merit", but too many "sketches" bought for the painter's sake. He was happy to sell two-thirds of them back at cost price; if Petit wanted to give more for them, that was fine. Any money he (de Bellio) made on them, he would be happy to lay out on more "finished" paintings by Monet. In conclusion, de Bellio was hurt that anyone should accuse him of exploiting his friend's darkest hours. Monet was, he felt sure, destined for "very great and very well-deserved success". And without going back on his threat to sell, he assured Monet that he would never part with his paintings nor ever make of them "a question of money". The incident was, it seems, closed.

fetters of ice; that Monday, the day was given over in part to a further walk upstream from Vétheuil. Four January days, when the sun rose at eight and set at four was very little time to paint all the *Breakup of Ice, Floating Ice* and some *Sunset at Lavacourt* (559–577). Certain of these paintings must have been finished indoors or even painted after the event; we know that this was the case, as we shall see, for one *Sunset on the Seine, Winter Effect* (576) and for the biggest of the *Floating Ice* (568).

On the other hand, the cold spell returned, and the appearance of the landscape changed only very slowly. On 14 January, the *Journal de Mantes* noted that though most of the flood plains were no longer under water, the river had deposited quantities of pack-ice on the fields. With 21 January close, the temperature was still almost permanently below zero and the snow was still firm in many places. On 31 January, the river again flowed with ice. Monet and the Hoschedés had to wait until mid-February for more normal temperatures.

The break-up of the ice had been a catastrophe for the inhabitants of the banks of the Seine, but Monet had little to complain about. Despite the damage done to the landing-stage, which Gabriel Guerbois had failed to tow out of danger, the studio-boat was only slightly damaged. The cost of repairing the garden walls fell on the "Elliott women", and Monet told Maître Delaplane so when he settled his quarterly rent on 12 January. As to Monet's paintings, the pictures

Breakup of Ice , Grey Weather
1880
Cat. no. 560

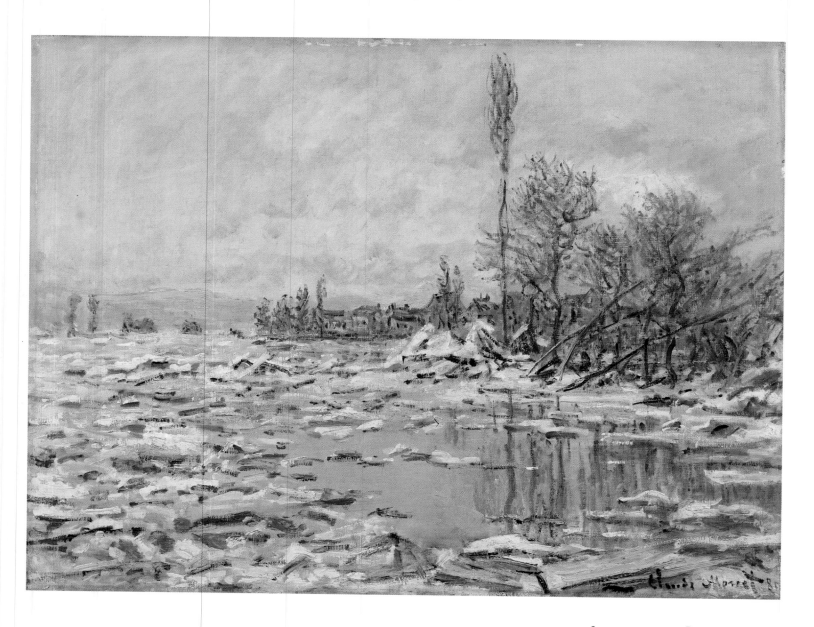

The *Gaulois* Affair

Just when the future seemed brighter, a disagreeable incident occurred. On 24 January 1880, under the heading "Paris Days", *Le Gaulois*, which had traditionally favoured the Impressionists, published an announcement typical of the period:

"In some days time, the admirers of the 'New School' of painting will receive, by post or otherwise, a letter to this effect:

The Impressionist school regrets to inform you of the sad loss that it has suffered in the person of M. Claude MONET, one of its revered masters.

The funeral of M. Claude MONET will be celebrated on 1 May at ten o'clock in the morning, the day after the private view – in the church of the Palais de l'Industrie. – M. Cabanel's salon.

Please do not attend.

De Profundis.

From M. Degas, leader of the School: M. Raffaelli, successor to the deceased: Miss Cassat: M. Caillebotte: M. Pissarro: M. Louis Forain: M. Bracquemond: M. Rouard [sic] etc... his ex-friends, ex-students and ex-supporters."

In the comments that followed, the columnist, who signed with "Tout Paris", suggests the scale of the damage done to the Impressionist cause by this defection, gives a thumbnail portrait of the deserter and describes his establishment in Vétheuil where he lives with "his family: a charming wife and two pretty babes of seven or eight years old". The two babies hardly correspond to the eight Monet-Hoschedé children, but the "charming wife" could be none other than Alice Hoschedé; the columnist was too well informed not to know of Camille's death. The allusion was made clearer by the fact that the only friend of Monet's mentioned in the article was Hoschedé himself. "He was ruined – the dear man – by buying, at very high prices, the Impressionist works of every art student that had fallen out with a studio... Today he has become a platonic admirer, and spends his life in the studio of Monet, who clothes, lodges, feeds and...puts up with him."

In the remainder of the article, the baker and collector Muret was scoffed at, but the artists faithful to the movement, Mary Cassat, Degas, Pissarro, Forain and Raffaelli came off unscathed, particularly the last-named, who was labelled as Monet's successor.

Monet reacted immediately. He wrote a letter of protest to *Le Gaulois*, requesting that they print it, and also wrote to de Bellio, whom he suspected of knowing something about the affair, if not, indeed, of having a hand in it. *Le Gaulois* confined itself to printing in its "Miscellaneous news" column of 29 January a very brief note specifying that Hoschedé was not living at Monet's expense. De Bellio replied that he had been unable to discover the name of the "hack" involved, and seemed satisfied with the correction published. He felt that the article – "inspired by extreme malice" – was typical of "what is today called the 'freedom' of the press". De Bellio took pains to soften the impact of his earlier (12 January) letter, which had first caused Monet to doubt his loyalty.

Monet was apparently satisfied by de Bellio's reply, and turned to Pissarro, whose influence within the group he well knew. The letter, dated 2 February, is by way of an interrogation. Pissarro, in reply, declared how indignant he and his friends felt, and condemned the journalist who had attacked Hoschedé "with such animosity". As to the possibility of Monet defecting to the Salon, he was much less categorical: "I learned from Duranty, a few days before the appearance of the article, that you were intending to exhibit at the Salon; I mentioned it to Caillebotte, who completely reassured me." Concluding rather

prematurely that Monet's loyalty was above suspicion, he admitted that he "would have been very unhappy to see one of our veterans, one of our heroes leave us after we had already lost artists such as Renoir, Cézanne, Sisley, etc.".

Since *Le Gaulois* had failed to print his objections, Monet asked Hoschedé to pass on a second version of his letter to the *Voltaire*, via its former editor Aurélien Scholl. The request was transmitted via Alice. The very same day, Hoschedé wrote to Arthur Meyer, the editor of *Le Gaulois*. Noting that he had received many "marks of sympathy" on account of the "more than defamatory" article, he demanded that the paper print his protest along with that of Monet. A copy of this letter, signed and dated 2 February, remained among his papers. If the original was indeed sent to Meyer, he must have thrown it away, since not a line about the incident was printed. And the *Voltaire* did no better. The "*Figaro* of the Republicans" had too much on its plate with the serialisation of Zola's *Nana* to get mixed up in this polemic. In its February issue, *L'Artiste* reproduced the article from *Le Gaulois* almost unchanged. The efforts of Monet and Hoschedé to deny their mutual complaisance about Alice were thus completely unsuccessful.

"I am working furiously"

At Vétheuil, the financial position was again extremely precarious. Having paid Mme Hoschedé the 40 francs that Caillebotte had given him for travel expenses, Monet could not travel to Paris without Hoschedé paying him back. Worse, Alice had no money to frank the letter requesting Hoschedé to do this, and was afraid the postmistress might simply refuse to frank yet another letter without payment.

On 14 February, Claude managed to leave for Paris. Shortly afterwards, Madeleine and the Lauvray family made a very public journey to Magny to bring a case against Hoschedé; the magistrate ruled in their favour, requiring Hoschedé to pay the outstanding 300 francs. In the afternoon, the Hoschedé girls went out for a walk in the splendid weather, returning with violet-roots to plant on Camille's grave. That evening, Marthe returned to kitchen duty, in which she continued exhausted until a new cook was recruited to replace Madeleine.

Monet's Paris trip had been fairly satisfactory. His account-book shows a total revenue of 1,150 francs for the month. Theulier had bought an *Ice Melting* at 500 francs, the price paid by G. Petit for *The Pheasants* (549). On his return, he handed 100 francs to Alice. This was little enough, but there were several items recorded as "given to Mme Hoschedé" over the course of the month. Moreover, Monet was responsible only for himself and his sons, that is, only three-tenths of the household expenses; the other seven-tenths were Hoschedé's responsibility. The money that Monet did not add to the kitty went towards old debts.

On 8 March, two weeks after his return to Vétheuil, Monet informed Théodore Duret of a decision in which the example of Renoir had obviously weighed heavily: he would run the risk of being called "a deserter by the whole bunch" and return to the Salon, for which he was "working furiously" on large-scale paintings (1 x 1.5 metres). A third painting turned out too much to his own taste to be worth submitting to the jury, but he continued it nevertheless for his own pleasure.

Instead of this painting – which was almost certainly *Sunset on the Seine, Winter Effect* (576) – he undertook "something safer and wiser, something more

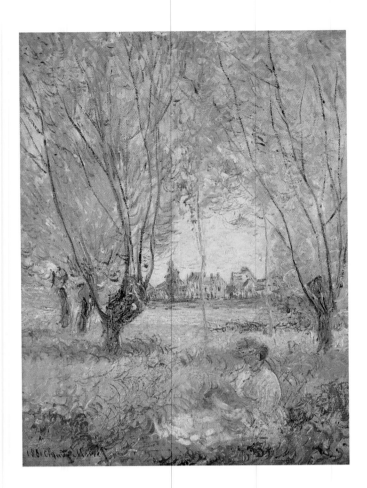

LEFT:
Woman Sitting under the Willows
1880
Cat. no. 613

RIGHT:
André Lauvray
1880
Cat. no. 620

bourgeois". This is particularly true of the big *Lavacourt* (578), which he submitted along with *Floating Ice* (568). The vegetation of the *Lavacourt*, its light-toned and shallow waters, suggest an image of summer. We know that it was painted in early March, 1880, and that it must therefore have been painted from studies made out of doors either one or two years before. The house at Vétheuil did not possess a studio; Monet painted either in his own room or in the attic, when he painted indoors at all. Weather permitting, he set himself up in the courtyard, which was well protected from the wind. When he needed to, a few steps would take him down to the bank, where he could check the lie of the landscape; the season was wrong, but by now he knew the landscape almost by heart.

All the same, things did not go perfectly smoothly; with 15 March approaching, Narcisse Coqueret, a local art-lover, had to encourage his protégé who was talking of giving up the Salon projects for lack of time. Monet succeeded in submitting the two canvases before 20 March, the traditional deadline; he gave his Paris address as "Rue Vintimille, 20." How would the jury react to the return of the prodigal son to the official pomp and ceremony of the Salon?

Lavacourt at the Salon

On 24 May, the paintings jury was elected. In 1879, the right to vote had been extended to all artists who had had works accepted three times, this had considerably expanded the electorate. Monet's works had been admitted in 1865, 1866 and 1868, and he very probably insisted on applying the new rules. The regulation also provided that, out of the 15 jurors, the paintings section must contain five representatives of landscape and still life. Top of the specialist list was Vollon with 667 votes; Harpignies was last with 289. Guillemet came second to last, among the five supplementary jurors, and was thus able to keep his friends, notably Manet, informed of the jury's activities.

Easter passed at Vétheuil in the absence of Hoschedé and in an atmosphere of tense expectation. Hoschedé's defection angered Alice: "I am wondering which one of us is mad... I shall never again expect or announce your coming", she wrote on 24 March.

An invitation for the fifth Impressionist exhibition, addressed to Hoschedé, reached Vétheuil on 1 April, the day of the opening; Alice referred to it as the Caillebotte exhibition when informing Hoschedé about it. Monet did not go. The "Tout Paris" column of *Le Gaulois* was virulent in its criticism of the "independent artists" as they now styled themselves; it preferred to pass in silence over the names of "Pissarro, Rouart, Untilot and Zandomeneghi". This rather confirms that when "Tout Paris" published its anti-Monet article of 24 January, it was instigated by those to whom it now showed its true colours and its contempt.

In early April, the decisions of the jury were known to those who had entered works. *Floating Ice* (568), for all its moderation, had not found favour; only *Lavacourt* (578) had been accepted. Monet's participation in the Salon did not escape Murer's eagle eye: pointing out that he was still due one work from their 1877 deal at 50 francs per rough sketch, he had the temerity to ask if he could not have one of the two pictures submitted to the jury! Monet replied on 9 April, making things quite clear: since the two paintings, one admitted, one rejected, were both valued at 1,500 francs, the receipt that would allow the baker to remove one or other would cost him 1,450 francs. Some days later, Monet went to Paris, though he is not known to have attended the funeral of Duranty on 13 April, at which the mourners included Manet, Degas, Pissarro, Renoir, Zola, Daudet and Huysmans. By 19 April, he was back at Vétheuil.

The preview of the Salon was held on 30 April; the critics had had their own private view. On 1 May, the Salon was opened to the public. The Secretary of State for the Fine Arts, Edmond Turquet and the General Commissioner Lafenestre had proposed that the alphabetic classification of works be replaced by four categories. The ones not submitted to the jury received pride of place; the excluded works were tolerably displayed and those that had to be submitted to the jury – were, in Zola's words, "crammed in like soldiers in cattle-trucks". *Lavacourt* (578) was hung in Room 15 near the entrance and right next to the excluded. Burty, writing in *L'Art*, noted – with some satisfaction – that it was hung in the last row, six metres from the floor, so that "all the delicacy of the palette vanishes without benefit to him or to the public, which was beginning to acquire a taste for his subtle suggestions." The Marquis de Chennevières, a former Director of the Ecole des Beaux-Arts, had something similar to say in *La Gazette*: "The light-toned, luminous quality [of *Lavacourt*] makes all the landscapes surrounding it in the same gallery seem dark."

Renoir, whose two submissions had been accepted, was similarly disadvantaged. The two friends wrote a letter of protest to the Minister for Education

and Fine Arts, seeking "to be better exhibited next year...in more suitable conditions". On 10 May, Cézanne sent a copy of the letter to his friend Zola requesting him to have it printed in *Le Voltaire*, and to add something of his own to contribute to the Impressionist cause. Zola ignored the letter "incident", preferring to write an in-depth study of his friends' works. He had decided, once and for all, to spare no one, and when his article for the *Voltaire*, "Naturalism at the Salon" appeared during the second half of June, it satisfied no one. The administration of the Salon was taken to task for classifying by categories, the jury should simply be dissolved, and none of the Impressionists had "powerfully and definitively achieved the formula which they all exemplified".

In the course of this judgment, Monet, who was given fuller consideration than Renoir, came in for his share of criticism. Zola condemned the hanging of *Lavacourt*; he had been particularly attracted by the "joyful rising sun" depicted. As a young man, he had himself set a novel called *Madeleine Ferat* in Vétheuil. On the other hand, the overall verdict on Monet, who was "an incomparable landscape artist" and "painter of wonderful seascapes", enlarged on some of the themes that had been sketched in the *Messager de L'Europe* of the previous year. Monet was accused of hasty work that came close to being "trashy". Zola was willing to pass over in silence certain "personal considerations" which he "hesitated to mention", and which no doubt referred to the strange *ménage* with Alice. Monet should now devote himself to "major pictures, the work of many months" without worrying about "the question of exhibitions", for Zola was certain that Monet's "great and beautiful art" would one day be prominently exhibited and sold for very high prices. The article appeared on 21 June 1880, when Monet's one-man exhibition at *La Vie Moderne* was in full swing.

La Vie Moderne

Monet's return to the Salon had put him at loggerheads with certain of his friends, notably Degas, but it had strengthened his friendship with Renoir. The latter was now on very good terms with Zola's publisher, Georges Charpentier, dubbing himself "painter – in – ordinary" to Charpentier's wife. In 1879, his *Mme Charpentier and Her Children* had been a great success; in June of the same year, he had exhibited on the premises of *La Vie Moderne*, a weekly illustrated magazine founded by Georges Charpentier two months before and which possessed its own gallery at 7 Boulevard des Italiens. Charpentier had known Monet since the latter's Argenteuil period, but it was no doubt Renoir who was behind the offer of a one-man show, now that Monet had returned to the Salon and thus entered the purview of an eclectic magazine that gave considerable space to official painting and promoted Antoine Vollon no less than Edouard Manet.

In April, 1880, Monet accepted the offer, which ultimately came from the editor of *La Vie Moderne*, and agreed to receive Emile Taboureux, one of the magazine's regular contributors, for an interview at Vétheuil. The article appeared only in June, but should be put in its April (or "Aprilian", to use the flowery epithet affected by the journalist) context. It is too long to be either reproduced or exhaustively analysed here, but it does provide information about Monet's lifestyle at Vétheuil. Taboureux described "Port Monet", the landing-stage which consisted of a few planks hammered together within a rickety balustrade, and its two vessels, the one for excursions on the water, the other for painting. The house was "absolutely modern", and Monet's room very simple and completely covered in pictures. As to his entourage, discretion was the

Jerusalem Artichoke Flowers
1880
Cat. no. 629

PAGE 161:
Bouquet of Sunflowers
1880
Cat. no. 628

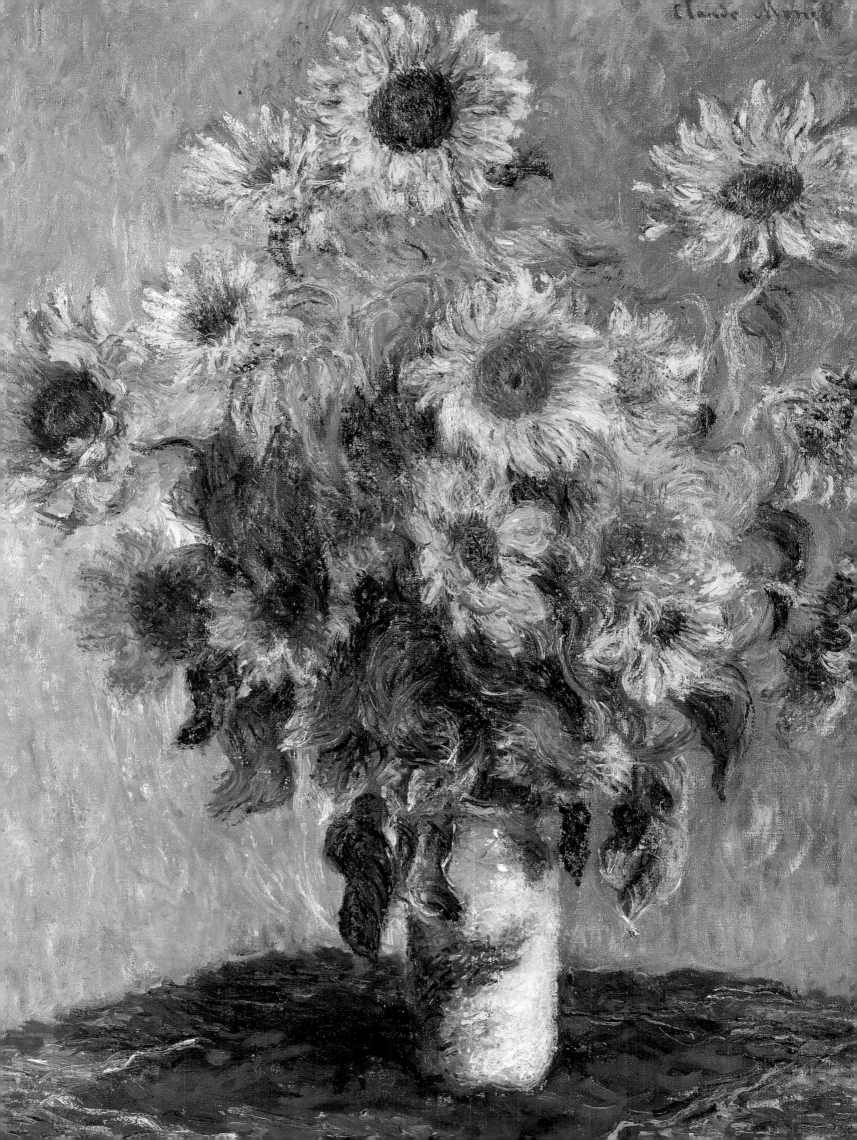

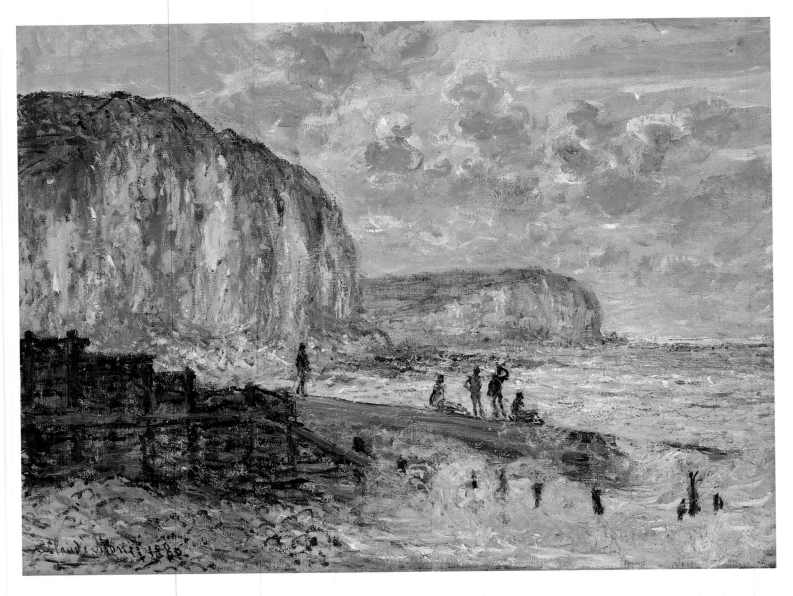

The Cliffs of Les Petites-Dalles
1880
Cat. no. 621

order of the day. Two children and two dogs were glimpsed down by the port, and no one was visible in the house. Monet's work at the Gleyre studio had, it appeared, lasted only three months, which helped to perpetuate the myth of the self-taught painter. Recent attacks were met head-on: "I still am and will always be an Impressionist" expressed Monet's loyalty to principles if not to persons, though it seemed that this Impressionist's existence might become a solitary one at a time when "the little church has become...a banal school that opens its doors to the first dauber who happens to come along."

The highlight of the interview was Monet's abrupt reaction to the request to see his studio: "My studio! I have 'never' had a studio, and can't understand how one can shut oneself up in a room. To draw, yes; to paint, no." And then the declaration: "There is 'my' studio!", with a sweeping gesture embracing the Seine, the hills and Vétheuil as a whole.

The statement may seem exaggerated, but perfectly matched the image that Monet wished to convey in this self-publicising venture. Duret was to follow this line in his introduction to the catalogue of the *La Vie Moderne* exhibition; with Monet, "no profusion of preliminary sketches, no more crayons or water-colours to be used in the studio, but oil-painting begun and wholly completed before the natural scene that inspired it, directly interpreted and rendered." And here is the artist, "paintbrush in hand". "He abruptly begins to cover [a blank canvas] with areas of colour that match the patches of colour offered by the nat-

ural scene. Often, during the first session, he can only obtain a sketch. The following day he returns to the spot, adds to the first sketch and the details are strengthened, the outlines grow more precise. He continues in this way for an unspecified time, until the picture satisfies him."

This was undoubtedly true of many pictures, which Monet called "studies"; their scrupulous fidelity to nature is unmistakable. But as we saw with the Salon paintings, studies made spontaneously out of doors could also be worked up to create pictures painted out of season and away from nature. This second procedure was studiously ignored by Tabouret, Duret and all those who afterwards received Monet's "imprimatur"; they thus helped to define the image that he chose, that of the Impressionist par excellence, the unconditional devotee of outdoor painting.

After considerable preparatory work, 18 works were entered in the catalogue of the exhibition, in which Duret's introduction was preceded by a portrait of Monet by Edouard Manet. *Floating Ice* (568), rejected by the Salon, was number 1 in the list; other recent works alternated with paintings dating from the Argenteuil period and even earlier works, such as *A Hut at Sainte-Adresse* (94) of 1867. *The Rue Montorgueil, 30 of June 1878* (469) was also included. Monet arrived in Paris the day before the private view of Sunday 6 June; on the following day, the gallery opened to the public, who flocked in. Charpentier and Bergerat worked hard to promote the exhibition: on 12 June, *La Vie Moderne* published the Taboureux article, set in columns around the Manet portrait. In the next issue, a drawing by Monet himself, reproducing the 1867 *Marine* appeared, along with a flattering report stating that almost all the paintings had been sold on the first day. Since many of them were no longer the artist's but had been lent by their owners, this was somewhat misleading.

Mme Charpentier herself expressed an interest in *Breakup of Ice*, alias *Floating Ice* (568). She wished to give it to her husband. Monet initially requested 2,000 francs; she offered 1,500 francs, payable in three instalments, in October, 1880 and January and April 1881. Monet reserved his decision until he had consulted Ratisbonne and Ephrussi, but since both were happy to buy lesser works, he decided to accept Mme Charpentier's offer on certain conditions, one being that he should be enabled immediately to pay off a creditor who was seeking a distraint on his paintings. Creditors in fact absorbed a large proportion of the Charpentier instalments; the April 1881 payment was made to the exclusive benefit of one among them. Degas condemned what he described as Monet's "frantic self-advertising", but though it was not immediately effective, it definitely contributed to a new and more favourable reception of his work and prepared the way for future success.

Flourishing

The day after he had submitted his works for the Salon, Monet went back to Vétheuil to work. There are signs of his being a little bored with subjects he had often painted, and of his therefore choosing new approaches and extending the range of his expeditions. He painted Lavacourt not from the by now customary point of view, but through a curtain of willows (611–613) or close up (614–615). The bank and the islands, upstream and down, offered hitherto unsuspected prospects (579–580; 590–596). The La Roche-Guyon road was painted, sometimes looking away from Vétheuil (582–584), sometimes towards it, but from further off than before (581). Monet took this road for excursions to Chantemesle (588) and as far as Haute-Isle (589), whose beauty had been celebrated by

The Sea Seen from the Cliffs
1881
Cat. no. 648

Les Petites-Dalles, the beach and the
Falaise d'Amont
Postcard, early 20th century

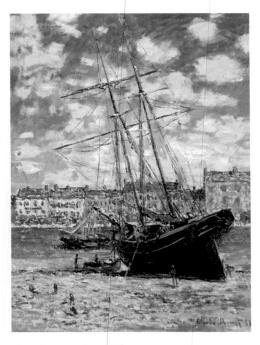

Boat Lying at Low Tide
1881
Cat. no. 644

the poet Boileau. Two "Spring Effects" (586–587) include panoramic views also found in other paintings (599–600, 603–604). There are also more intimate glimpses of the Seine (601–604). Alongside views of Vétheuil similar to those of the previous year, we find variants caused by the trees that had grown up on an island which stood between the painter and the village. A walk in the direction of Vienne brought together the movement of the leaves and the movement of a stream at a place called Paradis (616). The young woman to be found in certain of these paintings – often carrying a parasol – is Alice Hoschedé (579, 596, 608–609, 613).

In early July, while awaiting publication of Zola's study, Monet confessed in a letter to Duret that he was in fine fettle for work, something that he rarely acknowledged, and joyfully promised Duret a souvenir of this mood. He was in Paris for the first 14 July festivities. Hoschedé had come for that date to Vétheuil, which was all decked out with flags, and he seems to have drunk all the alcohol in Monet's possession, since Monet ordered a barrel of brandy from Duret immediately on Hoschedé's return. Monet, no doubt, honoured the local traditions with a glass of calvados drunk between courses, as he was later to do regularly at Giverny.

His family attachment to Normandy was also strong. His cousin Lecadre – probably the one whose caricature he had drawn – asked him to take part in an exhibition due to open in Le Havre on 1 August 1880. The Salon picture (578) was intended to attract admirers to the little batch of paintings that he decided to send with it in the hope of a sale. The inhabitants of Le Havre were, however, merciless with their former compatriot. Sock, in his *Comical Review of the Le Havre Salon* offered a vicious caricature of one of the paintings, which he christened *Spring Soup*. Those who still remembered the success of "Oscar", the caricaturist, tended to deny their man in the face of hostile criticism of his paintings.

Around 10 September, Monet went to spend a few days in Rouen with his brother Léon, who took him to Petites-Dalles, a tiny seaside resort in the Pays de Caux where he often spent country weekends. Its landscape was notable for spectacularly high cliffs and deep, dry, clefts between them. Monet made some studies that allowed his newer admirers some notion of his talent as a painter of seascapes (621–624). The excursion was to be the first of a series of visits to the Normandy coast over the next few years.

After a short lull, Monet's financial demands upon his loyal supporters, Duret and de Bellio, started up again; in the autumn they redoubled. This is somewhat surprising. Sales of the paintings fluctuated, attaining their minimum at 250 francs in September because of the Normandy trip, and a maximum in October at 2,380 francs. But the total for 1880, 13,938 francs, was a considerable advance over 1878 (12,500) and 1879 (12,285). The result was all the more respectable since it was obtained without any significant concession on price and because little of that year's revenue had any taint of the charitable. The devoted Caillebotte continued to pay the rent for the Rue Vintimille until April 1880; his name can still be found alongside various payments in Monet's account-book until February of the following year.

New admirers appeared. Among them was Delius, who paid 1,400 francs for two still lifes of fruits. Others disappeared, notably G. Petit, who bought nothing more after the month of February. In Vétheuil, a small local clientele had formed, first and foremost among them Narcisse Coqueret, a friend in time of need often mentioned in Alice's letters. His first purchase was in 1879 (532); he subsequently bought two other landscapes (583) and, in August 1880, had Monet paint his portrait (618). He commissioned two further portraits in early

1881, one of them of his son (**636–637**). Coqueret put Monet in touch with the Serveau family of Mantes, who purchased two landscapes and paid 150 francs for a portrait of their daughter, Jeanne (**617**). Finally, the notary Lauvray, unrelated to the plasterer of the same name, commissioned a portrait of his son André (**620**) in payment for his legal advice.

An addition to this little gallery of portraits was Blanche Hoschedé wearing a straw "riding hat" (**619**); Jean and Michel were also painted (**632–633**). Days of bad weather were given over to the production of a magnificent series of flowers and fruits. Fruit was easier to paint indoors than out; Monet had attempted to paint a view of apple trees laden with fruit, only to find the trees harvested as he worked.

The latter part of the year was overshadowed by the death of Mme Hoschedé senior on 10 December. Monet attended the funeral, afraid that creditors would make off with whatever had survived the depradations of Ernest Hoschedé during his mother's lifetime. There had been a lucky break for Hoschedé during the summer of that year; he was appointed manager of *L'Art de la Mode* whose first issue appeared in early August 1880. It seemed that he had finally come by a serious job. This "monthly magazine of elegance" was richly illustrated, had important backers such as Petit, Lucquet and Hébrard, and was to feature celebrated contributors. However, the celebrated contributors were less than forthcoming, and advertising too was thin on the ground. Monet and Alice were rightly worried; late that year, Hoschedé was replaced as manager. Under a new arrangement, he reappeared as editor-in-chief in the February 1881 issue. Yet paradoxically, this restoration of his fortunes was to be a source of new problems with his family and private life.

The Return of Durand-Ruel

In early autumn, a cold spell made life uncomfortable for the Monet and the Hoschedé families at Vétheuil, but their last country winter was ultimately less severe than the two previous ones. In December, incessant rain raised the level of the Seine considerably; in late January, at the end of a colder period marked by snow, a sudden thaw left the river again in spate; it reached its height on 15 February. This was when Monet painted the series of "Floods" (**638–642**) after a period of enforced idleness caused by an infected finger.

But the major event of the winter was undoubtedly the restoration of business relations with Paul Durand-Ruel, who was now able to call on substantial capital resources thanks to the support of Jules Feder, the Director of the famous Union Générale bank. (The bank was to be made bankrupt in the crash of 2 February 1882; the whole affair is described by Zola in his novel *L'Argent*.) Durand-Ruel's first renewed contact with Monet was in October, when he bought two paintings for 250 francs each. Four months later, the decisive meeting occurred when Durand-Ruel went to Monet's, Rue de Vintimille pied-à-terre. On 17 February and the following day, Durand-Ruel, overwhelmed by the quality of Monet's most recent work, bought 15 pictures for a total of 4,500 francs, of which 4,000 were paid immediately. The works included the "Floods" and a very recent *Chateau of La Roche-Guyon* (**643**), which Monet noted in his sales for February; Durand-Ruel, by contrast, noted it in April, when it was delivered. This shows that Durand-Ruel sometimes bought paintings that were only preliminary studies and which were finished at Monet's leisure.

With Durand-Ruel behind him, Monet now renounced the Salon for ever,

and took no part in the Impressionist exhibition for the second year running. As it was his seascapes that were most in demand, he decided to return to the coast of Normandy as soon as winter ended. This time, he chose Fécamp, where he had stayed before and which he knew well. He arrived there on 9 March, and lodged with M. Lemarrois on the Grand Quai.

The great fishing port offered a rich supply of subject-matter; big sailing-ships left high and dry by the tide (**644–645**), the spray-swept jetty (**646**), and admirable cliffs. It was those to the west (downstream, in local parlance) that attracted Monet. He set up his easel, sometimes at their foot (**651–652**), sometimes at the cliff-edge, where he painted vertiginous views down over the ocean; in the distance, one can make out Cap Yport (**648–650**). Some days, he followed the coast to Grainval, then turned back to face Fécamp whose jetty and Notre-Dame-du-Salut church can be seen clearly (**653–656**). One original view was taken from the cliff-face itself, looking out to sea (**657**), others again on a level with the waves (**658–660**). As he had done the previous year, Monet returned to the theme of *Rough Sea* (**661–663**). A short visit to Petites-Dalles, no doubt a weekend spent with Léon, allowed Monet to return to some of the subjects that he had painted there the previous year (**664–665**); it is possible

Rough Sea
1881
Cat. no. 663

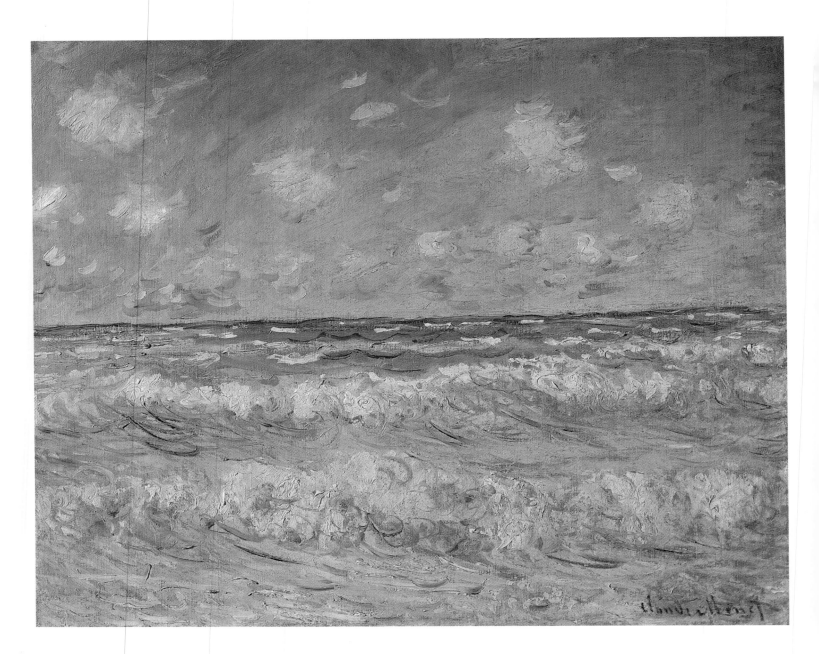

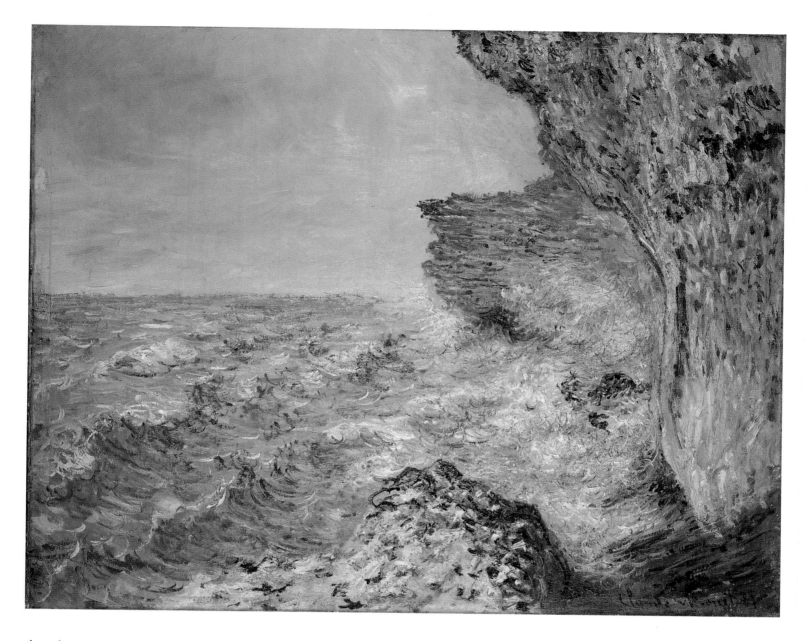

The Sea at Fécamp
1881
Cat. no. 660

that these are simply repeats of that year's paintings, but (**664**) is not wholly derived from any of these, and a second visit seems the more likely possibility.

Monet had originally expected to spend only three weeks in Fécamp, but was able to stay longer thanks to the funds that he received from Durand-Ruel. He returned to Vétheuil around 10 April, and took part in the birthday celebrations of Marthe's seventeenth birthday on 18 April. Hoschedé did not make an appearance, despite the coincidence of his eldest daughter's birthday with Easter Monday. Marthe was upset by his absence and by what she suspected of the relationship between Alice and Monet. She refused to imitate her brothers and sisters, who called the painter "papa Monet".

Monet stayed in Vétheuil until the end of the month, seduced by the charms of the countryside and by the need to work up the studies that he had made. He finally left for Paris on Friday 29 April, with a batch of recent works. A collector offered the pick of these works on the following day seems not to have chosen any. That afternoon it was the turn of Durand-Ruel, who had been imperiously summoned. He bought four pictures immediately; in early May, other purchases brought the total to 22 paintings bought for 300 francs each, of which 18 were views of Fécamp and Petites-Dalles. One thousand francs were paid on 5 May, a further 1,000 on 8 May, and the ironmongers Vieille et

Troisgros served as intermediaries for a further 500 francs. On his return to Vétheuil, Monet took to his bed, exhausted by week upon week of continuous effort.

Conflicts

As soon as he had recovered, Monet threw himself into his work. The Fécamp cliffs had reminded him that those of Chantemesle were close to the house (**667, 669, 671**). He painted further views of Vétheuil, some with the river in the foreground (**668, 670, 697**), others offering new prospects of the church and village (**672, 696**). The islands, especially the Saint-Martin island, continued to offer attractive prospects (**678–679, 700**). Nor did Monet forget the Lavacourt plain (**676–677, 698–699**) or a little branch of the Seine in which the descending line of the hills was masked by the strong verticals of tall poplars (**673–674**). His choice of panoramic viewpoint on occasion completely removed all trace of habitation (**675, 693, 704**). The framing of the views and the high horizons of some of these paintings betray a new audacity (**698–699**).

A whole series of paintings offers glimpses of the garden that led down from the road to the Seine. Alice stretches out dreamily under the shade of a fruit-tree; behind her, a paling fences off the orchard from the river (**680–681**). When the garden gate is open, we can see some of the houses of Lavacourt (**690–691**). By going a little way back up the slope of the garden, Monet could paint a prospect that included most of Lavacourt (**692**). Higher again, the whole meander of the Seine becomes visible (**693**). With his back to the river, Monet also painted the view from the garden towards the houses and the road. In April 1881 he had sold a preliminary version of this motif to Durand-Ruel under the title "La Maison de campagne". In the summer, he returned to the theme, standing closer to the flight of steps with its bordering of thick clusters of sunflowers (**682**); the blue patterned vases are reminiscent of the garden at Argenteuil (**683**). In one of the paintings in this series, the two young ones,

Michel and Jean-Pierre, are as though petrified on the stone steps (**684**); in another, a female figure is standing behind them (**685**). The right-hand house is Monet's; this was the first time he had painted it in such close-up. It is as if he wished to fix upon canvas the memories of a place that he was soon to leave.

Despite the definitive turn for the better in his financial affairs, he had not paid any rent since 12 January 1880. In July 1881, the landlady demanded payment within 24 hours of 968 francs, the sum of at least six quarterly payments outstanding. She was certainly not intending to extend his tenancy beyond the three years specified in the lease, which was due to expire on 1 October. Monet had, in any case, decided that he would no longer stay in Vétheuil. In addition to the debts that he had accumulated, there was the problem of finding a school at which son Jean could continue his studies after primary school. In May, he asked Zola to provide him with information about Poissy, a few kilometres from Zola's residence at Médan.

For Hoschedé, the planned departure was an opportunity. He pressed his wife to return to him, making no secret of his dislike of the status quo. In her reply, Alice reassured him: "You reproach me with the fact that I am unwilling to come and live with you, whereas I have, on the contrary, decided to return to Paris in October... I urge you to rent the house that you have found and move into it and prepare for our return in October." She defends herself by attacking him: "You reproach me with not being alone at Vétheuil; the situation is as it was, and you accepted it before; your absences have grown longer. Whose fault is that?" To convince her husband that he was in the wrong, she added: "Anyway, your behaviour towards M. Monet creates a very strange and completely unexpected situation." The letter ends with "a thousand sad thoughts". Hoschedé cannot have been surprised by this; Alice had not signed off with anything more affectionate than the very conventional "kisses" since the previous autumn.

As the summer of 1881 approached, the two men were at loggerheads; if Monet was at Vétheuil, Hoschedé was excluded. Hoschedé feared even to write

Field of Corn
1881
Cat. no. 676

Poppy Field near Vétheuil
1879
Cat. no. 536

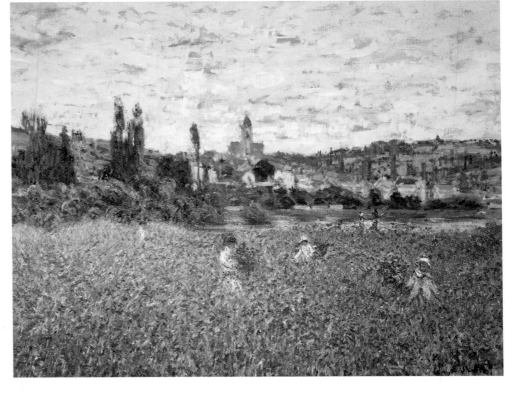

Vétheuil: a view from the Island
Postcard, c. 1900

The Steps at Vétheuil
1881
Cat. no. 682

Page 171:
Monet's Garden at Vétheuil
1881
Cat. no. 685

directly to Monet, and requested that Alice deal with the accounts. By late July, Hoschedé owed Monet over 2,000 francs in shared household expenses, though he seems to have paid some of this back over the course of the summer. When Hoschedé wished to attend the communion of his son Jacques on 28 August, Monet removed himself. He again went to the Normandy coast, as we know from the letter that he wrote to Durand-Ruel on 13 September, after his return to Vétheuil. The weather had been bad; he had come back almost empty-handed, but four paintings seem to have survived. They tell us that his trip to the sea had taken him to both sides of the estuary, to Trouville and to Sainte-Adresse: a return to his roots (686–689).

Leaving Vétheuil

Monet's surviving letters from 1881 are mostly to Durand-Ruel; this is increasingly true as the year goes by. After May, there is no trace of contacts with de Bellio and little sustained contact with Duret. In letters to Ephrussi, we find some indications of a transaction never completed. Concessions on prices were now a thing of the past. Monet preferred the regular outlet afforded by Durand-Ruel to laborious transactions with his former clients, and seems to have given him almost complete exclusivity. After the major transactions of May, which amounted to 2,500 francs, Durand-Ruel paid Monet 3,000 francs in June and 800 in August.

In October, there were more purchases. The standard price was 300 francs per work, but larger works reached 500 francs; the total for the month was 2,300 francs. November was better again, with 3,000 francs worth of purchases, including a *Sunset on the Seine, Winter Effect* (576) at 1,000 francs. With the revenue from December reaching 2,500 francs, the total for 1881 reached 20,400 francs. This was a considerable sum, though still less than in 1873, which remained Monet's best year, thanks to the first series of purchases by Durand-

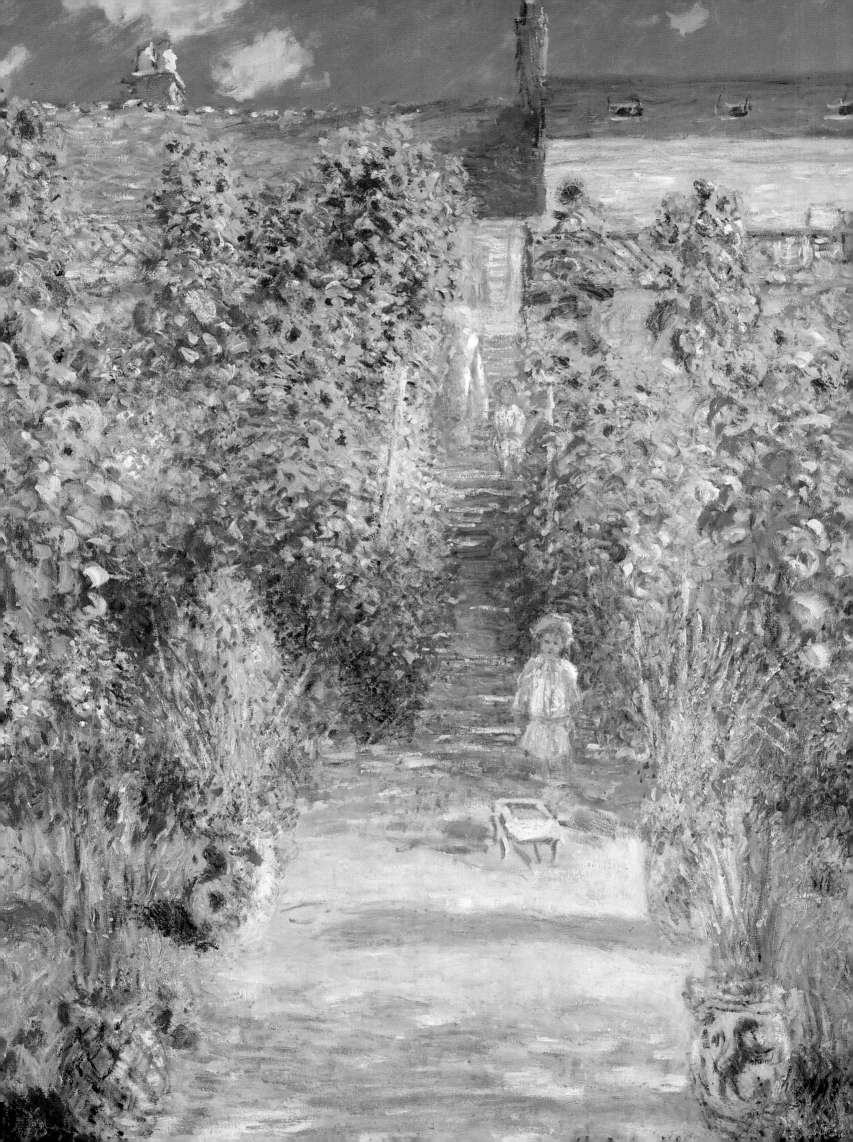

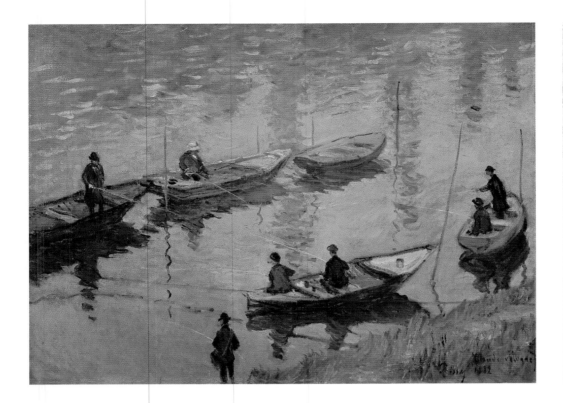

ABOVE AND PAGE 173 FROM LEFT TO RIGHT:
Anglers on the Seine at Poissy
1882
Cat. no. 748

Anglers at Poissy
Black crayon on Gillot paper with scraping
Cambridge (MA), Fogg Art Museum
(D. W. 1991, V, p. 126–127, D 435)

The Two Anglers
1882
Cat. no. 749

Ruel. The difference was that Durand-Ruel could be sure of selling not only recent works at good prices, but also those that he had now had in stock for almost ten years.

Towards the middle of September, Monet informed Durand-Ruel that he (Monet) had to "leave Vétheuil within the month" and "look elsewhere". Clearly, he was not intending to see out the lease, which expired on 1 October. He further noted his determination to do "lots of things" before he left. He made one or two brief trips to Paris to meet Durand-Ruel but quickly returned to Vétheuil, where he attended the baptism of his son Michel on 18 November 1881. Frantic voyages to Paris to seek the uncertain favour of his clients were now just an unhappy memory.

Alice's religious feelings lay behind Michel's baptism and the decision testifies to her influence over Monet. Though she had promised to resume marital life with her husband, she continued to equivocate, and when pressed to make up her mind, avoided the issue. But the household owed Monet more and more money: the debt rose from 1,505 francs on 1 September to 1,960 francs on 1 November and reached 2,962 francs on 1 December. If Hoschedé remembered his wife at all, Alice wrote, he should pay up. Hoschedé would not do so; quite probably he could not. Perhaps he was aware that these accounts, produced by Monet, were mainly intended to deter him from requiring Alice to return. But perhaps his refusal to pay had something to do with his unwillingness to receive a discontented wife and six children into his Paris life.

For Alice, to follow Monet to his new home was much more compromising an act than simply maintaining the status quo at Vétheuil. She needed a moral motivation to set against her own scruples and the criticisms that she suspected would be forthcoming from her family. That motivation was provided by Monet's two sons, whom she brought up with infinite devotion. Jean had been baptised; Michel had not. By agreeing to the baptism, Monet made an important concession to Alice, who could see herself ensuring their religious education. Monet's own religious feelings were unchanged.

The departure from Vétheuil was now long overdue, and it is by no means clear that Mme Ansault-Chauvel agreed to any extension. Local tradition has it that Monet and family stayed several weeks in a house in the Rue du Marché-au-Blé in the centre of the town. This house had belonged to the painter, Ennemond Collignon, since late 1880. A book of sketches of Vétheuil and the surrounding area made by his wife dates, in part, from 1882. It therefore seems possible that Collignon helped out a colleague in distress before moving into his house himself.

Sisley had been consulted about the educational resources of Moret-sur-Loing and had not been encouraging. Monet opted for Poissy, on the basis of the detailed information provided by Zola. Each Mantes-Paris trip had taken Monet through the little village, agreeably situated on the left bank of the Seine. He rented the villa Saint-Louis, close to the Seine, but we cannot be sure that he had moved in before 17 December. Jean and Jacques, the two older boys, went to school in the village; the Hoschedé sisters boarded at a religious school. On 25 January 1882, Monet made one last trip to Vétheuil to acquire at the town hall a fifteen-year grant of "two surface metres of earth in the part of the cemetery in which his wife, Camille Doncieux, is buried" as the official record has it.

The trip marked the end of an era. Monet's long period of struggle and hard work was starting to bear fruit. Under his brush, Vétheuil, like Argenteuil, had been immortalised in some of the greatest masterpieces of Impressionist art.

Poissy and the Collapse of the Union Générale Bank

By mid-December 1881, Claude Monet had left Vétheuil for his new home in Poissy. Poissy was then a small town of some 5,600 inhabitants, as yet little affected by the development of the outer suburbs. It stands on the left bank of the Seine some 20 kilometres west of Paris. The 1883 *Annuaire du Commerce*

tells us that it possessed one notary, two bailiffs and three doctors, and we know that it provided the required educational facilities for the Monet-Hoschedé children to continue their studies, which none of them were to take very far, in any case. The girls went to the Saint-Paul convent school, while the boys had the choice of state education or the Duplessier private school.

Although we have not been able to locate a complete collection of the local paper, *L'Indépendant de Poissy*, it seems likely that Monet's arrival passed largely unnoticed; the locals had eyes only for the very famous historical painter Meissonnier, who had lived in Poissy for forty years and been mayor in 1878–1879. Monet had chosen to rent the villa Saint-Louis, which had considerable attractions; to start with, it was much bigger than the house in Vétheuil had been. From its position in the northern area of Poissy it offered fine views over the little branch of the Seine (748–749), the islands, the old bridge upstream and the lime trees of the Boulevard de la Seine, which was lined with tall, picturesque, old houses (747). Monet, nevertheless, saw little in Poissy to paint on arrival, and his first impression proved a lasting one.

The moral quandaries that he was living through no doubt affected his desire to paint. At Vétheuil, Alice Hoschedé had continued to live with Monet in an arrangement for which her husband Ernest had been partly responsible. After Camille's death, Alice had taken responsibility for Monet's children and this had saved appearances in the eyes of both her family and society at large. But following Monet to Poissy was a completely different matter. The scandal was now in the open, and the protagonists of this bourgeois drama could no longer avoid it. Relations with Hoschedé were so tense that he no longer dared to visit his wife when Monet was present. Monet therefore hastened to finish some of the previous season's paintings; not without anxiety about what Alice might decide in his absence, he took his leave for a few days.

On top of these domestic worries came new financial difficulties. On the very day when Monet wrote to Durand-Ruel to tell him that he was leaving for Dieppe, there came news of the collapse of the Union Générale, a large merchant bank. Its shares had lost most of their value in January, and it had now suspended payments. On 1 February, Eugène Bontoux, its founder, and Jules Feder, its official chief executive were arrested; on the following day, the bankruptcy was officially declared. Feder, a great lover of painting, had made substantial loans to Durand-Ruel, who was now forced to repay them. He went on to assist Feder out of his own pocket. In short, in February 1882, Durand-Ruel was considering his own future with some trepidation.

Monet seems to have been unaware of the gravity of Durand-Ruel's difficulties, and continued to plague him with requests for money. Perhaps he had not had time to read the papers, which were full of the event. The *Gil Blas* serialised a novel, *L'Amour de l'argent*, in which a bank called "The Big Union" was directed by one Feedorth, a rather transparent version of Durand-Ruel's friend. Durand-Ruel now needed to restore his standing by means of a successful and prestigious event. He therefore set about organising – with the help of the principal Impressionists and one or two new artists recruited by Pissarro – an exhibition of modern painting. He would need all his patience and diplomacy to attain his goal.

At "La Renommée des Galettes"

Having left Poissy "first thing in the morning", Monet missed his connection at Mantes and went to Rouen by omnibus before taking the train to Dieppe. He

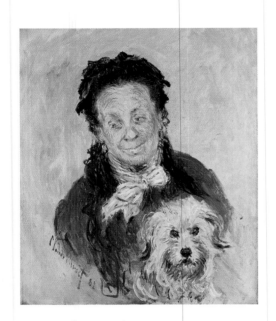

Portrait of Mère Paul
1882
Cat. no. 745

arrived at around two in the afternoon, and went to the Grand Hôtel du Nord et Victoria, on the Quai Henri-IV, where he took full board at 20 francs a day, in his view a high price for unsatisfactory accommodation.

The sea was wonderful, but the cliffs seemed to him less beautiful than those of Fécamp. And he found Dieppe too urban; he wanted to escape, and walked "all over the countryside, along all the paths, above and below all the cliffs." His search continued the following day at Puys and at the Chalet de la Dame Blanche: "I look at everything and nothing grips my imagination." He wondered about heading off towards Saint-Valéry-en-Caux and his beloved Fécamp. In the evening he was depressed, dividing his time between his lonely hotel room and the provincial cafés. But when a painter offered him the use of a studio, he decided to attempt a few subjects: the outer harbour, with the quay-side houses dominated by the bulk of the Saint-Jacques church (706), and a panorama of Dieppe with the Saint-Rémy Tower at the corner of the Castle walls in the foreground (707).

His dissatisfaction was enhanced by his memories of Fécamp, and the organisation of the group exhibition came as an added torment. If "certain persons were involved", Monet was disinclined to participate. Degas, who had reproached him for returning to the Salon in 1880, was not a participant; but this was not a motive in itself, as he made clear to Pissarro and Caillebotte. Durand-Ruel, on the other hand, was accusing him of endangering the entire enterprise. Monet then gained the apparently false impression that Caillebotte was to be excluded, and was furious that Guillaumin, Vignon and Gauguin were to be included. He stated that he would do nothing without Renoir, whose attitude to the business was very close to his own.

By 5 February, discussion of the exhibition had brought to light the serious divisions within the group. Monet had by then left the Hôtel Victoria for Pourville, which he had discovered two days before. Pourville, 5 kilometres west of Dieppe, was then a little fishing village adminstratively divided between Hautot and Varengeville; the nearest post-office was in Offranville. Summer bathing in Pourville had been sufficiently successful for a casino to be built at the west end of the beach, "right on the shingles", so that "the waves [broke] against the foundations of the house". This establishment included a hotel and restaurant called A la Renommée des Galettes, run by Paul Graff and his wife Eugénie, "good people", from Alsace. They were delighted to welcome an out-of-season visitor, for whom they "really put themselves out", they, their son and their daughter-in-law "Mme Eugène". His room cost Monet just six francs a day.

One day when the weather was bad, Monet painted two particularly succulent specimens of Paul Graff's speciality, the galettes on their wicker trays (746); on another occasion, he painted portraits of the hirsute old cook under his chef's cap (744) and Eugénie, thoroughly intimidated by the "Parisian gentleman", by whom her dog too seems fascinated (745). The warm welcome, combined with the beauty of the place, its high cliffs and deep valleys, were having their effect. Dieppe would have been completely forgotten had it not been for the kind colleague and his studio. The weather was very changeable, and Monet had occasion more than once to regret the fact that he was unable to find the cavities in the Fécamp cliffs where he could work in all weather.

While the first Pourville studies were being painted, Alice Hoschedé was finding that she hated Poissy. She was facing the usual financial difficulties, aggravated at the time by the illness of several of the children. She pestered Monet with demands for money, and he in his turn did the same to Durand-Ruel, even before agreeing to take part in the planned exhibition. When he

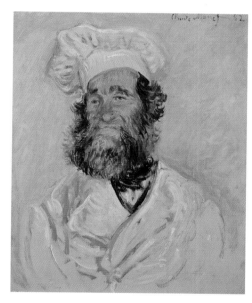

Portrait of Père Paul
1882
Cat. no. 744

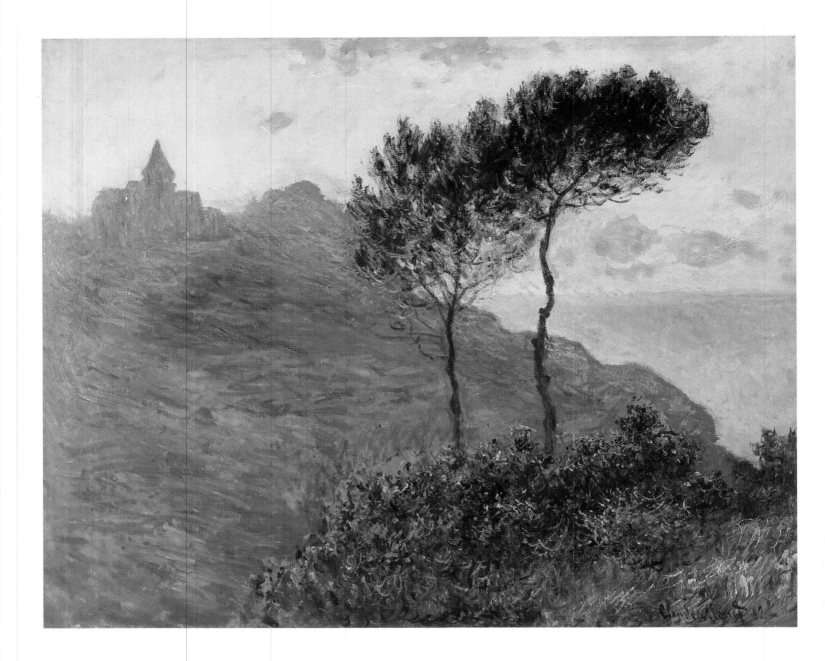

The church at Varengeville
Black crayon on Gillot paper
(D. W. 1991, V, p. 128, D 437)

ABOVE:
The Church at Varengeville, Grey Weather
1882
Cat. no. 725

finally agreed to participate, he had to choose pictures and titles from his hotel in Pourville, which he was unwilling to leave. The seventh Exhibition of Independent Artists finally opened on 1 March 1882; the catalogue listed 35 works by Monet, one less than Pissarro at 36 works, and more than anyone else.

From the Reichshoffen Panorama to the Pourville Seascapes

The exhibition, so laboriously put together by Durand-Ruel and his loyal supporters, was held at 251 Rue Saint-Honoré, in a room designed by Charles Garnier, in the palace constructed for the Panorama of the Battle of Reichshoffen. It was a curious choice to place the "phalanx" of independent artists – "seven grenadiers and a canteen-woman" as Henry Havard put it in *Le Siècle* – just above the premises on which "the death-throes of the guards at Fröschwiller", "one of the bitterest days of our 1870 defeat", were exploited by other artists. These were the ironic words of Clarétie in *Le Temps* and Burty in *La République*

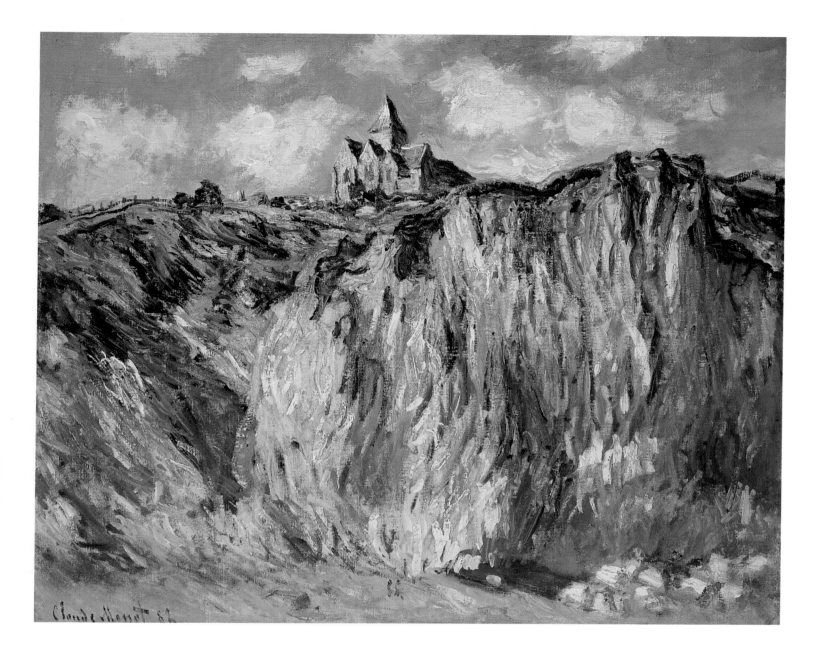

The Church at Varengeville, Morning Effect
1882
Cat. no. 794

Française. Their irony was misplaced; in 1882, the patriotic scene offered a kind of moral sanction to the exhibition. Long lines of carriages waited in the Rue Saint-Honoré as high society successively visited the Indépendants and what Albert Wolff deemed the "detestable" Panorama.

Many journalists came to the private view, and what was more, the daily papers went so far as to print what they wrote; the Impressionists were now a noteworthy phenomenon. Several articles pointed out that Degas was not among the exhibitors, and Albert Wolff complimented him on his defection. Raffaelli, too, was absent, and much honoured in his absence, but those who knew anything about the group were aware that the return of Monet and Renoir was something of an event. The verdicts of the critics were less forthright than they had been; those who praised did so with reservations, and those who condemned the exhibition made some allowance for attenuating circumstances. Opinions were no longer divided along political lines; the conservative papers were not systematically critical nor were the republican papers invariably sympathetic. *La Patrie,* a right-wing paper, recommended this "very interesting" exhibition to its readers, while the Voltairian *Le Siècle* rehearsed the old accusation that "these [were] merely preparatory drawings", in an unflattering culinary

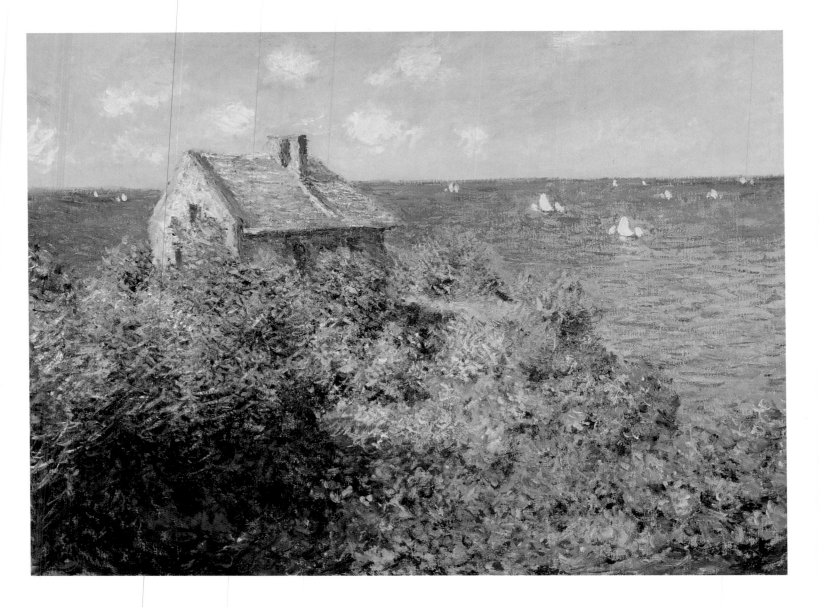

Varengeville, Petit Ailly Gorge, with the fisherman's house on the left
Postcard, early 20th century

ABOVE:
The Fisherman's House at Varengeville
1882
Cat. no. 805

metaphor: "the hare has been killed; but there can be no jugged hare until a sauce has been made." It was the colours that most surprised the critics, and accusations of colour-blindness were the order of the day. *L'Evénement* was glad that the afflicted should have chosen to "confine themselves to art rather than make a career on the railways". Some papers found grenadiers and canteen-woman much of a muchness, others attempted to make distinctions. The size of Monet's contribution caused some surprise, and he was not exempted from the prevailing criticism of the Independents' use of colour, though, oddly, there was no consensus as to the hue that prevailed. *Gil Blas* thought Monet perceived rocks and ocean in a shade of "light red", while *Le Petit Parisien* found his canvases were covered with a "vaguely blue wash".

Praise was divided between the Vétheuil landscapes and Fécamp seascapes. The latter were "abominable" in the considered opinion of *Le National* but otherwise had a most flattering reception. *La Patrie* had some reservations about the use of colour, but noted "absolutely remarkable perspective effects". The words of Ernest Chesneau in the *Paris-Journal* were appreciated by Monet himself: "I stop before these admirable seascapes, in which, for the first time, I see rendered – and with such extraordinary power of illusion – the upswells and long descending sighs of the ocean, the rivulets of the eddying waves, the glaucous surface of the deep water, and the violet hues of the low tide above its bed of sand."

The seascapes were a big success, and immediately after his return to Paris, where he stayed for the opening of the show, Monet returned to the task. He was now quite at home in this corner of the Caux, and, in a fever of creative energy, returned to a number of motifs simultaneously, rushing from the eastern end of the Pourville beach (709–712) to the Varengeville church in the west (725–728). He returned on 5 March, and was so disappointed with two paintings begun before his departure that he almost immediately scratched them out. His long walks up and down the shoreline tired him, but he felt sure of returning with "things better than anything I have done before". He suffered a bout of fever and there was a nasty midge bite to contend with. Dinner with the local curé was a pleasant diversion. On 24 March, a letter from Alice delivered to him as he was painting some one hour's walk from the hotel caused him considerable anxiety. But the following day he was writing to Durand-Ruel, telling him that certain pictures were finished, that the weather was splendid, that he was expecting to finish yet more, and was looking forward to "seeing the whole series of studies" on his return. He was expecting to be back in Paris for Easter (which fell on 9 April in 1882), but postponed his return for a few days and spent them working "like a madman". This was increasingly the way his painting trips went.

"Will you like what I am bringing back?"

At Poissy, Alice was assailed by problems of every kind. Her annual income of 680 francs was insufficient to support herself and six children. Ernest Hoschedé (whom she continued to address with the familiar "tu") was still, in law, her husband, and she wanted him to provide for the children's needs and pay off the debts from Vétheuil. At the same time, she asserted that she would no longer ask anything of Monet, claiming that she already owed him a great deal of money. This curious fiction was intended to preserve appearances. It was the more transparent since she was overtly looking after the painter's two children, something for which she might legitimately have requested payment and even an advance. Hoschedé was roundly instructed to pay up – he did indeed pay 100 francs in February, but nothing more was to follow – and was summoned to Poissy in Monet's absence. Since he had still not visited by the time of Monet's return, he was enjoined thereafter to specify the hour of his arrival in order to avoid meetings which might prove unpleasant for all involved.

Monet put the finishing touches to the pictures from the Normandy coast, then left for Paris; he had to vacate the Rue de Vintimille pied-à-terre, whose rent had hitherto been paid by Caillebotte, by 15 April. He made only a fleeting visit to Durand-Ruel, who had to wait until 22 April to see Monet return with a batch of 16 paintings, followed three days later by seven more. He could now answer with a resounding "yes" to the question Monet had asked by letter earlier in the month: "Will you like what I am bringing back?"

It is not always easy to distinguish the paintings executed during Monet's first stay in Pourville from those painted during the summer (751–808). The seascapes and views of the beach and lower cliff-face often show little sign of vegetation and were little affected by season. The *Fisherman's House, at Varengeville* (732), with its wintry vegetation is surely a product of the first trip. And we know the titles of the pictures sold in April 1882, though this is not always sufficient to identify them. They included a wide range of motifs: *Seascape*, several *Low Tide at Pourville*, several *Cliffs*, the *The Customs House* or *The Fisherman's House*, *The Gorge* and *The Church at Varengeville*.

The first 16 pictures brought in a total of 6,000 francs and the next seven 400 francs apiece, though these totals were, as so often in the past, partly written off against advances already received. Some weeks later, Durand-Ruel is said to have sold certain Monet paintings for 2,000 and even 2,500 francs each. But even if these figures, given by Boudin in a letter to Martin, are correct, they are likely to have been exceptional. What is certain is that Durand-Ruel appreciated the Pourville pictures, as he had those of the cliffs of Fécamp. In his accounts, he was often able to note "sold" next to the purchase entry, with the dates sometimes quite close together.

As Monet was still unhappy at Poissy – to the point of thinking of cancelling his lease – and as a planned trip to visit his brother Léon in Rouen had fallen through, Monet made a further trip to Pourville in early June to rent a house where the family could spend the summer. This was the Villa Juliette (**764**) in Pourville, not far from the bridge over the Scie (**765**). This time, Monet returned thrilled with the Normandy coast: "The country is wonderful at the moment and I can't wait to get back." He took the time to deliver eight pictures to Durand-Ruel on 9 June, restock his wallet, interrogate Georges Petit, whom he suspected of selling at too low a price, and then, as soon as the children's exams were over, on 17 June 1882, it was time to leave for a working holiday in Pourville.

From Euphoria to Despair

His family's presence and the certainty that he had the whole summer free for painting imparted a euphoria which, in the early days of this second stay in Pourville, overflowed even into his correspondence with Durand-Ruel. Monet was proud to show Alice his new domain and the subjects that he loved. These included the nets on the beach in which the fishermen brought in the fish at low tide to the joy of the children. The eldest boys were thrilled to make an expedition with Monet in the lifeguard's boat, and Blanche Hoschedé was pleased at the chance to paint outdoors for the first time.

Monet himself set to work with immense energy. He went even further afield than before. He went to the top of the Falaise d'Amont (**751–759**) on the Dieppe side, climbed the Cavée (or Côte) path (**760–763**), and walked the length of the Falaise d'Aval as far as Varengeville church (**794–796**). He stopped off en route at the custom's officer's cottage in the Petit Ailly gorge, which he painted from every angle (**802–806**). He was also attracted by pines and isolated trees standing on the high ground by the sea (**797–802**). The Scie was rather neglected (**765–766**). On the other hand, he often set up his easel at the foot of the cliff, which he reached either directly along the Pourville beach, or via the Petit Ailly path (**804**), or the steep way down through the Moutiers gorge (**796**). He normally painted the cliffs looking west (**776–791**), though there are a few views to the east (**792–793**). From the Pourville beach he painted both wavescapes (**771–774**) and boats out at sea (**775, 783–786**) as well as the very typical image of fishermen's nets (**768–770**).

The Pourville-Varengeville paintings exude an impression of creative joy that is rather destroyed by Monet's correspondence, at least after his first enthusiasm had faded. In the summer of 1882, the weather on the Normandy coast was poor, and Monet awaited bright spells with impatience. July was typical of this bad weather, and the arrival of Durand-Ruel, probably for the national holiday, brought a pleasant diversion, though a visit from a local bailiff caused understandable alarm. There was the second such visit in August. A few days of

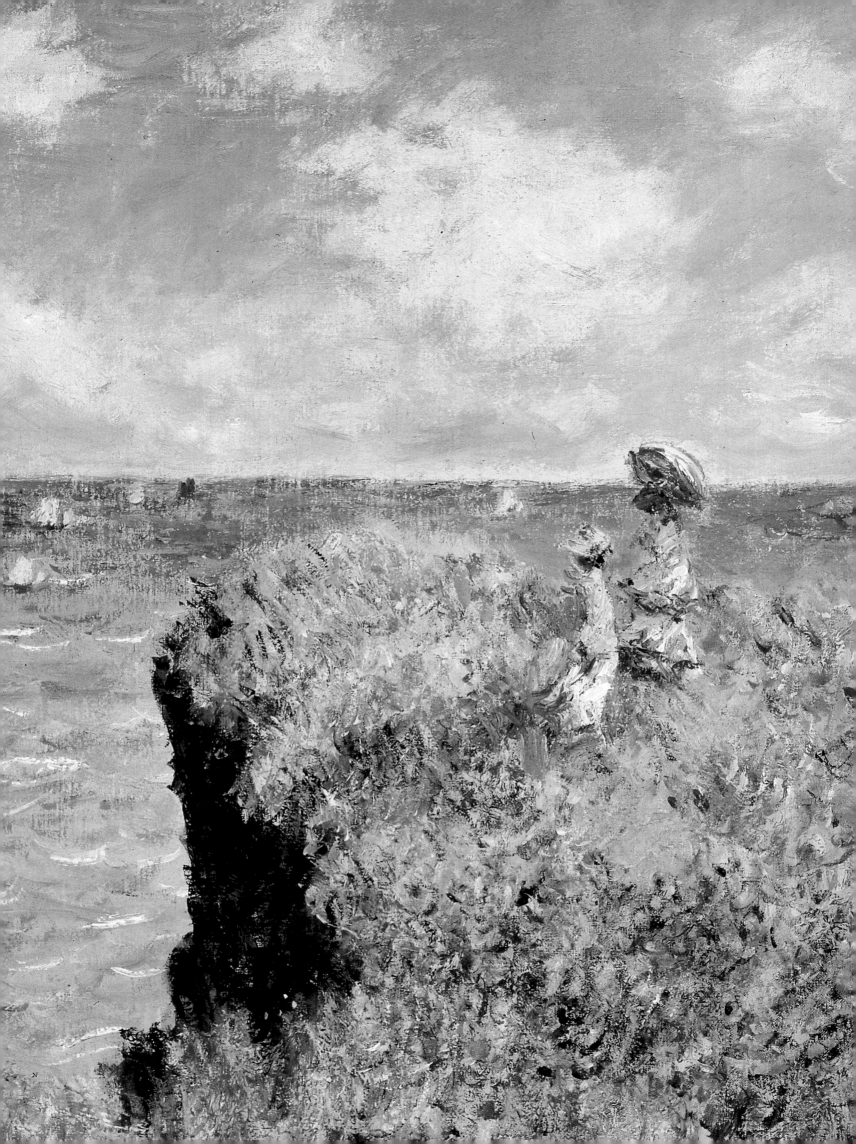

bright sun in mid-September improved Monet's morale, but the thought of the bills that would have to be paid before leaving was beginning to depress him. And there was also the children's new school year to think about. Rain settled in again. Monet was disheartened; the number of studies that he had begun was "crazy", yet none of them had been finished, or at least, none was satisfactory. He scratched over and even slit several paintings, including a large picture of flowers. On 18 September, Monet's despair was complete; he spoke of "giving it all up now" and reimbursing Durand-Ruel's advances with pictures that had remained at Poissy.

Fortunately, Durand-Ruel was aware of these problems, and immediately put 1,500 francs into the post with a letter of encouragement. The weather was again fine, but Monet was so dismayed that he shut himself up for "a whole week" with his bouquet of flowers, only to destroy the painting yet again. In late September, disgusted with himself and the neighbourhood, he left with the children to spend a few days relaxing in Rouen with his brother. Clearly, Alice's presence had not had the beneficial effect expected. She was, after all, still anxious about her own position; as her "most recent conversations" with Hoschedé had been "very grim" and a further meeting had produced nothing but "nonsense on both sides", she ordered Hoschedé to put his plans for the future down in black and white "after calm reflection" and promised that she herself would think at length about her reply.

Fishing Nets at Pourville
1882
Cat. no. 768

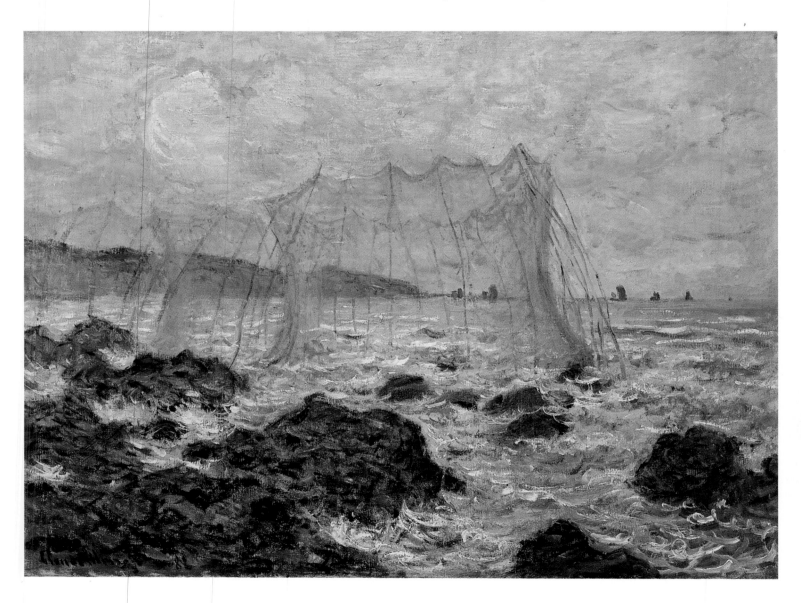

On his return from Rouen, Monet found the landscape so radically changed – something he had been worrying about constantly over the last few weeks – that there was nothing for it but a return to Poissy. He, Alice, the children, and a mountain of luggage and unfinished paintings removed to Poissy on 5 October 1882.

Provisional Reckonings and a Further Trip

Monet's activity on his return gives the lie to the claim that, after his formative years, he never finished a painting in the studio. His letters to Durand-Ruel, though they state the contrary, make it clear that he was working hard – in the studio – at finishing the Pourville studies. On 16 October, he delivered not eight or nine pictures, as he had first announced, but a series of 13 paintings for which he received 5,200 francs. Thirteen more paintings followed by the end of the month, for which he received a further 5,900 francs. And with one exception, they are all of Pourville. Simultaneously, from around 20 October Monet was working on new outdoor subjects at Poissy.

But the Poissy paintings never came to anything, and by early November, Monet took a few days' holiday along the banks of the Seine in search of a new place to live. He then began a painting of flowers; this was clearly a subject close to his heart that year (809–813). At the same time, Sisley was writing to him about exhibitions. Monet was, in principle, against collective exhibitions, but he also knew that separate exhibitions for all group members would bring new difficulties in their wake. He therefore suggested smaller groups, each of which would contain one landscape artist and one figure painter. The suggestion shows how well he understood the interests of all who were involved – there was no opposition from Degas to this proposal – and above all those of of Durand-Ruel, who should, Monet insisted, have the final say.

The Monet family had begun to get word of the fact that Claude's paintings were selling better; perhaps he even told Léon himself. At all events, Léon made a note of the fact when the two met in September, and the upshot was an abrupt demand for the return of an ancient loan of 1,500 francs. Monet, very consistent in such matters, had not been expecting to pay it back just yet.

In early December, there was alarm of another kind. The Seine had overflowed its banks and there was a danger of flooding. Despite the height of the bank in Poissy, the Villa Saint-Louis was surrounded by water, and since the servants, without whom life at Poissy, too, was unthinkable, had fled, Monet had to remain in the house and look after his entourage. Thus, despite Dr de Bellio's encouragement, he was unable to take advantage of the "very curious things" which he would have liked to paint. Fortunately the Seine reached its maximum height on 9 December, thereafter quickly sinking back into its course, and everything returned to normal. When Monet drew up the accounts for the year, the total for sales to Durand-Ruel was rather satisfactory, at 24,700 francs. But he had received 31,241 francs over the course of the year, and faced a 6,541 franc deficit; this was made up in part by a further delivery on 6 January 1883.

The sullen atmosphere of the Poissy household was aggravated by the climate of political insecurity prevailing throughout France in the wake of Gambetta's death. Economic stagnation seemed likely to follow. Monet nevertheless decided to return to the Normandy coast on 25 January 1883. After a short stay at Le Havre, his childhood home, from which he was quickly driven by the incessant rain, he went to Etretat. This was a place that he knew well; the

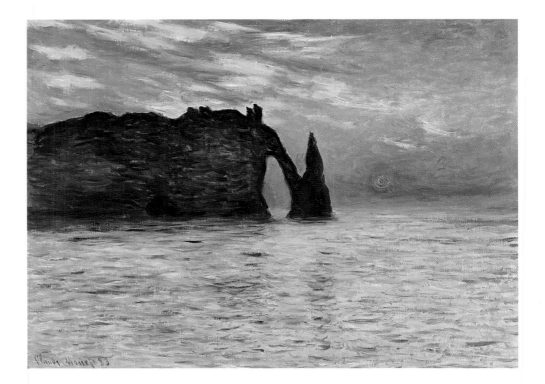

Etretat, Sunset
1883
Cat. no. 817

Etretat – Sunset
Postcard, early 20th century

spectacular landscape – "the cliffs here are like nowhere else" – filled him with inspiration and enthusiasm.

The Hôtel Blanquet at Etretat

The Hôtel Blanquet at which Monet came to stay on 31 January 1883 was on the left-hand side of the Etretat beach (looking out to sea), and a little behind the "perry", a dry dock for small craft; its sign described it as "The Artists' Rendez-Vous". Monet was enchanted with the place. "My subjects are at the door of the hotel and there is even a superb one from my window." Ten days later: "I have been able to set up in an annex of the hotel, from which there is a superlative view of the cliff and the boats." In bad weather, he could paint without leaving his room. In February, Etretat was almost deserted; no bathers, few passers-by to disturb him, and a single newspaper. Since Monet was not a man who felt the cold, this was the ideal season for uninterrupted work.

During the first few days of his stay, Monet contemplated two big pictures for a planned one-man show at Durand-Ruel's. One would be of the Falaise d'Aval, "after Courbet", the other of boats. He added, in a letter to Alice, that he would "bring back a mass of documents and do great things at home." Now, it seems, it was not just a question of finishing indoor paintings he had begun in the open air; he was going to create the whole painting in the studio on the basis of studies made at Etretat. This was a return to the practices he had adopted when working for the Salon, and prefigured his method of working on the *Water-Lilies*.

His joy at the spectacular scenery of Etretat was soon followed by a whisper of anxiety: would he be able to transpose to canvas even a quarter of these admirable sights? Meanwhile, he was prepared to run risks that he had shied away from fifteen years previously. But was he not more of a man by now, and, we might add, more likeable? He therefore braved places where had not previously ventured, writing to Alice to tell her so. Probably, this refers to the cleft in

the Jambourg which ran down from the top of the Falaise d'Aval and allowed Monet a prospect of the Manneporte (832–833) and the Porte d'Aval with the Needle rock (831), subjects that he had first painted in 1883. Some parts of the path were so vertiginously steep that when brother Léon came to spend the first Sunday of his stay with him, he had to "hold his hand as if he were a lady" on the way down.

Léon was of no assistance to him whatever; he was even a little irksome, whereas, confronted with "all these beautiful things", Monet would have liked to know Alice's reactions and regretted her absence. This was no simple compliment, since such remarks are found elsewhere in his correspondence and testify to Alice's importance to him on both emotional and artistic planes. His emotions were changing, and though he invariably began "Chère Madame" and never went so far as to use the familiar form "tu", his letters now went somewhat beyond the confines of bourgeois convention. Kisses, caresses, and one or two declarations of love are to be found. They suggest a crisis in his emotional life, which was soon to come to a head.

Hoschedé, taking a winter holiday at Vétheuil, had suddenly come to his senses and was speaking of taking back his wife and children. Monet, apparently so anxious that husband and wife should meet, was suddenly tormented by the thought that he might lose Alice, with whom he had now been living for almost five years. One day when she was slow to return from a trip to Paris, he made half-serious, half-joking remarks that he had to apologise for by return of post, bidding her farewell and addressing her as a woman of loose morals. When Hoschedé and Alice finally met on Sunday, 18 February, and he knew that Hoschedé was actually at Poissy, he was in a state of anguish, could not put brush to canvas, and sent off a telegram asking for news. He wept over the four laconic lines that he received the next day: "Must I learn to live without you?" And, to cap it all, he had forgotten Alice's thirty-ninth birthday on 19 February. It was a trivial point compared to the decision facing Alice, but he was compelled to ask her forgiveness yet again: "You know I am not a man for dates."

As if this were not enough, the weather was worsening. The sun had shone during the early days of his stay, but now gave place to rain; a storm forced the fishermen to move their boats from the positions they had occupied along the sea-wall, and the plan for a big painting had to be abandoned. A letter from the Durand-Ruel gallery had informed him that the opening date for his one-man show was 1 March, and he increasingly feared that he would have no Etretat paintings ready. Monet frequently continued his painting trips well beyond the date originally planned, but this time he knew that he could not stay beyond 20 February. It came to seem to him a fateful and premonitory date. He felt that his efforts were fruitless, that he was working too fast, that his work was unsatisfactory. All this is difficult to believe when one stands before the Etretat paintings of 1883; the cliffs with the Falaise d'Aval (816–822), the Falaise d'Amont (826–830), those "great arches... like two legs of cliff walking out to sea", the boats and "caloges" (823–825, 828–829), the Needle "of white, pointed rock" and the Manneporte (832-833) "an immense arcade under which one can walk dryshod at low tide". (The descriptions are taken from Maupassant's *Une Vie*.)

After these "terrible days", Monet left Etretat in the early hours of 21 February and arrived at Poissy in the afternoon. Hoschedé, no more anxious for a meeting than Monet, had presumably already left. If any decisions had been made, they did not change the status quo; Alice remained at Poissy, not unhappy to have obtained from Monet written declarations of love and commitment which she had, perhaps, long desired.

"The Fiasco of My Exhibition"

Very few — if any — of the Etretat paintings were finished on the spot, not least because Monet was also busy writing letters to invite collectors to his exhibition. Some of these were major collectors like Faure and de Bellio, others belonged to the Vétheuil circle such as Serveau and Coqueret (Monet made rather cruel fun of the latter). A more recent addition was Paul Graff, whom we thus discover to be the owner of *The "Galettes"* (746) and of his own portrait (744). Alice was a little worried about the portrait being included in the exhibition, but Monet felt that it would be a "diversion" and included it all the same.

The invitations for the private view had been sent out. It was to take place on Wednesday, 28 February from 8 to 11 pm in Durand-Ruel's new and expensively redecorated gallery at 9 Boulevard de la Madeleine. This was close to where the first group exhibition had been held, nine years previously. The catalogue, published by Gouery, contained 56 items. Some of these paintings still belonged to Durand-Ruel, others to persons who may just be men of straw, others again to some of Monet's earliest admirers, in particular Faure, de Bellio, Delius, Duret, Charpentier, Fould, Bérard, and his old Zaandam acquaintance, Michel Lévy. Serveau and Graff represented the newer generation of admirers; Graff was misspelt "Graft". The Pourville-Varengeville paintings had pride of place and there were no Etretat paintings at all.

Etretat: the Porte d'Amont, high tide
Postcard, c. 1900

This time, Monet was facing press and public alone, as the first of the group to have a solo exhibition. Camille Pissarro's letter to his son Lucien conveyed a rather optimistic impression — "great artistic success, very well organised" — that reflected the generosity and optimism of the eldest of the Impressionists rather than the facts of the matter. At first, the public simply stayed away, and the press published almost nothing, in stark contrast with the Exhibition of the Independents, which had been the subject of several articles a day from the moment it had opened. The event was noted by some papers without further remark, and there was a single, somewhat ironic sentence in *Le Journal de Paris*; nothing else at all during the first days of March. Monet quickly gained the impression that the show was a "catastrophe" and wrote to Durand-Ruel about "the fiasco of my exhibition". He wrote three letters in succession to Durand-Ruel, in which his extreme disappointment is exacerbated by the sense that he was being sacrificed to those who would come after him and profit by his misfortune. That was one side of the case. The letters also express his calm confidence in his own worth, along with his contempt for publicity, whose necessity he nevertheless acknowledged for those who, like himself, were anxious to sell in order to survive and create.

Since a scapegoat was required, Durand-Ruel was accused of having prepared things badly: of having failed in advance to elicit the cooperation of the press and of having neglected to put up blinds in the furthest room of the exhibition, where the sunlight was much too bright. On this point such amends were made that one critic confessed that "certain pictures in the back room [were] in complete darkness and completely escaped me...." Meanwhile, other publications had taken note of the exhibition. On 6 March, H. Marriott in the *Le Journal des Arts* spoke of "a very great success". But Pissarro, again writing to his son Lucien, had now recognised the error of his first report, and noted that "the Monet exhibition, which is marvellous, is not making a penny at the door." But then, as if to dispute Monet's rather unjust strictures about the "so-called art critics, each as stupid as the next", there appeared major articles by Fourcaud in *Le Gaulois*, Gustave Geffroy in *La Justice*, Dargenty in the *Courrier de l'Art* and Paul Labarrière in *Le Journal des Artistes*. True, they expressed some

reservations, but with the exception of the Dargenty article, which was openly hostile, all of these critics were favourably impressed and made many excellent points. Fourcaud imagined that Monet must paint standing up "as his horizons are very high", and Geffroy, who was soon to follow every new development in Monet's work, noted that "the pastries, cooked to a turn, crusty and golden, makes one think of Chardin's immortal 'brioche'."

Press-cuttings reached Poissy intermittently and late. On 21 March, Monet thanked one journalist for the understanding that he had demonstrated. The following day, he sent off a small picture to Philippe Burty to encourage him to write about the exhibition, and was rewarded with a long study in *La République Française* of 27 March. On 26 March, Emile Bergerat had placed an article on the front page of the *Voltaire*, for which he was thanked in a letter dated, oddly enough, 25 March. In short, the press for the exhibition was not abundant, but it did show the interest that this one-man show had created, and when Armand Silvestre celebrated a victory in the pages of *La Vie Moderne* of 17 March, he exaggerated the position as it stood, but stated what would thereafter be an undisputed truth.

The Manneporte
1883
Cat. no. 832

Etretat: The Laundresses and the Falaise d'Aval
Postcard, early 20th century

Somewhere Permanent to Live

In the April issue of *La Gazette des Beaux-Arts*, "a magazine which claims to be among the more conservative art journals", Alfred de Lostalot regretted that the Boulevard de la Madeleine exhibition had not excited "real curiosity", and offered a very balanced and subtle study of Monet's work. "M. Monet is a man of exceptional vision; he sees things differently from most of humankind, and, as he is sincere, he makes an effort to reproduce what he sees... The poetic quality of his works is very striking; I admire the audacity and sobriety of his treatment, and am astonished by the plastic results that he obtains in this way... But I am often astonished and even shocked by the tonality of a piece; the first impression is strange and unrealistic... To perceive M. Monet's paintings correctly and appreciate their exceptional qualities, one has to go beyond the first impression...; soon the eye grows accustomed and the intellect is awakened; the magic does its work... [M. Monet] is impressed by nature and he impresses; he knows his trade and he goes about things in no uncertain way... This is, I believe, a description matching the concept formerly entertained of the true artist."

Monet was not "an anarchist in paint", de Lostalot believed. He was, however, soon to be homeless. He had to leave the Poissy house by 15 April, and set out on a search for a new house; he wanted it to be far enough out for him to have to come to Paris only once a month, and he wanted it to be permanent, so that he could at last put an end to his exhausting travels. He could hardly know how permanent a residence he had found.

On 6 April, he informed Durand-Ruel in a P.S. that he was prospecting around Vernon. "I like the countryside round here very much", he wrote on the 15th. It seems that his choice had been made by that date and that a move was imminent. The owner of Poissy had extended the deadline by a fortnight after wearisome negotiations which at one point seemed likely to end in litigation.

On 29 April, we at last find out the name of the chosen place: Giverny. On that date, Monet moved in with some of the children; Alice arrived the following day. It was only right that the first person to read the soon-to-be-famous address "at Giverny, near Vernon, Eure" was Paul Durand-Ruel, whose loans and payments, amounting to 5,000 francs for the month of April alone, had made the move possible.

Some of the packing-cases were still unopened when, on 1 May, there came news of Edouard Manet's death the previous evening. Monet was the only Impressionist to be chosen as a pall-bearer for the funeral, which was planned for the following day. He made an urgent order for a suit from a tailor in the Rue des Capucines, then, on 3 May, left very early for Paris, stopped off at Durand-Ruel's in Rue de la Paix at about 9.30 am to pick up some cash, then rushed to Rue des Capucines to put on his brand-new attire. He was now ready to attend the ceremony at the church of Saint-Louis-d'Antin, not far from the Gare Saint-Lazare, with all its memories. From there, the cortège set off for the Passy cemetery. Of Manet's pall-bearers, all close friends of his, *La Chronique des Arts* recognised Antonin Proust (former Minister of Arts under Gambetta), Zola, Duret, Fantin-Latour, Stevens and Burty. *Le Figaro* alone recognised Monet's burly frame in this group. He was not, after all, often seen in Parisian society, and had now found in Giverny the solitary retreat that he had so long desired.

Giverny

Is there any need to describe Giverny? It lies on the hills on the right bank of the Seine, some four kilometres upstream of Vernon and on the opposite bank. The village, which in 1883 had 279 inhabitants, stretches along the country road for some two kilometres, a "B" road that runs between Gisors and Vernon.

ABOVE AND PAGE 188 FROM LEFT TO RIGHT:
Gustave Courbet
The Cliff at Etretat after a Storm
1870
Paris, Musée d'Orsay

Fishing Boats and the Porte d'Aval
1883
Cat. no. 822

Etretat, Rough Seas
1883
Cat. no. 821

Shortly after entering the village, the road divides, and the "high" road to the north, whose route was still more capricious in Monet's time than it is today, slopes up to the town hall and passes in front of the church before a steep descent takes it back down to the "low" road, also called the Chemin du Roy, which runs round the southern edge of the village, parallel to the Gisors-Vernon railway. The Ru, a tributary of the River Epte, branches off upstream of Giverny and joins the Seine a few kilometres downstream from the main course of the Epte.

On the subject of Monet and Giverny so much has been written that there is little for the historian still to do, but on closer examination, we note that few accounts date from before 1900. Lilla Cabot Perry visited the banks of the Epte between 1889 and 1909, but her *Reminiscences* did not appear until 1927 and give little indication of the different stages of an experience that lasted twenty years in all. The report by Maurice Guillemot, published in 1898, is much more direct, but dates from 15 years after Monet moved to Giverny. Thiébault-Sisson's 1900 interview with Monet took place in Paris; a critic of *Le Temps* could hardly be expected to venture out into the sticks. Over the next two decades, the journey was made by more enterprising journalists, such as Louis Vauxcelles, André Arnyvelde and Marcel Pays. With Pays' article, we are already in 1921, at a time when the great monographs were first appearing, and the story was beginning to take the shape in which it has been presented to posterity. After the artist's death, there was a great flood of articles and studies which often neglected the period of his move. None of the journalists and historians who wrote about Monet, with the possible exception of Gustave Geffroy, could claim to have known him at all well.

The expection here is Jean-Pierre Hoschedé who, near the end of his own life, wrote *Claude Monet ce mal connu* (Claude Monet as I knew him) on the basis of fifty years of intimate acquaintance with his subject. Of his partiality there can be little doubt, but he managed to avoid the trap into which others have fallen. This is telephoto effect that flattens into a single chronological plane the different moments of a life that one seeks to capture in all its complexity and uncertainty. If one wishes to understand the "Monet at Giverny" phenomenon not as a whole, but in the process of its making, one must take a gradual approach, following the chronological order of the events as these appear in contemporary documents and paintings; these are the two sources of information that allow us to evaluate subsequent written or oral accounts.

Monet knew Vernon. He had passed through it every time he had travelled between Paris and Normandy; during his stay in Bennecourt in 1868 he had, no doubt, come to know it directly. But Giverny, which is not as close to the Paris-Le Havre railway line and is 500 metres from the banks of the Seine, was less easily discovered. It has to be sought out, and this is what Monet did. J-P Hoschedé speaks of Monet looking for a new home by taking the little Vernon-Gisors train as far as Gisors, but he also speaks of a long walk. According to Jean-Pierre's sister, Mme Salerou, Monet was attracted by the blossoming fruit trees in the garden of the house; the information is entirely compatible with the season during which Monet was house-hunting.

Louis-Joseph Singeot, a big Giverny landowner, agreed to rent his substantial property at the place called Le Pressoir to this "outsider", whose history of bad debts was unknown to him. The property was entirely enclosed by walls, and with courtyard, garden and cottages, measured some 9,600 square metres; it was "bordered, in front, by the road from Gisors to Vernon, behind, by the 'High' or 'Village' Road" (the description is from the deed of sale to Monet dated 1890). The main house had four rooms on the ground floor and the same

View of the Church at Vernon
1883
Cat. no. 843

Vernon and the gothic collegiate church
Postcard, c. 1900

PAGE 190:
Etretat: The Beach and the Porte d'Aval (detail)
1884
Cat. no. 907

number on the first floor, two mansard rooms on the next floor and an attic and cellar. Its west wing was a kind of barn in which Monet set up his studio, its east wing contained a wood-shed, another little barn and the lavatory. A smaller house contained several rooms, including a kitchen, a stable and a cellar. There was room not only for all of Monet's double family, but to allow for any building projects that Monet might later undertake. For the time being, he was "enchanted by the place"; the future seemed to smile on him.

All the necessary arrangements were quickly made. The elder children were to board in Vernon, the boys at Dubois' school, the girls with the Sisters of Providence. The young ones, Michel Monet and Jean-Pierre Hoschedé, attended the state school in Giverny, whose teacher, Auguste Cellier, was later asked to give private lessons to both contingents of children. Since the Seine was within a kilometre of the house, Monet had a boathouse built on the bank of the river for his boats, easels and canvases. The letter to Durand-Ruel of 5 June 1893 is the first mention of this building on the Ile aux Orties, an island formed at the junction of the Epte and the Seine. The fact that Monet was prepared to store his canvases in this rather remote shed suggests that the "difficulties with the village" reported by Jean-Pierre Hoschedé should not be exaggerated. Monet's first work on the garden began at around this time.

Painting got off to a slow start – "One always needs a certain amount of time to get familiar with a new landscape" – and was soon frustrated by the rain. Monet therefore worked indoors for a time, finishing some of the Etretat pictures, painting flowers, sketching a portrait of Michel (847) and painting, half indoors, half out, *Luncheon under the Tent* (846). Towards the end of August, the fine weather returned and outdoor work could begin. As at Vétheuil, Monet was at first reluctant to paint the village. Having all but ignored the Seine at Poissy (748–749), he returned to it with new enthusiasm. To reach it, he took up his easel and paints and crossed the flood-plain to the south of the village, where the Epte ran into the Seine. There, he painted some views of the opposite bank, which was dominated by the Port-Villez hills (834–836). From another point a little way downstream, he painted three pictures (837–839). At some point, he crossed the Seine and set up his easel on the towpath at Grand Val (840); another view is taken from the islands in front of Port-Villez (841). Vernon downstream from Giverny also inspired him (842–845).

Three weeks after visiting his brother in Rouen, where he met Durand-Ruel and Pissarro, Monet was finally able to dispatch to Durand-Ruel a packing-case containing seven paintings. These are the first to bear Giverny titles: *View of the Church at Vernon* (843), *By the River at Vernon* (844), *The Hill at Notre-Dame-de-la-Mer on the Seine* (839), *Landscape at Port-Villez* (836).

The last few weeks of 1883 were taken up by an important commission, the celebrated panels intended for the great salon in Durand-Ruel's apartment at 35 Rue de la Rome. But in the second fortnight of December, Monet rested after his labours by taking a painting trip to the Riviera in the company of Renoir; the two friends went as far as Genoa, and the occasion produced Monet's first Mediterranean subjects (850–851).

Monet's accounts for 1883 were encouraging. He had sold some 29,200 francs (29,400 according to Durand-Ruel) worth of paintings, and, when advances were included, his income for the year amounted to 34,541 francs, which was considerably greater than in 1882. Futhermore, his paintings had been exhibited in London, in New Bond Street, and in the Gurlitt Kunstsalon, Berlin.

Bordighera

The Mediterranean trip had allowed Monet and Renoir to "use beautiful colours" in Renoir's words, and Monet had been particularly attracted by Bordighera. He was determined to return there alone and, convinced that Renoir's presence would hinder him in his work, asked Durand-Ruel to keep his secret until he set out on 17 January 1884.

Some twenty kilometres east of Menton, Bordighera, capital of the canton of West Liguria, then consisted of the old town, the "Città Alta", built high up

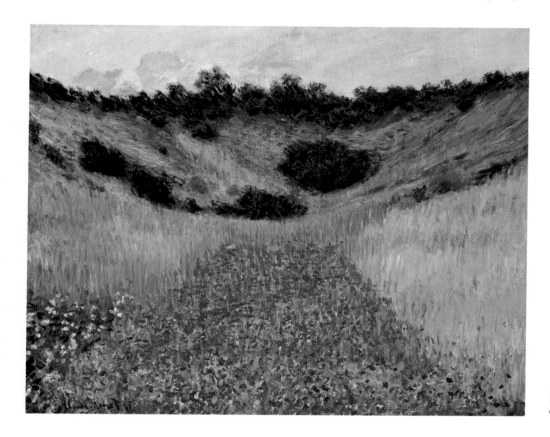

Poppy Field in a Hollow near Giverny
1885
Cat. no. 1000

at the northern end of the Sant'Ampelio headland. To the south-west of the Città Alta stands Borgo Marina, founded in 1820 and separated from the old town by the Orti Sottani gardens; this was the fishermen's town. The town had then expanded along the Via Vittorio Emanuele and the Strada Romana toward the west. The Genoa-Ventimiglia railway was opened in 1871, but the population of Bordighera remained stable at about 2,000 inhabitants. The flood of tourists, mainly English and German – many of whom settled in and around the city, as local names testify – brought with it a considerable expansion of the city's hotel industry.

Monet should therefore have found no difficulty with accommodation, but his aversion to Germans and the German language (somewhat surprising in a man who had been at pains to avoid combat in 1870) led him to take refuge in the Pension Anglaise at the foot of the old town. When he arrived, thirteen guests sat around the dinner-table, including some typical English ladies and a very pretty young American woman who was rarely to be seen without her "enormous Rembrandt-style hat"; she inevitably provoked Alice's jealousy.

The great attraction of Bordighera, in the view of both guidebooks and those who knew it, was the Moreno garden immediately to the west of the Città Alta, on either side of the Strada Romana (later known as the Via Romana).

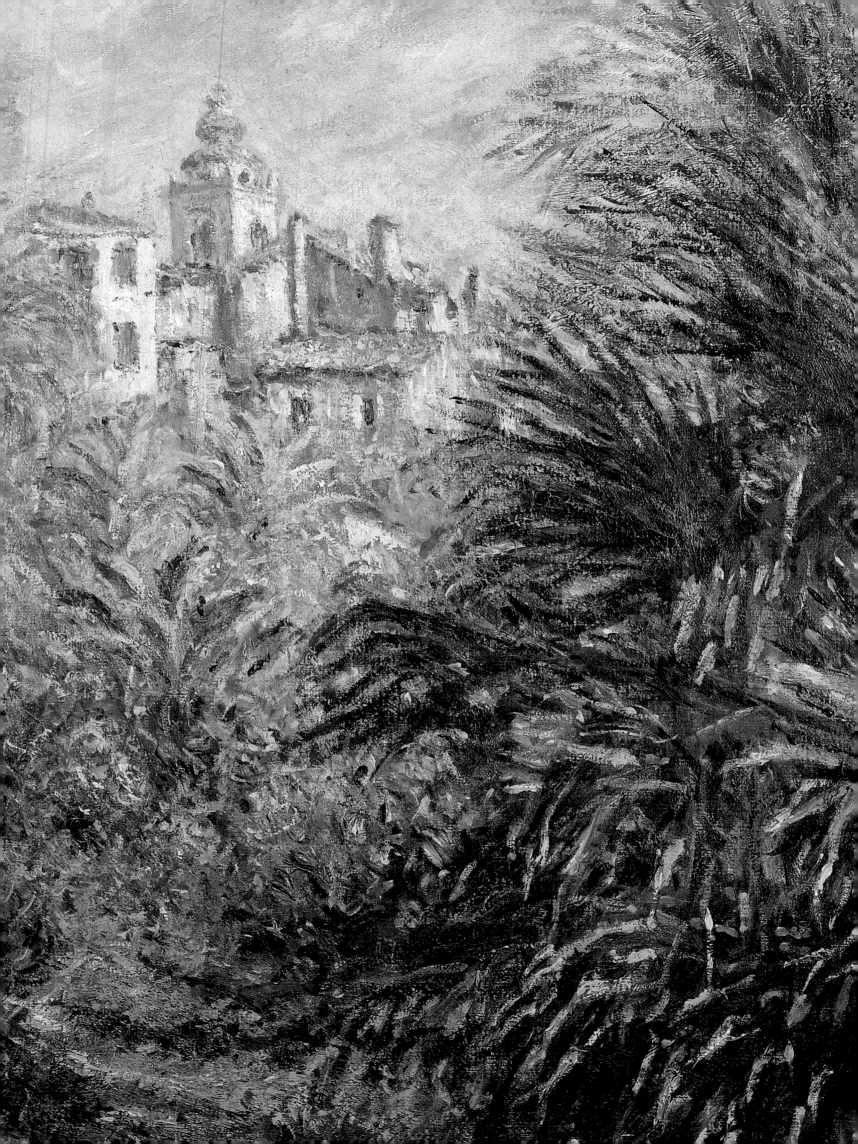

The owner, M. Moreno, had been in the habit of opening the garden to visitors, but an unfortunate incident had recently caused him to be more circumspect. Monet was therefore forced to seek letters of recommendation in order to gain admission to the gardens; they and their kind owner were to contribute a great deal to the success of his stay. Meanwhile, he explored Bordighera and its surroundings, walking "every path" of its rugged slopes. He decided that he would have to confine himself for the most part to palm trees and to "the more exotic aspects"; "water, beautiful blue water" he could paint elsewhere. For those who know Bordighera, this restriction may seem a little puzzling; perhaps the little Sant'Ampelio headland does not offer a sufficiently distant prospect of the coastline.

On 24 January, he began four paintings, which he wished to finish before starting a further four, and so on indefinitely. This was an ambitious schedule, and he could not keep it up. "The palm trees are driving me crazy; the motifs are extremely difficult to capture", he wrote to Durand-Ruel. Orange and lemon trees against a background of sea constituted a real challenge. "As to the blue of the sea and the sky, it's impossible." Overnight rain had revealed the snow-capped mountains, an unforgettable spectacle but too ephemeral to paint. An excursion with two English painters took him to three villages hidden away in the mountains, Sasso, Borghetto and Vallebona. When the fine weather returned, Monet returned to the fray: "I am working very, very hard, because I haven't yet grasped the colours of this country; I sometimes feel terrified by the colours that I am forced to use." By then he was working on six paintings a day, some of which required six sessions; nothing was yet finished, but for the moment the effects were returning unchanged with each new day. Progress came with familiarity- "I can see subjects where I couldn't see them in the first few days" – and with progress, a sense of disappointment with his earlier studies.

In all this, the role of Alice is clear: "With every subject that I do, every subject that I choose, I tell myself I must render it accurately so that you can see where I have been and what it looks like." His task was not to indulge Alice's aesthetic sensibilities, but to provide her with information for the end of the trip; a modest objective, but one which guaranteed exactitude. Monet's correspondence of the next few days offered Alice a more technical view of what he was doing, reassurance concerning his fidelity, and advice about saving on household expenses which proved very unwelcome and was grudgingly retracted.

As to Parisian life, and in particular the Manet exhibition, a letter from Renoir provided information that was immediately passed on to Giverny. Old debts from the Argenteuil period were still cropping up and causing problems, one of which related to *Luncheon on the Grass* (**63**). M. Bruno, "the hunter from Lavacourt", whom Monet had met at Vétheuil with Hoschedé, managed to obtain a letter of recommendation from acquaintances of M. Moreno in Marseilles, stating that Monet was "one of the most distinguished Parisian artists". It was now time to finish the things that he had begun – fourteen pictures by 2 February – and begin a "new series"; "Now that I feel the landscape better, I dare to put in all the shades of pink and blue; it's enchanting, delicious, and I hope you will like it."

The Castle at Dolceaqua
1884
Cat. no. 883

View at Dolce Acqua with the Borgho Antico, the bridge over the Nervia and the Doria castle
Postcard, c. 1900

PAGE 194:
The Moreno Garden at Bordighera (detail)
1884
Cat. no. 865

Monsieur Moreno, "A Veritable Marquis de Carabas"

On Tuesday, 5 February Monet visited M. Moreno, who received him hospitably and showed him around "every nook and cranny" of the property. Monet's enthusiasm was rewarded with the loan of a key. The presence of Mme Moreno, combined with what one feels to have been the rather worldly atmosphere of the Moreno household – though this was attenuated by the illness of their daughter – triggered Alice's almost inevitable jealousy. But Monet was not allowed to register the same sentiment when Ernest Hoschedé visited Giverny for his wife's fortieth birthday on February 19.

Monet was by now so tired that, before setting to work in M. Moreno's garden, he took a day off, making a little trip to Menton where two views that he saw on the Cap Martin demanded that he paint them at some later date. They were subjects with plenty of sea in them, whereas the sea was still largely absent from the Bordighera studies. On 7 February, Monet began work in the Moreno garden, painting a thicket of olive trees whose prevailing blue tonality rather disconcerted him. His host invited him to spend an afternoon at Ospedaletti, a little seaside resort close to Bordighera, where he enjoyed a few hours of relaxation; they were the more welcome because Alice was plaguing him with letters threatening separation and other unwelcome prospects. In the early afternoon of the following day he made a further trip, this time sallying forth to Monte Carlo with the two English painters. There he lost ten francs at the Casino, but saw subjects that seemed to him "more complete, more picture-like" than anything at Bordighera, which was full of "pieces with lots of details" and "jumbled-up things that are horribly difficult to render".

Painting remained laborious and uncertain. Each picture required ten or twelve sittings, yet none satisfied Monet, and none had "come out at the first try". The bad weather that set in for a few days reinforced his habitually plaintive tone. A further trip to Menton confirmed Monet in his intention of going there to make some studies before leaving the Côte d'Azur. Chance meetings with a fellow lodger from Le Havre, or with one of the Hecht brothers created contacts, and then there was Ernest May at Bordighera. On 17 February, a further excursion with the English painters in the Nervia valley brought them to Dolceacqua an "extraordinarily picturesque little town". Monet returned there two days later to attempt two "marvellous" subjects, the Doria Castle (**882–883**) and the bridge over the gorge with the chapel of San Filippo Nero (**884**). When he got back, his colleagues were "very thrilled" with what he had achieved in a single session. When circumstances and subject came together, Monet could still paint rapidly and brilliantly.

The Moreno garden was neglected for a few days, as the light was unsuitable for painting palm trees. When the fine weather returned, his host dragged him off to the Nice carnival, from which he returned exhausted at 10 pm. M. Moreno had been the perfect host, paying Monet's train fare and restaurant bill and, on his return, plying him with flowers and fruit, and suggesting that he send a parcel of fruit to Giverny. His great kindness was rewarded by the gift of a fine, large apple that had cost Monet nothing at all, since it had been bought for Monet at the Café Riche by Dr de Bellio.

Monet's task was difficult and his concentration now less intense. His complaints about pictures that would not shape up become increasingly frequent and occasionally rather ironic: "People are expecting me to return with miracles. I shall have to make an enormous effort if I am not to return with a complete failure." His hard work, combined with the heat which had now replaced the

View of Bordighera: the Palms
Postcard, c. 1900

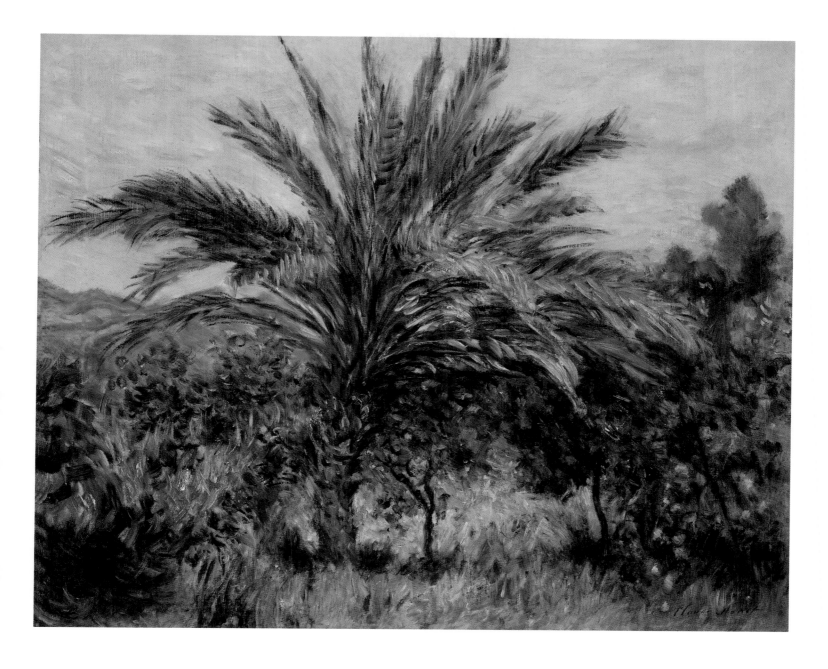

cold of his first days in Bordighera, gave him headaches, a temperature, and finally a cold. By late February, two paintings of olive trees under overcast skies were finished at last, and a third one was finished the next day; some thirty pictures were in various stages of progress. And still he regretted that the sea came into only two or three pictures, the sea that was "pretty much [his] element". Blue, as the dominant shade, gave way to an "extraordinary, untranslatable" pink, which took pride of a place in a description from which we also learn that he was now obtaining his oils from Turin. He moved to a larger room where he was able to stand back from the paintings and see them properly, and the breath of optimism this induced brought with it flattering words for Bordighera. This "enchanting country" with its "marvellous coastline", would people not find its characteristic "punch-flame and pigeon-breast" colours simply incredible? One rainy day was sufficient to dispose of these high spirits. Fortunately he could while away his time painting an orange branch for one of the Durand-Ruel panels (924). The same day saw a letter written to Durand-Ruel in which Monet evaluated his work to date. His morale improved with the return of the fine weather, but he was still as demanding with himself, and aware of an injustice that had also struck Renoir: "We are becoming so very difficult to please, and

A Palm Tree at Bordighera
1884
Cat. no. 876

yet people always accuse us of making no effort." But after two months of work, only eight paintings were ready.

M. Moreno was, in Monet's words, a "veritable Marquis de Carabas". He now carried off his artist friend to a property that he possessed in Andora, two and a half hours away by train – according to the 1884 timetable – to the east of Bordighera, in the Merula valley. This outing gave rise to a lyrical description, matched only by a subsequent idyllic evocation of Alice seated on the steps of the cross of Notre-Dame-de-Mer, on the hill opposite Giverny. The following day produced this undoubtedly sincere profession of his affection for Normandy: "I know, too, how charming these early spring days are at home – the heartfelt joy and pleasure they give." He ordered two bottles of champagne and morels to await his return and looked forward to smoking a pipe on the divan in the studio.

Monet's mood varied with the weather and the rather intermittent advances sent by Durand-Ruel, who was himself in increasing financial difficulty. His linen and clothes were in rags, he had lost a jacket, there was dirt on everything; but his face was (despite the sun) "pink and fresh", as 19th-century notions of beautiful complexion required. He finished paintings, but they were never satisfactory. When they could be retouched no further, they were thrust into a packing-case, and he would soon need a second case to fit them all in. At the same time, towards the end of March, he ordered new frames for Giverny, so that, when he returned, the studies could be examined "properly". He was so tired now that it was affecting his sight, and his doubts remained; with the experience that he had acquired, he could do everything much better if he started again. This impression was confirmed by a little rough sketch that was better "than lots of things on which [he] had wasted fifteen sessions' work".

His departure from Italy was first announced for 2 April and postponed because the weather was good. The imminent end of his stay spurred him to one last effort: "I don't know how I manage, to persue my profession with this trade, going from one subject to another, racking my brains to find a way of getting as much light as I can into my pictures, it's sheer folly; I am completely exhausted by it all." The weather turned bad, and he could no longer paint out of doors, but immediately turned to a study of an orange branch (887). The return of sunny weather gave Monet the idea of revisiting Dolceacqua, but the light had changed so much since his first trip that he found it impossible to work there. He was back in the Pension Anglaise at four in the afternoon, with his four pictures "finished" but not how he wanted them.

The next day, he had been working in the Moreno garden when M. Moreno introduced his son-in-law, M. Borelli, who was more "up to date" with painting than his father-in-law, who "knows not a thing about it"; M. Borelli wanted to see some paintings, and they had to be unpacked willy-nilly. The meeting was arranged for 4 April, when Monet exhibited before the astonished and soon admiring eyes of his hosts the harvest of his stay in Bordighera, some forty pictures of la Città Alta (852–854, 865–866), the Borgo Marina (864), the Via Romana and its villas (855–856), the coastline looking towards France, with Menton and Monaco (877–880), the Sasso valley (859–863), Dolceacqua (882–885), the Borghetto valley (858), the Nervia valley overlooked by snow-capped peaks (881), the palm trees (874–877), the olive trees (868–872), the lemon trees (887, 924) with the lemons on their branches (888, 923) and even a partial view of the Villa Moreno (867). His visitors expressed their admiration with true Latin enthusiasm, though it seems not to have occurred to them to buy any of the wonders that they praised. Nor, indeed, did M. Moreno's much obliged guest have any thought of giving him anything.

PAGE 199:
Villas at Bordighera (detail)
1884
Cat. no. 856

Bordighera to Menton

On Saturday, 5 April, after a farewell visit to his host, Monet went by carriage to Ventimiglia, where he intended to send on a basket packed to the brim with a variety of objects and a large packing-case full of pictures, perhaps the one containing a dozen paintings that he had warned Durand-Ruel to expect some three weeks previously. He innocently declared a "case of paintings for Vernon" and was requested by the post-office clerk to provide a certificate from the Italian Academy "stating the provenance of the said paintings". Neither explanations nor protests made the least difference. The clerk did not actually send Monet to Rome, but he did want him to go to Genoa to obtain an authorisation from the local representative of the Academy; this solution was politely but firmly confirmed by the customs office manager. Only the basket was sent on, after a methodical search that required it to be completely repacked. Monet, fuming, returned to Bordighera with his packing-case, unwilling to go as far as Genoa with a total of four such cases, all full of pictures.

M. Borelli was consulted, and took a variety of steps over the course of the morning in the hope of reconciling the interests of his father-in-law's protegé

Bordighera
1884
Cat. no. 854

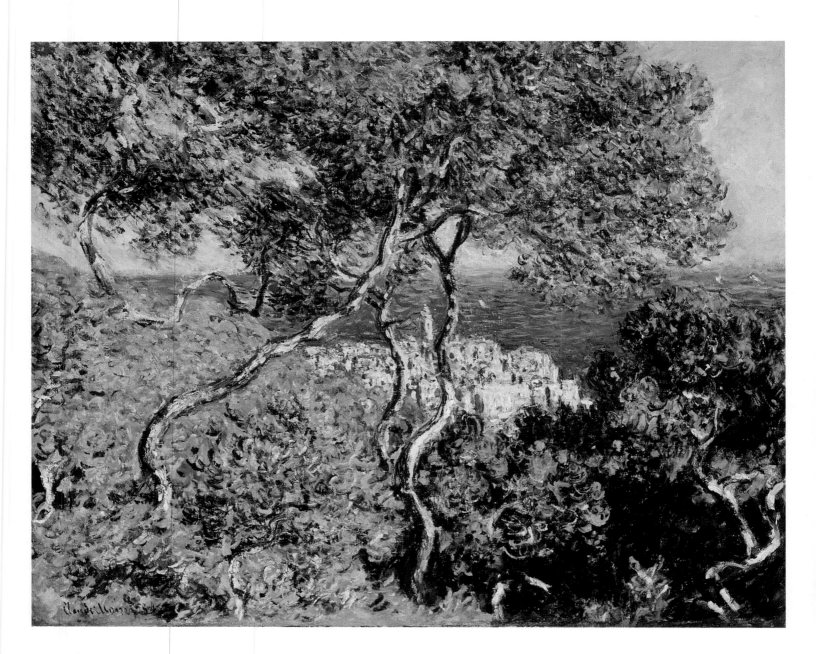

with the demands of Italian law. Monet was requested to draw up a complete list of the paintings, which had therefore to be unpacked yet again, the Mayor of Bordighera and M. Moreno then added a marginal note to this document, after which the packing-cases were sealed. At around four in the afternoon, everything was ready, the luggage was piled into two carriages, which were to take the relatively smooth corniche road and reach Menton without further contact with the Ventimiglia clerks. One of the seals was broken accidentally as the carriages were about to depart, to the great dudgeon of the driver, who broke all the seals and swore that he could take his customer anywhere and that no one would stop them. Taking advantage of the Sunday evening laxity of the customs officers, the convoy reached its destination without further ado.

Monet now had before him the town he had so long desired to paint. He put up at the Hôtel du Pavillon du Prince de Galles, which was fairly close to the Cap Martin where his motifs awaited him. The very next day he set to work, convinced that the landscape was "much more [his] kind of thing" than Bordighera. By evening, he was exhausted by the long walk between the hotel and the headland and by furiously hard work that had allowed him to start four paintings. On Wednesday morning, a "terrible" wind forced him to retire to the hotel, but this was as nothing compared to the anguish he felt at a trip to Paris that Alice had had to make the previous evening. Monet had been hoping that Jean would go along as a chaperone, but on hearing that his son had been dismissed, his imagination so "tormented" him that he spoke of never returning to Giverny and, a clear proof of his despair, spent a whole day without painting. A kindly letter received that Friday calmed his anxieties, and he mixed gratitude and apology in his letter to Alice before returning to the headland.

He had made an "irrevocable" decision to leave on the Sunday, then put it off for two days under the combined influence of a letter from Durand-Ruel advising him to stay and the advent of "exceptional, marvellous weather". On the Saturday, a meeting with the M. Hayem, the "ribbon-seller", showed Monet scrupulously observing the agreement with Durand-Ruel that he should have, if not exclusivity, at least first choice of Monet's production. Hayem sportingly invited Monet to dinner the following evening. Before accepting this invitation, which the state of his wardrobe came close to precluding, Monet granted a "satisfecit" to his three Cap Martin paintings. If the sun would stay out, he thought he might manage two more the next day.

All's well that ends well. When the 11.20 express left Menton station on Tuesday, 15 April carrying him toward Marseilles, Monet seems to have been slightly more serene. At all events, after a 24 hour voyage that took him via Paris to Vernon, Monet announced his arrival to Durand-Ruel with pride and confidence: "I think you will be happy with me."

View of Bordighera, Monteverde
Postcard, c. 1900

New Difficulties

As usual, none of the pictures, not even those deemed satisfactory at the time of their painting, was sent to Durand-Ruel without modification, and many weeks went by before the first delivery could be made. More serious news came during a brief stay in Paris in the first fortnight of May. The collapse of the Union Générale and the "general crisis in the art market" had considerably weakened Durand-Ruel's financial position, his creditors had formed a syndicate and it was rumoured that there was a danger of bankruptcy. Monet was "in despair about the whole business" and retired to Giverny, where he could follow events only through the intermediary of his friends. Pissarro gave him fairly encourag-

The door panels for the Durand-Ruel drawing-room: *Vase of Dahlias (Door C)*
1883
Cat. no. 931

ing news around 13 May, and Renoir informed him that he was encouraging Durand-Ruel to sell his pictures at low prices; Monet reluctantly offered the same advice, while plying Durand-Ruel with questions. He was reassured by his dealer's admirable faith in the future, but the question of Monet's selling directly to third parties arose again, with the disagreeable prospect of his again having to "hunt the admirer".

On 31 May, Durand-Ruel recorded delivery of thirteen pictures, followed on 12 June by nine more. These were pictures painted exclusively in Italy, with the exception of two views from the Cap Martin. Prices went from 300 francs for branches of fruit, to 1,200 francs for *The Moreno Garden at Bordighera* (865) and *The Farm at Bordighera* (874). The average was 820 francs, and the total 18,200, which was more than Monet had received in advances (12,000 francs) since the beginning of the year. He immediately began to agitate for his account to be brought up to date, and made contact with Georges Petit, who had just bought some recent paintings from Durand-Ruel, urging the latter to come to an understanding with his colleague. Monet was divided between his admiration at Durand-Ruel's unshakeable confidence and his own shame at taking money from him when "he had been at such pains to get it". Finally, he reproached Durand-Ruel with refusing to allow him to sell directly when on his way back from the Riviera. It was probably with this in mind that he asked for the addresses of Clapisse and Hayem; he now regretted having turned down Hayem's offer at Menton.

A trip down the Seine in Caillebotte's boat was followed by an exchange of letters, partly on literary matters, which some pious hand has censured; the remaining fragment of Caillebotte's letter does not mention Monet's request for financial help. The panel for Berthe Morisot (857), which Monet had been thinking about in Bordighera, was "more or less finished" by early August, but was not delivered until several months later.

The need to give priority to finishing most of the Côte d'Azur paintings meant that open-air work in Giverny had to be put back for several weeks. A letter to Durand-Ruel of 16 July makes cursory mention of his first outdoor subjects, the Epte (898–899) and haystacks in the field near his house (900–902). Work on them was interrupted for a few days in August by a short holiday with his family on the Normandy coast. Holiday or not, his easel and paints had not remained at Giverny, as the pictures painted at Petites-Dalles (903–906) and Etretat (907–908) show; he had returned to these places with studies begun the previous year. On visiting Faure, he hid his present difficulties but noted with satisfaction that the baritone's interest in his work was undiminished.

Back at Giverny by the first few days of September, Monet made repeated appeals to Durand-Ruel. Soon term would restart, and the Dubois school was refusing to accept Jean Monet until the money due for the previous year had been paid off in full. Until then, Monet declared with pride in a letter to Durand-Ruel, no one but his dealer had been offered any paintings, but it is clear that Monet was increasingly tempted by this possibility. He was also filled with alarm that certain people had been able to buy his works for "knockdown prices". Pissarro, who had originally passed on this – almost certainly false – rumour, questioned Durand-Ruel on the subject; he passed on the assurances that he received, and Monet's confidence was somewhat restored. It was in this state of mind that he told Duret: "I think the collapse and general fall in the price of paintings will prove advantageous for us." It was a surprising diagnosis, and at odds with his own decision to increase prices, a decision he would profit from still more thereafter.

Monet was working flat-out to finish the works he had begun on the banks of the Seine (909–917), at Jeufosse, opposite Giverny, before bad weather set in. But time was passing, and the inexorable change in the appearance of things elicited further complaints, among them the dispirited reflection that the older he got, the more trouble he had finishing studies to his own satisfaction. His current efforts were an irritating reminder that he was often accused of painting in a rather careless and offhand way. And now Durand-Ruel, in his letters, was encouraging him to "push, to finish" his paintings "as much as possible", on the grounds that Monet's lack of finish explained a recent drop in sales. Monet's pride was hurt, and he assured Durand-Ruel that, though he could never share the public's taste for "finish" or rather "polish", he was doing everything he could to supply "complete pictures" with which he was himself wholly satisfied; this was what took him so long and made him late with his deliveries.

Octave Mirbeau

The reader will perhaps remember that, when the seventh Exhibition of Independent Artists was being prepared, Monet had expressed his unwillingness to have Gauguin included. Gauguin did not return the compliment, but was not wholly enamoured of Monet. When he first saw the Italian pictures, which he considered "technically astonishing", he confessed to Pissarro that "he intensely disliked them, especially as a way forward", and when Durand-Ruel gave him an excellent Monet "as commission", he had it sold off for 400 francs in the "awful little shop" of Chercuitte, a wood-gilder in the Rue de Douai. Monet did not hear of this, but was convinced that his distance from the other Impressionists would harm him in the long run, and therefore suggested that they should all meet for dinner in Paris once a month. At the same time, he set himself to finish the big decorative panel that he had promised to Berthe Morisot several months before. This was a view of the Strada Romana at Bordighera (857) in the foreground of which was the villa built by Charles Garnier, another admirer of Bordighera.

On 17 November, Monet downed tools and travelled to Paris to deliver a batch of pictures to Durand-Ruel, who had organised a meeting with Octave Mirbeau. Mirbeau was the art correspondent of the conservative paper *La France*, and wished to interview artists for a series of articles entitled "Notes sur l'art". His meeting with Monet and their subsequent relationship constituted a significant event; Mirbeau had not yet published any of the works for which he is now known, but he was already a renowned journalist and pamphleteer, whose reputation had been established by his weekly pamphlet *Grimaces*. His name more – or – less guaranteed public interest, and Monet therefore went out of his way to explain his ideas. Three of the paintings that he was shown particularly impressed Mirbeau: a field of clover crossed by a path, a meadow with a haystack and a row of poplars, and a picture of Etretat by moonlight. The article featuring Monet appeared on 21 November 1884, but it was some days before he saw it. His first reaction was rather unenthusiastic: "There are many clumsy things in these articles [Mirbeau had written on Puvis de Chavannes and Degas before his article on Monet] and it would perhaps be better to take a gentler line in our defence, but I don't think they will do us any harm."

What had Mirbeau written to inspire Monet's anxiety? Nothing extraordinary by today's standards, but we must remember the period and the paper in question. In his introductory remarks, Mirbeau stigmatised the "mass of jokers" who were unable to appreciate the Impressionists when they first appeared and

Dahlias (Door C)
1883
Cat. no. 932

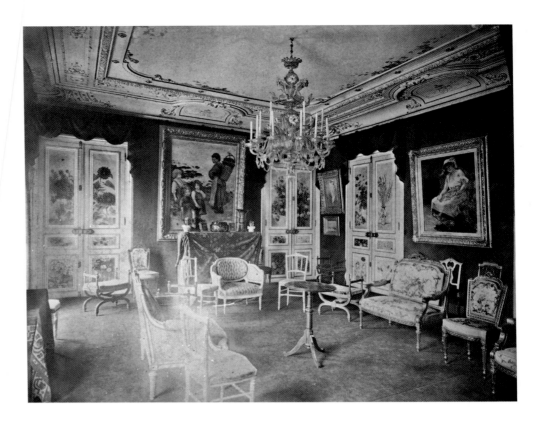

The Durand-Ruel drawing-room,
doors B, C and D
Photograph Durand-Ruel

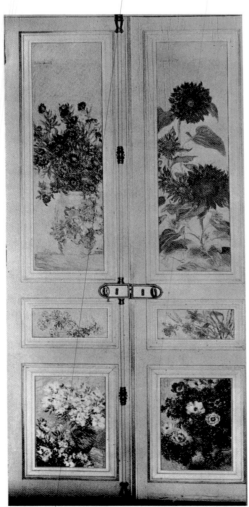

Door B of the Durand-Ruel drawing-room
Photograph Durand-Ruel

had been doubled up with laughter not long since at the sight of *Camille Monet in Japanese Costume* (387) and *Turkeys* (416). In doing so, he took a risk which he made up for by classing himself among the "deaf" and the "blind" whose hostility Monet had faced with such courage and tenacity. And now here was Monet, still "very young" – in Mirbeau's view – but with a corpus of painting behind him "already considerable and already respected". Mirbeau, at all events, knew of no other landscape artist "so complete, so vibrant, so various in the impressions he imparts". And Mirbeau's own eloquence was clear in the praise that he bestowed, emphasising Monet's own "clear, strong, harmonious eloquence".

All Monet's themes were reviewed in Mirbeau's at times rather purple prose: "Monet has wrought out of his palette every fire and every decomposition of light, every play of shadow, every magic of the moon and every evanescence of mist." Corot himself must bow down before Monet's "more delicately sensitive and in some sense more impressionable eye", his "vaster and more powerful comprehension". All of this might have been somewhat banal were it not for the descriptions of the three paintings and certain particularly accurate observations, such as "the sky, behind the leaves, is visible and leads the eye away, with such precision of perspective and tone that one can guess at the depths of countryside invisible behind these trembling leaves", and Mirbeau's intuition of what Monet's art was in several years' time to become in the series of Grainstacks and Poplars, a finger on the pulse of nature "a surprise every hour, every minute, ...[and] expressed in her ever changing aspect". By revealing what Monet now was and what he would become in the near future, Mirbeau made himself the perfect interpreter of the artist whom he praised.

De Bellio made no mistake, when, on 29 November, he congratulated Monet and expressed his joy that he had finally read from an authoritative source what he and all Monet's friends had privately thought and publicly proclaimed for years. This reaction, and other favourable responses which must have reached him, awoke Monet to the importance of Mirbeau's article, which

appeared, after all, not in some obscure paper that preached to the converted, but in a bourgeois paper whose audience, still unconvinced, was already much less hostile and would soon be at Monet's feet. As a mark of his gratitude, Monet, who as a rule, was, far from generous with his gifts, presented Mirbeau with a "very beautiful study", *The Customs House* (739). In his letter of thanks, the delighted Mirbeau promised that "he would never let any opportunity of proclaiming his artistic faith be lost" and only the cynical will doubt his sincerity.

From the Lathuille Banquet to the International Exhibition

Just when the Impressionists as a group were feeling the need to close ranks, an incident occurred that put their new-found solidarity to the test. Antonin Proust had suggested the idea of a banquet to take place on 5 January 1885 at Lathuille's to celebrate the anniversary of the Manet exhibition at the Ecole des Beaux-Arts. Manet's friends, having heard of the initiative and the mixed reception accorded it by the painter's family, decided not to take part, but Proust persisted and sent out invitations on 10 December. On receipt of his own, Pissarro wrote to Leenhoff, who was making up the list of participants, and notified him of his refusal. Shortly afterwards, he found out from Renoir that Renoir, Caillebotte, Degas and Dr de Bellio would take part. Surprised and annoyed, Pissarro informed Monet in the hope that he, at least, had acted as agreed. He was counting without Monet's canny Norman cast of mind. Monet had come to a compromise of his own; he had contributed his share of the expenses, but felt free not to go if Renoir did not. This was the usual pattern: Monet, unwilling to decide without consulting Renoir, whose moderation he found reassuring. He had, on the other hand, always been rather chary of the extreme positions adopted by the doyen of the group, Pissarro. Renoir having given him the go-ahead, Monet unostentatiously attended the banquet. Everyone, he thought, had found it "absurd and futile". But with the exception of Pissarro, very much left out in the cold, no one had had the courage to refuse. The orders for cider that the patient Pissarro continued to transmit from Monet to the Eragny cider-maker, M. Delafolie, were much more easily settled.

In January 1885, snow fell in abundance, and Monet started a whole of series of paintings of the outskirts (965–968) and centre (961) of the village and the banks (962) and immediate vicinity (963–964) of the Seine. The weather remained stable for several days, but Monet's sense of impatience and dissatisfaction, so frequent a reaction to the need to work hastily, was again to the fore. The fear of distraint over a court case dating from 1875 produced anxiety of a completely different kind; it was twenty years since he had first been visited by the bailiffs. The effect on his neighbours' attitudes would have been disastrous, but Durand-Ruel once again stepped in and averted the catastrophe.

Monet's relationship with Zola had been closer since the Manet banquet, where Zola had sat at Antonin Proust's right hand. One reason for this was Monet's continued interest in literary life. In late 1884, Monet had found time to read Huysman's *A Rebours* and in early 1885 he asked Zola to get one or two tickets at the Théâtre de l'Odéon for 3 March, the first night of a revival of the Goncourt Brother's play *Henriette Maréchal*. Whether he actually attended the performance, we do not know. He certainly read Zola's *Germinal*, first in serial form in *Gil Blas*, and subsequently in the volume that Zola sent in response to his compliments before the book was on general sale.

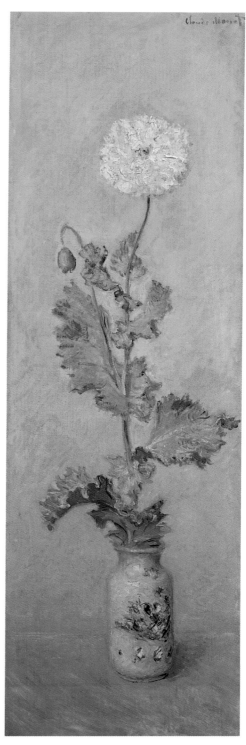

White Poppy (Door A)
1883
Cat. no. 920

The chance preservation of documents testifies to Charles Giron's visit to Giverny. Giron, a painter from Geneva, made a sketch of Monet and presented it to him, and bought a *Church at Vernon* for 600 francs, a generous price; he then noted a series of interesting observations about the master's palette. There were a few more – warm, friendly – letters from Monet, then silence. There must have been many, who, like Giron, passed irregularly through Monet's life, leaving little or no trace.

March was spent largely on the panels that Durand-Ruel had commissioned for his apartment in the Rue de Rome (919–958). And Monet, as usual, complained about the difficulty of the task and the time that it was taking, when outside his studio windows the landscape was casting its spell over him. Finally, on 2 April, he left for Paris with a number of panels, which he was anxious to deliver in person. Then he set to work outside with an ardour reinforced by good news about sales. The place that Burty accorded him in his article on Duret's *Critique d'avant-garde* (Avant-garde criticism), well ahead of Renoir, who apparently lacked "robust temperament", merely emphasised the rank that Monet now occupied in the Impressionist world. But Monet was about to establish his prestige in a quite different world.

Ever since 1882, when he had seen Paris society crowding around the paintings at the International Exhibition, he had been attracted to the very beautiful Georges Petit Gallery at 8 Rue de Sèze. At the time, there had been no question of Monet taking part in this important event, which had been confined to twelve artists, including the inevitable (three) members of the Institut de France. In 1885, if we are to believe Gauguin, connections, which played an important part in this self-elected assembly, worked in Monet's favour; he was supported by Cazin, who seems to have been on excellent terms with Georges Petit. On the other hand, Georges Petit's interest in Monet might equally explain how the latter came to be invited to take part in the fifth International Exhibition. Of the ten works of Monet's listed in the catalogue, five were of the Normandy coast, three were views from the Giverny area and two were souvenirs of his Mediterranean trip.

The exhibition was opened to the public on 15 May, on which date appeared the review most feared by the critics, that of Albert Wolff of *Le Figaro*. Having admired Gervex's *Rolla*, praised Cazin and Raffaëlli, and passed quickly over the others, the famous critic devoted his last paragraph to Claude Monet, whom he acknowledged to have "much talent" as a landscape artist. True, the colours "taken separately" seemed to him "wrong", but "overall", Monet's art worked a kind of "trompe-l'oeil" effect, which "caught the larger aspects of the landscape with surprising truth". It was seascapes, however, at which Monet particularly excelled, in Wolff's view, the best of his selection being a view from Etretat and another from Cap Martin. Such as it is, the conversion of Albert Wolff was all the more noteworthy, since the other reviewers were less detailed, when, indeed, they were not indifferent or simply hostile... *Le Rappel, Le Voltaire*, and *Le Journal des Arts* noted their satisfaction in a single sentence, *Gil Blas* confined itself to two words. *Le Courrier de l'Art* and *La Gazette des Beaux-Arts* judiciously blended praise and criticism, with praise perhaps to the fore. By contrast, Paul Gilbert, writing in *Le Journal des Artistes*, spoke of "mental illness", though when he stated that he had hitherto, "only ever seen the streaming light of molten gems in his dreams and in the *Thousand and One Nights*", he unwittingly paid Monet a fine compliment.

The International Exhibition made it clear to everyone that Monet was of interest to a major art dealer other than Durand-Ruel, namely Georges Petit. It can have been no satisfaction to Durand-Ruel to see Monet thus straying from

Branch from a Lemon Tree (Door A)
1884
Cat. no. 923

his own gallery, but he was a gentlemanly loser and, perhaps encouraged by the effect of the exhibition on his own sales, expressed his pleasure at Monet's success.

The Life of a Landscape Artist

The dinners at the Café Riche were now taking place on the first Thursday of every month, and Monet, at whose suggestion they had first been organised, attended when he could, which was not often. But on Thursday, 4 June 1885, he seems to have been expected, and Durand-Ruel invited him to lunch at the Rue de Rome on the same day, with Renoir, Pissarro and Mirbeau. Having now delivered his panel to Berthe Morisot, he could meet her without blushes, and he visited her the following Thursday. As one might expect, he left Giverny as

The Durand-Ruel drawing-room (Door C)
Photograph Durand-Ruel

LEFT:
Peaches (Door C)
1883
Cat. no. 935

Dahlias (Door C)
1883
Cat. no. 937

little as possible and spent the summer there working on landscapes that he had begun; he was also anxious not to abandon his son Jean to his own devices while the latter was working for an examination in September. A three-day excursion with Caillebotte made a pleasant diversion, but Monet paid for it, on his return, by "awful toothache and neuralgia".

There was negotiation with Portier and Heyman, who had come to Giverny expecting him to buy a Degas! Monet had given up the idea, he says, at Durand-Ruel's request. The dealer was again in financial trouble, and was making efforts to sell works in Belgium, Holland and the United States. Monet followed these efforts closely, but was concerned at the likelihood of some of his best paintings "leaving for the land of the Yankees". Having suffered so much at the hands of his uncomprehending compatriots, he was convinced that "it was mainly, indeed solely, in Paris that there remained some vestige of taste." But on this point, too, he was prepared to trust the judgement of Durand-Ruel, since no other prospect presented itself. Certainly Georges Petit, who had bought a picture during the International Exhibition, was taking his time paying for it. Durand-Ruel thus remained Monet's confidant for better and for worse, having, as such, the dubious privilege of hearing Monet's complaints and recriminations about changing effects and vegetation. These make for monotonous reading, but testify to the demands Monet made on himself and to his fidelity to the motif – qualities that make the 1880 Monets a classic Impressionist vision.

Immediately after Jean Monet had been to Rouen to take his examination (which he failed), the family spent a few days on holiday at Etretat in a house kindly lent to Monet by the baritone Faure. On 10 October, Alice and the children returned to Giverny, while Monet exchanged the Faure villa for the Hôtel Blanquet. The cold and rain did not stop him working continuously, outside, in a mysterious staircase, at various windows, and at Saint-Jouin, where he made a rough sketch despite the awful weather. When the sunshine returned, Etretat offered a prospect so complete and so various that "to render all that... one would need two hands and hundreds of canvases". Monet's collected correspondence allows the reader to follow the painter's daily struggle with the capricious weather and the inherent difficulties of his art. We shall confine ourselves to noting the most important events of his last long stay at Etretat.

Having known Etretat since 1883, Monet formed part of a composite social group made up of local people and "bathers", the charm of the place being such that the second category tended to merge with the first. Monet of course knew M. Deck, who ran the hotel with his mother-in-law Mme Blanquet, but he also knew M. Isnardy, the manager of the Casino, and M. Frébourg, owner of the Château de Grandval, who several times invited Monet to dine with him. We find a reference to a grocer who hunted larks, and who, coming across Monet while he was was painting from the clifftop, handed over part of his bag. It was not only the motifs afforded by their boats that attracted Monet's attention to the fishermen; he also sympathised with the dangers of their trade. Outsiders were increasingly rare as time went by. A young woman dubbed in a letter from Monet as "the Lady of the Footwarmer", who seems to have alarmed Alice somewhat, is revealed to be the wife of the Opéra Comique singer Léon Achard, and her nickname to derive from the Villa La Chaufferette [footwarmer] built by her father, the painter Eugène Le Poittevin. Le Poittevin had died some fifteen years earlier; he and Blanchard had designed the Hôtel Blanquet's sign. Artists were still to be found at Etretat. Monet knew Georges Merle who had exhibited at the Salon since 1876 and was staying at the Hôtel Hauville. When he departed, on 21 October, Monet reacted with a "good riddance!", but was

more favourably inclined toward his colleague Marius Michel, who was also staying at the Blanquet. He was a bit of nuisance at times, but had the undeniable merit of being "fanatical" about Monet's painting and letting him use his room whenever Monet wanted to work there. But their relations took a turn for the worse when Michel, the "sly dog", put Monet in a position where he was forced to give a sketch to M. Isnardy, and came to an abrupt end as a result of an argument about Maupassant's discernment as regards painting.

Since Jacques Offenbach's death, Guy de Maupassant had been the undisputed feather in Etretat's crown. On 14 October, Monet spent an agreeable evening with him. A fortnight later, the novelist visited Monet to see his paintings which "he claims to like very much", though Monet was not entirely convinced that he was competent to judge. A particularly well brought-off *Etretat in the Rain* (1044) thrilled him. A year later he transcribed his impression in "The Life of a Landscape Artist", published in *Gil Blas*: "With both hands, he [Monet] took hold of a shower that had fallen on the sea and flung it down upon the canvas. And it was indeed the rain that he had thus painted, nothing but rain veiling the waves, the rocks and the sky, which were barely visible under the deluge." His portrait of the painter at work is worth dwelling on: "Last year, in the same part of the country, I often followed Claude Monet in his quest for impressions. No longer a painter, he had become, truly, a hunter. He walked along, followed by the children who carried his paintings, five or six canvases showing the same subject at different times of day and with different effects. He took them up or abandoned them as the changing sky dictated. And the painter stood before the motif, waiting, examining the sun and the shadows, in a few brushstrokes capturing a ray of sun or a passing cloud, which, scorning the fake or the conventional, he rapidly set down on canvas."

The Manneporte

After 1st of November 1885, Monet was alone at Etretat. But even now he could not devote all his time to painting, as he had to attend to his voluminous correspondence. True, the evenings were long. The majority of his correspondence was with Alice, who required daily letters and complained whenever she felt neglected. But there were also his painter friends: Sargent, asking intrusive technical questions, Caillebotte writing to describe an Italian trip from which he was hoping to return in time to dine with the others on the first Thursday of the month, and Pissarro who had to be made to accept Monet's decision not to take part in the next Independents' exhibition; he would continue to exhibit at the International Exhibition instead. His relations with Georges Petit were closer now, as we see, and Monet was the more tempted by a policy of sharing his production between Durand-Ruel and Petit as "Durand" had set out on a veritable crusade against forged pictures and was making many enemies among his fellow art dealers. His isolation meant that he was selling some paintings at a loss, and Monet was furious with him, accusing him of making "one blunder after another".

One event that partly made up for his disappointment with Durand-Ruel's prices and policies was an invitation from the "celebrated Société des XX de Bruxelles", which officially invited him to take part in its next exhibition. In his reply, Monet told the Société's secretary, Octave Maus, that he was "exceedingly flattered" and that he would be sending "five things". A satisfaction of a different kind was Alice's visit to Etretat in mid-November, without children, the two youngest, Michel and Jean-Pierre, having been entrusted to the care of

Red Azaleas in a Pot (Door E)
1883
Cat. no. 943

their elders. Monet had written three weeks before to say that "It is true that I love the sea, but I love you after all"; now he could make his feelings clear. Discreet as ever, Monet's letters register first his joy, then his gratitude. Alice's replies were systematically destroyed by Monet on her orders as soon as he had read them.

Certain of Monet's 1885 motifs can be traced by checking information in his letters against the paintings themselves, though not all of these are mentioned. He painted the fishing-boats drawn up on the shingle beach from the height of the "perrey", the dry dock (1028–1031). From his window, he sought to paint the movement of the boats (1026–1027), but their constant and unpredictable changes of position made them very elusive. *Boats on the Beach at Etretat* (1024) with the local type of fishing-boat, provide the foreground for a departure of the fishing-fleet (1025). The place on the cliff where Monet encountered the lark-hunting grocer cannot be identified with any certainty, nor can the Payen house from which there was a view over the sea (1046–1047). On the other hand, the Trou à l'Homme cave dug into the Falaise d'Aval is well known, and appears in many paintings (1014–1018), as does the Passée, inland, where Monet worked the day after Alice's departure (1020–1022).

But it was the Manneporte to which Monet most often returned, that "huge vault under which a ship might pass". In the 19th century, one could reach the foot of its most monumental arch – from which it was possible to paint not only the entirety of the Manneporte (1035–1036, 1052–1053), but also the Porte d'Aval and the Needle (1034, 1042) to the right – only via the perilous staircase down the Jambourg cleft. Once down there, you are very much alone, especially in winter. Monet came close to ending his career and indeed his very life there. He made a mistake about the timing of the tides, and as his account of the same day tells us, on the evening of 27 November: "I was deep in my work, completely sheltered from the wind, at the foot of the cliff, at the place we went to together; convinced the tide was going out, I wasn't worried about

The Manneporte Seen from the East
1885
Cat. no. 1037

PAGE 210:
The Manneporte near Etretat
1885–1886
Cat. no. 1052

FROM LEFT TO RIGHT AND ON PAGE 213:
Fishing Boats
1885
Cat. no. 1028

Fishing Boats Leaving Etretat
1875–1886
Cat. no. 1047

Boats on the Beach at Etretat
1885
Cat. no. 1024

the little waves coming almost up to my feet. In short, I was so absorbed, I failed to see an enormous wave that flung me against the cliff and set me rolling in the backwash with all my things! My immediate thought was, I'm a goner, the water was dragging me along, but finally I got out on all fours, in such a state, Lord! My boots, my woollen socks and coat were soaked; the palette, still in my hand, hit me in the face, so my beard was covered in blue, yellow, etc. Once I got over the shock, it was nothing, the worst thing was I lost my picture, which was quickly broken, along with my bag, my easel, etc. Impossible to fish anything out. It had all been splintered by the waves anyhow... In short, a lucky escape."

Soaked to the skin, he had to go back up the cleft staircase with what remained of his materials; the exercise saved him from the cold. But by evening his voice was hoarse, and when he went to bed he had nightmares and slept badly. To Alice's understandable alarm about the accident, Monet replied that he was "just as I've always been". All the same, after the Manneporte adventure, something in him had broken, and a few days of rest at Giverny in early December, along with a quick trip to Paris, were not enough to repair it. When he returned to Etretat, the shadows were longer, storms and cold weather had set in. There were frequent invitations from M de Frébourg and the Gonneville Road offered "beautiful things", but the magic was gone. Etretat, 1885 "will certainly not go down as a good stint", Monet felt, and he even wrote of "filth" and a "wasted trip". Would things have seemed so bad if his conscience had been clear?

"Yesterday's Monet is Dead"

For on 10 December 1885, some days before returning to Giverny, Monet had to sit down and write a very awkward letter; he had to inform Durand-Ruel that he was defecting to Georges Petit. Petit had brought him to this by a discreet form of blackmail, proposing to buy several paintings immediately and then offering Monet a place in the next International Exhibition on the express condition that no paintings belonging to Durand-Ruel be included. By accepting Petit's dictate, Monet quite simply betrayed the man to whom he owed his living for the past five years. He was unable to hide his awareness of this, and announced while he was at it that he would be exhibiting at the XX in Brussels independently of his dealer, though he might ask him for paintings in case of need.

Indeed, he went further, and, claiming to be speaking for Pissarro and Sisley, he demanded the right to sell his paintings without intermediary. In fact, by granting an exclusive right to the International Exhibition, he had debarred himself from exhibiting with his friends. Now he was worried about the pressure that they – Pissarro and Caillebotte, in particular – were likely to put on him. He was therefore forced to retreat when he replied to Durand-Ruel's protests: "I probably expressed myself badly or you misunderstood me, but I have never said that Pissarro, Sisley, and I wished to act on our own; ... and I don't wish to present them as saying what they never said."

But on the matter of his relations with Petit, he was implacable, stating that Durand-Ruel could only gain by a competitor exhibiting and selling Monets. Convinced or not, magnanimous or merely afraid that the ungrateful artist might reject him altogether, Durand-Ruel chose not to break with Monet; instead he lent five paintings for the Brussels exhibition and continued to supply both everyday and exceptional expenses. Construction work for an extension to Monet's studio came under the latter head. On 31 December, Monet

delivered 11 pictures (of Giverny and Etretat) to Durand-Ruel for a total of 10,400 francs, of which the seven most expensive cost 1,000 francs apiece. But this did not dispose of their disagreements, and in early 1886, Durand-Ruel had to read more painful news from Monet's pen, accompanied by egregious incomprehension of the admittedly distant prospects that Durand-Ruel's contacts with the American Art Association were now opening up, and which were to lead him into a major US venture.

Monet was much more interested in being exhibited at the XX in Brussels, alongside Renoir, Besnard and Odilon Redon. The five paintings that he had originally planned to exhibit had now become ten – numbers 1 to 10 in the catalogue – and were on display at the Palais des Beaux-Arts from Saturday 6 February, the day of the opening ceremony. If the Marseilles artist Monticelli had not been persuaded to adopt the Italian colours for the show (of such things is an "International salon" made), the ten French artists would have occupied 50 per cent of the twenty places reserved for invited artists. Even so, the exhibition was, at best, a scandalous success. In 1887, Camille Lemonnier spoke of the "fuss...of last year", but in 1886 his normally prolix "Correspondance de Belgique" column in *La Chronique des Arts* contained not a single line about the exhibition. Monet had few illusions when he requested Octave Maus to send him any reviews that appeared. In his book, *Trente années de lutte pour l'art* (Thirty Years Combat on the Side of Art), Maus preserved an article

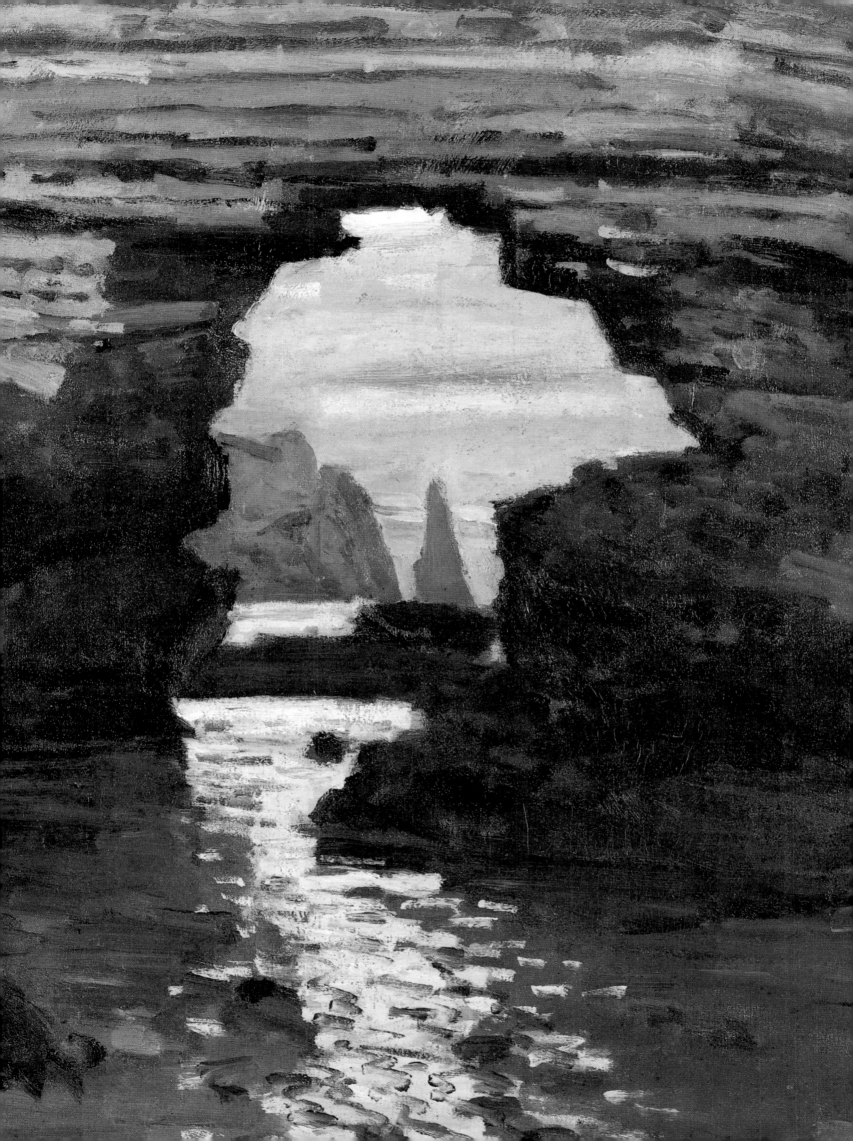

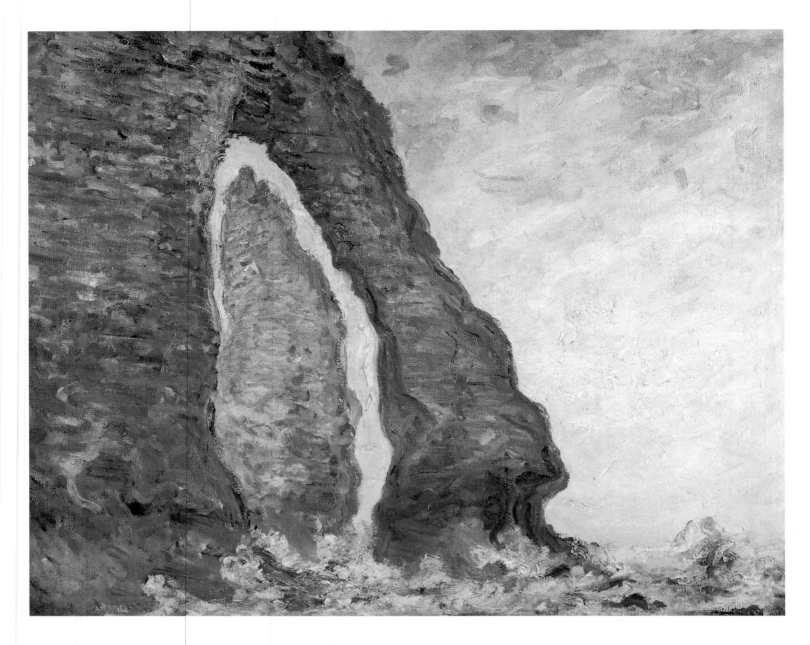

The Rock Needle Seen through the Porte d'Aval
1885–1886
Cat. no. 1050

which asserted that "Monet must have been one of the inventors of incoherent art", going on to say how "false, unhealthy and comical" were Monet's "passionate studies in decadence." Whether Maus sent it to Monet we do not know.

After working in the snow at Giverny, Monet returned to Etretat during the winter, as he had intended. But the date on which he arrived was 19 February, Alice's birthday, and this was no coincidence. Things had again come to a head in his private life. He made no attempt to hide his feelings when he wrote to Alice: "I arrived safely, but alas, sad as can be and in absolute despair to find myself here after everything I have been through." In 1883, also at Etretat, Monet had found the thought of Ernest attending the traditional Hoschedé family party for Alice's birthday almost unbearable. This time, Ernest Hoschedé must have asserted his rights well in advance and demanded that his wife and children return to him. Whatever the case, Monet now felt that he had been deluded in thinking of Alice as his own. There had been furious arguments, in which the Hoschedé daughters – Marthe, in particular, was still devoted to her father – had taken a major part; they were old enough now to be aware of the harm that their mother's unconventional situation was doing them, at a time when the eldest had their own marriage prospects to consider.

Monet was profoundly depressed by these arguments. From the very beginning of their "amours", he wrote to Alice, he had known that their affair was doomed, but now, when he was called upon to make a decision to separate, he felt that he could not live without her. He was not simply raising the emotional stakes; he was close to despair, and the artist's creativity was wounded in the man. As he wrote to her: "The painter in me is dead... Work would be impossible now, even if weren't raining... The Monet of before is dead." What greater compliment could he make to his invaluable, demanding and irreplaceable Alice than this confession that, without her, he could not be wholly, healthily and serenely himself.

Zola's *L'Œuvre*

On his return to Giverny in early March 1886, Monet faced new worries, whose source this time was Durand-Ruel's trip to America. Durand-Ruel had made a decisive step forward in his relations with the United States, as Pissarro knew: "During my stay in Paris, Durand invited me to dinner and introduced me to an American who is partner to the New York exhibition hall owner. Durand places great faith in his contacts with Mr Robertson, who seemed favourably inclined; I think they want to promote us in America."

Robertson did indeed persuade the authorities of the American Art Association to organise a big Impressionist exhibition in close liaison with the Paris Gallery. Having seen to the dispatch of 300 paintings, Paul Durand-Ruel boarded ship for the USA with his son Charles, leaving his eldest, Joseph, in charge of the gallery during his absence. On 10 April, shortly after his arrival in New York, the exhibition opened of Works in Oil and Pastel by the Impressionists of Paris at the American Art Galleries in Madison Square. Monet, whose merits had been trumpeted in the USA by Mary Cassat and John Singer Sargent, was represented by some forty pictures which covered his entire career, from Chailly to Etretat, from London to Vétheuil and Giverny. The critical reaction was on the whole encouraging, but Monet was quite unaware of the significance of this event and imagined that Durand-Ruel was abandoning him. He plagued both Paul and Joseph with recriminations and threatened to sell paintings directly to others. To Pissarro he wrote: "Now we're really stuck, with Durand in New York. There seems to be some kind of law that we must always be unlucky."

In the same letter, Monet speaks of another worry. This concerned the publication of *L'Œuvre*, Zola's book about the painters of his own generation, which formed part of his "Rougon-Macquart" sequence. During the winter, *L'Œuvre* had been serialised in the *Gil Blas*, which Monet read regularly, and it seems likely that his first contact with the novel was in that form. When the novel was published by Charpentier – its official publication date was 2 April – Zola sent him a copy. Monet wrote back on 5 April to thank him but also to express concern at the way in which Zola had presented various characters, notably the novel's hero, a painter called Claude Lantier. In a preliminary sketch of *L'Œuvre*, Zola had defined Lantier as "a Manet, a Cézanne dramatised", and "an incomplete genius, his potential not fully realised." Monet was afraid that his enemies would take this opportunity to "crush" the Impressionists, whom they already regarded as "failures" without the example of Lantier to encourage them.

What Monet did not say was that the similarities between the Lantier's story and certain aspects of his own life were quite disturbing. Lantier too was a

Self-Portrait with a Beret
1886
Cat. no. 1078

"Claude", and the three years that he spent in Bennecourt with his mistress were reminiscent of the time when both Cézanne and Monet had lived in the same village at the end of the Second Empire. But they owed much more to the harassed and impoverished life that Monet had led in Vétheuil, where he had painted Camille on her death-bed (543) as Lantier paints the body of his son (Chapter 6 of *L'Œuvre*). This last point was one that Monet could hardly overlook, even if he was not the model for Lantier. Pissarro was much less worried than his friend – this was, after all, the point at which he turned away from the traditional Impressionists towards Seurat and Signac – and did not think the book could do either himself or his friends much harm; he thought it "romantic" and "rather unsuccessful".

One last reproachful letter was sent off to Durand-Ruel before Monet took the train late on 27 April for Holland, where he was to be the guest of the collector, Deudon, the Baron of Estournelles de Constant, First Secretary to the Ambassador of the French Legation at The Hague. The Baron's recent marriage to Daisy Berend had, moreover, allied him to the family of another collector. The Baron was a great admirer of Monet's painting, and introduced him to the famous tulip fields that lie north of The Hague between Leyden and Haarlem. Monet's movements were restricted less by lack of transport than by the short time that he allowed himself, and he stayed largely on the southern edge of the flower-growing area. Sassenheim seems to have been the centre of his operations; its name appears in the title of one of the paintings exhibited at the International Exhibition in 1886. "For twelve consecutive days", he wrote, he found the weather "more or less the same", and this allowed him to paint, under ideal conditions, a subject which he had at first found "impossible to convey" (1067–1071).

Monet did not prolong his voyage to Holland, as he commonly did his painting trips. By Thursday, 6 May he was back in Paris and entering the Café Riche at 8 o'clock for the monthly dinner, which was particularly well attended that evening. Thanks to Pissarro, we know the names of some of the participants, though not those of the painters. Duret and Burty were there along with a variety of others, including Deudon, Bérard, the English naturalist Moore, and two eminent writers, the poet Mallarmé and the novelist Huysmans. This was the usual meeting, and not a banquet specially arranged to protest against *L'Œuvre*, as has sometimes been said. Huysmans sat next to Monet and regaled him with malicious remarks about Zola, reporting a recent quarrel and treating as an amusing anecdote the about-turn performed by Guillemet, who had been enthusiastic when Zola had announced that he was writing the novel, but had grown anxious since its publication. "My God, I hope the 'little band', as Mme Zola calls them, doesn't start recognising itself in your heroes", Guillemet wrote to Zola on 4 April. The "little band's" several reactions show that it did, indeed, recognise itself in the book, conferring on *L'Œuvre* the stamp of undeniable authenticity. On 13 February of the same year, Guillemet had written to Zola: "I came across the Bennecourt scene, it shows the hand of a master; so moving, so true that I relived my – our – youth again, and the little Jeufosse branch of the Seine and the Islands: everything." This was indeed Monet's world, with which Guillemet had been closely associated in 1868.

Young Woman with a Parasol

The opening of the fifth International Exhibition at the Galerie Georges Petit on 15 June 1886 was a further important step on the road to success. Monet exhibited thirteen recent paintings. Things nevertheless began badly, with the editor of the *Gil Blas*, Paul de Katow, acknowledging that Monet "sometimes showed talent... with a fairly accurate sense of light and the open air" only to denounce his "perverse eye [that] pushes exaggeration in reds and blues to extreme lengths". These rather disagreeable remarks were succeeded by a positive concert of praise, in which the few wrong notes were barely audible. "One [artist] who reminds one of no one at all is M. Monet", writes Charles Frémine in *Le Rappel*, while Marcel Fouquier in *Le XIX^e Siècle* states that "uncontestably, the artist who triumphes at, Rue de Sèze" is Monet. A. Dalligny in *Le Journal des Arts* noted "an extraordinary intensity of colour", and, for the anonymous columnist of *La République Française*, "The eminent artist has never rendered nature better." Fourcaud, in *Le Gaulois*, was scarcely less laudatory.

Albert Wolff himself, balancing his praise with his reservations, singled out an Etretat painting, which he found unrealistic but praised for its fantasy; he spoke of its "lake of enchantment" as though he had been vouchsafed some prescient vision of the water lily paintings. "M. Claude Monet's fantasmagorias" were damned by Paul Gilbert in *Le Journal des Artistes*, and he went on to apprise his readers of the satisfaction that these "chimerical paintings" would have afforded the "unfortunate monarch of Bavaria". This was in rather doubtful taste; the article appeared on 27 June 1886; Ludwig II, of Bavaria, the patron of Wagner, had died on 13 June 1886. It was in stark contrast with the essay that Félix Fénéon wrote for *La Vogue*, which had itself appeared only in April of that year. Not a word of it should be missed, but we must confine ourselves to one or two of the refined, decadent arabesques woven by the "critic-poet's" prose: "*The Needle Rock at Low Tide, Etretat* – and, their sails barely tinged

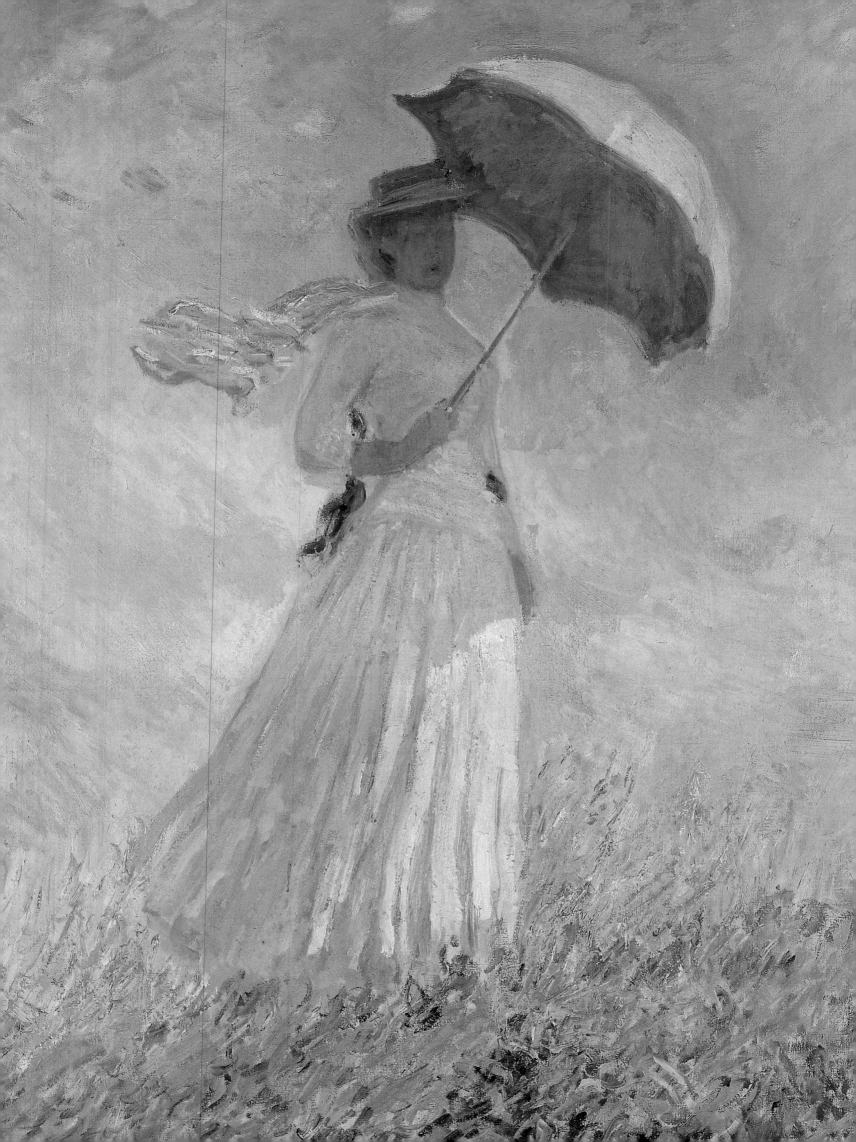

with blue, flying sails are sharply inverted in this sheet of water whose violet there reverts to icy greens, the precursors of hesitant blues and furtive incarnadines."

Friends too, old friends like Boudin, new friends like Huysmans, expressed their astonishment and admiration. More importantly, at least on the financial front, the International Exhibition allowed Monet to sell work, and very quickly, too, since by 23 June he was able to inform Joseph Durand-Ruel: "I have been able to do very good business, with both [Petit] and my admirers." The theme recurs in a letter to Berthe Morisot: "Everything in the show was sold at high prices and to the right people." Monet's account-book shows substantial income, with prices at 1,000, 1,200 and even 1,500 francs for a single painting. Durand-Ruel was wrong to tell Pissarro that Monet could not get his buyers to pay up. The sales came to 15,100 francs for twelve paintings, including three bought by Georges Petit and five by the baritone Faure. Payments from Durand-Ruel, which ceased between 12 March and 10 August while he was away in America, do not appear in Monet's accounts, so it is difficult to work out his total income for the year.

One of the few events of that summer cited in Monet's own correspondence was the exhibition in Grenoble to which he sent three pictures. A more poetic event, known only to his family, was the creation of the two celebrated paintings entitled *Young Woman with a Parasol* (1076 and 1077) now in the Louvre. It took place on the Ile aux Orties, a little grassy island at the mouth of the Epte, with an embankment to keep out the floods, that Monet had acquired to house his small boats under cover and moor the heavier ones, in particular the studio-boat, to a landing-stage. Returning from a painting session, he saw his favourite model Suzanne among the Hoschedé daughters standing at the top of the embankment silhouetted against the sky. "But that's just like Camille at Argenteuil! Well, tomorrow we'll come back and you shall pose there." That, at least, is the story as told by Suzanne's brother, Jean-Pierre, and confirmed by her sister Germaine, who also emphasised how demanding Monet had been. Suzanne was forced to keep the pose for hours at a time and fainted with exhaustion. When Monet painted her, Suzanne was 18 and unmarried. She was therefore rather a girl than a *Woman with a Parasol* (381); the traditional title was inspired by Monet's memory of Camille, while he himself had simply entitled the painting *Study of a Figure Outdoors*, which is how the picture appears in the catalogue.

Lilla Cabot-Perry tells us that one eminent critic – Mirbeau? Geffroy? – dubbed one of the pictures "Ascension" (perhaps the one in which Suzanne looks to the right) and the other, in which the figure seems more womanly, "Assumption". Monet was unhappy with one of the paintings, and is said to have kicked a hole in it; judicious repairs concealed the trace of his profane gesture. Jean-Pierre Hoschedé does not mention this anecdote, which we leave to Mrs Perry's own conscience, ably assisted by Monet himself, who was not averse to anecdotes about paintings that he had spoilt since he knew that nothing but protests and praise could come of them.

Towards the end of the summer, he spent some time at Forges-les-Eaux looking after Alice, who was ill. He did no painting while he was there. On the other hand, a sentence in a letter to Durand-Ruel about a matter in hand requires our attention: "I should be very happy to find the three Dubourg pictures with your notes, so that I can retouch them." *The Manneporte* (1053) was not, in fact, retouched at that date, but the way in which Monet willingly acceded to Durand-Ruel's suggestions is indicative of the concessions that he was willing to make in order to sell. For this reason, L. Venturi, anxious to give

Edouard Manet
The Spring also known as *Jeanne*
1881
New York, Private Collection

PAGE 220:
Study of a Figure Outdoors (Facing Right)
1886
Cat. no. 1076

The Hoschedé-Monet Family at Giverny
Photograph Jean-Marie Toulgouat

Woman with Umbrella
Black crayon on Gillot paper with scraping
(D.W. 1991, V, p. 131, D 446)

PAGE 223:
Study of a Figure Outdoors (Facing Left)
1886
Cat. no. 1077

currency to the thesis that Monet was implacable in technical matters, eliminated the letter from his selection in the otherwise invaluable "Les Archives de l'impressionisme".

Belle-Ile, Russell and Poly

Over the course of the summer, Monet several times expressed a desire to work in Brittany. Perhaps the example of Renoir, who was staying near Dinard, tempted him; perhaps the advice of Mirbeau, who was himself holidaying at Noirmoutier in the Vendée and plying him with invitations, was decisive. But Monet wanted to be alone, and therefore went some miles north of there, to Belle-Ile-en-Mer, just opposite the Morbihan coast. On 12 September, he disembarked from the Quiberon boat at Le Palais, the little capital of the "aptly-named" Belle-Ile, and booked into the Hôtel de France. But Le Palais was "a real town" – with a fishing port whose charm he discovered too late – and too far from the "beautiful, even admirable things" revealed to him by his first excursion. The so-called Wild Coast, open to the Atlantic, attracted him, and at the foot of the Great Lighthouse, two kilometres from the signal station at Talut, he discovered Kervilahouen, which commands the routes to the terrible sea: Port-Goulphar in the centre, Port-Coton, and Port-Domois on either side, "rocks, wonderful caves, it's sinister, diabolical, magnificent".

The little village had a tavern, whose landlord, J.M. Marec, had been captain of the coaster "Printemps de Redon". On the other side of a little square where dances were held on holidays or for weddings, was the inn's annex, a small peasant house of which Monet, the sole tenant, rented one room. Mme Marec's cooking was based on eggs, fish, and above all, lobster, which was the local speciality; the coast was full of it. The best ingredients can pall, but Monet was philosophical: "I can't expect the cuisine of the Café Riche." It also required some stoicism to sleep with rats and mice scurrying around overhead

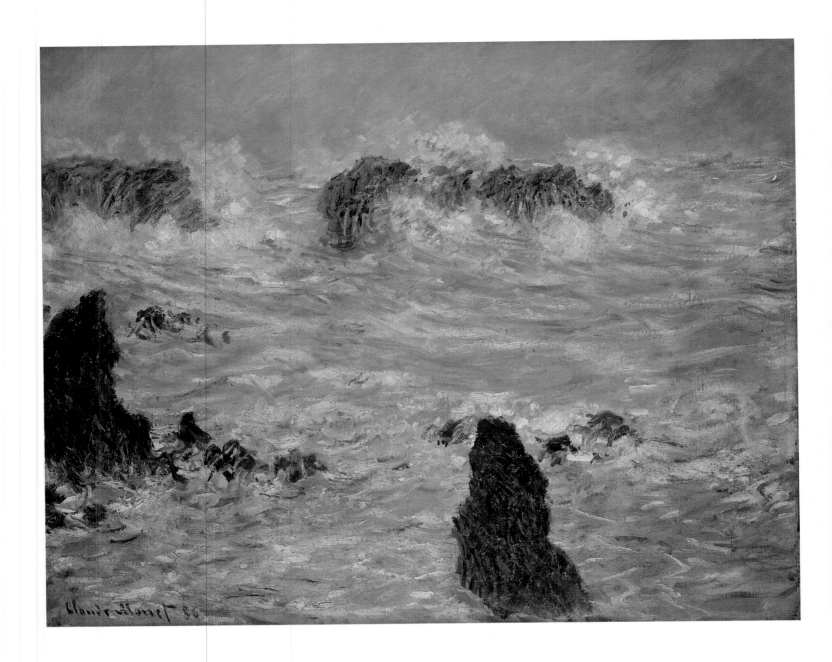

Storm off the Belle-Ile Coast
1886
Cat. no. 1116

and with the occasional interjection from his only neighbour, a pig. But Monet had seen worse in his youth and, all things considered, found himself better off amid this fauna than in the Hôtel de Paris at Le Palais.

He moved in on 15 September, and began his first painting on the same day. By the next day, the weather had changed, and a second painting was started in overcast light. Things seem to be going well, and his first, optimistic predictions were for a stay of only a fortnight. By 18 September, four paintings were in process. "It's superb, but it's very different from the Channel... it's all caves, headlands, and extraordinary needles, piled one on top of another." There was a magic to the "blue schists threaded with gold", very different from the chalk cliffs of the Caux; they offered new tones, in darker scales which required serious study, as did the sea, "of an unheard of colour", which remained "blue, green, and transparent" in all weathers. It required a really exceptional storm for it to lose a little of its "emerald colour."

Monet had thought he was alone with the terrible sea. He was not. In a neighbouring village were an American painter and his wife. This was John Peter Russell, born in Sydney, Australia, and eighteen years younger than the "prince of the Impressionists", as he referred to Monet on their first meeting. It

was an introduction well-calculated to win Monet's trust. Russell, who was known to the local as "the Englishman", was with his companion, Marianna A. Mattiocco, a North Italian who had modelled for many artists, in particular Frémiet, who had taken her at 16 to model for the Jeanne d'Arc of the Place des Pyramides in Paris. She was a buxom blonde whom Monet found "very pretty", and for once Alice was not jealous. As the couple had their own cook, dinner invitations followed thick and fast, making an agreeable change from the lobster dishes served by Mme Marec, who nevertheless attempted to vary her fare by sending to town for bread, meat and fruit. A walk in Russell's company on 25 September took them close to disaster. The two men had gone by boat at about one in the afternoon to an "enormous cave" accessible only at low tide; they there awaited the return of the fishermen who had brought them. Their anxiety grew until they were finally picked up at the very last minute and returned to land through very rough seas. Monet was unconcerned: "It was magnificent and great fun."

Before leaving, the following Tuesday, Russell used his contacts to find what Monet had lacked hitherto: a porter. Monet was immediately won over by

The Needles at Port-Coton
Postcard, c. 1900

Rocks at Belle-Ile
1886
Cat. no. 1086

the man: "an old sailor, a real type, very funny and very obliging." The description matches Monet's later words about the famous Pauli (or rather Poly) and must – despite a brief inexactitude- surely refer to him. Poly, born Hippolyte Guillaume, has been considered the very archetype of the Belle-Ile fisherman ever since Monet painted his "bearded, troglodyte's face" – thus Anatole Le Braz described him twenty years later. This old man of the sea had in fact been a baker by profession, but when his business failed, he had taken up lobster fishing; he lifted the lobster-pots. But competition was fierce, and he retired to dry land, where his face attracted the artists to whom he became a porter and model. When, after 1887, Russell built a house for himself in Goulphar Bay, he employed him as a gardener. Later, Poly was perfect as Monet's personal servant. When Le Braz admired the strange, tarred oilskin that encased Poly from head to foot, Poly immediately responded: "It is my invention. It's not pretty, but it's very practical. Ask M. Monet! As soon as I put it on in front of him, he wouldn't be satisfied until he had had his own made! Ah, the downpours we've been through in these things!"

At 57 years of age, with or without his tarred oilskin, Poly was squire to Monet's knight and carried his equipment morning and night, down the steep-

The Côte Sauvage
1886
Cat. no. 1100

Evening at Belle-Ile
Black crayon on paper
Tokyo, National Museum of Western Art
(D. W. 1991, V, p. 129, D 443)

est paths, through the most extreme weather, all for two francs a day. Monet's testimony of 12 October leaves us in no doubt about Poly's devotion to his service: "My old porter is also an excellent fellow and very obliging; he is unhappy when I don't work and when he sees that I am worried about something, in short, a good man." When Monet was painting, Poly would look on with admiration, but if Monet ever wished to add a few brushstrokes to existing rough sketches, Poly would be upset, "claiming that it was a crime to retouch such good things" and defying anyone "to do such fine ones". So it was a joy to both, when, on 17 November, instead of losing an entire day to the bad weather, Monet had Poly pose for him, and made "a rough sketch that was an excellent resemblance; the whole village had to see it." Poly had thought that the painting (**1122**) was for him, and was duly disappointed, but seized happily on a dedicated, framed photograph of his portrait, which was put up on the wall for Marec's clients to admire.

"Once I get started, nothing stops me"

Ten days after his arrival, Monet was expecting to conclude his work at Kervila-houen quickly and move one to "one or two very varied places" on the coast. But difficulties began to mount up. First, it was winds so strong that canvas and sunshade had to be tied down, then the neap tides which modified the appearance of his motifs. The weather suddenly turned bad on 28 September, but this was no obstacle, he could start painting in overcast light: "for lugubrious effects, you don't need sun." A brief respite in the weather coincided with a bout of severe fatigue. He therefore felt that he should continue with his "campaign"; his first estimate of ten days soon turned out to be very optimistic, and week after week went by. By working "in the same places in all weathers", Monet took a further step towards the "series" that he was later to paint, but it was a modest one, since only twelve paintings were under way altogether. A survey of the first paintings, one day when rain stopped him going out, produced a favourable verdict combined with the feeling that he now knew the country better.

Landscape at Giverny
1887
Cat. no. 1123

That was the position, when, on the evening of 2 October, Monet found his lodgings occupied by a man and a woman. After the initial embarrassment had worn off, conversation began. Writing to Alice Hoschedé that very night, Monet recounted: "On hearing my name, [the stranger] rushed up, shook my hand heartily and expressed his admiration; he is an art critic with *La Justice* who has written very good articles about me." Two days later, faced with the pictures already painted, the critic in question, Gustave Geffroy, was full of admiration. His admiration was redoubled by the sight of Claude at work: "Never has Brittany been painted before." From the seed of this apparently anodyne encounter on Belle-Ile there grew excellent articles and a fine book. The meeting also favoured the growth of increasingly close relations between the solitary artist from Giverny and the editor of *La Justice*, Georges Clemenceau.

A walk on a rainy morning took Monet as far as Port-Donnant, with its "delicious" bay and sandy beach, which he regretted not having seen earlier to paint; in fact he never managed to do so. He ordered new canvases, some of which were intended for "superb things that can be done all in one go". This was not the case with the subjects he had been painting hitherto, since nothing had been finished after three weeks' work. As the prospect of departure receded, he returned to a dream that had haunted him on each successive voyage, and which he had never been able to realise, that of one day returning to the same spot.

With mid-October coming on, bad weather seemed to be setting in for a while, and Monet was by turns anxious, angry, and full of admiration for the sea "which retains its beautiful green and blue colour". For lack of anything better to do, he "repainted the bad pictures from early on", whereas what was needed was "pure canvases". When the material that he had ordered finally came, Monet made light of the storms and rushed out to start work. It was more than ever necessary to tie down the easel and canvas, and he was forced to buy himself an "oilskin garment". When the elements were too severe, he had to resign himself to remaining under cover, though sometimes he attempted rough sketches directly from the window. A diversion came in the form of a

"veritable feast" when Geffroy and his friends left. And then work restarted on the fresh canvases in front of the huge Atlantic waves; sometimes Monet had to wait for several hours in the rain in order to work for half an hour. "Fortunately, my porter is tough as nails and nothing bothers him." With considerable effort it was possible to reach a sheltered spot on the so-called Curés' Beach where he could paint during the worst of the weather. "You know, once I get started, nothing stops me," he wrote to Durand-Ruel after one such skirmish with the weather. The result was the series of paintings of *Storm at Port-Goulphar, Belle-Ile.* Comparison within the series, all of which present the same jagged rocks projecting to the right, shows how carefully Monet varied his points of view (1115–1119).

When darkness fell, Monet would leave Poly to return his materials directly to his room, while he took a longer way back to make the most of a landscape that excited him more and more. After dinner, he listened to the conversation. Himself constantly exposed to the inclement weather, he admired the fisherman and especially the pilots, sharing the anxiety of those who awaited their return when the sea seemed about to claim them, and was as glad as they were when everyone returned safely. Before going to bed, he had still to spend an hour on correspondence. Alice, again, had the lion's share; indeed, she demanded it, and the least delay was cause for rebuke. But Monet himself could hardly have managed without these nightly conversations, in which material life – his "full winter costume" with big woollen socks – are found, alongside notes on his reading – he had started reading Tolstoy on the advice of Geffroy – and artistic issues sometimes extended into technical considerations. On 20 October, he con-

Trees in Winter, View of Bennecourt
1887
Cat. no. 1125

ducted a further survey of the paintings, and three were scratched out. But the count of three days later was nonetheless impressive: 38 paintings had been begun, and even if seven or eight sketches and the same number of "very mediocre" paintings were excluded, that left "a good 25 to be finished properly". Monet constantly evokes Alice's presence: "How I wish you were here to see this." "And then, I feel when I am painting that I want to give you the pleasure of it, to let you see what I am seeing, and that makes me do things well, I'm sure." Or again: "I redo the same subjects as many as four or six times; but I can tell you about all that so much better when we're together and have the pictures in front of us."

In between the constant stream of messages to Alice, a few letters to Durand-Ruel are much less dependent for their tone on the caprices of the weather and are generally more optimistic. Hearing of his artist facing the fury of the Atlantic, Durand-Ruel was worried and advised him to come back and spend the winter in the Midi – "because what he likes is sun", Monet told Alice. "They'll bore me to death with that sun of theirs", he added, and in answer to Durand-Ruel he pointed out: "I am excited by this sinister landscape precisely because it takes me quite away from the things I habitually do... I may well be a sun man, as you say, but one shouldn't specialise in just one note." Two days later, when thick fog came down, he told Alice that, all things considered, he was also "a fog man".

Octave Mirbeau could wait no longer to see his intended guest, and came to Belle-Ile on 3 November in the company of his wife and a friend. At once, he paid his tribute of admiration to the paintings presented. "It's true that Mirbeau is a real devotee," Monet rather circumspectly reported. His own unconditional admiration was reserved for "the beautiful Alice [Mirbeau] who is really very kind and very good", and who took charge of the Marec kitchen. She was not afraid to dress as a man to go out shooting: "It was a revolution in the village." Such admiration was ill-advised; he was called to order by his own Alice. "One strange thing about you is that you always have to have something to complain about", Monet sadly remarked.

After Mirbeau's departure on 9 November, he returned to work with new energy. But the effects had changed, some paintings had to be transformed, others abandoned, and some were spoilt. One interesting picture on which he had spent "at least twenty sittings" was scratched over. Another was finished at length, but "what an effort" it took. "I would have done better to leave three weeks ago... I should have brought back incomplete things, but it would have been better to have them in all their purity." Such was his harsh conclusion after more than two months work. Finally, despite a few excellent days of work favoured by the return of fine weather, Monet had to abandon all notion of finishing most of the paintings and leave Kervilahouen on 25 November. He was sorry to leave both on his own behalf and on behalf of his art. Having unwisely accepted Mirbeau's invitation, he first went to Noirmoutier.

Despite Monet's admiration for the landscape around Noirmoutier, which seemed to him "absolutely Bordighera", and despite the two sketches that he began (their fate is unknown), his stay at Noirmoutier is of little interest for the history of painting. He wrote three letters at Noirmoutier while awaiting the "day of return", a term of Homeric implications that Monet frequently used, though not without a certain apprehension as time went by: "Well, I am about to return; I hope that I shan't feel this time, as I sometimes have before, isolated and a stranger; that feeling has so often afflicted me." In this state of mind our Ulysses returned on Thursday, 2 December 1886, to Giverny and the demanding, plaintive Penelope who awaited him.

Sunlight Effect under the Poplars
1887
Cat. no. 1135

In late 1886 and early 1887, Monet left Giverny as little as possible, concentrating on finishing the paintings that he had brought back from Belle-Ile. If he was not too exhausted by his return from the island, he may have attended the Bons Cosaques dinner in Paris on 3 December with Mirbeau. These dinners took place, it seems, on the first Friday of every month at the Lyon d'Or. On Thursday, 16 December, he and Renoir were invited to dinner by Berthe Morisot. The Sunday before, Durand-Ruel had visited Giverny, forewarned that if there were six "very good" pictures among the forty that Monet had brought back from Brittany, he would receive only three. This condition, the delay in delivering the remaining paintings, and the angry return by Monet of a promissory note for 1,000 francs followed by the suggestion that they should hereafter conduct their affairs on a cash basis, do not imply a quarrel. Yet there was clearly some tension between Monet and the man who had funded his existence for the last five years. Durand-Ruel's frequent absences – he was still attracted by the United States, and Monet could still not see why – were no doubt one source of this ill-feeling. But the factor that had irrevocably changed their relationship was that Monet could now afford to be more demanding about prices and exploit competition for his works, so it was no longer possible

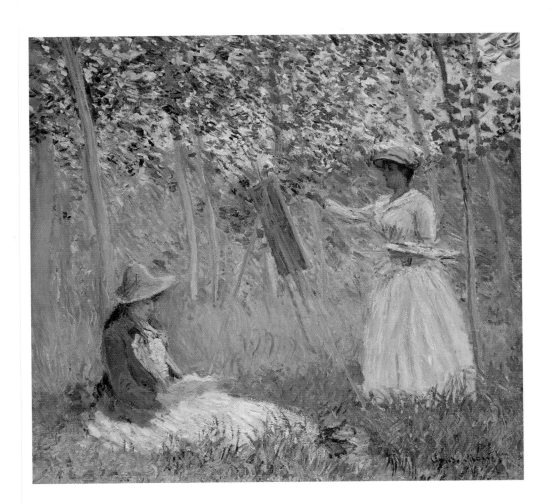

for a single dealer to buy in his entire production, more especially if that dealer was, like Durand-Ruel, facing cash-flow problems.

At the same time, what was left of the Impressionist group was once again in danger of breaking up. Since his conversion to the neo-Impressionist theories of Seurat and Signac, Pissarro's letters had been eloquent of the increasingly wide gulf between the new wave of painters and the first generation "naturalists" who were now, in Pissarro's term, "triumphant". In December, Pissarro heard that he might be invited to exhibit at Georges Petit's, and replied "I resolutely await them", expecting to refuse. But when he heard that he had been voted in, even he was delighted to change his allegiance. Monet and Renoir had been influential in obtaining Pissarro's admission, and Monet was asked to inform him of the decision, which he did in orotund fashion. Afterwards, he could not resist remarking to Berthe Morisot: "So [Pissarro] is no longer afraid that he will be compromised by the company; his convictions do not stay the course." Monet's own firm but eclectic convictions had gained him a role in the organisation of the International Exhibition. At around this time, Monet also began to sell to Theo van Gogh, who managed the Boulevard Montmartre branch of the Goupil (alias the Boussod) Gallery, and who visited Giverny on 22 April to ask for more paintings, having already sold a Belle-Ile-picture. "So he has six," Monet wrote to Georges Petit, "including four for the exhibition."

Thinking ahead to the exhibition, Monet attempted to finish some pictures of Giverny to provide "something other than views of Belle-Ile", but failed to do so, partly because the private view had been brought forward to Saturday 7 May. *Saint-Lazare Station, The Normandy Train*, which belonged to de Bellio, was brought in to "sound a note very different from my seascapes", along with *Apartment Interior* and *Vétheuil in the Fog*. Belle-Ile paintings accounted for

two-thirds of the 15 catalogue entries. None of the paintings exhibited belonged to Durand-Ruel, who was thus doubly absent as he had returned to the United States where many obstacles stood between him and a further exhibition. Comparison of the letters of Monet and Renoir in which they report impressions of the International Exhibition is revealing, and very advantageous to Monet in the matter of discretion and goodwill. Pissarro, writing to his son Lucien, railed against this "confounded exhibition which stinks of the bourgeoisie through and through", and attempted to convert anyone who would listen to his own low opinion of Monet's work. Albert Wolff had been asked to review the exhibition, but did not do so, and *Le Figaro* thus printed nothing about it. Since it was a group exhibition, the reviews of any one participant were for the most part less detailed than for a solo show. Besnard and Whistler were nevertheless given better coverage than members of the former Batignolles school. Rodin, the only sculptor exhibited, was showing *The Burghers of Calais* among other things, and rather annihilated everyone else with his lofty reputation and manner. There were very few hostile comments about Monet. But certain of his more favourable critics seemed hesitant; Roger Marx, for example, writing in *Le Voltaire*, confined himself to *Apartment Interior* and *Saint-Lazare Station*, while Huysmans remained faithful to "the admirable seascapes belonging to M. Durand-Ruel", preferring these to the "compact, aggregate masses" and "inpenetrable volutes threaded with veins like marble" that he perceived in the Belle-Ile pictures; he went on to speak of "painting seen through the eye of a cannibal" and "the rebarbative charms of this rough-hewn art".

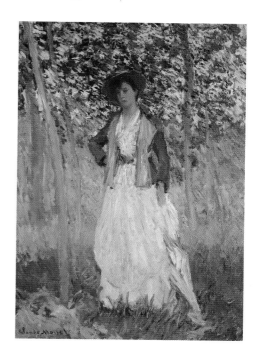

Taking a Walk
1887
Cat. no. 1133

Gustave Geffroy

Cutting through this general uncertainty there came, in close succession, two hymns of praise to Monet's art. The first was from Octave Mirbeau, and was not unexpected; the second from Gustave Geffroy, and was expected only by those in the know. In addition to the "Salon de 1887" entrusted to him by Clemenceau, Geffroy had decided to add a further column, "Hors du Salon", entirely devoted to Claude Monet, and the editor-in-chief of *La Justice*, Camille Pelletan, had placed the first column of this article on the front page and likewise had given over two front-page columns to the second part of the piece, published a few days later. There is no need to dwell on Geffroy's remarks about the incomprehension that Monet had long suffered, nor the curious idea that the only comparisons or witnesses "with which he perpetually confronts [his] works" are "the objects and elements that he seeks to reproduce". Geffroy is more interesting when he asks why people had changed their tune about Monet's work over the previous three years. Were his paintings vilified when they hung at Durand-Ruel's but spared when they were exhibited in the Rue de Sèze? Had Monet simply made progress? Could this not have been foreseen? Had he attenuated his audacity in any way? Not in the least. Was it simply that people had become used to him? It was more that the eyes of a small section of the public had at last been opened.

Geffroy did not neglect the older paintings that his colleagues had singled out, but he went on to consider the three regions in which the most recent works had been painted. Holland he evoked in fairly conventional manner, the Mediterranean he studied in the three paintings that it had inspired, but Belle-Ile he described as someone who had watched the painter at work in the landscape could have done. The places that Monet had painted – Port-Coton, Port-Goulphar, Port-Domois – were all correctly identified. "Solitary pyramids

The critic Gustave Geffroy
Photograph Nadar, 1893
Paris, Archives photographiques

standing in front of the cliffs" (1084), "peeling knolls, stained yellow and red by the autumn vegetation", "pachyderms with thick crusts" (1096 or 1097, 1093?), "rocks pierced like arches" (1106), "iron and rust-coloured promontories tall, square and solid as cathedrals" (1101?). – "And finally, here is the sea in all its terror, during the storm of last October (1119?)." All this he had seen with his own eyes. He had also seen "this rustic alchemist" (Monet) at work, (beginning) "ten studies of the same prospect in one afternoon." His accurate eyewitness account is strikingly superior to the banal observations published by the many who visited Giverny early in the 20th century. "All haste as he fills the canvas with the dominant tones, he then studies their graduations and contrasts and harmonises them. From this comes the painting's unity ... Observe...all these different states of nature... and you will see mornings rise before you, afternoons grow radiant, and the darkness of evening descend."

The *Portrait of Poly* (1122)was there too, to preside over this panorama of seascapes. This "untutored, kindly, brave, slow fellow, with his dreamy air and fierce determination", Geffroy continues, "takes my mind back to the days spent on Belle-Ile in Monet's company" on the sea-side paths, the inland pathways and at the little inn presided over by Mme Marec in her Breton headdress. And Geffroy's concluding paragraphs take on a melancholy tone as he evokes "that all too brief interlude of hard work, walks and conversation" in a moving homage to Belle-Ile and the great artist who had painted it.

The Château de la Pinède

Before the International Exhibition closed, Monet spent a fortnight in London with his friend Whistler. On his return, breaking with his habit of solitude at Giverny, he sent out a number of invitations to Mirbeau, to the poet Richepin and to Rodin. Dr de Bellio was invited with his daughter (soon to become Mme Donop de Monchy). He was unable to come, but his letter of refusal spoke of his own recent visitor, John Singer Sargent, who had praised Monet to the skies. Sargent's renewed contact with Monet's work brought him to Giverny too, where he sketched several portraits of his host. The summer of 1887 also marked the first visit by Singer's compatriot, Theodore Robinson, who was to become a regular guest at Giverny.

The presence of visitors did not keep Monet from his work. After an early spring "campaign" some way from the house (1125–1130), he spent most of the summer painting "figures out of doors... painted like landscapes." This was an old dream of Monet's and proved exhausting to fulfill; but the results were, almost without exception, dazzling (1131–1136, 1148–1153). The rest of his time was given over to landscapes in which flowers play an important role (1137–1139, 1146–1147). Sometimes he painted flowers without a landscape in the garden, which was now ready to serve as a backdrop or "model" in its own right (1140–1145). The last paintings of the year were a first attempt at the poplars (1155–1157).

Meanwhile, a letter from Mirbeau noted the lasting impression Monet had made in Kervilahouen (he was remembered as "Monsieur Bonnet"); it also recorded Rodin's first sight of the sea: "It's a Monet." Monet's letter congratulating Rodin on his having been made a knight of the Legion of Honour on 31 December 1887 suggests a sense of mutual admiration, though Monet's desire to continue in Rodin's good graces also transpires; Rodin was then by far the more famous of the two. The two men met at the Bons Cosaques dinner. A letter from Mirbeau provides interesting information about the Bons Cosaques mem-

bership while hinting at the plotting and internecine warfare that went on there. Monet had now adopted a gentler tone with Durand-Ruel, and there is a certain insistence in his invitations to Charles to visit him. Perhaps Monet's relations with Georges Petit, who tended to delay payment, were deteriorating. Meanwhile, Theo van Gogh was gaining ground in Monet's affections. Thanks to Theo van Gogh, the Boussod Gallery took on the dispatch of Monet's paintings to London for the Royal Society of British Artists exhibition; here his contact was Whistler. Several times Monet declared his intention of returning to London for the opening on 25 November, and even thought of painting "a few fog effects on the Thames". But the effects he next painted were under skies much more luminous than those of London. Monet's first destination of 1888 was the Mediterranean.

On 13 January, after a luxurious overnight journey by train, Monet reached Cassis. He spent the following night in Toulon and the next day went by omnibus via Agay and Le Trayas to Juan-les-Pins. From there he had himself driven to the Cap d'Antibes, where an "immense" room awaited him in the Château de la Pinède, a mansion now converted into a "painters' house". A recommendation from Guy de Maupassant had ensured him a pleasant welcome. Monet was not greatly impressed either by his first meeting with a group of painters centred around Harpignies or his first sight – it was raining – of the subjects that his colleagues insisted on pointing out to him. Two days prospecting for motifs took him west to Agay and Trayas, then east to Monte Carlo, whence he returned on foot as far as Nice via Turbie, Eze, Beaulieu and Villefranche, a good 25 kilometres' walk. He then went by railway from Nice to

Clematis
1887
Cat. no. 1145

Young Girls in a Rowing Boat
Pencil sketch
Paris, Musée Marmottan
(D.W. 1991, V, p. 110, D 341)

Head of a Woman
Sketch in red chalk
(D.W. 1991, V, p. 131, D 447)

Antibes where he saw "very beautiful things". He therefore decided to remain at the Château de Pinède. From there it was easy to reach both Juan-les-Pins on the west of the promontory, and, on the far side, the Salis gardens, the Garoupe plateau and the beaches that ran round the Bacon headland as far as Ponteil. All of these places offered admirable views of Antibes and the Alps. He quickly discovered five or six motifs which he found "superb" and which the "resplendent" weather enhanced; his optimism was at its height. On 20 January, he had decided on his first goal: "I am painting the town of Antibes, a little fortified town all golden in the sun that stands out against beautiful blue and pink mountains and the eternally snow-capped range of the Alps." But things were not as easy as they initially seemed; Agay quickly came to symbolise a paradise to which Monet should return forthwith and yet which he had somehow forfeited for ever. The company of Harpignies and his students proved onerous, and Renoir, who was staying with Cézanne at Aix and later on his own at Martigues, was not wanted either. The hostess of the Château, "a real character, a friend of Manet and Degas", was charming, and even took Monet to visit "a marvellous estate" whence they returned laden with flowers.

Few if any of Monet's painting "campaigns" had begun in an atmosphere like that of his first days in Antibes. He was obsessed with the idea of returning to Giverny and was reluctant to "start loads of paintings"; unhappy with his first pictures, he scratched out two of them. He was "worried and fretting" about work. The weather was still magnificent, it was the task that was difficult:

Young Girls in the Rowing Boat
1887
Cat. no. 1152

"It's so light, such pure pinks and blues that the least wrong touch makes a dirty mark", he writes on 1 February, when 14 pictures had been started, of which six "will be good". And he added: "What I bring back from here will be sweetness itself: white, pink and blue all wrapped in this fairytale air." The bright sunlight was tiring: "I have to confess that my sight is failing, and that I can no longer read in the evening." This was not surprising; Monet was approaching fifty years of age and was attempting to record the effect of snow-capped peaks some 60 kilometres away. "What a curse this damned painting is!" And how much simpler it would be to behave like his neighbours, the "tuppenny ha'penny painters", who, when their day's work is finished, "don't give it another thought", whereas he wakes at four am sweating with terror lest he be "finished, sucked dry" – and nonetheless bites his nails if there is the slightest prospect of rain.

Meanwhile, at the Lion d'Or in Paris, Rodin had been fêted by his friends along with the painter Besnard, who had also been made a knight of the Legion of Honour. A few days before this event, Mirbeau had treated Besnard's decoration with some irony in an article in *Le Figaro* entitled "The Road to the Cross". When Rodin, apparently offended, stopped answering his letters, Mirbeau wrote to Monet, asking him to intervene with Rodin. This Monet did with such discretion – "between ourselves" – and success that Mirbeau could naively announce: "Rodin is all smiles. He wasn't angry at all." The incident, for all its comic side, is revealing of Monet's cunning and tact – whenever his

own interests were not directly affected. He was never blinded by anger. He showed the same cunning in persuading Castagnary to intervene on his own behalf with the military authorities who granted him permission to paint in the fortified town of Antibes. Castagnary, who had been at the cutting edge of art criticism in the Salons and contributed to *Le Siècle*, was now Directeur de l'Ecole des Beaux-Arts. The key ministerial posts were gradually coming into the hands of friends of the Impressionists, and the change in the authorities' attitude was one factor in the new painting's growing success.

It was still an uphill struggle. While Georges Petit continued to withhold the payments that an increasingly exasperated Monet was demanding, Theo van Gogh was asking the price of *Trees in Winter, View of Bennecourt* (**1125**). When Monet demanded 2,000 francs, he had to wait a fortnight before hearing that he was offered only 1,500, as, according to Théo, there were plenty of Monets on the market at low prices. He attempted to draw a line at 1,700 francs, but the situation was aggravated by the Charles Leroux sale, which put eight Monet paintings on the market at once. On tenterhooks, he telegraphed all his dealers, including Durand-Ruel and Portier (of whom we hear little, but who had ten Monets in his possession) asking them to push prices up. He would have done it himself by selling some shares – this is our first indication that he possessed such things and was not living from day to day as he so often claimed – but there was no time to instruct Caillebotte to represent him. The Leroux sale finally took place on 27 and 28 February, and Portier immediately informed him that the prices were, as *Le Temps* confirmed, "fairly substantial"; "Houses at Falaise in the Fog" had gone for 2,055 francs, and the lowest price had been 1,000 francs. Durand-Ruel, unresentful as ever, had come to the rescue, along with the Boussod Gallery, and the best buyer of all had been "old Chocquet" who was now more anxious to acquire Monet paintings and "had really put himself out this time". Prices were safe, but Monet's resources were dwindling. He therefore agreed to let Theo van Gogh's have *Bennecourt* for 1,500 francs; it was resold for 2,200 francs before April was out.

The Whole Gang

The Antibes "campaign" followed a familiar pattern: Monet alternated between hope and despair, depending upon the weather and Alice's recrimination. Successive dates of return were solemnly fixed and blithely postponed, and week after week went by. To Alice, who remained in Giverny, he described the travails of each new day.

By 11 February, 1888, Monet was writing: "I really don't know how to make headway with a painting any more; I feel as if I were doing the same thing every day without getting anywhere... I assure you, I worry that I'm finished, used up." 1 March: "I've no hesitation about doing pictures whatever the weather; when it comes down to it, it's the only way to get things done and pass the time." 4 March: "The fine weather is back with a vengeance, and I'm working constantly; I'm so anxious to have it over with and be back with you that it spurs me on, it's like a fever." 16 March: "Hard as I work, I can't finish anything; there are only pictures I can't do anything more with, and they remain incomplete; then there's the feeling that the things I start again with are better anyway." 25 March: "This is the third day on which I haven't been able to paint! You can imagine how it torments me. Think of all the pictures I'll have wasted! And everything's growing, everything's changing under my very eyes. What rotten luck! ...I'm so angry, you can't believe how angry." 10 April:

Anecdote versus Fact

In the honours list of 15 July 1888, Émile Zola was made a Knight of the Legion of Honour and decorated by Édouard Lockroy in the salon of Mme Char-pentier, the wife of Zola's publisher. Certain of Zola's colleagues were less than complimentary about his acceptance of this great distinction, and he defended himself in letters to Maupassant, Edmond de Goncourt and Mirbeau; the latter was royally put in his place with a "You don't know what you are saying and are speaking of things you know nothing about." Attempts have been made to contrast the attitudes of Zola and Monet, who is said to have refused the Cross of the Legion of Honour with great dignity on the occasion of the same honours list. Alas, this story must be consigned to the "not proven" category, at least for 1888; there is no documentary proof that the offer was ever made.

The negotiations between Monet and Durand-Ruel over the course of the summer make it clear that Boussod and Valadon enjoyed a privileged relation-ship with Monet; Durand-Ruel, Monet's first dealer, was required to negotiate with them if he wished to obtain better conditions than the already "special" ones extended to him when Monet had reached agreement with his new clients. Disappointed and in bad health, Paul Durand-Ruel could not disguise his anger at this further proof of Monet's outrageous ingratitude. Theo van Gogh.

Opportunities thus remained for Boussod's representative, Theo van Gogh. He was now a habitual guest at Giverny, and was always eager to buy Monet's work. Between July and October, he bought four paintings from third parties — one of whom was the redoubtable Albert Wolff, who sold a Pourville painting — and one from the artist. In December, he bought a further seven pictures, for which he paid 8,700 francs on receipt, promising Monet a share of the profits under the same conditions as in June. But Monet had to wait until 1891 before the last of these left the stock of "Goupil and Co.'; one was sold in March and one in September of 1889. Monet's work was put back by a July trip to London, where he stayed not with Whistler but with Sargent. The bad summer weather also delayed matters; the early autumn was better, when the words "passion for work" that appear during his most creative periods are again found in his letters.

The year 1889 was to be a momentous in both Monet's life and the history of France: it was the year in which the Exhibition Universelle exhibited France's splendour to the world. But for Monet it began without incident. He was so amused by the quarrel of Whistler and William Stott in early January that he passed on to Mirbeau the letters in which Whistler, whom he suspected of megalomania, recounted his exploits. A few months later, the ebullient Whistler was able to visit a Monet exhibition at the Goupil Galleries in London; it repli-cated one organised by Théo van Gogh in his Parisian mezzanine. Mallarmé, for his part, wished to publish Le Tiroir de Laque, a collection of poems illus-trated by his painter-friends. Monet was asked to illustrate La Gloire, but wrote on 15 February to say that he had not had the time to do so. With the exception of Renoir, all the other artists also withdrew, and the project was abandoned.

Had Monet really been so busy? The facts of the matter come out in a letter to Berthe Morisot; the weather at Giverny had been unstable, preventing Monet from painting the snow and frost effects that he had been hoping to record. Marc Elder recorded the truth according to Monet: "Now, in 1889, in January, I was painting on the ice. The Seine was completely frozen over. I set up....." All the details are there – the hot-water bottle not for the feet but for the fingers – with that little touch of humour helping to create the image that Monet sought

Grainstack at Giverny
1889
Cat. no. 1216

PAGE 245:
Evening in the Meadow at Giverny (detail)
1888
Cat. no. 1206

burst out: "Ah yes, as poor Édouard always used to say, Monet is a genius." "You have made quite a conquest of this supposedly recalcitrant public", Berthe Morisot noted, her frank admiration unadulterated by a touch of envy. Gustave Geffroy had established his credentials as a Monet supporter in Belle-Ile, and on 17 June published a panegyric in *La Justice*. It caught the eye of the already enthusiastic Vincent van Gogh, who wrote to Theo: "Who will be to figure painting what Monet is to landscape?" Vincent cited Geffroy in recommending that John Russell see the exhibition; at this stage Vincent had clearly not seen it, as he refers to "fir-trees" (191) where Geffroy in *La Justice* had correctly identified pines.

For the painter Georges Jeanniot, writing in the *Cravache Parisienne* on 23 June, Monet's Antibes paintings brought to mind "the scent of orange and eucalyptus trees", and he sought to apply Baudelaire's words from "Correspondances": was Monet aware of "the strange affinity between perfume, sound and colour?" This might seem banal today; the extraordinary thing is that this occasional critic made the pilgrimage to Giverny and was the first to give us his impressions of it. He reported that Monet did not have "what one could call a studio", and the place which seemed to do duty for one was used exclusively by Monet for smoking his pipe, examining his studies – "never retouching", – and planning future work. This was a piety that everyone had observed since Taboureux's visit to Vétheuil in 1880. The non-studio was, as we know, used for finishing paintings brought there unfinished from the place where they had been started. Jeanniot described it as it looked in 1888, "a sort of barn" absolutely full of paintings "hanging up or piled up in the corners'; the floor was of beaten earth and there was a large, glazed window. Jeanniot was allowed to accompany Monet as he wandered through the meadows, admiring motifs of all kinds, finally stopping at the chosen site. There, at his easel, "he starts painting after a few charcoal outlines, wielding his long paintbrushes with surprising agility and assurance of line; his landscape is quickly fleshed out and could, at a pinch, be left unchanged after the first session." This session lasted "as long the effect lasted'; when the effect changed, a second canvas was started. If the second canvas had already been roughed out, the artist completed it, painting "with full brushloads, not mixing the paint, with four or five bright shades", juxtaposing or superposing the "strong colours." "Others do things in other ways, and do them successfully," Jeanniot added, unwilling to alienate certain tendencies, "but very few... can do what Claude Monet can, that is, seize the nature of a spectacle and draw out its harmony. This is the sign of a great master."

Jeanniot's article caught the attention of Mirbeau and passed Pissarro by unnoticed. True, Pissarro was on the watch for articles unfavourable to Monet; he approvingly pointed out to Lucien a rather disagreeable verdict handed down by Félix Fénéon in the July issue of *La Revue Indépendante*. Monet was now "a spontaneous painter" who had not an ounce of "contemplation or analysis," in him. His art was "served by excessive technical bravura', an improviser's fertil- ity" that could become "brilliant vulgarity". This was not "the art of a refined man". "It's more vulgar than ever" was Camille Pissarro's own verdict, and when he met Monet at Durand-Ruel's, he put before him another article, in which Monet was criticised "idiotically, with such stupid reasons... and equally stupidly praised." That would teach Monet to go around "wearing a quizzical expression" all the time.

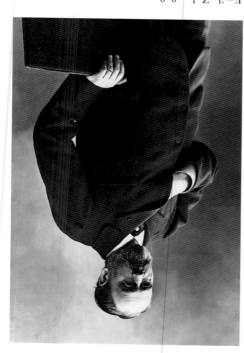

Emile Zola, 1898
Photograph: Nadar
Paris, Archives photographiques

Landscape with Figures, Giverny
1888
Cat. no. 1204

mented still further; he hoped that speculators would be encouraged, and that the chain-reaction would profit him too.

Now in possession of "ten seascapes of Antibes", Theo van Gogh hastened to display them in a private exhibition at his mezzanine at 19 Boulevard Montmartre. A stream of distinguished visitors began to flow through these two small rooms which possessed neither plush walls nor shiny picture-rails. Among them were Guy de Maupassant, who was interested to see the places that he himself knew well; Prince Eugene of Sweden, then studying art in Paris under the name Eugène Bernadotte, and more open to Monet's vision than the fellow-students who came with him; the German painter Hermann Schlittgen, who studied the pictures with great attention; and Stéphane Mallarmé who was dazzled and

In *The Pink Skiff*, painted three years later, one can trace the way Monet was to use the water motif in his *Grand Decorations*
1890
Cat. no. 1249

"Everyone will want to be in on it, and that's just what I don't want. I've done enough for the others; that was my mistake. Sisley... is asking me to tell him before I do anything; it's the thin end of the wedge." Less circumspect, Renoir had taken it on himself to book the "Durand place." Monet had one last hesitation, then seems to have made up his mind while he was leaving the Cap d'Antibes.

But no. When he passed through Paris in the very first days of May, a visit to Charles Durand-Ruel again left everything up in the air, and as soon as he was back at Giverny, he wrote to Charles to say that he was abandoning "any plan for an exhibition in the Rue Laffitte". And he attempted to persuade his friends to do the same, while denying any such intention. Rodin alone followed Monet's lead. Berthe Morisot, Renoir and Whistler took part in the Durand-Ruel exhibition alongside Boudin, Brown, Caillebotte, Lépine, Pissarro and Sisley – "the whole gang", in short.

Theo van Gogh's Mezzanine and the Giverny Studio

The breakdown of Monet's negotiations with Charles Durand-Ruel had rapid and decisive consequences. Theo van Gogh visited Giverny, as expected. Vincent van Gogh was envious and wrote from Arles in early May: "You'll see some beautiful things at Monet's." Theo, still working for the Goupil company, felt that the market was ripe and acted quickly: on 4 June 1888, he bought ten Antibes paintings for 11,900 francs, the price per painting varying between 1,000 and 1,300 francs. What was more, he contracted to pay Monet 50 percent of the resale profit. These additional gains are to be found in Monet's account-book from September onward: for six paintings, they came to 3,850 francs. *The Beach of Juan-les-Pins* (**1187**), for example, was bought from Monet for 1,300 francs, and sold on to Boivin on 12 June for 3,000; of the 1,700 franc profit, Monet received 850 francs, and so this one painting brought in 2,150 francs in total. Gauguin was delighted by the rise in Monet's prices, which rumour aug-

In the "Norvégienne"
1887
Cat. no. 1151

and am replying to him as he deserves." Monet was now beginning to wish that the exhibition would not take place, and was more than ever convinced that the gallery had been promised to others: "Really, how vile all this has been." Nevertheless, on 10 March, he was still encouraging his friends Berthe Morisot, Helleu and Whistler, to excel themselves, and afraid that the bad weather would affect the quality of his own contributions. In early April, a letter from Theo van Gogh and another from Renoir alerted him to the truth: a sale was to take place at Petit's on 16 May, the date on which the group exhibition was to have opened. "What infamous conduct, to to [sic] trick us like that!" His pen was stuttering with rage, and Cazin was the prime suspect in the matter – that same Cazin thought to have helped Monet into Petit's good graces in the first place.

Should he return to Durand-Ruel? Monet was reluctant, and his reasons are revealing: "I should just be falling back into the clutches of the whole gang plus their hangers-on, when I had trouble enough getting out. I've had enough, I was so stupid to get the others in with Petit; this is what's come of it." It is the Impressionists that Monet thus rejects. One of his earliest Impressionist friends is thus summarily dismissed: "I see Sisley thinks of writing to me only when he needs something." He therefore showed great circumspection about the issue of exhibitions when informing Paul Durand-Ruel that he would like "to return to doing business with him", but that he had already promised to show his paintings to others who might take precedence.

At this point, Octave Mirbeau, who was also very hostile to Cazin and Petit, intervened to advise taking part in the exhibition at "old Durand's". Before making a final decision, Monet asked Renoir to sound Petit out one last time about an exhibition of Monet, Renoir, Rodin, Whistler and no one else. Even before Renoir's telegram reached him, he had heard "amazing things" from Mirbeau himself, who had come south for a holiday: Petit was selling off his paintings at low prices to people who then sold them on to Durand-Ruel. Cazin, the inevitable Cazin, was one of those behind this strange proceeding. "So I have every reason never to set foot in the place again."

There was still the Durand option, but there too, problems arose:

"I am really upset by these stoppages, because I thought...things were going better...I've never had such problems." 16 April: "I've reached a point now when every brushstroke hits the mark." Two days later: "I'm working like a madman. Well, so what! I'm delighted!... A few of the pictures are going to be very good, and, I think, they're a real step forward, if I'm not mistaken." 22 April: "Of course, I'm not claiming I can finish everything.... I just want to save a few." The next day: "For four or five days now things have gone badly and you know how I am." 26 April: "To have taken all this trouble and still not be satisfied, it makes me furious." 29 April: "I am in despair; some of these pictures have come out best of all, but they won't do as they are." April 30: "I beg you, forgive me if I stay for another day or two.... I think [these pictures] will be very good, or else I'm too close up to them and can't see sense any more."

Assailed as he was by the pangs of creation and by family upheavals, Monet also busied himself with exhibition plans. The prospect of Blanche Hoschedé submitting a painting to the Salon – he had himself portrayed her painting (1131, 1132, 114) – seems not to have interested him. He was much more interested in preparations for the group exhibition planned for the Georges Petit gallery in May. As early as January, there was alarming news. "Everyone has opted out, except the Impressionists, Whistler and Helleu." Monet concluded that Petit was planning to use the gallery for some other event, but persisted in believing that the planned exhibition would be a "major artistic event". In mid-February, his already tense relations with Petit were worsening: "I am furious.

Grainstacks at Giverny
Pencil sketch
Paris, Musée Marmottan
(D.W. 1991, V, p. 91, D 192)

to impose. But the meteorological records are implacable; in 1888–1889, the winter was by no means severe, and no ice floated down the Seine.

We must also consign to the status of studio gossip an anecdote recorded by René Gimpel, who has it that Monet decided "around 1889, ... to more or less give up landscapes" for figure painting, on the advice of Renoir and other friends. Monet is then said to have recruited a "fine young woman", who was to come to Giverny but was quickly dismissed when Alice Hoschedé announced: "If she comes, I go." Alice's reaction is plausible, but the rest can never have amounted to more than a quip or a whim. As to the date, it is in clear contradiction with the increasing prestige of Monet as a landscape artist now firmly on the road to fame.

As if to underline Monet's ascent, there came the death in January 1889 of Alexandre Cabanel, for many years the epitome of the *Salon* artist; it was a first knell rung for the generation of academic painters and their famous hostility to Impressionism. It was the fate of its surviving members, Gérôme and Bouguereau, to witness, impotent and aghast, the apotheosis of a school that they considered the disgrace of French painting.

The First Grainstacks

At about the turn of the year, Monet began his first paintings of *Grainstacks* (1213–1217). For several years little haystacks had appeared in the Giverny paintings. They sometimes gave the painting its title, but their role was generally secondary; these were stacks of hay, whose presence in scythed fields was as ephemeral as the haymaking which produced them (900–902, 903–995, 1073). The "Grainstacks", which became the focus of several series successively painted by Monet, were in fact huge stacks of corn... Thus "haystacks" or "Heuhaufen" are mistranslations of the French "Meules" and should be proscribed. The history of grainstacks has been little studied by historians of agriculture, who are reticent about their origin. But it seems that, despite their quaint appearance, grainstacks are a relatively recent phenomenon. They came into being only when the countryside was sufficiently safe and the wheatfields sufficiently pro-

ductive, during the second half of the 19th century, and disappeared a hundred years later when the combine harvester came on the scene.

To shelter the sheaves until they could be threshed, the peasants would build their stacks on the freshly-mown field. Threshing was done using machines that travelled from village to village, and some farmers had to wait from late July, when the harvest took place, until February or even March of the next year. The appearance of the sheaf-stacks varied from region to region. In many places they were rectangular, but in the Paris basin as a whole and in the part of Normandy where Giverny lies, they were round. Popularised at school by textbooks and wall-maps, the round grainstack became synonymous with the traditional images of the French countryside. The stacks of the Barbizon-Chailly region can be seen in several of Millet's works; if the earlier depictions are compared with later ones, we see that the later stacks are larger, though not so perfectly shaped as those that Monet painted some thirty or forty years later. When the practice was at its height, round sheaf-stacks were invariably made with their "base" sloping upwards and outwards, and their "roof" cone-shaped; the roof would account for some two-thirds of the full height. The width of the construction would depend on the quantity of sheaves to be conserved and the abilities of the "tasseur" or stacker who built it. When it was finished, the top would be covered with a layer of rye straw, different in texture and colour from the lower part.

This was the subject that Monet began to paint after the 1888 harvest. A first motif, depicted in three paintings (1213–1215) shows two stacks, a large and a small one, silhouetted against the line of hills along the left bank of the Seine, with a few Giverny houses showing to the right. For a second motif, of which there are only two examples (1216–1217), Monet turned to the left, where a row of poplars veiled the line of the hills. His choice of stack was favoured by circumstance: a little to the west of his house, a large piece of land, the Clos Morin, served each year as a "floor" for the stacks of one of Giverny's bigger farmers. The "high road" passed the north face of the Clos Morin before reaching the town hall. From this road, and not from the more recent road that crosses it today, Monet would enter the enclosed field. These paintings consti-

Osterlind
Maurice Rollinat
Châteauroux, Musée Bertrand

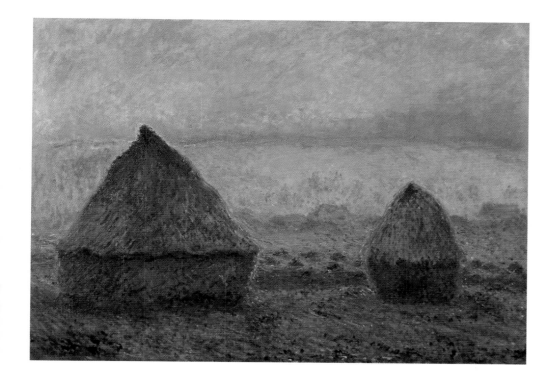

Grainstacks at Giverny, Sunset
1888–1889
Cat. no. 1213

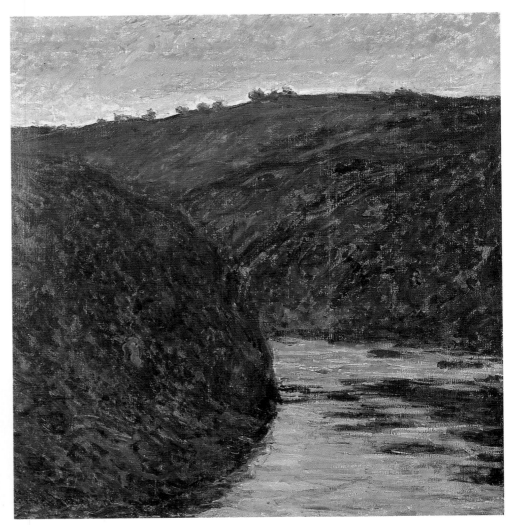

The Creuse at Sunset
1889
Cat. no. 1226

The confluence of Creuse rivers at Fresselines
Postcard, c. 1900

tuted a rather modest beginning and, despite the exaggerated claims occasionally heard, did not mark any real progress towards the systematic use of series. Monet's series were not magically born of his first encounters with the grainstacks; they were the result of many years of experience. In the grainstacks of 1890–1891 and, above all, in the poplars, they reached their apogee.

Chez Maurice Rollinat

On 15 February 1889, Monet felt that it was no longer practical to undertake a winter "campaign" far from Giverny. On 28 February, he was writing to Rodin to tell him how much he had enjoyed an excursion to visit Maurice Rollinat, having been dragged off to the Creuse by Geffroy in the company of Louis Mullem and Franz Jourdain. (This corrects accounts which place the trip in January; it took place in the second fortnight of February.)

Gustave Geffroy had known the poet Rollinat for years. He had published a long study of "Névroses" in *La Justice* when the volume first appeared, in 1883, and had not lost touch with Rollinat when the poet exiled himself to the village of Fresselines, near Crozant. There Rollinat lived with an actress called Cécille Pouettre, whose stage-name was de Gournay: "Cécilinette, Madonne à moi/ Etanche un peu ma soif de toi" (Little Cécile, Madonna of mine/ Quench my thirst for thee and thine). The couple lived on the outskirts of the village in a

had only partly kept. And on top of all this came endless family matters: there was the plan to rent a room in the Rue Godot-de-Mauroy; the cancellation of their lease in the Rue de Provence; Jean's military service; Jean's Easter leave, which he spent at Giverny; Alice's complaints as his absence grew longer and longer, and her hints that it was Cécile, Rollinat's mistress, who was holding him back in the Creuse. Monet did his best to reassure her: "Don't go getting ideas into your head about his wife, who is very likeable and obliging. I am yours alone and always shall be." But this constant tension worried him.

Maurice Rollinat was not, by nature, a tonic personality, but he continued to be full of attentions for Monet. "Indeed, you must expect me to assail your ears unmercifully with praise of this astonishing and good-hearted man."

Monet's admiration redoubled during the preparation and performance of chants and canticles; Rollinat performed in public for the major parish ceremonies, to the great satisfaction of the large congregation and its priest, Abbé Daure, who was convinced that "nowhere else is Mass sung like that." Monet was present in the little Fresselines church for the Palm Sunday Mass, listening to the chants performed by Rollinat and to the "very splendid" sermon of the Abbé, who was kind enough to thank "the great artists" who attended. On Maundy Thursday, after the evening service, there were lobsters and shellfish sent specially from Belle-Île for dinner: "a veritable orgy." Monet's attendance at church pleased Alice, but the self-confessed "orgy" brought new accusations, and Monet was forced to protest that "My only care, my life, is you."

Monet had stayed too long. During the last few weeks, art inflicted such tortures on the artist that Monet was reminded of another Normandy artist tormented as he had been: "If Flaubert had been a painter, what would he have written, my God!" Everything conspired to discourage him: trees were cut down, the sun was higher in the sky and the light correspondingly different, and he was dazzled by the "diamond spangles" that it made on the river. Two days later, the Creuse filled with mud and overflowed its banks after a torrential downpour. And more and more leaves were appearing.

Monet had decided on a policy, recently confirmed in a letter to Alice: "Here I fly from and avoid everything that savours of spring." How could he persist with this policy in the increasingly spring-like landscape? Monet decided to prolong the empire of winter by artifice. The oak at the confluence of the two Creuses was sacrificed to this strange ploy. On 6 May, Monet had made a large rough sketch of its leafy mass standing above the yellow rivers of the Creuse, but, now, thinking of the many pictures in which it featured (1229–1232), most of which were still unfinished, he offered the owner of the land 50 francs "to have all the leaves removed" and restore the tree to the winter state in which he had depicted it hitherto. The land owner gave his permission, and on 8 May, two men, leaning away from ladders which had been lowered with great difficulty into the ravine began to strip the old oak of its leaves. "Isn't it really the limit to be finishing a winter landscape at this time of year?" Monet asked Alice, nonetheless delighted to have prevailed with the landowner. To pervert nature out of fidelity to nature suggests an impasse, one which Monet thereafter circumvented by his use of series: poplars, grainstacks, Rouen Cathedral, and finally the artificial décors of his garden and lily-pond.

"For ever Monet! For ever Rodin!"

Monet's return to Giverny was almost certainly on Sunday, 19 May 1889. The following day, the physicist Sadi Carnot presided over the inauguration of the

Claude Monet in 1889
Photograph B.N.F., Paris

CLAUDE MONET
—
A. RODIN

GALERIE GEORGES PETIT
8, rue de Sèze, 8

PARIS
—
1889

Cover of the *Monet-Rodin* exhibition catalogue
1889

The Grande Creuse by the Bridge at Vervy
1889
Cat. no. 1233

sunny weather, they would probably have to be transformed when fine weather allowed him to return to them. The colours of the River Creuse were changing all the time: green in normal weather, it became yellow when in spate.

"Between two showers and even under the rain." Monet was hard at work, his chilblained, cracked right hand kept day and night in a glove smeared with glyc-erine. Should he transform the pictures to adapt them to the sombre weather, at some risk of having to restore them to their original state when the sun returned? In his confusion, he began to doubt himself: "It takes me so long to finish anything...." "Alas, the more I do this, the more difficult it is to capture the things I want."

With the first rays of sun, his old enthusiasm returned despite the new leaves increasingly visible in the landscape: "I was excited, making the changes I needed, and then, boom.", along came a fierce gale and everything was back to square one. Whenever a little sun broke through, Monet would hasten out to paint the sunset over the village of La Roche-Blond, not far from Fresselines. The next day, he returned to his paintings in brighter weather. Bursts of activity alternated with bouts of enforced idleness until mid-April, when it seemed that things were going better. But not for long: drought caused the level of the Creuse to fall and new complaints were forthcoming. On Easter Sunday, the date originally set for his return, a hint of optimism: "I am really overcome with it all, I have such a passion as I never had before." Forty-eight hours later, he collapsed into bed, feverish and aching. Two days' rest and two "whims", put paid to his lumbago, and battle was resumed in somewhat serener fashion.

How much easier things would have been, if it had only been a question of painting! But there was his career to consider. The Goupil exhibitions in Paris and London had posed no great problems, but the Monet-Rodin exhibition at the Georges Petit gallery required long and complicated negotiations whose suc-cessive phases formed a kind of counterpoint to the battle with the landscape. These incessant worries were leading Monet to neglect old friends: Boudin had every right to complain, and de Bellio was reminding him of promises that he

On 10 March, when the headlines were full of the Boulanger affair, *Le Figaro* published an article by Mirbeau entitled "Claude Monet" that took the place of its editorial. This positively dithyrambic piece eventually served (in translation) to preface the catalogue of Théo Van Gogh's Paris exhibition when this was transferred to the Goupil Galleries in London. Mirbeau was, moreover, chosen to introduce Monet in the catalogue of the Monet-Rodin exhibition; Geffroy was to do the same for Rodin. Monet made a lightning trip to Paris for the meeting at the Rue de Sèze on 13 March where these and other arrangements were made. He travelled via Châteauroux, whence he sent a note to Rodin on the 12th.

The *Figaro* article had brought visitors flocking to Théo van Gogh's exhibition, which he therefore extended, announcing that some of the paintings were for sale. Monet, meanwhile, concerned at the lack of urgency shown by both Petit and Rodin. He felt that he had to "jog their memories", which added considerably to his correspondence. A more welcome task was to thank Roger-Milès, who had published a sympathetic article in *L'Événement* of 15 March.

Less than a fortnight after Monet's arrival at Fresselines, some fourteen pictures were in progress, but then the weather turned bad and the rain seemed likely to bring spring colours to the landscape earlier than expected. How foolish he had been to start winter landscape work in March!

Fortunately, Maurice Rollinat took his depressed visitor in hand, and, one day when it was snowing, invited his guest out for a long excursion, from which Monet returned "dazed". "I am more and more charmed by Rollinat", he wrote to Alice, "he is a true artist, … replete with bitterness and melancholy"; Rollinat was so perpetually "unhappy" that he understood and respected the torments of creation in others. But Monet was not always so happy with this "respect"; at the end of the first month of his stay, he was, as usual, overcome with doubts, and there was a nuance of regret when he noted that "Rollinat never comes with me when I paint and only wants to see my pictures when they're finished; besides, I think he's a little blind to painting. If it's not strange and fantastic, he has neither time nor taste for it." Over Rollinat's bed there hung a print of Dürer's *Melancholy*, a very appropriate symbol for a soon-to-be-forgotten poet.

"If Flaubert had been a Painter"

Monet can hardly have known how difficult he would make things for himself by travelling to Fresselines in March. The landscape he had chosen lies close to the Massif Central, and the rigours of the continental climate mingle with the humid winds of the Atlantic. Even if we allow for his habitual dissatisfaction with work and conditions – "bad price, bad choice" as he proverbially put it – the fact remains that the cold, the rain, the changes of light and the thriving plant life as winter gave way to spring posed problems that he had rarely encountered before in so extreme a form. By observing him as he attempts to solve these problems, we gain a better understanding of how scrupulous his art was. Icy showers alternating with sunny spells had little or no effect on his health: "When I am working, I'm always well, even though I get terribly worked up." By the end of the month, 23 paintings were on the stocks, some of which had been undertaken because of changes in the light and seemed to Monet better than the earlier ones. In early April came the first signs of fatigue – "I feel I'm getting old" – soon aggravated by a sore throat caught by standing with his feet in the mud. The weather was "sinister" and had produced a series of "lugubrious" paintings, some entirely without sky. As to the effects begun in

single-storey house called la Pouge: "Ma maisonette montre aux horizons tran-
quilles/ Ses volets verts... (My house shows to the calm horizons/ Its shutters
green...). In his *Journal* entry for 18 March 1886, Edmond Goncourt describes
the eccentric Rollinat: "Hair a mass of curls like a serpent-haired Gorgon's
head, ... the beauty of Greek lines in a face whose flesh is tormented, as if it had
been chewed, and under this flesh lies a brain evidently haunted by bizarre, per-
verse, macabre, ingenuous thoughts, in short, a mixture of peasant, actor, and
child; such he is, a complicated being, but a man of undeniable charm."

Rollinat's annual income was as little as 5,000 francs, but he made it a
point of honour to welcome friends new or old to his table, thus sinking still
further into debt. This he did with Geffroy, Monet and company, though the
two nights of their visit were spent at the inn run by Mme Baronnet, opposite
the church. The day after they arrived, Rollinat took his guests to survey "the
stunning, sombre beauty of the two Creuses". They followed the Dun-le-Pales-
tel road to the Vervit (or Vervy) Mill on the Grande Creuse; went via the Con-
folent farm down to the bottom of the petite Creuse ravine over which the
hamlet of Puy Guillon looks, and finally reached the confluence of the two
Creuses, where Monet admired the "Faux Semblantes" – an expression dear to
the heart of Geffroy – and a huge, solitary oak. When the visitors set off on the
return journey, Monet promised Rollinat that he would return and set about
some serious painting in this wonderful landscape.

On his return to Giverny, Monet received Georges Petit's offer of an exhi-
bition at the Rue de Sèze presenting work by Monet and Rodin alone. It was to
take place during the Exhibition Universelle. Monet immediately grasped how
important this could be for his career. Preliminary discussions took place on
Saturday 2 March. The following day, a long article by Hugues Le Roux
appeared in *Gil Blas* on the subject of Claude Monet's Exhibition at Théo van
Gogh's. Le Roux had certainly met Monet, perhaps at Etretat where he
describes him at work, and reports a number of anecdotes about Monet's youth.
Monet had the gift of turning such stories to his own advantage, sometimes to
the detriment of the truth. Drawing on a course taught by the philosopher
Théodule Ribot at the Collège de France, Le Roux attempted to define "Im-
pressionism according to Claude Monet': "It is first and foremost the painting
of the 'enveloppe', this movement of ether, this vibration of light that palpitates
around objects." The article concludes with a description of the *Vétheuil in the
Fog* (518) painted at Vétheuil, that "symphony in white", which had not yet
acquired its finale, the anecdote about Faure first refusing to buy and Monet
later refusing to sell it.

On the evening of Wednesday, 6 March, after a further talk with Rodin,
Monet left for the Creuse. He reached Dun-le-Pastel station the following
morning and from there Rollinat took him by carriage to Fresselines. They
stopped only to drop off Monet's luggage at Mme Baronnet's inn before going
on to eat at La Pouge, where Monet took all his meals. The poet respected the
painter's need to work, and Monet's only complaint was that the evenings went
on a little too long, as Rollinat felt a need to recite verse and sing. On Sunday,
they played trente-et-un with the priest, the notary and the Vicomte de la Celle,
who lived in the Château Puy Guillon. Of course, Monet would stay no longer
than fifteen or twenty days. After hesitant beginnings, his subjects were quickly
chosen "for morning and afternoon, sun and grey weather". Thus the series
method, rather than being forced upon Monet by bitter experience as it always
had been hitherto, was employed from the start in the Creuse. Here the role
taken by Agay in Antibes, that of celestial subject glimpsed but never painted,
was occupied by Crozant.

new Palais des Beaux-Arts at the Universelle Exhibition, which had opened on the 6th. The Special Representative, Antonin Proust, warmly congratulated by the Ministre de l'Instruction Publique et des Beaux-Arts, Armand Fallières, had organised two exhibitions, a decennial exhibition of French art featuring Rodin – he was also responsible for the six great allegorical statues that decorated the palace facade – and a centennial exhibition which featured three works by Monet. Monet, apparently, failed to be impressed by the honour thus accorded to him.

For him, the important thing was the organisation of the Monet-Rodin exhibition at the Georges Petit Gallery. Before committing himself to this, he sought to thank Maurice Rollinat for his hospitality. He decided to send him a basket of apples, which, though they had been been picked that autumn, were scant recompense to the impoverished Rollinat for the the two meals a day Monet had eaten for the past three months. The letter of thanks that Rollinat felt bound to write parades before us the entire personnel of Fresselines: the inhabitants of la Pouge, the innkeeper Mme Baronnet, the animals, with Pisto-let the dog at their head, and last but not least, the oak from the Creuse ravine, which had already recovered much of its foliage. Having made this obeisance to the outward forms of gratitude, Monet devoted himself to the preparation of the catalogue for his exhibition, no inconsiderable task since it involved some 150 paintings. Faure and Durand-Ruel had initially refused to help, but eventually gave in to Monet's pleas; he was good at getting his own way.

The hanging of the exhibition began on Saturday, 15 June. That evening the Banlieue dinner, which was held, exceptionally, at Sapin's in the Palais des Beaux-Arts restaurant, brought together beneath the brand new Eiffel Tower and under the presidency of Edmond Goncourt, Monet, Geffroy, Frantz Jourdain, Gallimard, Toudouze and Mirbeau. Mirbeau went out of his way to impress his illustrious colleague, speaking of politics and literature, with some weasel words for Maupassant as he did so. "A silent man with expressive black eyes": thus Monet, as seen by Goncourt's *Journal.* Rodin seems not to have accepted the invitation. Preparations for the exhibition were at their height, but Rodin showed so little enthusiasm for inspecting the placement of his works that Monet and even Petit were obliged to insist. The arrangements made by the two artists were therefore badly coordinated, and on the morning of the 21st, when Monet arrived at the gallery, he found that the back panel, "the best one" of course, was hidden by a Rodin group – probably *The Burghers of Calais.* He complained bitterly to Petit and decided to return to the calm of Giverny at once. When the echoes of Monet's irritation reached Rodin, they caused a violent reaction. In Edmond Goncourt's words: "Concerning the joint exhibition of works by Rodin and Monet, it seems there have been the most terrible scenes, in which the gentle Rodin, suddenly bringing out a Rodin quite unknown to his friends, shouted: 'I don't give a damn about Monet, I don't give a damn about anyone, the only thing I'm worried about is me!'"

Thus the combined exhibition of the masters of modern painting and sculpture did not go perfectly smoothly. Mirbeau passed over these conflicts in silence in his laudatory review for *L'Echo de Paris,* which was entirely devoted to Rodin. After his preface for the exhibition catalogue, for which he had borrowed passages from his *Le Figaro* article of March, his inspiration on the subject of Monet must have been nearly exhausted; for *Gil Blas,* he confined himself to publishing extracts from his preface. But this did not prevent him from offering to write a review for *Le Figaro* when Albert Wolff refused to do so, on condition the article was not paid for by Petit. *Le Figaro* did not ultimately review the show. According to Monet, Wolff had asked Petit to pass on an invi-

Auguste Rodin, 1889
Photograph Braun

tation to Rodin and Monet, and been very shocked when Monet turned the invitation down flat.

There were, nevertheless, many reviews. Geffroy's column in *La Justice* contained no surprises, and Roger-Milès was content to refer his readers to the laudatory article which he had published about Monet in a March number of the same paper, *Beaux-Arts*. Also favourable were a short, anonymous article in *Le Matin* and a more in-depth study in *Le Rappel* by Charles Frémine, though Frémine spoke of "an exaltation of colours that bravely sing above their natural range". J. Le Fustec, writing in *La République Française* was more critical than not, and accused Monet of too often "making himself so clear as to offend the eye". Indeed, whether at Antibes or Belle-Ile, Fresselines or Giverny, Monet saw

ABOVE:
The Reader
Cat. no. 205
Painting featured in the *Monet-Rodin*
exhibition, no. 23

At Cap d'Antibes, Mistral Wind
1888
Cat. no. 1176
Painting featured in the *Monet-Rodin*
exhibition, no. 125

colours differently from the mere mortal, and it was this personal vision that the few hostile critics continued to attack. One such was Alphonse de Calonne in *Le Soleil*, whose title "L'Art contre la nature" summarises the rest of his argument. "A dreadful disease of the visual organ", in short, that old cliché, colour-blindness, is diagnosed, and Monet is also accused of creating an "unrealistic" version of nature under the influence of an obsession, while Rodin is denounced for "abasing nature and making it as ugly as possible".

Jules Antoine, in *Art et Critique*, did not agree, and went further than most of his colleagues in concluding that Monet had "arrived at the use of pure colour and simplified processes" without going as far as "pointillism". In *Le Journal des Artistes*, Raoul dos Santos emphasised the "extraordinary variety" of

EXPOSITION D'AUGUSTE RODIN

AUGUSTE RODIN. *Groupe de bourgeois de Calais.*

L'ART FRANÇAIS

Auguste Rodin
The Burgers of Calais
Photograph published in *l'Art français*
6 July 1889
Sculpture featured in the *Monet-Rodin*
exhibition, no. 1

ABOVE:

Auguste Rodin, *Satyresses*
1885
Helsinki, Ateneumin Taidemuseo
Sculpture featured in the *Monet-Rodin*
exhibition, no.14

Edouard Manet
Olympia
1863
Paris, Musée d'Orsay

Monet's work and his refusal to specialise. In the *Paris Vivant* column of *Le Siè-cle*, Fernand Bourgeat combined eulogy of both artists with an interesting indication of their respective reputations: "Monet's merits are the more disputed (indeed, only his are disputed, since no one any longer dares dispute those of Rodin)." This judgement explains why, of the two, Monet seems often to be the petitioner, whereas Rodin's reticence was made clear on various occasions. Joseph Gayda (*La Presse*), on the other hand, thought that both artists had much to gain by the exhibition: "Neither had yet reached the wider public, neither had yet received that vast and enthusiastic acclaim that changes reputation into fame, and makes a glorious name of a well-known one."

In July, while Monet continued to pester Petit with requests for small improvements, the weekly and monthly publications came into play, and some disagreeable surprises were in store. As to public attendance, the exhibition was not so immediate a success as articles born of the animated atmosphere of the private view might suggest. Mirbeau's letter is particularly revealing: "Don't be depressed. And above all, don't assume the apparent lack of success of your exhibition from the few who attend it at present. ... Believe me, the success of an artist is not determined by the number of people at the turnstyle." The exhibition was late on in the season, but the public continued to flock to the Champ de Mars for the Exposition Universelle. This was Monet's thought in a despondent letter sent to Petit in mid-July, but Mirbeau was nonetheless correct to affirm that the exhibition was, at a deeper level, "a very great success". The future was to confirm de Bellio's jubilant prognostication (half in English, half in French) of 17 May, well before the opening: "And now long live Monet! Long live Rodin! For ever Monet! For ever Rodin Hourrrrha!"

Homage to the Memory of Edouard Manet

No. 487 of the centennial exhibition of French art was a highly controversial painting that was to continue to make headlines: Manet's *Olympia.* The scandal caused by its exhibition at the Salon of 1865 had not been forgotten, and

Suzanne Manet, the artist's wife, had had to buy it in at the public sale of Manet's studio. But now an American visitor to the Exposition Universelle had, it seemed, shown signs of wishing to buy the painting. John Singer Sargent informed Monet, to whom he had been close for several years now. Wishing to make a grand gesture that would designate him in everyone's minds as the inheritor of Manet's mantle, Monet decided to buy the painting and donate it to the Louvre. Only by subscription could the necessary funds – 20,000 francs – be raised. If successful, this would be a splendid vindication of Manet's work some 25 years after it had first been exhibited. No sooner was his decision made than Monet took it upon himself to write personally to all those from whom he could expect a positive response. The first reply to have survived is that of Dr du Bellio, dated 16 July 1889; the enterprise had therefore been started in early July, or perhaps late June. The ever-generous Doctor subscribed 1,000 francs and admirably summed up the objectives of the operation: "It [the subscription] will have a triple merit: it will be a deserved homage to the memory of our poor dear Manet, it will be a discreet form of aid to his widow, and it will preserve for France a work of real worth."

Monet took up the first two points of this summary in his subsequent letters, notably in the one that he sent to Emile Zola on 22 July: "It is the finest homage that we can render to the memory of Manet, and a discreet way of coming to the aid of his widow." Monet's use of "we" was intended to recall their shared past; the *Olympia* enterprise also celebrated the glorious memory of the Batignolles school. But he was in for a surprise. Zola, whose battles on Manet's behalf were so famous, refused to subscribe. He was repelled by what he saw as a speculative side to the enterprise, and summed up his position firmly: "Manet shall go to the Louvre, but it must by his own merit, in full national recognition of his talent, and not in this indirect way, as a gift, which is bound to have an air of clique and puffery."

By the time this blow landed, on 23 July, Monet was too committed to the project to backpedal. Since de Bellio's subscription, he had received promises of similar amounts from Leclanché, Duret and Rouart. Soon afterwards, Mme S. Scey-Montbéliard, a young admirer of Monet's painting, offered 2,000 francs.

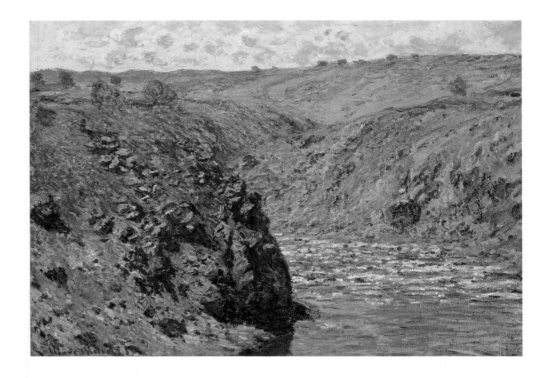

The Creuse, Sunlight Effect
1889
Cat. no. 1219

But most of the contributions were for much smaller sums, and the appeal had to be extended through the summer and much of the autumn. Only Rollinat was exempted from this self-interested solicitude, as is clear from a letter full of touching advice sent to Monet to thank him for a basket of plums: "Don't lose your taste for life: without working as hard as you did at Fresselines, train your mind, eye and hand upon the shapes and colours of Nature. In short, disaffection is better working than idle."

Two letters were needed to obtain 200 francs from Durand-Ruel, who showed great dignity in justifying both the small sum that he sent and his refusal to speak to others on Monet's behalf. Jourdain and Burty could offer only 25 francs. James Tissot promised 100 francs, but wove such a web of explanation around his promise that it is no surprise to find him missing from the eventual list of subscribers. Albert Hecht was willing to commit 500 francs, but under his initials rather than his full name; he was expecting the administration to refuse the painting, but thought that an official acceptance was still more dangerous, as the *Olympia* was "not appropriate to the Musée du Louvre." After Albert's death, his widow and his brother Henri Hecht took the same attitude. Others expressed a similar reticence about *Olympia*. Mary Cassat, Faure and Haviland, like Zola, refused. Unsurprisingly, Monet was often disheartened, especially as the weather was bad and he was unable to work at his painting as he wished. His discouragement was roundly and loyally rebuked by Mirbeau.

Monet as a Teacher

Among his visitors of the summer of 1889, Monet was particularly glad of a group of Americans composed of a young sculptor, a student, Lilla Cabot, and her companion, Tom Perry. Lilla found Monet delightful company, and wrote to the United States to point out to her compatriots that one could buy a Monet for 500 dollars. Only one of her correspondents commissioned her to purchase, and bought an Etretat painting which Monet was at first unwilling to hand over without retouching it from life. Whether he found the time to do so

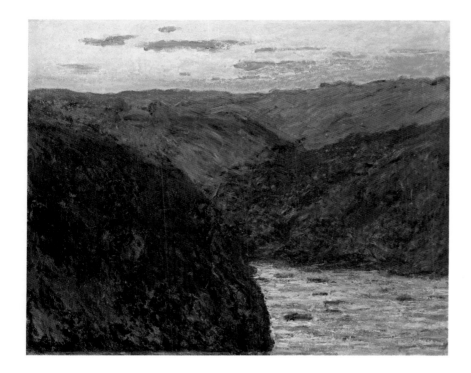

The Creuse, Sunset
1889
Cat. no. 1222 a

we do not know. At all events, Lilla Cabot returned to the States with the painting, which had found favour with John La Farge of Boston.

The Perrys (Lilla and Tom married) returned to Giverny regularly for some ten years or so; they rented a house close to Monet's and were proud to see him striding up and down their garden after lunch, cigarette in hand, before returning to his painting. What was more, Lilla Cabot profited from the example and advice of the master.

If Monet had been willing to accept students, would he, as Mrs Perry declares, have been a liberal teacher? The question remains hypothetical. But Lilla Perry worked with him, and her account of this experience and Monet's remarks are not without interest. For Monet, the first contact with the subject-matter was vital, and, at the very first session, the canvas should be covered, if possible, over its entire surface. Thus, a study on which Monet had worked just once would be covered in brushstrokes about 0.5 cm thick and about 2 cm away from each other, which were intended to outline the overall aspect of the motif. After two sessions, the strokes were much closer to one another and the subject was beginning to take shape. A picture had to be taken as far as the artist thought necessary; at a certain point, nothing further could be done, and only the artist could decide this. Lilla Cabot liked to paint figures in the open air; Monet's advice was to give as much attention to each leaf of a tree as to the face of the model. Many of Monet's own pictures are strikingly concordant with this requirement.

Many now considered Monet a great painter, but this did nothing to prevent attacks from those who saw little merit in his work. In *La Vogue* of September 1889, Félix Fénéon was full of velvet-gloved malice: "The variety of so many pictures is a matter of geography and the calendar. Nowhere do we find the quiddity of a landscape represented in unexpected or passionate style; everywhere the joy of the fine painter at colours waiting to be transferred from nature to the canvas; the exaltation of vulgar merits; all the virtuosity of a marvellous technique illuminating a lyrical banality; and immediate, impudent, external beauty... This is a corpus that attracts by its promised diversity, but how monotonous it is." Fénéon's is the language of symbolism, and not invariably

Oat and Poppy Field
1890
Cat. no. 1258

transparent; but these subtly delivered blows were something quite different from the critiques of the generation which favoured academic painters.

If poets are prophets, Fénéon was a true poet, for the monotony that he attacked, latent with promise or danger, was soon to assume an unprecedented role in Monet's work. Two reasons for this can be cited. Monet was coming up to his fiftieth year, and finding incessant travel increasingly burdensome. And, quite unexpectedly, the *Olympia* campaign had greatly inhibited his painting life for more than a year now. In the words of Jean-Pierre Hoschedé, "Instead of painting, [he] spent his days in his office, writing letter after letter with his creaking goose-quill pen." When he again took up his brushes in 1890, something had changed. Isolated paintings were increasingly rare, while the series gradually came to be his predominant, if not indeed his sole, mode of expression.

Antonin Proust under Fire

By mid-October, 1889, the *Olympia* subscription had exceeded 15,000 francs. Berthe Morisot, the sister-in-law of Edouard Manet's widow Suzanne, thought that things could probably stop there. Monet disagreed, and continued his appeal, though some of his donors were not quite up to his expectations. Thus, at 25 francs each, Geffroy, Huysmans, Roger Marx and Rodin together contributed only as much as Marie-Auguste Flameng. Despite the promise of a sketch, Mallarmé, too, was worth only 25 francs. He was disappointed that Monet would not, after all, contribute a drawing to illustrate his prose-poem *La Gloire.* But the list of subscribers continued to grow and the total had reached 18,550 francs by 23 November.

But by now the problem was no longer primarily financial. What would be the point of paying so high a price for the picture if the State then refused to accept it? Puvis de Chavannes, whom Berthe Morisot described to Monet as "charming" despite his rather bureaucratic manner, advised Monet to sound out the authorities' intentions via the Deputy for Deux-Sèvres, Antonin Proust, a

childhood friend of Manet's who had been Minister of Fine Arts under Gambetta, and more recently the special representative at the Exposition Universelle. By the time this suggestion reached Monet, he had already made contact with Proust, who was better placed than anyone to advance the cause of the *Olympia*. Suzanne Manet thanked Monet for his initiative, of which she had only now been informed, but Monet received another indication of the difficulties that faced him in the reaction of Joseph Reinach, the Deputy for the Basses Alpes; Reinach too had served in the Gambetta government, and refused to subscribe for reasons of "artistic conscience". And now, on 14 November, having been at great pains to avoid meeting Monet, Antonin Proust set out his position in writing. It was that Manet would go to the Louvre, but not in the form of paintings that the Museum might reject with the full support of the public, and the *Olympia* came into this category. Until public opinion evolved, the best thing would be to found an association which would buy contemporary works and present them to the State when the State was ready to receive them. With this in mind, he subscribed for 500 francs. Shortly afterwards, a further obstacle to the plan was announced by Georges Lafenestre, the Curator of the Louvre's Department of Paintings. In conversation with the sculptor-engraver Bracquemond, whom Monet had asked to consult him, Lafenestre suggested that a transitory admission to the Palais de Luxembourg could be contemplated. Monet seriously considered this intermediate solution, of which Berthe Morisot approved, saying that only he "could break down the doors [of the Louvre] if they can be broken down at all."

Berthe Morisot also told the story of Kaempfen, the Director of the National Museums, who was threatened in bizarre fashion by a fanatical supporter of the *Olympia*: "We're going to see about getting rid of you, then we'll get Manet in." The anecdote gives some idea of the passions that the affair had aroused. The time was propitious for such outbreaks. In December 1889 there was a highly-charged scene at the Société des Artistes Français which resulted in

Oat and Poppy Field
1890
Cat. no. 1257

one faction forming the Société Nationale des Beaux-Arts. From this point on, there were two Salons, the traditional Salon at the Champs-Elysées and the dissident exhibition at the Champ de Mars. Among the champions of the dissident Salon, presided over by the pugnacious Meissonier, were Puvis de Chavannes, less circumspect on this occasion, and several other *Olympia* subscribers: Carolus-Duran, Bracquemond, Roll, Duez, Gervex, Cazin, Besnard and Rodin. Both Guillemet, a former friend of Zola and Cézanne and a probable subscriber, and Vollon, who was asked to subscribe but refused, remained faithful to the old Société alongside Robert-Fleury, Gérôme, Bouguereau and other so-called "pompiers" painters.

Dissent among the old guard and decadence in the traditional institutions; this was the background to the *Olympia* affair. At first, it was largely the property of Monet's friends and acquaintances, but it hit the headlines with the premature announcement that the *Olympia* had been purchased by the State at the suggestion of Antonin Proust. On 18 January, *La Chronique des Arts* gave the lie to this announcement and declared that "the Louvre has no part whatsoever in this intrigue." Two days later, Proust declared in *La République Française* that he had not advised the purchase of the *Olympia*, a step which seemed to him both premature and lacking in respect for Manet, who would enter the Louvre as he deserved in succession to other great artists. There was no need to precipitate events. When questioned by Gaston Calmette in the corridors of the Chamber of Deputies, Proust further stated that the *Olympia* was not the painting of Manet's that he wished to see in the Louvre. He added that those who had promoted the affair were concerned less with the destiny of the painting and more with the "very sad, very lamentable" financial position of Mme Manet. This was why he and other friends had subscribed; Monet, the very "dedicated" originator of the scheme, had raised 17,000 francs on this understanding.

In referring to Suzanne Manet's poverty, Proust had merely taken up one of the arguments tirelessly repeated by Monet in his correspondence of the previous six months, apparently without offending anyone. But Proust's mention of this argument in Calmette's article, published in *Le Figaro* of 21 January, set off a wave of indignation on the part of the fund-raisers and their possible benefi-

Poppy Field
1890
Cat. no. 1253

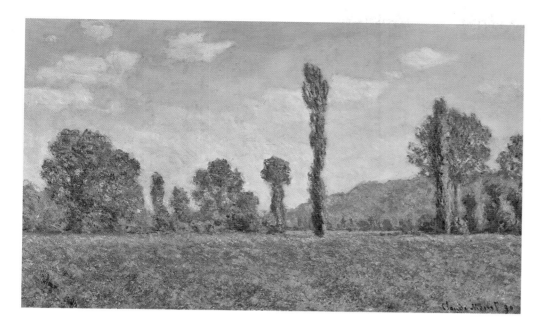

Poppy Field at Giverny
1890
Cat. no. 1252

ciaries. The fact that the indignation was belated no doubt contributed to its strength. The very next day *Le Figaro* printed a protest by Eugène Manet, in which he contested the authenticity of the sentiments attributed to Proust, which, he said "utterly distorted the intentions of the subscribers." This was also the position of Suzanne Manet, who informed the readers of *Le Figaro*, and, by the same token, the subscribers who had been petitioned on the grounds of her destitution, that "there was no need for anyone to come to [her] aid." Monet broadened the agenda by accusing Proust of taking part in the campaign against Manet. In his reply, Proust, a politician quite accustomed to electoral back-tracking, denied that Calmette had accurately reported his remarks. But he also confirmed his refusal to be associated with "a process whose objective was to submit to the Louvre jury one of Manet's works, and the *Olympia* in particu-lar"; Manet himself had not chosen this work, when, in 1882, Proust had been a Minister and had asked him to select a painting for the Luxembourg.

With the Manet family behind him, Monet declared that this was not suffi-cient and demanded a rectification in *Le Figaro*. He wrote to Proust to request this. On the very same day, the *Figaro* published an open letter from Mirbeau in which Proust was contemptuously dismissed. The only reason why Proust had been so energetic on Manet's behalf after the Exposition Universelle was his pleasure at seeing his own portrait in the main hall of the Centennial Exhibition of French Art. Since then, Proust had "discovered that [the *Olympia*] was some-what deficient... perhaps in the matter of not being Monsieur Proust's portrait." Hence Proust's sudden about-turn: the aesthetics of former Ministers for the Fine-Arts were quite unaccountable. The rest of the article was in similar vein, and glorified those "faithful hearts" who were in no danger of "losing them-selves in the underhand schemes of politicians or dirtying their hands with the sticky red-tape of bureaucracy."

Proust was understandably less amused by this article than Eugène Manet, and his resentment was clear in his tone: "For three weeks the newspapers have attributed to me an initiative that is yours. You remained silent, as you had a right to do. I spoke out, as was my right. Now you find my words invidious. If they offend you, I await your seconds." Mirbeau, fortunately, was in Nice and could not return, and Monet's two designated seconds were Thédore Duret and Gustave Geffroy. On the day after Proust's letter to Monet, Geffroy had written a conciliatory article for *La Justice*, which augured well for his mediation. He

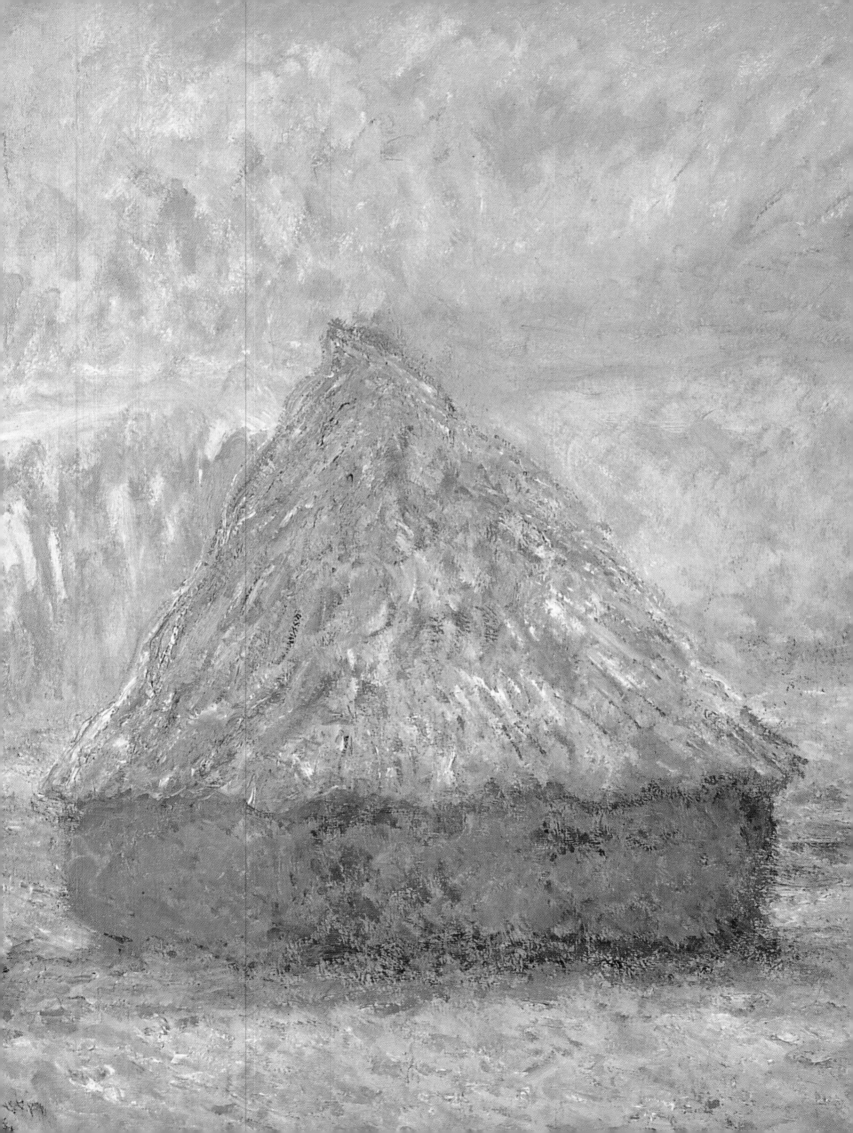

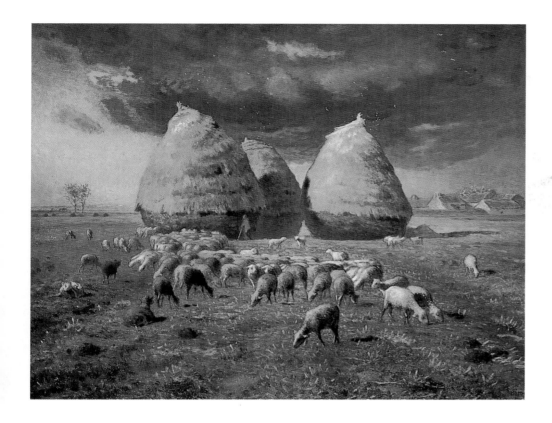

Jean-François Millet
The Autumn, the Grainstacks
1868–1875
Rijksmuseum H. W. Mesdag, The Hague

and Duret left Monet on the terrace of a café as they went to knock on Proust's door at 32 Boulevard Haussmann. They were reassured that the meeting would be a peaceful one. Monet then met Proust face-to-face, without witnesses, and Monet's letter to Geffroy describing the encounter suggests that Proust was almost too amiable, giving Monet the chance to rehearse a facile variation on "Timeo Danaos et dona ferentes" (I fear the Greeks even when they bear gifts). It may have been an unjust reflection on Proust, but it was certainly preferable to a duel between two old friends of Edouard Manet whose sole disagreement was, after all, about timing, committed as both were to advancing the cause of modern painting.

PAGE 264:
Grainstacks at Giverny, Morning Effect (detail)
1888–1889
Cat. no. 1214

View of the grainstacks from Monet's house at Giverny
Contemporary photograph

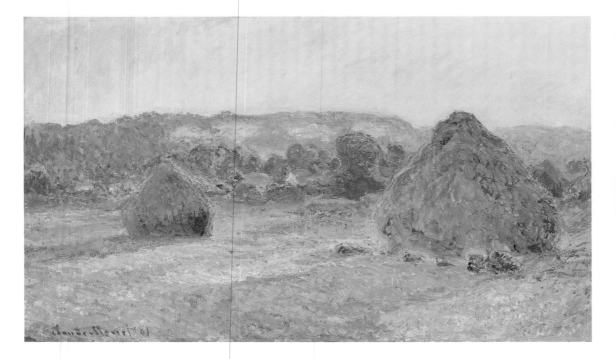
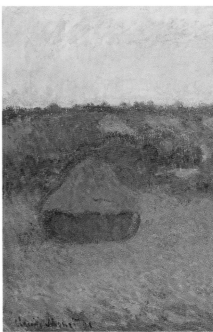

FROM LEFT TO RIGHT AND ON PAGE 267:
Grainstacks at the End of the Summer, Evening Effect
1890
Cat. no. 1269

Two Grainstacks at the End of the Day, Autumn
1890
Cat. no. 1270

Grainstacks, Snow Effect
1890–1891
Cat. no. 1274

Gustave Larroumet Besieged

Apparently galvanised by this happy ending to the Proust affair, Monet now acted with startling energy. His sense of mission was matched only by his masterful use of intrigue. Within the first week of February, he had prepared and printed a circular which he sent out to subscribers, asking them to pay their dues; the operation threw up some nasty surprises. Boldini, for example, a subscriber for 1,000 francs, was now willing to pay only 200 francs. Since he sent out a receipt to every subscriber, Monet's secretarial labours were considerable. His next task was a more delicate one. With Camille Pelletan, whom Antonin Proust had brought into the fray, Monet sought an audience with Armand Fallières, a future President of the Republic and then Minister of Education and the Fine Arts at the time. They were received on 7 February, and Monet handed to Fallières a letter announcing the donation of the *Olympia*. No artist's work could enter the Louvre until ten years after his or her death. Monet's letter therefore suggested that the Musée du Luxembourg was ideally suited to receiving and keeping the *Olympia* until the ten years should had passed, which they were soon to do. An appendix to the letter contained the names of the donors listed in alphabetical order. The following day, *Le Figaro* printed both letter and list, as did other newspapers and specialist journals.

Fallières was impressed by the wide range of political figures among the signatories; they included the radical Pelletan, the opportunist Proust and the socialist Alexandre Millerand. But as a good republican, he simply applied the laws which governed the actions of his own ministry. In a letter written on 12 February, he instructed the Director of Fine Arts and the Consultative Committee of the Museums to "examine the nature of this donation according to the regulations." This was no guarantee of admission. Academic circles maintained their traditional hostility, and certain neutral critics such as A. Dalligny and A. de Lostalot expressed their reservations. De Lostalot disagreed with Monet's letter to Fallières, which stated that the *Olympia* was "one of the most characteristic of Manet's paintings, the one in which he triumphantly emerges from the struggle, in full command of his vision and technique."

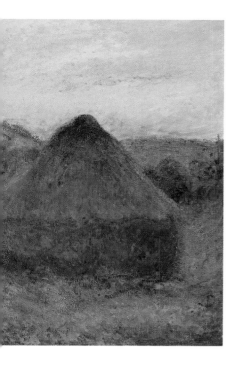

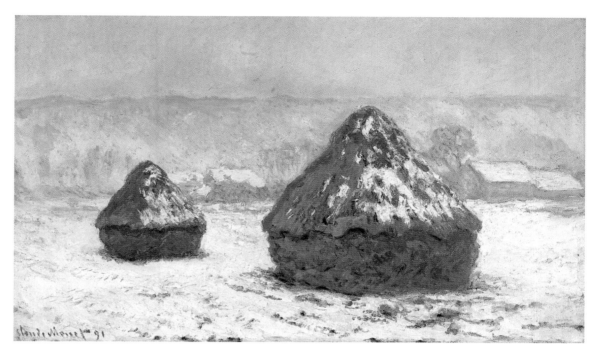

The Directeur de l'Ecole des Beaux-Arts, Gustave Larroumet, was aware of the importance of this decision. Before the statutory meeting of the Committee, he enquired of Monet whether admission to one of the two museums, the Louvre or the Luxembourg, was a requirement of the donation. Monet replied by telegram that it was. The meeting of the Committee at which the *Olympia*'s fate was to be decided was fixed for 13 March 1890. Two days previously, the great painting had been taken from Mme Manet's Gennevilliers house to be examined by the Committee members. The Committee was chaired by M. Kaempfen, Director of the National Museums. Three questions were asked. Should the *Olympia* be admitted to the Louvre forthwith? Answer: No. Should the painting be provisionally classified as part of the Luxembourg collection, with a commitment to send it to the Louvre on the expiry of the legal requirement of ten years? Answer: No. Should the painting be admitted to the Musée du Luxembourg? Answer: Yes, but with no commitment as to its eventual resting place. When he communicated this decision to Monet, Larroumet pointed out that the last point modified one of the conditions imposed by the subscribers, and asked if the donation offer still stood. Once he knew how things stood on this point, he would submit the text of the Committee's decision to the Minister when a new one was appointed; Fallières had lost his job when the Tirard cabinet had resigned.

This time, Monet requested time to consider his decision. He informed Pelletan about Larroumet's letter, and Pelletan immediately wrote to Léon Bourgeois, the new Minister of Education and Fine Arts of the Freycinet cabinet formed on 17 March, recommending that he adopt an interpretation of the Committee decision as favourable as possible to the donors' conditions. The Minister effectively refused to modify the stance that had already been adopted. Monet rejected the advice of Mme Scey-Montbéliard, one of the earliest subscribers, who deemed that the painting should remain the property of the subscribers, given that it would not be admitted to the Louvre; he decided that the offer should stand on condition that later admission to the Louvre was not excluded and that, while it awaited that admission, the *Olympia* should remain at the Luxembourg.

"I must point out that this is a new condition", Larroumet replied; he did not exclude the possibility of admission to the Louvre during some future rehang, and assured Monet that the administration would "make every effort to keep [the painting] permanently in Paris and on public view." He was in for a surprise if he imagined that this would satisfy Monet, who wrote back to demand that the Minister confirm "the assurance" given by the Director! The Director protested that he had simply expressed a "benevolent intention", and, somewhat exasperated, announced that he was placing the matter in the hands of Léon Bourgeois, whose decision in the matter was final. The ministerial decision took the form of a letter to Monet confining itself to the terms of the Committee decision, but this proved by no means irrevocable, particularly after Bourgeois had received a visit from the formidable Pelletan, who hastened to inform Larroumet of the success of his intervention. Léon Bourgeois was forced to recant: would Monet please return his first letter, and he would send a new letter closer to Monet's requirements! As soon as Bourgeois had received it, he wrote again, bestowing on Larroumet's "benevolent intention" his official ministerial approval; the promise was made that the *Olympia* would remain in Paris and on public view, while the question of a subsequent transfer to the Louvre was left open.

The drama thus had a happy ending. Before the deed of gift was signed by Maître Grimpard of Vernon, Monet and Larroumet exchanged further letters, the last echos of a long battle in which Larroument had been feebly supported by his minister and Monet strongly supported by Camille Pelletan, whose willingness to take the most indiscreet measures had no doubt owed as much to his desire to embarrass a member of the government as to his loyalty to Manet's cause. Throughout the affray, Georges Clemenceau, under whose direction Pelletan edited *La Justice*, had kept his own counsel; he had not even subscribed. The so-called "Tiger" had not yet recovered from the Boulanger affair, and was observing with alarm the first signs of the Panama scandal, in which he himself was implicated. As to the *Olympia* itself, there is some danger of our having forgotten about it as our more-or-less disinterested heroes went about the business of its admission to the Louvre. It was bought from Mme Manet for 19,415 francs in March, 1890, and entered the Luxembourg shortly afterwards, though it had to wait for the autumn rehang before being exhibited. It went to the Louvre in 1907, well after the ten year period specified by its supporters, on the order of Prime Minister Georges Clemenceau, who had by then returned to the forefront of politics, but whose apotheosis as France's prime minister during World War I was yet to come.

"Don't make a martyr of yourself by desiring the impossible"

On 1 May 1890, the Champs-Elysée Salon opened its doors. A fortnight later, its younger competitor opened at the Champ de Mars; among the paintings exhibited was a portrait of Ernest Hoschedé by Louis Picard. Alice's husband was well known in later life; he had taken up art criticism in the aftermath of his business failure, but was less and less interested in the Impressionists; they had accelerated his ruin, and one of them had taken his wife from him. Fortunately, he encountered Monet neither in the Palais de l'Industrie nor the Palais des Beaux-Arts. Gustave Geffroy did not need to encounter Monet to mention him in his review of the Salons, which he contrived to do despite the fact that

PAGE 269:
Grainstacks at Sunset, Snow Effect (detail)
1890–1891
Cat. no. 1278

FROM LEFT TO RIGHT AND ON PAGE 271:
Grainstacks, White Frost Effect
1890–1891
Cat. no. 1277

Grainstacks, Winter Effect
1890–1891
Cat. no. 1279

Grainstack in the Morning, Snow Effect
1890–1891
Cat. no. 1280

Monet was not represented at either. The desire to praise can lead one astray. Gustave Geffroy saw Monet as the "universal landscape-artist", able to "go from one place to another, to hasten through the world in a state of constant bedazzlement, avid to paint it in its entirety." In this he was, Geffroy stated, unlike Corot or Pissarro, who were destined to remain painters of a single region! Geffroy's apparently brilliant distinction revealed a thoroughgoing ignorance of the work of Corot, at least. As to Monet, it was hardly perspicacious of Geffroy to describe him thus in 1890, precisely at the point in Monet's career after which painting trips became the exception. And when Monet did make such trips, he tended henceforward to concentrate on a small number of motifs, using the "series" method, one of whose virtues was that it limited physical movement.

Geffroy was also in error when, in his Monet of 1922, he took the letter he had received from the artist on 22 June 1890 to refer to the Water Lilies series: "I have again begun on things that are impossible to do: water with waterweed undulating on the bottom... it's admirable to look at, but it's driving me mad trying to do it. Well, those are the things I always attempt!" J.-P. Hoschedé, better informed, corrects him: "The letter from which [these lines] are taken does not refer to the Water Lilies... Monet at this period was painting by the Epte, whose waters are fast-flowing and transparent; his subject was my sisters in a boat, and, in this water, Monet showed various aquatic weeds in perpetual undulating motion."

The bad weather, the illness of his "pretty models" – Marthe, Blanche, Germaine and, above all, Suzanne Hoschedé – and the lack of practice imposed by the *Olympia* affair; all these things were disheartening Monet when he wrote to Berthe Morisot and Mallarmé on 11 July. But a pleasant visit was in the offing: on Sunday, 13 July, Berthe Morisot and Eugène Manet made the expedition from Mèze to Giverny, accompanied by Mallarmé. To compensate Mallarmé for his failure to contribute an illustration to *Le Tiroir de Laque*, Monet invited him to choose a picture. Embarrassed, Mallarmé needed the encouragement of Berthe Morisot to choose a relatively large painting (910) of the banks of the Seine showing the Jeufosse church spire; diagonally across the painting falls the plume of smoke from a train – symbol of the century – running upstream in the

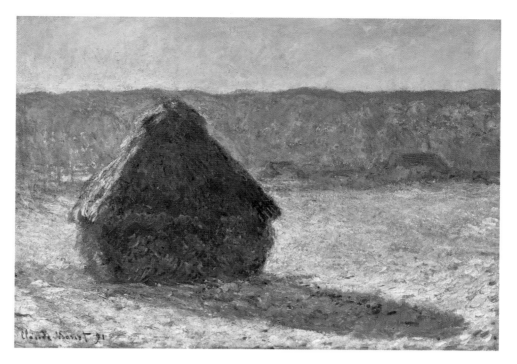

direction that Mallarmé and his friends were to take back towards Paris. On their return, the military bands, torchlit tattoos and other celebrations marking the eve of the national holiday occasionally blocked the route of the horse-drawn carriage taking them from Mantes to Mézy, the last lap of their excursion. Mallarmé's whole concern was to protect the painting and he blest the fate that had made him a contemporary of Claude Monet. Later, he showed his prize to Geffroy, with the words "It's as expressive as the Mona Lisa's smile"; poets are inclined to hyperbole.

Over the summer of 1890, other visitors too made what the Duc de Trévise describes as "the pilgrimage to Giverny". They were more fortunate than a certain Miss Rogers who was discouraged from making it by Theo Van Gogh, who himself had been intending to visit Monet on 14 July with Valadon. It would have been his last such visit. Theo, who had been such a convinced admirer of Monet's work, was traumatised by the death of his brother Vincent on 29 July 1890; in October he entered Dr Blanche's clinic, and left it only for a sanitarium in Utrecht, where he died on 21 January 1891.

Late July was fatal for the Van Gogh brothers and for Monet it proved to be something of an ordeal. His long exposure to rain and snow was taking its toll in rheumatism, and now the very weeds of the Epte that he had painted in June had been cleared. What better encouragement could he receive than this letter from Octave Mirbeau? "Oh, you who are strong and visionary, who have the spirit of creation in you, you who work at things salutary and true, let me tell you that you are a fortunate man and one of life's elect, and are wrong to complain. Behind you, you have a huge and splendid corpus; ahead of you lies even more, perhaps more beautiful still, for in characters such as yours, everything becomes greater, gains in depth, grows stronger with the passage of time. Don't make a martyr of yourself by desiring the impossible."

Seeking to show by example how various was Monet's art, Mirbeau finished his article by describing a number of characteristic paintings. Having heard from Geffroy that the painter had sent four drawings to illustrate his study, one of which showed a *Figure Outdoors*, he assumed that this must be the more graceful of the two figures for which Suzanne Hoschedé had posed (1076) and described her as "light, lissom, weightless". In fact, Monet had copied the other painting, showing a woman of more opulent form (1077), but Mirbeau was not informed of this and could not adapt his text. He wrote to Monet on the day of publication, already afraid that the publisher's negligence would result in blunders, and that these would make his article still more "stupid".

And he was wrong: at least in one case, he had instinctively grasped a quality which Monet, by some unconscious premonition, had imparted to a different portrait of Suzanne, a portrait of the young woman "sitting with her elbows resting on a lacquer table" (1261). Mirbeau's analysis soon reaches beyond the physical aspect of the painting: "Hers is a sad, delicate beauty, infinitely sad." Pushing still further with his scrutiny of this "enigmatic, strange [figure], strange as the shadow that envelops everything, and which is, like her, disturbing, and even a little frightening", Mirbeau is struck by the fact that "One finds oneself unavoidably thinking... of those women figures, spectres of the soul such as those evoked in certain poems by Stéphane Mallarmé." Coming across the article in a collection of old papers, these lines were fed into the strange dialogue that Alice Hoschedé's diary maintained with her late daughter: "'Was this not an extraordinary piece of clairvoyance?" (9 January 1903).

Mirbeau's study had just appeared when Alice found herself facing a more immediate concern, the slow death of Ernest Hoschedé. "Bon vivant", a big eater and an infamous drinker, Hoschedé had been suffering for some time from violent pains in the legs, which were diagnosed as a very serious attack of gout. There had been some remission in late 1889 when Dr Gachet had treated him. (Hoschedé had consulted Gachet on the advice of a mutual friend, the painter Goeneutte). But from November 1890 onwards the illness had grown

1888
(The Talisman)
Landscape in the Forest of Love
Paul Sérusier

Tōkaidō
Extract from *Fifty-three stages on the road from*
1833
Numazu, Dusk
Utagawa Hiroshige

Requiem for a Man of Letters

and dark."

parate emotions through which the drama of the earth passes between dawn ishing series of winter stacks – is sufficient for him to express the many and disenlightening than the measured observation: "A single motif – as in the astonloquence, "the illumination of the states of consciousness of the planet", is less attempts to define Monet's now celebrated art, Mirbeau's excessive grandiwhich he described as full of flowers in spring, summer and autumn. In his dwelt on the Giverny garden. He rather prided himself on his own gardening things." The article appeared on 7 March. Varying his own effects, Mirbeau impossible for you not to put the greatness of your genius into even the smallest surprised you. I was sure of it, because, being what you are, my dear Monet, it is was, as usual, all admiration: "For a man who can't draw, it must really have drawing, and the task of supplying the three illustrations was a chore. Mirbeau magazine that had attracted Durand-Ruel's eye. Monet had little facility at with his friend, had decided to give to *L'Art dans les deux Mondes*, a very recent *Grainstacks* (1267) to illustrate a study which Mirbeau, happy to collaborate

Monet then made a brief return to the past, copying the autumn step, which J.-P. Hoschedé blithely takes; we cannot confirm the story. that Monet paid the farmer to postpone the demolition of his motif is a single

same' stack of straw, painted at different times of day. Here we have the grey stack, the pink stack (six o'clock), the yellow stack (eleven o'clock), the blue stack (two o'clock), the violet stack (four o'clock), the red stack (eight o'clock in the evening), etc., etc.."

With no other guide than the catalogue of the exhibition, our information is limited: *End of Summer, Last Ray of Sun, Sun in the Mist, Setting Sun*. Did Monet even remember the details after the series was finished? Perhaps he felt no need to offer the public the inside story, content with having created these works, each of which possesses its own colouration, variations on a theme of which Monet alone, combining the roles of composer and performer, knew the exact intention and tonality. Fortunately, the topography of the stacks in places almost always known to us allows some of the effects to be more accurately defined. Obviously, we are dealing with different stacks from those painted in 1888–1889 (1213–1217); this time, the biggest is on the right in the now classic group of two stacks (1266–1271).

In early December, when the first snowfalls were followed by "superb weather", Monet was suddenly filled with the joy of creation. The weather continued favourable for several weeks in a row. The winter of 1890–1891 was an exceptional one: there was sustained but not excessive cold (the temperature went below -10 degrees on some ten days only and never went below -15 degrees). On more than one occasion, the relatively thin frost or snow covered the ground for several days in succession. The Seine was entirely frozen over from 11 to 24 January. It was the ideal decor for Monet, who worked frantically, interrupted only by the steps that he felt bound to take on behalf of his son Jean, whose military service was causing problems as his own had done. The business was no sooner settled – Monet obtained three months leave for Jean, but could not have him exempted from the rest of his service – than he was again "working madly away", with "loads of things in progress" so as to "take advantage of these splendid winter effects". The effects concern the Grainstacks almost exclusively; until the thaw, they wore snowcaps of varying thickness (1274–1290). When the thaw set in, the tenant-farmer of the Côte farm hastened to recover his sheaves and have them threshed. From there to claiming

Portrait of Suzanne with Sunflowers
1890
Cat. no. 1261

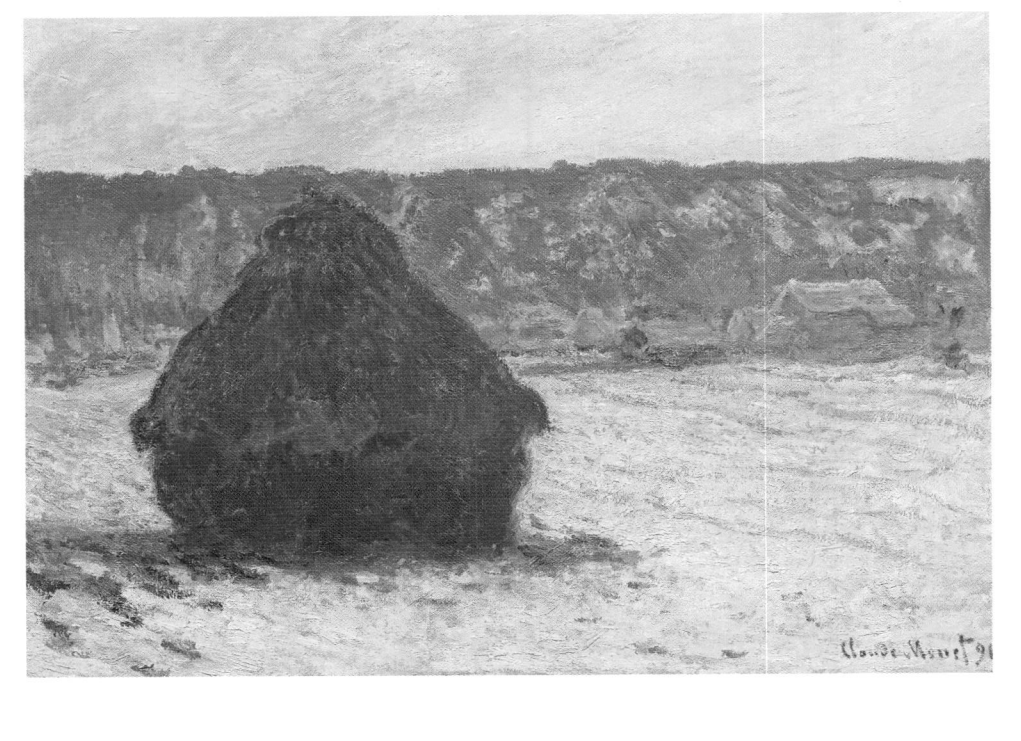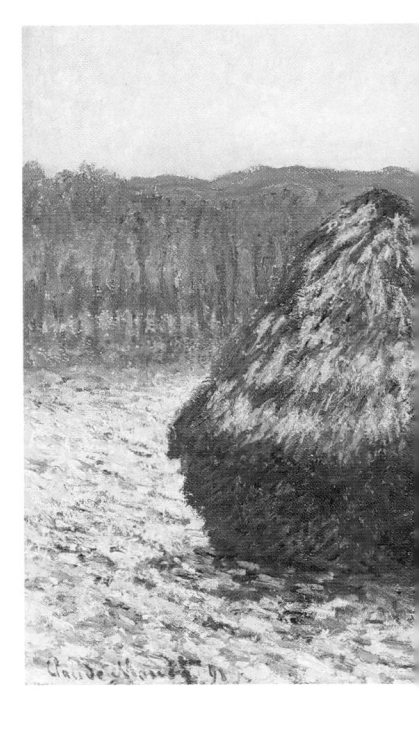

The sale took place on 17 November in the office of Maître Grimpard, who had befriended Monet after drawing up the deed of gift for Manet's *Olympia* in August. The description of the premises gives us an accurate picture of Giverny in 1890, with "a single painting studio in one wing" at the western end of the main house. The price was 22,000 francs, payable in four instalments on 1 November of each year, starting in 1891. These deferred instalments suited Monet perfectly, though they did not prevent him from asking Durand-Ruel to advance him 3–4,000 francs. Even so, when Durand-Ruel was rash enough to mention group exhibitions, he received the same reply that all such proposals had met with over the previous few years: "I am completely intractable on the subject of further exhibitions by the old group. That's my opinion; we can talk about it at greater length."

Variations on a Theme: the Grainstacks

Late in the summer of 1890, when Claude Monet returned to the Grainstacks, he also returned to the Clos Morin, in Gustave Geffroy's description that "humble piece of land adjoining several low houses, surrounded by the nearby hills", which he had first explored two years before. In a wheelbarrow pushed by a willing helper, generally Blanche Hoschedé, Monet would pile up as many canvases as there were impressions to record, and a few extra so as not to be caught out as he had been one day, when, the light having suddenly changed, he had had to request Blanche to "Go to the house, if you would, and bring me another canvas." "She brought it for me," Monet continued, dramatising his past for the Duc de Trévises, "but shortly afterwards, it was different again: another! and another! And I only worked on each one when I had my effect, there you have it."

It is a pity, then, that Monet did not mention the effects when it came to selling the Grainstacks, nor even when they were exhibited at Durand-Ruel's in May 1891. His contemporaries noted the unity and variety of the paintings in terms admiring or ironic. Henri Béraldi was ironic: "Five stacks of straw. 'The

Such a Beautiful Landscape

Did Mirbeau's encouragement have some effect? Or was it mere coincidence? At all events, in August 1890 Monet's pessimism was behind him: "I am so taken up with work", he wrote to Paul Durand-Ruel on the 6th, and on the 24th to Charles: "I am working a great deal despite variable and uncertain weather." On the same day, he wrote to de Bellio, who had been alarmed by Monet's long silence: "My excuse is that I am working enormously hard and by evening I am tired and absorbed in what I am doing." A brief survey of Monet's considerable production of the summer of 1890 shows us that Monet was again in full command of his art. It includes the *Poppy Fields* (1251–1255), the *Oat and Poppy Fields* (1256–1260) and the *Islets at Port-Villez* (1262–1265), the last of which were painted between swims in the Seine.

After the harvest came a return to the Grainstacks, parenthetically attested to in a letter to Geffroy whose original has not survived: "I'm grinding away obstinately at this series of different effects (grainstacks), but at this time of year the sun goes down so fast that I can't follow it." There then follow the usual complaints about how slow he is, though he hates "the easy things that come all at one go". Then a statement that amounts to an ethic: "the longer I paint, the more I see the work that is needed if I am to get down on canvas the things I want." Then his aesthetic: "'the instant', and above all, the surrounding light, the same light spread everywhere around." And a moving conclusion: "I am more than ever wild with the desire to get down what I feel, and I'm praying that I shan't live on too impotent, because I think I shall make some progress."

What matter, then, if some paintings were delivered late? Work, especially when favoured by weather, circumstance (and why not?) by inspiration, came before business. What matter if Boussod put Maurice Joyant in the post until recently held by Théo van Gogh, whom Boussod dismissed as "a kind of mad-man", and informed Joyant: "You will also find a certain number of paintings by a landscape artist, Claude Monet, who is beginning to sell a bit in America, but he does too much. We have an agreement to take his entire production, and he is beginning to overstock us with his landscapes, always the same subjects." In fact, of the six dozen Monets bought by Van Gogh, two-thirds had already been sold when Joyant started work, and Valadon, Boussod's partner, visited Giverny in early December. On the transactions of that day, Monet's letter to Durand-Ruel – "he took several, and I was only just able to keep hold of my Grainstacks" – is in flat contradiction to the accounts of the Goupil gallery, which dates its first purchases after the death of Théo van Gogh in February–March 1891: these related to three pictures only, all of them Grain-stacks. So Monet must have been trying to encourage Paul Durand-Ruel to increase his own purchases. As to the "agreement" that Boussod is supposed to have boasted of, while pretending to regret it on grounds of overstocking, that was on its way out. Durand-Ruel was about to be restored to the role he had occupied for so many years, that of Monet's main source of revenue.

Indeed, when in the autumn of 1890 Giverny was put up for sale and Monet decided to buy it, he seems to have counted mainly on Durand-Ruel: "I shall be obliged to ask you for quite a lot of money, as I am on the point of buying the house in which I live or I will have to leave Giverny, which would be a great blow, because I am sure that I shall never find another place like it, nor such a beautiful landscape." Monet's enthusiasm for Giverny as he came up to his fiftieth birthday will come as no surprise to anyone who knows Monet. Giverny, and all that each owed the other.

PAGE 272:
Grainstack at Sunset (detail)
1890–1891
Cat. no. 1289

worse, despite the "vaccination" discovered by the patient: Picon bitters! His sense of humour, at least, was still in good health. There were further visits from Dr Gachet, at the *Magazine français illustré* (14, Rue Baudin), where Hoschedé was the art editor, then in the hotel room two houses away to which he retreated, but the improvement was brief. "You find me in despair," Hoschedé wrote, in a last, undated letter to Gachet: "The left foot has started up again...[I] don't know if I shall be able to get up tomorrow. What am I to do?" What was still to do, Hoschedé found out in a room at 45 Rue Laffitte, where he took refuge, bedridden and paralysed, in the kind of abominable conditions that the 19th-century novelists have all too vividly described. He died at the address at which Monet had been born, though the street having been renumbered, it was not the same building.

Something – duty, remorse, or worldly convention – drew Alice to his bedside. For six days and six nights, "without a moment's rest," she attended this man who had loved her so passionately and whom she had abandoned ten years before; attended him as she had attended Monet's dying wife, Camille. And as she had for Camille Doncieux, she persuaded the dying man to accept the last rites. On 19 March 1891, at 10 o'clock in the morning, Hoschedé's brother-in-law, Georges Pagny, informed the Registrar of the 9th arrondissement of the "death of Jean Louis Ernest Hoschedé, aged 53 years, man of letters... yesterday at a quarter past midnight." The funeral announcement bore not Monet's name but that of Alice's family, the Raingos. The funeral took place at Monet's expense in the church of Notre-Dame de Lorette, where, some fifty years earlier, Claude Oscar Monet had been baptised. Hoschedé was buried in the Giverny cemetery at the request of his children. When everything was over, Alice had to take to her bed for three days.

Le Figaro honoured Hoschedé's death with a sympathetic though brief mention. *L'Art et la Mode*, the magazine to which he had contributed during the 1880s, ignored his death completely. *Le Magazine français illustré* published a posthumous article and a short, banal obituary. Thus ended the life of this former tycoon, the son of honest Parisian tradespeople. A complete absence of practical common sense combined with his indisputable artistic perspicacity had removed him from the certainties of his bourgeois background and elevated him to a world in which he did not belong and from which he fell so shamefully.

From the Grainstacks to the Poplars

On 4 May 1891, the exibition of Claude Monet's paintings opened at the Durand-Ruel Gallery at 11 Rue Le Peletier. It was dominated by fifteen Grainstacks paintings, which were accompanied by a few recent landscapes and the two famous *Figure Outdoors* (1076–1077), which the exhibition catalogue entitled "Essais de figures en plein air" (Figure Sketches of the Open Air). The preface was written by Gustave Geffroy, who was so satisfied with his performance that he also published it in *la Justice* (6 May) and *L'Art dans les deux Mondes* (9 May), then reprinted it in the first volume of his collection *La Vie artistique*. Press reviews were many, despite the small size and short duration of the exhibition, but the articles contained little that was new. A search for novelty would take us to Béraldi's letter cited above, with its timetable of polychrome stacks, to Pissarro's letters to his son Lucien, or to the virtuosity of Félix Fénéon's prose: "When did Monet's colours ever come together in more harmonious clamour, with more sparkling impetus? It was the evening sun that most exalted

PAGE 278:
Three Poplar Trees in the Autumn
1891
Cat. no. 1307

Anonymous
The Poplar as the Tree of Liberty
c. 1790
Paris, Bibliothèque Nationale,
Cabinet des estampes

Honoré Daumier
The Artists
Published in *Le Charivari* on 19 January 1865

View of Rouen
Black crayon on Gillot paper
(D. W. 1991, V, p. 126–127, D 434)

The Façade of the Rouen Cathedral
Pencil sketch, Paris, Musée Marmottan
(D. W. 1991, V, p. 88, D 168)

Grainstacks: in summer, they were haloed in purple flakes of fire; in winter, their phosphorescent shadows rippled in the sun, and, a sudden frost enameling them blue, they glittered on a sky first pink, then gold."

Our most direct witness is undoubtedly that of W.G.C. Bijvanck in his book *A Dutchman in Paris in 1891;* he was lucky enough to hear Monet in person criticise his own paintings in the Rue Peletier Gallery. This foreign visitor was somewhat bewildered by the "wild saraband" of colours until a Grainstack "in all its glory" captivated him and showed him how to see the others. Monet apparently told him: "You see this painting here...the one which first took your attention, that one alone is completely successful perhaps because the landscape was giving everything it could. And the others? There are some which are really not bad: but they only acquire their true value by comparison within the whole series." There, in all its modesty, is an evaluation which marks a pleasant change from the tiresome eulogies of Monet's friends, whose appreciation was not invariably determined by artistic concerns.

In June, the first communions of "our two young boys", Jean-Pierre Hoschedé and Michel Monet, testified to Alice's progress in her effort to convert the Monet household to a Christian way of life. On the work front, the late spring and early summer were occupied with finishing certain of the Grainstacks in the studio; there was considerable demand for them (at 2,500–3,000 francs apiece). The records of Boussod and Durand-Ruel alone allows us to set Monet's sales for 1891 at 97,000 francs, a fortune equivalent to 1,000,000 1978 francs. We can see in Monet's 1,000 franc loan to Pissarro on 1 May a sign of the increasing financial comfort that allowed Giverny's new owner to organise his house and garden as he pleased. Pissarro was enjoined to reimburse the loan quickly, which he did on 21 July. Monet's preoccupation with house and garden was one of the reasons why he travelled to Paris less frequently than his friends wished; the other was his desire to finish "quantities of new pictures". These were the series of Poplars (**1291–1313**).

The "amusing story" of the Limetz poplars is well known. They had been put up for auction by the village, and Monet's representations to the mayor to obtain a stay of execution had been refused; he therefore came to an agreement with a timber merchant, to whom he promised to "put in the extra" if the auction price went beyond the merchant's limit, on condition the trees remained standing long enough for him to finish painting them. "And so it turned out: my wallet felt the damage." Let us not exaggerate: since the auction price was no more than 6,000 francs, Monet's contribution was not substantial. The documents that tell us this also offer us interesting details about place and time. The auction was decided on by the municipal council at its meeting of 18 June 1891, and took place on 2 August. It concerned "a part of the poplars and trees in commune-owned property in Le Carouge and the marshland, along the banks of the river Epte." We can rule out Le Carouge, near Villez, for obvious topographical reasons, so the poplars in question were those which followed the sinuous course of the Epte on the edge of the Limetz marshland, which also belonged to the commune. This is confirmed by Monet's title *Poplars on the Banks of the River Epte, as seen from the Marsh* (**1312**) of 1892.

To reach this motif, no more than 2 kilometres from his house as the crow flies, but considerably further by the Limetz or Gasny roads, Monet used a rowing-boat, as J.-P. Hoschedé informs us. To reach the poplars, he would have had to row up the Epte to beyond the point where the Limetz branch of the river forks off. There, the boat was indispensable for almost all the motifs. The usual complaints and recriminations were forthcoming in a series of letters: "Since your last visit I have had nothing but disappointments and difficulties

Rouen, old houses leaning against the Tour
Saint-Romain (also known as the Tour d'Al-
bane)
Postcard, 1900

The Cour d'Albane
1892
Cat. no. 1317

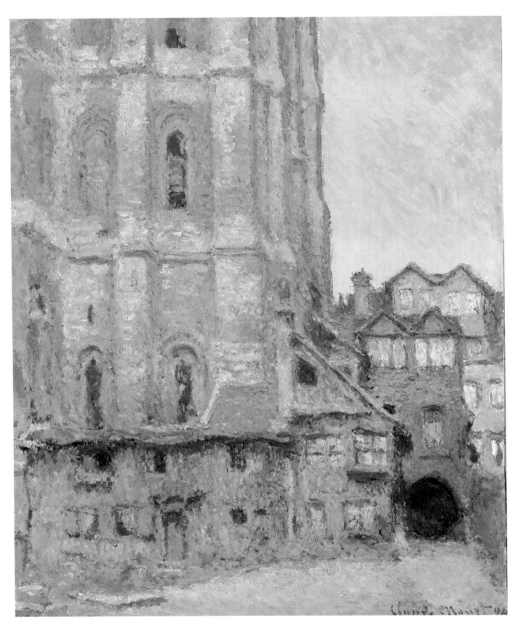

with my poor trees, and I am not at all satisfied with them"; "Despite this awful
weather which reduces me to despair about my trees"; "I have again been bat-
tling more or less successfully with admirable landscape motifs that I've had to
do in all kinds of weather...they amount to little more than good intentions."

Monet now heard that Dr de Bellio was selling some of his Monets, and
wrote to him to reproach him with the fact. De Bellio, in reply, declared his
affection for the great works which he had bought: "Have no fear, my dear
Monet, none of your important paintings will ever leave my collection." Late in
the year, Monet made a quick trip to London, where Whistler presented his
colleague to the Chelsea Club. Meanwhile, the death of Albert Wolff, on the
evening of 22 December, deprived the academic painters of one of their most
influential spokesmen. Those who had so long feared the verdict of Wolff's
columns were understandably unmerciful to his memory; in the 20th century
he has been delivered up to the ignorant censure of those who have never taken
the trouble to read him.

The Blue, Pink or Yellow Cathedral

1892 was the year in which Georges Lecomte published his *L'Art impressionniste d'après la collection de M. Durand-Ruel,* (Impressionist Art from the Collection of M. Durand-Ruel) a fine work which confirmed the prestige of both the "new painting" and Paul Durand-Ruel himself. It was also the year in which Guy de Maupassant, the eponymous "bel-ami", attempted suicide; he died some 18 months later. For Monet there were the last echoes of his trip to London (a painting of Winter Effect was being exhibited in Old Bond Street) and a welcome start to the year in the form of 5,000 francs sent for Christmas by Durand-Ruel, who was again asking him for paintings. Maurice Joyant bought several paintings of the Poplar series for Boussod and Valadon, and organised an exhibition of this "interesting series of studies" in the small rooms of the Boulevard Montmartre gallery. Pictures that needed finishing kept Monet in his studio at Giverny, while winter cast its spell outside the windows.

Material interests must be attended to whatever the circumstances. After the death of their half-sister Marie, the legitimised daughter of their father Adolphe, Claude and Léon bought their step-mother's share of Marie's legacy in February. This allowed them to retrieve paintings by Claude that Adolphe Monet had left to his daughter; their greatly increased value was unknown to Adolphe's widow, who had retired to her native Criquetot. The two brothers grew closer than ever when Claude went to stay with Léon in Rouen in early February. Indeed, they met rather more often than was compatible with Claude Monet's desire to paint. For greater independence and to avoid wasting time walking between Leon's house and his motifs, Monet took a full-board room at the Hôtel de l'Angleterre, at 7–8 Cours Boieldieu, near the Seine. The owner of this first-class hotel, M. Monnier, acted as his intermediary in finding a porter.

After several days of prospecting, during which Monet indulged himself by painting some of the Rouen motifs most often painted since Romanesques times (1314–1316), he finally set up his easel in an empty apartment that overlooked the cathedral facade. This first contact was soon interrupted by a few days of enforced rest at Giverny. When he returned to Rouen, a disappointment awaited him: house-painters were at work in the apartment. Fortunately, a "linen-draper" placed at his disposal a "new" window which provided a convenient viewpoint. These clues, provided by Monet's correspondence, allow us to identify the places where he painted the Cathedral motifs, to explain the different angles from which they were made, and establish their chronology, for though all of them are dated 1894, they were, in fact, painted over the course of the two preceding years.

The hospitable "linen-draper" of 1892 was the milliner Fernand Lévy, who owned a shop classified under "lingerie and fashion" in the "Almanach de Rouen" at 23 Place de la Cathédrale. The shop was in a fine building, the former Finance Office which in the 19th century contained several shops. M. Levy's was on the corner of the square with the Rue du Petit-Salut (alias Rue Ampère), in a site now occupied by the Tourist Information Bureau. The changing rooms were upstairs. M. Lévy's chic women clients resented the post-prandial presence of a bearded man with his back to them, whose gaze seemed to swing like a pendulum between the facade of the cathedral and the easel on which his canvas received a few new strokes with every swing. A screen obligingly lent by the collector, François Depeaux, who frequented Monet's company assiduously, put an end to this resentment, which emerged somewhat after the event; it had little influence on the series of Cathedrals painted from M.

Lévy's shop. The distinctive feature of these is the gap visible between the facade and the left-hand tower.

The successive impediments that prevented Monet from using the empty apartment during his 1892 "campaign" seem to have been much more serious than the irritation of M. Lévy's clients since, as far as we know, only two pictures were painted there. And yet in 1893, Monet continued to use the premises, obtaining the keys from one Monsieur Louvet, whose identity is well known to us: he was J. Louvet, the owner of a shirt and underwear shop at 31 Place de la Cathedrale. From there, the cathedral can be seen at exactly the angle of the two surviving paintings (1319–1320).

These, then, are the two sites from which Monet worked in 1892, with contrasting degrees of success: the window of the linen-draper M. Lévy, and that of the vacant apartment in the house of M. Louvet. Monet also painted *The Cour d'Albane*, on the north side of the cathedral and behind the tower of the same name (or Saint-Romain tower) (1317–1318), when weather permitted. The correspondence gives us a clear account of Monet's 1892 "campaign". It tells us how important the light and time of day were for Monet, specifying that he worked particularly well between midday and two o'clock (two hours behind current French time), when the light fell across the facade from right to left. The letters describe the problems inherent in "such a strange way of working", circumstantial difficulties, canvases destroyed, and, by the end, overwhelming fatigue: "I am worn out, I give up, and what's more, something that never happens to me, I couldn't sleep for nightmares: the cathedral was coming down on top of me, it was blue or pink or yellow." Finally he packed up and returned to Giverny in mid-April, exhausted and for the time being unable even to look at his paintings, let alone judge them.

The Marriages

By now, Monet's financial worries had definitely given way to solid comfort. But the revenues of the wealthier Monet are much more difficult to calculate than those of his lean years. The account-books for the relevant years are missing, and if we simply add together the sums paid out by Durand-Ruel and Boussod, we remain well below the truth, since no gallery had exclusive rights to his work. We know that their total payments in 1892 came to well above the 100,000 franc annual income estimated by Gauguin during the Poplars show at Durand-Ruel's gallery.

Monet returned from Rouen for the exhibition and himself directed the hanging of his fifteen paintings on Monday, 29 February, the day of the opening. He was absent for the closing night, but must certainly have seen the article written by Georges Lecomte in *Art et Critique*, which was partly reprinted in *Le Journal des Artistes*. In Paris, his detractors would soon lack the courage to make themselves heard, while his devotees took every occasion to insult the unconverted. And in New York, according to the report of Theodore Robinson, a loyal supporter, there was increasing interest in his work from "people of taste".

Once he had recovered from the trauma of his exhausting Rouen "campaign", Monet began to show his first Cathedrals to visitors; for the time being, he was determined not to part with a single one. Initially held back by his accumulated fatigue, work on them was then further delayed by family events that were to take up a part of the spring and summer. Suzanne's meeting with the painter Theodore Butler (1330) produced a very strong reaction in Monet, and his counsels of prudence went beyond even what Alice's bourgeois conventions

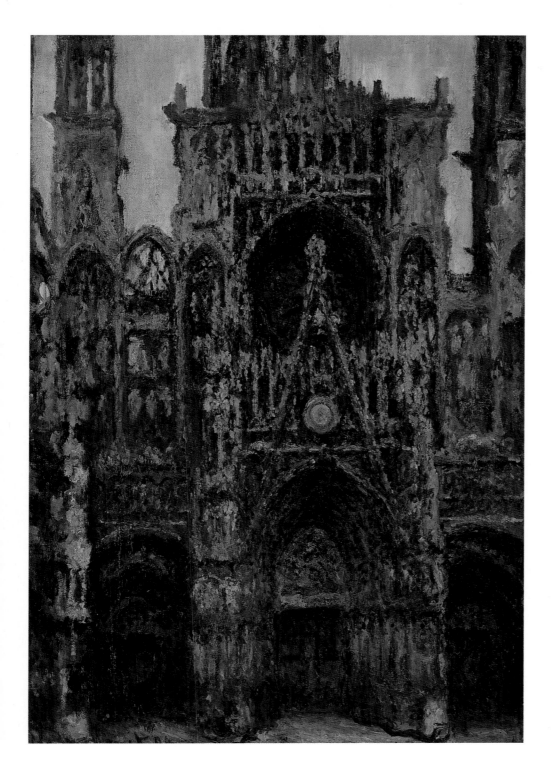

Rouen, the façade of the cathedral
Photograph, 1900

The Portal, Harmony in Brown
1892
Cat. no. 1319

required. Indeed, she stood accused of not keeping a weather eye on her children. Monet wrote from Rouen: "I can't think of anything else; the more I think about it, the more worrying and grievous I find it... You have the duty, after what has happened, to refuse your daughter to an American, unless he is known to us through connections or an introduction, but not just met on the road... If she is madly in love, if it is a passion, let her see how inappropriate it is after inquiring; if, as must surely be the case, it is no unconquerable passion, put an end to all hope." It is when he goes on to threaten to throw everything over – "whether or not you follow my advice, I can no longer remain at Giverny" – that we perceive how difficult it was for Monet to resign himself to the fact that his prettiest model was soon to be his no more.

In the long run, commonsense prevailed, and though for the couple the

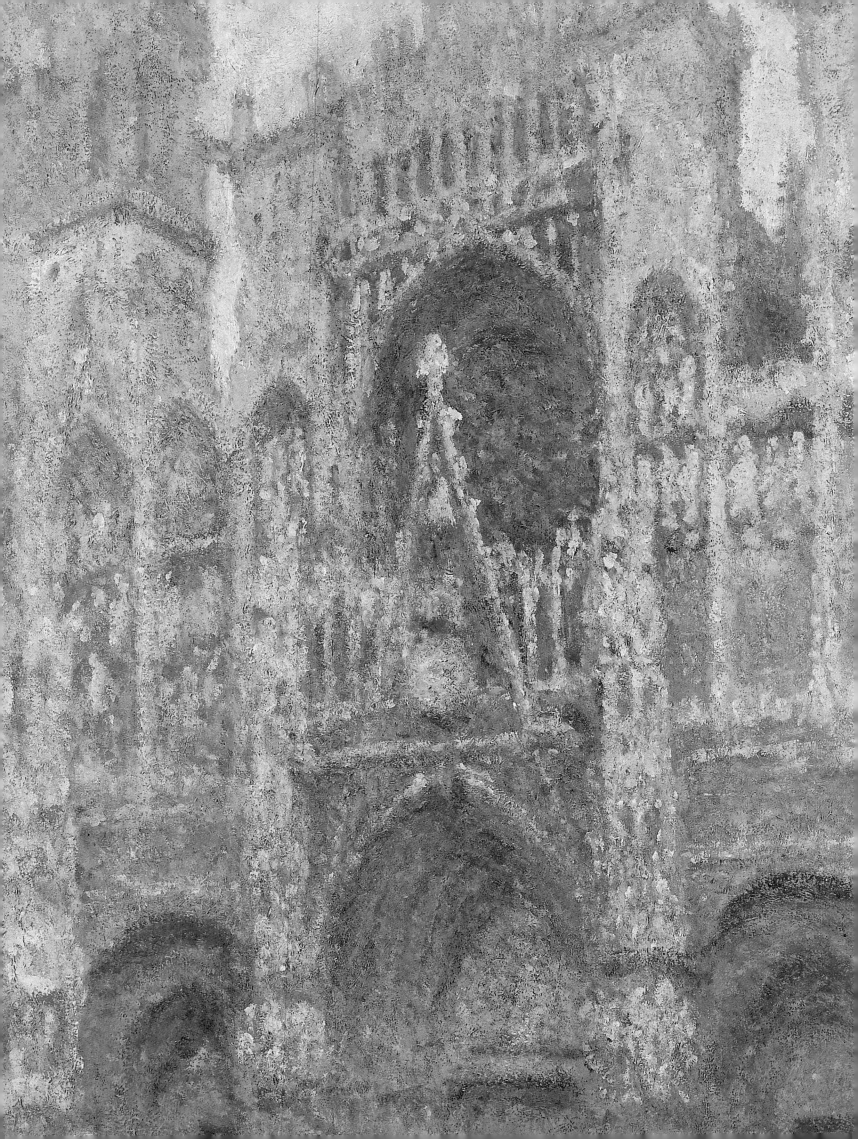

wait seemed a long one, it cannot have been more than a few months, since around mid-June Monet wrote to tell Durand-Ruel that the marriage would soon take place. He failed to add that he had arranged to marry Alice a few days before, thus acting in a way that Ernest's existence had hitherto prevented and ensuring a normal family situation. A marriage contract was signed in the office of Maître Leclerc, a Vernon notary, and on 16 July the Mayor of Giverny, Léon Durdant, declared "Monet Oscar Claude and Raingo Angélique Emélie Alice" husband and wife. The witnesses were Léon Monet, Georges Pagny, Alice's brother-in-law, and the painters Caillebotte and Helleu. Robinson had just returned from the USA and was invited to the wedding breakfast. He was also invited to the wedding of Suzanne and Butler on 20 July, and describes the rustic pomp of the ceremony, whose highlight was the procession entering the church at Giverny, with, at its head, Claude Monet proudly walking arm-in-arm with his step-daughter.

In parallel with family duties came those of friendship. Pissarro's house in Eragny had been put up for sale, and Pissarro had no choice but to buy it if he wished to avoid moving out. Pissarro having been detained in London, Mme Pissarro visited Monet, who agreed to lend 15,000 francs. The delays in completing the purchase were sufficient to alarm Monet, who began to imagine, quite wrongly, that the purchase had merely been a pretext to trick him into lending so large a sum. When Pissarro received the letter setting out these insulting suspicions, he was dumbfounded, and it required all his self-control, combined with his desire to go through with the purchase come what may, to set things right. By the time of Monet's letter to Pissarro of 19 August, their friendship had, it seems, returned to an even keel.

The Hôtel de Ville Affair

Around mid-November 1892, there was a note about Monet in the trade press. Following the resignation of Jules Breton, who had been commissioned to paint one of the large landscapes for the galleries overlooking the north and south courts of the Paris Hôtel de Ville, "the decoration committee designated M. Pierre Lagarde to replace him, by ten votes against the four given to M. Claude Monet."

Monet as candidate for an official commission, and what was worse, rejected as such! No wonder Geffroy protested in *Le Journal des Arts* (pointing out that Monet's name had been put forward by Rodin). But the facts of the case are not without interest. The reconstruction of the Hôtel de Ville, an act symbolic of the renaissance of Paris in the aftermath of the Franco-Prussian war and the Commune, had been followed with great interest. In 1879, Edouard Manet sent the Prefect of the Seine a plan for decoration of the municipal council chamber on the theme of Zola's *Le Ventre de Paris* (The stomach of Paris). His plan was not even considered, but his proposal seems to have influenced the Paris magistrates; five years later, the Municipal Council decided that allegories, symbols and other emblems had enjoyed excessive favour, and that commissions too often went to members of the Institute. Impelled by public opinion, a decoration committee was set up in March 1887 under the presidency of the Prefect, Poubelle, famed inventor of the dustbin that bears his name. The committee was instructed to organise half the work on the basis of direct commissions and half through open competition. The panels for the two first-floor halls known as the Tourelle galleries were to come into the first category: five large decorative panels were planned, and 40,000 francs was made

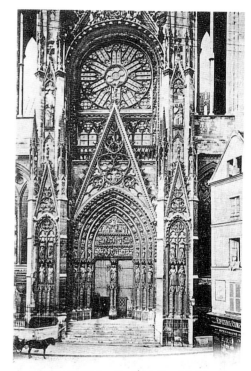

ROUEN. - Cathédrale. - Portail de la Place de la Calende

Rouen, the Cathedral, the Calende portal
Postcard, 1900

PAGE 286:
The Portal (Grey Weather) (detail)
1892
Cat. no. 1321

available for the commissions, which went to Jules Breton, Harpignies, Damoye, Pelouse and Rapin. But Breton, an old enemy of the Impressionists, and one of those who had contributed to Monet's rejection from the 1867 Salon, showed no enthusiasm for fulfilling his contract and abandoned the project four years later.

In the meantime, Rodin had been appointed to the decoration committee in place of Eugène Veron. When, in November, 1892, the committee was called upon to designate a successor to Breton, Rodin and his colleague Bracquemond attempted to impose Monet. Two other committee members had been convinced, but ten votes went to a former student of Dubufe and Mazerolle, Pierre Lagarde. Thirteen years younger than Monet, Lagarde represented one of the great hopes of official art and was already a Knight of the Legion of Honour, having previously received a gold medal for painting at the Exposition Universelle of 1889. In its resolution of 20 December 1892, the Municipal council had no choice but to accept the committee's advice and authorise the Prefect to "entrust to Monsieur P. Lagarde, for the price of 8,000 francs, the landscape panel awarded by the resolution cited above [20 December 1888] to Monsieur J. Breton." Lagarde duly painted a *Vue du grand lac du Bois de Boulogne* (View of the big lake in the Bois de Bologne) for the north Tourelle gallery. It was admired at the time for the "striking effect" produced by its "feeling of reverie and solitude". As to the "Impressionist notations" also praised, these were consistent with the partial and much criticised conversion to Impressionism of many painters reputed for their eclectic technique.

There are no references to the Hôtel de Ville affair in the surviving letters of Monet; it seems not to have concerned him greatly. Indeed, it is by no means certain that he ever requested the commission. Rodin may have put his name forward without permission, thinking – rightly or wrongly – that if the vote were favourable, Monet would not repudiate it.

Much more important than municipal pomp and ceremony was Monet's need to start working outdoors again as soon as possible after such a long interruption. From this point of view, the winter of 1892–1893 fulfilled his every wish. There was a long period of intense cold, quantities of snow fell, and there were ice floes in the Seine for three weeks before it froze completely on 18 January. The ice broke up on the 23rd. The following day, in a letter to Durand-Ruel, Monet lamented the fact that the thaw had arrived before he was ready. He was, he said, out of practice, and had had to destroy the "bad stuff" that he had done. The remaining studies were still incomplete, but could be reworked if the weather would only turn cold again; there were less than six of them. This estimate is strikingly lower than the fourteen winter paintings catalogued (1331–1344). Though some of them are dated 1894, all of them were at least roughed out in January, 1893, the only month for the next two years in which the required meterological conditions – freeze and thaw – were present. It follows that Monet knowingly underestimated his own production when writing to his dealer. If so, the reason was probably not the self-critical attitude that we have so often encountered, but his desire to justify new price demands on the well-established grounds that rarities are worth more.

The works of January 1893 were painted, for the most part, some way away from Giverny, and suggest that Monet used a horse and cart to reach his subjects; he could hardly have walked through the snowbound roads to Jeufosse (1332), the most distant of them, nor even to the slightly less distant outskirts of Bennecourt. There he painted from the banks of the Seine opposite the Ilot de Forée, which figures in eight paintings (1333–1340). Since Monet knew that he could find his classic motifs as close as Port-Villez (1341–1344), one is almost

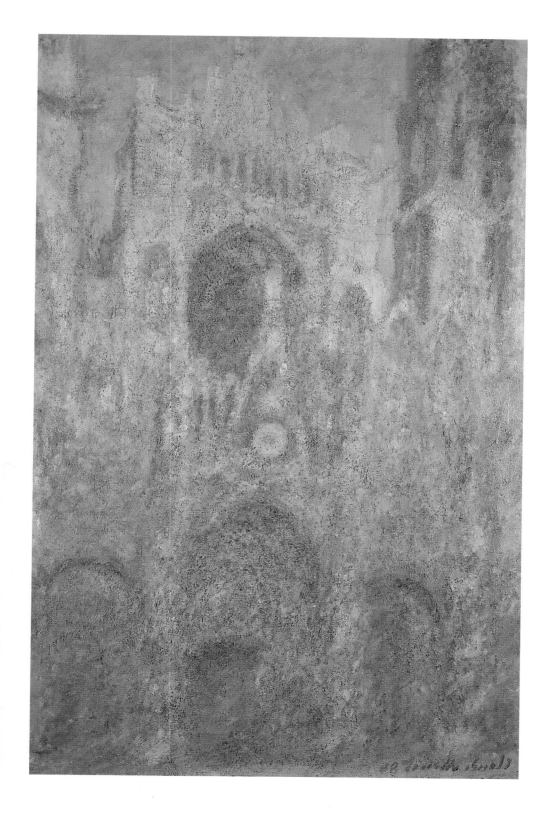

Rouen Cathedral, Symphony in Grey and Rose
1892
Cat. no. 1323

tempted to think that Bennecourt was chosen in honour of the "beautiful snow effects" painted there by Claude Lantier in Zola's novel *L'Œuvre* of a few years before.

A Pond to Make, A Cathedral to Paint

On Tuesday, 1 February 1893, Monet visited the Durand-Ruel gallery to see the exhibition of Utamaro and Hiroshige prints, something he had been planning to do for some time. In the little "faded-pink and pistachio-green" rooms of the

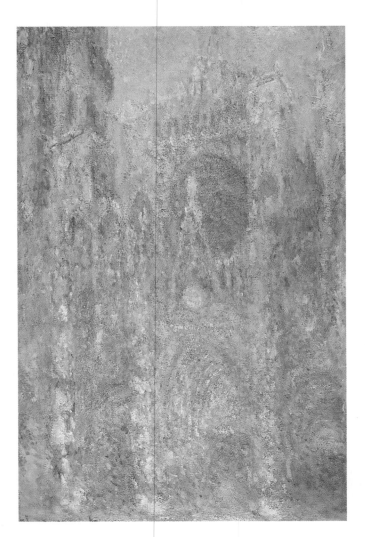
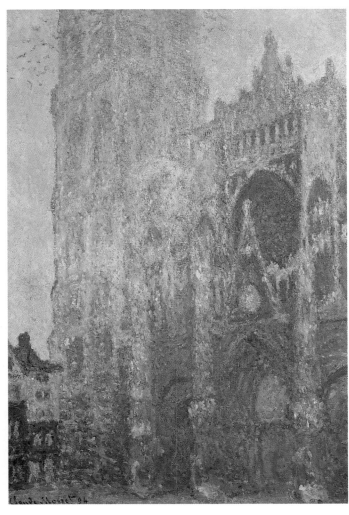

FROM LEFT TO RIGHT:
Rouen Cathedral
1892
Cat. no. 1328

*The Portal and the Tour d'Albane
(Morning Effect)*
1893
Cat. no. 1346

Rue Le Peletier gallery, he met Pissarro who shared his admiration. For his old friend Pissarro, the Ukiyo-e works constituted an "a posteriori" justification of the direction that Impressionism had taken. Monet, by contrast, took from the exhibition images of still waters, exotic plants, miniature bamboo forests and Japanese bridges. It must have been a mere coincidence that, on 5 February, he signed in Vernon the deed of sale for a strip of land that lay below his property, between the Ru and the railway line. The notarised documents must have been prepared some time before, but this strip of land, added to the stretch of the meadow that he had already bought, made it possible for Monet to gradually make his dream come true of a water garden, which was to become the lily-pond of the Water Lilies series.

Monet was so full of this project that when shortly afterwards he stayed in Rouen for his second Cathedrals "campaign", he continued to take an interest in the work on his new acquisition. He needed planning permission for the excavation work that he had already decided to undertake, and this required considerable correspondence. The doubts expressed in the village combined with the halting progress of his planning permission, left him absolutely furious: "Don't rent anything, don't order any fencing, and throw the aquatic plants in the river; they will grow there. Let me hear no more about it, I want to paint. 'Merde' to the Giverny natives and the engineers." He recovered his good humour thanks to the support of the journalist C.F. Lapierre, whose portrait Monet had once painted (78). Lapierre had recently given up the management of the *Nouvelliste de Rouen,* but was still a man of considerable influence in the

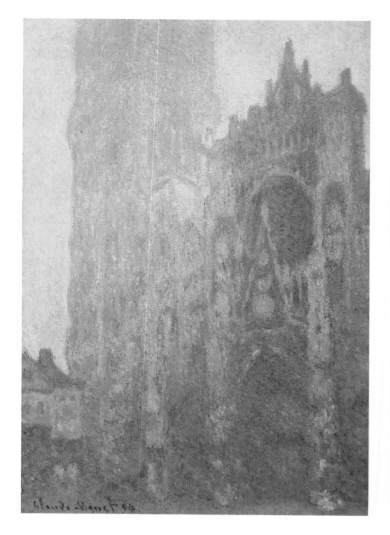
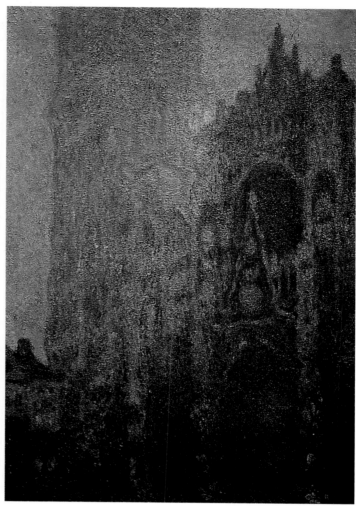

region. Monet's petition, handed directly to the Prefect of the Eure by Lapierre, must have produced the desired effect; had it not done so, there would have been no water lilies to paint. Throughout Monet's second stay he showed himself much more interested in gardening than he had been in the past. As soon as he arrived, he visited M. Varenne, head of the botanical gardens, who was kind enough to open his hothouses to Monet's inspection. What is more, Monet bought plants from the Rouen gardeners, sent them to Giverny by the basketful with abundant advice as to their treatment and continued to advise on the treatment of the specimens already planted.

His horticultural preoccupations were one thing, his desire to paint quite another; painting was the priority. Almost immediately after his arrival in Rouen, he again took a room in the Hôtel d'Angleterre and had his easels and paints taken by his habitual porter to the two places where he was hoping to work on his Cathedrals: the apartment that he had used the previous year in the big house belonging to J. Louvet and a new site on the Rue Grand-Pont, where work had just finished on a location that seemed to him "very good." The shopkeeper, M. Lévy, at 23 Place de la Cathédrale, had found his custom too much disturbed by the previous session to allow Monet's return. Needing an angle on the cathedral similar to that of the series begun in the former tax office, Monet had had to seek a new location, either at the end of his 1892 "campaign", or during a trip undertaken for that purpose. It would have been ideal to set up at 83 Rue Grand-Pont, which only the narrow Rue du Petit-Salut (alias Rue Ampère) separated from 23 Place de la Cathédrale, but there Monet came up

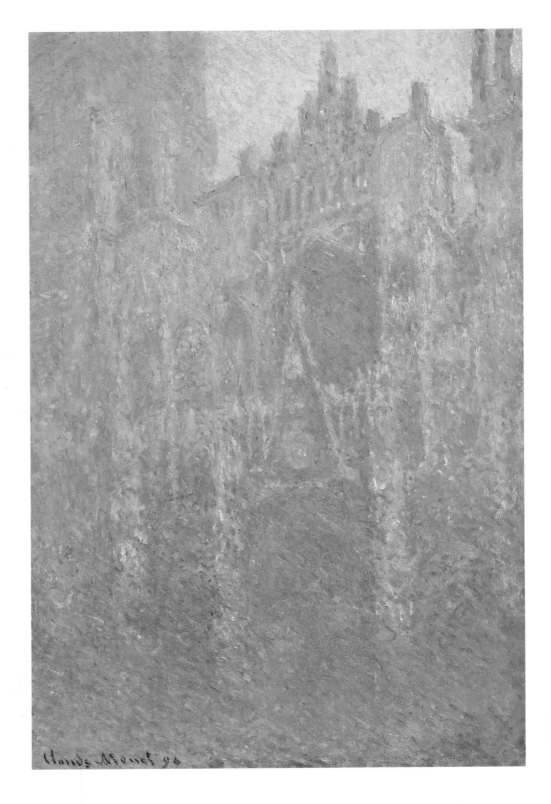

The Portal (Morning Fog)
1893
Cat. no. 1352

against the categorical refusal of Mme Majolier and her son Emile, who ran an optician's. Next door, at number 81 (now 47), things went better. We know this because the occupant of the premises that Monet coveted, one Edouard Maquit, replied to an enquiry conducted in the pages of *Le Journal de Rouen*: "During building work [at 22 Rue Grand-Pont], I succeeded in obtaining from M. Meyer, who was then a ribbon-seller at 81 Rue Grand-Pont, the remainder of his lease so that I could temporarily set up my shop there. Claude Monet came, with M. Depeaux, to ask my permission to set up his equipment on the first floor, near the balcony of the building, with the windows open. He worked there for several months and when he left, he said 'I've finished'."

The Mauquit house was quite close to the Lévy shop, and Monet hoped that he could work on the same effects as in 1892 without having to modify the structure of his paintings of the cathedral facade. The fact that the sun rose higher in the sky as the months went by worried him greatly, whether he was working on new canvases or old studies. A slight difference is detectable between the new paintings (1345–1361) and 1892 series (1321–1329). This was imposed by the new viewpoint, somewhat to the right of the previous one (looking towards the cathedral); the light visible between the left-hand tower and the bulk of the facade in 1892 disappears in the 1893 paintings. For one of the 1893 series, Monet turned slightly further to the left and painted the full width of the Saint-Romain tower and the houses around it (1345–1349).

After a promising start, we again encounter Monet's habitual moodswings, caused not by the changing weather – these were not landscapes – but by the difficulties inherent in the subject itself, the lacy gothic stonework in the endlessly shifting play of light. And so, by the end of three weeks' work, Monet's morale plummeted, and he wrote to Alice in despair: "Hard as I work, I am not getting anywhere... I was right to be unhappy last year; it's horrible, and what I am doing this time is bad too, it's just bad in a different way... I am worn out, and that shows that I've given absolutely everything I had." This feeling of impotence was accompanied by a tragic irony: "Heavens, they really don't know much, the people who think me a master: great intentions, but that's all."

Of course, there were days when the depression gave way to something better, and Monet "worked unreasonably hard" at 9, 10, 12, or 14 paintings simultaneously. After a month and half he came to a conclusion that we have heard before: "Now I am beginning to understand my subject." But then he reverted to anguished contemplation of what seemed to him a disaster: "I shall never manage anything good, it's an obstinate overlay of colours,... but painting it's not." The truth would begin to dawn on him only in mid-April after he had returned to Giverny: "I am less unhappy than I was last year, and I think that some of my 'Cathédrales' will do," he told Helleu.

In a P.S to his letter to *Le Journal de Rouen*, E. Mauquit noted: "I have forgotten to tell you that, by way of thanks, I received from Claude Monet a shop-soiled doll for my little daughter and a little basket of sweets."

The New World, The Old World

While Monet was returning to Giverny, the organisers of the *World's Columbian Exposition* in Chicago were finalising the arrangements for this very important event, which was opened on 1 May 1893 by President Cleveland. The central building and two wings of the enormous Art Palace had been constructed specially for the Exposition in the best Greco-Ionic tradition and were crammed full of paintings, drawings, engravings and sculptures from all over the world. The eastern pavilion had been almost entirely commandeered for French art. Conscientiously selected by a committee presided over by Gérôme, assisted by vice-presidents Bonnat and Puvis de Chavannes, the French selection contained no Impressionist works, despite the fact that the jury included Geffroy, Paul Mantz, Roger-Marx and Rodin. The Impressionists were, however, presented in a special section set up, apparently, on the initiative of Potter Palmer and containing foreign works belonging to private American collections. Officially entitled "Group 146", this "Loan Collection" occupied "galleries" 40, 41, and 42: one whole side of the pavilion, and was in a very strategic position.

This was a reality of which the French officials had no notion. Blinkered by

their obsessive pursuit of medals, mistaking the new world for the old, they decided that the awards committee was not of sufficient standing, and declared their section excluded. The proceeding was reminiscent of the Salon in the days of Cabanel and the Count de Nieuwerkerke.

Alice had suffered a fainting fit during one of Monet's "little excursions", and this developed into "an exceedingly worrying illness" followed by a long convalescence. Monet therefore spent the late spring and the summer of 1893 at Giverny without doing much outdoor painting. With the exception of a short outing to Port-Villez (**1365**), he worked only in the meadow next to the house, known as La Prairie, where, painting a Grainstack against a background of willows, he could keep an eye on the excavation work for the pool. The task of perfecting the "Cathédrales", which lasted well beyond the summer, took up some of his time. The remainder was given over to the habitual visitors, Durand-Ruel, Mirbeau and others, along with a growing contingent of newcomers. Among these was J.E. Blanche, who dates his highly-coloured memories of Giverny to this time; they are particularly valuable for the insight that they give us into the background of Monet's life ten years after he had first settled in Giverny and before the transformations permitted by his increasing wealth.

"The only time that I was received at Giverny, in or around 1893, the original house seemed to me deliciously cool and gay, overflowing with fashionable esparto grass, cretonne, and cheap Japanese wall-paintings and fans; bamboo and turkey-red cotton were all the rage. Monet had covered the walls of his dining room with damasked white cloth, a silvery background on which the images from a Japanese album stood out. The beautifully arranged table settings, like those at Whistler's, suggested exquisitive fare. Monet was a gourmet well-known for the succulent surprises he put before his guests. One felt he was a simple, sensual man, happy to have a very comfortable roof over his head, before wealth, unanimous praise, and a respect bordering on devotion had assured him a unique position."

Monet in 1893 was already on the road to wealth, as witness the payment he obtained from Durand-Ruel for the Potter Palmer account: 24,000 francs paid in two instalments for four paintings, in addition to other sums claimed and received shortly afterwards. Before the year's end, Camille Pissarro was able to reimburse 4,000 francs of the 15,000 he had borrowed from Monet, thanks to a visit from Charles Durand-Ruel.

Pissarro had, until then, been more open than his colleagues to post-Impressionist styles, but even he was quite disconcerted by Gauguin's exoticism and thought it "too Kanak". As to Monet, he, like Renoir, had never waivered in his original hostility, and found the forty or more Gauguins exhibited at the Durand-Ruel gallery in November 1893 "quite simply bad." He was now as hostile to experiments that exceeded his grasp as the Bouguereaus and Cabanels of his own time had been. No doubt his age was partly responsible for this, but the routine panegyrics delivered by his friends at the least prompting may also have contributed. One of the chief offenders was Geffroy, whose rhapsodic chapter on Monet opened the series of studies that he published in the *Revue encyclopédique* of 15 December 1893.

Legacies, Sales and Added Value

As time went by, the increasing number of deaths among his friends and acquaintances, some of them premature, left their mark on Monet's own life. The first months of 1894 were particularly tragic, and made a deep impression

on Pissarro, the most sensitive of the Impressionist group: "Our poor friend de Bellio, and our comrade Caillebotte have gone. Caillebotte was 46, de Bellio 66... Yes, de Bellio was a true and sincere friend, and so we are all sad... And poor Tanguy, such a good man, so kind and honest!"

Monet's reactions, insofar as they have come down to us, are not of the same order. Three weeks after Dr de Bellio's death, commercial preoccupations seem to have overridden all other feelings. By contrast, he seems to have been impressed by "the sad ceremony of [his] poor friend Caillebotte", and agreed to form part of the subscription committee for Tanguy's widow. This generous enterprise, which bore fruit on 2 June in an auction presided over by Georges Petit, seems not to have inspired much interest in the public. Monet had supplied a "Bordighera", which obtained the highest price, at 3,000 francs; Cézanne's maximum price was 215, Sisley's 185, and a Gauguin was sold for 110 francs.

The problem posed by the Caillebotte legacy was on a quite different scale, and in many respects resembled the *Olympia* affair. Caillebotte had left the 67 paintings in his collection to the State, for exhibition first in the Musée du Luxembourg and later in the Louvre. Since the collection included 16 of his works, Monet was regarded as an interested party, and thus released from any part in the negotiations, which were long drawn out and delicate. The task fell to Auguste Renoir, who had been designated as executor in 1876. The Caillebotte legacy provides a measure of the combativity of the forces involved, the growing

PAGE 296:
The Portal of Rouen Cathedral at Midday (detail)
1893
Cat. no. 1358

BELOW:
Apartement Interior
1875
Cat. no. 365

A Monet painting in the Gustave Caillebotte collection.

LEFT:
Gustave Caillebotte
Young Man at his Window
1875
New York, Private Collection

comprehension of the new painting by officials of the National Museums, the relative neutrality shown by political circles, the fluctuating position of certain academic artists and the obduracy of others; it occupied the headlines for several years to come.

During the early months of 1894, Monet himself was concerned mainly with preparing the exhibition of the Cathedral series; throughout February he was working at this without "managing as well as [he] would have liked". A month later, with the problem of the exhibition still unresolved, he returned to painting in the open air, taking on several motifs at once. After an interruption in mid-April caused by poor weather, "the new leaves" forced him to "start... several spring pictures again"; he set about it with a passion.

On first hearing about the forthcoming Duret sale, Monet condemned it as "base speculation". It took place on 19 March at Georges Petit's gallery, and offers us an interesting insight into prices. For the six paintings sold, of which the most recent, a *Vétheuil Seen from Lavacourt* (528) was knocked down for 7,900 francs, the prices varied between 4,650 francs for *A Hut at Sainte-Adresse* (94) and 12,000 francs for *Turkeys* (416), which suggests an appreciable rise. In fact the last two were bought in by Duret and three others went to Durand-Ruel (172, 433, 528), so that only one found a previously unknown owner in the shape of Edmond Simon.

Monet had expected the Duret sale to be a complete fiasco, and had eyes only for the favourable impact on his prices. He therefore felt entitled to be very demanding in relation to the Cathedral paintings. Paul Durand-Ruel visited him on Sunday, 29 April, and was alarmed at the scale of Monet's demands; he wanted 15,000 francs for each picture. Durand-Ruel took advantage of the presence of a third party to avoid further discussion of the matter. "If we had been able to have a talk... we would have come to a better understanding, I feel sure", Monet wrote, and immediately after the dealer's departure began a letter-writing propaganda campaign intended to bring Durand-Ruel round. Monet was not excessively scrupulous in his methods, which included a kind of blackmail. Thus he announced that a visit from Valadon was imminent; moreover he was sending out letters to "persons who have expressed the desire to have Cathedral pictures", and they might well select the ones that Durand-Ruel liked best. In a retaliatory gesture, the exhibition for which Durand-Ruel had already reserved the gallery was postponed to the following year. Then, fearing that he had thrown away a means of pressurising Durand-Ruel, he changed his mind and suggested that October or November were possible dates. At the same time, he announced a major concession: the paintings deemed most significant would be provisionally excluded from the negotations, allowing the others to be sold at higher prices.

Paul Durand-Ruel, unaffected by this last offer, was determined to make matters clear. Monet's paintings were selling badly when they were marked up from the excessively high purchase prices that he was asking. Several collectors had decided to make the most of the added value of their Monets by selling them, and when he could not prevent this, Durand-Ruel was forced to "push [prices] up [himself] or see them fall". "The most enthusiastic buyer..., Potter Palmer", had sold several works and was thinking of selling others. In conclusion: "Don't listen to the platonic admirers who never buy; trust to the experience of a true friend like myself, who has always espoused your cause with conviction and impartiality."

One of the most representative of the "platonic admirers" was Gustave Geffroy, who had just published the third series of *La Vie Artistique*, which he dedicated to Claude Monet. This series began with a *Histoire de l'Impressionisme*, in

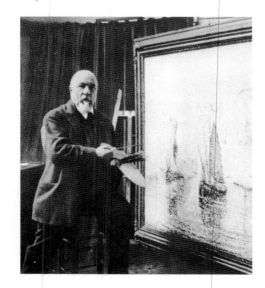

Paul Signac with his painting
The Port of La Rochelle
c. 1900

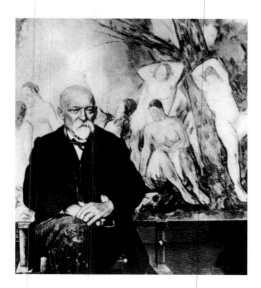

Paul Cézanne in his studio at Aix, in front of his *Grandes Baigneuses*
1904
Photograph Emile Bernard

which the chapter on Monet was by far the longest. In Gustave Geffroy's hands, the work of informing the public was beginning to resemble a publicity campaign.

Stéphane Mallarmé at home in the Rue de Rome
c. 1900
Photograph Agraci

Camondo, Signac and Cézanne

Paul Durand-Ruel's characteristically firm, measured tone convinced Monet to accept the position set out on 23 May 1894. He was about to find out that even his most enthusiastic supporters were losing their enthusiasm when faced with his demands; with the exception of François Depaux, "everyone's afraid of my prices", he confessed to Maurice Joyant. He now concentrated his efforts on Valadon and on Joyant, who had begun to work as an independent dealer late in the previous year. Valadon, seconded by Glaenzer, who managed his New York gallery, sent a collector to Giverny; Joyant, in partnership with Manzi, had, in the person of Isaac Camondo, a serious client. Monet's tactic was to play one camp off against the other, and persuade each that, if there were no immediate decision to buy, the pictures in which they were interested – almost always four at a time – would be sold to their rivals. When he added that he was

View of the village of Sandviken, now known as Sandvika
Photograph taken in 1883, courtesy of the Sanvika Bok-og Papirhandel

ABOVE:
Sandviken Village in the Snow
1895
Cat. no. 1397

not in the least seeking "to put pressure on them", there was little danger of his being taken at his word.

Camondo visited Giverny in early September with Joyant and his partner; he bought four paintings from the Cathedral series, which Monet arranged to deliver when he had put the finishing touches to them. The purchase once concluded, Manzi, carried away by Latin enthusiasm and the prospect of a healthy commission, exclaimed: "Count, thank you in the name of France!" This very Mediterranean-style grandiloquence overjoyed Fénéon, to whom we are indebted for the anecdote.

Camondo's purchase not having reached the prices originally asked by Monet, Joyant was advised to keep the affair quiet, so that the naive could continue to believe that the minimum price was 15,000 francs. Valadon was not taken in. Having reached an agreement with Durand-Ruel and Montaignac, he went to Giverny and offered a price well below 15,000 francs. Monet immediately wrote to Durand-Ruel, speaking of "compulsion" and "syndicates". In his father's absence, Joseph Durand-Ruel replied by return of post: Monet should not be angered by the courtesy agreement that had always prevailed between the three galleries relative to purchases of Monet's work. Though the firm of Durand-Ruel might perhaps take no further interest in the Cathedral series, it

was still interested in his other works; but it could not suddenly raise its prices until "the considerable stock of your paintings currently on the market had been partly liquidated". On the following morning, 12 September, Monet agreed "to let the "Cathedrals" go at the price of 12,000 francs, instead of 15". This was not a large enough concession, it seems. When Paul and Joseph Durand-Ruel left for the United States on 6 October, nothing had been settled, and Georges, who remained in France, was left with a difficult situation.

While keeping these delicate negotiations going, Monet spent his afternoons working out of doors. While he strode around the Giverny landscape carrying canvases in sizes of 81 x 60 cm up to 100 x 81 cm, Paul Signac at Saint-Tropez was confiding to his journal that painting an entire 25 canvas (81 x 60 cm) had been a waste of time. "Let's leave that to the 'Impressionists', who, for that matter, have done some marvellous ones... To think that these painters, because they have condemned themselves to working exclusively from nature, imagine that they are 'naturalists'. No, Monsieur Monet, you are not a naturalist... Bastien-Lepage is much closer to nature than you! Trees in nature are not blue, people are not violet... and your great merit is precisely to have painted them thus, as you felt them to be, out of your love of beautiful colours, and not as they are..."

In Signac, we recognise an artist who, while he judges the Impressionists from an intellectual standpoint, is a direct descendant of Monet and considers him a master. Other painters in the Impressionist tradition, as we know, owed much more to Cézanne. Geffroy was perceptive enough to note this as early as 1894: "There is a direct relationship, a clearly established continuity, between the painting of Cézanne and that of Gauguin, Emile Bernard and so on. As well as with the art of Vincent van Gogh." The article in *Le Journal* in which these lines appeared was intended to restore to Paul Cézanne "the place which is rightfully his"; it seems to have been inspired by the flattering though still modest prices attained by Cézanne's works at the Duret sale. Knowing how close Geffroy was to Monet, Cézanne attributed the journalist's interest to the influence of the painter. The gratitude that he felt bound to express led him to sacrifice his isolation and spend a part of the autumn at Giverny. The Hôtel Baudy, not far from the church, received this inaccessible guest.

Sandviken near Christiania

The year 1894 ended with an event, the seriousness of which was not to emerge until some years later, the court martial on 22 December of Captain Alfred Dreyfus. Those other than family and friends who were later to campaign for a retrial were quite unable to predict the role that they would soon find themselves playing. Clemenceau, for example, was astonished by the leniency of the judges, which Jaurès attributed to government intrigue. Only Emile Zola felt that reflection was in order. When Léon Daudet wrote to him, recounting the scene of Dreyfus' degradation and the insults shouted by those who had witnessed it, Zola declared: "Under no circumstances should one appeal to the mob. I heartily reject the ferocity of mobs stirred up against a single man. Were he guilty a hundred times over!"

In artistic circles, there were no signs of disaffection with the verdict yet; people felt passionately about the Caillebotte legacy and were preparing a banquet to celebrate Puvis de Chavannes' 70th birthday. Claude Monet was a member of the organising committee, over which Auguste Rodin presided. On 16 January, when the speeches were being made, Catulle Mendès raised cheers

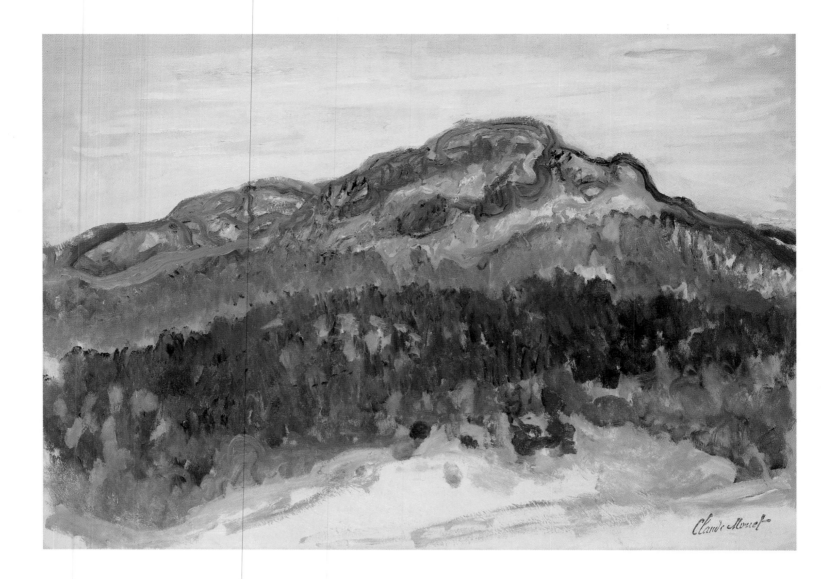

Mount Kolsaas, Norway
Photograph taken in 1890, courtesy of the San-
vika Bok-og Papirhandel

by praising Baudelaire, whose posthumous reputation Brunetière had recently attacked. After the dinner, Signac met Geffroy, Lecomte, Monet, Renoir and Bergerat at the Bodega café, and noted that night in his journal: "Monet is leaving for Norway."

Monet's decision to go to Norway is sometimes put down to the influence of Fritz Thaulow, a native of Christiania (now known as Oslo) present at the Puvis de Chavannes dinner. But Monet was not the sort of man to decide on a voyage on the impulse of a chance remark at a banquet, however convivial, and the presence in Norway of Jacques Hoschedé, Alice's eldest son, is quite sufficient explanation in any case. Monet had several times complained over the previous few years of the speed with which snow and ice had come and gone at Giverny, and could not have known that, at the end of January 1895, France and the rest of Europe were to experience one of the coldest months of the century, with the Seine frozen just outside his door as it had been in the coldest days of the winter of 1879–1880.

On 21 January, Monet informed Durand-Ruel that he was going to Norway on the 28th. Rather than go by steamer from Le Havre to Christiania, he took the express train across the snowbound north of Europe, from Paris to Kiel via Cologne, whence he sent a telegram to Alice, and Altona, near Hamburg, whence he wrote to her. At Kiel, he took the Danish ferry by night to Korsør in Zeeland; the crossing should have taken five hours, but the ice-floes and two blizzards meant that it took nine in fact. His connection had already

left, so that he was twelve hours late when, on the afternoon of 31 January, he reached Helsingør, on the further tip of Zeeland, from which he could see the Swedish coast. Taking the time only to write to his wife again, Monet took a further ferry that crossed the Oresund without incident, and left him in Helsingborg in Sweden. After a few hours' rest, partly given up to writing a further letter, he left that evening by the 11 o'clock train, which was due to arrive at Christiania twenty-two hours later.

This last leg of the journey was too much for him, and despite the beauty of the landscape when the sun came up, by the time Monet reached Christiania, late on 1 February, he was overcome with fatigue. His arrival had been announced in an article by Andreas Aubert in the *Dagbladet*, "Claude Monet kommer", and the artists of Norway had attempted to find out exactly when he would be arriving in order to arrange a triumphal reception. But Jacques Hoschedé knew his stepfather well enough to avert this ceremony, and took him "incognito" to a modest hotel where he had reserved a room.

For the next few days, Monet, guided by his stepson, moved around the Christiania region in search of subject-matter sometimes by rail, sometimes by sleigh. He did not dare to try skiing, but the cold made little impression on him. Indoors and on trains, he complained of the heat. In the sleigh, wrapped in bearskins, his face covered in ice and his eyelashes in frost, he astonished the Norwegians with his stamina and endurance. An anonymous article in *Dagbladet* was full of praise for this "sturdy, elegant little Frenchman", who, in his sturdiness, contradicted the standard Northern image of Frenchmen as slim and elegant. Though flattered by the admiration of his Norwegian colleagues, he began to find their repeated and sometimes indiscreet visits burdensome. It had

Mount Kolsaas in Misty Weather
1895
Cat. no. 1411

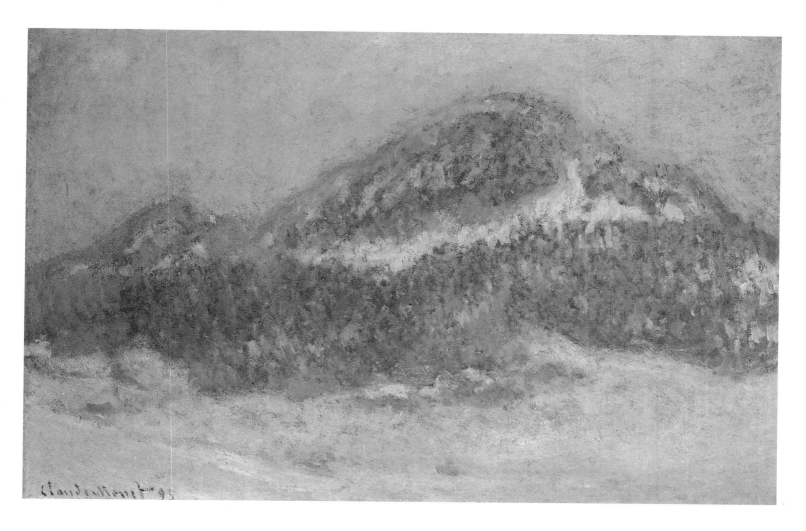

never taken him so long to set to work. Towards the middle of February, he even spoke of giving up altogether in the face of the mainly physical difficulties that he encountered. And then there was the fact that Christiania was a big town with its 160,000 inhabitants and its two electric tramways that had been opened just over a year ago; Monet needed to find somewhere to stay that was closer to the places that he might want to paint. "A very beautiful place" which fulfilled these requirements was finally discovered, on the advice of the painter Otto Valstad, during a long walk with Jacques.

The well-known path on which they walked was some fifteen miles south-west of Christiania and led to Sandviken (also known as Sandvika), which lay on the fjord of the same name. There, in a little village called Bjørnegaard, there was a sort of artists' farm – a few houses almost buried in the snow (1393) – about one kilometre from the centre of the village. The hostess at the farm was Jenny, the first wife of the famous Norwegian dramatist Bjørnson; she allocated Monet right next to the common room of the house, where noisy conversations ensued day and night. In the dining-room, meals were taken around the table with the other guests, who included several Norwegian artists and the Danish writer, Herman Bang. Bang spoke French, and though their first introduction gave rise to excessive compliments on both sides, his diary recollections of Monet, comfortably established "in a corner of the sofa, ...smoking his pipe like a peasant" for the most part ring true: "What is there to say about me? What can there be to say, I ask you, about a man interested in nothing in the world but his painting – and his garden and flowers." Or again: "Now, I can get no rest, colours haunt me like an obsession. I even dream about them." Other diary entries are reminiscent of words spoken or written elsewhere, though they may be authentic nevertheless: "I want to paint the air around the bridge, the house and the boat. The beauty of the air where they are, and it is nothing short of impossible. Oh, if I could only be content with the possible!"

As if in Japan

On 18 February 1895, Monet had still not begun to paint. He put this down to the mist and snow which had stopped him "seeing things properly" and to Jacques Hoschedé, who had failed to show him things. Three days later, a letter to Alice for the first time states that painting has begun, though with many false starts and hesitations. Monet was increasingly anxious at the sight of "so many beautiful things that are impossible to do" and he was so discouraged that he was thinking of returning home. Finally, on Sunday, 24 February everything was prepared for a good start to the week: the canvases were prepared, and painting-sites appropriate to different times of day chosen. Unusual precautions were necessary to allow Monet to reach his motifs: "armed with shovels", Monet and Jacques had "cut paths in the snow", an activity for which Jacques showed great talent. To move around on the surface of the frozen fjords, they used "paths... worn by the sleighs", though here too a shovel came in handy.

"I am in the best of health, despite the horrid food"; thus Monet to Geffroy on 26 February. This sounds too much like the traditional French traveller stigmatised by Montaigne for us to take it very seriously, especially since it is contradicted by what Monet wrote to Alice the very next day. The information he vouchsafes on artistic matters is of greater interest. He was now working on eight paintings, and, as he began to set down the image of this "wonderful country", Monet was forced to confess that the Christiania region was "less terrible" than he had expected; the Far North was far away, and once again the

Katsushita Hokusai
Shower at the Foot of Mount Fuji
from "Thirty-six views of Mount Fuji"
1831–1834

Katsushita Hokusai
The South Wind Chases away the Clouds
from "Thirty-six views of Mount Fuji"
1831–1834

PAGE 305:
Mount Kolsaas (detail)
1895
Cat. no. 1408

Floes at Bennecourt
1893
Cat. no. 1334

tourist's pleasure had taken second place to the labours of painting. This labour was going well enough, despite the changing weather, which meant that further canvases had to be started. He was, in short, using the series method, with the advantage of never idly waiting for the right weather, and the disadvantage that more and more paintings were started though none were deemed "possible" without a second session.

A letter to Blanche Hoschedé makes it possible to specify the three motifs on which Monet was working on 1 March. First and foremost, the fjord at some half an hour's sleigh-ride from Bjørnegaard, close to the edge of the ice-floe, with "little islands almost level with the water" (1400–1403). Then there was a corner of Sandviken "which resembles a Japanese village", and which inspired the Løkke bridge series (1397–1399). Then there was the Kolsaas mountain which reminded Monet of Fujiyama (1406–1418). Over the next few days, Monet's mood fluctuated as he undertook a race against time; the longer days meant that a thaw could be expected soon. For the time being, the snow remained, and new falls were expected. While Monet painted, his "beard covered in icicles", Jacques, nearby, worked on his Norwegian grammar in a little igloo built for the purpose. But now came news that traffic was forbidden to use the ice on the fjord. As the distance between the farm and the subject was too great to be covered on foot, the fjord-side paintings must all have been done before the ban, which Monet mentioned to Alice on 12 March.

At this stage, Monet's timetable was as follows: he rose at 6.30 am, worked from 8.00 to 1.30, and lunched at two. He then returned to the task until seven in the evening. His verdict on the paintings that he had done by 15 March is significant: "they will be neither impressions nor very finished paintings." Meanwhile, the combined efforts of the thaw and the local population had removed all snow from the roofs, causing Monet to abandon a "fine motif" and

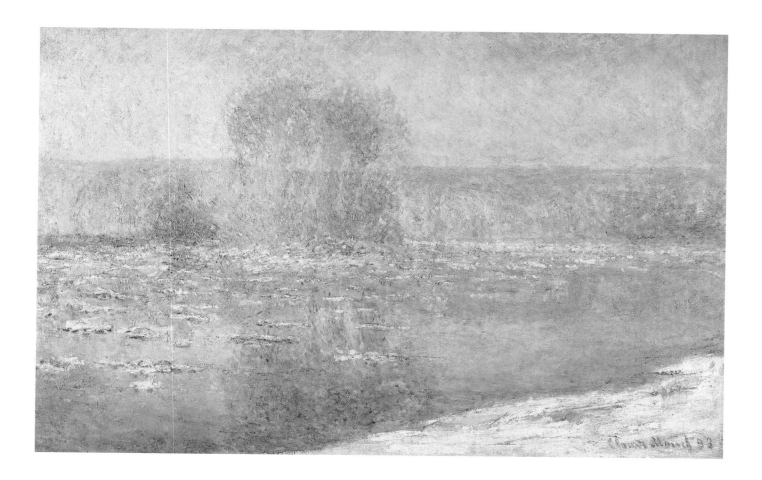

the three canvases thereof. This was in all probability the little series of *Blue Houses* (1394–1396). With Mount Kolsaas, the opposite occurred, and a new cold spell allowed him to paint twelve versions, and even a thirteenth, to judge by the paintings catalogued (1406–1418).

The rest is mostly social events. There was a party in honour of a young assistant of Mme Bjørnson's, during which there were many toasts and a positive "frenzy" of waltzing. A visit to Christiania included a tour of the spring exhibition, in which Monet had refused to participate. The members of the commitee were in full evening dress and pumps. Monet moved past the pictures without a word. When they left, Bang was concerned that Monet's silence might give offence, and Monet apparently replied: "My dear Bang! What do you expect me to say about all those colours?"

Now it seemed that the thaw was definitely setting in, and Bjørnson had decided to sell his house; the little colony of artists was dispersed. It had, in any case, been a less friendly place of late, as Monet had been judged altogether too unsociable. On 26 March, he returned to Christiania and took a room at the Grand Hôtel. The following morning, he was given a tour of the fjord by the harbour master in a small icebreaker, and returned almost speechless with admiration. He spent three successive evenings at the theatre, which gave rise to a brief but pertinent note on the performance of the plays of Ibsen and Bjørnson, reminding us of Monet's interest in literature.

On Friday, 29 March came a long-expected visit, that of Prince Eugene of Sweden, accompanied by his aide-de-camp and a group of painters, who were brought to see Monet by Thaulow, if we are to believe the Prince's subsequent account of his visit. But it seems as though some royal liberties have been taken with the truth. Prince Eugene claims, for example, that Monet showed him a selection of works painted prior to his Norwegian trip, amongst which was "one

of the now almost legendary series of Rouen Cathedrals". The Prince's considerable suite flowed through Monet's room, all of them expressing – conviction or convention? – their admiration. "They are really not very demanding", Monet noted; he was "touched by their words, which seemed so sincere". The words were badly at odds with Fritz Thaulow's later verdict: "Monet's Norway is the purest nonsense. We are all agreed on that."

One who did not agree was the columnist who wrote a very sympathetic article for *Dagbladet*. There we find a homage to Monet's vigorous creative energy and his precise sense of colour. The article also shows a detailed knowledge of the series system and Monet's habit of allowing only half an hour for any one effect. It quotes him as saying: "The motif is secondary for me; what I want to paint is what there is between the motif and me."

Monet read these lines in French translation shortly after his return to Giverny. He set off for France on Monday 1 April at 11 pm, accompanied to the Ostbanegaard by his stepson and a group of artists whose festive presence was this time deemed appropriate. The return journey was very similar to the outward leg – interminable. On arrival at Giverny, before resting, Monet sent Durand-Ruel a short note about his next exhibition, with the post-script: "I am not too unhappy with the things I've brought back."

"Cathedral Revolution"

Almost from the moment of his return, Monet worked furiously to prepare the Exhibition of Pictures by Claude Monet which opened on Friday, 10 May 1895 in the Durand-Ruel galleries at 16 Rue Laffitte and 11 Rue Le Peletier. Invitations made in Monet's name were widely distributed. The catalogue, at 40 items, recorded most of his production of the last three years. Three groups are defined by title: *Rouen Cathedral* (nos. 1–20), *Panoramic View of Vernon* (nos. 21–28), *The Surroundings of Christiania* (nos. 29–36). The fourth group (nos. 37–49) had no title and comprised an anthology of paintings, two of which dated from before 1890 and were intended to reassure the less adventurous viewer.

Monet's recent production gained mixed reviews from other painters. Gérôme, the most combative of the academic generation, gave interviews in which he "called down curses on Monet, the Impressionists, and anyone at all who admired a work like the 'Cathedrals'." In the opposing camp, Eugène Boudin, Monet's teacher at Honfleur and Sainte-Adresse, recommended the exhibition to Bracquaval as "interesting to see", but found the Cathedrals "very strange", with "something very recherché about them, at the extreme limits of impasto." Pissarro, by contrast, declared himself "really excited by this extraordinary mastery". Cézanne met Pissarro at Durand-Ruel's on 25 May, and shared his enthusiasm: "It is the work of a determined man, carefully thought out, trying for the most subtle and elusive effects", – a kind of experiment that some artists considered unnecessary. As to the young artists, Pissarro describes them as being openly hostile.

Insofar as we can claim to know, the post-Impressionist generation were also of mixed opinions about the show. Théo van Rysselberghe was "taken with the technique" of the Cathedrals, and decided they were "Monet down to the ground, with his good and bad qualities, both of them greater than ever – take him or leave him." Cross inclined to leave him, speaking of "elaborated centrepieces", as did Luce, who judged that "the painterly qualities don't make up for the lack of composition." Signac, to whom these verdicts were announced, was

away from Paris, but seemed happy to accept them, especially the last: "That's obviously the problem." Then, noting that Georges Lecomte was not greatly impressed either, he corrected himself: "I can see what these Cathedrals are: wonderfully executed walls."

In the press, the predominance of favourable judgements was much more pronounced than in artistic circles. But nothing else seems to have produced so great or so immediate an effect on Monet as the "admirable article" by Clemenceau, whose five columns spread across the front page of *La Justice* on 20 May. Clemenceau's newspaper had never had a very large circulation and, since the Panama Affair, had been close to insolvency. Discredited and indebted, Clemenceau had temporarily moved out of political life and was concentrating on his newspaper. It was there that he turned his attention towards writers and artists, Carrière, Raffaëlli, Rodin, and, above all, Monet. Geffroy had led Clemenceau into this new world, but now found himself superseded; the result was the astonishing article "Révolution de Cathédrales", which allowed the anti-clerical Clemenceau to sound almost like a mystic. Clemenceau's cyclical vision of the Cathedrals anticipated the great "Decorations with Nymphs" in the Orangerie. And when he appealed to Président Félix Faure, his "sovereign for the day", to "endow France with these twenty paintings" and "tie his claims to posterity" onto the "shirt-tails of Claude Monet, the peasant of Vernon", we hear not only the irony but the expression of an ambition that he would later fulfil on his own behalf, a peacetime triumph to be placed alongside the victories that he would win in the embattled France of 1914–1918.

Monet and the Environment

The year 1895 was looking forward to 1900, when the Exposition Universelle was expected to astonish the world. One of the first decisions made to this end was the demolition of the Palais de l'Industrie, the old fiefdom of the "Artistes Français". None of its members were destined for such posthumous fame as Camille Corot, whose centenary was celebrated as a farewell to the 19th century. Meanwhile, the unveiling of *The Burghers of Calais* in the town that they cele-

brated marked the triumph of modern sculpture. The telephone became part of everyday life, lifts were installed in blocks of flats, and bicycles and motor vehicles made their appearance in the streets. It is as if history had undergone a sudden acceleration in its march towards the unknown future, though jerkily like the shaky cinematographic images that the Lumière brothers brought to the public in that same year.

And the dangers to the environment inherent in progress came to the fore. In the spring came the scandal of the Bois de Boulogne trees cut down at the request of the officials of the Cercle des Patineurs (Skaters' Circle); there were protests, explanations, duels and recantations. The extremes of feeling whipped up by the incident testified to the new sensitivity of public opinion. The newspapers devoted long articles to the affair, showing how far things had already gone. Thus *Le Petit Parisien* lamented the disappearance of a handsome elm tree on the Boulevards: the authorities had found it difficult to install a gaslamp near the tree. Unwilling to move the lamp, they had the tree cut down, and had to remove the gaslamp in order to do so!

The polemic which filled the pages of the newspapers is not, perhaps, unconnected with Monet's reaction when he heard that the Giverny village marshland was to be sold to allow a factory to be built. Offered 900 francs at three percent annual income, the council had approved the transaction on 14 April 1895. The law required that a public inquiry take place before public property be sold off, but this was dispatched so hastily that Monet, who was away from Giverny, did not have time to see that his objections were entered. Immediately upon his return he made his feelings known, and communicated his implacable opposition to the Prefect of the Eure: "I can assure you, for my part,

At Val Saint-Nicolas near Dieppe in the Morning
1897
Cat. no. 1466

that if this plan is carried through, I have decided to leave [Giverny] at once, as it will be the ruin of the village."

On 26 May, the municipal council held an extraordinary meeting and the conclusions of the investigating commissioner, who favoured the sale, were upheld. The objections were rejected, including Monet's, which were considered "personal" and "contrary to the prosperity of agriculture and the well-being of the village". Unabashed, Monet set out his position for the benefit of the Sous-Préfet, who had come from Les Andelys specially for the meeting; Monet expanded on this in three letters written during the first fortnight of June, in which he denounced the intrigues of those who supported the sale and the building of a starch factory and pointed out that he was not alone in his opposition, as he had the support of some of the municipal councillors. It was, he asserted, a cause for which he was willing to make sacrifices. At the same time, Octave Mirbeau made use of his own connections and even thought of asking Poincaré to request the Minister of the Interior, Georges Leygues, to order the Prefect of the Eure (to whom he had also written) to stay the proceedings.

After spending a little over a week in Argelès-de-Bigorre and Salies-de-Béarn in the Pyrenees with Alice and Suzanne Butler-Hoschedé, whose health was causing intense concern at this time, Monet returned to Giverny on 24 June. Learning that the prospective purchaser, M. Rayer, had increased his offer from 900 to 1,000 francs annually, he wrote to the mayor, M. Durdant, to inform him that he was willing to make the commune a gift of 5,000 francs "with no other conditions than that it should desist from sale of the publicly owned marshland." A second copy of his letter was sent to the Prefect. On 29 August, an extraordinary meeting of the municipal council gave rise to lively

On the Cliff near Dieppe, Overcast Skies
1897
Cat. no. 1467

FROM LEFT TO RIGHT:
On the Cliff at Le Petit Ailly
1896
Cat. no. 1428

The Pointe du Petit Ailly in Grey Weather
1897
Cat. no. 1447

debate. The Mayor supported M. Rayer's offer, but was repudiated by his councillors, who voted for Monet's conservationist proposal; this had, in the interim, risen to 5,500 francs for "the improvement of the marshland", which would then remain the inalienable property of the commune for the next fifteen years. The affair was not conclusively decided until the meeting of 22 November, and the 5,500 francs was finally accepted on 9 February 1896. Three months later, Albert Collignon was elected Mayor of Giverny by ten votes out of ten. He was a loyal admirer of Monet, and never missed an opportunity to celebrate the munificence of the artist nor the advantage that his gift represented for the village, which now possessed a small capital sum and administered it wisely.

Monet here appears in a new light, as the defender of Giverny, which has come down to us more or less unchanged not least because of Monet's efforts in 1895. Was Claude Monet an ecologist ahead of his time? He certainly seems so, in the portrait that Frantz Jourdain presents in his *The Decorated* of 1895: "If you do not feel a raging passion for nature, do not dare to confess your weakness in his presence, or he will send you his two seconds, Octave Mirbeau and Gustave Geffroy, to demand an apology or a duel."

Returns and Repetitions

Relations with Durand-Ruel were briefly inflamed in late November 1895, Monet having heard rumours to the effect that Durand-Ruel had prevented the sale of the Cathedral series in a joint operation with other dealers. Paul Durand-Ruel's dignified refutation is best read in full; Monet accepted it and his trust was restored. During November, the Cézanne exhibition at Ambroise Vollard, though it did not enjoy the success of Monet's then recent exhibition, made a considerable impression in artistic circles; everyone was curious to work out exactly what it was that made Cézanne's work so profoundly original.

The time had now come for the Batignolles group to close ranks. First there had been the death of Caillebotte, whose legacy continued to pose problems for the authorities. Then the group was deeply affected by the death of Berthe Morisot on 2 March 1895. When the news had reached Monet at Sandviken, he had been deeply depressed by it, and had given unusually frank expression to his grief in letters to Alice and Durand-Ruel. So when the question arose, in early 1896, of a Berthe Morisot exhibition at Durand-Ruel's, Monet helped to

organise it alongside Degas, Renoir, and Stéphane Mallarmé, who wrote the preface to the catalogue.

Melancholy thoughts about "precious friends hid in death's dateless night" inspired in Monet the desire to return to places where he had worked in the past. This was an ambitious plan, and he was quite unable to complete it; the first staging-post was Pourville, near Dieppe, where he had spent several months in 1882 and to which he returned in mid-February, 1896.

Things in the little Normandy seaside resort were not what they had been when Paul Graff and his wife, now dead, ran the casino-hotel. The sea and the cliffs were fortunately unchanged, as were Monet's reactions. He felt an almost juvenile enthusiasm at the beauty of the views and thought "a month's practice" would be required before he could capture them. That he should have hesitated so long in choosing his subjects before setting paint on canvas might seem surprising, given that he knew the landscape well. But the "extreme timidity" that he confessed to Alice must certainly have been aggravated by his working methods; since the sites chosen must each serve for a whole series of studies, they had to be very carefully selected.

The demands imposed by "series" before work could start were a source of delays, but they had a compensating feature, in that they limited the walking to be done. This was important now that Monet was beginning to feel the accumulated effect of thirty years of working out of doors in all weathers. Indeed, though he still made forced marches, sometimes more than one on the same day, and though he sometimes remained outside in the rain for two hours at a time, we cannot help but feel that his physical stamina, though still considerable, was no longer what it had been. This is clear, not merely from the smaller perimeter within which he worked – he no longer thought of going beyond the Petit Ailly gorge (**1427**) or as far as the Varengeville church (**725–728**) – but from the care he took not to expose himself to the elements unnecessarily. He sought out "motifs sheltered from the wind", he made use of a beach-hut, he improvised an awning, and he gave up one study after an hour because, in mid-March, "a glacial east wind" was blowing along the cliff – though his concern in some of these cases was simply to protect the canvases and easel.

Painting series meant that he was moving around less, and there was a spectacular reduction in the number of his subjects. The diversity that was still a strong feature of his 1892 campaign now gave way to a great uniformity of motifs, several of which were attempted at the very first session. The most

important series was painted on the beach looking west (1421–1426). Two others were started from the top of the cliff east of Pourville, at a place called Côte aux Hérons looking towards Dieppe and the Bay of the Somme (1430–1434). Finally, at the end of his stay, there appears a "little house" – the former customs cottage Petit Ailly (1427–1429) – which Monet firmly intended to make use of again in a year's time.

For Monet, the 1896 "campaign" proved unsatisfactory. Delayed by his initial hesitations, troubled by the wind and rain, and, towards the end of his stay, by the greening of the leaves on the cliffs (he preferred leaves of an autumnal yellow), he had to leave too much unfinished. The decision to return to Pourville, which he made around mid-March, allowed him to bear a further spell of bad weather without excessive impatience, and he returned to Giverny for the first few days of April, hoping that his experience could be put to good use the following winter.

"So all of them are Manets, all Monets, all Pissarros"

Just as 1895 had been an eventful year, 1896 was a calm one. Méline's premiership began in 1896 and lasted into 1898, something of an achievement under the Third Republic. For Monet, it was a year in which everything conspired to strengthen his position without his having to lift a finger. The May elections in Giverny produced a Mayor and Deputy Mayor entirely won over to the cause of "Monsieur Monet", now an influential local dignatary whose favour was worth courting. The sum of 5,500 which he had promised to pay to the collector of taxes for the conservation of the marshland was neatly compensated by the return of the remainder of his loan to Pissarro in the amount of 5,000 francs.

Pissarro had heard from Raffaëlli about the vogue for Monet in the United States. So great was the enthusiasm there that a woman had been heard to say: "Monet is so great that all painters should do Monets." Absurd as this seemed, Raffaëlli stated that it was "exactly" what was happening in the United States. At the same time, in France, Emile Zola wrote a stinging indictment of the Impressionists' feeble imitators; his article in *Le Figaro* expressly named Monet and one or two of his colleagues. Zola had just visited the Champs de Mars and Champs-Elysées Salons: "First of all, what strikes me is the predominance of brighter tones. So all of them are Manets, all Monets, all Pissarros now! ... Well, really, is this what I fought for? For this light-toned painting, for these patches of colour, these reflections, for this analysis of light? Lord! Was I out of my mind? It is ugly; it is repugnant!" True, the man most to blame is Puvis de Chavannes, that "very great and very pure artist"; whose following is "perhaps even more disastrous than that of Manet, Monet and Pissarro". For Zola, Manet's merit had been to "simplify procedures"; Monet and Pissarro had been the "first to make a delicious study of reflections and the decomposition of light". Let there be no mistake: despite these compliments, Zola still held to the thesis set out ten years before in *L'Œuvre* that there was no great artist of his generation, "no Ingres, no Delacroix, no Courbet". Even Cézanne remained, in Zola's eyes, an incomplete artist "whose partial genius people are only now beginning to discover".

For Monet, placed on a level with Pissarro in Zola's polemic, the settlement of the Caillebotte affair offered a small promotion. After a transaction approved by the Conseil d'Etat, the Curator of the Musée du Luxembourg had been authorised to select – with the help of the artists – the works to be exhibited

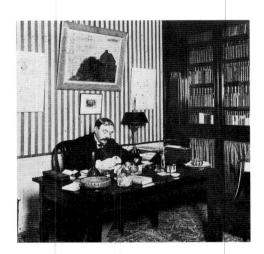

Octave Mirbeau in his office
Photograph B.N.F., Paris

The painter and sculptor Gérome in his studio
c. 1890
Photograph B.N.F., Paris

under the conditions specified by Caillebotte in his will. Of the forty works chosen, the eight Monets were the largest individual quota. In the order in which they appear in this catalogue and with their 1896 titles, they were: *Regatta at Argenteuil* (**233**), *The Luncheon* (**285**), *Apartment Interior* (**365**), *The Tuileries* (**403**), *Saint-Lazare Station* (**438**), *The Church at Vétheuil, Snow* (**506**), *Frost* (**555**) and *The Côte Sauvage* (**1100**).

The Musée du Luxembourg had been conquered without a shot being fired, the Louvre was within reach, the National Gallery in Berlin had bought a *View of Vétheuil* (**609**), and now new prospects were opening up in Sweden thanks to Prince Eugene. Monet thus took a firmer line on prices, asking Durand-Ruel for 12,000 francs for a painting of *Floating Ice* that he coveted. Monet's refusal to "do some more" if the winter were unsuitable rules out any notion of his making copies in the studio.

The same anxiety to do nothing away from nature characterised his summer and autumn "campaigns", but the weather was so "abominable" that the series of "Mornings on the Seine" (**1435–1437**) that Monet began on the Ile aux Orties had almost all to be finished the following year. It seems likely that the same held for the "Chrysanthemums" (**1495–1498**) on which Monet was working in November, 1896, all of which bear the date "97". The two "Floods" (**1438–1439**) that he painted in the meadow, its willows now bordering the lily-pond, were scant compensation for the torrents of rain that fell from September to November.

And while the inhabitants of Giverny looked out on a landscape of driving rain and wind and dreamed of the return of summer days, the health of Suzanne Hoschedé-Butler continued to give cause for concern; for Suzanne, the days of parasols (**1420**) were gone for ever.

The Henri Vever Sale

By early 1897, with invitations to exhibitions in Berlin, Brussels, Venice and Stockholm, Monet's career was assuming a distinctly international aspect. The certainty of his own success made him, if anything, more demanding of himself; he was further than ever from the temptations of the facile. This was clear when he returned to Pourville on 18 January, about a month later than in 1896. Like a general before a battle, he reviewed "all his motifs", from the "little house" or customs-hut in the Petit Ailly gorge in the west (1445–1458) to the Côte aux Hérons in the east (1459–1471). His living conditions were even worse than they had been the year before; his room was dirty and inadequately heated. The beach-hut that he had used the year before had been sold, and its replacement was too small to shelter Monet effectively from the wind, rain and snow. In early January, the ground was still so damp that the grass on the cliffs was greener than in 1895.

For the first few days, the wild seas were ignored; there was no question of doing any painting, he told Alice; he had brought a "veritable office" with him. He continued his negotiations with Durand-Ruel, whom he placed in competition with a mysterious collector, eventually revealed as the dealer Montaignac. At the same time, he was asking Durand-Ruel to be a witness in a case brought against Alice in relation to the affairs of the late Ernest Hoschedé. Paul Durand-Ruel was guaranteed exclusivity whenever it was time to perform some service for Monet, and behaved, as always, like the perfect gentleman he was. He supplied the documents requested, assured Monet of his unconditional support, and merely regretted that he had not yet had a definitive answer on the subject of the *Floating Ice*. That reply, which was almost certainly negative, had to wait for Monet's return to Paris for the trial. The verdict of the court case was delivered on 27 January 1897 and was in the Monet's favour.

A sumptuous illustrated catalogue was published and considerable press advertising booked before the Henry Vever sale took place at the Georges Petit gallery on 1 and 2 February 1897. On sale were some 200 modern paintings, and the prices were likely to determine the value of an artist's works. Nine Monet paintings were in the sale, and he was worried, but when the results of the sale were announced, his anxiety was turned to joy, though not all the prices were as high as the organisers had hoped. Thus two old pictures, *The Beach at Sainte-Adresse* (92) and *Banks of the Seine at Lavacourt* (495) and a more recent *Floes, Dusk Effect* (1344) had been evaluated at 12,000 francs for the first and 8,000 francs for the other two; they were sold at 9,000, 6,700 and 6,000 francs respectively. *La Chronique des Arts* noted that the *The Pond, Snow Effect* (350) painted at Argenteuil had been sold for 255 francs (250 in fact) at the Drouot sale of 1875; it now sold for 5,000 francs, which was a considerable profit. *Floating Ice at Bennecourt* (1336), valued at 12,500 (or 12,600) reached 12,000 francs, retrospectively justifying Monet's demands in his recent negotiations with Durand-Ruel. *The Church at Varengeville, Sunset* (726), was estimated at 10,000 and sold for 10,800; *View of the Church at Vernon* (843) was estimated at 12,000 francs, which it reached. Bidding for *The Pheasants* (549) started at 5,000 and reached 7,000 francs. But the greatest success by far was *The Road Bridge at Argenteuil* (312), which, at 21,500, exceeded its estimate by 6,500 francs.

Puvis de Chavannes narrowly exceeded Monet's top price with 22,500 francs for *Ludus pro patria*, but none of the Impressionists achieved anything like Monet's prices. It should be said that the pictures by which they were represented were not all of the highest quality. (To put these prices into perspective, a Corot reached 55,000 francs, a Daubigny 78,000 and a Meissonier 94,100.)

Monet therefore emerged from the sale with his position considerably strengthened, and sent a letter to Durand-Ruel rejoicing in the fact. In this, he showed some real or apparent naivety, since he knew that Durand-Ruel had been one of the main buyers. Georges Durand-Ruel replied on behalf of his absent father to say that the Gallery had bought four Monet pictures and pushed prices up on the others. Georges did not know who had bought *The Road Bridge at Argenteuil* (312), but on the same day the better-informed *La Chronique des Arts* published the name of the happy purchaser, M. de Curel, whose family long retained possession of this hotly-disputed work.

Léon Gérôme

Encouraged by the result of the Vever sale, Monet went to work with renewed energy. But after ten days of this regime, he felt a fatigue that he could not shake off, aggravated by shooting pains in his back and recurrent problems with

Arm of the Seine near Giverny at Sunrise
1897
Cat. no. 1479

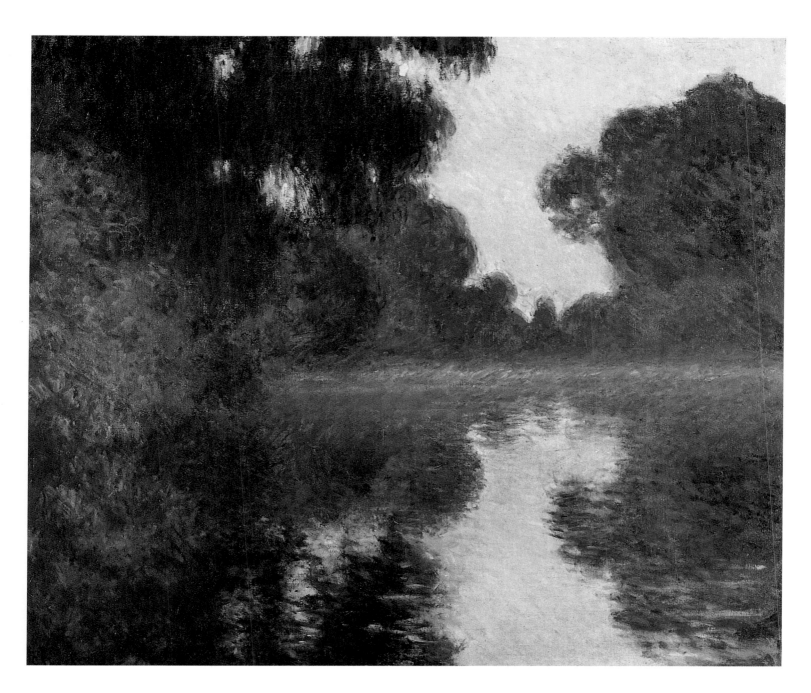

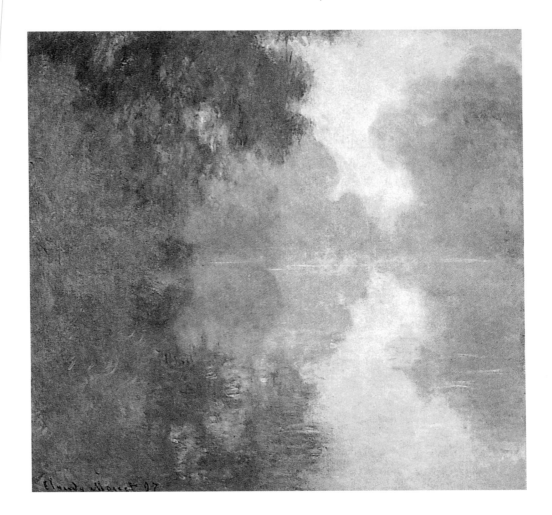

Arm of the Seine near Giverny in the Fog
1897
Cat. no. 1474

his digestion. As if this were not enough, the landscape was beginning to show the first signs of green, the dry grass was being burnt off and men were levelling down "the beautiful movements of the land". Even the sea was uncooperative, refusing to synchronise its tides with the effects that Monet sought.

There is something almost comical about these complaints. But behind them lie Monet's anguished doubts about his capacity to paint things quickly and well and the methodology of the series. When effects did not immediately reappear, should he start new canvases or transform the paintings that he had begun? In other words, how was he to choose between a proliferation of studies that he might never be able to finish, and an obstinate persistence with pictures that, when finished, might prove "bastardised, inaccurate things"? His increasing awareness of this dilemma as it manifested itself at Pourville in 1897 sounded the death-knell for outdoor work, at least in its pure form. The solution to the dilemma lay in the greater certainties afforded by the Giverny garden.

While Monet was reaching these conclusions, the Caillebotte collection was being presented to the public in an annex to the Musée du Luxembourg, restoring his glorious Argenteuil and Vétheuil years to the centre of public attention. Léonce Bénédite, the curator, was delighted to see the collection thus enriched, and declared: "this little artistic event... will be much remarked on." It was indeed. The Académie des Beaux-Arts sent a protest to the Ministry of Education, describing the Caillebotte legacy as "an insult to the dignity of our school". A veritable storm of protest followed. Though the protest letter was not an open one, the press got wind of it and a reporter from *L'Eclair* went round to interview one of the signatories of the "Four Arts", in all probability the painter Gérôme. He did not mince his words: "Whatever next! That the State

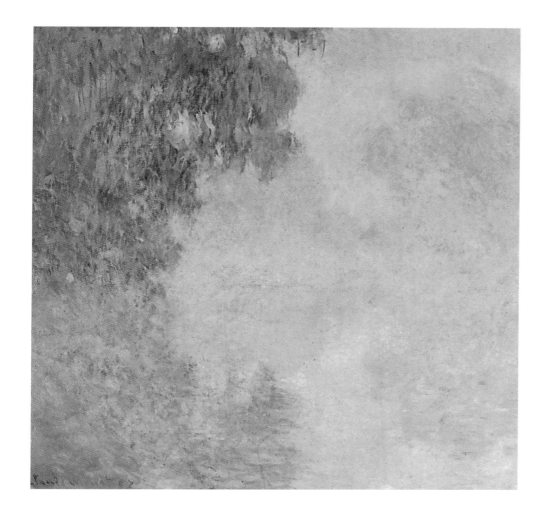

Arm of the Seine near Giverny in the Fog
1897
Cat. no. 1476

should protect filth of this kind! ... Nature is nothing to them, I can assure you! This Monsieur Monet, do you remember his Cathedrals? And to think that he could once paint! Yes, I have seen good things by that man, but now!"

Maurice Guillemot, an Inspired Reporter

In early 1897, Monet was confronted with two family problems, and both were resolved in ways he would not have wished. His brother Léon, who had been a widower since 1895, ignored Monet's objections and married a second time; the bride was 33 years old. And Jean Monet, inspired by his uncle's example – he was working for Léon at Déville – was talking of marrying Blanche Hoschedé. Claude attempted to reason with his eldest son: was it possible to feel carnal love for a young woman who had lived under the same roof as him since childhood? But Alice decided things in her own way, and the invitations were sent out on Thursday, 10 June. The choice of guests for the wedding breakfast was made according to the strictest bourgeois criteria. Pissarro was of insufficient standing and was crossed off the list. Monet apologised to his old friend, who was well aware that Monet was not always master of the Giverny household. The influence of the Raingo clan, to which Mme Monet flattered herself that she still belonged, was particularly obtrusive in the social domain, and poor Jean was forced to accept Georges Pagny as his first witness; Pagny was brother-in-law to Alice, who now became both mother-in-law and step-mother to Jean.

News of Blanche's marriage seems to have reached a Vétheuil creditor, who took this occasion to write to Alice and claim reimbursementof a debt con-

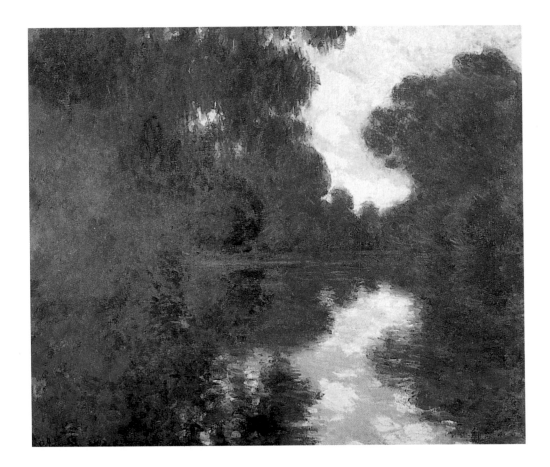

Morning on the Seine, Clear Weather
1897
Cat. no. 1480

ZOLA-MOUQUETTE
Le fondement de l'affaire Dreyfus

tracted by Ernest Hoschedé. The creditor was willing on this condition to return to Mme Monet family papers that Ernest Hoschedé had left as a surety. Alice refused to consider herself responsible for Ernest's debts, and made it clear that her marriage contract with Monet had precluded his being called upon to answer any claims made on her.

The considerable family pressure that he was under led Monet to cultivate his non-family connections, and in particular his friendship with Rodin. When the furore over Rodin's proposed *Victor Hugo* monument broke out, the meeting place that Monet suggested in solidarity was at the Champ de Mars Salon in front of the model of the monument displayed there. At Giverny, he was looking forward to Rodin's coming with Helleu and Mirbeau, and confirmed his invitation when Mirbeau was forced to drop out. Replying to a letter in which Monet had congratulated him on the publication of his drawings by Manzi and Joyant, Rodin went out of his way to express the "feeling of fraternity" that bound him to his "comrade-at-arms;" their love of art was "one and the same". Rodin included Geffroy and Mirbeau in these sentiments; they and Monet formed a group "for which he had great affection".

What weight should history give to the record of an artist's family or social relationships compared to the evidence offered by a well-informed journalist? We have already encountered Maurice Guillemot as the author of an article in *Le Figaro*. Now we find him sent by *La Revue Illustrée* to visit Monet at Giverny; it is dawn on a fine day in August 1897, and Monet is wearing "a picturesquely battered brown felt hat" and is, as ever, smoking, his cigarette "a dot of light shining in the depths of his great beard". It is half past three in the morning, and Monet, in fine form, invites Guillemot to accompany him on a painting expedition. He is no longer the man who wrote, before leaving Pourville in March: "If I don't manage to do something good, it's because I'm

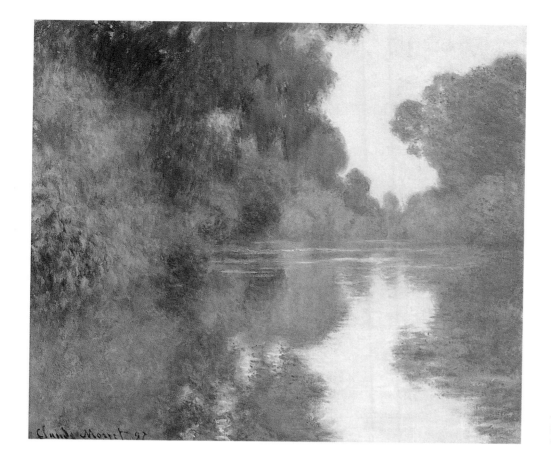

Arm of the Seine near Giverny
1897
Cat. no. 1481

really finished and done for."

The two men go down the central pathway of the garden, cross the road and railway, go round the lily-pond and cross the Ru, then make their way down to the Seine across the meadows still drenched in dew. When they reach the point where the Epte joins the Seine, Monet unties a boat moored amid the reeds of the Ile aux Orties and rows to the "big wherry" which he uses as his studio-boat. A garden-helper unpacks canvases, which are numbered and in packages of two. These are fourteen paintings all started at the same time and at a place at which Monet has now been working for a year – that is, since 1896: almost the entire series of the "Mornings" dated "97".

Driven from the river by the rising sun well before lunchtime, Monet and his visitor return to the village and take refuge in the cool shadows of Monet's studio. Or rather, "Salon", Guillemot corrects himself, knowing how offensive the word "studio" would be, since "the open-air painter paints only out of doors"; "museum" might be a better word, when he considers what can be seen there. And indeed, in this, Monet's first studio, the one which he had built on to the westernmost corner of the house, there is a veritable retrospective of his works hung in three rows on the walls, exactly as the photographs show it.

Here Monet shows his visitor the fourteen studies on which he is working, these "Mornings", which are the fruit of patient and endlessly repeated efforts: "I should like people to know how it's done." Monet knew that Guillemot would pass on this sentiment to his readers; he wanted the public to know that his "impressions" were generally the work of long hours, like the "impromptus composed at leisure" of which Molière speaks. This was a truth that Monet was happy to spread. About his indoor work, he was more discreet, and Guillemot knew that his concluding sentence – "Nature is his studio" – would stand him in good stead with the painter.

Lionel Royer
The Degradation
published in *Le Journal Illustré*
on 6 January 1895

PAGE 320 BELOW:
Anonymous
Zola-Mouquette
c. 1898
Paris, Musée Carnavalet

GIVERNY (Eure)
Pont près la Gare

Giverny, the bridge by the station
Postcard, 1900

Theodore Robinson
Bird's Eye View: Giverny, France
1889
New York, The Metropolitan Museum of Art

But should we refer to "nature" when we consider the form in which Monet now approached it? Guillemot revealed that the "still mirror" of the lilypond was now Monet's model for "a decoration, for which he has already begun some studies." These studies were "big panels", and they, in their turn, were shown to Guillemot in the studio. They were the first elements of a planned "circular room whose walls ... would be completely covered by the horizon of water and the dark patches of vegetation." What follows, the "transparent walls shaded sometimes green, sometimes mauve", the "still water reflecting the open blossoms" and the "indefinite, deliciously vague tones with their dreamlike delicacy," is a description of Monet's dream, a great decoration that he was to realise at the Orangerie thirty years later. It is proper to associate the name of Maurice Guillemot with the birth of this, one of the major works in the history of art; he was the first and lucid witness of Monet's extraordinary enterprise.

Zola's Admirable Courage

After the success of the Vever sale, the auction of the Paul Aubry collection in May 1897 was a considerable disappointment. The results of the sale would have been still less satisfactory without the intervention of Durand-Ruel, who bought four out of the five Monets in the catalogue himself. The prices went from the 8,000 francs attained by *The Guibel Rock, Port-Domois* (**1106**) to the 4,000 paid for *Pyramids at Port-Coton, Rough Sea* (**1084**). Monet accepted the warning constituted by the lower price, and it would be some time before he was again to ask Durand-Ruel for 15,000 francs as he had for a Cathedral or 12,000 as he had for the *Floating Ice*. He was not, on that account, any more forgiving in his relationship with his most loyal defender and client. When a statement of his account was sent without explanation showing him 75 francs in debt, he got on his high horse and sent them a draft for that amount made out to "MM. Durand-Ruel et fils", requesting an immediate acknowledgement. He received the acknowledgement, along with the information that the statement had been sent only to find out if he concurred with it. Monet probably showed himself equally touchy in his relations with the inhabitants of Giverny,

Giverny, the old mill on the Epte
Postcard, 1900

but those who had at first regarded him with suspicion as an outsider and an artist had begun to think him the glory of the village. They had been helped to do so by the mayor, Albert Collignon, who lost no opportunity to publicise the merits of this illustrious resident. When it proved necessary to provide the town hall and school building with a playground, Collignon informed the municipal council that the interest from the Monet donation and the subscription for the improvement and embellishment of the marshland would provide sufficient income for this. A few months later, noting that 162 francs of the interest on the said donation had not yet found a home, he allocated this sum to the provision of a savings bank book for every student attending the school. "Happy to perpetuate the memory of the generosity of M. Monet and thus bear witness to its gratitude, the council unanimously decided that this distribution would take place on 14 July." And thus the voluntary exile of 1870, the eternal debtor of Ville-d'Avray, Argenteuil and Vétheuil, became the official benefactor of his town in the the most popular fashion of the times: the distribution of prizes to the children of the republican, secular state-school system.

The local political life of his adopted Clochemerle did not have a monopoly over Monet's sense of civic duty at a time when the Dreyfus Affair was dividing opinion throughout France; though it had begun three years ago, it had recently taken on a whole new dimension thanks to Emile Zola's "great and good battle... the battle for truth". In a first article, which appeared in *Le Figaro* of 25 November, Zola defended Scheurer-Kestner, the Vice-President of the Senate, who had dared to make public his belief that Dreyfus was innocent. Then, when the anti-dreyfusards declared that those who favoured a retrial were a "syndicate" backed by major Jewish banking interests, Zola wrote a second article, proclaiming "Yes, there is a syndicate of men of good will, truth and equity... Yes indeed! I belong to this syndicate and I hope that all upright people in France will join it!" Two days later, Monet took up his pen to compliment his old friend: "Bravo and again bravo... You alone have said what was needed – and said it so well." One further article from Zola, a summary of the case to date, broke the camel's back; the editor of *Le Figaro*, de Rodays, was forced to exclude Zola from its pages because so many readers had cancelled

Giverny, the second studio and the greenhouse
seen from the Garden
Photograph G. Truffaut, 1924

PAGE 325:
Monet in his garden by the water-lily pond
with the Japanese bridge in the background
Photograph Bulloz, summer, 1905

their subscriptions in protest, and he himself was forced to resign shortly afterwards.

Unsatisfied with the effect of two brochures that he had circulated, Zola now wrote an open letter to Félix Faure, the President of the Republic, which he showed to the director of the newly-established *l'Aurore*. This was Ernest Vaughan, who had already assembled an impressive team of writers that included Bernard Lazare, Reinach, Mullem, Geffroy and Clemenceau; Clemenceau had recently been convinced of the innocence of Dreyfus by Mathieu Dreyfus (the victim's brother) and Scheurer-Kastner. Noting how often the expression was used in Zola's philippic, Clemenceau proposed the title *J'Accuse* which was immediately adopted. That was the evening of 12 January 1898. That night, 300,000 copies of *L'Aurore* were printed with the open letter occupying six columns of the front page. The following day, *J'Accuse* burst on to the political scene like a comet. On 14 January, Monet again wrote: "My dear Zola, bravo again and with all my heart for your gallantry and your courage." Monet went further: he signed the petition, known as the "Intellectuals' manifesto" that *L'Aurore* published daily. The 18 January number, in which the name Claude Monet appeared, also contained an article by Clemenceau reporting the many statements in support that Zola's article had elicited. Monet was cited alongside Duclaux, the Director of the Pasteur Institute, Anatole France, Eugène Carrière, – and Louise Michel, the survivor of the Commune, whose presence in the list was not greatly appreciated by some of the other signatories.

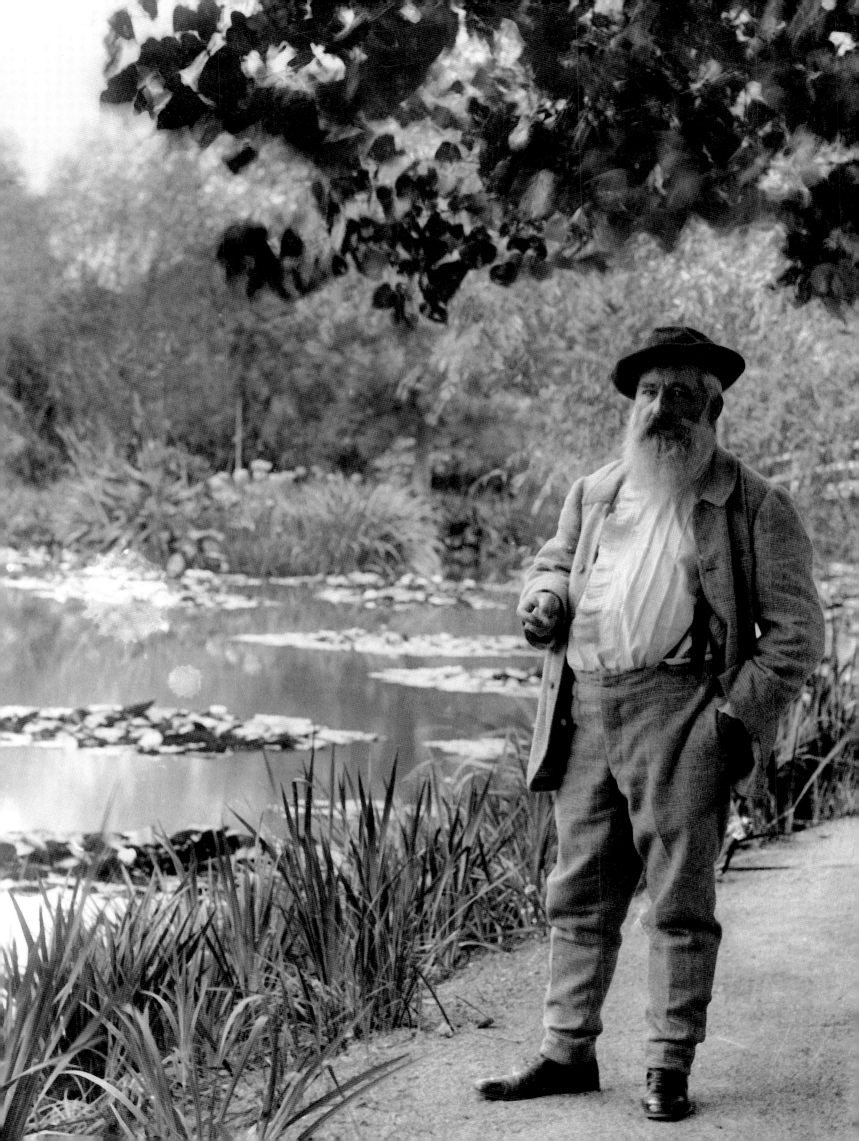

J'Accuse led Zola directly before the court of assizes Seine Department, where his "ignoble trial" opened on 7 February, followed "passionately from afar" by Monet. He followed it from afar because his health forbade him to go to Paris and lend Zola more direct support. Had he any real desire to go? It seems unlikely, when we consider the two successive letters in which he wrote of a future return to calm and order that would allow all honest, "sensible" people to do homage to Zola. When these idyllic visions were immediately contradicted by the vengeful clamour that greeted news of Zola's sentence, Monet nevertheless refused to take the least responsibility in an organisation intended to bring together those who favoured a retrial: "As to taking part in some committee or other, that's not my business."

Monet's refusal to commit himself any further, however much it contrasts with his previous statements, will come as no surprise to those who know him well. He was capable of impulsive generosity and monumental bad temper, but he remained what he had shown himself during the deliberations of the *Société anonyme coopérative des artistes*, a man who preferred compromise and balance to extreme solutions, in short, a conciliator or moderate who deliberately left it to others to adopt heroic attitudes.

The central pathway with flower arches leading towards the house
c. 1926
Photograph Nicholas Murray
New York, Museum of Modern Art

Boredom or New Start

June 1898 marked a high point in Monet's career. His work was exhibited in two major galleries simultaneously, in a mixed exhibition at Durand-Ruel's and a solo show at Georges Petit's. In the Rue Laffitte, where he was exhibited alongside Pissarro, Renoir and Sisley, he had an entire room to himself; Pissarro thought the paintings "superb". The fifth exhibitor was Puvis de Chavannes, who was now President of the Société Nationale des Beaux-Arts; the presence of the four musketeers of Impressionism alongside such an official figure was an indication that official recognition could not be long withheld.

Monet was forced to "work furiously" in preparation for the exhibition that opened on 1 June at the Georges Petit gallery, and he could not attend the Salon du Champ de Mars as soon as he wished. The object of his visit was to demonstrate his support for Rodin, whose *Balzac* had just been refused by the *Gens de lettres*. He nevertheless agreed to sign the petition – this was clearly a time for signatures and petitions – in favour of a work of whose beauty he felt "serenely" certain even before seeing it.

The polemics about the *Balzac* affair and the traditional reviews of the

Suzanne Butler and her son Jimmy in front of the house at Giverny
c. 1893
Photograph Durand-Ruel

Salons occupied most of the scant column space remaining to the fine arts in the aftermath of May's legislative elections. So there was little press coverage of Monet's exhibition, and few visitors came to the famous, Rue de Sèze gallery. On display there was a veritable festival of series, from the Cathedrals dated (94) to the Flowers of 1897, including those of Norway, Pourville and Mornings. The press comments on the exhibition are not without interest, in that some of the critics were aware of the changes in Monet's painting over the last few years and tried to formulate their understanding of this change.

The problem of the inevitability of change was thus posed by a post-Impressionist painter, whose eye had perceived, behind the surface of things, the first signs of a latent decline that the professional critics had failed or refused

Giverny, the pond seen through the branches
of a weeping willow
c. 1933
Photograph from the magazine *Country Life*,
London

to perceive. The only critic who wondered what the future held was Gustave Geffroy, and he dismissed the question. "One cannot predict the changing phases of such an artist." Even Monet, he said, determined as he was "to understand and learn, does not know what nature has in store for him." This would have surprised anyone who, thanks to Maurice Guillemot, knew about the planned lily pond, a programme of great decorative paintings that was to revolutionise French art and mark for Monet, on the eve of his sixtieth birthday, a new departure toward unmatched and incomparable achievements.

"The Paganini of the Rainbow"

In late 1898, an important transformation was under way in Monet's work. It was a change of direction rather than a repudiation of his earlier style, and it was to eventually lead to the *Grand Decorations*. Yet at the time hardly anyone seems to have grasped the significance of the news revealed by one of Monet's visitors that the artist was at work on the first water lily painting. Instead, the question that exercised public opinion was whether his recent paintings were as good as his earlier work. When safely out of earshot of those zealous guardians of the temple of Giverny, such as Mirbeau or Geffroy, some critics privately

expressed a preference for pictures painted some ten or twenty years earlier, or even for Monet's pre-1870 work.

Paul Signac was one of these. Bowled over on a visit to Durand-Ruel's gallery by a *Woman with a Glove*, otherwise known as *Camille or The Woman with a Green Dress* (65), which had long been the private property of the Houssayes, he wrote: "this very fine Monet ... shows what a successful Carolus-Duran he might have made." The verdict is ambiguous; Carolus-Duran's work has enjoyed a mixed critical reception. Yet an unfavourable judgement of Monet's more recent work is implicit. This is confirmed by Signac's reference to the "powdery and much-scoured *Banks of the Seine in Fog*", which was on show at another dealer's. A few days later, Signac broadened his target to include Renoir, whose palette was clogged with earth tones; Pissarro, who like Renoir, sang "hymns to the glory of mud"; and Monet, who stood accused of producing paintings that were "white, chalky and flat." The leader of the Neo-Impressionists went on to explain what he considered the "bankruptcy" of the traditional

Giverny, the northern bank of the water-lily pond, surrounded by weeping willows with the Japanese bridge in the background
c. 1901–1902
Photograph G. Truffaut

Impressionist school. His efforts were in vain; two days after his irreverent comments were published, Durand-Ruel and Vollard took him to task for not continuing to paint in the style of Monet!

Thanks to both solo and group exhibitions, Monet's reputation continued to spread throughout Europe and the USA. Consider, for example, the exhibitions he took part in outside France or which were organised specifically for him during the first months of 1899. The Imperial Society for the Encouragement of the Arts in Russia presented an exhibition of French art, first in St. Petersburg, then in Moscow, drawing heavily on the two Paris Salons, and on the Durand-Ruel gallery. The result was a heteroelite group of 380 pictures by 177 artists. Monet and Renoir each had twelve entries in the catalogue; of the jumbled assortment of mainly traditional painters who made up the rump of the exhibition, none was so strongly represented. The Frühjahrsausstellung in Dresden was more selective, bringing together certain German painters, such as Claus and Liebermann, and with the finest representatives of French Impressionism and Post-Impressionism. Again Monet occupied a prominent position with six canvases, two of which were reproduced in the catalogue. In the United States, things were better still: solo exhibitions were organised, first in New

Pink Water-Lilies
1897–1899
Cat. no. 1507

York (22 paintings), then in Boston (28 paintings). The booklet produced for the New York show included a lengthy biographical and analytical preface by William H. Fuller. Fuller, whose compatriots were fascinated by the myth of the big city, celebrated in Monet an artist who had shown exceptional courage: he had lived for "fifty years [of his life] in the country!"

Certainly Monet was more a countryman than an intellectual, but his art lacked neither method nor invention. Georges Rodenbach, for one, recognised this. In *L'Elite*, he ranked Monet alongside Puvis de Chavanne, Bernard, Carrière, Chéret and Whistler as "one of the great contemporary artists"; Monet's claim to this title rested on the premise, however, that "painting is a sufficient end in itself" and "is not intended to express ideas and literary feelings." In the "vast serenity" of Monet's face, the Belgian poet identified "an extraordinarily rapid eye that shines, pierces, cavorts, is dipped in sunbeams, swarms, shimmers, is as though carved into facets and filled with spasms of diamantine light." This symbolic intuition led him to offer his own variant on Cézanne's famous remark; for Rodenbach, Monet was "[a]bove all an eye, a fabulously sensitive retina." Whence his aesthetic of spontaneity that made poetry of everything "through the simple power of well-judged lines and subtle, harmonious colours." Rodenbach's study went on to develop this theme, culminating in a spectacular epigram whose brilliance implied the artist's limits: "M. Claude Monet is the Paganini of the rainbow."

The Front Page of the supplement to the magazine *Le Gaulois,* 16 June 1898

"So much pain and heartache"

The first months of the year 1899 were marked by two personal tragedies. One struck a friend from the painter's youth, the other a member of his immediate family. Alfred Sisley summoned Monet to his deathbed and entrusted him with the care of his children, for whom he could not provide from his own resources. He died the same day. On the first of February, a few days after their "final farewell", Claude returned to Moret, with Alice, to attend his friend's funeral. The service was conducted in the ancient church that Sisley had so often painted. Then the funeral procession, made up of about thirty mourners, moved off towards the cemetery under the leaden sky of a winter afternoon. Twenty minutes' walk in the damp, cold air along the banks of the Loing was quite long enough to meditate on the agony of a death caused by "the smoker's canker", as it was called in those days. When they were assembled at the side of the open grave, and the time came for speeches, the shortcomings of Sisley's Impressionist comrades became quite clear. Neither Monet, Pissarro, nor Renoir, all present that day, were competent public speakers, and "Impressionism" had long since ceased to be an organised movement. Cazin spoke on behalf of the Société Nationale des Beaux-Arts, where the deceased had regularly exhibited; he was not personally acquainted with Sisley, and his expression of "deep regret" was something of a formality. He was followed by Adolphe Tavernier, whose more personal homage, delivered in a "voice both vibrant and sincere", drew tears from all those present.

Breaking their journey in Paris, Claude and Alice Monet arrived back in Giverny two days later. Mme Monet immediately left for the Rue du Colombier. The health of her daughter Suzanne had long been fragile, and had recently begun to cause renewed anxiety. Although suffering from a heavy cold, the young woman seemed delighted by the flowers and presents her mother had brought her back from the capital. The next day when Alice called, she found that her daughter had taken to her bed, "just to be on the safe side", as she put

it. Alice told her to "sleep, and call me when you wake up ." She then withdrew; it was two o'clock in the afternoon. A little later, suffering from a severe attack of bronchitis which she had picked up in Moret, Alice herself took to her bed. When she returned to her daughter's side, on the evening of 6 February, Suzanne had passed away. The flowers that Alice had brought with her from Paris were laid on her daughter's coffin.

Suzanne Hoschedé-Butler's death at the age of thirty was a major event in Monet's life. He lost a step-daughter whose few fine figure paintings had earned his respect and to whom he was more attached than any other of his new relatives. But he also had to face the acute despair which afflicted his wife in the wake of her child's death. From that day on, Alice's journal is a record of absolute spiritual desolation. These repeated blows did nothing to shake Monet's determination: "So much pain and heartache – and yet I must be strong and console my loved ones."

A "Complete and Unanimous" Success

The painful events of early February 1899 did not prevent Monet from taking an active interest in the preparations then underway for a group exhibition at George Petit's gallery. The show was to open on the 16th, and brought together a selection of works by five painters: Bernard, Cazin, Sisley, Thaulow and himself. The care he took over the chronology of his works for the catalogue – a small brochure presenting the artists in alphabetical order – shows the significance that he accorded to the history of his own work. He attended the official

Water-Lilies
1897–1899
Cat. no. 1501

Germaine Hoschedé and Madame Joseph
Durand-Ruel on the Japanese bridge
c. 1898
Photograph Durand-Ruel

opening which took place on 15 February at the gallery in the Rue de Sèze,
described by Mangeant as "just big enough", but excellently lit. The back wall,
facing the entrance, was given over to Cazin; Bernard and Thaulow shared the
rail on the left, Sisley and Monet that on the right. Chaplet's pottery filled two
large glass cases. But when Mirbeau arrived, Monet had already left for Giverny.
Disappointed at failing to meet him, Mirbeau set down his impressions of the
event: "There was a huge crowd. Scarcely room to move. Your success was com-
plete and unanimous. I don't believe that among all these people three could
have been found to dispute it." None, certainly, to brave the formidable Mir-
beau, who decreed that Monet's "genius dwarfed the work of his fellow
exhibitors". He went on to offer some interesting remarks concerning the *The
Luncheon* (**132**), and another painting that is probably *Camille or The Woman in
a Green Dress* (**65**): "What a pity that you won't go back to figure painting.
You'd be the best of the lot, and by a long way!" Mirbeau evidently saw art as a
competition, or rather, as one of those prize-giving ceremonies so characteristic
of the kind of French education that had formed his own character, with all its
qualities, prejudices and blind-spots. The first prize naturally went to the boy

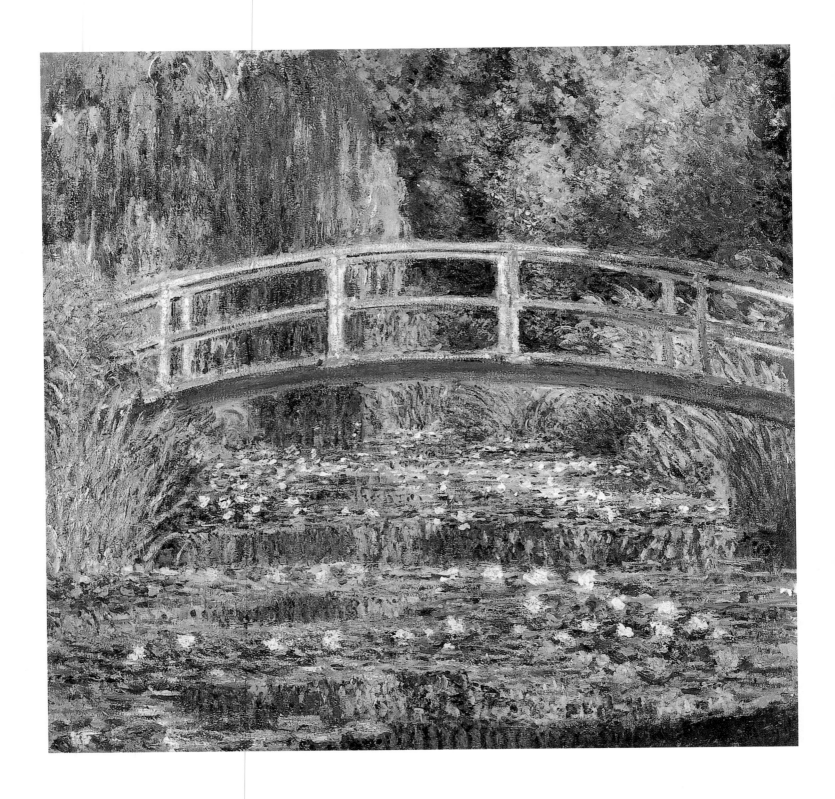

Water-Lily Pond
1897–1899
Cat. no. 1509

with top marks, in this case Claude Monet, while the dunce's cap went to "poor old Cazin": "What an odd idea it was, turning out next to you, to be slapped down so definitively!"

Less dogmatic minds than Mirbeau's found George Petit's selection puzzling; but, contrary to what one might today imagine, most commentators emphasised not how heterogeneous the ensemble was, but how coherent.

The press coverage would certainly have been more extensive if the President of the Republic, Félix Faure, had not died on the evening the exhibition opened. Edifying accounts of his final hours (the convention for a head of state), his funeral and the election of his successor, dominated the papers and monopolised public interest for many days.

Apotheosis or Decline?

One month after the end of the George Petit Show, it was Paul Durand-Ruel's turn to present a small group exhibition. This time there was no risk of disparity. And by now the line-up Monet, Pissarro, Renoir and Sisley was a guarantee in itself of commercial success. The inevitable attacks by disgruntled visitors, which had once drawn the attention of the press, seemed to belong to an age gone by. But if the old guard had fallen silent, the younger generation was beginning to show signs of disaffection when it felt free to do so. Signac, who visited the Durand-Ruel exhibition one evening before the official opening, noted in his journal an opinion which stood in marked contrast to the otherwise universal verdict that the "hour of the apotheosis of Impressionism" had dawned at last. What Signac saw instead was "the definitive victory" of Renoir, secured by the paintings of 1878–82 in particular, and which justified a place in the Louvre. Monet had also done good work during the same period, and had in addition two fine *Poplars on the Banks of the River Epte* (**1296, 1312**). But his early paintings were spoiled by poor quality colours and the successive layers of varnish; the composition was often weak. Sisley was singled out for the prominence he had given to brush work; taken as a whole, the works exhibited were "perhaps more sumptuous than Monet's. ... As for Pissarro, he comes a poor fourth." All four had renounced "brilliant colours", and since they had rather lost interest in the "quest for luminosity", they could only suffer from the comparison with Corot: "Corot painted pictures. They, with the exception of Renoir, have produced only studies."

The allusion to Corot was not fortuitous. Behind the four rooms, each reserved for one of the Impressionists, a further room was devoted to a selection from the earlier master's work. Thus the comparison came naturally to the critics. "Corot is the father of them all", was the opinion of Julien Leclercq, writing in the *Chronique des Arts.* But his "presence does not completely destroy his

Utagawa Hiroshige
Wisteria
1857

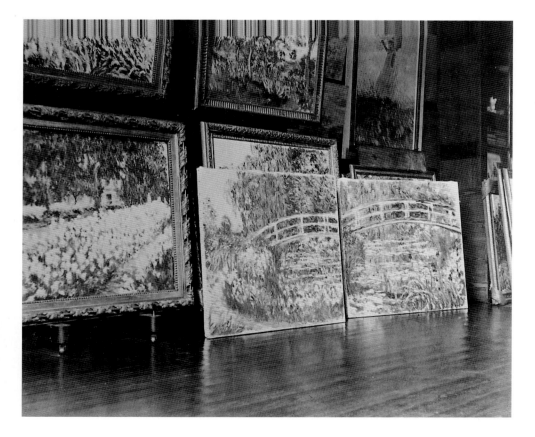

The second studio at Giverny, 1900
Photograph Durand-Ruel

neighbours ... Monet and Renoir, both masters. Pissarro, a remarkable secondary figure, and Sisley too." The supremacy of Corot is apparent both in the titles of certain articles and in the amount of space devoted to his work.

The judgement of the professional critics was confirmed by the taste of the collectors who attended public sales during the spring and summer of 1899. When the collection of Count Doria was broken up for auction, as if to prove Signac right, Pissarro arrived firmly in fourth place, with no single painting of his making more than 2,500 francs. This left him a long way behind Monet, whose *Barges at Asnières* (270) went for 7,000 francs, Sisley, who did well despite the almost simultaneous sale of his studio, and above all Renoir. *The Thought*, at 22,100 francs, surpassed (if only by a whisker) even Degas' *Dancer at the Photographer's Studio* (22,000 francs). A new name, known only to the happy few, was also added that day to the list of painters whose value was recognised on the open market. Cézanne's *Melting Snow* (Study of the Forest of Fontainebleau) was bought for 6,750 francs by Durand-Ruel, acting under strict orders from Monet who had instructed him not to let the picture get away at any price.

Monet's devotion to the work of his less fortunate colleague, and his faith in its artistic value, knew no bounds; he was said to be obsessed with Cézanne. When the estate of the widow Chocquet was to be auctioned, he wrote to Count Isaac de Camondo to try and persuade him to purchase Cézanne's *The House of the Hanged Man*, even though thirteen of his own pictures – ten oils and three pastels – were also among those to be sold. Such self-abnegation is, of course, admirable. Did Monet know that he was contributing to the success of a painter who would be his own greatest rival among the artists of his generation? And that he was doing so at a time when Signac, once Monet's most faithful supporter, was confiding to his diary that "the fine tenor of former days has been struck dumb, the virtuoso is paralysed"?

The Japanese print collection in Monet's dining room at Giverny.

Page 337:
Water-Lily Pond
1899
Cat. no. 1518

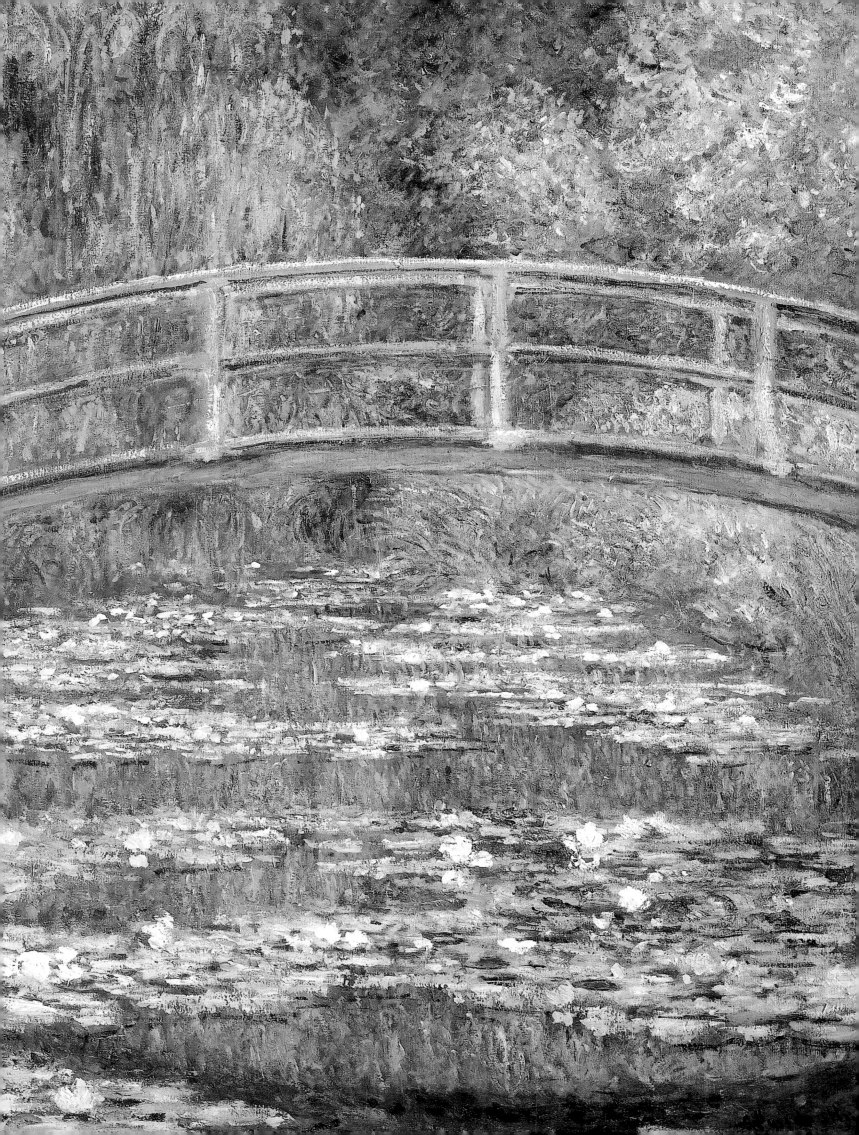

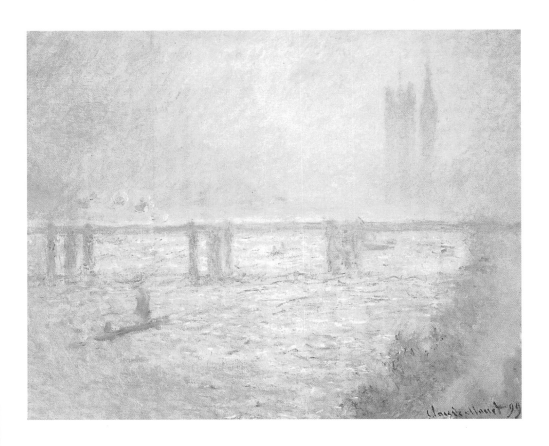

London, the Charing Cross Railway Bridge,
seen from Waterloo Bridge
Photograph: John Fischer Collection, 1912

ABOVE:
Charing Cross Bridge
1899–1901
Cat. no. 1522

The First Series of Japanese Bridges

"Monet knew Cézanne's work and admired it, but he was not in the least influenced by him." Written twenty years later, Arsène Alexandre's remark can readily be applied to this summer of 1899, when Monet began to demonstrate his mastery in a new manner, more personal than ever, and as little like Cézanne's as possible. The result was the first great series of water lily ponds (1509–1520). As early as 1895, Monet had been attracted to the Japanese bridge as a motif (1392, 1419, 1419b), but at that time, even in fine weather, he had always treated the surface of the pool as a pure mirror, unenlivened by a single flower. Now his approach was quite different. In the canvases of 1899 the large lilies, arrayed in successive layers, jostle for space with reflections of the trees and the irises. The small pond has been transformed into a coloured microcosm, poised beneath the immaculate curve of the footbridge. The date inscribed on almost all these canvases, 99, might seem to imply that Monet had more or less immediately achieved the perfection of these images. But from the testimony of Maurice Guillemot, we know that the painter had in fact been working on this problem for several years, and that these pictures in fact represent the first fruits of a long and arduous quest.

Most of the paintings in the series have an unusual, almost square, format, save for two canvases in portrait format, a no. 30 and a no. 50, (1518 and 1520) and another which is a no. 40 in landscape format (1517). The first (1518) is further distinguished by the absence of the clump of irises on which the Japanese bridge seems to rest in all the other paintings. The third (1517) places the bridge high in the canvas, so that its curve almost touches the upper edge of the frame. A careful examination of the bridge in these different versions reveals other variations: of the seven pairs of uprights that support its handrail in reality, only four are visible in most of the paintings, while in four cases a fifth is added, to the right (1514–1516 and 1519). Using the laws of perspective to compare the dis-

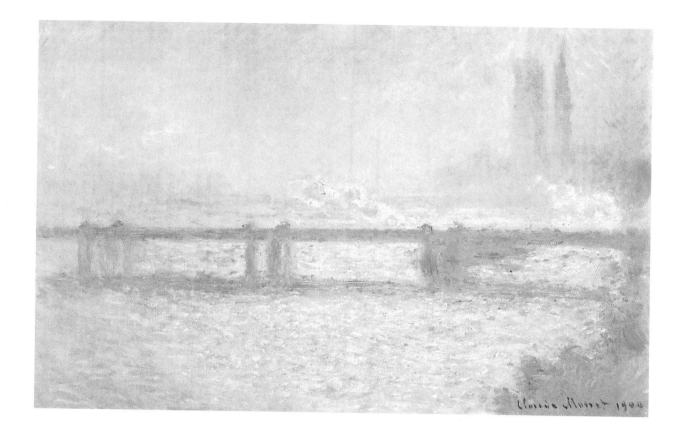

position of these pairs of uprights allows us to see if the painter changed position between canvases: only tiny differences can be discovered, such as might be attributed to chance or the painting process. There is no evidence, then, that the easel was moved. Indeed, it seems most likely that Monet executed the whole of the 1899 series from a single point near the outflow of the pond, using the curious arrangement that can be seen in a photograph of Durand-Ruel's, and which Arsène Alexandre referred to as "a large studio stuck in the middle of a flowering marsh, which resembles both a tent and an observatory."

The almost insolent perfection of the first water lily pond coincided with the completion of work on a second studio. This was a large two-storey building to the north-west of the property, as we know from the prosaic descriptions of the surveyors and the more poetic accounts left by successive visitors to the house. On such tours, Monet would invariably lead the way up a well-waxed staircase, past walls covered with Japanese prints. From here a door led into a huge square room, not quite a full floor's height off the ground. It was lit by two large bay windows, one of which gave onto the road to the north while the other looked out to the south across the greenhouses, the garden and the valley beyond, towards the hills on the left bank of the Seine. Inside, spread over the walls and the easels, was an array of canvases covering Monet's entire *œuvre*, amongst which the alert visitor might pick out a fragment of the *Luncheon on the Grass* (**63/2**) and the *Woman in the Garden* (**67**).

Other easels – or perhaps the same easels, restored to their original purpose once the visit was over – were used to paint the final stages, if not indeed the whole, of an increasing number of pictures. Monet himself acknowledged this, when he admitted to Maurice Kahn how disappointed he was with his London "campaigns": "After four years working and retouching on the spot, I had to resign myself to just taking notes and finishing the work here, in the studio..."

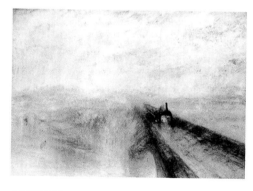

J.M.W. Turner
Rain, Mist and Speed – The Great Western Railway
1844
London, The Trustees of the National Gallery

ABOVE:
Charing Cross Bridge, Overcast Weather
1899–1901
Cat. no. 1526

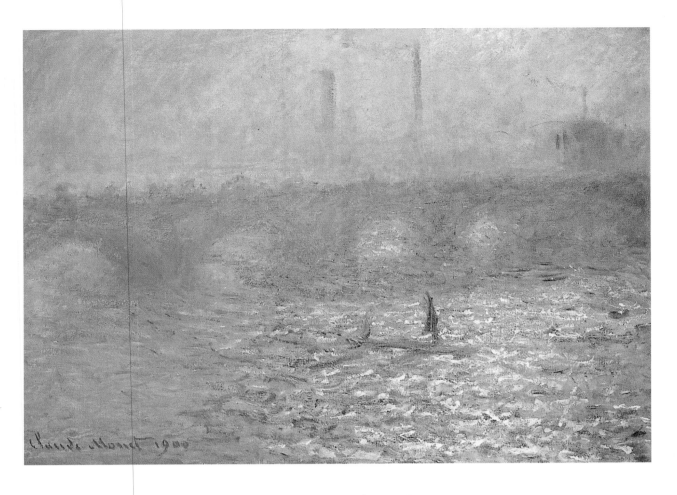

Waterloo Bridge, London
1899–1901
Cat. no. 1555

The First London Bridge Pictures

The autumn of 1899 was a period rich in new departures. It was then that Monet undertook the first of three long working visits to London. He returned in 1900 and 1901. The original reason for this first journey, besides his long-standing affection for the fog-bound capital, was his desire to see his younger son Michel, who had taken lodgings there in the spring. Monet went to inspect the rooms in which his son was living, and not to assist him in his choice, as has sometimes been claimed. Michel Monet, a tall young man of twenty-one, had taken rooms with the Darby family of 92 Bromfield Road, with a view to studying English. His frequent letters to his "chère maman" were full of affection, and Alice, maternal and anxious as ever, decided to accompany her husband to London. As a result, there was no correspondence between the couple during this period, which accounts for our relative lack of information about the journey. However, we do know that they left France on or around 15 September and that they stayed at the Savoy Hotel, a first-class establishment on the Victoria Embankment, just above Cleopatra's Needle. From the windows of their sixth-floor suite, which overlooked the Thames, Monet enjoyed a splendid view: to the right, looking upstream, were the Houses of Parliament rising above the iron apron of the Charing Cross railway bridge, while to the left his gaze was drawn to the massive arches of Waterloo Bridge, now replaced by a newer construction and then across towards the smoking chimneys of the factories on the far bank.

Alice and Germaine Hoschedé, who had accompanied the Monets, were left to visit the city accompanied by Michel. Monet, who had brought with him "a few small canvases to sketch on", just in case, proceeded to transform the first holiday he had taken abroad with his wife into the purgatory of a "campaign".

He must certainly have started work on more than just the five canvases dated 99. But since these five are all devoted to the double motif of Charing Cross Bridge and the Houses of Parliament, it is reasonable to assume that they mark the beginning of the London series (1521–1524 and **1531**). In the most clearly legible of the five (**1521**), it is possible to make out the arches of Westminster Bridge behind Charing Cross Bridge, in which two trains are crossing simultaneously, their presence revealed by plumes of smoke. On the right stands the Palace of Westminster, dominated by Victoria Tower, which is flanked by the Clock Tower with its thin spire. This first visit to London lasted more than a month. On 17 October, Monet informed Durand-Ruel he would be returning "within a fortnight", adding that he had "tried out a few views of the Thames" and felt sure that his correspondent would be glad to hear this. A letter from Michel to his "maman chérie" on 27 October tells us that by then Monet and his companions had been back for at least two days and that they were to visit Jacques Hoschedé at Saint-Servan on their way home.

On 5 November, Charles Durand-Ruel went to Giverny and put his mark on a "huge" number of canvases, seven water lilies and eleven Thames pictures. None of this last group were yet finished, but five or six of them were nearing completion – probably those dated 99. Feeling himself incapable of "finishing [the others] here", Monet was already planning to take them back with him to London on his next journey. In the end, he was happy with none of these views of the Thames, and eventually crossed out the eleven that he had entered into his account-book for November. By contrast, the entries for the water lilies remained intact: six at 6,000 francs each, and one at 6,500. For the year 1899, Monet's activities had earned him the pleasing sum of 227,400 francs, compared with only 173,500 for 1898. Thus a year that had begun catastrophically closed on a more positive note.

In early December Alice and Monet travelled to Paris, where they stayed, as usual, at the Hôtel Terminus, opposite the Gare St Lazare. One of their visits

Waterloo Bridge, Overcast Weather
1899–1901
Cat. no. 1556

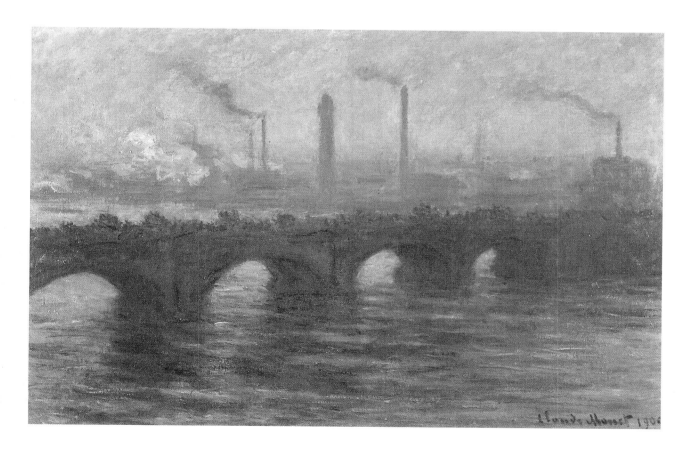

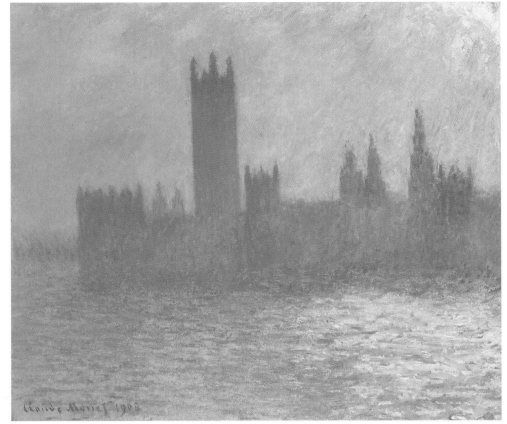

Houses of Parliament, Sunlight Effect
1900–1901
Cat. no. 1597

J.M.W. Turner
*The Fire in the House of Lords and the House of
Commons, 16 October 1834* (detail)
c. 1835
Philadelphia (PA), The Philadelphia Museum
of Art

PAGE 343:
Houses of Parliament, Sunset (detail)
1900–1901
Cat. no. 1607

was to Paul Nadar, who was to take their portraits. Among the other events of
the winter were the gift of the *Study of Rocks* (**1228**) to Clemenceau, and some
winter painting at Giverny, where Monet was encouraged by the sharp, cold
weather. As in the good old days, the river filled with drift-ice on 15 December
and froze over three days later. The young skated on the frozen marshland and
Monet, oblivious of his recent ill-health, went out painting in the frost-covered
countryside (**1618–1619**). The ice broke up on 20 December, and the thaw came
as a surprise to him; he was still "full of enthusiasm", just as he had been in
younger days.

The Dawn of the 20th Century

Despite the conventions of official chronology, most people believed 1900 to be
the first year of the twentieth century, and it was in this spirit that the New
Year was celebrated in the France of the Belle Epoque.

Seen from France, and especially from Paris, 1900 was above all the year of
the great Parisian *Universal Exhibition*. It would be many years before there was
another undertaking on such a scale. The Palais de l'Industrie was razed to
make way for the Grand and Petit Palais, which were to house the prestigious
fine arts display. This was divided into three sections: a retrospective exhibition
covering French art from its origins up to 1800; a centennial exhibition which,
despite its title, covered only the period from 1800 to 1889, the latter date being
that of the previous *Universal Exhibition*; and a contemporary or decennial ex-
hibition, the only international section which constituted a sort of enlarged
Salon. Here the regulars of the Artistes Français were, for once, brought
together with representatives of the Société Nationale des Beaux-Arts in a selec-
tion of works dated between 1889 and 1900.

FROM LEFT TO RIGHT:
Houses of Parliament, Sunset
1900–1901
Cat. no. 1602

Houses of Parliament, Sunset
1900–1901
Cat. no. 1603

Early that year, a rumour reached the four surviving Impressionists that they might have to participate willy-nilly. It is not clear whether they were to be included only in the Centennial, as a letter from Renoir seems to imply, or whether the organisers also had them in mind for the Decennial, as Durand-Ruel believed. What is certain is that as soon as the painters got wind of the official initiative, they united in resistance to it. In the past they had complained that their work was always refused. Now they put all their energy into protesting against the violence being done to them – albeit a very moderate, republican kind of violence. Monet, supported by the ever-radical Pissarro, delivered a categorical refusal to Roger Marx, one of the principal organisers of the Fine Arts exhibit. His main complaint was that he had not been consulted, and he feared that he and his friends, tolerated rather than desired, might find their works badly hung. In short, the veto was clearly not definitive, and could easily be revoked, and the group gave up the idea of taking the matter to court.

Paul Durand-Ruel was the lynch-pin of the group's resistance to the siren-calls of official recognition. In private, he also remained Monet's principal source of financial and logistical support. The painter asked the gallery to promote the work of his son-in-law, the painter Theodore Butler, who had returned to the United States with his two children, accompanied by Marthe Hoschedé. Georges Durand-Ruel, the family's representative in New York, was duly approached, and decided to organise an exhibition for Butler at the beginning of March. Paul Durand-Ruel's devotion, which he had proved time and again, did not prevent the occasional unpleasant surprise, such as Monet's accusation that he had overcharged him for a picture by Renoir. Monet's short stay in France was not without incident – a visit from Clemenceau and Geffroy to Giverny, a trip to Rouen, an order to Nadar for more copies of their portraits, the engagement of Julie Manet to Ernest Rouart which occasioned warm congratulations, a brief visit to Paris, and much essential advice to be dispensed to the gardener. But none of these events could delay Monet's departure for London, where there was work to be done.

"I am a Complete Imbecile"

In theory at least, Monet's timetable in London was perfectly organised. During the morning and after lunch, he would work at his window in the Savoy Hotel, painting one of the two bridges, Charing Cross or Waterloo. In the late afternoon, he would go to the hospital where, for his first session, he was greeted by a magnificent sunset which lit up the Houses of Parliament. In fact, the problems he so often encountered when working outdoors were aggravated further by the smog, which was deeply discouraging even for one as accustomed to Normandy fog as Monet. The range of light turned out to be terribly narrow: if there was too much cloudcover, work was impossible; if, on the other hand, it was too bright, the London atmosphere he sought for would be lacking. Fortunately, pollution came to his rescue: "When I got up, I was terrified to see that there was no fog, not even the least trace of a mist; I was in despair, it seemed all my canvases were going for naught, but then little by little, as the fires were lit, the smoke and the mist returned." Like a sentinel on the city wall, the painter would lie in wait for the returning effect. When it came, he rushed to his canvas, abandoning everything else, even a letter to Alice: "Now, my darling, I must leave you, for the effect will not wait."

With each successive day, the sun was higher in the sky. Soon, the sunset would no longer illuminate the Houses of Parliament as seen from St Thomas' Hospital. Monet worked ceaselessly, adding to the number of canvases in progress: forty-four on 1 March, they numbered "something like 65 covered with colours" only three weeks later. The inevitable result was "colossal expense" and a "terrible bill" waiting for him at Lechertier-Barb's, his London supplier. In mid-March, working at the hospital, Monet noticed that he could have "caught Parliament better", and straight away set to work transforming those of his pictures "whose effect cannot be retrieved". Delighted at first, he was overcome with doubt the very next day. So he returned to his original idea of starting new canvases "in all weathers and all harmonies", while cursing "these wretched reworkings which are all utterly useless".

The inevitable crisis was not long in coming. On the morning of Monday 19 March, Monet was up by six. Outside, the roofs were white with snow; then a "terrible" fog kept him champing at the bit, despite his impatience. At last, at

FROM LEFT TO RIGHT:
Houses of Parliament, Stormy Sky
1900–1901
Cat. no. 1605

Houses of Parliament, Reflections on the Thames
1900–1901
Cat. no. 1606

half past ten, he could get down to work. The light was changing so often that he had "to use more than fifteen canvases in turn, picking them up, then putting them down, and still it was never right." A few clumsy brushstrokes brought things to a crisis: the canvases were dismissed as "awful" and returned to their packing-cases. By midday, Monet was writing a forlorn appeal to Alice: "Forgive me if I carry on so, but you know how I suffer when I get like this, and who can I confide in if not you? Forgive me, console me." After lunch, he tried again, but this only made things worse, and "poor astonished Michel" had to watch powerless as the storm broke over his father. Then Monet dragged his son out onto the streets and they walked for hours across London, even taking in a visit to the Tower, until they were completely tired out. When evening came, he had achieved his aim: "I shall dine and then to bed. I'm exhausted."

The next day, the light was more favourable, and battle was again joined. Monet's mood continued to fluctuate. He decided to return the following year, with a particular view to completing the hospital series, which "would have been as interesting as the Rouen Cathedral paintings", and a short respite followed: "Every day my understanding of this strange climate grows and I've reached a point now when I make slashing brushstrokes on paintings which had given me the utmost trouble, which were almost finished but didn't have enough London atmosphere. That is what I'm trying to give them now, with great big strokes." A few days later, all conviction had been lost: "I am a complete imbecile. The least little thing throws me right off course."

One attenuating circumstance can be cited. Monet's family were of little help to him at this time. Indeed, it is quite astonishing to see someone on whom so many people had come to depend receiving so little support in return. Thus, he was paying for Michel's stay in London so that he could improve his English. Yet on the one occasion when he asked Michel to come and help him at St Thomas' Hospital, the forgetful boy "didn't show up"; nor did he offer a word of apology. He was otherwise occupied, having got into the habit of endless skating sessions which left him quite exhausted. And when the prodigal finally reappeared, Monet, so often quick to lose his temper, failed to rebuke him. Thereafter, whether ill or away on his travels, Michel continued to be a source of concern to Monet throughout his life. The nonchalance of the son is

FROM LEFT TO RIGHT:
Houses of Parliament, Fog Effect
1900–1901
Cat. no. 1608

Houses of Parliament, Fog Effect
1900–1901
Cat. no. 1609

in striking contrast to the self-discipline of the father. Yet Monet liked to indulge Michel, as he did his elder brother, Jean, who worked for Léon Monet in his chemical factory at Maromme, near Rouen. Jean was not an excessively diligent employee, but rather than encouraging him to work harder, Monet simply wrote: "I hope ... Jean isn't having too much bother with his uncle."

Nor was his wife a great source of moral support. While Monet struggled with his painting in London, Alice was still recovering from the shock of Suzanne's death, and her principal concern was how her grandchildren were coping with their journey to the United States in the company of their father and Marthe Hoschedé, their aunt. Th. Butler's exhibition at Durand-Ruel's New York gallery was a failure. "Disappointed and mortified", Butler set sail for France, bringing his entourage with him, and Alice was quite upset by the very thought of the sea crossing. Determined to show that he shared her concern for the fate of those members of his family to whom he was related only by marriage, Monet took his role as "grandfather-in-law" (to borrow J.-P. Hoschedé's expression) so far as to annotate his letter of 29 March: "day of their departure, fine weather." But his remark to Alice that "these last few days, I really needed all my faculties" fell on deaf ears. Blanche, Germaine and Jean-Pierre were all devoted to Monet; in contrast, their brother Jacques was not. Without leaving Saint-Servan, Jacques contrived to plague his father-in-law with requests for money even while Monet was working in London. He had decided that henceforth he would "touch" the old man for whatever he could get. Jacques was now thirty years old, and his behaviour did not improve with age.

London Society

It would be a mistake to think that Monet allowed his work and his domestic worries to take up all his time. He did not lack company in London, and the kind of the people he spent time with tells us a lot about the painter's public self. On his arrival in London, Monet had been taken under the wing of Mary Hunter, the wife of Charles Hunter, who owned several large coal mines. It was through her that he was introduced to Dr Payne, who assisted him in his deal-

FROM LEFT TO RIGHT:
Houses of Parliament, Effect of Sunlight in the Fog
1900–1901
Cat. no. 1610

Houses of Parliament, Seagulls
1900–1901
Cat. no. 1612

Claude Monet photographed by Nadar, 1899
Paris, Archives photographiques

ings with St Thomas' Hospital. At Payne's house, he met the director of the British Museum, whom he had been introduced to some time ago in Paris at Durand-Ruel's. A succession of dinner-parties was given at Mrs Hunter's house in Dover Street; at one particularly brilliant reception, Monet hoped he would be introduced to the Secretary of State for War and to "the Countess Something-or-Other, who is related to the Queen, sculpts, and prides herself, I am told, on being a real artist, but is nonetheless quite charming." A few days later he was invited to dinner again, this time together with the novelist and art critic George Moore. But then he was suddenly dropped by the Hunters, without any explanation. Monet was very upset at the idea that he "might have offended Mrs Hunter, who had shown herself so hospitable to us and so helpful to me." He eventually discovered that the fault lay with Moore, who had given offence with his overtly oppositional politics. Mr Hunter was, for the time being, unwilling to receive him . "As for me, not a word."

Eager to reingratiate himself with Mrs Hunter, Monet called on John Singer Sargent, who numbered himself among her good friends, and asked him to act as intermediary. Sargent was busy with portrait sittings, but Monet never-

theless found a moment to visit him in Chelsea. It was a brief call: the Thames was waiting. Next it was Monet's turn to receive Sargent in his room at the Savoy. The visitor seemed to be "a little astonished by some of the canvases, but full of admiration for others." In fact, the main impression Sargent took away was of too many pictures in progress simultaneously. His account of the visit is well known: he watched Monet struggling, surrounded by 80 canvases, searching desperately for the right one when the effect he was waiting for occurred, and as often as not unable to lay hands on it until the effect had passed.

Although he kept himself abreast of what was happening in France, Monet followed the example of the philosopher Montaigne, and studiously avoided the company of his fellow Frenchmen in London. Sometimes they would seek him out. In late February, Georges Clemenceau and Gustave Geffroy called on him. On Sunday 25 February, the three friends attended a "very fashionable dinner". On the 27th they went to see the Minstrels at St James. The next day the visitors left at dawn, and at ten o'clock Monet wrote to his wife: "They were both very considerate and did not in the least interfere with my work." Four pages are devoted to this visit in Geffroy's *Claude Monet*. One detail stands out amid Geffroy's habitual tones of praise. Whenever the fog had completely blotted out the view, Monet would remark: "There's no more sun", and stop painting. When, a little later, he would all of a sudden pick up his palette and brush again, saying: "The sun is back", his guests were often bemused. It took them a good while before they could discern the faint premonitory glow of the emerging sun; Monet alone had been able to detect it.

Another important visitor from France was François Depeaux. The celebrated collector from Rouen had intended to reach London on 19 March, the day of Monet's great crisis of depression. By a stroke of luck, of which he was doubtless ignorant, he was obliged to postpone his arrival by one day. The day after he arrived, the foolhardy Depeaux called on Monet at the hospital. Predictably, Monet was incensed at interruption. Realising his mistake, Depeaux took Monet and Michel out to dinner at the Café Royal in Regent Street to make amends. He even invited Michel to visit him in Swansea, where he owned a coal mine. The news he brought about the recent Tavernier sale was reassuring. He himself was reluctant to split up his collection, "but it would happen sooner or later, it's the collector's fate." Amid the bustle of his impending departure, Monet found time to meet the Baron d'Estournelles de Constant. Michel was about to embark upon his military service, and Monet wished to persuade the former diplomat to help his son to obtain, if not an exemption, then at least favourable conditions. To this end, he also attempted to influence Paul Cambon, the French ambassador in London.

But everyone has their limits. Monet was rapidly reaching his. He was exasperated by Michel's behaviour and anxious about his future. He was demoralised by the increasingly anxious tone of Alice's letters. And he was exhausted by unceasing work, by the ever longer periods he spent on his feet as the days gradually grew longer. The final blow was a bad cold accompanied by headaches, which forced him to abandon the few last sessions he had hoped to complete. There was only one consolation: the atmosphere and the light had by now changed so radically that he could no longer rework studies begun by winter light. Tired and dissatisfied, he had no choice but to pack up and send off the eight crates of canvases and other items he had been requested to acquire for various members of his family. He reached Dieppe, probably on Wednesday 5 April, but had to make a detour by Rouen, or possibly even Le Havre, to wait for Butler, Marthe and the children to disembark from the steamer *Touraine* which had brought them back from the United States.

During the same sitting with Nadar, the photographer also took a picture of Alice Monet, who was only 55 years old at the time, but grown old prematurely due to the pain of the recent demise of her daughter, Suzanne Hoschedé-Butler.
Archives photographiques, Paris

The Centennial Exhibition

On Tuesday 1 May 1900, two weeks after the official opening of the *Universal Exhibition* in Paris, the President of the Republic opened the Fine Arts section. Emile Loubet arrived at two o'clock and was on his way back to the Elysée Palace at half past three. It took him less than two hours to walk round the retrospective exhibition in the Petit Palais and the Centennial and Decennial exhibitions in the Grand Palais. Considering that he was being followed by an official cortège of several hundred people, this was a remarkable achievement. Lépine, the Prefect of Paris, marshalled the procession through the half-assembled displays, setting a cracking pace. A reporter from *Le Gaulois* saw the Prefect remind the President that they had not a minute to lose: "If the President should get it into his head to look at something, we'll still be here tomorrow." In his haste, Loubet "almost knocked his head against" the bust of Casimir-Perier. Recognising his predecessor, he bowed to him respectfully. Gaston Leroux, the creator of the fictional character Rouletabille, glimpsed the President three-quarters of the way through his circuit, as he prepared to move from the Centennial to the Decennial: "M. Loubet bows and bows and shakes hands. Perhaps he wishes he could stop for a moment before these venerable canvases, but alas! You would think he had five hundred enthusiasts for the new painting behind him, who could not bear to see him pause to contemplate the old. So, they press him onwards! ... And he keeps on smiling agreeably; with six kilometres of painting and sculpture already behind him he murmurs 'not so bad' now, for there are only two kilometres still to go."

It was in this atmosphere of amiable chaos and Republicanism that Léon Gérôme is supposed to have taken his stand outside the gallery devoted to the Impressionists, his white hair cropped short and his Légion d'honneur well in evidence. "Stop, Monsieur le Président! France is dishonoured", he cried, or so the story goes. I have combed the contemporary press and the works of authors who might have questioned Gérôme directly without finding the least shred of evidence to substantiate this. Yet the myth lives on in the annals of Impressionism which is why I mention it here.

Concerning the presence of the Impressionists there can be no doubt. No one had ever really doubted that they would be represented, though they had protested volubly when first asked to participate. This is not the place for a detailed history of their recantation. The episode can be followed in Monet's letters from London; he was in regular contact with Emile Molinier, one of the principal organisers of the Centennial. The outcome was that the traditional Impressionists – Degas, Monet, Berthe Morisot, Pissarro, Renoir, Sisley – were exhibited on the first floor of the Grand Palais in Room 17. They occupied the room next to Manet and Bazille, who shared Room 16 with Levis Brown, Eva Gonzalès, Fantin-Latour, Legros, Regamey and Ribot, among others.

"Mieux vaut faire envie que pitié". It is better to be envied than pitied, or so the saying goes. Yet the career of the Impressionists seems to disprove this proverb. In 1900, the Impressionists' supporters criticised the fact that their heroes were represented in the Centennial but excluded from the Decennial exhibition. Did the Impressionists *want* to take part in the Decennial? The leading protester on their behalf was André Mellerio. In a pamphlet published "in response to [his] first impression", Mellerio claimed that the Impressionist selection was both "narrow and incomplete", and that the artists should have been shown as a group "in a space set apart" for this purpose, just as Rodin had been. (Rodin was showing a complete retrospective of his work at the Pavillon de l'Alma in the Cours-la-Reine.)

Paul Durand-Ruel in his gallery
c. 1900

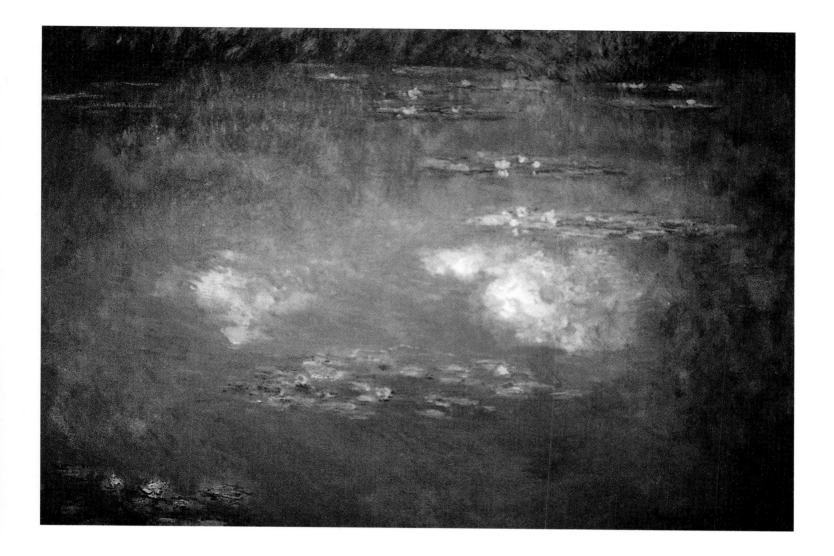

If Mellerio had taken the time to consult the official catalogue, he would have seen that his friends were, in fact, quite substantially represented. Edouard Manet had three works reproduced, which set him level with Chassériau, Daumier, David, Greuze and Puvis de Chavanne. Monet, Renoir and Bazille, with two portrait-format illustrations each, received the same treatment as Delacroix, the Baron Gros and Millet, while academic artists such as Baudry, Bouguereau, Breton, Cabanel and Gérôme himself were illustrated by a single work each. According to the general catalogue, Monet was the best represented of all the Impressionists, with fourteen paintings, ahead of Pissarro (7), Sisley (8), Renoir (11) and even Manet (13). So Mellerio seems to have been wrong to accuse the organisers of deliberately under-representing the Impressionists.

André Michel, a curator at the Louvre, contributor to *La Gazette des Beaux-Arts,* and a member of the general commission for the exhibitions, replied to Mellerio: "An impartial yet scrupulous friendship has secured a place of honour in the Centennial exhibition for [the Impressionists] – and while I note that some think it worthy of them, they have no real cause for complaint."

The Water-Lily Pond

Throughout the summer, the entire French nation lined up to file through the halls of the *Universal Exhibition.* Even Zola was there, photographing it from every possible angle. Monet wondered whether he would find time to go to

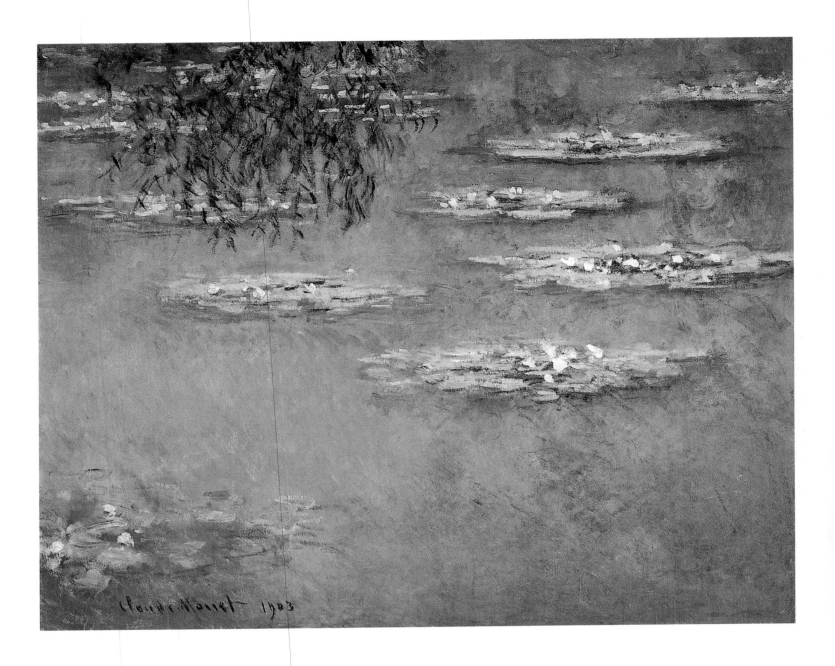

Water-Lilies
1903
Cat. no. 1657

Paris. His personal uncertainties contrast sharply with his public success at the Grand Palais: "I am going through a period of great discouragement", he wrote to Paul Durand-Ruel. "So this is not the right moment for you to come, even though I have done nothing but work since I returned from London. But I am incapable of finishing anything as I should like ... Right now I am sick of the whole thing." This seems to be typical Monet. Even when things appeared to be going well, his doubts remained, and the demands he made on himself were as great as ever. "It is not that I haven't been working hard, but as I am getting slower and more demanding, I haven't been able to achieve what I wanted." An injury to one of his eyes had left him unable to paint for a month: "Now it's all over, I hope I will soon be back at work and able to make up for lost time."

During the summer of 1900, Monet worked mainly in the garden at Giverny: in the orchard (1620–1623), close to the central path of the flower garden, which had not yet been cleared of its tall spruces (1624–1627), and above all at the lily pond opposite the Japanese bridge. There he painted two different motifs, producing three versions of each. The first was quite close to the one he had worked on the previous year and testifies to Monet's concern never to repeat the same picture. The footbridge has thus been shifted to the right to

give more space to the clumps of vegetation in the foreground on the left (1628–1630). In the second motif, the bridge was moved still further, revealing the elegant curve of the path bordered by aquatic plants on the left-hand side. The sky, almost entirely absent from the first series, is now clearly visible on the left. Monet was clearly aware of these changes, for he altered the title for the second group of pictures slightly by adding the word "Irises" (1631–1633).

Water-lilies and irises are recognised today as two emblems of the Belle Epoque. But in 1900, they were not perceived as such. And in later years, when the contemporary resonance of these motifs had become clear, its relation to Monet's work was largely ignored. Critics preferred to see Monet in isolation from his society and his times, as if he had invented the water-lily all by himself. Thus Gaston Bachelard, writing in 1952 in *Verve:* "A philosopher, dreaming before one of Monet's water scenes, might dare to invent a dialectic of the iris and the lily, a dialectic of the upright leaf and the leaf that is calmly, quietly, weightily resting on the water. Such dialectics as these are proper to aquatic plants: one seeks to rise up, driven by some mysterious revolt against its native element, the other remains faithful to its origins... Since the day Claude Monet first looked at a water-lily, the lilies of the Ile-de-France have grown more proud and more beautiful."

"This is not a country where you can finish a picture"

The last days of 1900 busy ones, despite an eye accident that forced Monet to interrupt his work for a while. Lucien Guitry promised to come to Giverny with Anatole France. There was a brief, but intense, quarrel with Paul Durand-Ruel over the sale of three canvases to Rosenberg for the sum of 25,000 francs. Monet's relationship with the brothers Gaston and Joseph Bernheim-Jeune continued to develop, and he purchased a Panhard car. By the close of the year, he had recorded an income of 213,000 francs. The difficulties involved in mounting an exhibition of the water lily series were made clear to Octave Maus, a spokesman for Impressionism in Brussels, in early January. Monet, meanwhile, was preparing for another trip to England. He set off on Wednesday, 23 January, and arrived in London the following evening.

Durand-Ruel had organised an Impressionist show at the Hanover Gallery, and Monet visited it on 25 January with Sargent. There the two painters saw pictures by Renoir, Sisley, Pissarro and Monet himself. He was disappointed by the exhibition: "Just as I thought, the effect is pathetic. What a terrible way to try and get us known in this country." While he waited for the crates to arrive with the pictures he wanted to rework or finish "in situ", he tried his hand at pastels. This pleasurable exercise produced a mine of information on which he could draw for the paintings. Finally the crates were delivered, and Monet got to work. At first, he painted only from his window at the Savoy, where on 3 February he was working on four different canvases. The next day, he returned to his old haunt at St Thomas' Hospital. Henceforth, he followed the same timetable as he had the previous winter, spending his mornings at the hotel, and his afternoons at the hospital. However, he now limited himself to a single motif in the mornings, which to begin with was Waterloo Bridge. He was soon working simultaneously on ten or more different versions. The advantage of this new system was that he had "a smaller number of canvases to keep track of". It is not clear at what point he switched from the Waterloo Bridge to Charing Cross.

Monet's grasp of his subject was improving, but several productive days failed to convince him of the merits of the system he had adopted the previous year: "It has to be said that working in two different places is a bad idea. Often I have to put down a canvas that I could have finished within the hour because it is time to go to the hospital." Thus he wrote on 2 March. On Sunday, 10 March, he was even more pessimistic. "This is not a country where you can finish a picture on the spot; the effects never reappear. I should have made just sketches, real impressions. With that and some drawings I could have made something of it, whereas instead I have reworked some canvases as many as twenty times, spoiling them as I went, and ending up redoing them as a sketch anyway in double-quick time." Among these sketches, we should mention the short series devoted to Leicester Square (1615–1617), painted, unusually for Monet, at night, with the lights of the Empire Theatre. He did these unusual views from the Green Room on the corner of St. Martin's Street, where "a terrible poseur" had shown him a room "no bigger than a handkerchief", but whose window had "a superb view".

His social life included a succession of dinners at Mrs Hunter's. He spent time with G. Moore, whose contempt for British politics had not abated, with Sargent (at the house of the American poet, Harrison), and with Raymond Koechlin, London correspondent of *Le Figaro*. One event stood out against the daily grind: the funeral of Queen Victoria, who was buried on Saturday, 2 February. Monet watched the cortège pass by from the first-floor window of a house where he had been taken by Sargent, and where he met the American novelist, Henry James. "I would have loved to have made a sketch of the occasion."

Vétheuil, at Sunset
1901
Cat. no. 1645

Vétheuil, the small arm of the Seine
Postcard, 1900

The Meadow

Hardly had Monet recovered from his trip to England, than he made it plain to Paul Durand-Ruel that he should come to Giverny. He had spent "a crazy amount" in London, and needed to sell paintings. Negotiations with his main client account for much of his correspondence in 1901, which shows Monet engineering a steady but not excessive rise in his prices. At the same time, he stoutly denied being a "money man". Over the course of the year he sold 17 canvases – to Bernheim-Jeune, Shchukin, Pitet (acting for Julius Oehm) and above all Durand-Ruel, who bought twelve – for an average price of 7,500 francs each, making a total of 127,500 francs. Though lower than in previous years, his income was still more than sufficient, and his stock of unsold pictures augured well for the future. They included many unfinished studies, in particular a large number of London and a few gardens, though the latter had not been well served by the poor weather of the spring and summer. The Panhard had not helped matters either. Finding a suitable chauffeur-cum-mechanic was not easy, though it was hoped that outings in the car would help to cheer Alice, who was still very depressed. Ultimately the car was to prove an asset not just for leisure, but also for Monet's work.

The water-lilies series, on the other hand, were soon to be eclipsed, through a decision taken by the painter himself. Monet felt confined by the sight of his tiny pond, and was determined to find a larger surface from which he could obtain more varied effects. As the property was too small for him to enlarge the water garden in its present location, he decided to purchase a strip of meadow running parallel to his own land on the other side of the Ru. The owner of the meadow was one Mme Rouzé, a widow from Mantes, and she agreed to part with the land that Monet coveted. The sale took place on 10 May 1901 in Ver-

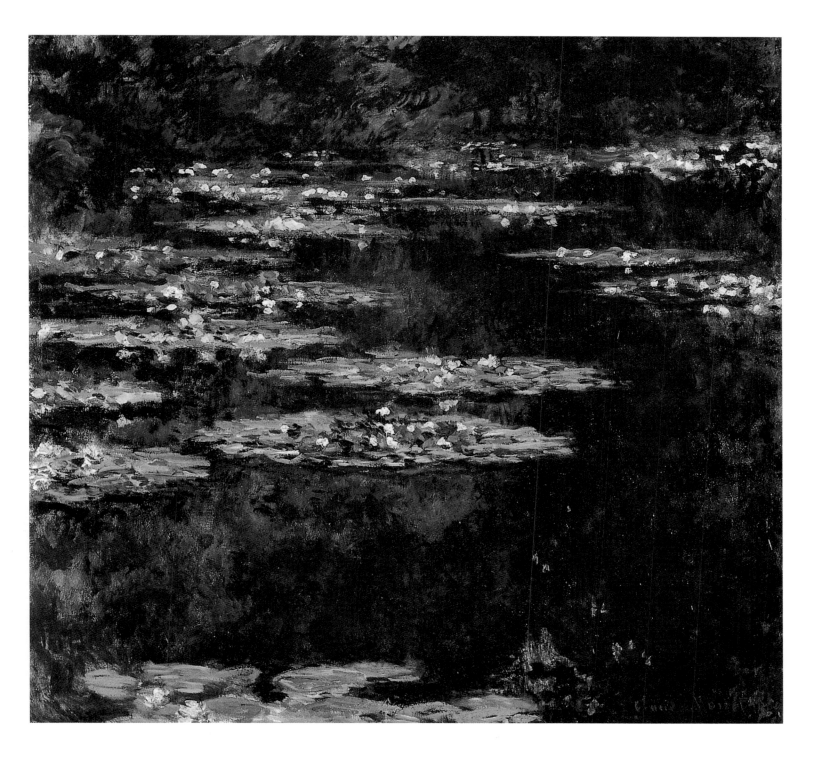

Water-Lilies
1903–1904
Cat. no. 1664

non. The land in question was "a part of a meadow ... of an area of 39 acres 20 centiares to be measured out along the smaller branch of the Epte, called the stream [ruisseau, or Ru]." It was to be 173.4 metres long, with an uneven border. At its greatest width upstream it was 35 metres wide. Monet was in such a hurry to take possession of it that he handed over the agreed sum (1,200 francs) at once. A clause in the deed of sale indicates the buyer's intentions: "Whether he should keep the river in its present course, or arrange for its diversion, M. Claude Monet will do nothing which might infringe the rights [of Mme de Rouzé] as herein specified." These individual rights were further complicated by the existence of collective rights affecting the fate of the Ru. In France, a watercourse cannot be diverted without the agreement of all those who reside along its path. Formidable as the obstacles may have seemed, the enterprise was fairly quickly brought to a successful conclusion.

Farewell to Vétheuil

When Arsène Alexandre came to visit him during the summer of 1901, Monet showed him round his property. But he either failed to mention the alterations that he had in mind, or asked Alexandre not to reveal them in his article. Monet's distrust of the journalist dated from the previous autumn, when Alexandre had told the readers of *Le Figaro* that Monet had, "so they say, flooded part of his garden at Giverny, planted it with water lilies, and thrown across this pond a bridge after the Japanese fashion." Alexandre clearly wanted to make amends. In *Le Figaro* of 9 August, he wrote: "Many myths have been invented about this garden. It has been said that one day, on a whim, Monet flooded part of his garden and planted it with aquatic flowers; and then the following summer, he painted the series shown to the public last autumn." Nothing could be further from the truth. "The pond has been there for more than ten years; the series of paintings was begun almost as long ago, and has been continued on and off ever since." As for the painter, "sometimes he works in this garden, till his eyes and imagination are intoxicated by the play of intangible reflections on the marquetry of blossoming flowers and reflective molten metal. More often, however, he labours in a great studio that has been built in the midst of this flowering marsh, and which is part tent, part observatory."

Thanks to Alexandre, we know that Monet worked beside the pond on certain days during the spring and summer of 1901. We are much better informed about the work he did during the same period at Vétheuil. This was his last attempt to go back to his roots, as he had done at Pourville. It was also an opportunity to make use of his recently-acquired car. His destination was not

Water-Lilies
1904
Cat. no. 1666

Vétheuil itself, where the neglected tomb of Camille in the little graveyard was too painful a memory. Instead, he went via Gasny, La Roche-Guyon (which at that time was linked to the left bank of the Seine by a bridge) and Moisson to Lavacourt. Here, looking out across the houses and the road that separates them from the bank of the Seine, there was a wonderful view towards Vétheuil, dominated by the church tower and the gentle hills behind. How many times had he already painted this motif, and from how many different angles, twenty years ago! Now there was no question of moving his easel from place to place. A single point of view was enough. Variety, in so far as there was variety, would be provided by changes in light and atmospheric conditions.

By studying the paintings we can tell where Monet set up his easel. This was just to the left of the inn "Au rendez-vous des canotiers" (looking away from the river), level with a bungalow which was at one time notable for its half-timbered façade and ochre roughcast. Moreover, we know from local informants that Monet's trips to Lavacourt at this time were closely connected with the owner of this house, Mme de Chambry. Monet, who probably met Mme de Chambry during his long stay in Vétheuil from 1878 to 1881, found her a most welcoming landlady. Although she received only a modest widow's pension of some 2,000 francs a year, she still had the manners of a great lady, even going as far as to make a gift of a brooch to Germaine Hoschedé.

Monet did not come to Lavacourt alone. Jean-Pierre Hoschedé vividly remembered the outings in the brand new car: "I was usually his chauffeur. My mother and my sister Germaine – who was not yet married – were always with us on these pleasant trips. Sometimes Mlle Sisley, who often came to stay at our house after her father's death, would come too." On occasion a young painter,

Water-Lilies
1904
Cat. no. 1667

Abel Lauvray, whose brother Monet had once painted on an earlier trip to Vétheuil, would cross the river and, in some trepidation, watch his older colleague at work. He was attracted by the charming Germaine, but she gave him no more encouragement than she had Pierre Sisley.

All the evidence suggests that Monet painted the Vétheuil series (**1635–1649**) from Mme de Chambry's chalet, but there is some disagreement as to where exactly he stood. On the bank in front of the house? On the ground-floor balcony? Or on the first-floor balcony? Careful examination of the paintings reveals that he painted from one spot only; this was probably the first-floor balcony. We also know that the painter worked on these pictures during the afternoons, as Jean-Pierre Hoschedé, his part-time chauffeur, confirms. Monet himself tells us how long he worked on these paintings: "I undertook a series of views of Vétheuil, which I thought I would get through quickly, and which have taken me the whole summer, so everything else went by the board." Since these lines were sent to Paul Durand-Ruel at the beginning of the autumn, it seems likely that work on the series had continued till then. The rustic pleasures of Lavacourt must have been more restful for his entourage than for the ageing man who for one last time came to watch the light play on the church and town of Vétheuil where he had left so much of himself.

Towards a Subjective Impressionism

Early in 1902, a solo exhibition brought 38 of Monet's paintings together at Durand-Ruel's gallery in New York. At the same time, the water garden was

Water-Lilies
1906
Cat. no. 1683

Water-Lilies
1907
Cat. no. 1696

being turned upside down by the work to alter the course of the Ru and enlarge the pond. It was extremely cold at Giverny in mid-February. This did not hinder the excavations, but it was a daunting obstacle for the planting programme. The new lake was to be covered with water-lilies and the new banks were to be decorated with aquatic plants and shrubs. As the weather began to improve, Monet had to spend more and more time supervising the work. This was both a source of irritation and a good excuse not to leave Giverny for long periods of time. When Jacques, the elder of the Hoschedé sons, was ill with typhoid, Monet let Alice travel alone to Saint-Servan, near Saint-Malo, to visit him. This separation had one fortunate consequence for the historian. It produced something quite exceptional: a series of letters written by Monet to his wife from Giverny.

While Alice was away, Anna Bergman, Jacques Hoschedé's stepdaughter, came to stay. Jean-Pierre had brought her back from Brittany, for fear of possible contagion. Monet did his best to entertain her, with assistance from Jean and Blanche who had the young Norwegian girl to stay with them in Rouen for a week. The Butlers were temporarily without a servant and would come to lunch and dine at the Pressoir. They were a pleasant distraction for Monet, but their presence could also be a source of tension when Michel and Jean-Pierre were there at the same time. Monet was frequently called on to act in his twin roles of father and grandfather. Monet's temper was redoubtable, but the prospect of the two coming to blows was very alarming to him. At the same time he was careful not to neglect his duty as a husband, anxious as he was not to incur the displeasure of his wife whom he both feared and adored.

Germaine's departure had not made things any easier, as she usually helped Alice run the house. The youngest of the Hoschedé daughters was staying at Cagnes-sur-Mer, as a guest of the Deconchy family at their house, La Bégude.

Still Life with Eggs
1907
Cat. no. 1692

When she heard that Jacques had fallen ill and that Alice had gone to Saint-Servan, her first instinct was to return to Giverny in all haste. But later news of Jacques put her mind at rest and she delayed her departure. There was good reason to stay in Cagnes as long as she could: she had just met and fallen in love with a young lawyer, Albert Salerou. The Deconchys, who were the kindest of hosts, did everything they could to keep their guest, hoping that they might persuade her parents to join them. But Monet was in no mood to undertake such a long journey by car, especially since he would in any case have to travel to Saint-Servan in the near future. Germaine found a travelling companion to escort her as far as Paris, whence her stepfather brought her back to Giverny. The interest of these details lies in the fact that Ferdinand Deconchy, Germaine's host at Cagnes, was the brother-in-law of the architect Louis Bonnier. Bonnier was later to play an important role in Monet's life, since he drew up the first plans for a building to house the *Grand Decorations*.

While Giverny was being turned upside down by all this commotion, the Galerie Bernheim-Jeune at 8 Rue Laffitte in Paris, was showing an exhibition entitled *Œuvres récentes de Camille Pissarro et une nouvelle série de Claude Monet (Vétheuil)* – (Recent works by Camille Pissarro and a new series by Claude Monet (Vétheuil). The catalogue lists only six works from this series, but it is

clear from reviews that around a dozen were exhibited. How much the critics actually saw of these paintings which, according to Paul Durand-Ruel, were "atrociously" hung in "ill-lit" rooms, we cannot be sure. What we do know is that when Monet authorised him to complain to the organisers on his behalf, Durand-Ruel toned down his remarks considerably, and even pleaded extenuating circumstances: "I think it is best not to say anything to the Bernheims. They are well-intentioned and, of all the Paris dealers, they're the most reliable. Their premises are not suitable for an exhibition, but that is not their fault. They are also very young [and] don't yet know that one must expect to be misunderstood, even by those who think themselves 'enlightened'."

The events that made up Monet's life at this time can be seen to fall into four broad categories. The first, and most fundamental, was his work. The second, which influenced and on occasion impeded the first, was his relationship with the two sides of his family. The third was his social life in Giverny and elsewhere, particularly in Paris, which included his relationships with friends, journalists, clients and, pre-eminently, with Paul Durand-Ruel, who was both client and adviser. The fourth, less obvious but no less important, was the gradual increase in his fame, and the corresponding increase in the prices his work commanded both at home and abroad.

After the delays caused by work on the diversion of the Ru and the enlargement of the pond, the summer brought a welcome return to painting. In August, Monet was "absorbed in [his] work" and not "too unhappy", even though the weather was against him and he had "great difficulty finishing". This must refer to work in the open-air; he was almost certainly painting in the flower garden (1650–1653) while he waited for the lilies to grow back. By October, he was less happy with his progress than he had hoped. Even though he claimed to have reached a state of "relative calm, at last", it is clear that he was anxious about the time that he would lose in preparations for Germaine's marriage. He invited Durand-Ruel to come and see what he had done, or at least, what he had not been able to do, that summer. Durand-Ruel reassured him: "I understand that a man like you cannot get down to serious work at a time like this. But you will easily make up for the wasted time this winter." A cheque for 20,000 francs, closely followed by another for 10,000 before the end of the year, helped to free Monet of any financial worry.

Documentary evidence suggests that Monet was a little neglected by his Parisian friends and the press at this time. Dealers visited infrequently. This should not surprise us. By now, Monet was sufficiently well-off to be free of any urgent need to sell his work. Instead he took his time, making a small number of sales, each of which comprised several paintings. Thus the Bernheim-Jeune brothers bought six of the Vétheuil paintings for 48,000 francs. Boussod and Valadon took two Vétheuils for 16,000 francs. Durand-Ruel purchased two Vétheuils for the same sum, and two Rouen Cathedrals for 25,000 francs. The total for the year's sales was 105,000. Monet now had a substantial income from his investments. He was therefore able to write "No Sales" in his account-book for 1903, without undue anxiety. In 1902, the 10 Vétheuil paintings had fetched 8,000 francs each, and the two Cathedral paintings had brought 12,500 each. Prices were holding up, though the kind of improvement Monet seems to have expected when he initially tried to sell the Cathedrals at 15,000 a piece had not occurred. In terms of exhibitions, however, he was making considerable progress. During 1902 his work could be seen in Paris, New York, Boston, Brussels, Mulhouse, Karlsruhe, Edinburgh, Prague, Pittsburgh, Le Havre, Dresden and Berlin. With the exception of Paris and New York, Monet's contribution was limited to a few paintings as part of larger exhibitions, but this was the way

forward if he was to become more widely known. His increasing success in Germany was particularly striking. This he largely owed to Paul Cassirer, Durand-Ruel's agent in Berlin, who covered the whole country on behalf of the Paris dealer. Cassirer spoke out bravely on behalf of French Impressionist art despite the great resistance it still met with throughout the German Empire.

"Study and research, which will prove fruitful"

Monet's correspondence for 1903 is somewhat misleading. On the one hand, much painful labour was expended on the London series, at which Monet worked long and hard without achieving what he considered satisfactory results. On the other hand, the brief water lilies series (1654–1661), a brilliant success, is hardly mentioned in his letters. "My work is not advancing at all", he admitted to Rodin. "I am full of doubts and thoroughly discouraged." In these moments of candour, his essential modesty is clear: "I thought that one day I might do something worthwhile, and when I look at what I am doing it seems to me so insignificant, and I feel I have so much progress still to make, that I have no strength to go on." To be still talking of progress when one is on the wrong side of sixty deserves our respect. But the most astonishing thing was that Monet was to go on and make progress even more·profound than he had hoped.

In the short term, though, it was doubt that predominated. No one was more worthy of Monet's confidence in this matter than Rodin. Despite their philosophical differences, they were bound by the brotherhood of genius. When Théodore Duret informed Monet that Constantin Meunier, the miner's sculptor, had been commissioned to create a monument to Zola, Monet did not conceal his distaste for a choice he was convinced must have been made on party political grounds: "Let me begin by saying that I deeply regret that the monument to Zola was not entrusted to Rodin. This should be an artistic question, the homage of a great sculptor to a great man, and no political question should ever have arisen." Monet's reaction was that of any independent mind faced with the sectarian manoeuvring that characterised the Combes administration.

On a visit to the Durand-Ruel Gallery in early February, Monet rashly promised to show his London series there in May. Doubtless he was encouraged by the favourable notices he had been receiving both in the United States, and at the Vienna Secession where eight of his earlier works were on display. He dreamt of exchanging recent paintings for the *Turkeys* (416) which he coveted as a souvenir of the happy days he had spent at Montgeron. Meanwhile, he was working harder than ever on a view of the Thames. He kept them all in his studio, refusing to part with a single one; he wanted to be able to see and work on each item all at once. But his dissatisfaction and anxiety are palpable. Inclusion in the exhibition, *Œuvres de l'Ecole Impressionniste* (Works of the Impressionist school) at the Bernheim-Jeune gallery did nothing to revive his spirits. On 10 May 1903, he sent a despondent letter to Durand-Ruel, informing him of his decision to abandon the London series, and offering to repay the advances he had received. He intended to make one last attempt to resolve the problem when the weather had improved: "Then I will see if I am still of any use." Chivalrous as always, Paul Durand-Ruel declared himself only partly surprised at this news, since he had not expected to see the pictures for some time. In any case, there was no question of repaying the advance: Monet, he was sure, would easily find some pictures against which it could be offset. In fact, neither Monet's notebook nor his accounts record any transaction during the entire year. Yet Durand-Ruel certainly came to visit in June at Monet's invitation; he

Claude Monet in his car, probably the Panhard-Levassor purchased in December 1900.

Sylvain Besnard, Claude Monet's "car driver"
or rather his appointed chauffeur
c. 1900

was instructed to avoid Sundays, when the family would go for a ride in the car.

The Panhard was by now an established part of the Giverny lifestyle. To avoid disrupting Monet's work, it was only used on days of rest. "The automobile driver", Sylvain Besnard, became so indispensable to them that the military authorities granted him a dispensation, as having "a family to support", for the thirteen days he should have spent with the reserves at Evreux in September.

Monet's correspondence scarcely mentions his open-air work of that summer. He was painting the newly enlarged pond. Its lily-covered surface now offered a subject in itself, which did not require the framing device of the Japanese bridge: "I have slaved away all summer amid numerous showers", he wrote in November, "but that was all study and research, which will, I think, prove fruitful." Monet's researches at this time extended in several directions. Some of the paintings (1654–1656) remained relatively faithful to the traditional impressionist landscape, with a partial view of the far bank of the pond beyond the lilies in the foreground. In another picture (1659), the far bank is simply suggested by the reflections of the trees in the water, which is treated in a realistic manner. But others (1657–1658) deliberately eliminate the far bank by their abrupt framing, while using a thin curtain of weeping willow to evoke the near bank where the painter stands. In yet others (1660–1661), there is nothing to be seen but the great masses of flowering lilies. Thus the essential themes of the water lilies series – the floating blooms accompanied by reflections of the sky, clouds and vegetation – had already been outlined by 1903.

Monet was disturbed in his work by "the horrible weather" that had continued all summer. He also complained, in early November, of the disruptions caused by Germaine, who was expecting a child, and Jean-Pierre, who was about to be married. Both events were to take place in Giverny, despite the fact that the protagonists now lived elsewhere. Giverny was a haven for the

Hoschedé family and a natural source of sustenance, both spiritual and material. Paul Nadar was to take the portrait of Jean-Pierre and his fiancée, and Monet wrote to him outlining his views on photographic aesthetics: "I hear that you ... have been asking them for draperies and goodness knows what? So let me ask you, in my turn, to photograph them as simply as possible, as they are ... I say this merely to remind you of my predilection for the simplest possible portraits, without any artifice." In photography, Monet applied the principles of naturalism and rejected the convolutions of Art Nouveau. By contrast, his painting now took as its subject an artificially arranged nature and was moving closer to Art Nouveau ideals.

Enthusiasm to Order or Spontaneous Admiration?

In the night of Saturday to Sunday, 10 January 1904, Léon Gérôme, one of the most famous opponents of Impressionism, passed away in his *Hôtel Parisien*, 65 Boulevard de Clichy. Gérôme, whose path crossed Monet's several times, was in many ways a tragic figure. He sought to defend the academic tradition while a new artistic universe was springing up around him which wanted nothing to do with his work, and which seemed intent on devaluing his own career in the eyes of posterity. By an extraordinary coincidence, Gérôme's death was almost immediately followed by Monet's greatest triumph since the beginning of his career. His views of the Thames were shown at Durand-Ruel's in May and June 1904. At the end of the preceding year, the painter had declared that he intended to resume work on his London series. This work was, of course, done in his studio, despite the many claims to the contrary. Thus, for example, René-Albert Fleury: "He neither has nor needs a studio – Claude Monet never works from memory." Only the second statement is correct. Visual memory has its limits; we have seen that Monet refused to give up even "a single canvas of London, because, for the work in hand, it is indispensable to have them all where I can see them." On 16 February, he scribbled a few lines to Durand-Ruel "... in haste, for I am in the thick of work." His dealer rightly assumed that he would soon be able to exhibit the "beautiful views of the Thames", and Monet confirmed this at the end of the month.

While he was putting the finishing touches to the three dozen canvases he had chosen to show, another serious family problem arose. A secret file seems to have been assembled which contained accusations against his son-in-law Jacques Hoschedé. Monet was obliged to go and see Georges Clemenceau several times in person to ask for his help. Political relations – at such an exalted level – can be very useful, but they cannot be exploited from the heights of the ivory tower. A descent is required. Monet took advantage of a charity tombola for Russian soldiers wounded in the war against Japan to attract his protector's attention and donated one of his paintings. This was an exceptional gesture for Monet, who was not renowned for his generosity. But it also shows him very much a man of his time, convinced of the value of the celebrated alliance with Russia; this had now lasted for ten years, and its ultimate test was just ten years away. Meanwhile the Entente Cordiale with England was signed on 8 April 1904. In March of that year, Wynford Dewhurst published his *Impressionist Painting*, which was dedicated to Claude Monet – an act which thus came to symbolise a rapprochement that was both political and cultural, and from which the forthcoming London exhibition was to benefit considerably.

The first crates of paintings were already on their way from Giverny to Paris, when Durand-Ruel enquired what title he should give the exhibition:

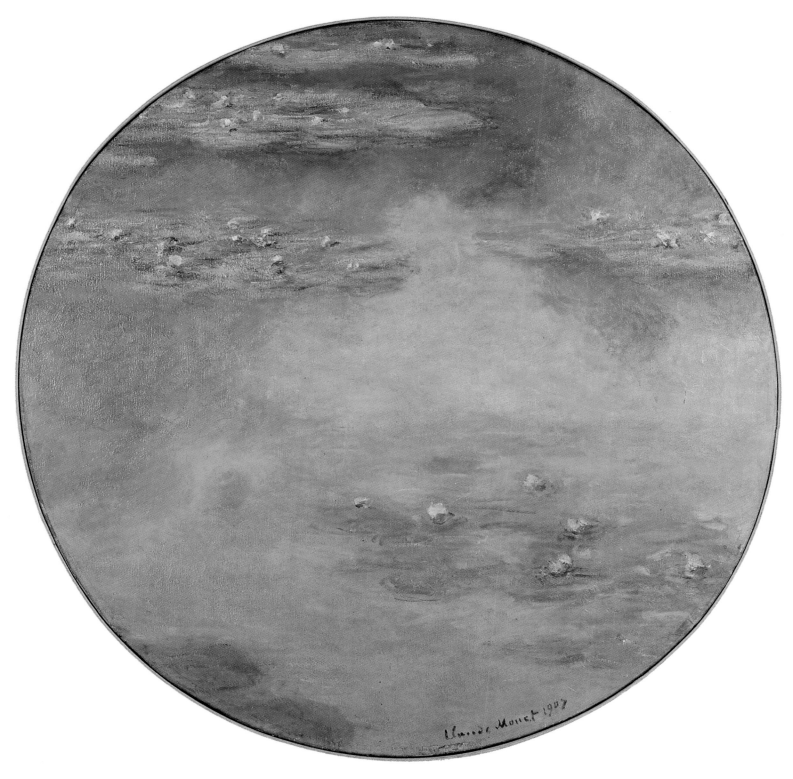

Water-Lilies
1907
Cat. no. 1701

"London" or "The Thames"? Monet replied the next day with a draft invitation on which the two possibilities were neatly reconciled: *Vues de la Tamise à Londres – 1900 à 1904* (Views of the Thames at London – 1900 to 1904). Monet's "fine white beard" and "kind smile" (as de Bettex described them) were also on display , where he received "the most sincere compliments". On 10 May, the day after the gallery was opened to the public, Durand-Ruel wrote to Havemeyer to announce that the exhibition was an "enormous success." The same day, Georges Niel wrote in *Le Soleil* under his pseudonym Furetière: "Between two and five o'clock every day, carriages and automobiles can be seen making their way from the Champs-Elysées to the Rue Laffitte. Claude Monet is a worthy rival to the Salon, with which he is no longer on the best of terms."

Water-Lilies
1907
Cat. no. 1703

That his solo exhibition could rival the Salon itself was a clear sign of Monet's public consecration. Nobody sought to contest this triumph, though some of the painter's more ardent supporters may seem to have stooped rather low in underlining their hero's success. The main culprit was Octave Mirbeau, whose preface to the catalogue was reproduced on 8 May in *L'Humanité*, the newspaper recently founded by Jean Jaurès. Mirbeau began with a formal attack against art critics, singling out for special attention Camille Mauclair and Charles Morice, both of whom wrote for the *Mercure de France*. Their cardinal sin, in his eyes, was to have criticised Pissarro, Mauclair in the past, Morice "quite recently." Was it fair to criticise the living for lavishing insufficient praise on an artist only recently dead? Mirbeau was not to be deterred by such subtleties. Having thus vented his spleen on the two critics, he went on to fill column after column with his "cries of admiration" – to use his own term – for Monet's London paintings.

"Gardening and painting apart, I'm no good at anything"

The success of the show *Vues de la Tamise à Londres* in the spring of 1904 was to be followed the next year by a triumphant exhibition in London itself. Together, these two events would mark a turning point in the artist's career. Monet was now a public figure, ever more in demand for interviews, and the subject of a growing stream of articles. He had become famous.

On 11 May, Monet had sold eighteen London pictures to his dealer. On 7 June, he handed over another six. The prices varied between 8,000 and 11,000 francs, and the two transactions together brought in a total of 252,000 francs. Together with 19,000 francs for two paintings he had sold to Sutton, his total income for the year 1904 was therefore 271,000 francs. This considerable sum, together with the interest on his investments, was enough to leave him free of financial worry. But Monet's principal anxieties at this time were not financial. Painting was an implacable mistress who allowed him little respite. As in his youth he lamented the bad weather that stopped him working. Then, when the clouds cleared and the sun re-emerged, he would paint from dawn till dusk. Sometimes he worked "with enthusiasm and full of high spirits", sometimes he was "disillusioned, unhappy"; this depended on the whims of the weather. There is nothing new here. It is the continuity that is striking. Monet at sixty was still a devoted plein air painter, the vicissitudes of his moods intimately bound up with the fate of his motifs.

Despite these conflicting moods, a feeling of great serenity emanates from the water lilies dated 1904 (**1662–1667**). These few large, almost square canvases show long, oval rafts of lilies banked up on top of each other, receding in perspective towards the far bank. Underneath, a blue-green, almost transparent mirror of water suggests the depth of a third dimension. Unfortunately, the surviving documents give us no account of how these masterpieces were created. All we know are the external, anecdotal circumstances of their making. In *Le Jardin de Claude Monet* (Claude Monet's Garden) Maurice Kahn offered the reader of *Le Temps* an overview of the world of Giverny: the location of the village, the prestige that Monet enjoyed there, the influx of Americans who loved to copy his motifs and ask his advice, and who were promptly shown off the property: "I live in the countryside so that I can have peace ... Do as I do: Work! Look!." Whence his "reputation for boorishness". The journalist was

Water-Lilies
1907
Cat. no. 1713

shown "into a little Japanese drawing room" by a maid, where he had time to note some of the authors whose works lined the bookshelves. Then Monet appeared before him in classic guise: "heavy footstep", "long grey beard" and a look of "boredom and resignation". He invited his guest up to his studio (this being the two-storey studio to the west of the house). There he showed him paintings from every period of his career, starting with a fragment of the *Luncheon in the Grass* (**63**) and finishing with the water-lilies. Of the London paintings, Monet confessed: "After four years of working and reworking on the spot, I had to resign myself to merely taking notes and finishing them here, in the studio..." Maurice Kahn added: "I sensed in these words a tinge of regret. For Monet, painting in the studio is not really painting..." They walked through the two gardens. The lily garden had a marked Japanese feel to it, which Monet said he had not consciously sought, but which M. Hayashi, a Japanese resident of Paris, had also remarked upon. When they reached the pond, Monet beamed with false modesty "under his great parasol ... leaning down towards his beloved lilies." He could not resist a little joke: "Gardening and painting apart, I'm no good at anything." Which leads the reporter to conclude: "Having seen Claude Monet in his garden, one understands why such a gardener paints as he does."

The appearance of Kahn's article in the widely-read *Le Temps* helped to spread Monet's fame. He also took pride of place in Fernand Caussy's *Psychologie de l'impressionnisme*, which appeared in the *Mercure de France* in December. At the same time, Cassirer was trying to obtain the loan of some of Monet's

Water-Lilies
1907
Cat. no. 1715

views of the Thames for his Berlin gallery. Durand-Ruel had plans for a major
exhibition on the other side of the Channel, but Monet preferred to limit the
venture to the London paintings, and take on all the costs himself.

At Giverny, the motorcar now ruled supreme. So much so, that the munici-
pal council was soon forced to impose a ruling limiting "all vehicles to a moder-
ate speed". Monet was among those directly affected by this ruling. He was
fined, in the spring of 1904, for travelling at excessive speed through Freneuse,
between Giverny and Lavacourt. He made a point of appearing in person before
the magistrate at Bonnières to assure him that he too disapproved of travelling
too fast. Speed was, in any case, out of the question when Monet, Alice and
Michel came to make a long journey to Madrid in October. One can imagine
the old couple wrapped up in their overcoats and swathed in scarves, their eyes
protected by thick goggles, balancing the Touring Club map on their knees.
The Panhard trundled and backfired along the 800 kilometres that separate
Giverny, which they left on the 8th, and Biarritz, which they reached on the
11th. There the car was left for essential repairs, and they finished the journey in
a crowded Sud Express train. They arrived in Madrid on the 14th, where Paul
Durand-Ruel was waiting for them, delighted at this happy coincidence in their
travelling plans. There they visited museums, churches and art academies.
Monet was moved to tears by the paintings of Velázquez. An excursion to
Toledo reminded him of his time in Algeria as a young man; the El Grecos
astounded him. The return journey to Giverny went off without a hitch,

although the Panhard was still indisposed after its stay in Biarritz and refused to go faster than thirty kilometres an hour. No sooner had Monet and his family arrived home, than they set off again, this time to see the car races at Gaillon, where they enjoyed a twentieth-century "luncheon in the grass", seasoned with dust and exhaust fumes.

In early November, a political storm broke out on the banks of the river Epte. Since the defeat of 1870, a significant current in French public opinion had been hoping for a war of revenge, in which the eastern marches would be reduced to a desert strewn with corpses and ruins. Predictably, many supporters of the war party also hoped that this might be achieved without prejudicial consequences for their own home territory. The municipal authorities of Vernon and Giverny were of precisely this cast of mind. When the army decided to create a shooting range for the troops garrisoned at Vernon, the municipal council insisted that it must be located outside the commune. There was uproar in Giverny when it emerged on the first of November that the army had its eye on the Heurgival quarries just to the north of the town. Albert Collignon won the eternal gratitude of those whose lives he administered by leading a vigorous campaign against the site. He embarked upon an endless process of lobbying, which he took to the highest levels of both the military and civilian hierarchies. On 2 November, he delivered letters of protest to the councillors and other local figures, to be signed by themselves and their households. Monet received and signed such a letter, which was also signed by Alice, by the Salerous, M. and Mme A. Hilderson, the chauffeur Sylvain Besnard and Félix Breuil, the head gardener. The letter displayed at the Hôtel Baudy was signed by more than twenty foreign artists, who thus conveniently overlooked the traditional principle of non-interference in the internal affairs of a country they were staying in. But they had every right to make their feelings known when not only the local administration, but certain high-ranking officers, who happened to be friends of Collignon, approved both of the battle he was waging and of his appeal to the interests and desires of the artistic community. The affair was finally settled in January 1905, in the office of Maurice Berteaux, Minister for War. In the presence of the plaintiff, Berteaux signed and addressed "to M. le Général Joffre, Chief of the Engineers, a written order to choose a firing range other than Heurgival for the Vernon garrison." Giverny breathed a sigh of relief, and Monet, his fears allayed, could set off for London to begin preparations for his one-man exhibition.

London: The Entente Cordiale

In January 1905, Camille Mauclair published an article in *La Revue Bleue* under the surprising – and ambiguous – title, *La Fin de l'impressionnisme* (The End of Impressionism). Mauclair's title was very much in tune with the concerns of the moment. The 1904 *Salon d'Automne* had revealed, alongside the familiar cohorts of post-Impressionists, a new school of artists. In 1905, they acquired the name of "Fauves" (or wild beasts). Mauclair did not seek to deny Impressionism's crucial role in the history of French art. But he refused to believe that it was the "cenotaph" of French art. Monet's followers, he rightly agreed, were of lesser stature than their master. It was time for young artists to look for new ways forward. "That is why it is not a disavowal or a denial of the past to talk about [the] end [of Impressionism]."

When Durand-Ruel read these lines, he was moved to write to Mauclair to express his concern over the title and certain passages of the article. "There are

those who think or would like to think that, in your view, the prestige of Impressionism is at an end, which was not at all what you meant." However, "most art dealers and a large number of artists are increasingly determined to stem this movement which is spreading through the entire world." They were, apparently, wasting their time, at least in London, given the enormous success of "our exhibition [which] is drawing many visitors. The newspapers are full of laudatory articles, and the impact on the public is quite extraordinary."

Paul Durand-Ruel was right. The exhibition he had organised at the Grafton Galleries had opened at just the right moment to benefit from public enthusiasm for the Entente Cordiale. Pictures by Boudin, Manet, Pissarro, Cézanne, Monet, Renoir, Degas, Morisot and Sisley had been brought together: 315 works, of which 55 were by Monet. The press was ecstatic, and the

Water-Lilies
1908
Cat. no. 1721

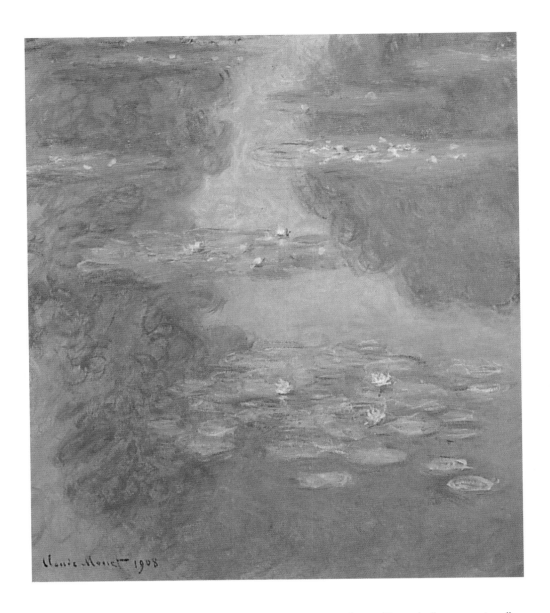

Water-Lilies
1908
Cat. no. 1725

general enthusiasm overwhelmed the reservations about French "mannerism" expressed here and there. This success, for which much of the credit was his own, encouraged Monet to press ahead with his plans for a solo exhibition at the Dowdeswell gallery. His idea was to exhibit his London paintings, none of which were included in the Grafton Galleries exhibition. As soon as he had got over a bout of flu, he was back at work, in the hope that the views of the Thames he was preparing for the occasion "would be as good as the rest, if not better".

However, all was not plain sailing. On 6 February, Paul Durand-Ruel admitted to Monet that there were problems. "There is a lot of opposition. In London, many artists and almost all the dealers are against us. They have come to laugh and to scoff. But he who laughs last, laugh longest." Shortly thereafter, Durand-Ruel was so disturbed by one incident that he asked Monet "not to involve [him] at all in this affair". Two friends of Sargent, Sir William Rothenstein and L.A. Harrison, had voiced some highly critical remarks during their visit to the Grafton Galleries. In particular, they had singled out Monet's Cathedral paintings which, they said, "looked as though they had been painted ... from a photograph." Georges Durand-Ruel had hastened to assure the visitors that Monet always painted from nature. In reply, Harrison had told him that "Monet paints dozens of pictures in his studio; and only recently he asked me to send him a photograph of the bridges of London and the Parliament so

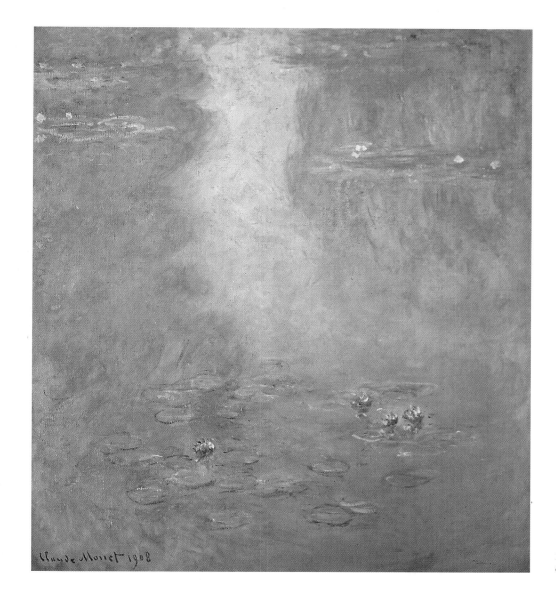

Water-Lilies
1908
Cat. no. 1731

that he could finish his views of the Thames." "You would do well not to ask people like Harrison for photographs in the future", advised Paul Durand-Ruel. "It could endanger the success of the exhibition you are planning." Monet's reaction is well known. Harrison had indeed been asked, through Sargent, to obtain a small photograph of the Parliament for him, but in the end Monet had not been able to use it. "It doesn't mean much. Whether my Cathedrals, my London pictures and all the others are painted from nature or not, is of no significance, and is nobody's business but mine." Before telling Sargent what had happened, Monet wished to know more about the personalities of his two opponents, "so as not to put my foot in it". In any case, he was uncertain whether he could count on Sargent's support, for he suspected him of being as jealous as his colleagues. Paul Durand-Ruel reassured Monet about these matters, and in particular about Sargent. Sargent's success, according to Durand-Ruel, had placed him above jealousy. This remark did greater honour to Durand-Ruel's good nature than to his judgement, but it was enough to reassure Monet, who never mentioned the matter again.

Despite such setbacks, Durand-Ruel's attempt to introduce Impressionism to England had been a considerable success. Monet, who was not, as a rule, much inclined to praise congratulated him upon it. But the incident was a warning to him, and may well have influenced his decision to give up the idea of a solo exhibition at Dowdeswell's gallery.

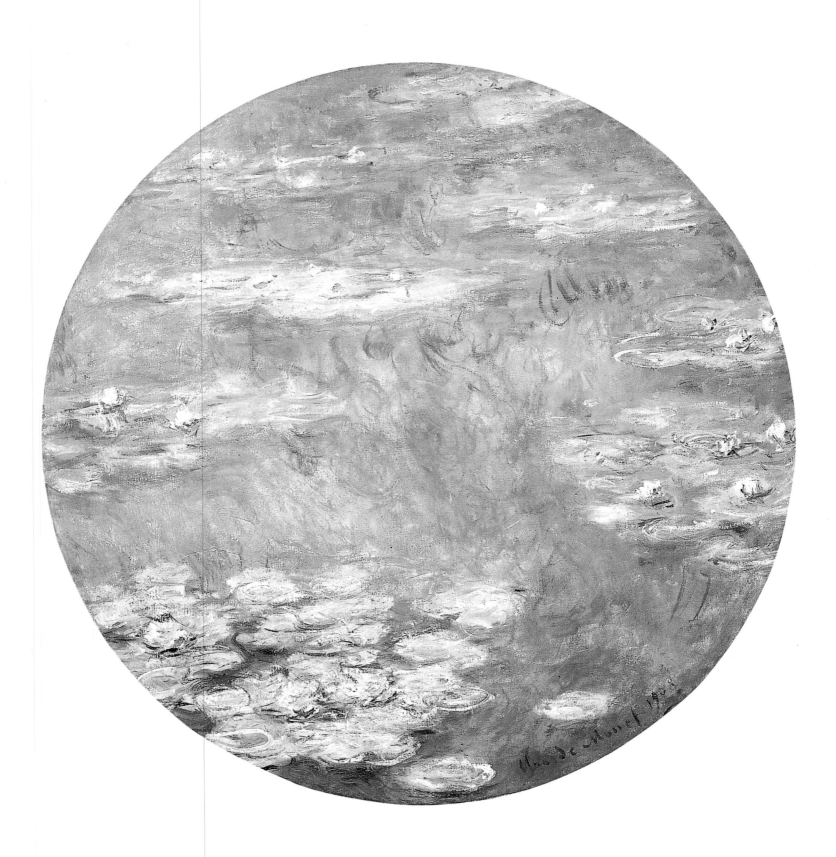

Water-Lilies
1908
Cat. no. 1729

Louis Vauxcelles at Giverny

In February 1905, Emile Combes' government fell. It had lasted three years. Monet was forced to ask Clemenceau to speak to the new Interior Minister on behalf of one of his family, a humiliating step for one who openly boasted that he never asked anyone for anything. The bad weather of early April depressed him as it might have a young lad painting his very first picture. However, the sale of the Bérard collection at the Georges Petit gallery, in which he had six works, lifted his spirits: *Melting of Floes* (**569**) sold for 27,100 francs. Once

more, Paul Durand-Ruel had been instrumental in ensuring that his painters continued to fetch good prices.

Monet continued to work on his views of the Thames, which were in great demand. In response to a question from Georges Durand-Ruel, acting on behalf of a Detroit journalist, he listed the six colours that made up his palette. This incident showed both the growing interest in Monet's painting in the United States, and the scientific pretensions of the American approach to art at this period. This contrasted with France, where interest in the Impressionist movement at that time seems to have focused mainly on its history. People had begun to realise that the pioneers of Impressionism would not survive indefinitely. One of their number, Théodore Duret, had decided to write a *Histoire des peintres impressionnistes* (History of the Impressionist Painters), for which he was interviewing admirers and collectors who had, like himself, been involved with the movement from its earliest days. Murer's replies were instructive, but the famous pâtissier was not forthcoming about Monet, with whom he had had a serious quarrel many years before. Monet no longer pretended to be poor, but he was no less ruthless in business matters. Henry Lapauze's request, passed on by Durand-Ruel, that Monet consider donating some of his works to the Petit Palais, as Henner and Ziem had done, was met with a blank refusal. Having been badly treated by the French authorities throughout his life, Monet felt no inclination to oblige them now.

The monotony of daily life was relieved, as in preceding years, by outings in the car. In July, the family were photographed on the shingle of a Normandy beach; in August they were in Mantes to watch a car race. A different kind of distraction was provided by the select few who were allowed to visit Monet at Giverny. Visits from the Durand-Ruel family, alone or accompanied by a client, were a long-standing tradition. Now there were also the Bernheim-Jeune brothers to be seen, and journalists, each of them eager to write an eye-witness account of history in the making. To this end, prospective interviewers would undertake the expedition to Giverny, leaving the express train at Vernon to take the little "slug-train" that ran to Gisors, as it was amusingly described by an anonymous reporter for *Le Cri de Paris*. For this journalist, the standard clichés – the "polychrome" and supposedly "flooded" garden, or the modesty of the artist who refused all public honours – were quite insufficient. He went on to discuss Monet's wealth, to value his automobile collection at 32,000 francs, and specify the power of Monet's own car (24 hp). The reader learnt that Monet's "son-in-law" – in fact, his stepson, Jean-Pierre Hoschedé – ran "a successful automobile business" in Vernon, and that his stepdaughter, Blanche Hoschedé, exhibited with the Independents. There was, in addition, "a person closely related to him, also a landscape artist, who signs his Impressionist canvases with the American surname: Butler." All this was true enough; the reporter was simply wrong to assume that they in any way contributed to Monet's income.

A more discreet and informative article was published by Louis Vauxcelles in *L'Art et les Artistes* (Art and Artists), under the title, *Un après-midi chez Claude Monet* (An Afternoon with Claude Monet). He had visited Monet during the summer with the German painter, Felix Borchardt. The previous year, Vauxcelles had relied on quotations from other writers to explain his admiration of the London exhibition. But by 1905, he was determined to be his own man, an ambition that was brilliantly realised when he coined the name Fauves for the innovative school whose paintings were the revelation of that October's *Salon d'Automne*. But that was still to come. Before venturing into the cage of the Fauves, he had come to observe the old Impressionist lion in his den. The article was beautifully illustrated with photographs by Ernest Bulloz. These

illustrations confirm Vauxcelle's pen-portrait of Monet in his final incarnation as a "gentleman farmer", whose "appearance reminds one of Meissonier" with his "steel-grey eyes". One could scarcely divine Monet's "affable and exquisite manners" and "lordly charm" from the scruffy appearance he exhibits in the photographs. The neatly creased jabot could not disguise either this or the solid corpulence of his figure. By now, Monet described himself for the petitions that he signed as "père de famille". The bourgeois world in which Alice's influence had finally established him could offer no higher accolade.

After a brief halt in the first studio, where thirty or so canvases offered an overview of the painter's career from his earliest works to the first series of water-lilies, Monet led his visitors down to the pond so they could see the great lilies "which close up before five o'clock in the summer". Framed by poplars and willows, the massed flowers on water and land seemed to Vauxcelles "pretty rather than grandiose, a very Oriental dream". One of Bulloz' photographs shows the Japanese bridge crowned by the arches on which wisteria was to be trained. The second studio was admirably well lit, with a view across the haystacks of the Clos Morin. There the visitors again admired canvases from all stages of Monet's career, including a "second series of water-lilies". Retiring to the library, they found the painter more interested in "turning over" memories of past times than discussing the present. However, they did learn that he considered Cézanne to be "a master", that he had "never taken Gauguin seriously" and that he held Loiseau to be typical of the hangers-on who "plagiarise us." Vuillard, in his opinion, had "a very fine eye", and Maurice Denis was "a very pretty talent, and a crafty devil with it!" Vauxcelles apologised to the reader for not having more to report, but Borchardt stated later in his memoirs that Monet was very interested in discussing the plans for the *Salon d'Automne*, and disapproved of the organisation of an Ingres retrospective as part of that year's exhibition.

The two visitors were taken to see Monet's personal collection which was kept on the first floor of the house, then returned to the studio where their host treated them to a concise explanation of "his method of painting". None of what Vauxcelles reports, however, is very new or entirely certain. "The many easels lined up in a row of empty hotel rooms" so as to allow the painter to work on "a hundred canvases at once" during his stays in London are not found in any other contemporary document. Vauxcelles describes the water lilies as "stunning", and adds that "certain of these canvases look as though they were done in an afternoon, when in fact the master worked on them for several years", taking them up "at a whim", then leaving them again to go maybe "eight days without touching a brush". In short, Monet's methods of that year remain a well-kept secret and we must content ourselves with the results, which are superb: three versions of the Japanese bridge seen across the full width of the enlarged pond (1668–1670), and a series of water-lily paintings in which the banks have completely vanished and the eye perceives only the sky reflected in the lily-covered water, or the lilies themselves, floating on the blue-green depths of the pond (1671–1682).

Many artists would have been happy to lie back and bask in praise such as *L'Œil de Monet* (Monet's Eye) in Rémy de Gourmont's *Promenades philosophiques* (Philosophical Excursions). De Gourmont was categorical: "We stand here in the presence of perhaps the greatest *painter* who has ever lived." De Gourmont had some reservations: "I have put the word *painter* in italics, so as to assert my opinion in the fullness of its restrictions. Monet should not be compared with the great *artists* ... [His] judgement is as imperfect as Victor Hugo's." Nevertheless, what most readers remembered was the phrase "He is

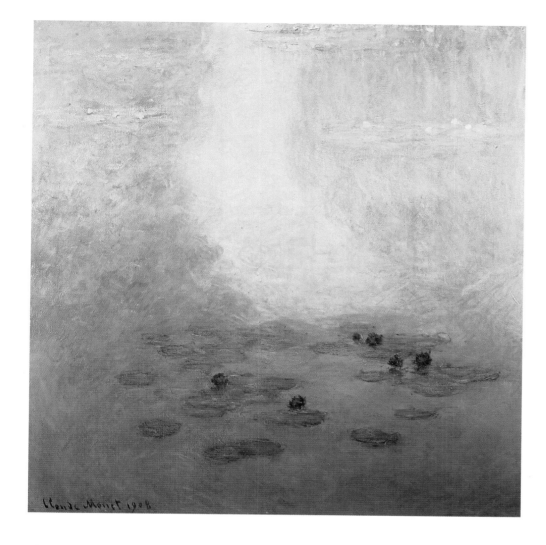

the painter, as Victor Hugo is the poet." This was no mean praise, at a time when Hugo's supremacy was one of the founding tenets of the Republican cult.

A Pond of Light

1907 brought renewed tributes in the press; it was also a fruitful year in terms of work, once a few initial difficulties had been overcome. Monet began with a still-life motif that had caught his fancy, a basket of eggs on a table surrounded by various other objects. Perhaps the memory of Cézanne still haunted him. He devoted two months of hard work to this motif; he had not tried his hand at the genre for a long time, and this was to be his last attempt at it. The result was two very similar paintings (**1692–1693**). Then he returned to the water lilies, working on them in his studio as the winter drew to a close; he had committed himself to exhibiting the series in May at Durand-Ruel's. No sooner had the dealer expressed his satisfaction at this – he left the technical details to his son Georges – than Monet showed signs of changing his mind. When he wrote to Durand-Ruel on 25 May, Monet still spoke of the exhibition as "settled". But he added: "I have much to do, and I am not progressing as fast as I would like. As usual, there are times when I feel that nothing is going right and that everything I do is bad." A fortnight later, he went back on his agreement, offering the usual excuses, and the exhibition had to be rescheduled. In theory, it was now to take place the following year, which would give Monet time to "rework" several pictures "from life". Nature was not only Monet's point of departure for

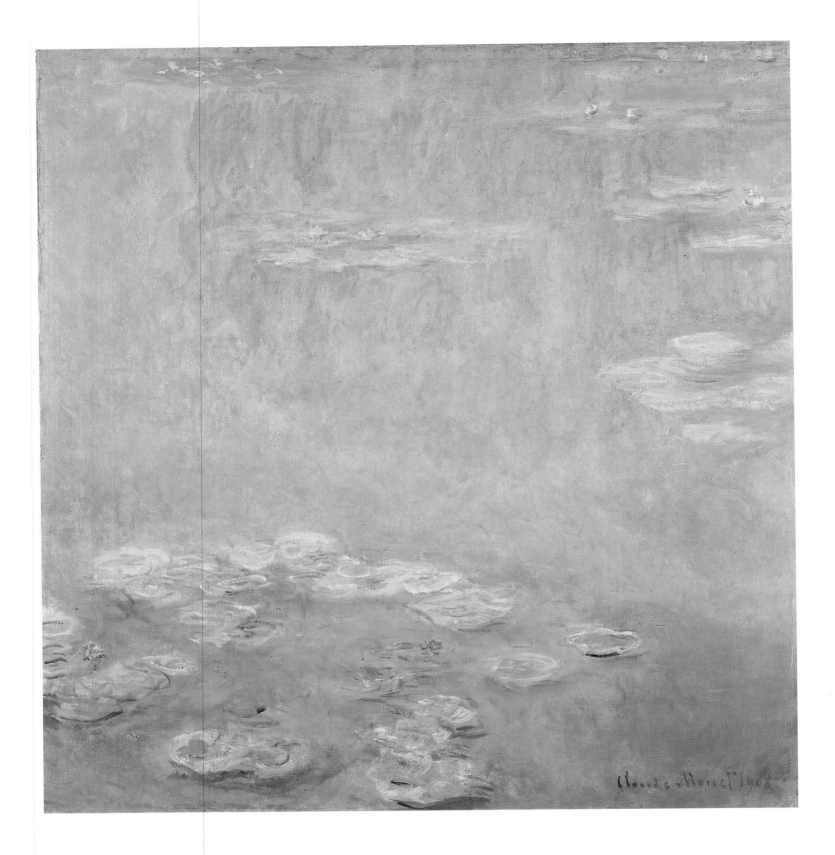

Water-Lilies
1908
Cat. no. 1733

the water-lilies, but the model he continuously needed to have before him until the pictures were definitively finished.

It is easy to sympathise with Paul Durand-Ruel in his disappointment. But Monet had yet more surprises in store for him; Durand-Ruel was not even granted the small compensation he had hoped for in the form of "two or three of the finished canvases". Monet wrote to explain that only exhibited as a group would the new works produce the effect he was looking for. He spoke at some length about his horror of mediocrity, and announced with "great satisfaction"

the destruction of at least thirty canvases. In May, the painter was still nervous and ill at ease. He went so far as to refuse a visit from Georges Durand-Ruel, who had hoped to bring the American collector, Arthur B. Emmons, and his wife and daughter on a pilgrimage to Giverny. Paul Durand-Ruel had to offer to accompany the party personally before Monet would give way to his insistence and open his doors to them.

In mid-June, Monet was complaining of the weather, which was still variable. Thereafter, he wrote no more letters until the summer was almost over. By late September, he could record his satisfaction at a long stretch of time well-spent. "Here all goes well. I have worked, and I am still working, with passion." He continued to work as long as the fine weather lasted. Durand-Ruel was invited down to inspect the results. "They are still a sort of groping research, but I think they are among my best efforts." This "research" was centred on the image of the sky reflected in the pond in a long slick of light. In each picture the islands of lilies are more or less identical. Monet must have found an ideal spot; he made numerous slight variations on a single theme, the majority of them in a vertical format (**1694–1717**).

In 1907 Monet took part in the *Salon d'Automne*. He was not showing his own work, but loaning five works by Berthe Morisot from his personal collection. Morisot was the subject of that year's retrospective, and Monet had agreed to lend the paintings at the request of Julie Manet-Rouart. In late October, the state purchased a Rouen Cathedral (**1319**) directly from Monet for the Luxembourg Museum for 10,500 francs. Frantz Jourdain and Clemenceau, then Prime Minister, had taken part in the negotiations. The picture was exhibited at the Ecole des Beaux-Arts on the Quai Malaquais, along with all the year's other public acquisitions. *Le Cri de Paris* took an ironic view of the event. Official purchases were usually made from "the same well-known figures, whose talent is very slight. This Cathedral by Monet is M. Dujardin-Beaumetz' shield ... it is there to bear witness to his broadly eclectic taste, and to disarm the avant-garde critics, to whose attacks he is very sensitive."

Delicate Comparisons and a Well-orchestrated Campaign

One of the unforeseen consequences of his fame was that Monet had to get used to seeing pictures that he had not painted attributed to him. Several such cases arose during the year 1908. This was the price of fame, as was an invitation by Dubufe, acting with Durand-Ruel's approval, to participate in the Franco-British exhibition that was to be held in London. But none of these compliments distracted him from the need to work on his water lilies, which he wanted to complete for the show of "new things" that had been postponed from the previous year, and was now scheduled for the spring. It was a race against the clock. Paul Durand-Ruel brought encouragement from time to time, though less impressed than usual by the works he was allowed to see on a visit to Giverny in March.

Durand-Ruel was alarmed at the number of paintings that Monet wanted him to buy before they were shown to the public. He needed a partner and turned, naturally enough, to the Bernheim brothers. Gaston Bernheim then provoked Monet's anger by referring to this purchase as a "possibility". Monet's rage was unrelenting, and his letters allow us to follow it through to its inevitable conclusion: the postponement of the exhibition. Durand-Ruel's mis-

givings about the conditions that Monet wished to impose made it easier for him to accept this decision.

A man of great insight, Durand-Ruel had been ahead of his time for over half a century. But now the movement that he had helped to create was moving on and leaving him behind. Not only was he finding it difficult to appreciate the importance of Monet's researches in his water garden, but he was increasingly sceptical of the irresistible rise of Cézanne, Gauguin and Van Gogh. Seemingly unaware of the risk for his favourite painters, he went out of his way to organise a still life exhibition where their works could be compared with those of Cézanne. Durand-Ruel's son, Joseph, knowing Monet's anxiety, wrote to him on 21 April 1908, the day of the opening: "You have nothing to fear from the presence of Cézanne." A little later, Paul Durand-Ruel confided to Renoir: "The Cézannes ... are in my opinion and in the opinion of all true connoisseurs very dull beside your works and those of Monet. The reputation of this excellent, conscientious painter has been terribly inflated. The wags who claim that there are only three great masters, Cézanne, Gauguin and Van Gogh, have, alas, exploited people's credulity to the utmost, especially in Germany and in Russia." To avoid another such mistake, the next exhibition to be organised at the Durand-Ruel Gallery was confined to landscapes by Monet and Renoir. Here, the public and critics were on familiar ground, especially as the most recent pictures by Monet dated from his Norwegian "campaign" and his last Pourville period. Mirbeau, knowing how demoralised his friend was, took the opportunity to send him a letter of congratulation in which he was able to deploy his gift for hyperbole without restraint.

At this point, in a carefully orchestrated campaign in the English-speaking press on both sides of the Atlantic, a rumour was spread that Monet had destroyed a significant quantity of canvases valued at $100,000 dollars or £20,000. This was an oblique way of persuading collectors that every painting

Monet paintings in the second studio in March, 1908
Photograph Durand-Ruel

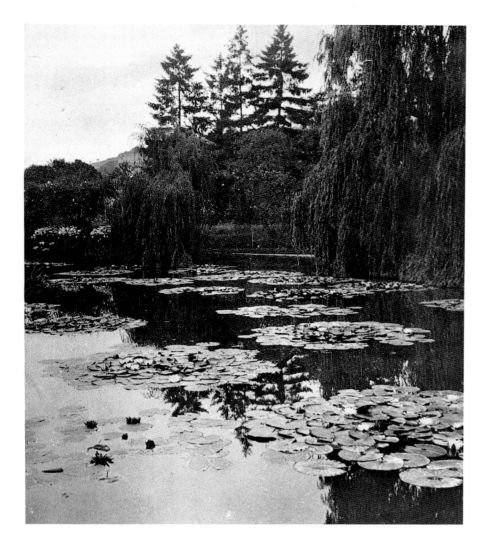

The north bank of the water-lily pond
c. 1900
Former photograph collection of Michel
Monet

Postcard showing: Giverny (Eure)
Property of the Master Claude Monet – general
view of the ornamental lake

by an artist so demanding was a first-class work, and that if they waited for much longer there might be none left. Indeed, the best way to be sure that every American could have "his" Monet would be for the artist to come and work there. The proposal made in this letter of invitation seems to have been prompted by a French politician visiting the U.S.A.; indeed, he was perhaps the instigator of the whole campaign. The letter was handed to Monet personally by Walter Patch, a reporter for *Scribner's Magazine*. Monet declined. He was too old, he said in reply, to adapt to life in such a distant country and preferred to keep working at the motifs he knew well. Everyone should follow his example. American artists would be better advised to paint the country they had known since birth, rather than insist on painting Brittany, its costumes and inhabitants. He might equally have attacked those who had set up camp beside the Epte in order to "Givernise", but that would have upset the colony of foreign artists who had taken over the Hôtel Baudy and spread out from there into the village. Monet grudgingly accepted their homage rather than see them swell the ranks of the Pont-Aven school.

Social Progress?

On Thursday, 12 June 1908, among the society mourners crowded into the church of Saint-Augustin in Paris for the funeral of the recently-assassinated M. Rémy, a reporter from *Le Gil Blas* spotted the bulky figure of Claude Monet. Monet was not there out of homage to a former stockbroker who had become

one of the capital's last *boulevardiers*, and who had prided himself on his artistic connections. He was there because Rémy had married Cécile Raingo, the youngest sister of Alice Hoschedé née Raingo, and had thus become Monet's brother-in-law by marriage. Alice could remember the time when, ruined by Ernest Hoschedé's bankruptcy, she had had to turn to Rémy for help. The help she had received had been, in her opinion, quite insufficient, and had been accompanied by advice and reproof of an all but tolerable kind. This had lasted for several years, until Monet's growing success had brought financial independence for both Alice and himself, whereupon Cécile, like her other sisters, had not been above visiting them in Giverny.

Rémy had been assassinated in mysterious circumstances. Only after the funeral was the first light shed upon this murder, which rapidly turned into a scandal, with the exposure of Rémy's homosexuality and the implication of a nephew of his wife, Léon Raingo. The Rémy affair cast an unexpected light on the great bourgeois family to which Monet was related through his second marriage, whose members had long viewed him as an interloper. His marriage to Alice may have seemed a kind of social promotion, but his ascent in fact owed little to his connections and everything to his talent and determination.

There is a striking image of Monet's single-mindness in a letter to Geffroy written two months after Rémy's death: "I am completely absorbed by my work. These landscapes of water and reflections have become an obsession. They are beyond the strength of an old man, and yet I am determined to set down what I feel. I have destroyed some ... I have begun others over again ... and I hope that something will come of so much effort." This effort was structured by a timetable, revealed to us by two letters dated 24 August and 5 September 1908. At that time of year, the morning and the early afternoon, with an interruption for lunch, were taken up with work. Then there was a long break from three until five or even six, during which Monet could receive visitors. He adopted this schedule, not in order to accommodate his visitors nor because he had need of a rest, but because the light on the pond was then changing and the lilies were closing up. Once the flowers were closed for the night, Monet would return to work in the evening light. Then the sunset would stain the water with streams of fire and gold, framed in the green reflections of the trees, and dotted with the pale or blueish islands of lily-pads. Once the flowers had closed, the water-lilies lost their fascination as a motif.

Venice, the Rialto
Contemporary postcard

The pigeons in St Mark's Square
Contemporary postcard

Page 382:
Claude and Alice Monet with the pigeons in St Mark's Square in Venice
After a postcard from 1908
Former photograph collection of Jean-Pierre Hoschedé

A little later in the season, J.-C. N. Forestier, the botanical correspondent of the review *Fermes et Châteaux* (Farms and Castles), visited Monet in his garden and watched him at work. "In this mass of intertwined verdure and foliage, ... the lilies spread their round leaves and dot the water with a thousand red, pink, yellow and white flowers ... The Master often comes here, where the bank of the pond is bordered with thick clumps of irises. His swift, short strokes place brushloads of luminous colour as he moves from one place to another, according to the hour." And Forestier quotes this "precise and charming" phrase: "Monsieur Claude Monet paints not only the landscape, but the hour..." For Forestier, this was true not only of the traditional series, but also of the water lilies: "The canvas he visited this morning at dawn is not the same as the canvas we find him working on in the afternoon. In the morning, he records the blossoming of the flowers, and then, once they begin to close, he returns to the charms of the water itself and its shifting reflections, the dark water that trembles beneath the somnolent leaves of the water lilies." Monet worked on the paintings that inspired this sensitive description until the autumn of 1908 (1721–1735), when he left Giverny for other shores and other waters.

An Autumn in Venice

It is almost inevitable that one should know little about the early years of an artist's life, when he or she is still largely unknown to the wider world. But it seems almost inconceivable that we should know next to nothing about an event which took place late in Monet's life, when virtually his every move was considered newsworthy. Yet, judging by the studies that have been published to date, we know as little about Monet's stay in Venice in the autumn of 1908 as about some of his youthful holidays in the countryside. The fault for this lies with those of his contemporaries who preferred to indulge in the usual purple prose about Venice, rather than ask the painter himself about what he was doing there. To this lack of written evidence we must add the fact that Alice travelled to Venice with Monet; the letters that they exchanged whenever Monet was away from Giverny are therefore lacking. Nevertheless, by comparing recent discoveries with earlier publications and scrupulously verifying both,

we have been able to avoid certain widely-held fallacies and fit a chronology around the few indisputably dated events.

On 25 September 1908, Monet informed Paul Durand-Ruel of his imminent departure for Venice, where he planned to spend a month with Alice in response to an invitation whose origins he did not specify. Durand-Ruel was told that he could write to Monet at the Palazzo Barbaro. Monet's stay in this gothic palace on the northern bank of the Grand Canal is attested by several documents, one of which was the European (Paris) edition of the *New York Herald* for 11 October. Under the title *M. Claude Monet in Venice*, a short item accompanied by a photograph of the artist informed readers that "the great French painter and Mme Monet are staying at the Palazzo Barbaro, in the company of Mrs Charles Hunter." But the impressive Mrs Hunter was herself a natural focus of attention and the rest of the brief article was devoted to her. She had given a soirée, during which her sister, Ethel Smyth, sang various songs, accompanied by the Venice Orchestra... As to the activities of Monet himself at the same period, we can glean a little more information from the Florentine writer Carlo Placci, who was spending five days in Venice at the beginning of October. According to Placci, the most pleasant surprise of his visit was to meet Monet at a dinner given by Mrs Hunter. Placci describes Monet's long white beard and frank, affable manner. "The only great living Impressionist" was accompanied by "la sua vecchia compagna"; Monet told Placci that he had put off coming to Venice for fear of being disappointed. And to begin with, this was indeed the case; yet scarcely a week after he arrived, he was once again gripped by the compulsion to work, a need which he was trying to assuage by visits to San Giorgio.

Monet had quickly selected his first subject, *The Palazzo Ducale seen from San Giorgio Maggiore* (1751–1756). His took a boat to the island San Giorgio Maggiore in order to reach the point of view that he desired. There he quickly spotted another perspective in the form of a small balcony, inaccessible to the public. Placci obtained the necessary authorisation for him, but, by that time, Monet had observed that ships frequently passed between the balcony and the desired motif. He had to find "another spot". Almost immediately he started work on views of the *The Grand Canal and Santa Maria Della Salute* (1736–1741), and of the *Palazzo Contarini* (1766–1767). He painted these two motifs while staying at the Palazzo Barbaro, which he left on 19 October, according to a letter to Durand-Ruel. Mrs Hunter's activities may have tended to over-

Palazzo Ducale
1908
Cat. no. 1742

Venice, The Ducal Palace
Photograph Etta Lisa Balsadella, Venice

shadow Monet's real hostess, Mrs Daniel Curtis, the owner of the Palazzo Barbaro and related, via her deceased husband, to the painter Sargent. Why did Monet and Alice move? There is no need to suppose that they were obliged to leave by some social incident. It seems plausible that Monet, with the help of the more socially-experienced Alice, simply realised that, now that he was totally absorbed in his work, they would soon reach a point where they had outstayed their welcome. And Monet now had no plans to leave Venice for at least another few weeks.

He therefore moved to the Grand Hotel Britannia, a first-class establishment located between the Palazzo Barbaro and the Ducal Palace, where the Grand Canal meets the Canal San Marco. The owner, Charles Walther, was rightly proud of the comfort he offered his guests: electric lighting, central heating and lifts. But Monet's choice must have been determined above all by the admirable view from the front windows and the hotel garden over the Lagoon towards the island of San Giorgio. This was to provide Monet with a new motif (1745–1750), which allowed him to savour the experience of painting in solitude, as he had at the Savoy in London.

It is one thing to discover a fine point of view and to make the first studies. It is another to be satisfied with the finished result, especially when work is interrupted by rain for several days on end. When the sun reappeared, "radiant", the fine "spirit and enthusiasm of the first days" was lost. Monet returned to work "grumbling", while Alice admired the passing boats and the light on the water. The effects seemed so difficult to "render" that, when she wrote to Jean-Pierre Hoschedé on 29 October, she felt that she understood her husband's endless complaints much better than before.

In Paris, Monet's correspondents were unaware of these difficulties, and both Paul Durand-Ruel and the Bernheim brothers wrote urgently requesting exclusive option on the finished work. But Monet was uncertain what he would return with: perhaps only "a few sketches or experiments". He therefore refused to commit himself. He had unhappy memories of recent negotiations and was

Venice, San Giorgio Maggiore
Photograph Etta Lisa Balsadella, Venice

determined to remain "absolutely free". For the time being, what mattered was the work itself. In November, he was so engrossed that Alice had to take charge of part of his correspondence. Her reply to a letter from Gustave Geffroy gives us a charming and affectionate picture of their life in Venice: "Yes, Monet is working passionately. Venice has got hold of him and won't let go! I can't tell you the joy it gives me to see him like this. My only worry is that he might overtire himself. I have spent some unforgettable days here at the side of my husband, following every movement of his brush. You will come to Giverny, won't you, to see all these wonders, these superlative reflections, the mother-of-pearl sheen on the water that he alone is able to catch? We have to return, everything is changing and yet Monet cannot tear himself away from his beloved motifs." There is an echo of this lyrical prose in a letter from Monet to the Bernheim-Jeune brothers: "As for the date of our return ... that will depend upon the weather which at the moment is quite wonderful, just a little cold in the mornings, but so beautiful that there's no time to worry about it."

Still, the decision had to be taken. On 3 December, the day Monet made a study of the *Gondola in Venice* (**1772**) which he later gave to Clemenceau, Alice was writing to her daughter Germaine with the timetable of their return journey. Departure was set for Monday, 7 December at ten o'clock at night. On Sunday, Monet wrote to tell Clemenceau that he was still under "the spell of Venice", and saddened to be leaving so many wonders. The next day, when the trunks and crates were already packed, he wrote to Geffroy, telling him of his enthusiasm for the city that he was about to leave. He regretted not having come when he was young and "not afraid of anything", but was consoled by the idea of making another stay there the following year. This was not to be, as we know. But throughout his long career, it was always the hope of one day returning that made it bearable for Monet to leave the places where he had worked. One letter remained to be written, signed by both husband and wife, to thank Mrs Curtis, to whom they owed their stay in Venice. Then they set off for France: by Tuesday, they were in Genoa, and on Wednesday, in Bordighera. (It

would be fascinating to know how Monet reacted to returning there for the first time since 1884.) On Thursday they reached Cagnes, where they spent several days with Germaine and Albert Salerou, and took the opportunity to visit Renoir at the Villa des Collettes.

To his great regret, Paul Durand-Ruel was beaten to Giverny by the Bernheim-Jeune brothers, who were able to buy up the first fruits of the Venetian harvest on the spot. However, they were not able to show them until 1912, for Monet would not release the pictures until he had painstakingly reworked them in his studio.

The Water-Lilies Exhibition in 1909

Alice was quite seriously ill during the first few weeks of 1909. This was probably related to their Venice trip rather than the cold weather which greeted them at Giverny. Monet, on the other hand, seems to have returned with his spirits lifted, and prepared to look more kindly on the paintings he had done in his water garden. He was now prepared to go ahead with the exhibition "often postponed" at Durand-Ruel's gallery. By the end of January, Monet felt able to fix the date and suggest the definitive title: *The Water-Lilies, a Series of Water Landscapes.* On Saturday, 6 February, Paul Durand-Ruel came to Giverny, where Alice was still ill in bed. He was vexed at the sight of the superb paintings which Monet had brought back from Venice, and which Monet "had been foolish enough to promise to the Bernheims." But his irritation did not stop him from signing a cheque for 30,000 francs made out to his disloyal client as soon as he returned to Paris, and he agreed to collaborate with his rivals on the forthcoming show. Monet sought to make the most of this situation, by invit-

FROM LEFT TO RIGHT:
Venice, the Palazzo Dario flanked on the left by the Palazzo Barbaro Volkoff
Photograph Etta Lisa Balsadella, Venice

Venice, the Palazzo Dario
Pencil sketch
Musée Marmottan, Paris
(D. W. 1991, V, p. 118, D 404)

ing the two partners to choose as quickly as possible which water lilies they wanted for the group of paintings each was committed to buying from him. Then the canvases were crated up and sent off. The catalogue was reduced to the simplest possible form: the pictures were grouped by year and Monet was, as ever, incapable of producing titles which might help differentiate them. Preceded by five crates of paintings, he arrived at the Gare Saint-Lazare on Monday, 3 May, bringing a sixth crate with him. He went straight to the Hôtel Terminus, as he did whenever he spent more than a single day in Paris.

The pre-publicity for the exhibition was expertly managed. A leading role was given to Arthur Meyer's review, *Le Gaulois*. The managing editor was delighted at the opportunity to thank Monet for having agreed to a delicate request he had made (see catalogue, **1773–1776**), and sent his contributor Jean Morgan to Giverny. The reporter's detailed account of his visit appeared on the front page in a column entitled *Causeries chez quelques maîtres* (Conversations with Some Masters) on Wednesday, 5 May. The exhibition opened the following day. "Le Tout-Paris" flocked to the Durand-Ruel Galleries at 16 Rue Laffitte, where forty-eight variations on a single theme were displayed in three rooms. These works perfectly matched the aesthetic of the first years of the 20th century. The fathers of the snobs who came to see them had decried Impressionism at its birth, but their children adored these late flowers. Jules Renard proved an exception to the rule when he confided to his diary: "It's too pretty. Nature is not like that ... There is a yawning chasm between this art and ours..." But this was the Belle Epoque, when "our art" was to be found less in academic eclecticism than in the decorative grace of Art Nouveau, to be seen on the streets of Paris in the form of Mucha's posters, the entrances to the Metro designed by Paul Guimard, and in all the curves and spirals whose near relatives inhabited the aquatic mirror of Giverny's murky pond.

The Palazzo Dario
1908
Cat. no. 1757

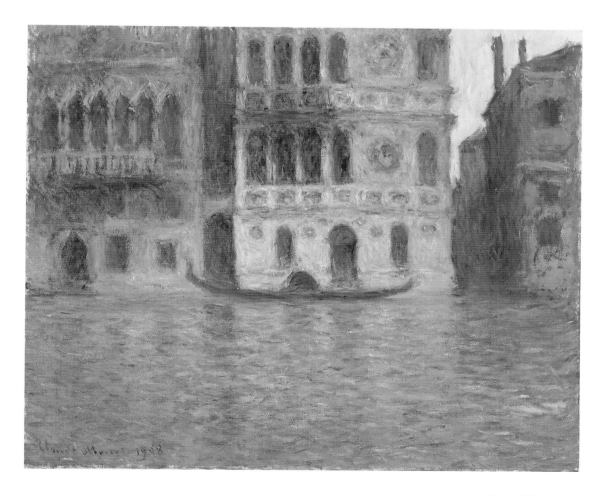

From Decoration to Abstraction

The visitors to the exhibition of May–June 1909 almost all remarked on the variety of effects which corresponded to different times of day. Fortuny merely saluted "the splendour of his noons and the poetry of his evenings." Others went further. Thiébault-Sisson picked out five principal moments, from the "saffron notes" of dawn through to the "transparent shadows" of dusk. Others, such as F. Robert-Kemp in *L'Aurore*, thought they could make out both the weather and the season. In relation to classic motifs such as the hay and grain-stacks and Rouen Cathedral, this detail of nuance could be taken for granted. In the case of the water lilies, it shows how clearly the range of different effects that Monet strove for was perceived by his contemporaries. The hanging of the paintings in a single gallery, as prescribed by Monet himself, doubtless enhanced the visibility of these variations, which are less immediately perceptible now that the pictures have been divided up.

Encouraged by public enthusiasm for the show, the press continued to print a growing number of commentaries and articles. The dream of a decorative ensemble, of which Monet first gave notice in his remarks to Maurice Guillemot, was taken up openly by the critics. De Fourcaud, Geffroy, René-Marc Ferry and, in particular, Arsène Alexandre all refer to it, Alexandre in the conditional perfect: "The painter would have liked to decorate a circular room, of modest, well-calculated dimensions. All round the room, up to chest-height, there would have stretched ... a painting of water and flowers ... No furniture. Only a central table for this room, which was to be a dining room..."

This dream was one of Monet's continuing preoccupations, as he told Roger Marx, who questioned him while researching an article for *La Gazette des Beaux-Arts:* "I once thought of making these water-lily paintings the theme of a decoration. It's a plan I shall realise one day." Marx's article is a good summary of earlier writing on Monet, incorporating some new insights and many details supplied to Marx by the painter himself. Monet spoke of his "uneasiness" when first confronted with the apparent monotony of the canvases assembled in the gallery, his awareness of a break not only with the Barbizon school, but with the whole of the Western tradition, and of his affection for Gallé (whose works were the true archetypes of Art Nouveau), first inspired by their common love of plants. Marx, in writing his article, ignored the chronological ordering adopted in the catalogue, and constructed his own classification. Starting with the only painting which included the Japanese bridge, he arranged the works in order of decreasing importance given to the "terrestrial frame" which finally disappeared, replaced by the "the evocative magic of reflections". There follows a lengthy prosopopoeia, in which the painter is made to expand on the facts he had set down in his letter to Marx. He discusses his affinities with his age, with Mallarmé and Debussy, and his relationship with abstract art: "Those who talk about my painting conclude that I have arrived at the utmost degree of abstraction and imagination compatible with the real. But I would rather they recognised in my work the gift of self, my entire self-abandonment." Marx's Monet goes on to insist, rightly, on the "fervent, exclusive attention" with which he pursues "the representation [of a single motif] under all possible conditions." In vain. As the different series of water-lilies evolved, and as abstract art took on an importance Monet could not have foreseen, the question of the degree of abstraction achieved by them was to attain ever greater prominence.

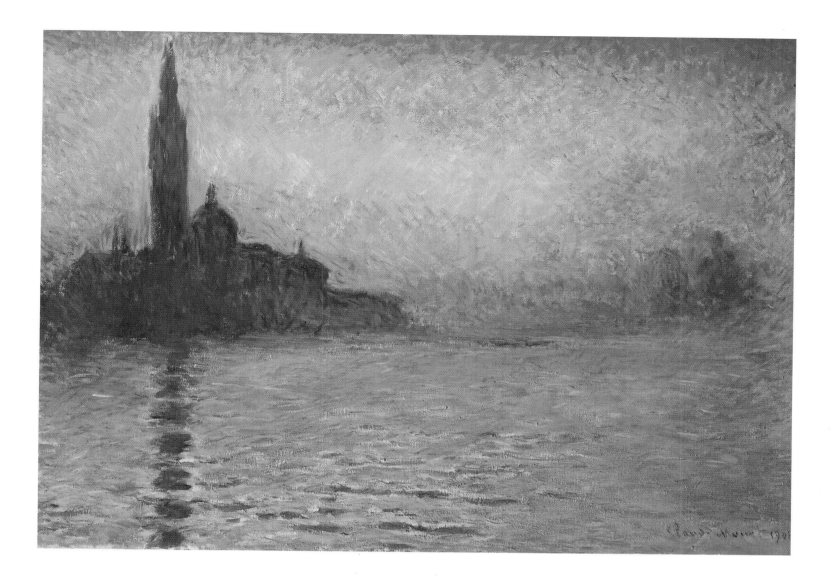

San Giorgio Maggiore at Dusk
1908
Cat. no. 1768

The Flood of 1910

December and January were marked by heavy rainfall. The earth was already
saturated with the rain that had fallen throughout the summer. The result was a
series of dramatic floods in January and February in Paris and the valley of the
Seine. The effect is recorded to this day on many photographs and postcards. At
Giverny, the junction of the Epte and the swirling river of the Seine was trans-
formed into a huge lake, alternately whipped up by the wind or smothered in
mist. Because most of the village was situated on the flank of a hill, it suffered
less than Lavacourt, Bennecourt, Limetz or Vernon. However, the lower road
and the railway line were impassable for much of their length. The water
reached half-way up the central alley of Monet's garden. The banks of the lily-
pond disappeared under water, and only the humpback of the Japanese bridge
emerged from the flood. Communications with the outside world were ex-
tremely difficult and provisions ran low. Octave Mirbeau had fallen ill and
found this spectacle "of desolation and of terror" quite daunting. He wrote to
Monet: "The sad thing for you is that you have several days of this still to
endure, almost entirely isolated, with your wife ill and having all the trouble of
making sure things don't run low." But Mirbeau remained true to his role as
Monet's optimistic mentor: "So remember, my dear friend, that you are one of
those who has lost least, and that your beautiful garden, which was the great joy
of your life, has certainly not suffered so very much. You will see it emerge from

the water, I don't say intact but having suffered a great deal less than you imagine ... Come now, my dear old Monet, be brave."

Despite Mirbeau's efforts, Monet remained anxious. Though the water level had begun to drop on Tuesday, 1st February, on the Sunday following he wrote to Julie Manet-Rouart: "We were in the midst of a great flood and I, in my selfishness, could think only of my garden, my poor flowers that have been soiled with mud." A few days later, it was Paul Durand-Ruel's turn to learn that "[f]or a moment I thought that my whole garden was lost, which was a great sorrow to me. Now the water-level is slowly falling, and although I am losing many plants, perhaps it will not be the great disaster that I feared. But what a calamity! What misery!" As mid-February approached, the water began to rise again. Mirbeau wrote to Monet: "It will never be over. I am beginning to believe it is the end of the world. If we survive, ah! the work you will have! But more work, I think, than real loss. If your plants have not been uprooted, they will survive ... Has the tall bamboo been damaged? If not, just wait and see how it grows! So do not lose heart, my dear Monet, until you know what the situation really is." At last, the Seine returned to its normal levels. The damage it had done to the garden was not irreparable, but it did require the reinforcement of the banks of the lily pond, which then acquired the shape it has to this day.

Even in times such as these, intellectual life in the capital continued. Thus Mirbeau, in his attempts to take Monet's mind off the problems caused by the weather, entertained him with accounts of the première of Rostand's *Chanticleer* at the Porte-Saint-Martin Theatre, and an exhibition of paintings by Matisse at the Bernheim gallery.

The Death of Alice

At the request of Henry Roujon, permanent secretary to the Académie des Beaux-Arts, Monet agreed to donate a Charing Cross Bridge painting (1529) to the tombola organised for the victims of the floods. It is to Monet's credit that he did so despite the long-standing hostility that he had been shown by several leading academicians. But this was a time of reconciliation, in spite or perhaps because of the recent events. At the beginning of March 1910, Giverny was still cut off from Vernon. Alice had taken to her bed "in a state of extreme weakness". By mid-April, there was only a "faint hope" of recovery. Monet clung to that hope with all his strength.

Alice's suffering was not merely physical. Seriously depressed since Suzanne's death, her anxieties were aggravated by Jacques' unceasing demands for money. In this, Jacques was quite unlike the other Hoschedé children, who were respectful and even, in the case of the devoted Blanche, placed too much trust in affection; Monet left her nothing in his will. When Monet learned that his prodigal stepson had sold his place as a ship broker at Saint-Servan, he decided to break with him definitively. Jean Monet was also a source of concern. Suffering from an illness which neither medicine nor hydropathy could cure, he had lost his job at the factory at Maromme (near Rouen) where his uncle, Léon Monet, had been remarkably patient with him. In November, as the mists descended, Jean, all (misplaced) optimism, made a new start, founding a trout farm at Beaumont-le-Roger in the Department of the Eure.

Alice was very seriously ill. She had myeloid leukaemia. But spring 1910 brought with it a remission, and in early June she was able to leave her room to eat lunch with her family and to admire the luxuriant blossoming of the garden.

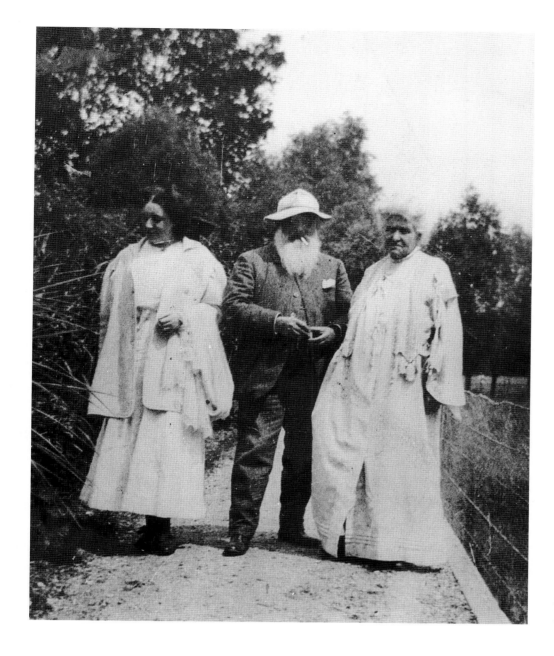

One of the last photos of Alice Hoschedé Monet, taken in July 1910, on a path in the garden at Giverny, with her husband and her granddaughter, Alice Butler.
Former photograph collection of Jean-Pierre Hoschedé

Despite his anxieties, and a series of persistent headaches, Monet was once again receiving visitors. He even accepted an invitation from Mirbeau, who wanted to show him his new house at Triel. Moreover, the Academy proved the first beneficiary of a new vein of generosity. As a memento of his youth, he gave three canvases to the City of Le Havre for the derisory sum (proposed by the council) of 3,000 francs for the lot! At the same time, the sculptor Paulin was granted several sittings both in Giverny and in Paris. His own painting was the exception in this state of grace. Not until 11 November did he finally decide to "finish off some of these Venice paintings". Three days later, Rodin's seventieth birthday was marked by a ceremony on the Place du Panthéon, while Monet celebrated his own quietly at Giverny. The event, however, did not go entirely unnoticed. Geffroy published an article in *La Dépêche de Toulouse*, substantial extracts of which were reprinted by the *Mercure de France*. The title of G. Coquiot's article reminded readers of the *Excelsior* of the time when one could obtain *Des Monet, des Renoir pour cinquante francs* (Monets and Renoirs for Fifty Francs). M. Guillemot, whose imagination must have been running dry, republished virtually unaltered in *Le Siècle* an interview that had appeared ten years earlier in *La Revue illustrée*.

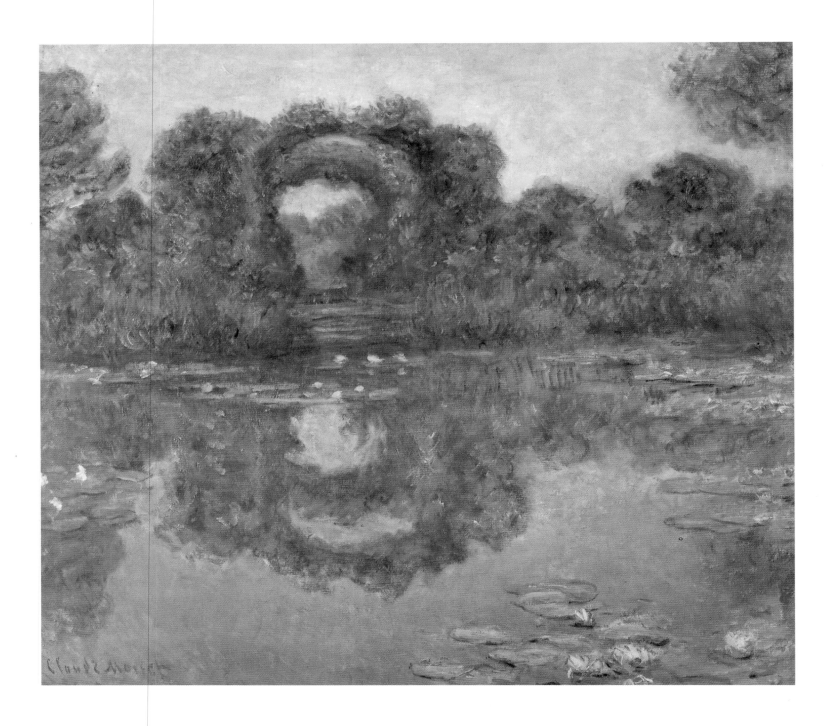

The Flowered Arches at Giverny
1913
Cat. no. 1779

Throughout this period, various exhibitions continued to add to Monet's fame, of which the most important was that held in New York in February 1911. Shortly afterwards, on Sunday, 26 March, the main architect of Monet's ascension, Paul Durand-Ruel, visited him at Giverny. There he bought eight canvases from the water lilies series for the sum of 113,000 francs. Although Alice was in a very fragile state, such business meetings were still possible. However, her relapse in early March soon proved to be the first sign of an irreversible decline. Thereafter the news from Giverny was constantly bad, and Monet's friends began to fear the "terrible blow" that Alice's death would deal him. On 18 May, he informed two correspondents that his "dear companion [was] in her final agony". Her ordeal lasted until four in the morning; despite the strength of her beliefs, so manifest during Camille's fatal illness, Alice did not receive the last rites. At nine a.m. on the 19th, Jean-Pierre Hoschedé and Théodore Butler went to the town hall in Giverny to report Alice's death. The secretary having forgotten to note down that Claude Monet was an artist ("artiste-peintre"), his

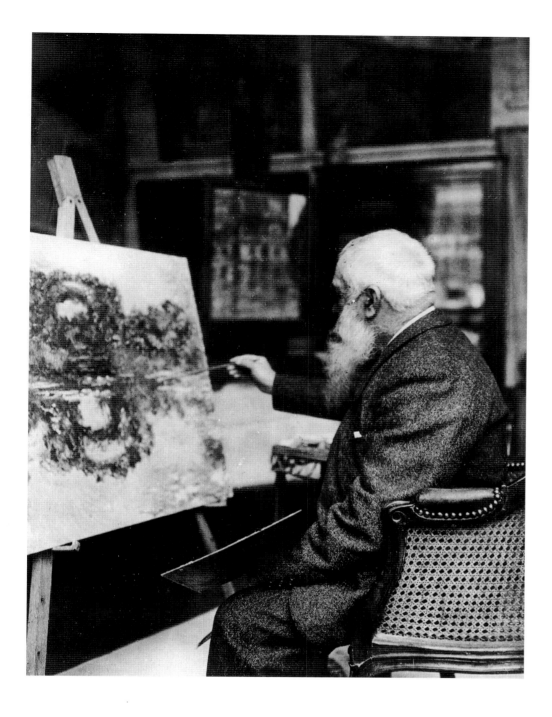

two relatives added this in the margin, followed by their signatures. *Vanitas van-itatum*! The bereavement cards, of which a great number were sent out by the family, excluded all mention of the Monets, save for Claude and his two sons, but listed at great length the members of the prestigious Raingo family to whom Alice belonged by birth. The funeral took place in the church at Giverny on Monday, 22 May at half past ten in the morning. After the religious ceremony conducted by the Abbé Hervieu, the cortège moved to the quiet corner where the family tomb lay beneath its marble cross, erected to the memory of Ernest Hoschedé. There Alice's remains were laid beside those of her first husband and her daughter, Suzanne. In the front row of those who gathered to pay their respects, as Geffroy put it, "to the grief of the man whom she had left behind", stood a "fumbling, almost blind" patriarch who "represented the group of yore". It was Degas, who had made the journey from Paris out of sympathy for his old companion. Degas' gesture was a touching one, the more so in that many now believed Monet altogether lost to the cause of painting.

Claude Monet busy retouching
The Flowered Arches
Former photograph collection of Jean-Pierre Hoschedé

Claude Monet, Germaine Hoschedé Salerou
and Blanche Hoschedé-Monet in the third
studio, 1917
Former photograph collection of Jean-Pierre
Hoschedé

"I am completely fed up with painting..."

Alice had occupied an important place in Monet's life for many years. To those who were close to him, the widowed Monet appeared bewildered and lonely. Blanche, Clemenceau's "blue angel", was not yet living at Giverny. Marthe and her husband, Théodore Butler, along with Jean-Pierre, who had married Geneviève Costadau, lived in the village. But they had their own families and their own lives. Jean-Pierre was a devoted stepson, but Marthe had not forgotten past events from which she had suffered more than her younger siblings. Time, however, and a sense of her own interests, did eventually reconcile her to the man who had been her father's rival. In the first months after her mother's death, she spent a part of each day at Le Pressoir. There, she often came upon Monet painfully rereading Alice's letters before burning them.

Those who knew Monet best, however, never doubted that the painter would transcend the man who suffered. On the day of the funeral, G. Geffroy felt able to assure Jean-Pierre Hoschedé "that with Monet, there is nothing to fear, he will certainly take up his brush again, because he has not yet 'finished expressing himself'." A few weeks later, Clemenceau intervened to help his friend on the road back to life and art. He advised him to remember "the old Rembrandt whom you know from the Louvre... He clings on to his palette, determined to battle through to the end despite his terrible ordeal. There is your example." Meanwhile, it required considerable insistence on the part of Jean-Aubry to obtain a meeting with Monet, whom he wished to interview for a study he was preparing on Boudin and Monet. The first fruit of his insistence was an important article published in the *Havre-Eclair*. The piece concentrates on Monet's youth, but in an aside we glimpse the old man, his "energetic face" and "penetrating eyes" veiled by sadness. The Monet of whom Jean-Aubry took "pious" leave was a "grave, handsome old man" who made him think of a "rentier" living out his last amid the decor of assets long consumed.

There was indeed little evidence of creative energy. In October, Monet intended to "finish a few Venice paintings"; later in the month, writing again to Durand-Ruel, he had reworked those of Durand's paintings that needed it, had done so "without too much difficulty" and could now start on the Venice paintings. But this task soon came to seem onerous, and finally impossible: "I am completely fed up with painting and I am going to pack up my brushes and colours for good." If only he had left the Venice paintings as they were "in memory of those happy days with [his] dear Alice"! Now he felt that he had spoiled several of them to the point where they should be destroyed. Two months later, his courage had returned and he informed the Bernheim-Jeune brothers that his Venice paintings would soon be finished and that the exhibition could take place in their gallery if they still wished to organise it. On hearing this news, Paul Durand-Ruel overcame his initial disappointment, and he and his two sons rivalled Clemenceau in their eloquence of their encouragement. Clemenceau was about to undergo a prostate operation, but remained as courageous as ever and a great comfort to Monet. Their efforts were in vain. As the date of the opening approached, Monet sank into the depths of depression: "I am quite aware that you will think my paintings perfect. I know that the show will be a great success, but all that means nothing to me, for I know myself that they are no good and no one can persuade me otherwise."

Of course the critics who wrote about the exhibition disagreed with Monet. A tidal wave of admiration swept over Monet's Venice. Encouraged by Mirbeau's preface, Geffroy, A. Alexandre, G. Lecomte and many others displayed their customary fluency in praise and admiration. They were not alone. Those who had,

on occasion, ventured criticism, and those who were too young to have voiced either approval or reproof were united in the chorus of praise. Among them were Henri Genet, Roger Allard, André Michel, Gustave Kahn, Georges Besson and Henri Ghéon, to mention only those authors who signed their articles.

Onset of the Cataract

Scarcely had the Venice exhibition over at the Bernheim Gallery closed than the exhibition *Art Moderne* opened on 5 June 1912, at Manzi and Joyant's mansion at 15 Rue de la Ville-l'Evêque. Monet was represented in the catalogue by 21 canvases, most of them painted before 1900. *La Chronique des Arts* saw the exhibition as prefiguring a "future room in the Louvre". The *Mercure de France* on the other hand pointed out that Van Gogh, although present, had been omitted from the advertisements, and went on to regret the absence of the masters of pointillism. A month later, the *Triennial* exhibition of French art opened at the Jeu de Paume gallery in the Tuilerie Gardens. Monet was represented in this heterogeneous selection of artists by two works sent by Durand-Ruel (**552** and **796**). However, there were more important exhibitions abroad, in particular in St Petersburg and Frankfurt. For the first of these shows, there is an interesting review by Louis Hautecœur, who judged Monet to be "perhaps the most prestigious of the landscape artists" on show, but did not say whether the Russ-

Self-Portrait
1917
Cat. no. 1843

Visit to the second studio, c. 1919
Photograph Roger-Viollet

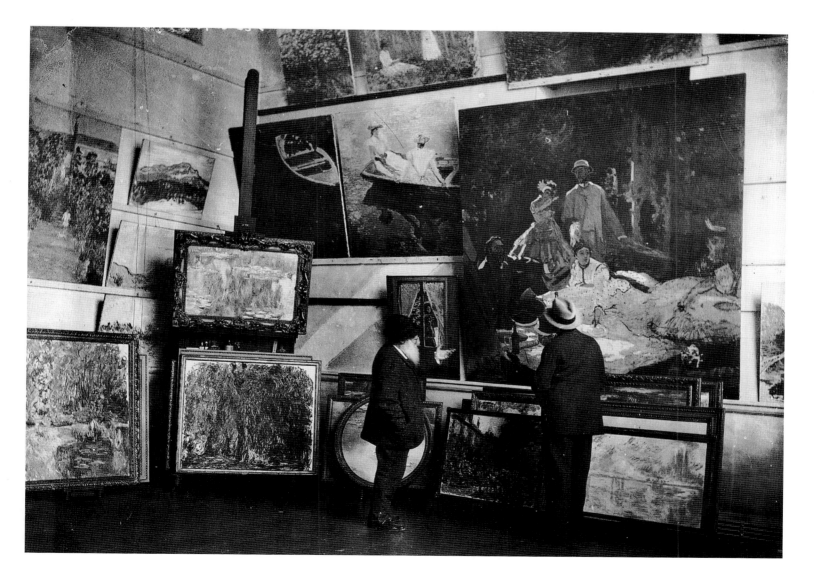

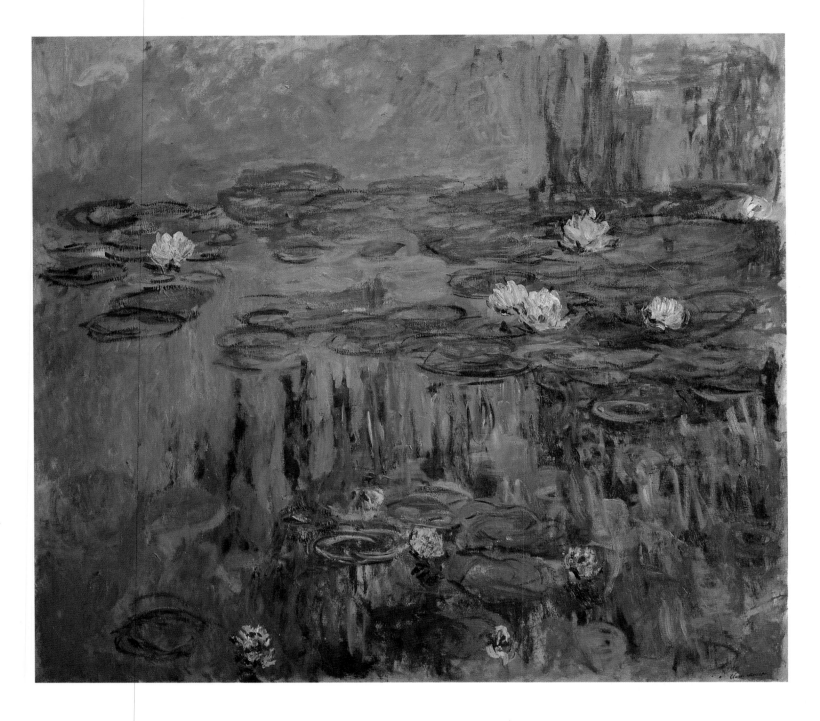

Water-Lilies
1915
Cat. no. 1795

ian public agreed with him. Many of the German visitors to the Frankfurt exhibition preferred Manet, Renoir and Cézanne if we are to believe Erich Hanke, who, writing in *Kunst und Künstler* (Art and Artists), placed Monet in the second rank along with Sisley and Pissarro. Hanke also repeated Pissarro's claim that "Monet is not a landscape painter, but a great decorative painter".

Monet's relationship with decorative art, which for Pissarro represented a limitation to his genius, was seen in quite a different light by Gustave Kahn. In his study *Les Impressionnistes et la composition picturale* (The Impressionists and Pictorial Composition), Kahn considered the set of paintings in each series – the Cathedrals, London scenes and the water lilies – as "a successful attempt at a new form of composition". However, when Kahn came to consider whether Impressionism, which had long been refused all public commissions, might one day prove its aptitude for large-scale decorative work, it was not to Monet, but to the followers of Cézanne, Van Gogh or Gauguin that he referred. Indeed, there is no reason to think that in 1912 Monet saw himself as a candidate for

such large-scale work any more than Kahn did. His doctors had just diagnosed a double cataract, and the operation had been provisionally postponed. At the same time, his son Jean's state of health was giving grave cause for concern, while Jacques Hoschedé's open hostility towards his stepfather now lead to Alice's personal estate being put up for sale by public auction in the autumn.

Despite all these difficulties, Monet began to work again in the open air. We know this indirectly from a remark in a letter to J.-P. Hoschedé's mother-in-law, and from the two canvases representing the artist's house, one of which is dated 1912 (1777–1778). Even so, many of the inner circle thought Monet lost to the art of painting. He seemed content merely to exploit the stock of work that he had built up and was to cash the cheques he received from Durand-Ruel and the Bernheims. For the year 1912 alone, these amounted to 369,000 francs. The painter himself encouraged the impression when he wrote to Durand-Ruel in January, 1913, claiming that he "no longer felt anything". Questioning the value of all his work to date, he was convinced that he could make no further progress and that he would never again come up to his own expectations. He agreed to put some finishing touches to canvases which his friend persisted in liking, but "after that, I really have finished."

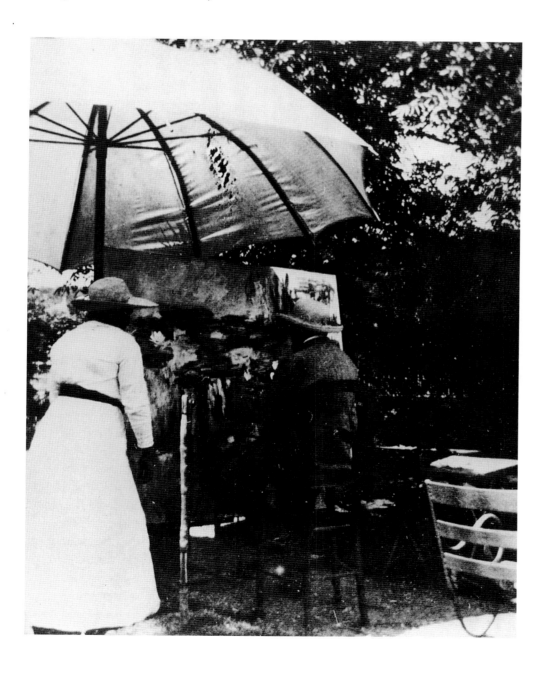

Monet and his daughter-in-law Blanche Hoschedé-Monet in the summer of 1915 Former photograph collection of Jean-Pierre Hoschedé

In mid-February, a short journey to St. Moritz in Switzerland with Michel and the Butler children seems to have breathed new life into Monet. Those members of his family who had remained in France were inundated with post-cards. On his return to Giverny, he told Durand-Ruel that he wanted to go back to Switzerland the following year to paint "that admirable country". Nothing was to come of this plan, but the fact that Monet had conceived it testifies to his improving spirits. When Jean, who was now almost wholly incapacitated, had to leave Baumont-le-Roger for good, Monet took the news well enough. His son sought refuge in Giverny, where Monet bought the Villa des Pinsons for him. As for the problems with his eyes, there was a brief moment of optimism when a German oculist who was visiting Paris claimed he would be able to cure him of his cataracts without resort to an operation. For this treatment, Monet would have to reside for a while, free of charge, in the oculist's clinic near Gotha. However, when information was sought from third parties, the doctor's reputation proved so discouraging that Monet decided, not without some regret, to forego his services.

The summer of 1913 nevertheless brought some happier moments. First of all, in July, there was the visit of a famous horticulturist, Georges Truffaut, whom Monet showed around the property. After his visit, Truffaut published an article by Félix Breuil, the head gardener of Giverny, in the review *Jardinage*. This text is an important source of information on the different kinds of iris that had been planted in both the flower and water gardens. This was followed by a short stay at Yainville, near Jumièges, at the invitation of Sacha Guitry and Charlotte Lysès, and in the company of Mirbeau. Guitry visited Giverny at the same time as the American singer, Marguerite Namara, and took her photograph as she posed, one arm nonchalantly resting on Monet's shoulder. Monet beams from under the brim of his panama hat; in the background are the Japanese bridge and the water-lilies. In early October, both Bernheim and Durand-Ruel visited. Germaine brought her younger daughter with her to collect the elder who had spent a part of her holidays at Giverny. All this badly interfered with Monet's painting, as he admitted himself. There is not a word, however, of the short series of "The Flowered Arches at Giverny" which he executed that year (1779–1781). These paintings show that Monet's vision was relatively unimpacted, since they depict the whole length of the pond with its covering of blossoming water-lilies.

These were among the canvases which Monet was glad to finish off in his studio in mid-November; he hoped soon to "return to painting from nature". A few days after this letter, he posed while reworking one of the *The Flowered Arches at Giverny* (1779) for the photographer of *Je sais tout*. The photograph was to illustrate an interview with André Arnyvelde. Arnyvelde was a most Parisian journalist: he confused the Seine with the Eure, and rehearsed several anecdotes of a kind more apt to swell the myth than to cast light on Monet's early years.

"I feel I am undertaking something very important"

1914, that fatal year, began for Monet with a serious bout of flu, which kept him in bed for part of January. By early February he was back on his feet, only to find himself the witness of his son Jean's final agony. Jean collapsed during a visit to his father's studio and was too ill to be moved. "What a torture to witness this collapse, there, right in front of me, oh how hard this has been!" Jean died on 9 February at nine o'clock in the evening. For all who knew him, his

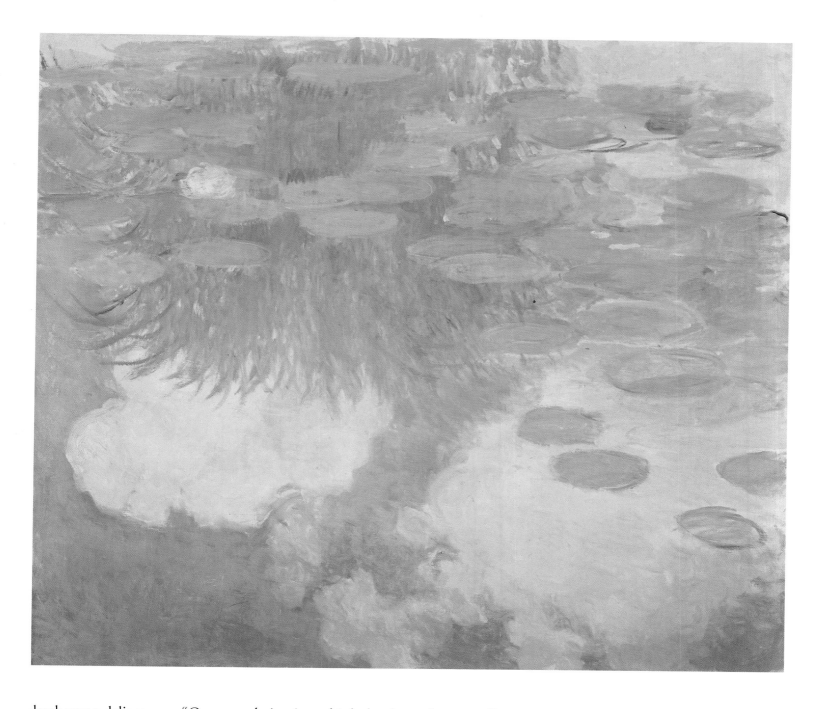

death was a deliverance: "Our consolation is to think that he no longer suffers, for he has truly been a martyr." Monet's grief over his eldest son cannot be compared with the distress he felt at the loss of Alice. Many explanations are possible: that by now he was accustomed to such blows or that with age he was becoming more egotistical. He may even have been glad to think that Blanche, now a widow, would be able to devote herself to looking after him. Hardly had they had time to reply to the letters of condolence when Monet and Blanche were called to Michel's bedside at the Hôtel Terminus in Paris; he was convalescing after an operation. Monet took advantage of this opportunity to go with Geffroy to visit an exhibition organised in his honour by Durand-Ruel. Fifty of his works were on show, covering all the periods of his career, from Argenteuil to Venice. On his return to Giverny, he devoted himself to the pleasures of gardening for the benefit of Sacha Guitry and Charlotte Lysès. Meanwhile the "conservateurs" of the Louvre were getting ready to open the rooms that were to house the Camondo bequest. Monet was represented by 14 paintings.

A long period of near total inaction was drawing to a close. Suddenly,

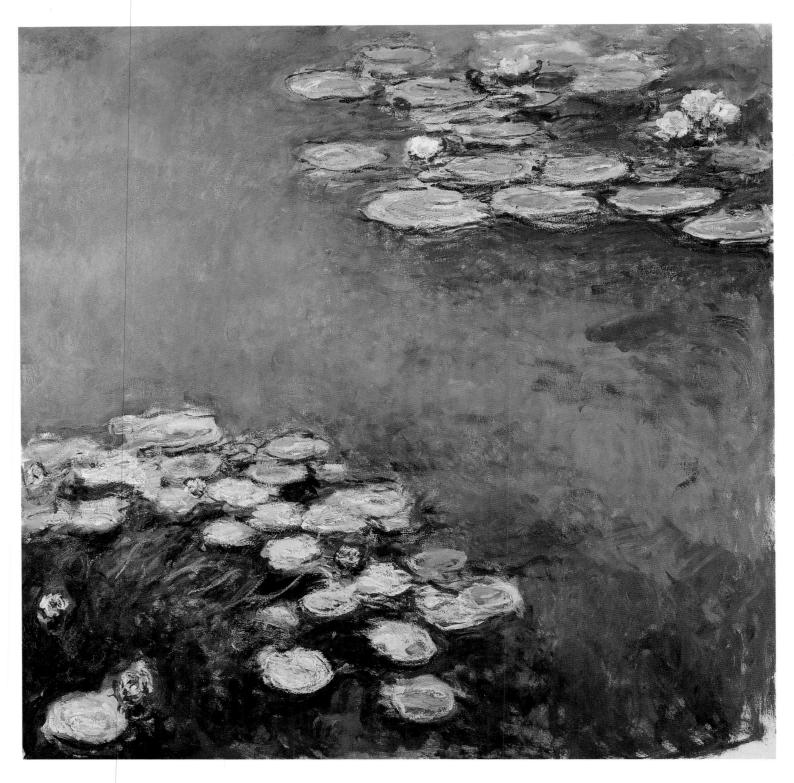

Water-Lilies
1914–1917
Cat. no. 1811

abruptly, the need to paint made itself felt again with a new intensity. More-over, Monet's conception of the work ahead of him now took on a scale and an ambition which were unprecedented in the history of the Impressionist move-ment. We know this from a letter addressed to G. Geffroy on 30 April 1914. Monet was impatient, having made a "false start" due to "a deterioration in the weather": "I feel I am undertaking something very important. You will see some old attempts at what I have in mind, which I came across in the basement. Clemenceau has seen them and was bowled over. Anyway, you will see them soon, I hope." These lines put an end to all previous speculation on the origins of the *Grand Decorations:* it was chance, or at least a lucky foray into the store-room, which resurrected the forgotten first attempts. These were almost cer-

tainly the canvases which M. Guillemot had mentioned in 1898. Seeing them again, Monet resolved to exorcise this long-standing temptation by undertaking a large-scale decorative ensemble. If we exempt the few old pictures found in his cellars, we can say with certainty that the great work that Monet decided upon on the eve of war, and which was to occupy the remaining years of his life, was begun only in May 1914. As for Clemenceau's often evoked intervention at this decisive moment – "Go ahead and stop procrastinating", "you can still do it, so do it" – the letter to Geffroy clearly confirms Clemenceau's role and his own account of it.

Did Monet immediately decide to build a special studio to accommodate this "very important" undertaking? Apparently he himself told Thiébault-Sisson that "the workmen ought to have begun excavation on 1 August". But this date is too neat and dramatic a coincidence, coinciding as it does with the date of general mobilisation of troops in France and Germany. Monet was dramatising. There is no trace in contemporary documents of the decision to build a new studio having been made before the outbreak of war. On the contrary, the evidence we have for this period shows Monet totally preoccupied with painting, at first indifferent to the weather, then, as atmospheric conditions took a turn for the worse, demoralised as he always was by such delays.

By late June, he was back into his summer rhythm: "Up at four, I struggle all day, and by evening, I am completely exhausted... My sight is fine again." On 6 July, he wrote to Geffroy: "It would be a great pleasure for me to show you the start of the vast work I have begun. For two months now, I have been working without interruption, despite the unhelpful weather." Having visited Giverny with Clemenceau, Georges-Michel remembered "two enormous panels of water lilies ... in a sort of large hangar", and that the large "octagonal" (?) studio was still just an idea in Monet's head. Monet apparently told Georges-Michel that he hoped to "finish at least another ten" of these panels before deciding exactly what was to become of them. This seems to have been in response to Clemenceau's immediate suggestion on this first visit that the ensemble might be donated to the state. Georges-Michel's account was written long after the event and is too vague to constitute serious chronological evidence about the *Decorations*. The relaxed atmosphere he describes suggests that the visit took place before war broke out. The two panels might then be some or all of those which Monet had wanted to show Geffroy in early July. Thus we can be fairly sure that, when the war began, the first *Decorations* already existed, at least in embryonic form.

A Studio Constructed in the Midst of War

"Bravo! Monet's great water-lilies will make wonderful targets for our firing ranges!..." This joke in somewhat doubtful taste is attributed to Renoir and gives a good idea of how the First World War came to dominate people's lives. It is true that Renoir paid a particularly heavy price, with two sons seriously wounded in the very first weeks of the conflict. Jean-Pierre Hoschedé was mobilised for service in the transport corps, and announced his departure for the front on 10 August. Michel was declared unfit for active service, but nevertheless volunteered, and saw combat, notably at Verdun. Away from the front lines, civilian morale was badly hit by the first setbacks. At Giverny, panic broke out. Mme Salerou and her two daughters left for Touraine, while Monet considered storing his canvases in a safer place: Paris. Durand-Ruel rightly discouraged him. Monet theatrically declared that he was willing to fall beneath the

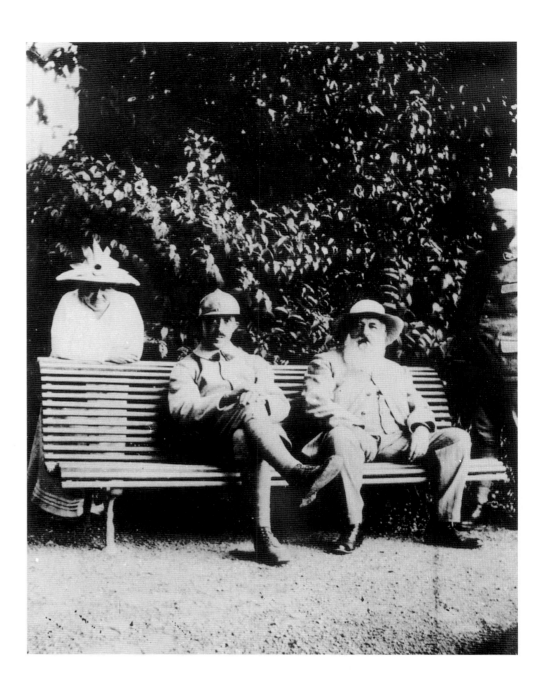

Monet proudly posing in 1916 with the two soldiers in the family, Michel Monet sitting and Jean-Pierre Hoschedé standing. Blanche, the sister-in-law is also present.
Former photograph collection of Jean-Pierre Hoschedé

blows of "these barbarians ... while defending [his] life's work". This was far removed from his behaviour in 1870, though entirely in keeping with the times. The wounded were rapidly pouring in, reaching even the smallest villages. Since the outbreak of war, the commune of Giverny had been placed under the administration of an appointed commission, one of whose four members was the former mayor, Albert Collignon. A small hospital of 14 beds, nicknamed the "ambulance", was installed in the house of the American sculptor, MacMonnies, whose wife, herself a painter, paid most of the conversion costs. Monet undertook to supply "all the vegetables necessary". The wounded were cared for by the singer Eugénie Buffet, who was thus promoted to the rank of "matron".

After the battle of the Marne and the race towards the coast, the front line grew more stable and immediate anxieties receded. Monet was able to travel to Paris on 10 November and planned to return there to lunch with the Goncourt brothers at Drouant's, to which he was now frequently being invited. Towards the end of the month, he got back to work, slightly ashamed to be devoting himself to "little investigations into colour and form, while so many men are suffering and dying on our behalf." Clemenceau's visit on 10 December helped

to soothe these scruples, which were out of place in a man who had just celebrated his 75th birthday. More seriously for Monet, the war was bad for business, and money became a scarce commodity. Durand-Ruel responded to an appeal from the painter with 10,000 francs paid in two instalments before the end of the year. Larger sums would have to wait. Monet was out of sorts shortly after the end-of-year festivities but back at work by mid-January 1915. As for the nature of the task he had undertaken, he told Raymond Koechlin: "I am still pursuing my idea of a *Grand Decoration* ... this is the project I conceived some time ago: water, water-lilies and plants, spread across a huge area." Six weeks later he was still hard at work, and was questioning Maurice Joyant about the dimensions of his gallery. Presumably he was considering hanging his panels from the picture rails of the mansion in the Rue de la Ville-l'Evêque.

It is clear from the above that Monet could now work all year round. For the summer of 1915, we have letters that record his progress. Two photographic documents shed an interesting light on this period. The first is a photograph, dated 8 July 1915, in which Monet poses under a parasol, transposing the horizontal expanse of the pond onto the vertical plane of the canvas. There he sits, perched on a high chair, as though painting the side of an aquarium. The second is a sequence of film which shows him painting beside the same pond. The film in question, *Ceux de chez nous* (Our people), was made by Sacha Guitry, and was shown in autumn at the Théâtre des Variétés, where Guitry read out a commentary. Monet is known to have attended one of the projections.

Many different sources tell us about Monet's winter work during the early months of 1915. At that season, Monet was working indoors. Sometimes he used the second studio to the north-west of the house; there his enormous canvases were hoisted up to the first floor. Sometimes he worked in a sort of "large shed" which Georges-Michel mentions, and which may simply have been the ground floor of the same building. The accounts of the members of the Académie Goncourt who visited Giverny on 17 June, 1915 provide no assistance on this point. The party comprised Mirbeau, his wife, Geffroy, Lucien Descaves, Léon Hennique, Rosny the elder and, perhaps, Paul Margueritte. Descaves described the scene in these words: "A surprise lay in store for us in his studio. Monet had been reworking, on a larger scale, the impressions he had shown before the war

A sequence from the Sacha Guitry film *Ceux de chez nous* (Our people) showing Monet at work
Summer, 1915

Sacha Guitry about the time he was shooting his silent film about French artists film *Ceux de chez nous* (Our people)
c. 1915

Sacha Guitry
Portrait of Claude Monet
Published in *Excelsior* on 12 January 1921

under the general heading: 'Water-Lilies'. He set out these impressions on huge canvases some two metres high and between three and five metres wide. He had already painted the whole surface of several of them, and he was 'having a studio constructed' specifically for this series, which he was planning to extend." When Mirbeau asked him "how long the work in hand might last", Monet apparently replied: "It will take me another five years." Mirbeau would have none of it. "You exaggerate. Perhaps two years, given your single-mindedness", he retorted.

The construction of the new studio was authorised by a decree issued by the sub-prefect on 5 July 1915. The spot that had been chosen was in the north-eastern part of the property, in the corner between the upper road and the Ruelle de l'Amsicourt. Before work could begin, various dilapidated buildings belonging to a neighbouring property that Monet had recently acquired had to be pulled down. These demolitions formed the first stage of the project, for which the foreman was Maurice Lanctuit of Vernon. Work must have proceeded apace, for by mid-August 1915, the structure of the building was sufficiently advanced for Monet to be disgusted by its ugliness. At the end of September, he was still "held up here by the end of the work on [his studio]". A little less than a month later, before the last touches had been added, he had begun the "definitive move into [the] new studio", where he would "at last be able to judge what [he had been] doing".

The *Grand Decorations* Before All Else

Having acquired a suitable working space, Monet was now able to devote all his time to the *Grand Decorations*. From late 1915 and for many years to come, his life was entirely given over to his struggle with the "the Work". His mood swung between hope and despair as he realised that he had embarked upon a task that was beyond the strength of a man of his age, brave and energetic as he might be. On 8 February he wrote to J.-P. Hoschedé: "I am so taken up with this confounded work of mine that as soon as I am up, I run to my big studio. I leave it only for lunch, then return till the end of the day." On 1st May, he wrote to Koechlin: "My sight is, would you believe it, good enough to enable me to work hard ... on these blessed *Decorations* which obsess me." On 26 August, he wrote to Sub-Lieutenant P. Desachy: "I am working so furiously, that I am literally haunted by the work I have undertaken." On 13 November, he wrote to G. Geffroy: "Clemenceau ... has just left, filled with enthusiasm for what I am doing. I told him how happy I would be to have your opinion of this redoubtable work which is, if the truth be told, sheer madness." On 14 December, he wrote to Sacha Guitry: "I am going through a very bad period with my work, and am in a state of complete exasperation. I have lost good things that I wanted to improve, and which I have to try and get back at all costs."

At other moments, Monet implied that the war itself lay behind the *Grand Decorations*, which provided him with a powerful source of distraction from the anxieties of the time: "I have my work, which is, after all, the best way of managing to forget a little. – The *Decorations* have the merit of keeping my mind occupied." Another positive effect of the conflict was the dispersion of the colony of (mainly foreign) artists who had settled in Giverny over the preceding decades. And there were fewer visitors, now that the few journalists who had not been called up had more pressing subjects to write about. The occasional visit from a friend or a dealer was not in itself enough to disturb Monet's industrious and near total solitude.

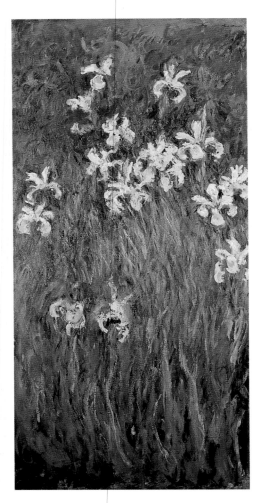

Yellow Irises
1914–1917
Cat. no. 1826

PAGE 407:
Water-Lilies and Agapanthus (detail)
1914–1917
Cat. no. 1821

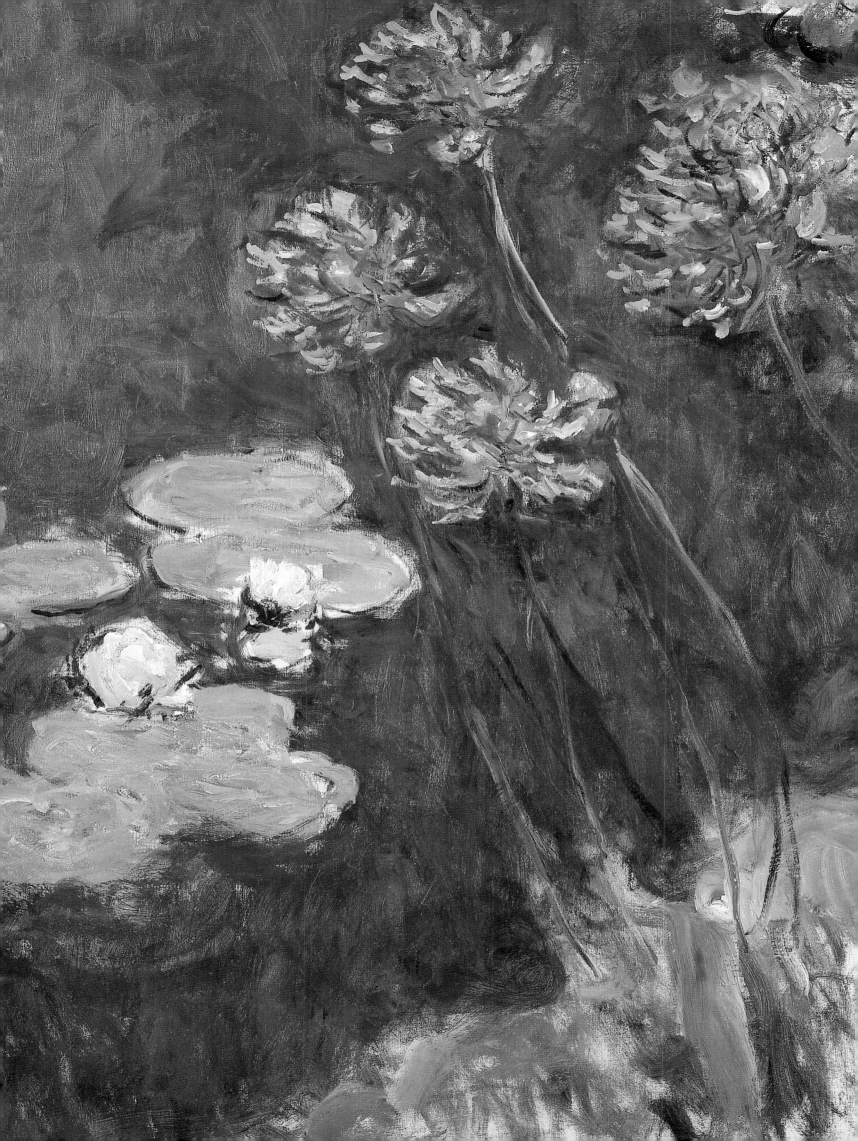

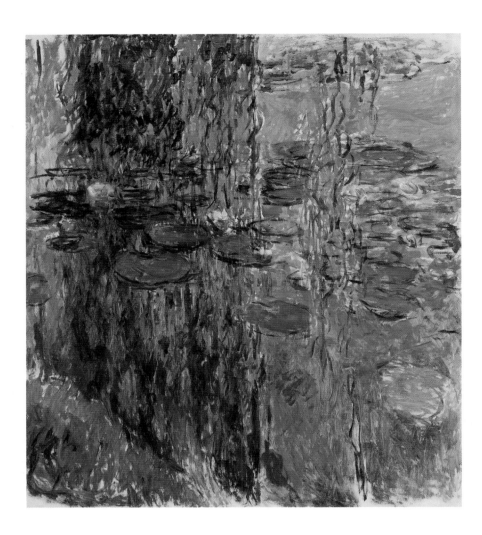

Water-Lilies
1916–1919
Cat. no. 1850

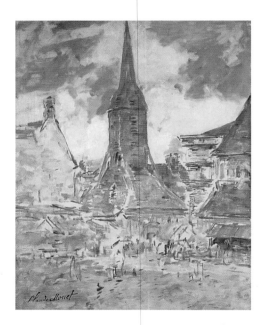

The Bell-Tower of Saint-Catherine at Honfleur
1917
Cat. no. 1847

Until the third studio was built, winter had been a period of rest for Monet, even after he had given up the open countryside to concentrate on his own garden. Now he was able to work indoors throughout the winter, and ran the risk of overtiring himself. Thus he wrote in January 1917: "Disgusted with what I've done, which I now realise I shall not finish, I feel I have no more energy and am no good for anything any more." Did he know that as he wrote, Jeanne-Marguerite Lecadre, the pretty cousin whom he had once painted in the gardens of Saint-Adresse (**68** and **95**), lay dying in Le Havre? His relations with the Monet-Lecadre family were not what they had once been; this was Alice's influence. The death of his brother Léon in August produced no reaction from Monet beyond a simple letter to his widow expressing his sympathy. This contrasts with the emotion he showed at Mirbeau's funeral on 19 February 1917. As G. Lecomte described it: "Bareheaded under the misty winter sky, this rough-mannered but sincere man stood and sobbed. From the depths of his eyes, red with grief, tears rolled into the thickets of his long beard, which was now quite white." Monet was also present at Degas' funeral in September of the same year.

The nightmare of the war was one with which France was learning to live. Monet now felt able to make a few trips to Paris, in particular to consult a dental surgeon. On one of these occasions, he invited Geffroy to dine with him and Blanche at Prunier's. However, he was too busy to take up Sacha Guitry's regular invitations to attend the dress rehearsals of his plays. Exhibitions were sometimes held, and some of those featured Monet's work. The companionable warmth of the wartime galleries on occasion thawed Monet's habitual reserve,

and one journalist heard him recounting Courbet's booming summons to the waiter of the Café Guerbois: "Garçon, a lager for the Maître d'Ornans!" Charity sales became occasions for unexpected displays of unity, with Monet's pictures cropping up beside those of Rochegrosse, in groups led by presidents of the Salon such as Bonnat, Roll, Frantz Jourdain and Signac. However, such events had their drawbacks; the prices were not infrequently "disastrous for the donors" and undermined their standing on the collector's market.

Monet was increasingly seen as the official painter of the Republic. He was visited by two serving ministers, to whom he submitted an idea for a "tapestry". They, in their turn, made him an unusual proposition: "Go to Reims and paint the cathedral in its current state." Monet was "extremely interested" and when the ministerial decree arrived, officially commissioning him to paint the mutilated cathedral, he was "flattered and honoured". Nevertheless, the painting was never executed, and the few echoes of this affair that reached the press seem to have caused Monet some displeasure.

The time and energy this project would have required went instead into the *Decorations*. Monet's schedule was now well-established: in the winter he worked in the studio and in the summer in the open air, where he was at the mercy of the weather and complained, as ever, at its interruptions. In 1917, he moved indoors on around the 10 October; till then, he had exhausted himself by dividing his time between the studio and the garden. He decided on an excursion to Normandy to revive his spirits. His journey took him to Honfleur, where he made a few studies (1845–1847), and thence to Dieppe, via Le Havre, Etretat, Yport and Pourville – the sacred places of his youth and his middle age. Such a return to his roots would have plunged a more romantic man into a state of nostalgic reverie. Monet, however, emerged from this trip with his energies redoubled and threw himself into his work with new passion. This ardour soon bore fruit: in February, Monet had said that he did not want the *Decorations* photographed before he was satisfied with them. Now, on 11 November, he allowed Georges and Joseph Durand-Ruel who were visiting Giverny to take photographs of the studio and the ten or so panels which it contained. These amateur pictures – the details are not always easy to make out – are an important landmark in the chronology of the *Grand Decorations*. They show that the *Willows* occupied an important place in Monet's scheme from the very beginning. However, the other canvases present on that day in 1917 do not form part of the definitive ensembles. They fell victim to Monet's creative energy, whose rigour and force can be gauged by the elimination of paintings such as these.

A Triumph in Two Panels

Urgent orders for materials – brushes, stretchers, canvases – addressed to his supplier, Mme Barillon, testify to Monet's feverish activity at this time. The railways would no longer transport packages above certain dimensions for civilian purposes, and Monet appealed for help to Etienne Clémentel, Minister for Commerce and Industry. But when, a few days later, J. Durand-Ruel asked Monet if he would have a word with Clemenceau on behalf of his son Pierre, candidate-officer at Fontainebleau, the painter replied in all apparent seriousness that he had passed on his friend's request, but that he himself never asked any favours of Clemenceau ... A little while later, he responded angrily to the news that a photograph of himself intended for Butler had been mislaid en route at Durand-Ruel's New York gallery. In reprisal, he delayed rather more

Clemenceau, nicknamed "Le Dompteur"
("the Lion-tamer")
Postcard, c. 1918

PAGE 411:
The Water-Lily Pond at Giverny
1918–1919
Cat. no. 1878

than the dealers would have liked in delivering the five canvases they had chosen in November of the preceding year.

There is plenty of evidence that the Bernheim-Jeune brothers visited Giverny on 17 March 1918. However, there is little proof that Thiébault-Sisson met Monet there during the first ten days of February, as he much later claimed. Since his account is problematic on a variety of grounds, we will mention it only in passing. (We shall return to the important information it contains when we come to deal with Thiébault-Sisson's well-attested visits to Giverny in 1920.) A chronologically more reliable document is René Gimpel's notebook, in which he recorded events as they happened, day by day. Thus we know that he travelled to Giverny on 19 August 1918 with Georges Bernheim. The account of this first meeting with Monet should really be cited in full: the anecdotes Bernheim told him during the journey down, his impression in the garden of being confronted by gigantic flowers, the effect produced upon him by the astonishingly youthful painter, and the contents of their conversation. However, I shall only quote Gimpel's account of the "strange artistic spectacle" with which the new studio presented him: "A dozen canvases resting on the ground in a circle, one beside the other, each of them two metres wide and one metre twenty high." Gimpel's estimate of the dimensions of the pictures was exactly right for the width, but slightly exaggerated the height of the canvases. It matches both the 1m by 2m stretchers ordered from Mme Barillion in April and the series of paintings of which four were purchased by the Bernheim-Jeune brothers in November 1919. These are not, then, the *Grand Decorations*, which were 2 m high and 4.25 m wide. Monet worked on the larger canvases in his studio that winter, but he had used the smaller format, which could be carried about more easily, to make small open air studies of the pond during the summer of 1918. This alternation between summer and winter work, which we have already noted, is implicit in Monet's parting words to his visitors: "Come back and see me at the beginning of October, the days will be getting shorter, and I will take a fortnight off."

Georges Bernheim and René Gimpel delayed their second visit by a few weeks. By the time they returned to Giverny, the armistice concluding World War I had been signed at Rethondes on 11 November 1918. Nothing could be more striking than the contrast between the anxiety that characterised public opinion throughout the terrible battles of the final year of war, and the apparent indifference to these events evident in Monet's correspondence. So obsessed was he that he regularly worked until completely exhausted; he seemed to have forgotten the existence of the outside world. But as soon as the armistice was announced, Monet wrote to Clemenceau to tell him that he intended to donate to the state, with Clemenceau as intermediary, two decorative panels that he was "on the point of finishing" and that he intended to "sign as of the day of the Victory". And he asked Clemenceau to choose the canvases which should, he said, be sent to the Musée des Arts Décoratifs. Six days later the so-called "Father of Victory" (Clemenceau), ignoring all other honours and obligations, came straight to Giverny to make his choice. To Geffroy, who travelled with him, he looked "ten years younger". Geffroy's account refers to "*several of the canvases ... that Cl. Monet gave to France as one might a bouquet of flowers to honour victory in war and the conquest of peace.*" If the words that I have put in italics are to be taken literally, the number of pictures to be donated had increased. It is tempting to conclude that the idea of a more substantial donation had been adopted by 18 November. If so, this was Clemenceau's work.

When Bernheim and Gimpel visited Monet again at the end of the month, there was no question of anything being donated to anyone. Monet refused to

sell any of "these immense canvases he had painted during the war" and which were "cluttering up" his studio, so that it looked "like a riding-school". The argument he used to justify his decision was the usual one: "Impossible, I need each of them to work on the others." Thus like Sisyphus, Monet set himself his gargantuan task, little knowing how great it was.

The Law of Silence

In summer 1919, Monet was working harder than ever in the open air. As before, he used the canvases smaller than those specifically made for the *Decorations*. His enthusiasm for his work gave his stepdaughter some concern until she acknowledged that his fatigue affected him relatively little. However, the hours he put in beside the mirror-like surface of the pond did eventually take their toll. The use of a parasol sheltered him only partly from the brilliant light, and his sight began to trouble him again. On 9 November, Clemenceau, drawing on

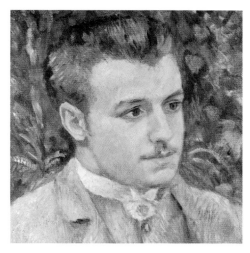

Auguste Renoir
Portrait of Georges Durand-Ruel (detail)
1882

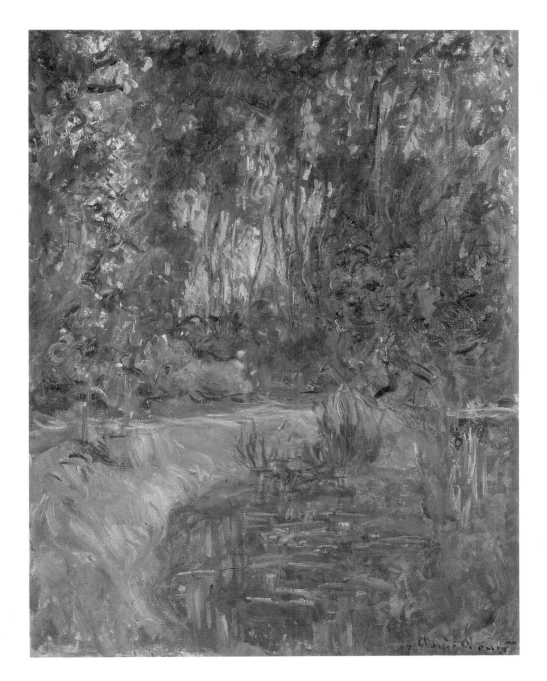

Auguste Renoir
Portrait of Charles Durand-Ruel (detail)
1882

Auguste Renoir
Portrait of Joseph Durand-Ruel (detail)
1882

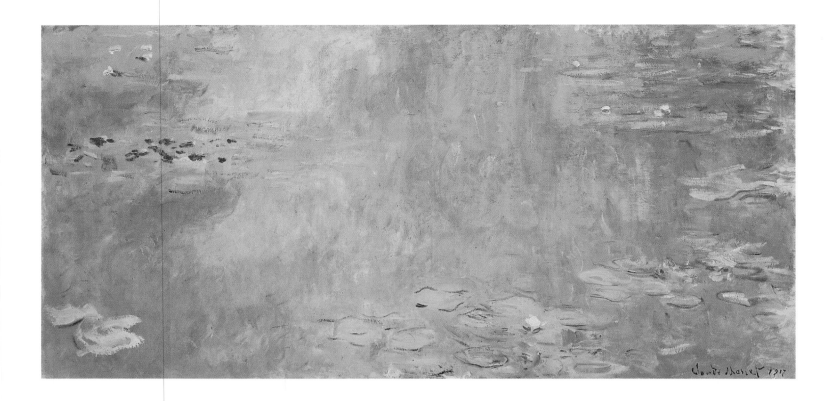

The Water-Lily Pond
1917–1919
Cat. no. 1886

his memories of his medical training, recommended he be operated on for cataracts. Monet thought about this proposition, but could not make up his mind: "I prefer to make the most of my poor sight, and even give up painting if necessary, but at least be able to see a little of these things that I love". Far from restoring his sense of peace, the idea of having to give up "so much work that has been begun" plunged him into a state of "abject distress." Maurice Joyant wrote to answer the question Monet had put to him during the war about the dimensions of his gallery and its suitability for an exhibition of his large panels, but received only a polite prevarication in reply. The death of Renoir on 3 December was a blow to Monet's morale. Clemenceau visited him regularly, bringing what encouragement he could. Then on 16 January 1920, by one of those "accidents" that bedevil the lives of those who hunger after glory, the "Father of Victory" was ousted from the Presidency of the Republic. The following Sunday, while the Versailles Congress was electing Paul Deschanel to take his place, Clemenceau was on his way to visit Monet.

For some time after this date, no more mention was made of the project to donate the *Decorations* to the State. Did Clemenceau's fall put the projected donation at risk? It has been alleged – though no evidence is forthcoming – that Clemenceau took a foreign collector to Giverny by way of revenge against his ungrateful countrymen. They do not know their man. No, Monet and Clemenceau must have simply agreed not to publicise a project which Monet was uncertain of being able to finish to his own satisfaction. We know that negotiations with the state were well advanced by early 1920. The condition, imposed by the artist, that the state would buy the *Women in the Garden*, in return for the gift of the *Decoration*, had by then been accepted, as is shown by a letter of thanks from Monet to R. Koechlin, President of the Society of Friends of the Louvre, who had helped him negotiate this transaction. But Monet was careful to say little about his plans to anyone not immediately concerned. On 1 February, he told Gimpel and Bernheim that Clemenceau came to see him "almost every Sunday", but he was careful not to mention any link between these visits and the great work in hand. On the contrary, he spoke of

offers to purchase it, which he was, he said, reluctant to consider, as he was in no hurry to finish it.

The Donation Made Public

On 8 May, Monet told Thiébault-Sisson that he intended to resume work outdoors. But a month later he informed Geffroy that his sight had prevented him from working in the open air, and that he was therefore "saving [his] strength for work on [his] *Decorations*, when the heat in the studio is not too intense." Since the studio was unbearable during summer afternoons, we might have expected that the bulk of Monet's work was done in the mornings. However a letter to an unknown correspondent would seem to prove the contrary; the addressee was invited to visit Giverny in the morning, as afternoons were reserved for painting. This change in Monet's timetable can only be explained by his having returned to open-air work. A note to Arsène Alexandre shortly afterwards, when Monet was hard at work in the garden, confirms this.

In early June, Monet received three important American visitors who were introduced to Giverny by Durand-Ruel, but the meeting had no known consequences. Shortly after this visit, the affair of the donation to the French state entered a decisive phase. The negotiations were then being conducted through Thiébault-Sisson, who was lucky enough to be both persona grata at Giverny, at least for the time being, and a close friend of the Prime Minister, Alexandre Millerand. Towards the end of June, Monet sent a letter to his acting representative in which he stipulated the two conditions of his donation, and further reserved the right to keep possession of the paintings until such time as he had approved the arrangements made for their exhibition. As soon as he received this letter, Thiébault-Sisson forwarded a copy to Millerand, advising him to visit Monet as soon as possible. He offered to go with him, and, leaving nothing to chance, he informed Paul Léon, Director of Fine Arts, and invited him to accompany them. In this, however, Thiébault-Sisson was a bit too quick off the mark. Only a week later, Monet rebuked him for his presumption and precipitation in terms which effectively terminated his involvement in the affair.

With Thiébault-Sisson out of the way, it was Arsène Alexandre's turn to approach Monet. Alexandre had been chosen by the Bernheim brothers to replace Geffroy as author of their proposed book on Monet. Alexandre travelled to Giverny at the beginning of August. There he found Monet willing to confide his plans, against the advice of Clemenceau, who was not at all happy when Alexandre visited him to discuss the "possible donation, which is none of his business". Undaunted, Alexandre pressed on with his negotiations, and informed Monet that the Ministry of Fine Arts had asked him to examine the works in question and the conditions of their donation. He intended to perform this task while working on his monograph. Monet was entirely absorbed in painting from life, and anxious that the effects he was seeking might soon be lost. He asked Alexandre for a delay, but Alexandre, far from granting his request, persuaded him to let Paul Léon visit him on a date set by Léon. Monet was driven to accept, and was lucky that Raymond Koechlin, invited at the very last minute, could be present to advise him. The meeting took place on Monday, 27 September 1920, and an agreement in principle was reached. The very next day, Paul Léon telephoned the architect Louis Bonnier and asked him to take charge of constructing a pavilion to house the water lily paintings in the gardens of the Hôtel Biron, which had become the Musée Rodin shortly after the end of the war. Léon stressed to Bonnier that he had been chosen at Monet's express

Edouard Vuillard
Josse and Gaston Bernheim
1912
Paris, Bernheim-Jeune Gallery

request. Monet was acquainted with Bonnier as the brother-in-law of his old friend, Ferdinand Deconchy, but his choice of architect was based not on their friendship but on Bonnier's eminent reputation. Bonnier was trusted equally by the French state and by the city of Paris, both of whom had already granted him major commissions.

Bonnier's first meeting with Monet took place on 3 October 1920. He was accompanied by the Deconchys and by his grand-daughter, Jacqueline. After a lunch worthy of Giverny's traditional hospitality, the architect was shown the water lily paintings. Having paid his tribute of admiration, he measured the panels and noted down their organisation. Afterwards, he wrote: "foresee great expense for the pavilion." He set to work on a preliminary project, based on the hypothesis of an elliptical space. He submitted this plan to Monet on 5 October. In his letter, he explained the technical problems which this shape posed, and put forward a second hypothesis, a circle, which would resolve some of these difficulties.

Shortly afterwards the planned donation came to public notice. No indiscretion was involved; a negotiation in which so much public money was directly at stake could not be kept secret once it had advanced beyond a certain point. Georges Bernheim learned of it while visiting the Musée Rodin. When questioned, Monet confirmed that it was true and gave him further details. Soon the press had picked up the story. On 14 October, *Le Petit Parisien* devoted a column on its front page to the news: "The painter Claude Monet donates twelve of his finest canvases to the state." The journalist noted that the government would be asking the lower house for the necessary funds, and that the request was expected to be quickly ratified. On the same day, *Le Temps* published an article by Thiébault-Sisson, who thus got in ahead of his colleague, A. Alexandre; the latter's article appeared in *Le Figaro* only on the 21st. The art periodicals also reported the donation.

By collating these different sources of information, we can obtain some idea of the terms in which the donation was conceived in October 1920. Monet was to give the French state twelve panels measuring 2 x 4.25 metres, which together made up four large-scale compositions. The state, in return, promised to purchase the *Women in the Garden* (67). To house the series of new paintings, a specially-designed building would be erected in the gardens of the Hôtel Biron, on the Boulevard des Invalides side. The initial project was for an elliptical space, in which the four compositions would be arranged as follows: at either extremity of the major axis, on the narrower sides of the room, there would be two triptychs, each 12.75 metres long – *The Clouds* "in blue major", which Monet had decided to offer to his country the day after the armistice was signed, and *Agapanthus*, "in which molten gold dominates". Facing each other across the minor axis would be the "dark votive columns" of the *The Three Weeping Willows*, whose four panels were 17 metres long, and the *Green Reflections*, a diptych which conveyed "the tenderest coolness of morning". (The titles and measurements are taken from Bonnier, and the quotations from Alexandre.) Thanks to Thiébault-Sisson, we know that the space between the canvases and the ceiling was to be occupied by decorative motifs, a frieze of wisteria whose first garlands Monet had already shown to the Duc de Trévise. Another extended composition was planned for the lobby through which visitors would enter the rotunda. Throughout October, Bonnier worked hard on the plans, often staying up all night. On 28 November, he travelled to Giverny with André Honnorat, Minister of Education and the Fine Arts, P. Léon and R. Koechlin. He arrived there with the conviction that his designs would be accepted, at least in their overall scheme. But no. That evening, he confided to his diary: "We

returned to Paris. The whole project has to be rethought." Bonnier's long and fruitless labours had, alas, only just begun.

From the Hôtel Biron to the Orangerie

Monet's eightieth birthday on 14 November 1920 was an event of national importance. The Prime Minister, Georges Leygues, and the senator, André Berthelot, proposed to attend the celebrations. The announcement of this distinguished visit gave hope to the once rebuffed Thiébault-Sisson that as the intermediary he might thus be restored to Monet's favour. In vain: despite his good offices, the door of Giverny remained firmly closed to him. He might have otherwise left us some record in *Le Temps* of the family party to which only "a few intimate friends" were invited, Leygues having finally withdrawn, no doubt because his mediator had been rejected. The Duc Edouard de Trévise, who had already visited Giverny that summer, was present. In the studio-salon he declaimed some twenty stanzas that he had composed in honour of the octogenarian painter. Later, he published his *Le Pélerinage de Giverny* (Pilgrimage to Giverny), in which he mentioned neither the party nor his poetry. But the text remains a valuable source of information for the historian. The Duke seems to have had the freedom of the house, and recorded his impressions without trying to glamorise them. He described the way Monet manoeuvred the panels in the third studio by means of heavy easels on castors, comparing the space to an empty stage, on which the visitor was enclosed in successive layers of "fabulous screens". He also confirmed that while Monet was working on the *Deco-*

The Water-Lily Pond
1917–1919
Cat. no. 1889

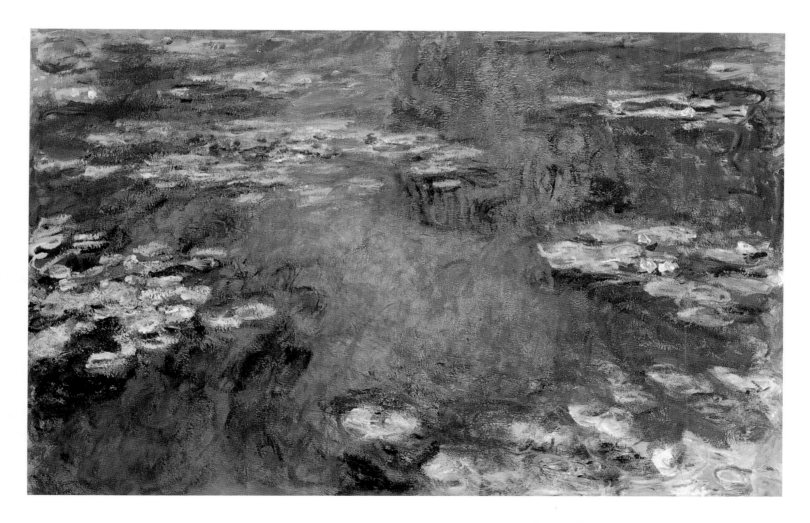

rations, he was also painting huge, disconcerting "studies of the motif", "skeins of related colours, which no other eye than his could have disentangled, strange floating threads of wool." These bizarre studies were, of course, further evidence of the progress of his cataracts.

As a birthday present, Geffroy devoted a detailed study to his friend's work in *L'Art et les Artistes*. Monet could not hide his satisfaction, though he did remark on "a few small errors". The offer of membership of the Institute was not so well received. Henri Martin, Le Sidaner and Ernest Laurent made approaches to him on this subject, but were unsuccessful. We know this from Marcel Pays in the *Excelsior*, but the article he wrote about his visit to Giverny found no favour with its subject. Monet was hardly generous with compliments during this period. But the success of an exhibition of forty-five of his paintings at Bernheim-Jeune's in late January, 1921, and the departure of the *Women in the Garden* (**67**) on 2 February (it now belonged to the state) helped to cheer him up. It was a difficult winter. The dullness of the grey skies was compounded by his own rapidly fading eyesight.

Meanwhile, the Hôtel Biron pavilion was at a standstill. A first estimate based upon the oval plan had proved too costly for serious consideration. Bonnier had presented a second study to P. Léon on 20 December, which proposed a circular room. This was significantly less expensive than the first plan. The exterior was to be polygonal, and the construction would be in reinforced concrete. The windows would be placed high up, and would provide plenty of light for the paintings which would hang "almost level with the ground". The last words are those of Geffroy, quoted by M. Pays. Bonnier himself specified that the "length of the picture rails" would be 12 x 4.25 metres, making 51 metres in

The Water-Lily Pond
1917–1918
Cat. nos. 1891–1892

total. To this should be added four gaps which were to be left free so as to separate the compositions; two of the gaps would be occupied by doors. It was intended that visitors should be able to stand 18.5 metres away from each of the compositions.

In January 1921, Bonnier learned that the Public Buildings Council, amongst whose members he had enemies as well as friends, considered that the projected building was "not sufficiently Louis XV"! This objection to an overtly modern building could hardly prevail if the Hôtel Biron location were abandoned. But for the time being, P. Léon saw no need to substitute another site. Once the necessary funds had been allocated, Bonnier told Monet, "we can override the Council's opinion." But they still had Monet to contend with; he was tired and consequently more captious than ever. He had seemed happy with the idea of a circular room, but changed his mind and dismissed the notion in a letter which left Bonnier in despair. In a letter to P. Léon, he said that he was "disappointed by the form of the room which is too regular, and, as it stands, would be a veritable circus-ring." He reminded Léon that it was a "formal condition" of the donation that the works be presented as he desired. The "only way" out was to reduce the number of panels that made up the *Decorations* to ten, or even eight.

While Louis Bonnier once again modified his plans, Léon sought to prevent any reduction in the number of panels. He began to think that, instead of commissioning a special building for the paintings, the authorities should save money by adapting existing premises. We do not know if this idea was canvassed when the Minister for Education and the Fine Arts, Léon Bérard, visited Giverny on Sunday, 13 March, with his principal secretary, Paul Léon and Gef-

froy. But we do know that on 1 April, Clemenceau, P. Léon, Geffroy and Bonnier went to inspect the Salle du Jeu de Paume and the Orangerie, both of which were then earmarked for use as museums or exhibition space. The Jeu de Paume seemed too narrow, but the Orangerie fitted their needs perfectly, being 13.5 metres wide. Clemenceau informed Monet immediately, and advised him to "call it a deal". The following Wednesday, 6 April, the painter, the minister and the architect Victor Blavette met the group who had made the initial survey, and it was decided to "settle on the Orangerie".

Thus, in place of a modern building designed by an architect later responsible for the overall plan of the Decorative Arts Exhibition, Monet accepted a sort of dungeon on the ground floor of an elegant pastiche erected under the Second Empire. Occasionally over the coming decades, visitors to the high-profile exhibitions held on its first floor would lose their way and wander down into this pseudo-basement, where they would stumble upon Monet's water-lilies. Monet's acceptance of the Orangerie was greeted with delight. No sooner had this faded than Monet began to doubt the wisdom of his decision, and then withdrew the donation altogether. In a letter to Paul Léon, he explained that he had conceived his *Decorations* with a special kind of room in mind, where "each

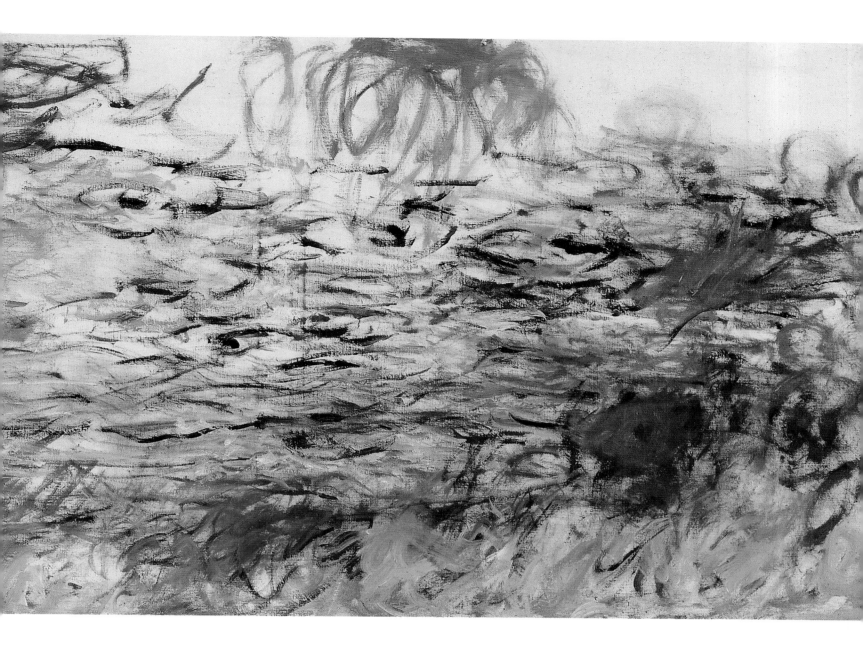

Water-Lilies
1919–1920
Cat. no. 1902

of the different motifs could be shown in an arc". This original intention would be unacceptably betrayed in a building so small that these different motifs would have to be "shown absolutely straight." Those anxious to see the project realised were obliged to try to persuade Monet to change his mind yet again. Marcel Pays published an interview with G. Geffroy in *Excelsior* under the ingenious title: "Un don précieux: *Les Nymphéas* de Claude Monet attendent un emplacement" (A precious gift: Claude Monet's *water-lilies* are in search of a home). Geffroy used the opportunity to discuss the problems posed by the choice of an appropriate space, and recounted the memorable visit to the Jeu de Paume and the Orangerie. But he made no mention of Monet's subsequent change of heart. Monet, meanwhile, had waited three weeks for a reply to his refusal. When he read this article, he wrote to P. Léon. Monet clearly wished to re-open negotiations, but his wording was somewhat confused. Léon saw his opportunity, and simply informed him that he would respect his decision, though he deeply regretted it. This was the right tactic. Monet authorised Alexandre to tell the relevant people that he was still willing to go ahead with the donation, and that he would even increase it so that "it made two rooms".

Vernon (Eure) *Atelier de Claude Monet 1917*

The Donation is Formalised

The danger of a breakdown in negotiations was all too real by January 1922, and Georges Clemenceau knew that an agreement between the Administration and the artist was ever more urgent. Having received verbal assurances that the Orangerie would be ready "within two years at the latest", Monet felt that the time had come to draw up a deed of gift. Léon was slow to reply, and Monet began to suspect that he was being trifled with. Nevertheless, he continued to work on the *Decorations*, despite the increasing problems that his sight was causing him. When Clemenceau visited him at Giverny, he found Monet was "once more ... ready to change his mind" and "begged" Paul Léon to "conclude matters". The correspondence between Monet and Clemenceau over the next few days testifies to the unfailing patience that Clemenceau needed in his efforts to keep the project on course.

The first fruit of these efforts was a letter Monet sent to Paul Léon dated 23 March, which contained "the list of the decorative panels" to figure in the documents then being prepared. And here there was a surprise: instead of the twenty panels that had figured in the Lefèvre plan, there were now "22 forming a set of twelve [sic] compositions which may be modified during installation." This last clause suggests that nothing was yet fixed in Monet's mind. Indeed, in one undated typed draft of the deed, which seems to have been drawn up by the Administration working from information supplied by the artist, only 18 panels are mentioned. In the final deed of gift, signed by Cl. Monet and Paul Léon in the offices of Maître Baudet at Vernon on Wednesday 12 April 1922, there are only 19 panels. This document specifically refers to the Lefèvre plan of 20 January, but differs from it in one important aspect. According to the terms of the deed, the first room was to contain eight panels measuring 4.25 metres and one measuring six metres. They were to be arranged as follows: *Sunset* (6 m) to the west, and to the east, the diptych *Green Reflections* (8.5 m); on each of the long walls, a triptych (12.75 m), *The Clouds* to the north and *Morning* to the south. The second room was to house six panels of 4.25 metres and four of 6 metres, grouped as follows: on the short wall that separated the two rooms, a diptych, *Reflections of Trees* (8.5 m); facing it, a polyptych entitled *The Three Weeping Willows* (17 m); on each of the two longer walls, a diptych (12 m), each of which was to be called, without further distinction, *Morning*.

The signing of the deed was noted in various art magazines. Clemenceau wrote from his estate at Saint-Vincent-sur-Jard in the Vendée to congratulate Monet on the conclusion of a deal to whose success he himself had contributed more than anyone else and to reassure the artist of the value of his gift. On his return to Paris, Clemenceau invited himself to Giverny for lunch on Sunday, 7 May. His presence at this moment was crucial. Monet had just realised that by continuing to rework the *Decorations*, he had spoiled some of them, which he had then felt obliged to destroy. He was therefore in great need of the comfort his friend could bring, and waited impatiently for each new visit. To comfort the painter during his absences, Clemenceau wrote the *Réflexions philosophiques du Très-Haut sur le Très-Bas* (Philosophical reflections of the Most-High on the Most-Lowly), a sort of extended prosopopoeia in which "God" speaks to his "son", Monet. The son is "a blind man who refused to have his eyes opened", and God exhorts him to "want what everyone wants", that is, to have the operation. Was it this curious text, or the frequent visits of his friend that encouraged the artist back to work? Whatever the cause, Monet was working again by the end of June: "I have started quantities of things and they are giving me a lot of trouble." Indeed, when Albert André asked if he and his wife could call at

PAGE 420:
The third studio at Giverny
1917

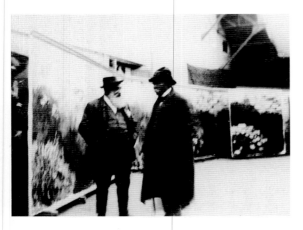

Giverny, Monet asked him to postpone his visit. Only for Clemenceau was the door always open. He was there on Sunday, 25 June, when Monet thanked Geffroy for his magisterial essay on his art. On 4 June, the decree accepting Monet's donation was signed by Léon Bérard, Minister of Education. This news encouraged Monet to persevere, and his letters at this time are full of phrases which hark back to his youth: "I'm hard at work. I want to paint everything before my sight is completely gone."

Preparing for the Cataract Operation

Monet persisted with his work on the motif despite repeated disappointments, and in his endeavours all but destroyed what little vision was left in his long overworked eyes. A visit to a specialist was now necessary. Clemenceau tried to joke about it: "I'm keen to know what the vet said about your eyes." The "vet" in question was, in fact, one of the most highly regarded ophthalmologists in Paris, and a personal friend of Clemenceau, Dr Charles Coutela. Monet visited him at his surgery, 19 Rue de la Boétie, during the first week of September. His anxiety was partly allayed when he discovered that the doctor was a sprightly fifty-year-old with mischievous eyes, an abundant crop of hair, and a cordial yet slightly gruff manner softened by deference for his eminent patient. The double cataract that had been diagnosed ten years earlier had made substantial progress in the intervening years. The sight in his left eye was now reduced to 1/10, and in the right there was "perception of light only, though with adequate projection." This last point indicated "a satisfactory retina", and made an operation on the right eye the logical first step. Should anything go wrong, the loss incurred would be minimal. Faced with Monet's unconcealed terror at the idea of an operation, Dr Coutela agreed to postpone it, prescribing "mydriatics (euphtalmine and homatropine)" for the left eye, the better of the two. The result was an immediate improvement to between 2 and 3/10. Monet was overjoyed with the improvement, and felt that it eliminated the need for an operation in the short term.

The Monet who left the surgery seemed a younger man. He went directly

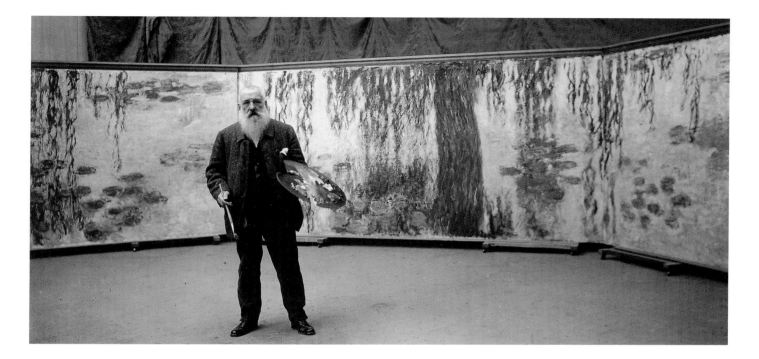

to the Orangerie to see how work was proceeding, and was greatly disappointed to find: "No trace of any works and complete silence; a little pile of plaster along one of the walls, and nothing else." He asked Paul Léon what was happening, and Clemenceau, informed of the situation, also made enquiries. Léon was masterful in handling such situations; Monet was so reassured by his explanations that he could not thank him enough. But he was still "scared stiff that [he] might not be there on the great day." This fear was aggravated by the prospect of the operation, to which he was now resigned as the only way to improve his sight. (Doubtless the friendly pressure brought to bear by Clemenceau had contributed to this decision.) It was in this state of mind that Joseph Durand-Ruel found him when he visited Giverny with his son-in-law and his son Charles on Sunday, 15 October. Monet appeared to be "in quite good health and not too sad" at the prospect of the planned two-phase operation. He had been painting "a large number of canvases in his garden" until very recently. The motifs of these pictures were similar to those with which Durand-Ruel was familiar, but the set seemed to him too "black and sad" to sell easily, given the prices that Monet was asking. The dealer thought that Monet's "great success with the Japanese had gone to his head." Foremost among these Japanese admirers was Kojiro Matsukata, who was represented in France by his agent Léonce Bénédite, chief conservator of the Musée du Luxembourg.

Blanche Hoschedé-Monet, Claude Monet and Clemenceau in the third studio
1920
Former photograph collection of Jean-Pierre Hoschedé

An Operation in Three Stages

The first phase of the cataract operation, delayed for several weeks by the success of Coutela's prescription, had been planned for November. However, a bout of flu had left Monet "rather out of sorts", and the operation was again postponed, finally taking place on 10 January, 1923 at the Ambroise Paré Surgical Clinic in Neuilly. There, Dr Coutela performed the exeresis of a fragment situated in the upper part of the iris. This operation took place under local anaesthetic. The reaction of the patient was described by the doctor in the following terms: "When the iridectomy took place, the patient was nauseous and even vomited. These were exceptional and unforeseeable reactions, caused by

ABOVE:
Monet in front of the polyptych *Three Willows* in the third studio
1921
Former photograph collection of Jean-Pierre Hoschedé

his emotion, and extremely awkward and alarming; yet everything went off quite well." Indeed, a week later, Monet was able to write to P. Léon in his own hand to tell him that he was preparing for the second phase of the operation and that his hopes about its ultimate effect were high. The second phase took place on Wednesday, 31 January in the same clinic. In Coutela's words: "Having taken every possible precaution, it was still with some apprehension that I proceeded, after iridectomy and with the solid protection of a broad conjunctival bridge (so as to avoid the need for sutures), to extract the right cataract (an extra-capsulary extraction), trying to ensure the complete aspiration of any residue. Before the evening was out, the anterior chamber had already reformed: this was a great relief to see." It must have been a great relief to Monet as well: he had undergone the entire operation under only local anaesthetic.

He now had to put up with the three days of complete immobility that Coutela prescribed. But whether it was the post-operational shock, or simply his attachment to the role of the tempestuous old man which he played to perfection, Monet's first night was terrible: "He was so nervous and overexcited, that he was moving all the time", records Blanche Hoschedé, who stayed at his bedside. "He even got up several times and it was very difficult for us to persuade him to stay lying down. He wanted to tear off the bandages, saying that he preferred to be blind to lying still, etc. Finally he calmed down, but this fit of exas-

Wisteria
1919–1920
Cat. nos. 1906–1907

peration has delayed things and he will be in the clinic for another week." Intelligent care and a robust constitution helped Monet to make a quick recovery. On Saturday, 17 February, he was allowed to leave the clinic to visit the Orangerie with Clemenceau and P. Léon. The next day, he went home, where he was looked after by his own doctor, Jean Rebière from Bonnières.

Coutela having sent Clemenceau an encouraging report on Monet's progress, the two men travelled together to Giverny on Sunday, 4 March. Coutela declared the state of Monet's eye to be normal, but reckoned that he would not be able to wear glasses until April. For several months, Monet was unable to write and had to dictate all his correspondence to Blanche. But already he was making plans. He wanted to meet the architect and the canvas-maker, and hoped to be able to begin working again "any day now". He was the more eager to be getting on since the Administration had raised the question of installing some of the *Decorations* that very year. However, before he could act on his intentions, he began to have problems with the eye that had been operated on. Clemenceau described the symptoms as the effect of "a certain 'vascularisation', which might restrict his vision, and would possibly require a third operation." He reassured Monet that this third phase would be much less serious than the first. As Dr Coutela was in Morocco and would not be back for several more days, Monet's spirits fell. But his interest in the garden, which had

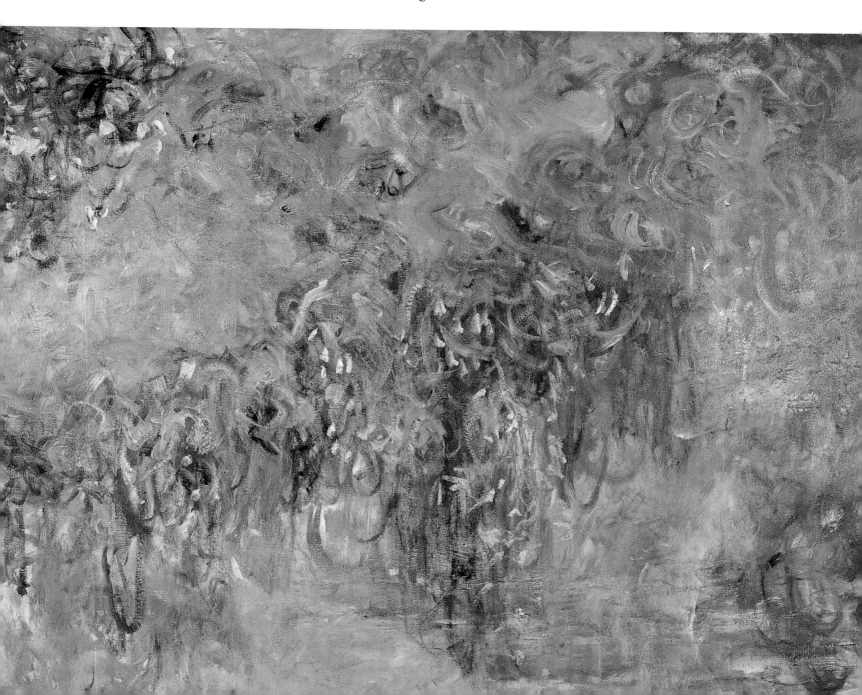

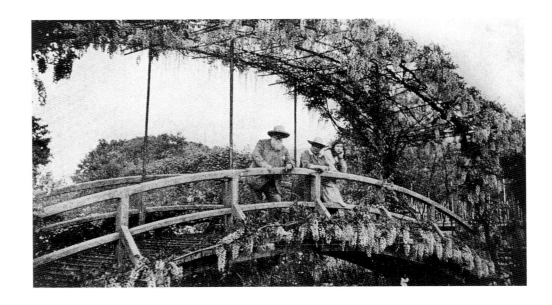

The wisteria-covered bridge or Monet with
Blanche and Simone Salerou
1920

Page 427:
The Japanese Bridge, seen from the west
1926
Photograph Nicolas Murray
New York, The Museum of Modern Art

never faded, helped to distract him, and his sight did in fact continue to improve; he was able to begin reading again, and planned to go to Paris to consult the expert as soon as Coutela had returned from his vacation. Clemenceau was always welcome, even when he turned up at Giverny with a "cohort" of invasive Americans. Certainly, his request to bring Monet a luncheon guest was difficult to refuse when the guest in question was the Duchess of Marchena, "an aristocrat as unpretentious as her millions ... whose husband is a descendant of Louis XIV." The epistolary style of "Renée Vert, wife to Adolphe Albert" suggested a less exalted lineage. She had known the artist in the past as "a gentleman with a brown beard who wore a beret" – a description which matches Monet's self-portrait (**1078**). Monet loaned her a canvas for an obscure exhibition to be held at Le Petit Andelys and received an effusion of gratitude for his pains.

The Patience of Dr Coutela

The day after the third operation on his right eye, Monet was able to take a little walk in the garden, much to the joy of his stepdaughter Blanche, who hastened to tell her friends this good news. Blanche did not know that Coutela had expressed doubts as to the success of the operation in the confidential report he had sent to Clemenceau. But these doubts were removed by his visit to Giverny on 20 July 1923 to check up on his patient: "Excellent morale. At last I was able to see the membrane (that had disappeared into the depths): it has been extensively cut through, so all is for the best. The window is still occupied by a clot that will in time be reabsorbed."

When Coutela returned to Giverny on 6 September, after "many letters and telegrams", his arrival immediately raised Monet's spirits. That evening, he sent Clemenceau a particularly detailed report: "As for his near sight: it is quite perfect", ever since "this excellent man" had decided to obey the orders of the family doctor, Dr Rebière, and wear his spectacles. "As for long sight: the sharpness of vision is adequate ... There is no more double vision. Deformation is minimal – and will diminish yet further, if M. Monet agrees to wear his distance spectacles ... His sense of distances is not yet perfect." The patient should beware of staircases, particularly those at Giverny which are "not very well lit". The major problem is "colours: he sees everything too yellow. This coloured

The Footbridge over the Water-Lily Pond
1918–1924
Cat. no. 1916

vision is common enough in those who have been operated on for cataracts (normally they see red or blue, xanthopsia is rare)." Coutela came to Giverny unprepared for this new difficulty, which Monet had not mentioned when his lenses were chosen, and did not have the necessary equipment with him. He tried "to remedy it by combinations", and admitted he was "feeling his way". But his overall assessment was nevertheless positive, thanks to the "minute, apparently exaggerated precautions [he had] felt obliged to take."

Having received his first hand-written letter from Monet, Clemenceau seized the opportunity to heap praise upon the doctor who had so richly and patiently deserved it: "I must say that I think that Coutela has coped with all these difficulties in the most admirable manner. I have great confidence in him." However, Monet's mood varied and he did not always agree with his old friend. Three days after this letter, he received "a whole series of tinted lenses", which he *knew* in advance would be "of no use". He wrote to Clemenceau that: "Your Coutela seems to be taking the whole question of the transposition of colours a bit too lightly." However, it is difficult not to sympathise with Coutela, since Monet himself no longer seemed to know where he was with this problem. The manuscript of a letter in which he claimed that he could now only see two colours, yellow and blue, shows that he hesitated between green and yellow before finally opting for yellow. The next day, he stated categorically: "I continue to see green as yellow, and all the rest is more or less blue." Another problem which Dr Coutela observed and analysed, resulted from the difference in quality between his near sight, which was satisfactory, and his far sight, which was less good. As a result, Monet could see his palette and the marks that he made on the canvas, but could not judge the effect they produced when, as he was wont to, he "stepped back some four or five metres".

In order to counteract all these problems, Coutela proposed operating on the left eye, which had been the best of the two for a long time. He had originally decided to desist after Monet's "rages". But he now felt the painter was "such a fine man ... despite his fits of anger" that he was willing to operate on him again. Monet had now had some "practice" as a patient, and it should therefore be possible to do everything "in one go". These phrases are extracted from the secret consultation which Coutela wrote at Clemenceau's request, deliberately putting to one side "all questions of psychology and emotion". Coutela's advice corresponded so closely to Clemenceau's own feelings that he immediately passed it on to Monet, advising his friend to make up his mind as quickly as possible. In that way he would be able to "make [the] rectifications to the panels and have them ready for April." This was sound advice, but it inevitably seemed to Monet that Clemenceau was considering the progress of the donation rather than the patient's interests. Coutela's letter and Clemenceau's comments plunged Monet into a predictable state of excitement. He "absolutely" rejected the proposed operation – unless they could find "a painter ... who had been operated upon ... and who could affirm that he was again able to see all colourations." This challenge was passed on to Albert Besnard, who, not unexpectedly, failed to unearth any such specimen. The eye operation was thus postponed indefinitely, and the problem posed by Monet's colour-blind reworking of the *Decorations* remained.

The "Patriarch of Art"

Coutela's proposal to operate on Monet's left eye sparked off a conflict between Clemenceau, who favoured this course of action, and the artist, who was happy with the "coloured lenses" that the doctor had tried out with him at Giverny on 29 September 1923. When Clemenceau learned that Monet had postponed any further decisions indefinitely, he "spoke his mind" in a letter which was gentle but undeniably firm. Monet's distraught reaction convinced "the Tiger" that he should give up any further attempts to persuade him. The struggle that had marked their recent correspondence thus came to an end without either having given way. Fortunately, this did not impair their friendship.

Even when his private correspondence was being conducted in the most pitiful of tones, Monet remained quite capable of writing or dictating business letters. We know that he was ordering plants by the replies he received from horticulturists. Likewise, he was quite capable of playing the affable host when he received visitors. The Durand-Ruel brothers visited on 20 October and were welcomed according to the best Giverny traditions: a tour of the studios to choose paintings, followed by a sumptuous lunch with Monet the patriarch, his stepdaughter and carer, Blanche, and his son, Michel, who was infatuated with his latest acquisition, a Voisin car. If the lunch was to the visitors' satisfaction, the choice of paintings left something to be desired. No more water-lilies, no more irises – or at least the painter did not show them any. In their place, instead, a plethora of canvases from "the last garden series", which the Durand-Ruels deemed to be "horrible, violent", marked by the painter's inability to see colours correctly. Monet himself confessed to this failing, yet was quite ready to sell what no one wanted to buy. Instead, the dealers took four canvases which belonged to earlier periods, the most recent of which, described as "a view of the garden ..., a very beautiful motif" (1778), was a little more than ten years old.

October saw Monet make substantial progress. In early November, a letter to Etienne Clémentel revealed an important development: "I have taken up my

brushes again; I am working with some difficulty, true, but I am working, and I am determined to finish my *Decorations* for the date that has been set." A message to Clemenceau must have conveyed the same news, for on 11 November he replied: "You tell me that your work 'is not going too badly'. So it must be going marvellously well." Three weeks later, he wrote again: "You are working and, since your name is Cl. Monet, all we have to do is let you work. Before it was my duty to pester you in your own interest. Now, friendship tells me I can do nothing better than leave you in peace." From this time forward, Clemenceau began to visit Giverny again, the two men's mutual trust having been restored. Returning from one of these visits with Dr Coutela, Clemenceau was wounded in the face in a car accident, a story he recounted with his usual verve. The stitches in his nose and mouth had not yet been "unsewn" (as he put it) by Professor Gosset when he received Paul Léon, who was anxious to know the fate of the *Decorations*. The Orangerie would be ready to receive them by mid-April. Clemenceau informed him that Monet was hard at work, and that he would speak to him again in a month's time. Altogether, then, the year 1923 finished much better than it had started. The improvements in Monet's sight were most promising. Nor had he been forgotten by the outside world, as this message from Joseph Durand-Ruel to his brother Georges in New York testified: "Right now people are talking a lot about Monet again, and all the dealers who had stopped buying his work are again on the look out for it."

It was in this eminently favourable climate that Georges Petit organised an impressive Monet exhibition, whose proceeds were to go to the victims of the Tokyo earthquake of 1 September. Léonce Bénédite did not always separate his official functions from his other activities. On this occasion, he loaned Petit twenty pictures from the Matsukata collection; having acquired the paintings for Matsukata, he was now their guardian. When Monet learned that two large water-lily canvases were among the pictures to be exhibited, he took the news badly and immediately informed Clemenceau, who agreed that Bénédite's action might "severely prejudice the Orangerie panels", as he wrote to P. Léon. Léon was Bénédite's superior in the Fine Arts hierarchy, and made sure that the most revealing of the canvases (**1971**) was withdrawn. Clemenceau immediately

Monet, Clemenceau and Mrs Kuroki 1921
Former photograph collection of Jean-Pierre
Hoschedé

The Japanese Bridge
1918–1924
Cat. no. 1931

told Monet of this, encouraging him to take the matter up with Bénédite directly. Monet thereupon sent the unhappy curator a vigorous rebuke, whose arguments Bénédite did his best to refute in his reply.

The exhibition was a success, as befitted one of the official stars of the Third Republic, a man whom *Le Figaro Artistique* had described as "one of the leading figures of contemporary French art". The state was itself an unavowed gerontocracy and, as such, particularly well-placed to celebrate the achievements of the "patriarch of art". The exhibition was also popular because of its dedication to the misfortunes of a nation in the Far East, about which almost nothing was known, save that it had been France's ally during the war, and that the old master had studied its art. The art press devoted several articles to this event, of which the most brilliant was that of Louis Gillet.

"As if he had all eternity before him"

Amid the excitement generated by George Petit's exhibition in the first days of 1924, Monet continued to work on the *Decorations* "as if he had all eternity before him", to quote Clemenceau's words. His friend never ceased to encourage him, but now what was most urgently needed was a serious conversation so

The Japanese Bridge
1918–1924
Cat. no. 1933

that a timetable could be agreed upon for the completion and delivery of the panels. "Every project must have a beginning and an end", the Tiger reminded him. But Monet continued to rework his paintings, running the risk that his poor vision would spoil pictures best left as they were. A meeting was arranged for Sunday, 3 February, but, if it took place at all, it was certainly fruitless. Clemenceau was obliged to watch, helpless, as Monet continued with these labours like a latter-day Penelope.

Two weeks later two groups of visitors met by chance at Giverny. The leader of each group recorded a version of the event, Jeanne Baudot in a book published many years later, Maurice Denis in a series of notes written down straightaway: "Astonishing series of large water-lilies. This little man of eighty-four pulling on the wires of his window blinds, shifting his easels ... And he can only see through one eye with a lens, the other is closed up. Yet his tones are more exact and more true than ever." If Monet had been able to read these lines from the diary of his respected colleague, perhaps he would have been able to stave off the depression that was shortly to follow. Clemenceau, struggling to revive his friend's spirits in a letter dated 1 March, incidentally provides us with a detailed history of the events that had led up to the present set-back. After a break in his work due to the cataract operation, Monet had begun work again

"with half [his] sight." This had not prevented him from producing a "a fin-
ished masterpiece (the *Cloud* panel) and some marvellous preparations".
Encouraged by this success, he had continued to work until a feeling of impo-
tence made him "take a break". Was this feeling "due to the weakness of his
sight, or to a failure in his creative powers?" Clemenceau argued on the basis of
"the incredibly vigorous treatment in *Cloud*" to dismiss the first hypothesis, and
said little about the second. Convinced that the unwise promise to deliver the
panels that spring had contributed to Monet's despondent state, he promised to
obtain an extension of the deadline from Paul Léon. Meanwhile, he counselled:
"Calmly get a hold of yourself again, and accept that you are only a man, that
you have weaknesses as well as strengths".

From Charles Coutela to Jacques Mawas

Monet was unwilling to let his paintings go during the summer of 1924 because
his sight had, he thought, improved sufficiently for him to rework them to
some purpose. This improvement, a natural part of the recovery process, has
often been presented as the miraculous intervention of a supreme opthalmolo-
gical authority. The origin of this story is an account written in 1957 for Jean-
Pierre Hoschedé by the painter André Barbier. Barbier's version of events is
coloured by his own vanity. According to him, all that was required was that Dr
Coutela, who was out of his depth, be replaced by Dr Jacques Mawas, whom
Barbier himself had introduced to Giverny. Overnight, all Monet's problems
were solved, thanks to the Zeiss lenses which Mawas prescribed and provided
on the spot. Contemporary documents, however, most of which are published
here for the first time, show that this flattering scenario is somewhat inaccurate.
I shall confine myself to what I have been able to establish by a careful study of
all the available evidence.

Barbier had learned about Zeiss' recent technical innovations from a bro-
chure the company had published. Thinking that Monet might benefit from
them, he told Coutela about his discovery. On 25 May 1924, Coutela told Mo-
net about this possibility while he was visiting Giverny. After some promising

Claude Monet listening to the American opera
singer, Marguerite Namara, at the piano in his
third studio, July 1922.
International Studio magazine collection

Photo signed by Marguerite Namara and
dedicated: "A vous ...Très grand et cher maître
in the happiest recollection of my life ... to
have met you and to have chantait pour vous".
Summer, 1922

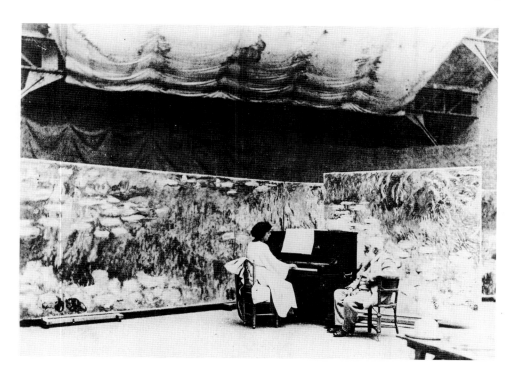

Maurice Denis
Claude Monet
Sketch
Private Collection
Photograph Lauros-Giraudon

trials, he announced that he would order new lenses from Zeiss. Monet asked Barbier to take charge of their delivery, and Barbier accordingly called on one of Zeiss' Paris representatives. It was this optician who directed Barbier to Dr Mawas. Whether it was because he considered Coutela insufficiently qualified to take "the very precise measurements" required, or because he knew that Mawas, who was one of his best clients and was interested in the visual peculiarities of painters, would like to be introduced to Monet, we do not know. In any case, Mawas was all too grateful to take this opportunity to supplant his colleague.

On 4 June, Monet wrote that he was expecting, on a date which he did not specify, "the arrival of Dr Mawas, M. Denis' oculist, accompanied by [Barbier]". There are two accounts of this first visit, both of which were obtained from Mawas himself towards the end of his life. The most complete of the two describes the whole visit, from the moment the ophthalmologist arrived at Monet's house: "I was led to the garden where Clemenceau was waiting for me. I had not yet met Monet. The Tiger gave me an icy reception. After an 'I am honoured to meet you, sir...', we went in to dine." Clemenceau's attitude is easily explained by his friendly relations with Dr Coutela. He had admired Coutela's patience in dealing with a difficult case, and was reluctant to accept his replacement by a rival when his treatment was nearing its completion. The painter, however, gave Mawas a quite different welcome: "Monet was [at table], and was in a charming mood. He said to me: 'You are going to look after me'. After lunch, [he] took me to his studio, where he burst out laughing before his last paintings; 'It's revolting, disgusting, I can only see blue now' – 'But how do you know you are painting in blue?' – 'By the tubes of paint I use'." These remarks on his colour vision are developed in the painter's comments recorded in the second version: "I can see blue, I can no longer see red, I can no longer see yellow. It annoys me terribly because I know that these colours exist; I know that red and yellow are on my palette, and a special green and a certain violet. I cannot see them as I used to, and yet I remember exactly what colours they used to make."

The blue vision, or cyanopsia, which Dr Coutela had described as typical of cataract victims after operation, seems to have replaced the xanthopsia or yellow vision of which Monet had complained the previous September. On 25 June, he sent Barbier various lenses that the optician Unger had proposed, with his comments. He suggested exchanging "the palest one ... which has a noticeable effect on my sight" for a "yellow ore just like the model". A few days later, he was ready for Unger to visit Giverny for further tests, though he added that he must be free to work by half past ten. From a letter to the Bernheim-Jeune brothers,

Reflections of Clouds on the Water-Lily Pond
Cat. nos. 1972-1973-1974

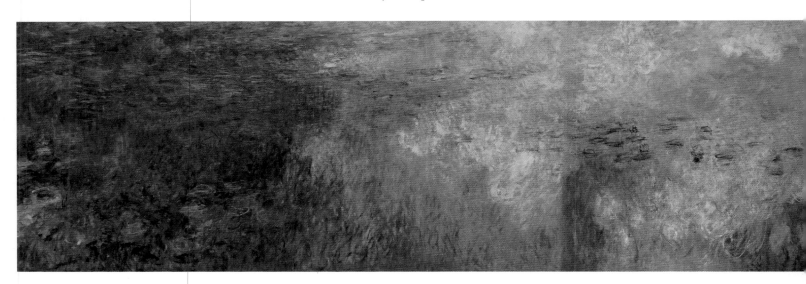

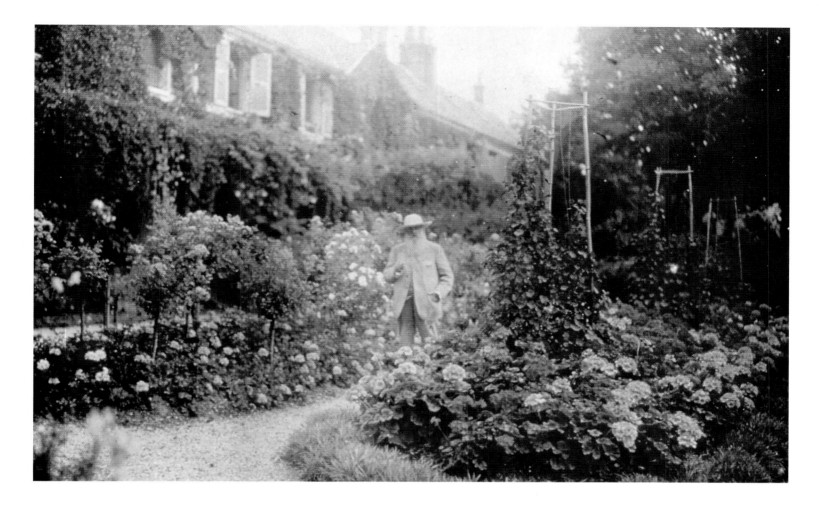

we know that he was again working from nature and that things "[seemed] to be going well". On 22 July, Monet was expecting glasses from Unger and lenses from Meyrowitz. On 5 August, he complained of the "inadequate effect" produced by the first, but declared that "Mawas' glasses [are] perfect."

Monet in his garden at Giverny
c. 1923
Autochrome-postcard, c. 1923

The Donation Under Threat

On 2 November 1924, Dr Mawas came to Giverny with Barbier, at Monet's invitation, "so that he could at last take decisive steps, though can they, by now, be decisive?" He prescribed two new pairs of spectacles, one tinted, the other

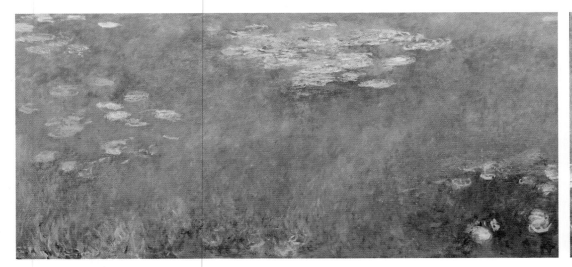

Agapanthus (present state)
Cat. nos. 1975-1976-1977

clear. Meyrowitz had made them up, and the clear spectacles in particular gave "excellent results": "I can see colours 'much better' and so can work in greater security." Given the time of year, it was mainly the *Decorations* that stood to benefit from this improvement.

According to Barbier, who wrote to Monet on 13 December, commenting on Meyrowitz's opinion that "the present glasses are only a temporary pair", the improvement in Monet's sight was evident because he could now wear glasses with clear lenses, "as Coutela and Mawas had wished". Once he was used to these lenses, Barbier notes, it would be possible to prescribe Zeiss lenses, which would likewise be clear, and which were unanimously decreed to be the best by both the optician and the ophthalmologists. In the same letter, Barbier remarks on the recent series of Japanese bridge paintings: "I should, however, say that there can be no comparison between the two canvases which you showed us, one done before, the other after the operation. The first has a curious, rich, sumptuous harmony, but the colours are transposed. The second depicts the bridge on a fine summer's day. My admiration is limitless, when I think that after forty-four sessions the picture possesses such unity, such freshness, despite nature's constant changes, which cause so much trouble to all painters who work from life – all except you ..." This last statement may surprise those familiar with Monet's frequent complaints about the mutability of both plant life

Water-Lily Pond
Cat. no. 1978

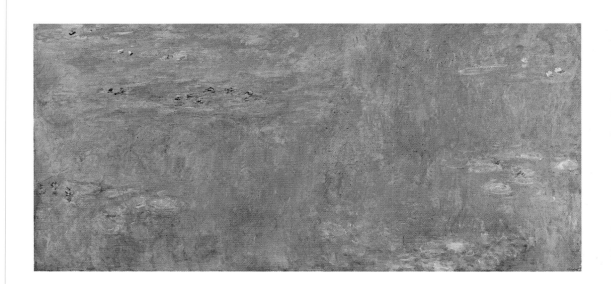

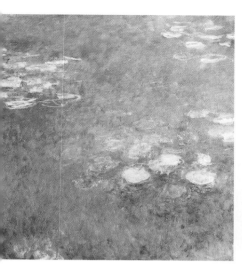

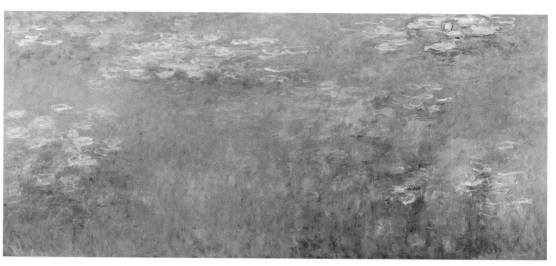

and sunlight. However, it did not prevent Monet expressing his gratitude to this brazen flatter of praise. Barbier was shameless: "You indeed are the man I admire, the man whom I love most in all the world ... I feel such adoration for you! For you, there is nothing I would not do." His words were accompanied by an "excellent, absolutely delicious bottle" and a grapefruit.

Clemenceau was not unaccustomed to receiving good news from Giverny. So he was all the more delighted when he learned of the progress made by "his abominable old hedgehog": "You admit that you can see better and better, and that perhaps you will get around to finishing something ... I know you have started again on the large panel. That in itself is quite a confession of mastery." However, Monet soon convinced himself that he was unable to finish the *Decorations*. Was this a result of the overwork that seemed inevitably to follow whenever Monet felt that he could at last do nothing but paint? Or was he now paying for the factitious excitements of the New Year festivities, which had never agreed with him? Whatever the reason, he wrote to inform Paul Léon of his decision not to honour the contract of the deed of gift. Clemenceau's reaction, faced with this *fait accompli*, showed that for once his anger was not feigned: "However old, however weak he may be, a man, whether he is an artist or not, has no right to go back on his word of honour – above all, when it was to France that he gave it ... By writing to Léon without giving me the opportu-

Green Reflections on the Water-Lily Pond
Cat. no. 1979

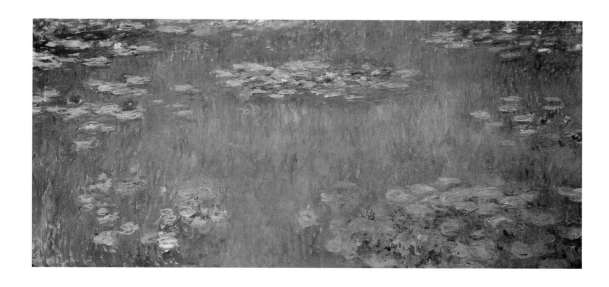

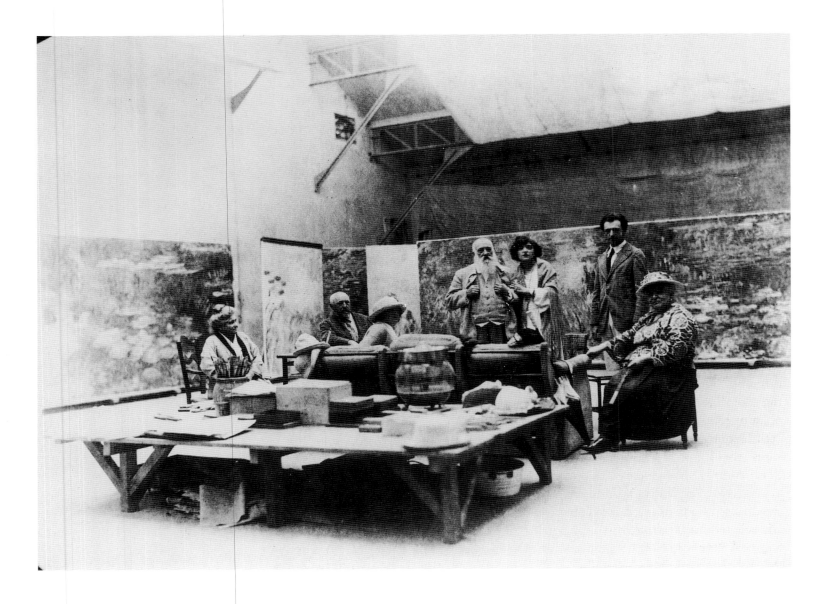

nity to speak, you sought – as weak men do – to burn your bridges. This was an insult which my friendship did not deserve ... If you are no longer the 'you' ... whom I saw in you, ... I will still be an admirer of your painting, but my friendship will no longer have anything to do with this new 'you'." A month later, when Blanche appealed to the Tiger to intervene, he refused point-blank: "I will have nothing more to do with this unhappy affair. If P. Léon writes to me, I will simply tell him to speak to Monet."

We have accounts of two visits to Giverny which took place during the first quarter of 1925, a period of depressing deterioration in Monet's eyesight. The first of these accounts is that of Florent Fels, who arrived driven by Vlaminck at the wheel of a huge car. Vlaminck was expecting Monet to be a sort of "freshwater Neptune, ... with the allegorical face of a classical river." Instead, he found himself in the presence of "a proud, small old man, who dodged the obstacles in his path uncertainly. Behind the thick lenses of his spectacles, his eyes appeared enormous, like those of an insect, searching for the last light ..." Vlaminck "ran towards him, uttering long words of stumbling admiration." Monet told him: "I am looking at you, but I cannot see you ... For two years now, since my operation, I have been able to see only a sort of fog in which, from time to time, certain details appear more precisely. For me, there are colours which no longer exist ... I had hoped things would improve. With my eyes as they are, it is useless for me to continue painting."

And yet he did continue painting, if we are to believe an article of April 1925, entitled the *Voyage fait à Giverny par les conseillers municipaux de Saint-Etienne qui y allèrent pour acquérir pour le musée un tableau* (Journey made to Giverny by the town councillors of Saint Etienne, who went there in order to acquire a new picture for their museum). This testimony of the French psyche was published just as the *Exposition des Arts Décoratifs* (Decorative Arts Exhibition) was opening in Paris. The narrator, Jacques Le Griel, first presented the *Réflexions d'un conseiller municipal* (Reflections of a town councillor), which revolved around the question: how would the 200,000 inhabitants of Saint Etienne react to the purchase of a "pink reflection on green water" for 30,000 francs? This section was followed by a series of *Réflexions* attributed to the painter himself: "Those people are going to come in a gang. They're going to dirty everything, pillage everything ... I'm fed up with them." Fortunately Blanche was there: "You did well to come ... Cl. Monet is so shy that he sent you a message to tell you not to come ... He was afraid of you ... Indeed, he does not receive visitors, and works all day on his *Decorations* for the Tuileries." The visitors were invited to wait in the "immense hall" of the salon-studio, which to their anxious eyes seemed even larger than it was. They examined the furnishings, which they declared to be "of the simplest sort", with only two or three "valuable" pieces, including "a superb mahogany desk." In the middle of the room "on an easel, the canvas which Monet [had] chosen for the museum of Saint Etienne" was displayed. There is no indication of the reaction of the councillors to this painting (1701). However, the "hundred or so unframed canvases" that hung on the walls looked to their eyes like "sketches that the painter [had] chosen not to finish." Then the master himself appeared. He seemed "as young as the Monet that Manet had drawn" (the visitors had mistaken a reproduction of this picture on the desk for the original). Conversation began. Like any self-respecting Frenchman, Monet knew no geography, and enquired about Saint Etienne. He smiled at the news that the museum there had, besides paintings by Henri Martin, Ravier and Flandrin, two pictures by Dubois-Pillet. But when told that Séon was also represented in the collection, he brusquely replied that he had never heard of him. The visitors were surprised to hear Monet say that the dealers sold his work for "much more than it is worth". Was he about to offer them a discount? No, he was not. Instead, he asked, "after much hesitation", for an extra 200 francs for the cost of the frame. As he "hurried away to his studio", Blanche guided the visitors "as far as the water-lilies". J. Le Griel concludes his account of the visit with a description of the wintry scene: "The pond is small but charming, with grey cracked clay in its depths, from which the water-flowers that have survived the winter emerge in a long thin scrawl of blackened filaments. A small cloud passes across the watery mirror, and the whole range of the pond's colours shivers at its caress! But here it is, after all, winter. While on the canvas which will now leave Giverny for our museum, it is and always will be, even when the winter rages outside, the eternal festival of an ideal, a veritable dream, of spring."

Etienne Clémentel
Claude Monet
Sketch
Photograph in the collection of Mesdames
Barrelet-Clémentel and Arizzoli-Clémentel

The Swan Song

No one will be surprised to learn that Monet's quarrel with Clemenceau did not last forever. After a few letters which still bore the marks of his resentment, the Tiger agreed to answer Blanche's appeal for help. Though convinced that his actions "would be of no use", he decided to visit Giverny on Sunday, 22 March 1925. It is easy to imagine the two old men falling into one another's arms, then

drawing up their chairs around the luncheon table. Their reconciliation was all the warmer for the tacit agreement that neither would mention the question of Monet's donation. A week later, their reconciliation was confirmed by a note from Clemenceau, who restricted himself to topics such as flowers and the "horrid weather" that was holding up his departure for the Vendée. His casual PS. further emphasised his return to the light-hearted style which he usually adopted when writing to Monet. Clemenceau was helpless, however, to prevent a new crisis, precipitated by the death of Marthe Hoschedé-Butler. Monet took this cruel blow to heart and withdrew into himself. Having invited Joseph Durand-Ruel to visit him and agreed on the date, he cancelled the meeting at the last minute. Even Gustave Geffroy received a telegram cancelling his visit, though Monet almost immediately wrote to retract it.

Despite his doubts and the persistence of cyanopsia, Monet resigned himself at the end of May to another examination by Dr Mawas. He made no secret of his condition: "I can see less and less, whether at a distance or close to for reading." Mawas decided to cover up Monet's left eye completely, and this led to a marked improvement in his sight. About a month after Mawas' visit, Clemenceau observed: "Your account of yourself seems generally satisfactory." Indeed, when he told Monet that he would visit on the first Sunday in July, Monet wrote him "a very good letter" telling him that he would be "going back to work straight after lunch". He drew the correct conclusion: "I shan't go and see Monet on Sunday ... I know all too well what it is like to be disturbed when one is hard at work. So I shall leave him in peace." A few days later, Monet was already hard at work by the middle of the morning. He told Barbier: "I have to be free by ten o'clock, as I am in the midst of work. This is an unparalleled joy for me. Since your last visit, my eyesight has vastly improved. I am working as never before, am happy with what I do and, if the new lenses are even better, I ask only to live until I am a hundred."

André Barbier was thus deprived of a good lunch. But Monet at least still agreed to see him. Esther Pissarro was simply requested to cancel her trip: "M. Monet has only just begun to work again after a long period of discouragement, and wants to take advantage of the fine weather to work without distractions. So at this time, he does not wish to see anyone." There was no sign that his ardour was flagging, when, in mid-August, he wrote to Gaston Bernheim-Jeune: "I am very well and working with passion and joy."

The postscript to Marc Elder's book, *À Giverny chez Claude Monet* (At Giverny with Claude Monet), records this state of grace, a veritable swan song, before time, inevitably, ran out: "His sight having returned, the painter is once again tempted by the magic of the world to take up his brushes. They no longer mislead the artist as his still youthful hand is guided by his still sure eye. At peace with himself, Claude Monet sets to work."

Clemenceau, the faithful mentor, was perhaps more indulgent than judicious in showering Monet with encouragement, since Monet was clearly working himself too hard: "My dear son, since you have hold of happiness, hang on to it. Work. Let no one bother you. Make masterpieces. I shan't complain if you do." And again: "I embrace your old beard that has turned yellow with tobacco smoke." The joke was harmless enough, but it pointed to a terrible truth. On 7 September, Paul Valéry was holidaying at Le Mesnil with Julie Manet and Henri Rouart and accompanied his cousins to Giverny. On his return, he wrote in his *Cahiers* (Notebooks): "Visit to Monet – All white (I had not seen him in ten years). Glasses – one black lens, the other tinted. He showed us his latest canvases. Strange tufts of roses depicted under a blue sky. A dark house... – We went to the water-lily studio. Vast, pure poems –" In the

Monet, Roussel and Vuillard
30 June 1926
Photograph Jacques Salomon

showed a relative improvement in Monet's condition. When Evans Charteris came to question Monet about his relationship with John Sargent, he was warmly received and thought Monet astonishingly youthful for his age. The painter J.-E. Blanche, who saw Monet through the garden gate one sunny morning in May, had expected to find him diminished by his illness, and instead went away reassured by his "robust appearance". This impression contrasts, however, with Blanche Hoschedé's words to Lucien Pissarro on 23 May. Blanche, who was naturally inclined to cling to the least glimmer of hope, confided that "M. Monet is not very well at the moment. He keeps getting colds; the weather is so bad!" Four days later, she told Barbier that the spectacle-fitting would have to be postponed indefinitely," as Monet still has a cold and is rather out of sorts."

The seriousness of Monet's condition was perfectly clear to Dr Rebière by early June, when he alerted his friend and colleague, Charles Coutela. Coutela immediately visited Clemenceau to apprise him of the situation. Clemenceau was himself ill and concealed the purpose of Coutela's visit when he wrote to Monet: "This morning, Coutela turned up, at Rebière's instigation, to enquire after the date of my funeral ... I thus learned that you're not in radiant health either." He followed up this gentle litotes with a joke: "Perhaps we could combine our two half-illnesses and make one healthy man between us." A week later, Clemenceau was on the mend, and hoped to "make the journey to Giverny in about a week". "Since I understand that you are not working at the moment, I presume you won't mind if I come on a Sunday".

On 14 June, Alice Butler, daughter of Suzanne Hoschedé, was married to the designer Roger Toulgouat. It was the last but one family occasion that Monet lived to see. The match filled Blanche with joy, despite her increasing concern about her stepfather: "Lily Butler was married on Monday to a very nice young man who has been living in Giverny these past six years and who is

and this has discouraged me, since I can only work in short bursts and am making hardly any progress. It is so sad." Three days after he had written these melancholy lines, Blanche sought to reassure both Esther Pissarro and herself:

"M. Monet is not ill. He was merely suffering from intercostal pains, which are now over." The pains thus located were ascribed to a pre-gouty condition. The diagnosis did not surprise Clemenceau, who was well-acquainted with the gastronomic traditions of Giverny: "I expect your doctor has forbidden you your little glass of schnapps, and that is what you're letting off steam about."

The improvement noted in Blanche's letter marked the beginning of a period of remission. Monet took advantage of it to finish a first series of panels, which were to be sent off at the beginning of February, once the paint had dried. He immediately returned to work, pushing himself to the limit of his declining strength: "I work ceaselessly, despite my age and the weakness that increases with each day." News of his determination reached the lower order of Parisian journalists, one of whom offered this ironic commentary: "The great painter Cl. Monet has promised to bequeath to the state a magnificent series of paintings representing water-lilies at every hour of the day. Until the fatal moment comes, he is keeping the pictures in his studio at Giverny ... But he loves them too much. He does not consider them beautiful enough. And so, with sacrilegious hand, hoping to improve what is already so well done, he reworks them continually. O Maître, be careful!"

Monet's immediate circle was not yet much alarmed by his condition. Otherwise Clemenceau's humour would have seemed too black: "I am glad to hear that the monster is still alive and sometimes even returns to the fray." But Monet was rapidly reaching the limits of his strength. On 1 April, he confessed that he was "almost unable to write, a new state for me." On Sunday 4th, Clemenceau, who had at last recovered, visited Giverny bringing news that was unlikely to raise Monet's spirits: Geffroy had died that same morning. The next day, he wrote to Mme Baldensperger: "Yesterday I visited Monet and found him much weakened. The machine is breaking down completely. He is stoical, and even cheerful at times. His panels are finished and he will not touch them again. But he does not have the strength to let them go. The best we can do is just to let him live from day to day. There may come a reaction that will put some strength back into him." But as things were, "poor Monet didn't even have the courage to walk around his garden. Its upkeep is now so expensive, he wonders if it wouldn't be best if he were rid of it. The brave little woman was carrying him in outstretched arms." The presence of his old friend seemed to do him good: "I reminded him of our youth, and that cheered him up. He was still laughing when I left." If only we could close our account of Monet's life with that burst of joyous laughter.

"Monet ... may still get back in the saddle"

When his close friend Geffroy died, André Barbier at last received the invitation to Giverny he had been waiting for. Monet presented him with the gift that he had promised him, but in the wake of this ceremony came a short but revealing epistolary sermon: "Let me tell you that I was happy to give you the three pastels. But let me ask you also not to show me such exaggerated admiration in the future. I know what I [am] and, above all, what I am not." While stressing that he was not strong enough for an "extended visit", he made Barbier promise to return with a technician for "a last fitting", the spectacles that had been sent to him having proved useless without major adjustments. This enterprising spirit

course of the visit, Monet spoke of the trouble with his vision: "Talks about his eyes. When they were removing the crystalline lens, he saw a blue circle. Then he could see only yellow. The blue gave him a delightful sensation. Then, when he could see again, he found a picture he had done before and which was a cacophony of tones – He had been mistaking yellow for white."

Monet received these visitors without any sign of impatience to return to work, which suggests that his intense activity had already drawn to a close. This impression is confirmed by a letter written to Geffroy four days later. In it, Monet spoke of the summer's work in the past tense. There was no denying the passion and the joy that he had felt; he simply regretted that he had been unable to "finish the many canvases that [he had] begun" because of the bad weather, though he had faced it out stoically "and been soaked". The summer "campaign" was Monet's swan song, a marvellous farewell to his house and his roses (1953–1963). Nothing so happy awaited him.

"Nothing to be done"

When he wrote to Geffroy on 11 September 1925, Monet was determined to "at last" deliver the *Grand Decorations*. He launched into a last "campaign" of winter painting, but the enthusiasm which had swept all before it throughout the summer was no longer there. To begin with, he seems to have painted only during the mornings. In the afternoons he would receive select visitors – the Bernheim-Jeune brothers, for instance, or Moreau-Nélaton, accompanied by Hélleu and his daughter, Paulette. A little later, Monet agreed to reward André Barbier for all he had done for him, despite a certain "misunderstanding" that had occurred over the price of one of his paintings. However, Barbier had to wait for his reward. Monet felt claimed by the work he was so "passionately involved" in. But behind the temporising words lay a truth of a very different kind: "For the moment, there is nothing to be done, although I am often very tired, and feel I have used up all my energy."

This growing state of exhaustion can be observed in Clemenceau's letters to Monet, in which the humorous tone gradually gives way to a mixture of admiration and melancholy affection. In September, he was writing: "Press on, not for the sake of 'glory', which is worthless, but in order fully to become the monstrous artist that you are." A month later: "Your letter gave me the utmost pleasure because in it you seemed just as you were in the good old days." And in November: "For our part, let us rub our worn old pelts against one another, and see if we can restore some of their youthful sheen that way. Your old ghost of times past." But despite such encouragement, Monet's spirits were flagging and he was getting behind with his work. Michel visited the Tiger at the beginning of December; Clemenceau was himself ill, but tried to remain his usual optimistic self: "He told me that you had had the flu like everyone else, but that you were now back on form." And Monet did indeed go back to work; he reported that he was still "improving" the panels, though afflicted with pains that he attributed to his gout. In Clemenceau's reply to Monet's "affectionate letter", he described gout as "a horrid beast that makes its victims suffer", but had to admit that the information about Monet's health was, at best, disappointing.

1926 got off to a gloomy start. Much of December had been bitterly cold and heavy rains followed. Rivers burst their banks, and damp seeped from the walls. In his large studio, battered by winds and rain, Monet stood and suffered before his masterpieces: "For some time now, I have been decidedly off colour,"

Claude Monet and Gustave Geffroy
c. 1920
Photographed by Sacha Guitry, Roger-Viollet

Monet and Bonnard
c. 1926
Photograph courtesy of Antoine Terrasse

very well known to everyone. I am very happy for her ... M. Monet is ill, and unable to go out or to do anything. As you can imagine, he is bored and unhappy. He has tracheitis, and to begin with, was coughing horribly. Now the cough is on the wane, but he is still suffering. His morale is suffering worst of all: he cannot work or go out into the garden, especially with the horrible weather that we are having. So I am afraid I can't ask you to come and visit us for the moment." The previous day, Roussel and Vuillard had been refused a visit on similar grounds. The situation thus seemed fairly desperate by the time Clemenceau set off for Giverny on Sunday, 20 June. He recounted his visit in the following words: "Excellent journey to Giverny. Strong sunshine. Monet neither one thing or another. He may still get back in the saddle, but he needs to be guided, even pushed a bit. His doctor is treating him for God knows what complaints. He is ageing, that's all. If I lived beside him, I would have him back on his feet in a fortnight. It was three weeks since he had been outside the house. I kept him in the garden for more than an hour after lunch. He wasn't eating. I got him to eat, etc., etc..." Clemenceau's diagnosis was based on a monumental error, for Monet's illness was only too real. Yet his treatment, helped by the return of the fine weather, had a positive effect. The day after Clemenceau's visit, Monet dictated a reply to the questions E. Charteris had insisted on sending him about Sargent's definition of Impressionism. On the same day he invited Roussel and Vuillard to lunch. They arrived on the morning of 30 June, in radiant weather, bringing with them Roussel's daughter, Annette, and her husband, Jacques Salomon. Salomon drove a Ford convertible. His account of the excursion makes fascinating reading.

The first thing that struck Salomon was how short Monet was. Monet had always been short – at the age of 21 he had measured 1.65 m (about 5' 6") – and had grown even shorter as age and illness had compressed his spine. Salomon follows other visitors in remarking on Monet's garb and his "magnificent head".

Photo H. Martinie.

GEORGES CLEMENCEAU
QUI VIENT DE PUBLIER
CLAUDE MONET
(*Nobles Vies-Grandes Œuvres* — N° 14)

Advertisement for book about Claude Monet published by Georges Clemenceau, in 1928, through Plon.

Mr. Ryerson - C. Monet - Joseph Durand-Ruel
F358 Giverny

Claude Monet.
Giverny.

He continues: Monet "wears thick glasses, the left eye entirely masked by a dark lens, and the other is extraordinary, as if were hugely enlarged by a magnifying glass." At table, Monet was, the perfect host, seasoning the duck wings himself before they passed through the "fires of hell", encouraging his visitors to eat and drink, and even setting an example by swallowing "great swigs of white wine" in defiance of the diet he was supposed to be following. Over coffee in the salon-studio, he entertained the visitors with a much-rehearsed anecdote, the story of the Vétheuil painting that Faure, the baritone, had once foolishly dismissed and which now seemed likely to secure Faure's immortality. Another story led to a heated discussion: Monet claimed that Manet had once criticised a study that "poor Renoir" had made in the garden at Argenteuil, saying: "I really think he isn't cut out for painting!" The visitors also gleaned some detailed information about Monet's technique – his rejection of black, ochre and earth tones, and the importance he placed upon drawing and the layout of the composition.

About four o'clock, they went down to walk around the garden and J. Salomon took some striking photographs. Drinking tea near the Japanese bridge, Monet simply shrugged his shoulders at the mention of cubism and Picasso: "I've seen reproductions in the reviews, and it doesn't do anything for me ... I don't want to see it, it would make me angry." Returning to the house, the visitors were allowed to see inside the large studio. The works displayed there, "the work of a colossus", left them speechless. Monet was no longer able to manoeuvre the stretchers and easels himself, and left these tasks to others, while he offered his commentary on what they saw: "Several times I wanted to tear it all down and give up completely, it was Clemenceau who stopped me ... Well, if you don't think it's too bad..." One detail attracted Salomon's attention: "On the large tables, among piles of tubes of paint, [were] spread great sheets of blotting paper covered in pure colours." When he asked Monet

FROM TOP TO BOTTOM:
Monet with Martin A. Ryerson and
Joseph Durand-Ruel at Giverny
Monet at Giverny
Photograph Durand-Ruel

Albert André
Monet in his Garden
1922
Photograph Durand-Ruel

about this, the artist replied "that there was always too much oil in the tubes, and in this way he was able to paint with more of a matt finish." This makes it sound as if he were still working, when we know this was not the case. But perhaps in the euphoria of the moment he still hoped that he might one day paint again. Determined that his guests should not think his energies were waning, he led them up to his first-floor room to see his personal collection, where Vuillard recognised one of his own paintings. When the time came to part, Monet bid the party farewell with words that were soon to be belied: "Come back soon. For you, I will always be here."

"A disease which cannot be cured"

One can easily imagine the contradictory emotions Blanche must have felt as she watched her stepfather give of himself in this reckless way. The next day, she confided her hopes to Barbier: "He has not been well, but with the help of the fine weather, I hope that we may be near to a cure ... Monet has not worked in two months, but I hope that the fine weather may tempt him to start again. At the moment, he does not want to see anyone." This was the rule, but exceptions were made, as we have seen; the rule was never applied to Clemenceau. As soon as he heard that Monet was having difficulty eating, he announced that he would visit Giverny on Saturday, 10 July. He found his "poor friend ... still ageing" but, in general, not as weak as he had feared. Monet was able to take "a good walk around the garden" with him. Doubtless Clemenceau took the opportunity to repeat one of those phrases that were so characteristic of his attitude: "Stand up straight, hold your head up, and kick your slipper up as far as the stars. There's nothing like it if you want to keep well."

FROM TOP TO BOTTOM:
Monet with Mr and Mrs Ryerson at Giverny

Albert André and Claude Monet at the entrance to the third studio
Photograph Durand-Ruel

Albert André
Portrait of Claude Monet
1922
Photograph Durand-Ruel

René Gimpel had already visited Giverny on business at the beginning of July. Two weeks later, on 17 July, he returned with his wife. He bought two paintings and obtained further information about two others he had purchased on his previous visit. In the intervening time, Monet claimed he had destroyed about sixty paintings, though Blanche disagreed on the figure. The procedure was the same each time: Blanche would use a knife to detach a scrap of canvas from the paintings Monet indicated. All the paintings thus selected would then be burned under Monet's watchful gaze. Blanche made it plain to Monet that she disapproved of this new immolation, but a respite of one day was all she was granted. When the conversation came round to modern painting, Monet was

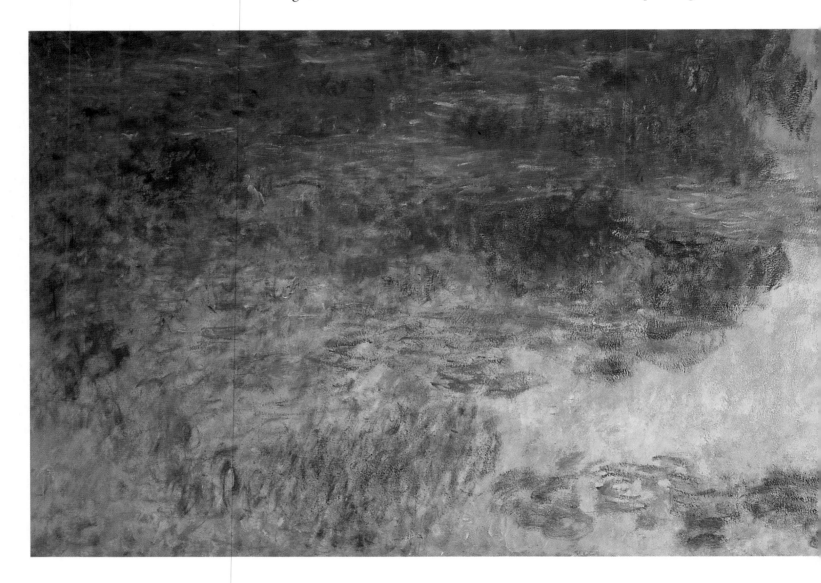

Water-Lily Pond, Evening
Cat. nos. 1964–1965

more moderate than before: "I don't understand, but I don't say it's bad. After all, I can remember those who didn't understand my own paintings and who did say: 'That's bad'." Michel Monet was also present at lunch, after which there was the traditional walk around the gardens; this time, Monet did not accompany his visitors. Gimpel took the opportunity to question Blanche about Monet's health. Was it his poor sight which prevented him from working? – "No, not at all, his sight is very good, or rather, it is when corrected by the spectacles ... but it is strength that he lacks, he no longer has the strength to paint, it exhausts him. This winter he had tracheitis; for two months he was coughing horribly. Everything went to pieces, even his digestion which used to be so

good. He didn't eat. Now he can eat, but he can't smoke, or he soon chokes. He cannot take alcohol. He has great difficulty seeing things close up. It is more difficult for him to sign his name than to paint." The poor woman wanted Gimpel to agree with her that Monet was better than he had been on his previous visit. "She must be right", was Gimpel's non-committal reaction. He admired Blanche's devotion, which contrasted so sharply with Michel's attitude. Monet's son kept himself "to the far end of the house", where, according to Blanche, he lived but made no attempt to earn his keep.

From his estate in the Vendée, Clemenceau wrote to ask: "Is M. Claude Monet cold? Or hot? Is he in a good mood, or a bad mood? Does he scold his

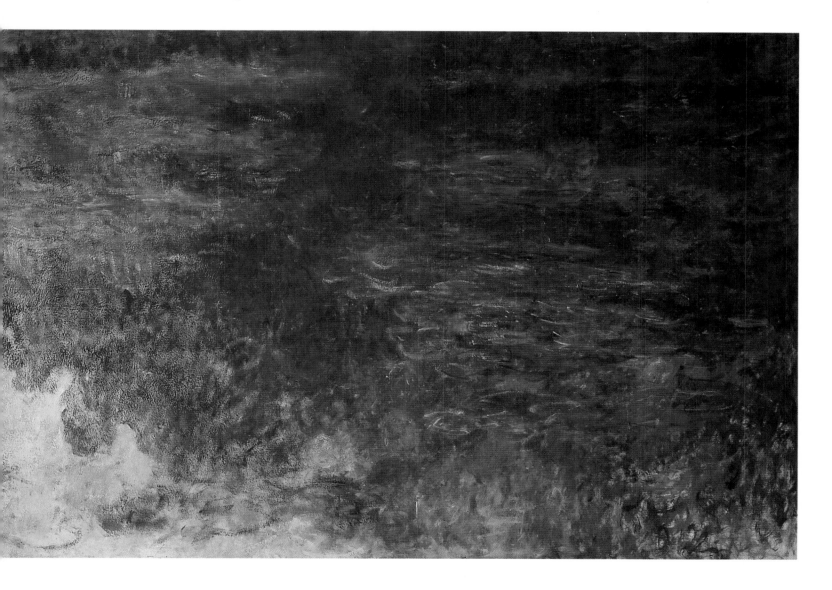

angel, or does she scold him? Is he indulgent towards his roses, or do his roses reprove him? Does he believe, as Poincaré does, that by putting together a dozen Bouguereaus, one can make a Velasquez or a Rembrandt?" After these pleasantries, the Tiger exhorted his "poor old crustacean" to be patient, and advised him not to make "eccentric demands upon [his] 'specialists'" – by which he seems to have implied that Monet had no real need of their help. Dr Rebière, however, was of another mind. Monet was losing weight persistently, continuously in pain and increasingly tired. Rebière decided that an X-ray was required, which probably took place at his very advanced surgery in Bonnières. Having discovered an incurable pulmonary disease, he immediately informed

PAGES 450–451:
Water-Lily Pond with Irises (detail)
Cat. no. 1980

Michel and Blanche. Blanche told Esther Pissarro: "Unfortunately, M. Monet has a disease which cannot be cured … There is a lesion and a congestion at the bottom of his left lung." Clemenceau heard the news from Rebière and shared his fear "that all we can expect now is haemoptysis, a fearful prospect." Monet's family were advised to "avoid any shock to the patient's system", given his "extremely nervous disposition": in other words, they should not inform him of the nature or gravity of his illness.

The Last Remission

Despite his suffering, Monet continued to be optimistic and spoke of a return to painting. He shared his projects for the future with Clemenceau, who pretended to take them seriously. Clemenceau still wrote to Monet in jocular vein, though his humour must have been wearing thin even in his own eyes. He told Mme Baldensperger that his friend "was definitely a little better", despite the difficulty of "keeping going with only one lung". Paul Léon, who had been waiting for months for information about the donation, finally received a response written in Monet's own hand. In this letter, Monet spoke of his illness as belonging to the past, and announced that, though his recovery was not complete, he had been able to start work again "in very small doses". If he contin-

Water-Lily Pond
Cat. no. 1983

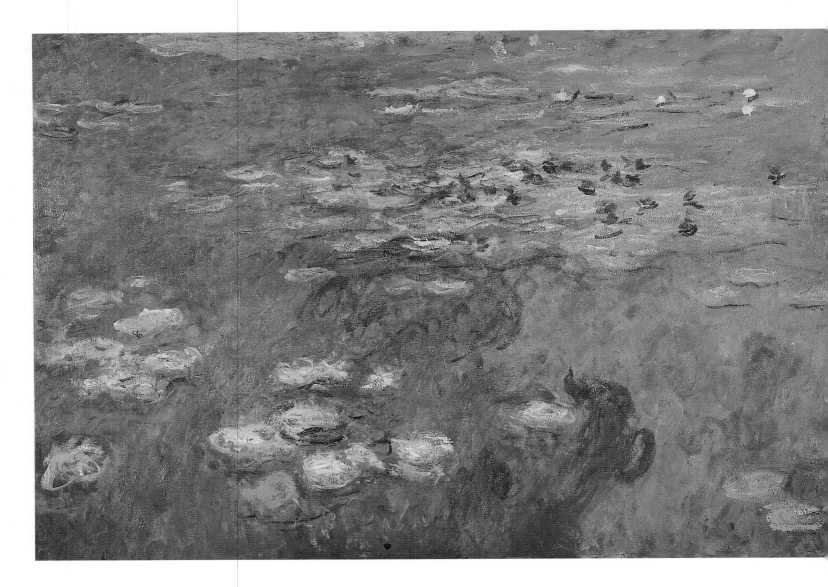

ued to improve, he planned to visit first the architect Lefèvre, then the director of Fine Arts himself!

Monet's courageous decision to think only of what remained to do is reflected in the fine portrait of him by the American photographer Nicolas Murray. The picture, in which Monet is standing, his gaze tired but direct, was made at the beginning of this, his last summer. This is a more fitting image by which to remember him than the better-known snapshots which Murray took in the water garden, in which, fearing the cold, Monet is wrapped in an over-coat that was already far too big for him. Later on that summer, the poet and columnist, Marcel Sauvage, was allowed to glimpse the patient. Sauvage had read in the press that Monet was ill. He had no access to a car and travelled to Giverny by rail via Gisors. As he stepped off the train, he admired the "perfectly tarred" road which had been built at the artist's request and led directly to Monet's house. Calling there, he discovered that Monet had partly recovered from the "beginnings of a bout of flu", and was at that moment "out walking" with Michel. While Sauvage waited for the painter to return, he was allowed to visit "the beflowered paradise" of the garden. There he was witness to a specta-cle which gave him some idea of Monet's popularity and the fame of his prop-erty at Giverny: "On the other side of the wall, a line of cars files slowly past. Many admirers of the painter come here each day, among them many foreign-ers. They stop, look round, and would like to enter, but no visitors are

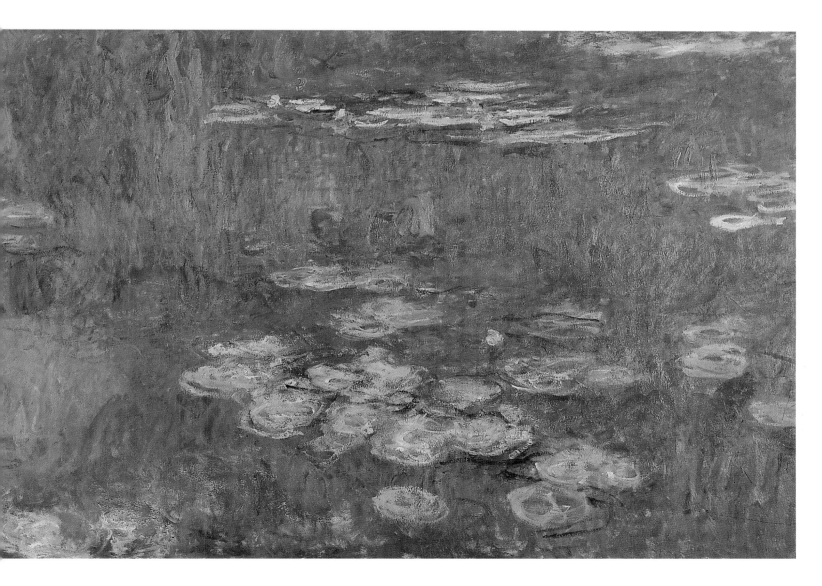

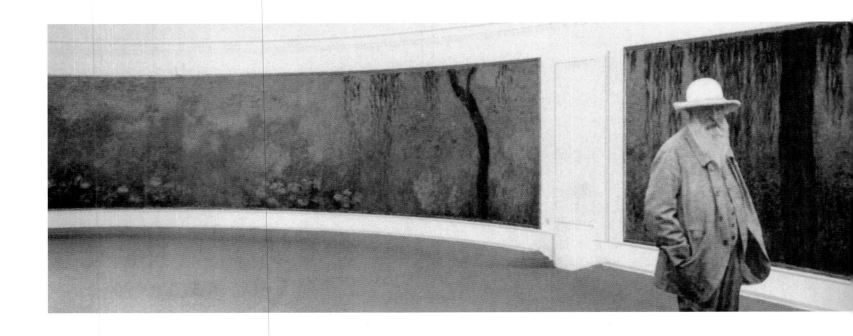

ABOVE:
Photographic montages, Advertisement for the
Paris Musée National de l'Orangerie

received." And then, "there was Claude Monet", whose sudden appearance Sauvage perceived as a sort of farewell: "He was returning on the arm of his son. He looked as though he had retreated into the depths of his great white beard. He has big eyes, which have been operated on for cataracts and with which he can now hardly see anything ... The little old man, eighty-six years old, walked painfully up the three steps leading into his house. He turned round and waved to me with one hand. 'No'. He does not want an interview. He has nothing more to say."

A Gentle Death

Water-Lilies
Hung in the Paris Musée National de l'Orangerie

Henri Saulnier-Ciolkowski, in his *Paris* column in *The Art News* of 6 November 1926, reassured Monet's many admirers and friends that the artist's health

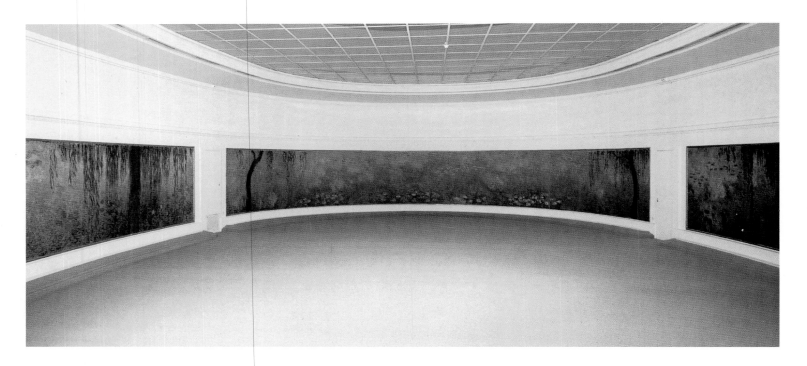

should give no cause for alarm. He claimed that he did so on the authority of Durand-Ruel, who had visited Monet (recently?). Unfortunately, by the end of 1926, this was no more than a pious hope. The cloak of silence that now surrounded Giverny was eloquent in itself. There was only one recorded visitor at this period: Georges Clemenceau. Soon afterwards, he confided his impressions to Thiébault-Sisson: "I knew he was lost and I came every Sunday, to distract him as much as I was able from his pain. To tell the truth, he suffered very little. Occasionally, he would be assailed by feelings of oppression, but without knowing what had caused them. He was not even confined to bed. A fortnight before his death, I had lunch with him and he could still sit up at table. He spoke about his garden, said that he had just received a whole consignment of Japanese lily bulbs. That was his favourite flower. He was expecting any day to take delivery of two or three crates of very expensive seed which would produce the most marvellously coloured flowers. 'You will see all that in the spring. I

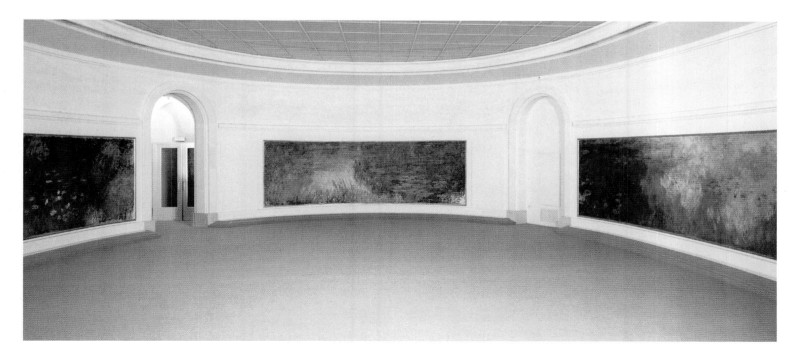

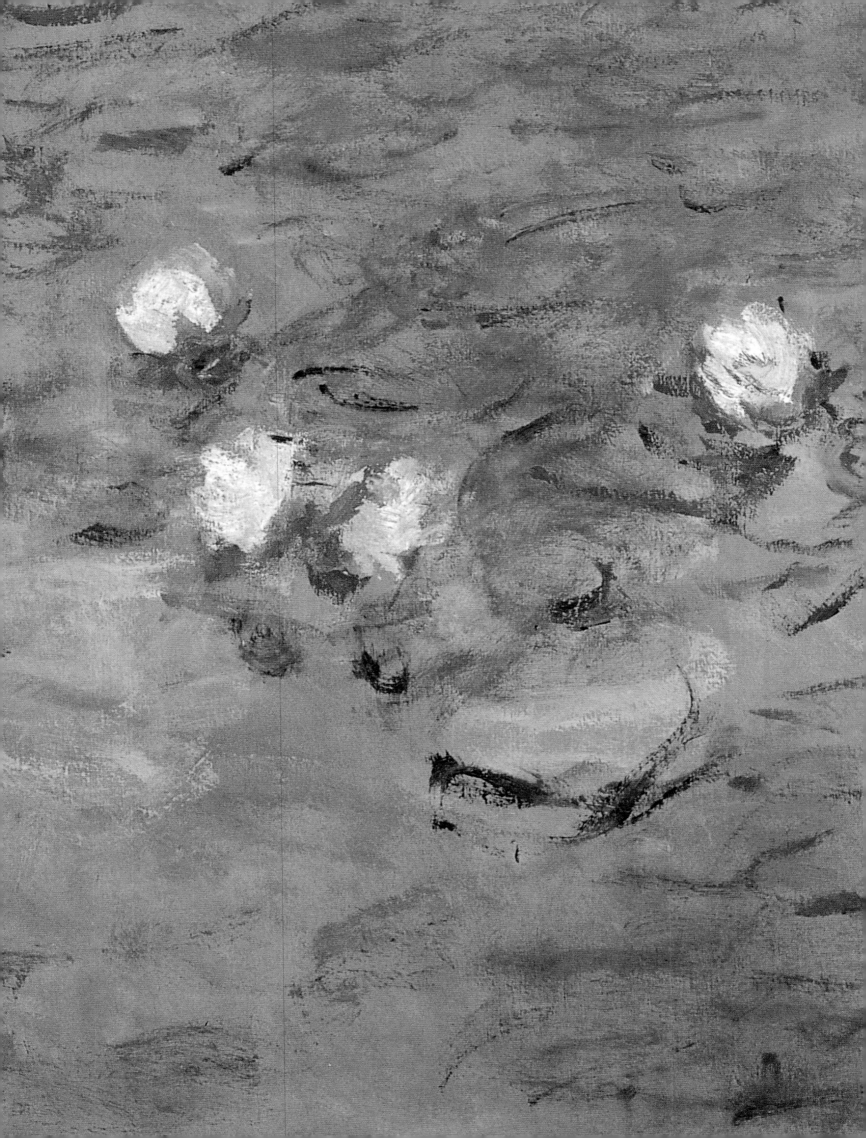

shall not be here', but I could feel that in his heart he did not really believe what he said, and that he was hoping to be there in May to enjoy the show they'd make." Monet's projects were now restricted to gardening; there was no further mention of painting. Blanche Hoschedé-Monet described her stepfather's final preoccupations to Thiébault-Sisson in similar terms: "He suffered a great deal during those last two months. He no longer thought of painting, but spoke only about his flowers and his garden." It is as if Monet sought strength in an alliance with the new life that he committed to the earth that last autumn.

After Clemenceau's visit, Monet "lost strength rapidly and took to his bed." On hearing this, Clemenceau decided that it would be best not to return to Giverny unless expressly invited to by Monet. He explained his reasoning to Blanche on 1 December: "I understand all too well that you do not have time to send me news. Whether his illness now is chronic or proceeds by crises makes little difference. My main concern is not to disturb the patient. I am ready, at any time, to come and see him if he asks for me. But I think that it will be best for him that I wait until he asks." He did not have long to wait, since he arrived at Giverny the following day, according to a letter from Georges Durand-Ruel to his brother Joseph: "Paul Rodier telephoned yesterday morning [2 December] to say that the day before he had seen Sacha Guitry, who told him that Monet was in a very bad way ... Pierre [Durand-Ruel, son of Joseph] left for Giverny at eleven, and was back by five. He could not see Monet who is, indeed, very ill, but he saw his son, Michel, and his stepdaughter, Blanche. Cl. Monet has been unable to eat for four days. He suffers greatly, and is being given regular injections to relieve his pain and keep him alive. This state cannot last, and his death is expected at any minute. Blanche Monet told Pierre that she would write to tell me if Monet could see me. Clemenceau arrived a few minutes after Pierre. Monet had asked for him, and he went up to see him." The dying man thanked his old friend for his unswerving support of him with a smile.

Clemenceau found Monet in the state that Durand-Ruel described; he returned to Paris grief-stricken but ready to make the journey again should he be asked. On the morning of 5 December, he returned to Giverny and once again mounted the narrow staircase to the room where Monet lay in his final agony. "One can feel a part of the fear and suffering that are [his] at the end, but one's respect for one's fellow human being forbids one from imagining any further." This slightly-adapted quotation from Marguerite Yourcenar will serve to introduce Clemenceau's account as related to Thiébault-Sisson: "On the day of his death, I could feel his breath coming with ever greater difficulty, so I took his hand and asked: 'Are you in pain?' – 'No', he replied in an inaudible voice. A few minutes later, there was a faint death rattle, and that was all." Michel Monet's account confirms that, after suffering greatly, Monet went gently at the end: "My poor father died quietly. He wasn't aware of his end, which was a great consolation to us. But how painful the preceding days had been!" Monet died at around one o'clock in the afternoon on Sunday, 5 December 1926.

The Funeral

Once it was all over, Georges and Pierre Durand-Ruel, who had arrived in the early afternoon, were allowed to go up to the first floor to pay their last respects. Monet's body was laid out on his deathbed. A telegram was sent from Vernon to Paris that same afternoon. The next morning, the news of Monet's death was on the front page of every newspaper, usually with an illustration. Often the

PAGE 456:
Morning (detail)
First of the Decorations Rooms in the Orangerie (4b)

article took the place of the editorial. The press was united in its praise for the great master who had passed away; his death was described as an immeasurable loss to the art not merely of France but of the whole world. Most articles mentioned the fact that Clemenceau had been at his bedside to receive his last words. The coverage continued uninterrupted to the day after the body was buried. One article even omitted to mention that the painter had died, as if the better to emphasise the immortality of his work. This immediate reaction was followed by a profusion of notices, homages and studies in the periodicals, both of the art world and general.

Monet did not like to talk about his death, and thus omitted to make certain arrangements. But he had made clear to his immediate circle that he did not want a religious ceremony. A list of more precise instructions has come down to us, though its authenticity is disputed: "Bury me as if I were just a local man. And you, my relatives, only you shall walk behind the coffin. I do not want my friends to have the sadness of accompanying me on that day ... Above all, remember that I want neither flowers nor wreaths. Those are vain honours. It would be a sacrilege to plunder the flowers of my garden for an occasion such as this." This last phrase, at least, is entirely in keeping with what we know of the man. His wishes were respected, and a single wreath was laid on his tomb.

On the Monday following Monet's death, a reporter took the liberty of approaching the house at Giverny, which stood silent, apparently deserted. According to his account: "At the sound of my footsteps on the gravel, a door swung open. It was one of the sons of Claude Monet. He stood speechless before me, his face haggard with grief. He would say nothing, see no one. 'Yes, yesterday at half past twelve. No more questions. Now he is at rest forever. We have left him in peace, do the same by us'." Friends who insisted on knowing the date of the funeral were finally informed that it would take place on Wednesday, 8 December, at half past ten; they were also encouraged not to attend. In keeping with this spirit, Jean-Pierre Hoschedé telephoned Evreux to ask the Prefect of the Eure "not to give the customary speech. Monet's wishes on this point were categorical: there should be no speeches."

The atmosphere in the village of Giverny on the morning of 8 December has often been described. Mist shrouded the houses, the hills and the trees along the banks of the Epte, draining them of all colour. The instructions to stay away were respected by local people only and onlookers lined the sides of the Chemin du Roy. When Clemenceau arrived at a quarter past ten, he was unable to hide his displeasure at the crowd through which he had to force his way to reach the gate. Once inside, he brusquely removed the black flag that had been draped over the coffin: "No black for Monet!" he claimed, replacing it with a flower-patterned material. One eye-witness described the new drape in these terms: "A piece of old cretonne, bearing the colours of periwinkles, forget-me-nots and hydrangeas. It had faded with time; the colours were dulled like the tones of the veiled skies that he loved."

Monet had painted the central pathway of his garden many times. Now, in late autumn, there were only a few last chrysanthemums, a few leafless roses. Down this path, at around eleven o'clock, the cortège set out. It turned right into the Chemin du Roy and headed in the direction of the church (which it was not to enter) and the cemetery. The route was about a kilometre long. Wearing his mayor's sash, Alexandre Gens walked before the hearse, a small two-wheeled carriage, painted black, above which rose a bier of black cloth. The bier was crowned, spangled and hung about with decorations of silver. The carriage was drawn by two local men, with the help of two others who pushed

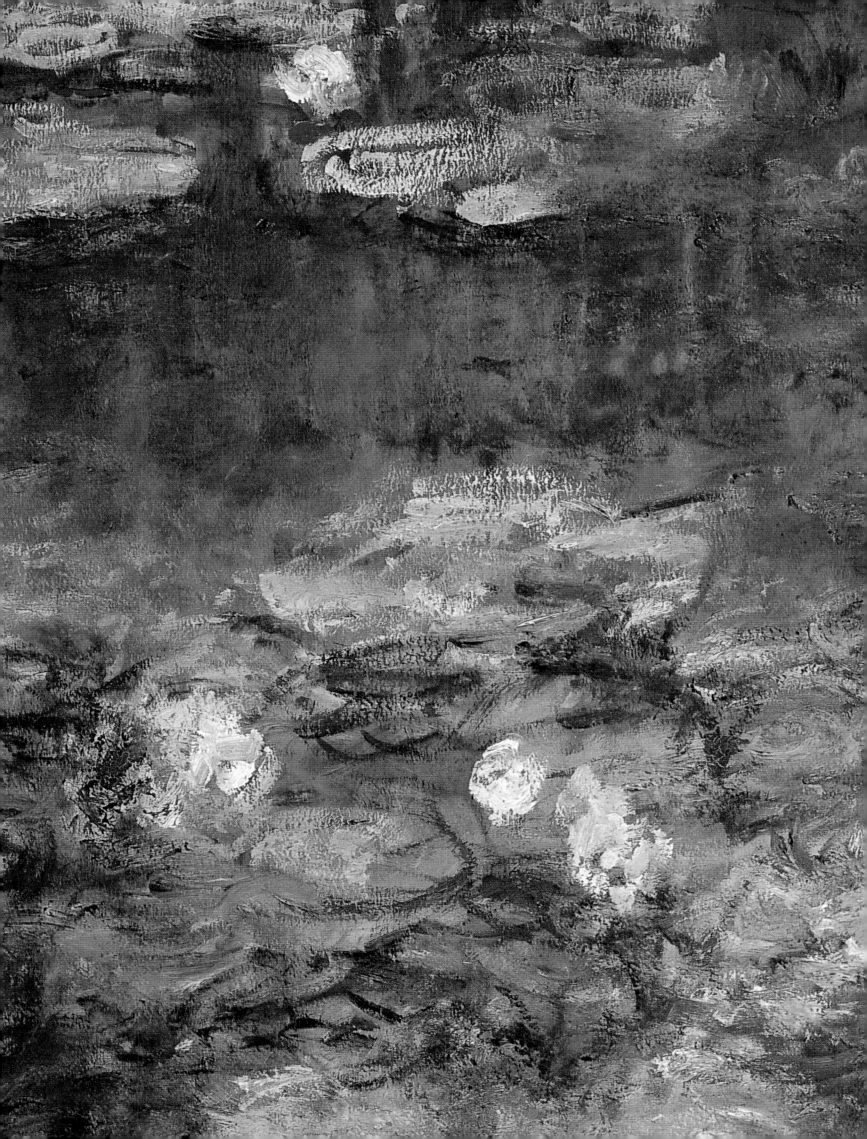

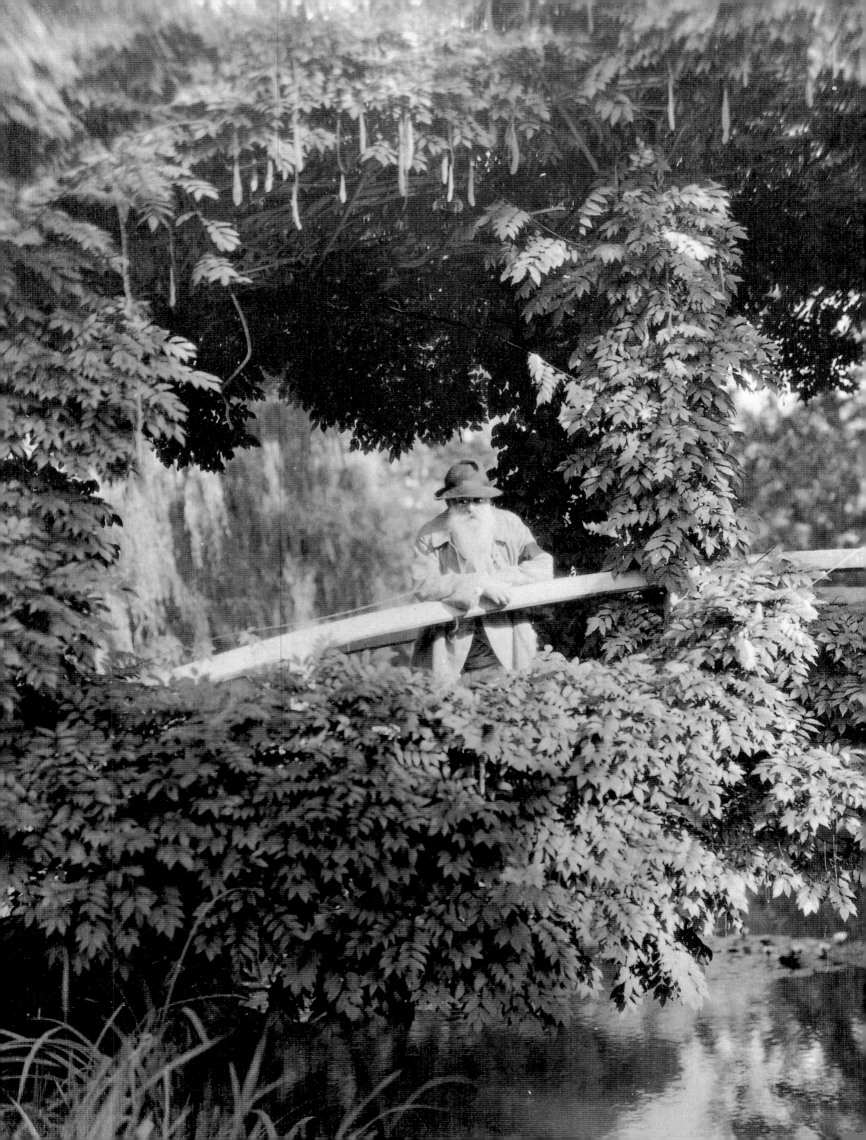

from behind. All four wore their Sunday best, and not their work clothes, as has often been said. There were no pallbearers. In accordance with the old custom, the men, including non-relatives, walked in front of the women. The women were led by Monet's stepdaughters, their faces invisible behind their black veils. From their doorsteps and behind their windows and fences, the people of Giverny watched the procession pass, bearing away the body of the man through whom their village had secured a place in history.

Although J.-P. Hoschedé vigorously denied it, Clemenceau was certainly part of the cortège. His presence was documented by several journalists, who described him walking along, resting his weight on his stick, enveloped in a capacious great-coat with a velvet collar. He was spotted at one point near the women (a photograph published by *L'Echo de Paris* confirms this), and at another was right at the tail-end of the procession, arm in arm with Dr Rebière. But before they reached the graveyard, Clemenceau was overcome, whether by fatigue or by emotion: "Halfway along the road, M. Clemenceau stopped, his hands shook and his eyes filled with tears. Someone called for his chauffeur." Thus when the cortège arrived at the cemetery, the Tiger was already there. J.-P. Hoschedé either never knew or later forgot that in order to arrive there, the old man had pushed himself to the limits of his strength.

Behind the apse of the church is a white marble cross that bears the name of Ernest Hoschedé. It rises above the tomb in which Monet was to be laid alongside Alice, her first husband, Ernst Hoschedé, Jean Monet, and Suzanne and Marthe Hoschedé-Butler. At the foot of the cross, a square of black earth bore a few yellow pansies. A sort of small window had been opened in the ground earlier that morning. From the entrance of the cemetery to the tomb the ground sloped steeply upwards and the earth was slippery. Behind the four coffin-bearers who had taken the box in their arms, the rest of the procession was left to plod through the mud. People gathered round Clemenceau to help him, but he indicated that he wanted to manage without their aid. A film crew was there to record the event, and a photographer who captured the mourners arrayed in a semi-circle around Clemenceau, while the coffin lay to one side as if abandoned under its strange shroud of pale cretonne. For a moment, Monet was forgotten, and all eyes were fixed on the "President", so as to miss no detail of his grief. After a moment of silent meditation, when it seemed that the ceremony might be over, Clemenceau was heard to murmur: "I want to see him lowered in." The coffin was duly lowered into the ground. Its painfully slow descent ended in two muffled thuds.

That was the signal for the mourners to disperse. Those who were there to see and be seen rushed to the gate so as not to lose sight of Clemenceau. The Father of Victory was now in full control of himself again. His gaze had regained its vigour as he got into his limousine and he sat bolt upright as it drove away. Those who sought a different consolation from that of the presence of an illustrious man were left to the silence of prayer and the sure knowledge of having breathed the same air as the artist's fathomless genius.

Epilogue

After the funeral, two important problems remained. One concerned Monet's estate, the other the *Decorations*. The second problem was more easily solved. The arrangements for the transport of the panels were decided on 21 December 1926, when Paul Léon visited Giverny with Messrs Guiffrey and Masson, curators with the Musées Nationaux, and the architect, Camille Lefèvre. A few days

PAGE 460:
Claude Monet on the Japanese bridge
1925
Paris, Archives of the Musée Clemenceau

Wednesday, 8 December 1926, Claude Monet's funeral procession, lead by the Mayor of Giverny, Alexandre Gens and followed by Michel Monet, James Butler, J.-P. Hoschedé and Theodore E. Butler leading the Master to his tomb.
Photograph Madame Ciolkowska Collection

Monet's family tomb in the cemetery at Giverny

later, the enormous canvases set out on the road to Paris where they were photographed, prior to their restretching, in the Cour Visconti of the Louvre. These photographs are reproduced here. They irrefutably demonstrate that the *Decorations* comprised exactly 22 panels, a figure that the authors of even the most official accounts have sometimes misstated.

With Georges Clemenceau's vigorous encouragement, the Fine Arts Administration installed the paintings in the Orangerie during the first months of 1927. They worked so fast that the gallery was officially opened to the public by mid-May. However, work then ceased for some time. "Yesterday I went to the Orangerie", Clemenceau noted on 7 June 1928. "There was no one else there at all..." This state of affairs continued for over half a century.

From a legal perspective, Monet's estate was a very simple matter. Since the artist had not left a will, his son Michel inherited everything. Monet having issued no particular instructions either, despite repeated promises to do so, Michel was under no obligation to the children of Alice Hoschedé-Monet, his father's second wife. The fate of Jean Monet's widow, Blanche, was also in Michel's hand. Michel was well aware of the role she had played in his father's final years, and that she had given up painting to devote all her time to him. Michel thus entrusted Blanche with the administration of the property at Giverny, as well as with the preservation and management of the large collection of pictures that were to be found there. Some of these pictures are mentioned on lists of prices which were drawn up for Blanche to submit to prospective purchasers. The profit from these sales was now Michel's essential source of income. He put his life into some sort of order, building a house at Sorel-Moussel between Dreux and Anet, where he lived with the former model, Gabrielle Bonaventure, whom he married in 1931. His great passions were motor cars and all things African. But he did not simply turn his back on Giverny, and continued to pay for the upkeep of the gardens, in so far as his means (which were far from negligible) allowed.

After Blanche's death in 1947, her brother, Jean-Pierre Hoschedé, took over her role as guardian of the estate for several years, before retiring to the Maison Bleue. There he wrote his moving memoir, *Claude Monet, ce mal connu* (Claude Monet as I knew him), which he was able to see through the press a few months before his death. With Jean-Pierre's retirement, Michel's visits to the garden and the tombs at Giverny became more frequent. Not even his wife's death, which shook him badly, lessened his attention to these relics of his father. In February 1966, in the course of one of these trips, he was fatally injured at Vernon while driving a powerful car, a practice in which he had persisted despite encroaching deafness.

His sole heir was the Musée Marmottan, which belongs to the Académie des Beaux-Arts. The Académie undertook substantial work in order to provide a proper setting in the museum for the important collection of pictures it inherited. They are exhibited there under the title *Monet and His Friends.* The Académie has also managed the restoration of Monet's property at Giverny, to great acclaim.

After Michel's death, the only surviving witness to Monet's heroic days at Vétheuil and Poissy and to his early years at Giverny was Germaine Hoschedé-Salerou. She survived Michel by three years, and visitors to the Villa des Pinsons were always astonished by how vivid her memories of the younger Monet remained. Alice's descendants have continued to show their affection for Monet's memory, and the children of his niece, Louise, Léon Monet's daughter, and her husband Dr Lefebvre, who own the moral right to Monet's works, have also contributed greatly to the restoration of the gardens of Giverny.

Index
of Proper Names

A

Achard, Léon, 208
Alexandre, Arsène, 338, 356, 390, 396, 413, 414
Alexis, Paul, 104
Allard, Roger, 397
Amaury, Abbé, 146, 147
André, Albert, 446, 447
Andrieu, Jules, 30
Anker, Albert, 46
Ansault-Chauvel, Mme, 148, 173
Antoine, Jules, 255
Arnyvelde, André (alias André Lévy),
36, 37, 145, 191, 400
Arosa, Achille, 117
Astruc, Zacharie, 61, 63, 67, 70, 76
Aubert, Andreas, 303
Aubourg, Ernestine, 70
Aubrée, François-Léonard, 9
Aubrée-Monet, Louise-Justine, 9, 12, 17
Aubry, Louis-Eugène, 93
Aubry, Paul, 322
Aubry-Vitet, Mme, 93, 111
Auger-Dauvel, Mme
(born Sophie-Julienne Lebis), 138, 144
Aumont-Thiéville, Maître, 80, 101
Authier, Henriette, 104

B

Bachelard, Gaston, 353
Baldensperger, Mme, 443
Balsadella, Etta Lisa, 386–388
Ballu, Roger, 129
Bang, Herman, 304, 307
Barbier, André, 433–437, 440, 442–444, 447
Barillon, Mme, 413
Bastien-Lepage, Jules, 301
Baudelaire, Charles, 243
Baudet, Maître, 422
Baudot, Jeanne, 432
Baudry, L.-E., 101
Baudry, Paul, 107, 351
Bazille, Frédéric,
45, 46, 48–50, 52, 53, 56, 58–61, 63, 66, 67, 69,
70, 73–76, 78, 84, 85, 92, 103, 350

Becq de Fouquières, Louise-Marie, 22, 60
Béliard, Edouard, 104, 106
Bellio, Dr Georges de,
120, 128, 130–132, 135–138, 142, 144–148, 152, 154,
155, 164, 170, 186, 196, 205, 234, 252, 256, 257,
273, 282, 297
Bellio, Victorine de: see Donop de Monchy
Benassit, Emile, 29, 30
Bénédite, Léonce, 318, 423, 430, 431
Béraldi, Henri, 274, 279
Bérard, Léon, 417, 422
Bérard, Paul, 186
Berend, Daisy
(Baroness d'Estournelles de Constant), 218
Bergerat, Emile, 163, 187, 302
Bergman, Anna, 359
Beriot, 101
Bernadotte, Eugène:
see Eugene, Prince of Sweden
Bernard, Emile, 298, 301, 331–333
Bernheim-Jeune, Gaston et Joseph,
353, 360, 361, 375, 379, 388, 396, 398, 400, 410,
412, 414, 440, 442, 443
Bernheim, Georges, 400, 410–414
Bertall, Albert, 119
Berteaux, Maurice, 370
Berthelot, André, 415
Berthier, Paul, 120
Besnard, Albert, 214, 233, 237, 262, 430
Besnard, Sylvain, 363, 370
Besson, George, 397
Bigot, Charles, 119
Bijvanck, W.G.C., 280
Billot, Léon, 69, 73
Bjørnson, Bjørnstjerne, 304, 307
Blanchard (teacher of Monet), 11, 208
Blanche, Dr, 270
Blanche, Jacques-Emile, 294, 444
Blavette, Victor, 418
Blémont, M., 121
Blémont, Emile, 117
Bodmer, Karl, 31
Boileau, Nicolas, 164
Boivin, 241
Bonaventure, Gabrielle:
see Mme Michel Monet
Bonheur, Rosa, 27
Bonington, Richard Parkes, 25
Bonnard, Pierre, 445
Bonnat, Léon, 293, 409
Bonnier, Louis, 360, 413–415, 417, 418, 420
Bontoux, Eugène, 174
Borchardt, Félix, 375
Bordat, Madeleine (married Lauvray),
148, 151, 152, 157
Borelli, Jean-Baptiste, 198, 200
Boubée, Simon, 119
Bouchet-Doumeng, Henri, 45
Boudin, Eugène, 17–24, 26, 27, 33, 39, 53, 62,
69, 73, 75, 77, 84, 93, 94, 99, 107, 114, 142, 180,
221, 241, 251, 371, 396
Bouguereau, William, 246, 262, 294, 350, 449
Boulade: see Raingo, Coralie
Boulanger, General Georges, 249, 268
Bourgeat, Fernand, 256
Bourgeois, Léon, 267

Boussod and Valadon (Gallery),
238, 244, 271, 273, 280, 283, 361
Boyme, Albert, 48
Bracquemond, Félix, 107, 155, 262, 288
Braquaval, Louis, 308
Braque, Georges, 131
Brandon, Edouard, 107
Braun, 253
Breton, Jules, 63, 287, 288, 349
Breuil, Félix, 370, 400
Brown, John Lewis, 241, 350
Brunetière, Ferdinand, 302
Bruno ("the hunter from Lavacourt"), 195
Bruyas, Alfred, 53
Buffet, Eugénie, 404
Bulloz, Ernest, 325, 376
Burger, William (alias Thoré-Burger), 61
Burty, Philippe,
79, 107, 142, 159, 176, 187, 189, 206, 218, 258
Butler, Alice or Lily, 393, 438, 443
Butler, James or Jimmy, 327, 461
Butler, Marthe: see Hoschedé-Butler, Marthe
Butler, Suzanne:
see Hoschedé-Butler, Suzanne
Butler, Theodore-Earl, 284, 341, 345, 347, 374,
394, 396, 438, 461
Byvanck: see Bijvanck

C

Cabadé, Dr Ernest, 67
Cabanel, Alexandre, 50, 56, 155, 246, 294, 351
Cabot, Lilla: see Perry
Cadart, Alfred, 59, 67
Caillebotte, Gustave,
98, 114, 117, 120, 125, 132, 140, 142–144, 148, 155,
157, 159, 164, 179, 202, 205, 208, 238, 241, 287,
297, 301, 312, 314, 318
Calmette, Gaston, 262, 263
Calonne, Alphonse de, 255
Cambon, Paul, 349
Camondo, Isaac de, 299, 300, 336
Cantin, 149
Carjat, Etienne, 17
Carnot, Sadi, 253
Carolus-Duran
(alias Charles Durand), 67, 262, 329
Carpentier (ironmonger), 103
Carrière, Eugène, 309, 326, 331
Casimir-Perier, 350
Cassatt, Mary, 137, 143, 155, 217, 258
Cassinelli, Henri
(nickname: Rufus Croutinelli), 20, 73
Cassirer, Paul, 362, 369
Castagnary, Jules, 29, 80, 107, 238
Caussy, Fernand, 369
Cazin, Jean-Charles, 206, 240, 262, 331–334
Cellier, Auguste, 192
Cézanne, Paul, 26, 56, 61, 63, 70, 111, 118, 119,
129, 157, 160, 218, 236, 262, 299, 301, 308, 312,
314, 331, 336, 371, 376, 377, 380, 398
Chabrier, Emmanuel, 133, 137
Chambry, Mme de, 357

Fresson, Antoinette-Reine, 9
Freycinet, Charles Louis de Saulses de, 267
Fromenthal, M., 117
Fromentin, Eugène, 38
Fuller, William, 331
Furetières (alias Georges Niel), 365

G

Gabrielle (model), 58, 59
Gachet, Dr Paul, 132, 276
Gaillard, Isidore, 9
Gaillard, Marie-Jeanne (wife of Lecadre), 10, 16, 21, 23, 27, 28, 39, 40, 42, 49, 61, 62, 68, 76, 83
Gallé, Emile, 390
Gallimard, Paul, 253
Gambetta, Léon, 85, 183, 261
Garnier, Charles, 176, 203
Gaudibert, Louis-Joachim, 21, 53, 70, 73–76, 78
Gaudibert, Louis-Joseph, 53
Gaudibert, Mme
(born Marguerite-Eugenie Marcel), 53, 70, 71, 73
Gauguin, Paul, 175, 203, 206, 241, 284, 294, 301, 380
Gautier, Amand, 16, 21, 22, 27, 32, 39, 40, 42, 43, 46, 49, 50, 52, 60–62, 91, 93, 104
Gayda, Joseph, 256
Geffroy, Gustave, 28, 31, 36, 186, 187, 191, 221, 228, 229, 233, 234, 243, 247–249, 253, 254, 260, 263, 265, 268, 270, 271, 273, 274, 276, 279, 287, 294, 299, 301, 302, 304, 309, 320, 324, 328, 342, 348, 387, 390, 394, 396, 403, 406, 408, 413, 417, 418, 422, 442, 443
Genet, Henri, 397
Gens, Alexandre, 460
George, Charles, 136
Georges-Michel, Michel, 403, 405
Gérome, Léon, 45, 46, 77, 246, 262, 293, 308, 315, 317, 319, 351, 364
Gervex, Henri, 206, 262
Ghéon, Henri, 397
Gigoux, Jean-François, 25
Gilbert, Paul, 206, 219
Gill (alias André Gosset de Guines), 61
Gillet, Louis, 431
Gimpel, René, 63, 135, 246, 412, 448, 449
Giron, Charles, 206
Glaenzer, 299
Glatigny, Albert, 29
Gleyre, Charles, 43, 45, 46, 48–50, 53, 58, 59, 61, 63, 76, 80, 133, 162
Goeneutte, Norbert, 276
Goncourt, Edmond de (and his brother), 205, 244, 249, 253, 404
Gonzalès, Eva, 350
Gosset, Prof. Jean, 430
Gouery, 186
Gounod, Charles, 110
Gourmont, Rémy de, 376
Graff, Paul and Eugénie, 175, 186, 313
Gravier (a framer and ironmonger's shop), 17
Greco, El (Domenikos Theotokopulos), 369

Greuze, Jean Baptiste, 350
Grimm, Baron (alias Albert Millaud), 129
Grimpard, Maître, 268, 274
Gros, Antoine, Baron, 351
Gudin, Théodore, 17
Guerbois, Auguste, 76
Guerbois, Gabriel, 150, 153
Guiffrey, Jean, 461
Guillaume, Hippolyte: see Poly
Guillaumin, Armand, 104, 175
Guillemet, Antoine, 70, 106, 159, 218, 262
Guillemot, Maurice, 191, 316, 319, 320–322, 328, 336, 390, 403
Guimard, Paul, 389
Guitry, Lucien, 353
Guitry, Sacha, 400, 401, 405, 406, 408, 442, 457

H

Hadol, Paul, 17
Hagerman, 63
Hancke, Erich, 398
Harpignies, Henri, 159, 235, 236, 288
Harrison, Alexander, 354
Harrison, L.A., 372, 373
Hatté, Alfred, 67
Haussmann, Georges Eugène, Baron, 122
Hautecœur, Louis, 397
Havard, Louis Gustave, 146
Havemeyer, 365
Haviland, Ch. Ed., 258
Hayashi, Tadamara, 368
Hebrard, 165
Hecht, Albert and Henri, 101, 117, 138, 196, 258
Helleu, Paul, 239, 240, 258, 287, 320, 442
Helleu, Paulette, 443
Henner, Jean-Jacques, 375
Hennique, Léon, 406
Herbet and Loreau, 121
Hersent, Louis, 45
Hervieu, Abbé, 395
Hervilly, Ernest d', 107
Heyman, 208
Hilderson, M. and Mme A., 370
Hilverdink, Johannes, 89
Hiroshige
(known as Utagawa Ichirijusai), 276, 289, 335
Hokusai, Katsushika, 100, 304
Holtzapffel, Jules, 61
Honnorat, André, 414
Hoschedé, Edouard-Casimir, 121, 122
Hoschedé, Ernest
(son of Edouard-Casimir), 110, 117, 120, 122, 124, 125, 128, 130, 135–140, 143–153, 155, 157, 159, 164, 165, 167, 169, 170, 172, 174, 179, 182, 185, 268, 276, 279, 287, 316, 396
Hoschedé, Honorine (born Saintonge, wife of Edouard-Casimir), 120–122, 138, 140, 144, 146, 147, 151, 157, 165
Hoschedé, Jacques (son of Ernest and Alice), 120, 121, 122, 151, 152, 170, 173, 287, 302, 303, 306, 341, 346, 358, 359, 364, 393, 400
Hoschedé, Jean-Pierre (son of Ernest and

Alice), 125, 151, 169, 191, 192, 209, 221, 260, 270, 273, 276, 280, 346, 358, 359, 364, 375, 386, 393, 395, 396, 400, 404, 406, 423, 461, 462
Hoschedé, Mme Jean-Pierre
(born Geneviève Costadau), 396
Hoschedé-Butler, Marthe
(daughter of Ernest and Alice, second wife of Théodore-Earl Butler), 122, 138, 149, 157, 167, 216, 347, 349, 396, 438
Hoschedé-Butler, Suzanne (daughter of Ernest and Alice, first wife of Théodore-Earl Butler), 120, 121, 122, 151, 155, 221, 276, 284, 315, 327, 332, 346, 349, 393, 396, 446, 462
Hoschedé-Monet, Alice (born Raingo, (wife of Ernest Hoschedé and Claude Monet), 121, 122, 124, 125, 136, 138, 141, 144, 146, 149–152, 155, 157, 159, 164, 165, 168–170, 172, 174, 183, 185, 186, 189, 195, 196, 198, 201, 209, 211, 212, 217, 221, 225, 228–230, 238, 246, 250, 252, 268, 276, 280, 287, 294, 302, 304, 331, 332, 340, 344, 346, 349, 354, 358, 359, 369, 376, 383, 385–389, 393, 394, 400, 403, 462
Hoschedé-Monet, Blanche (daughter of Ernest and Alice, wife of Jean Monet), 120, 121, 122, 124, 125, 165, 180, 274, 306, 319, 346, 359, 375, 393, 396, 403, 409, 426, 428, 430, 439, 443–446, 449, 452, 458, 462
Hoschedé-Salerou, Germaine (daughter of Ernest and Alice, wife of Albert Salerou), 121, 122, 124, 145, 150, 192, 221, 339, 346, 357, 359, 360, 361, 363, 388, 401, 462
Houssaye (alias Arsène Housset), 73, 78–80
Hugo, Victor, 377
Hunter, Charles, 347, 348
Hunter, Mary, 347, 354, 385, 386
Huysmans, Joris-Karl, 159, 205, 218, 221, 233, 260

I

Ibsen, Henrik, 307
Ingres, Jean Auguste Dominique, 313, 375
Isabey, Eugène, 24, 25
Isnardy, M. (Director of the Casino), 209

J

Jacque, Charles, 25
James, Henry, 353
Jaurès, Jean, 301, 367
Jean-Aubry, Georges, 18, 396
Jeanniot, Georges, 243
Joffre, General Joseph Jacques Césaire, 370
Jongkind, Johan Barthold, 39, 40, 42, 49, 53, 89, 104, 142
Jourdain, Frantz, 248, 253, 258, 379, 409
Jouy, Anatole-Jules de, 112
Joyant, Maurice, 273, 283, 299, 300, 317, 397, 405, 411

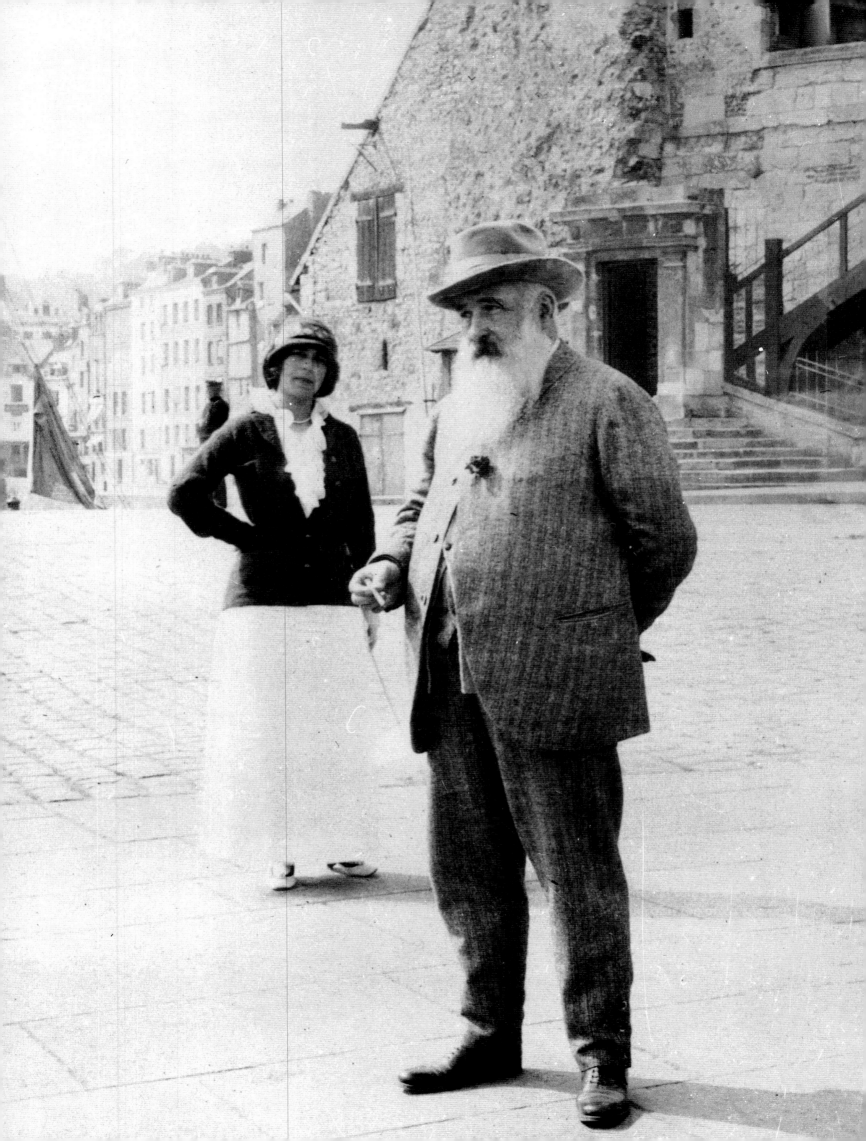

List of Illustrations

Acknowledgements

The publishers wish to thank all the museums, private collections, private collectors, archives and photographers who have supplied photographic material for reproduction in this catalogue. The illustrations stem from the museums named in the captions, and from the archives of the Wildenstein Institute and of Benedikt Taschen Verlag. The following acknowledgements are also due:

© THE ART INSTITUTE OF CHICAGO.
ALL RIGHTS RESERVED:(1991) 1757; (1992) 546, 110, 284, 758, 854, 1024, 1204, 1253, 1397, 1683; (1996) 1269, 1270, 1278, 1281, 1283, 1284, 1645

© ARTOTHEK, PEISSENBERG: 132

© BEN BLACKWELL, SAN FRANCISCO: 415

© NATIONAL GALLERY OF ART, WASHINGTON, BOARD OF TRUSTEES: 61, 101, 130, 312, 381, 613, 629, 685

© STERLING AND FRANCINE CLARK ART INSTITUTE, WILLIAMSTOWN, 1993: 1358, D 434

© THE CLEVELAND MUSEUM OF ART: 257, 676, 1975

© WALTER DRÄYER, ZURICH: 1979

© THE FINE ARTS MUSEUMS OF SAN FRANCISCO: 1736, 1788

© PRESIDENT AND FELLOWS HARVARD COLLEGE, HARVARD UNIVERSITY ART MUSEUM: 745

© DÉNES JÓZSA, BUDAPEST: 154

© KUNSTHAUS ZÜRICH. ALL RIGHTS RESERVED, 1995: 38, 54, 1607, 1964, 1965, 1980

© CLICHÉ H. MAERTENS, NANTES: 1886

© THE METROPOLITAN MUSEUM OF ART, NEW YORK: 605; (1980/93) 628; (1989) 91, 95, 134, 832, 1609; (1993) 60; (1994) 281, 1133, 1891, 1052, 1279, 1518

© PHOTOGRAPHIE MUSÉE DE GRENOBLE: 1878

© MUSÉE D'UNTERLINDEN COLMAR, PHOTO O. ZIMMERMANN: 1226

© MUSÉE MARMOTTAN, PARIS: 176, 263, 455, 883, 1154, 1327, 1606, 1783, 1811, 1821, 1902, 1933

© MUSÉE EUGÉNE BOUDIN, HONFLEUR: 1847

© MUSEUM OF FINE ARTS, BOSTON (1993): 382, 387, 621, 687, 805, 1000, 1176, 1219, 1252, 1280, 1289, 1348, 1356, 1481, 1526, 1738

© THE MUSEUM OF MODERN ART, NEW YORK, 1996: 1972, 1973, 1974

© NASJONALGALLERIET, OSLO: 1044

© THE NELSON GALLERY FOUNDATION. ALL REPRODUCTION RIGHTS RESERVED, 1995: 293, 1977

© NIEDERSÄCHISCHES LANDESMUSEUM, LANDESGALERIE, HANNOVER: 448

© PORTLAND ART MUSEUM, PORTLAND: 1795

© RHEINISCHES BILDARCHIV, COLOGNE: 822

© PHOTO R.M.N. MUSÉE D'ORSAY, PARIS: 6, 10, 14, 16, 63a, 63b, 67, 69, 79, 121, 133, 155, 203, 274, 365, 416, 438, 469, 532, 543, 567, 1076, 1077, 1100, 1116, 1151, 1319, 1321, 1346, 1610, 1843; MUSÉE DES BEAUX-ARTS, CAEN 1667; MUSÉE DES BEAUX-ARTS, LE HAVRE 1608; MUSÉE DES BEAUX-ARTS, LILLE 1605; MUSÉE DES BEAUX-ARTS, LYON 821

© PETER SCHÄLCHLI, ZURICH: 58

© FOTO G. SCHIAVINOTTO, ROME: 1507

© STICHTING KRÖLLER-MÜLLER MUSEUM, OTTERLO: 323

© TRUSTEES OF PRINCETON UNIVERSITY: 1509, 1612 (Photo Credit Clem Fiori)

© VIRGINIA MUSEUM OF FINE ARTS, RICHMOND: (1996) 287 (photo: Katherine Wetzel)

© OLE WOLDBYE, COPENHAGEN: 57

© WORCESTER ART MUSEUM: 1733

PAGE 470:
Monet at the Lieutenance in Honfleur, late October, 1917.

PAGE 479:
Monet and Clemenceau. Photograph taken by the Japanese photographer, Kuroki, when he vistited Giverny with his wife in June, 1921, Archives of the Musée Georges Clemenceau, Paris.